GREAT EVENTS
FROM
HISTORY II

GREAT EVENTS FROM HISTORY II

HISTORY II

Arts and Culture
Series

Volume 1
1897-1921

Edited by
FRANK N. MAGILL

SALEM PRESS
Pasadena, California Englewood Cliffs, New Jersey

THE UNIVERSITY OF TOLEDO LIBRARIES

Copyright © 1993, by SALEM PRESS, INC.
All rights in this book are reserved. No part of this work
may be used or reproduced in any manner whatsoever or
transmitted in any form or by any means, electronic or
mechanical, including photocopy, recording, or any in-
formation storage and retrieval system, without written
permission from the copyright owner except in the case
of brief quotations embodied in critical articles and
reviews. For information address the publisher, Salem
Press, Inc., P.O. Box 50062, Pasadena, California 91105.

∞ The paper used in these volumes conforms to the
American National Standard for Permanence of Paper
for Printed Library Materials, Z39.48-1984.

Library of Congress Cataloging-in-Publication Data
Great events from history II. Arts and culture series / ed-
ited by Frank N. Magill.
 p. cm.
 Includes bibliographical references and index.
 1. Arts, Modern—20th century. 2. Arts and so-
ciety—History—20th century. I. Magill, Frank Northen,
1907- . II. Title: Great events from history. 2. Arts
and culture series.

NX456.G72 1993
700'.9'04—dc20
ISBN 0-89356-807-4 (set) 93-28381
ISBN 0-89356-808-2 (volume 1) CIP

PRINTED IN THE UNITED STATES OF AMERICA

NX
456
'G72
1993
v. 1
Reference

PUBLISHER'S NOTE

Great Events from History II: Arts and Culture Series is the third set in the *Great Events from History II* series in the Magill family of reference books. This new series was inaugurated by *Great Events from History II: Science and Technology Series* (1991) and continued with *Great Events from History II: Human Rights Series* (1992). The current series joins the original twelve-volume series *Great Events from History: Ancient and Medieval* (three volumes, 1972), *Modern European* (three volumes, 1973), *American* (three volumes, 1975), and *Worldwide Twentieth Century* (three volumes, 1980). Combined, the volumes in the original *Great Events* series survey, in chronological order, major historical events throughout the world from 4000 B.C. to 1979.

The new series, *Great Events from History II*, presents entirely original articles treating twentieth century events never before covered. The current five volumes of *Arts and Culture* address 493 topics spanning the cultural and artistic life of the modern world, from landmarks in such fine arts as ballet and painting to developments in such popular genres as rock music and television comedy. *Great Events from History II* also extends and supplements the original series by treating events by topic, rather than by geographical occurrence. Future volumes in *Great Events from History II* will concentrate on other major areas of contemporary culture.

Like the original *Great Events*, the articles in *Great Events from History II: Arts and Culture* are arranged chronologically by date of event, beginning in 1897 with Konstantin Stanislavsky's invention of method acting and ending in 1992 with the literary and artistic furor surrounding the five hundredth anniversary of Christopher Columbus' arrival in the Americas. A broad range of artistic and cultural topics is addressed. Twenty-six essays in the new series discuss the evolution of modern architecture; forty-five concern important developments in the visual arts; twenty-seven focus on the world of dance; nineteen look at changes in fashion and design; ten examine journalism and the print media; ninety-five discuss the century's most influential works of literature; seventy-six focus on motion pictures and filmmaking; eighty-seven concentrate on modern music, both serious and popular; fifty-five focus on the world of the theater; and fifty-three examine the quintessential twentieth century phenomena of television and radio.

The articles in this series run somewhat longer (2,500 words) than the entries in the original *Great Events* set, allowing for more in-depth coverage of events that may have years of background and many areas of long-range significance. The format of these essays, while retaining the basic outline of the articles in the original series, has been revised somewhat to reflect the needs of the new subject orientation.

Each article still begins with ready-reference listings: "Category of event" (architecture, art, dance, fashion and design, journalism, literature, motion pictures, music, theater, or television and radio), "Time" (range of years, year, or, where applicable, specific date of event), and "Locale" (geographic location). Each article then gives a brief (two- or three-line) summary of the event and its significance. A list of

"Principal personages" who were key players in the event follows. The text begins with a "Summary of Event," a description of the event itself and background relevant to it. Here the reader will find a narrative of the circumstances that led up to the event and the backgrounds of the people involved. The "Impact of Event" section (which did not appear in the original *Great Events* series) devotes itself to an assessment of both the immediate and the long-range significance of the event. Next, an annotated bibliography lists and describes between five and ten sources for further study, enabling the reader to choose among books and articles that will cast more light on the topic. These sources have been chosen for relevance to the topic in question and for accessibility through most libraries. Finally, the "Cross-References" appearing at the end of each article direct the reader to other articles of related interest that appear in the current five volumes.

The articles in *Great Events from History II: Arts and Culture* have been arranged chronologically to provide a temporal perspective on the individual events, and the editors have thus thought it useful to add a complete chronological index of all 493 articles at the end of each volume. Several other indexes, found at the end of volume 5, have been included to provide maximum flexibility in retrieving information. At the end of volume 5, the reader will find five indexes: The "Alphabetical List of Events" indexes events alphabetically by article title; the "Category Index" lists all articles by general topic (such as dance or music); the "Geographical Index" separates articles by their country of occurrence, reflecting the international scope of the volumes; "Principal Personages" lists all key figures appearing in the corresponding subsection of each article, so that readers can easily find the events in which a particular person played a key role. Finally, the "Subject/Key Word Index" expands on the "Key Word Index" found in earlier entries in the *Great Events from History II* series; the new index directs readers to articles that give substantial treatment to specific topics of interest. In all five of these useful indexes, both the relevant volume number and page number appear following each index entry.

Great Events from History II: Arts and Culture, unlike the original *Great Events*, lists the full names of the academicians and scholars who wrote these articles, both in a byline at the end of each article and in a listing of contributors to be found in volume 1. We wish to acknowledge the efforts of these specialists and to thank them for making their expert knowledge accessible to the general reader.

CONTRIBUTING REVIEWERS

McCrea Adams
Independent Scholar

Michael Adams
Fairleigh Dickinson University

Richard Adler
University of Michigan—Dearborn

Pegeen H. Albig
Radford University

Patrick Allitt
Emory University

Madeline C. Archer
Duquesne University

Frank Ardolino
University of Hawaii

Gerald S. Argetsinger
Rochester Institute of Technology

Anne Atwell-Zoll
Independent Scholar

Bryan Aubrey
Maharishi International University

Susan Benforado Bakewell
Kennesaw State College

JoAnn Balingit
Independent Scholar

Mary Pat Balkus
Radford University

David Barratt
*Chester College
England*

Thomas F. Barry
*Himeji Dokkyo University
Japan*

Felicia Bender
Independent Scholar

Richard P. Benton
Trinity College

Charles Merrell Berg
University of Kansas

S. Carol Berg
College of Saint Benedict

Wayne M. Bledsoe
University of Missouri at Rolla

Julia B. Boken
State University of New York at Oneonta

Michael R. Bradley
Motlow College

John Braeman
University of Nebraska—Lincoln

Cynthia L. Breslin
Independent Scholar

Thomas C. Breslin
California State University, Northridge

John A. Britton
Francis Marion College

William S. Brockington, Jr.
Historical Perspectives

Keith H. Brower
Dickinson College

Robert W. Brown
Pembroke State University

Charles R. Caldwell
Independent Scholar

Charles Cameron
Independent Scholar

Edmund J. Campion
University of Tennessee

Byron D. Cannon
University of Utah

Thomas J. Cassidy
South Carolina State College

Nan K. Chase
Appalachian State University

Richard G. Cormack
Independent Scholar

Ralph L. Corrigan, Jr.
Sacred Heart University

Maureen Needham Costonis
Vanderbilt University

John R. Crawford
Kent State University

Jim Cullen
Independent Scholar

LouAnn Faris Culley
Kansas State University

Merrilee Cunningham
University of Houston, Downtown

Frederick E. Danker
University of Massachusetts at Boston

Mary Virginia Davis
California State University, Sacramento

Frank Day
Clemson University

Bill Delaney
Independent Scholar

Tom Dewey II
University of Mississippi, Oxford

J. R. Donath
California State University, Sacramento

Marjorie Donovan
Pittsburg State University

Brian R. Dunn
Clarion University of Pennsylvania

Robert P. Ellis
Worcester State College

Thomas L. Erskine
Salisbury State University

James Feast
*Baruch College of the
 City University of New York*

John W. Fiero
University of Southwestern Louisiana

Richard A. Flom
Independent Scholar

Howard L. Ford
University of North Texas

Robert J. Frail
Centenary College

David Francis
University of Washington

Susan Frischer
Independent Scholar

Keith Garebian
Independent Scholar

Paul Giles
Portland State University

Donald Gilman
Ball State University

Douglas Gomery
University of Maryland

Sidney Gottlieb
Sacred Heart University

Scot M. Guenter
San Jose State University

Daniel L. Guillory
Millikin University

Surendra K. Gupta
Pittsburg State University

William M. Hagen
Oklahoma Baptist University

Gillian Greenhill Hannum
Manhattanville College

Fred R. van Hartesveldt
Fort Valley State College

Terri Hartman
Independent Scholar

Terry Heller
Coe College

Joyce E. Henry
Ursinus College

John R. Holmes
Franciscan University of Steubenville

Glenn Hopp
Howard Payne University

Ronald K. Huch
University of Papua New Guinea

Lawrence E. Hussman
Wright State University

William Hutchings
University of Alabama, Birmingham

Clyde Owen Jackson
Tuskegee University

Jeffry Jensen
Independent Scholar

Eunice Pedersen Johnston
North Dakota State University

Steven G. Kellman
University of Texas at San Antonio

Timothy Kelly
Chatham College

William B. Kennedy
Clarion University of Pennsylvania

Christine Kiebuzinska
*Virginia Polytechnic Institute
and State University*

Jim Kline
Independent Scholar

Grove Koger
Boise Public Library

Steven C. Kowall
Independent Scholar

Lynn C. Kronzek
University of Judaism

Marc J. LaFountain
West Georgia College

Gary Land
Andrews University

Karl G. Larew
Towson State University

Eugene S. Larson
Pierce College, Los Angeles

Katherine Lederer
Southwest Missouri State University

Douglas A. Lee
Vanderbilt University

Richard M. Leeson
Fort Hays State University

Leon Lewis
Appalachian State University

Scott M. Lewis
Independent Scholar

D. Tulla Lightfoot
University of Wisconsin—La Crosse

Chris Lippard
University of Southern California

James Livingston
Northern Michigan University

R. M. Longyear
University of Kentucky

Janet Lorenz
Independent Scholar

David C. Lukowitz
Hamline University

R. C. Lutz
University of the Pacific

Janet McCann
Texas A&M University

Richard D. McGhee
Arkansas State University

Roderick McGillis
*University of Calgary
Canada*

Tony Macklin
University of Dayton

John L. McLean
Morehead State University

David W. Madden
California State University, Sacramento

Paul Madden
Hardin-Simmons University

Paul D. Mageli
Independent Scholar

Philip Magnier
Independent Scholar

Nancy Malloy
Archives of American Art

Dinford Gray Maness
University of South Carolina at Sumter

John Markert
Cumberland University

Laurence W. Mazzeno
Mesa State College

Kathleen Mills
Independent Scholar

John M. Muste
Ohio State University

Gregory Nehler
Indiana University

William Nelles
Northwestern State University

Byron Nelson
West Virginia University

Frank Nickell
Southeast Missouri State University

Terry Nienhuis
Western Carolina University

George O'Brien
Georgetown University

Wendy T. Olmstead
Purdue University

Robert J. Paradowski
Rochester Institute of Technology

David B. Parsell
Furman University

Jeremy K. Pearl
Independent Scholar

Constance A. Pedoto
Samford University

William E. Pemberton
University of Wisconsin—La Crosse

Toni A. Perrine
Grand Valley State University

Nis Petersen
Jersey City State College

Donald K. Pickens
University of North Texas

Steven L. Piott
Clarion University of Pennsylvania

Francis Poole
University of Delaware

John S. Reist, Jr.
Hillsdale College

Ralf Erik Remshardt
Denison University

Paul August Rentz
South Dakota State University

Betty Richardson
*Southern Illinois University at
 Edwardsville*

Ernest G. Rigney, Jr.
College of Charleston

Douglas Rollins
*Dawson College
Canada*

Jill Rollins
*Trafalgar School
Canada*

Carl Rollyson
*Baruch College of the City University
 of New York*

Evelyn M. Romig
Howard Payne University

Paul Rosefeldt
Delgado Community College

Robert L. Ross
University of Texas at Austin

Susan Rusinko
Bloomsburg University of Pennsylvania

M. David Samson
Worcester Polytechnic Institute

Daniel C. Scavone
University of Southern Indiana

Jean Owens Schaefer
University of Wyoming

Robert M. Seiler
*University of Calgary
Canada*

R. Baird Shuman
University of Illinois at Urbana-Champaign

Catherine Sim
College of Marin

L. Moody Simms, Jr.
Illinois State University

Andrew C. Skinner
Brigham Young University

Genevieve Slomski
Independent Scholar

Clyde Curry Smith
University of Wisconsin

Gary Scott Smith
Grove City College

Steven Smith
University of Virginia

Ira Smolensky
Monmouth College

Marjorie Smolensky
Carl Sandburg College

CONTRIBUTING REVIEWERS

Mary Ellen Snodgrass
Independent Scholar

Michael Sprinker
State University of New York at Stony Brook

Tony J. Stafford
University of Texas at El Paso

Gretta Stanger
Tennessee Technological University

N. J. Stanley
Agnes Scott College

August W. Staub
University of Georgia

Leon Stein
Roosevelt University

Carmen Stonge
Duquesne University

Gerald H. Strauss
Bloomsburg University of Pennsylvania

Patricia A. Struebig
University of Texas at San Antonio

James Sullivan
California State University, Los Angeles

Frederic Svoboda
University of Michigan—Flint

Glenn L. Swygart
Tennessee Temple University

Thomas J. Taylor
Independent Scholar

Terry Theodore
University of North Carolina at Wilmington

Maxine S. Theodoulou
Union Institute

Eric Thompson
University Du Qué Chicoutimi
Canada

Alecia C. Townsend
University of Redlands

Mary E. Virginia
Independent Scholar

Willis M. Watt
Fort Hays State University

Gregory Weeks
Purdue University

James M. Welsh
Salisbury State University

Donald M. Whaley
Salisbury State University

Thomas Whissen
Wright State University

Richard Whitworth
Ball State University

Clarke Wilhelm
Denison University

Cynthia J. Williams
Hobart College
William Smith College

Philip F. Williams
Arizona State University

John D. Windhausen
St. Anselm College

Stacy Wolf
University of Wisconsin—Madison

Shawn Woodyard
Independent Scholar

Clifton K. Yearley
State University of New York at Buffalo

Paul J. Zbiek
King's College

Loretta E. Zimmerman
University of Portland

LIST OF EVENTS IN VOLUME I

GREAT EVENTS
FROM
HISTORY II

STANISLAVSKY HELPS TO ESTABLISH THE MOSCOW ART THEATER

Category of event: Theater
Time: 1897-1904
Locale: Moscow, Russia

A meeting between Konstantin Stanislavsky and Vladimir Nemirovich-Danchenko led to the establishment of the Moscow Art Theater and to a collaboration that was to provide new directions in modern acting techniques

Principal personages:
KONSTANTIN STANISLAVSKY (KONSTANTIN SERGEYEVICH ALEKSEYEV, 1863-1938), a Russian actor and director, cofounder of the Moscow Art Theater
VLADIMIR NEMIROVICH-DANCHENKO (1858-1943), a Russian playwright and drama scholar, cofounder of the Moscow Art Theater
ANTON CHEKHOV (1860-1904), a Russian playwright
VSEVOLOD MEYERHOLD (1874-1940), a Russian actor and director who initially worked in the Moscow Art Theater and who was later to establish his own revolutionary theater
OLGA KNIPPER (1870-1959), a Moscow Art Theater actress who performed in Chekhov's plays and later became Chekhov's wife

Summary of Event

Konstantin Stanislavsky was already an innovative actor and director before he met Vladimir Nemirovich-Danchenko, the head of the drama department at the Moscow Conservatoire, on June 22, 1897, in a historic meeting that was to last eighteen hours. Stanislavsky had been active as an actor and director in the Alekseiev Circle, an amateur group devoted to staging light comedy and vaudeville sketches. There, he had formulated the beginnings of the directing techniques for which he would become famous. At this juncture in his career, however, Stanislavsky desperately needed his own theater as a showcase for his talent. Though Nemirovich-Danchenko was a successful drama teacher, among whose students were Olga Knipper and Vsevolod Meyerhold, he realized that the theoretical foundations he was creating in his classes would be of little consequence unless a new professional theater could be established to provide an arena for new techniques in the theater. Nemirovich believed that the success of such a new theater depended on extending its repertoire beyond the well-known classics to include contemporary Russian plays, and he was convinced that he had found the inspiration for the new theater in the work of Anton Chekhov. Stanislavsky, on the other hand, was drawn to a more traditional repertoire; he believed that the legacy of the past was more accessible to both the actors and the general theater spectator. Despite these differences, they shared in the con-

viction that there was an urgent need for a public theater in Moscow, and they spent the eighteen hours planning for the joint venture.

It took another year for Nemirovich-Danchenko and Stanislavsky to get both approval and funding for what was to become the Moscow Art Theater, and Stanislavsky assumed his role as principal director. In the meantime, Nemirovich-Danchenko gave him Chekhov's *Chayka* (1896; *The Sea Gull*, 1909) for consideration for the opening of the first season at the new theater. Stanislavsky was apprehensive, since *The Sea Gull* had closed with bad reviews in St. Petersburg; in addition, he did not understand the nuances of Chekhovian writing. In the end, Nemirovich-Danchenko convinced Stanislavsky to place the play into the repertory of the first season.

The Sea Gull proved to be a challenge in that it demanded equal attention to ten characters, not one of them faceless or undefined and each with at least one moment of passion. Nor could histrionic effects, crowd scenes, and elaborate sets substitute for the essence of *The Sea Gull*'s realism, and thus Chekhov's play was to be the turning point of Stanislavsky's career. First, Stanislavsky created a picture and an atmosphere for each act, and the opening imagery was sharply focused by physical behavior integrated into the scene. Insights into Chekhov's characters provided the greatest challenge, since Stanislavsky's previous goals of "truth" in acting and directing needed to be adjusted to project the complexity and ambivalence of the many characters. Consequently, Stanislavsky concentrated on achieving verisimilitude through painstaking demonstration of action, thought, and dialogue, organizing these elements around the performance of physical tasks and other forms of activity on the part of the characters. At the same time, Stanislavsky carefully provided stage actions that would reveal the spiritual truths about the characters: Konstantin's dropping of a glass on the floor in the last act, heedless of any consequences of his action, perfectly symbolized and expressed his resolution to commit suicide. Similarly, the character Masha called out the numbers in a lottery game automatically to show the emptiness of her life. Stanislavsky had discovered a central truth: that a moment's spiritual essence had to be set in the physical, observable world. His attention to bringing out each character's "subtext," or inner life, was illustrated in his own role as Trigorin and Knipper's as Arkadina. On opening night, after the curtain for the first act, there was a prolonged silence, but then the applause began, and act 1 got six curtain calls. By the end of act 3, the actors were weeping with excitement. The play was a triumph, and the press unanimous in its praise. Later, the sea gull became the emblem of the Moscow Art Theater and was emblazoned on the theater's curtain to commemorate the moving success of the collaboration between Nemirovich-Danchenko, Stanislavsky, and Chekhov.

The development of Stanislavsky's insights into the *mise en scène* was to continue as the Moscow Art Theater produced Chekhov's subsequent plays *Dyada Vanya* (1897; *Uncle Vanya*, 1914), *Tri Sestry* (1901; *Three Sisters*, 1920), and *Vishnyovy sad* (1904; *The Cherry Orchard*, 1908). Stanislavsky concentrated on creating a "grammar" of acting that relied on his actors' ability to use the totality of their experiences and a method that would facilitate the actors' access to their own emotions. Stanis-

lavsky was convinced that the prime task of any systematic approach must bring the two aspects together into a creative relationship. This could only be done by breaking down the role into its component parts, since, he believed, a role was not something to be comprehended in its totality but needed to be broken down into a series of smaller, more manageable explorations of problems, each to be studied individually. Only when each aspect was mastered could the actor integrate the parts into a whole concept of character. This then became the basis for the Stanislavsky approach to acting and provided the revitalization of not only the Russian theater but of the American theater as well.

Impact of Event

Stanislavsky's careful attention to the *mise en scène* and the development of his own individual style characteristic to the staging of his plays had an immediate effect in revitalizing Russian theater. Since Stanislavsky demanded strict adherence on the part of the actors to his approach to interpretation, several of his actors left the Moscow Art Theater to establish theaters of their own. Among these were Vsevolod Meyerhold and Evgeny Vakhtangov. In opposition to Stanislavsky's more atmospheric naturalism, Meyerhold foregrounded obvious theatricality as his style by openly borrowing from the circus and cabaret as well as from the highly conventionalized traditions of *commedia dell'arte* and the Japanese theater. In addition, he broke down the approach to acting into a system he called "biomechanics," consisting of expressive, gymnastic-like body movements that were to complement the stage constructions of ramps, towers, and slides on which the plays were acted out. Unlike Stanislavsky, Meyerhold exaggerated the discontinuity of plays by fragmenting action into short scenes to create the effect of montage.

Similarly, Alexander Tairov, in his Moscow Kamerny Theater, worked on theatricalizing the *mise en scène* by projecting his actors' movements within a spatial arrangement. Tairov's style, while close to Meyerhold's in its use of stage constructions, foregrounded the fluidity found in music and ballet as an expressive approach for actors. Vakhtangov, who was the director of Stanislavsky's First Studio Theater, created a style that was the synthesis of Meyerhold's strong theatricality and Stanislavsky's psychological naturalism in acting. While the three directors, in their practice of exaggerating theatricality, departed significantly from Stanislavsky's atmospheric realism, it is important to remember that Stanislavsky provided the foundation for creating a strong director's theater with its own highly individualized style of interpretation. Consequently, it was Stanislavsky's approach of breaking down action into minute parts that gave the other Russian directors the possibility for exploring their own individual approaches. Nor did Stanislavsky feel that their departure was a betrayal; he continued to support the endeavors of his former students and frequently interceded on their behalf when they encountered difficulties with the Soviet government. Thus, the development of the highly individualized Russian theater of the 1920's would not have been possible without Stanislavsky's model at the Moscow Art Theater.

The impact of Stanislavsky on the contemporary American theater was the result of several factors. An extended tour by the Moscow Art Theater in 1923 gave American directors and actors the opportunity to view the effect of Stanislavsky's approach; moreover, many actors from Stanislavsky's theater remained in the United States because of the repressive political climate in the Soviet Union. Many of them, including Richard Boleslavsky and Maria Ouspenskaya, took over the directorship of New York theater groups, while others established schools for actors in other parts of the country. Consequently, at a time when the American theater was still in its developmental stages, the Moscow Art Theater had an incalculable effect on the approach to acting and staging in the American dramatic arts. In particular, Boleslavsky as the director of the American Laboratory Theater (among the members of which were Stella Adler, Harold Clurman, and Lee Strasberg) was instrumental in shaping the course that American teaching of acting was to follow. The publication of Stanislavsky's *My Life in Art* (1924) and *An Actor Prepares* (1936) extended Stanislavsky's influence to national repertory companies beyond direct connection with the New York theatrical world.

A second factor that promoted Stanislavsky's system among American actors and directors was the Group Theatre's adoption of the Stanislavsky method in rehearsals. Clurman and his wife Adler focused particularly on two aspects of Stanislavsky's system—improvisation and affective memory—as keys to generating true emotion on stage. Strasberg took over the direction of the Actors Studio classes and created an approach designated as "the Method," a methodology of acting strongly derivative of Stanislavsky's approach. In time, the Method and Stanislavsky became synonymous, though there were fundamental differences between the two approaches with respect to the building of character. In turn, the actors and directors trained by Adler, Clurman, and Strasberg became influential in their own right and created a second generation of method actors and directors. Among these was Elia Kazan, who used method actors such as Marlon Brando, Eva Marie Saint, and Karl Malden, among others, in his productions of the plays of Tennessee Williams. When Kazan became a film director as well, his approach to directing and acting became a model for the projection of dramatic naturalism in film. Consequently, the effect of Stanislavsky on the American theater and film industry is of an extraordinary, deeply rooted nature. To some extent, it is ironic that while in the Soviet Union the Stanislavsky system was subsumed to the needs of projecting Socialist Realism in the theater and in film, Stanislavsky's heritage continued its afterlife as a dominant influence in American theater.

Bibliography

Benedetti, Jean. *Stanislavski*. New York: Routledge, 1988. An overview of Stanislavsky's life and art. Since Benedetti introduces material not previously published or translated, her book addresses many issues overlooked in previous biographies. An excellent, well-written, easily comprehensible introduction to Stanislavsky's views on theater art. Photographs, bibliography, index, and appendix, with a year-

by-year account of Stanislavsky's career, are included.

Edwards, Christine. *The Stanislavsky Heritage.* New York: New York University Press, 1965. A fine exploration of Stanislavsky's contribution to the development of the art of acting. Edwards focuses on Stanislavsky's influence on the Russian and American theater and traces the theories and methods of American stage practice from 1890 to 1925. Photographs, extensive bibliography, and index are provided.

Gorchakov, Nikolai M. *Stanislavsky Directs.* Translated by Miriam Goldina. Westport, Conn.: Greenwood Press, 1973. An inside account of Stanislavsky the director, by a former student at the Moscow Art Theater who was later himself to become a director there. Gorchakov provides insights into Stanislavsky's approach in his thorough account of five Stanislavsky productions; however, the lack of photographs leaves the reader without visual aids to accompany the descriptions. A glossary of theater terms is provided.

Goriachkina-Poliakova, Elena. *Stanislavsky.* Translated by Liv Tudge. Moscow: Progress Publishers, 1982. A detailed account of Stanislavsky's career as both actor and director. Goriachkina-Poliakova provides interesting descriptions of performances as well as personal observations by many of Stanislavsky's contemporaries in the theater. Though the translation at times lacks a fluid style, the information provided is invaluable to the student of Stanislavsky. Photographs.

Magarshack, David. *Stanislavsky: A Life.* Boston: Faber & Faber, 1986. A reprint of Magarshack's 1950 edition. A thorough, accessible account of Stanislavsky's life and art. Until Benedetti's more up-to-date exploration, this was the main source of information for non-Russian Stanislavsky scholars. The accounts of the stagings of Chekhov's plays are particularly illuminating. Photographs and index are included.

Nemirovitch-Danchenko, Vladimir. *My Life in the Russian Theatre.* Translated by John Cournos. New York: Theatre Arts Books, 1968. A personal account of the cofounder of the Moscow Art Theater. Nemirovich-Danchenko provides insights into his career as a teacher of dramatic literature, his love for Chekhov, his meeting with Stanislavsky, and his efforts as director/producer at the Moscow Art Theater. His account complements Stanislavsky's autobiographical *My Life in Art.* A chronology, index, and introduction by Joshua Logan are included.

Stanislavsky, Konstantin. *My Life in Art.* Translated by J. J. Robbins. New York: Meridian Books, 1956. Stanislavsky's personal account traces his life in art from his first childhood fascination with acting and the theater to his position as director of the Moscow Art Theater. The account ends with the outbreak of the Russian Revolution. The translation is accessible, and Stanislavsky's style provides dynamic reading. An index and an appendix listing Stanislavsky's productions are included.

Christine Kiebuzinska

Cross-References

Duncan Interprets Chopin in Her Russian Debut (1904), p. 113; Reinhardt Becomes Director of the Deutsches Theater (1905), p. 145; The Group Theatre Flourishes (1931), p. 874; Kazan Brings Naturalism to the Stage and Screen (1940's), p. 1164; *A Streetcar Named Desire* Brings Method Acting to the Screen (1951), p. 1487.

MAHLER REVAMPS THE VIENNA COURT OPERA

Category of event: Music
Time: May 11, 1897-December 9, 1907
Locale: Vienna, Austria

Gustav Mahler established a concept of operatic performance with the Vienna Court Opera that has been widely described as the outstanding musical achievement of the era and, in the eyes of many, the last artistic gasp of a great but crumbling empire

Principal personages:

GUSTAV MAHLER (1860-1911), a conductor and composer who, through his work with the Vienna Court Opera, established a level of artistic achievement that placed him at the head of the "music of the future" movement in turn-of-the-century Europe

ALFRED ROLLER (1864-1935), a stage designer who, through his work with Mahler, contributed significantly to the latter's success and established new norms of staging in the musical theater

HANS RICHTER (1843-1916), Mahler's predecessor in Vienna, a conductor regarded by most of his contemporaries as the major interpreter of German Romantic music

ALMA MARIA MAHLER (1879-1962), a major figure in arts and letters of the early twentieth century who, as Mahler's wife, offered in her writings many insights into one of the most influential musical intellects of the age

Summary of Event

As the seat of the declining Austro-Hungarian Empire, Vienna had long been a center of musical influence, and nothing held the attention of the Viennese, and the broader musical community in general, more securely than the opera. Performances were built around familiar stars, and the easygoing attitude for which the Viennese were famous carried over to the operatic stage in the form of pleasant, entertaining exhibitions of vocal skill. Gustav Mahler first appeared at the opera in Vienna as assistant conductor in a performance of Richard Wagner's *Lohengrin* (1850) on May 11, 1897; his extraordinary musical success with that and subsequent performances led to his appointment as director on October 8. He brought to the royal opera a new concept that saw each work as a complete entity in itself, one in which all operatic elements—orchestra, singers, staging, and scenery—were to be focused toward achieving a unified whole, marked by the most rigorous standards of technical execution. No detail was too small to receive his careful attention. For example, in the "Norns" scene from a production of Wagner's *Götterdämmerung* (1876), the

players were required to pay out rope for an extended period, but with no actual rope present; Mahler insisted that the performers practice for hours with an actual rope in hand, although none was used during the public performance.

He collaborated with Alfred Roller in achieving new stage designs that were based on light and symbolism rather than on the stereotypical painted backdrops that had for so long inhibited attempts to create the illusions necessary in opera. Roller's first stage design, for a production of Wagner's *Tristan und Isolde* (1859), bathed the stage in deep red for the passions of the first act, deep purple to suggest night in the second, and a pervasive gray for the extended death scene of the closing—all innovative effects for the time.

Mahler insisted on complete accuracy from the singers and orchestra in matters of text and tempo; the vocal cadenzas that had accrued to Wolfgang Amadeus Mozart's scores were deleted, and the Wagner operas were performed without the usual cuts, extending some performances by as much as an hour. Singers were expected to follow exactly Mahler's sometimes tyrannical directions in matters of interpretation in order to achieve his concept of the complete work. Within a fairly short time following his arrival at the opera, many of the established singers left, as did a significant portion of the orchestra. Those who remained, however, stated repeatedly that the musical ideas they encountered with Mahler compensated for the heavy demands he placed upon them. Mahler used his position to encourage many new singing talents. He was constantly searching for new singers, and he often would favor a performer whose voice might be less than the most beautiful if that singer could sustain the elements of dramatic acting that fit with his idea of the whole. This was a marked departure from the reigning tradition of bel canto and all it implied.

His attention extended to audience conduct as well, a fact reflected in a published list of rules for visitors to the opera. Cannons were to be fired in the city to inform the citizens of the appropriate time of their departure for each evening's performance; late arrivals, be they aristocrats or not, were refused admission until the first intermission. Mahler also forced the singers to sign an agreement eliminating the claques (fans paid by the singers to applaud their individual entries and solos). Persons of both sexes entering as couples might be required to give proof of their marital status, and strikingly beautiful ladies, who might attract the attention of gentlemen, could be refused admission (a response to the social intercourse for which the Vienna Court Opera had become famous). Those who enjoyed bringing a musical score to the opera were forbidden to turn pages because of the distracting noise.

Although he continued much of the traditional Italian repertory, Mahler became most famous for the attention he gave to the operas of Wagner, establishing complete performance of the four operas of Wagner's *Der Ring des Nibelungen* (1874; the ring of the Nibelungs) and insisting that these and all other works be given without cuts. Here he came into conflict with the locally revered conductor Hans Richter, who had worked with Wagner at the festival in Bayreuth and who, presumably, had been annointed by that master as interpreter of his works. Mahler himself, though, was very much a champion of Wagner's idea of the total work of art; he announced

within a short time that he would assume responsibility for all Wagner performances, and soon after, Richter, one of the most celebrated interpreters of German Romanticism, left for London. Mahler came to be recognized as a spokesman for the music of the future movement as it had been championed by Wagner, and his uncut performance of Wagnerian music dramas became one of the highlights of his tenure as director.

Clearly, Mahler was in control; he imposed his extraordinary talents and musical concepts not only on the performers but on the audience as well. The resulting intensity led to a level of performance that was acknowledged by all who attended the opera as the outstanding musical achievement of the age—the crescendo of criticism notwithstanding.

The impact on Mahler's own career as a conductor and composer was at least twofold. As a conductor, he achieved international recognition, was invited to appear in many major musical centers, including New York's Metropolitan Opera, and was recognized as a leading virtuoso of the baton. That his activities with the opera relegated his composition to the relatively short months of summer vacations may have been detrimental to his productivity as a composer, yet his work toward achieving an operatic performance that represented a totality of the composer's intent also appears in his symphonies, large-scale works that are self-sufficient musical entities, creations that extend well beyond the traditional four-movement sequence. That many of these works carry autobiographical connotations may also reflect his total and personal immersion in each of his operatic endeavors. Certainly, his awareness of the problems of words and music would have figured in both activities, and a significant portion of Mahler's compositions call for the combination of orchestra and voices, either solo or chorus.

The intensity of his personal involvement with any work he addressed as either conductor or composer may have contributed to or been a facet of his own personal problems, conditions sufficiently disturbing to lead him to a consultation with Sigmund Freud. The similarity of Freud's approach to his new science of psychoanalysis and Mahler's approach to his creative processes, either as opera conductor or as composer, attracted the attention of many.

Impact of Event

While Mahler alienated many by his uncompromising standards and dictatorial musical administration, he also brought to fruition a type of operatic performance that united all facets of the musical theater into the service of one entity—the conception of the composer as interpreted by Mahler. The performance of an opera as a unified whole, one into which all musical elements were cohesively bound, stood as the hallmark of the productions for which Mahler was responsible as director, even when he was not on the podium himself. This was in striking contrast to most existing operatic traditions; the Vienna Court Opera came to be identified as a crucible for new musical ideas and, without exception, the center of Viennese cultural life. It was said that Mahler was the second-best-known person in the city, his eminence

surpassed by only that of the emperor.

His fidelity to the composer's intent, although with some noted exceptions, set the tone for musicians in many other areas, a quality reflected in practices of notation and performance that endured well beyond the middle of the twentieth century. Composers, with Mahler as a model, annotated their scores with great care to the nuances of articulation, dynamics, fluctuations in tempo, and similar matters. Performers were expected to respond in kind through a careful and accurate realization of such notation. Gone was the element of free additions, inserted improvisations, and "creative" interpretations dominated by the performers' individual personality.

Mahler's collaborations with Alfred Roller in matters of stage design broke with the past and established procedures that were emulated at Bayreuth and in most other opera houses of the twentieth century. Mahler and Roller established the principle of using light instead of fixed lines, symbolism instead of literal and inherently limited statement, to project desired illusions.

Mahler's concern for the whole ensemble led him to place the conductor's desk on the far side of the orchestra, between the instrumentalists and the audience, the better to command the attention of the orchestra as well as the performers on stage. Previously the conductor had worked from an area near the stage where he could address the singers directly, with the orchestra seated between the conductor and audience. As with other innovations, this ensued from Mahler's concern for the whole ensemble, orchestra as well as singers.

Through his extraordinary musical achievements in the opera house, Mahler restored to Vienna some of the musical glory that city had lost with the passing of Franz Joseph Haydn, Wolfgang Amadeus Mozart, Ludwig van Beethoven, and Franz Schubert. The opera had symbolized all that was great and glorious in the principal city of the Austro-Hungarian Empire, and the declining political fortunes of that city made these musical developments all the more notable in the eyes of the Viennese. Whether they approved or vilified him, there was no question that Mahler was the major artistic and intellectual force in the city.

His elevation of the complete dramatic concept above the merely musical led to the emergence of a new type of singer, one who above all could project the illusion of the drama. While this emphasis led to the departure of several prominent stars, who probably were ready to depart for vocal reasons under any circumstances, it also led to the establishment of several new and important operatic careers. Anna von Mildenburg, Leo Slezak, Marie Gutheil-Schoder, and Richard Mayr were among the singers who came forth during Mahler's tenure, and they dominated the German operatic repertory until well into the twentieth century. Through the process of careful selection of his own singers and painstaking training through many rehearsals, Mahler developed one of the most renowned operatic ensembles of all time.

Mahler's central position on the musical scene and his forceful musical intellect brought him to the forefront among the young musicians, such as Alexander von Zemlinsky, Arnold Schoenberg, Anton von Webern, and Alban Berg, who were champions of new styles in music. While not always in accord with their views,

Mahler and his work as composer and conductor nevertheless stood for what many of them thought was needed to free music from the encrustations of nineteenth century Romanticism. It was from the creative work of these composers, particularly Schoenberg and Webern, that music of the twentieth century received much of its impetus.

Bibliography

Banks, Paul. "*Fin-de-siècle* Vienna: Politics and Modernism." In *The Late Romantic Era*, edited by Jim Samson. Englewood Cliffs, N.J.: Prentice-Hall, 1991. A study of the broader cultural forces at work in Vienna during the last years of the nineteenth century. Mahler's work is reviewed within the context of the political and cultural firmament of which it was a part.

Bauer-Lechner, Natalie. *Recollections of Gustav Mahler.* Translated by Dika Newlin. New York: Cambridge University Press, 1980. An account of personal associations with Mahler from childhood through his years in Vienna. Aside from many items of purely personal interest, the work offers much data concerning Mahler's musical development and the sources of his ideas.

Gartenberg, Egon. *Mahler: The Man and His Music.* New York: Schirmer Books, 1978. One of the most accessible biographical studies of Mahler. Frequent reference to and quotation of source materials; extensive list of photographs of Mahler and his associates supplemented by biographical sketches; extensive bibliography.

Kennedy, Michael. *Mahler.* 2d ed. London: J. M. Dent, 1990. Primarily biographical and analytical, but supplemented by a calendar of Mahler's life and activities, a catalogue of works, a sketch of Mahler's associates, and a select bibliography. Brief and accessible.

Kralik, Heinrich. *The Vienna Opera House.* Translated by Michael H. Law. Vienna: Brüder Rosenbaum, 1955. A useful history of the physical structure known as the Vienna Opera. Addresses many of the unwritten traditions of the house and the differences between directors, supplemented by many color plates of the interior.

La Grange, Henry-Louise de. *Mahler.* Garden City, N.Y.: Doubleday, 1973. The first volume of a projected three-volume set. Extensive biographical study through 1902, presumably based, at least in part, on the original text of Natalie Bauer-Lechner. Much of the text derives from personal correspondence, which is quoted liberally, although the context of many quotations is not clearly identified. Many photographic plates, annotations, and an extended bibliography.

Newlin, Dika. *Bruckner, Mahler, Schoenberg.* Morningside Heights, N.Y.: King's Crown Press, 1947. A cornerstone for studies concerning musical developments in Vienna around the turn of the century. Much attention is given to the relationships between the three composers named and to musical traditions in Vienna; a short chapter addresses Mahler's tenure as director of the opera.

Prawy, Michael. *The Vienna Opera.* New York: Praeger, 1970. A documentary study of the Vienna Opera, its productions, traditions, famous performers, and conductors. Many photographic plates, playbills, and other documents describe the his-

tory of this famous institution; the whole comprises a valuable collection of source materials.

Douglas A. Lee

Cross-References

Freud Inaugurates a Fascination with the Unconscious (1899), p. 19; Strauss's *Salome* Shocks Audiences (1905), p. 151; Busoni's *Sketch for a New Aesthetic of Music* Is Published (1907), p. 166; Schoenberg Breaks with Tonality (1908), p. 193; Mahler's Masterpiece *Das Lied von der Erde* Premieres Posthumously (1911), p. 298.

JOPLIN POPULARIZES THE RAGTIME STYLE

Category of event: Music
Time: 1899-1914
Locale: The United States

Scott Joplin's ragtime compositions sparked a musical craze that swept the United States

Principal personages:
SCOTT JOPLIN (1868-1917), the influential composer of the "Maple Leaf Rag," "The Entertainer," and other classic piano rags
FERDINAND "JELLY ROLL" MORTON (1885-1941), a New Orleans pianist who moved among ragtime, barrelhouse, and jazz styles
JAMES SCOTT (1886-1938), a prominent composer of technically difficult rags, including "Frog Legs Rag"
JOHN STARK (1841-1927), the music publisher who published most of Joplin's and Scott's famous rags

Summary of Event

In 1899, the tiny Midwestern publishing company John Stark & Son published a piece of piano music entitled "Maple Leaf Rag" by a little-known African-American pianist and composer named Scott Joplin. The irresistible instrumental composition quickly became a national success and ushered in a ragtime craze that swept the United States in the early years of the twentieth century. Copies of the sheet music for rags and ragtime songs, written by scores of composers, both black and white, were sold by the thousands.

In ragtime's heyday, the music was played everywhere—from honky-tonks and clubs to respectable middle-class parlors. In the motion-picture theaters that were springing up in the early years of the twentieth century, ragtime piano players provided live accompaniment for many a silent film. Ragtime was the first music of African-American derivation that crossed over to reach a wide white audience (discounting the clichéd, bastardized music used in minstrel shows), and it did so at a time of deeply entrenched discrimination and segregation.

The most immediately distinctive feature of ragtime music is its bouncy, syncopated rhythm. The pulse and bounce of ragtime is achieved by a balancing of rhythms between the pianist's left and right hands. The steady, even rhythms played by the left hand provide the basis for the syncopated melodies and counterrhythms supplied by the right hand. ("Syncopated" refers to rhythms that accent the offbeats, rather than the regular beats that are normally accented.)

Ragtime grew out of African-American folk music, with its emphasis on lively, syncopated rhythms that urged listeners to dance. Ragtime could have evolved only

in the United States, as in many ways it is actually a combination of African musical traditions (as passed on and adapted by generations of African slaves in the American South) and European musical forms, such as the march. There is a significant difference, however, between rags and earlier African-American musical forms: Rags were written down in standard European-style musical notation.

"Maple Leaf Rag" was not the first rag ever written or published, and Joplin was not the first ragtime composer. Different sources date the beginnings of ragtime anywhere from the 1840's to the 1890's. By the 1890's, there were a number of African-American piano players in cities and towns along the Mississippi River who were playing in a style that was becoming known as "rag" or "rag time" music. By 1895 or 1896, music had been published that was ragtime in nature, if not in name. "Mississippi Rag," a composition by white Chicago bandleader William Krell that was published in 1897, is often cited as the first published rag. "Harlem Rag," by black pianist Tom Turpin, was published later that year. It was the success of Joplin's "Maple Leaf Rag," however, that launched the ragtime craze nationally.

Joplin, born in 1868, moved to St. Louis in the mid-1880's, before he was twenty years old. He was already an accomplished pianist. He moved to Chicago in 1893 and to Sedalia, Missouri, a few years later. This move, made because Sedalia's large red-light district could provide employment for a black pianist, turned out to be propitious. In Sedalia were both a new college for African Americans and a white music publisher named John Stark. The George R. Smith College for Negroes gave Joplin the chance to study music theory and notation. Then, in the summer of 1899, Stark heard Joplin performing in the Maple Leaf Club, for which the most famous of all piano rags was named. He was impressed. Stark agreed to publish "Maple Leaf Rag"—two other publishers had turned it down—and signed Joplin to a five-year contract. The huge success of "Maple Leaf Rag" brought Joplin fame and, if not riches, at least a measure of financial security.

The song's success shifted the ragtime phenomenon into high gear. Joplin was one of the most prolific composers of instrumental piano rags, writing about thirty himself and another six or seven in collaboration with others. Among the many Joplin rags that appeared in the first years of the twentieth century were "Peacherine Rag" (1901), "The Entertainer" (1902), and "Palm Leaf Rag—A Slow Drag" (1903). Joplin was a particularly influential ragtime figure both because his sheet music sold so many copies and because his work was admired by other ragtime musicians and composers.

Other notable composers of piano rags included James Scott, Joseph Lamb, Tom Turpin, and Scott Hayden (a Joplin protégé). Turpin's "Harlem Rag" and "St. Louis Rag" and Scott's "Frog Legs Rag" and "Hilarity Rag" became standards in the ragtime repertoire. Scott, like Joplin, started young; he had published two rags by the time he was seventeen. Scott's rags are particularly difficult to play, and his music has been called more flamboyant than Joplin's. Lamb, a white devotee of Joplin's style, is sometimes considered the third great composer of classic rags (alongside Joplin and Scott). There were also a number of women ragtime composers; May

Aufderheide's "Dusty Rag," from 1908, was one of the most popular rags written by a woman.

A distinction should be made among "classic" ragtime (instrumental piano rags), ragtime songs, and the more general use of the term "ragtime" to denote an era and nearly any uptempo music or dance of the time. A piano rag, strictly speaking, is an instrumental composition. Ragtime songs, less complex than the rags, had both music and words (many of which perpetuated grotesquely stereotyped and racist views of black life). The term "ragtime" is now often used in a general sense to evoke a bygone era existing between the Gay Nineties and the Roaring Twenties—a slower, quieter time of pre-World War I innocence and optimism. In this sense, "ragtime" has come to refer to a range of music and dances of the prejazz era, including rags, cakewalks, novelty songs, and the popular songs turned out by early Tin Pan Alley tunesmiths.

The defining characteristic of the classic rags was their inventive syncopation, but by 1910 or so, publishers were referring to nearly any uptempo popular song as "ragtime." The famous song "Alexander's Ragtime Band," for example, written by Irving Berlin in 1911, contains virtually no syncopation. As "Maple Leaf Rag" can in some ways symbolize the beginning of ragtime, so the hugely popular "Alexander's Ragtime Band" symbolizes its coming end. By 1915, ragtime had become watered down by commercial imitation and as a creative musical form had run its course.

Impact of Event

Although the ragtime era lasted for only twenty years at most after publication of the first rag, the effects of the music were felt much longer. Ragtime influenced both the development of jazz and, to a much lesser extent, twentieth century classical music. It would be wrong to claim that ragtime developed into jazz, but jazz would not have developed quite the way it did had it not been for ragtime. One major contribution that ragtime made to jazz was simply the role of the piano. As the music that was evolving into jazz moved from the parade into the dance hall, honkytonk, and brothel, the piano began to assume greater importance. The early jazz players' approach to the piano was deeply indebted to ragtime.

Ragtime piano players in clubs from New Orleans to St. Louis to Chicago to New York evolved their own local styles that contributed to the development of jazz. Ferdinand "Jelly Roll" Morton is considered both a ragtime player and composer and an important figure in the development of jazz. Morton, who had a talent for self-aggrandizement as well as for music, went so far as to claim that he invented jazz. Many other musicians, however, also played both styles and spanned the gap between them, including Bennie Moten, Eubie Blake, and even Duke Ellington. New York pianists James P. Johnson and Thomas "Fats" Waller, who both began in ragtime, are considered the originators of the "stride" style of piano playing, a style strongly influenced by Joplin's approach to the instrument. Composer and musicologist Gunther Schuller cites a composition by Eubie Blake entitled "Charleston Rag"

as an example of the transition from ragtime to jazz. The piece's left-hand part contains a jazzlike "walking bass" pattern, and its rhythm approaches that of early jazz.

One essential difference between rags and jazz music is that rags were entirely composed and were written down in the European style of notation. Early jazz, on the other hand, was learned by ear; players would simply show one another how a song went by playing or singing it. Moreover, jazz, unlike ragtime, encourages and expects improvisation on the part of the musicians. The basic rhythms of the two styles also differ strongly; classic ragtime does not possess the swing of jazz, which was often referred to at the time as "hot" rhythm.

Yet these differences are not quite as clear-cut as they might seem. For one thing, although a middle-class white woman (the typical purchaser of sheet music) playing a rag on the parlor piano would attempt to play it as written, many professional piano players of the 1890's and 1900's who played ragtime almost certainly improvised on the songs they played, just as jazz players did. Also, both ragtime and jazz involved rhythmic styles that could be applied to songs not originally written as jazz or ragtime numbers. Both words were used as verbs as well as names; to "rag" or "jazz" a piece meant to apply the distinctive rhythms of one or the other style. Further confusing the issue is the fact that the definitions and boundaries of the two terms have always been subject to debate. It seems likely that even some musicians of the time considered ragtime to be more or less a synonym for early jazz.

Most African-American composers of piano rags were familiar with the European classical tradition, and some of them—Joplin especially—longed to be considered composers of "serious" music by the musical establishment. Joplin wrote two longer operatic works once his ragtime pieces won popular acceptance, but neither gained popular or critical recognition. The second of these, *Treemonisha* (1911), however, has been performed on rare occasions (to mixed response) since his piano rags gained new acclaim during the ragtime revival of the 1970's. Joplin's futile, almost desperate struggles to find acceptance for *Treemonisha* are often said to have contributed to his mental breakdown in 1915; he died in a mental hospital only two years later.

There was considerable cultural resistance to the ragtime craze, some of it coming from guardians of morality and some from arbiters of musical taste. Many conservative community leaders considered rags and ragtime dances to be destructive to the morals of youth, much as jazz and rock and roll would be deplored in later generations. There was undeniably a racist element in many of these arguments. Ragtime was also hotly debated in music societies, magazines, and journals, with many classical musicians excoriating it. One conductor declared that ragtime "poisons the taste of the young"; a classical pianist likened it to a "dog with rabies" that had to be exterminated. Nevertheless, ragtime elements began to appear in the work of more open-minded and influential twentieth century composers, both in Europe and in the United States.

Three European composers notable for their inclusion of raglike musical figures were Claude Debussy, Erik Satie, and Igor Stravinsky. Debussy wrote a ragtime-

influenced piano piece entitled *Golliwog's Cake Walk* in 1908 and included ragtime elements in two piano preludes as well. Stravinsky wrote a number of pieces with rag-influenced rhythms, including *Ragtime* (1918). A section of Stravinsky's major work *The Soldier's Tale* (1918) contains syncopated rhythms that are undeniably related to ragtime.

American composers drawing upon ragtime have ranged from Henry Gilbert to John Alden Carpenter, but the most well-known are Charles Ives and George Gershwin. All four were seeking to write classical music with a uniquely American sound; among the sources with which they experimented were spirituals, hymns, folk songs, American Indian music, ragtime, and jazz. Ives wrote a series of "ragtime dances"; among his other works that obviously reflect ragtime are *The See'r* (1913) and *Ann Street* (1922). Gershwin was unique in that he was both a songwriter and composer of rags as well as a composer of symphonic works. Much of his work, including *Rhapsody in Blue* (1924) and his piano preludes, contains ragtime and jazz elements.

Although ragtime music had faded from mass popularity by World War I, it never quite disappeared. Any piano players who entertained by playing "old-time" or honky-tonk piano had ragtime pieces or ragtime-influenced songs in their repertoire. Moreover, a number of performers and composers (including Eubie Blake, who lived to the age of one hundred) kept the style alive and passed it on to new generations. Beginning in the 1940's, periodic ragtime revivals occurred, reflecting both the interest and the evolving stylistic interpretations of new devotees.

The biggest single ragtime revival occurred in the early and middle 1970's. In 1970, classical musician Joshua Rifkin recorded an album of Joplin rags for Nonesuch, a classical music label. Instead of selling a few thousand copies as expected, the record sold many times that, becoming popular with both classical music aficionados and a wider audience. An influential classical music critic for *The New York Times* soon wrote an article sanctioning the Joplin revival, and Rifkin's *Piano Rags of Scott Joplin, Volume 2* went to number one on the classical music charts in 1972. Ragtime was no longer a pariah in the world of the classics; more than half a century after his death, Joplin had achieved the recognition from the establishment that had eluded him in life.

This was only a prelude, however, to the mass popularity of Joplin's "The Entertainer," which was used as the theme of the motion picture *The Sting* in 1973. "The Entertainer" went to the top of the popular music charts and became more famous than it had been in 1902. In the ensuing years, popular interest in ragtime waned once again, but the many recordings and performances of ragtime, as well as the substantial body of scholarship on the music, ensure Joplin and ragtime a secure place in the history of American music.

Bibliography

Blesh, Rudi, and Harriet Janis. *They All Played Ragtime.* New York: Alfred A. Knopf, 1950. Blesh is sometimes credited with spearheading the ragtime revival of the 1950's. His pioneering and painstakingly researched study remains an excellent

survey of the music, its players, and its composers.

Gammond, Peter. *Scott Joplin and the Ragtime Era.* New York: St. Martin's Press, 1975. One of a number of short biographies of Joplin written for the newcomer to ragtime. Gammond alternates between chapters on Joplin's life and chapters containing contextual information on ragtime and its era.

Hasse, John Edward, ed. *Ragtime: Its History, Composers, and Music.* New York: Schirmer Books, 1985. An amazingly wide-ranging collection of fine essays on ragtime. Includes essays on Joplin and other major figures, women ragtime composers, musicological examinations, and ragtime's influence on early country music. Gunther Schuller's "Rags, the Classics, and Jazz" can be found here.

Schafer, William J., and Johannes Riedel. *The Art of Ragtime.* Baton Rouge: Louisiana State University Press, 1973. Schafer and Riedel's book, aimed at the serious student of ragtime, covers a broad area. Like Blesh and Janis' work, this is a scholarly account and is rich in detail.

Waldo, Terry. *This Is Ragtime.* New York: Hawthorn Books, 1976. Waldo, a onetime protégé of ragtime pianist Eubie Blake, surveys ragtime from its beginnings to its resurgence in the 1970's. He devotes separate chapters to ragtime in the 1940's, 1950's, 1960's, and 1970's.

McCrea Adams

Cross-References

Handy Ushers in the Commercial Blues Era (1910's), p. 252; Bessie Smith Records "Downhearted Blues" (1923), p. 572; Gershwin's *Rhapsody in Blue* Premieres in New York (1924), p. 598; Armstrong First Records with His Hot Five Group (1925), p. 670; Ellington Begins an Influential Engagement at the Cotton Club (1927), p. 739; Gershwin's *Porgy and Bess* Opens in New York (1935), p. 1016; Joplin's *Treemonisha* Is Staged by the Houston Opera (1975), p. 2350.

FREUD INAUGURATES A FASCINATION WITH THE UNCONSCIOUS

Category of event: Literature
Time: November 4, 1899
Locale: Vienna, Austria

Sigmund Freud's The Interpretation of Dreams, *the foundation text of psychoanalysis, reintroduced a scientific world obsessed with Darwinian and Marxist materialisms to the subtleties of unconscious and creative processes*

Principal personages:

SIGMUND FREUD (1856-1939), the founder of psychoanalysis, whose exploration of the unconscious shaped the twentieth century's understanding of the human mind

CARL JUNG (1875-1961), the Swiss disciple whom Freud hoped would inherit his mantle but whose own research led to the founding of a rival school

JAMES STRACHEY (1888-1967), the general editor of the English edition of Freud's psychological works

A. A. BRILL (1874-1948), an early student of Freud who made the first translation of *The Interpretation of Dreams* into English

Summary of Event

On November 4, 1899, Sigmund Freud's *Die Traumdeutung* (*The Interpretation of Dreams*, 1913) was published by Franz Deuticke of Leipzig and Vienna. In it, Freud argued that dreams are the disguised expressions of sexual wishes that the dreamer's conscious mind cannot accept and that have therefore been repressed. The book was Freud's masterpiece, and he was to revise and enlarge it in seven subsequent editions spanning the rest of his life.

Freud had been interested in dreams since at least 1882. He mentioned in a footnote to *Studien über Hysterie* (1895; *Studies on Hysteria*, 1936) that he had experienced a series of vivid dreams as a result of having slept in a different bed from usual over a period of several weeks, and he had taken the trouble to write the dreams down and had tried to "solve" them on awakening. Freud was able to trace all the dreams in this series to one of two factors: a continued working out of ideas that he had briefly touched on during the day and a compulsion to link or associate ideas together. It was in *The Interpretation of Dreams*, though, that Freud's theory of dreams was to find its major expression.

Briefly, Freud held that a dream is the disguised fulfillment of a wish. The dream work consists of the unconscious mind's translation of these wishes, which it knows to be unacceptable to the conscious mind, into the actual contents of the dream; the purpose of analysis is to translate dreams back into their origins through the technique of association. *The Interpretation of Dreams* thus opens with Freud's assertion

that "in the pages that follow I shall bring forward proof that there is a psychological technique which makes it possible to interpret dreams. . . ."

Freud wrote that *The Interpretation of Dreams* was complete "in all essentials" by the beginning of 1896 and that he held it back from publication for several years. Although first issued in 1899, the book bore the publication date of 1900 on its title page, along with a motto taken from Vergil's *Aeneid*: "Flectere si nequeo Superos, Acheronta movebo" ("If I cannot bend the higher powers, I will move the infernal regions"). It was an apt motto, suggesting—as does the book—that wishes that are rejected by the mental "higher powers" can nevertheless influence a person's life through unconscious processes.

The motto is apt, too, in its description of Freud's wishes for the book itself. If his theory of unconscious repression met with resistance from the higher powers of academia, he would stir up hell itself against them. There would be, Freud predicted in a letter written while he was reading the proofs of the book, a "thunderstorm" when the book was published.

There was no thunder. The first three reviews struck Freud as "meaningless," "idiotic," and "vague," respectively, and only the first reviewer's use of the word "epoch-making" gave Freud any grounds for pleasure. "Not a little leaf has stirred to reveal that *The Interpretation of Dreams* has touched anybody's mind," he wrote in March of 1900. Indeed, over the course of the next six years, *The Interpretation of Dreams* sold only 351 copies of the 600 originally printed.

Perhaps Freud's convoluted language had something to do with it. "What displeases me," he wrote later, "is the style, which was quite incapable of finding the noble, simple expression and lapsed into facetious, image-seeking circumlocutions"—this from a man who would in 1930 win the coveted Goethe Prize for literature. The book's title, *Die Traumdeutung*, may also have contributed to the poor sales; *Traumdeutung* can be literally translated as "dream interpretation," and the book may have sounded all too much like one of those facile dictionaries of dream symbols from which one can learn that sweet red apples in dreams signify coming good fortune while bitter green apples predict a coming loss. Above all, perhaps, Freud had sinned against the spirit of his times. In 1907, he acknowledged that he had ventured, "in the face of the reproaches of strict science, to become a partisan of antiquity and superstition."

Yet Freud was sure of the importance of his magnum opus, and over the years he has undoubtedly been proved right. In a letter of 1910, he referred to it as his "most significant work." Indeed, he would continue to work on it through most of the rest of his life. In 1901, while the book was still selling very poorly, he set himself the tedious task of writing a digest of the book, published as *On Dreams*. Toward the end of his life, in his preface to the third English edition of 1931, Freud looked back over the years and said that in his judgment, *The Interpretation of Dreams* contained "the most valuable of all the discoveries it has been my good fortune to make." He was well satisfied. "Insight such as this," he wrote, "falls to one's lot but once in a lifetime."

In the interim, Freud continued to work both at the interpretation of dreams—his own and those of his patients—and on the theory of dream interpretation. From 1913 on, the Freudian *International Journal for Psychoanalysis* printed a regular column devoted to dream analysis, but in 1933, Freud lamented that the analysts he had trained "behave as though they had no more to say about dreams, as though there were nothing more to be added to the theory of dreams."

The trickle of analytic papers on dream theory had dried up. This development was the sadder because, for Freud, it was with the theory of dreams that psycho-analysis moved from being a therapeutic technique to being what he called a "depth-psychology."

Impact of Event

For Freud, *The Interpretation of Dreams* was a work continually in progress, and his hope was that the analysts he trained would regard it both as the cornerstone of their science and as a program to be developed and improved. For the world, how-ever, it marked a turning point, and its influence has been enormous.

The reason both for the book's slow initial reception and for its eventual great influence can perhaps be found in Freud's shrewd self-assessment: He had ventured to become a partisan of antiquity and superstition. He had taken dreams seriously. "The interpretation of dreams," he wrote, "is the royal road to a knowledge of the unconscious activities of the mind."

In a sense, Freud's impact can only be evaluated in the context of the great conver-sation that has echoed down the centuries, the conversation between Plato and Aris-totle, Johannes Kepler and Nicolas Copernicus and Isaac Newton, Blaise Pascal and René Descartes, Benjamin Franklin, William Blake, and Charles Babbage, Charles Darwin and Karl Marx. It is, fundamentally, a conversation about the presence—or absence—of the gods. Take thunder, for example. Is it the sound of gods in combat? An expression of the one true God's wrath at the sins of Israel, or one's own sins of just the day before? A part of the same God's wind-up toy, Nature, running down? Or simply an acoustic phenomenon produced by the discharge of large quantities of electricity? Over the centuries, there has been a shift in the tone of this conversation. From at least the time of Galileo on, scientists have tended to extend the areas of nature explainable in terms of natural forces such as electricity, and thus to diminish the role of the supernatural in the universe.

Darwin, with the publication of *On the Origin of Species* in 1859, had, in Aldous Huxley's words, led science "from the idolatries of special creation to the purer faith of Evolution." Marx had published his *Critique of Political Economy* earlier that same year. Between them, Darwin and Marx took the conversation ever more surely in a materialist, reductionist direction. Physical and economic survival were the two great drives they addressed—and the gods again receded.

It was Freud's great contribution to this conversation that he brought back the realm the gods inhabited—though not, in a sense, the gods themselves. For it was not Freud's wish to swing the great conversation back in a religious direction—far

from it. In weaving dreams, jokes, and the unconscious forcefully back into the conversation, however, he had reintroduced imagination to the discussion.

Freud was forty-three when *The Interpretation of Dreams* was published. He was a disappointed man, having narrowly missed making the discovery of the anesthetic properties of cocaine and having not yet received his extraordinary professorship—a failure that he attributed at least in part to anti-Semitism. His fortunes were soon to change.

In 1902, he was granted his professorship. The year 1905 saw the publication of three of his major works, of which *Drei Abhandlungen zur Sexualtheorie* (*Three Essays on the Theory of Sexuality*, 1910) was the most important. In 1906, he received a medallion from his disciples on the occasion of his fiftieth birthday. Carl Jung and Ludwig Binswanger visited him in 1907 and founded a small psychoanalytic group in Zurich. In 1908, the first International Congress of Psychoanalysis met in Salzburg.

The Interpretation of Dreams, too, was making headway. The year 1909 saw the publication of a second, enlarged and revised, edition; a third edition was published in 1911, a fourth in 1914, and a fifth in 1919. Translations, too, began to appear. The book was published in Russian in 1912; A. A. Brill's rather weak English version first appeared in 1913; a Hungarian edition was published in 1915, a French one in 1926, and a Japanese one in 1929. The eighth German edition of 1930 was the last revision of the work that Freud would undertake. James Strachey's authoritative English translation would not appear until 1953, in volumes 4 and 5 of the standard edition of Freud's psychological writings.

Along with the fame of the book, the psychoanalytic movement grew apace, until by the end of Freud's life it had come to dominate the psychiatric world. His theories were expanded and commented upon, until strains of psychoanalytic thought could be found scattered through much of the academic world, from the anthropological work of Géza Róheim to the literary criticism of Lionel Trilling.

Yet neither his theory of dream analysis nor the founding of his school of psychoanalysis—with its accompanying quasireligious dogmas—nor indeed his impact on the varied academic disciplines was to be Freud's enduring legacy. The world swings as the great conversation swings, and Freud, in that conversation, had opened the door to the unconscious; he had turned the attention of the thinking world inwards. Freud opened the door for the return of the repressed, and it was to be the part of his one-time disciple, Jung, to usher—under the name of archetypes—the gods back into intellectual life.

Bibliography

Ellenberger, Henri E. *The Discovery of the Unconscious: The History and Evolution of Dynamic Psychiatry*. New York: Basic Books, 1970. A standard history of psychiatric theory from its origins in shamanism through the works of Freud and his disciples. A weighty book of almost a thousand pages, including copious notes and index.

Freud, Sigmund. *The Interpretation of Dreams.* Translated by James Strachey. 3d ed. New York: Basic Books, 1960. Strachey's authoritative translation of Freud's work. A particularly useful version, since it incorporates all the changes Freud made in the text over the course of his lifetime. Contains Freud's bibliography and an index.

Gay, Peter. *Freud: A Life for Our Time.* New York: W. W. Norton, 1988. An excellent biography of Freud. Takes a moderate position regarding some of the recent controversies regarding Freud and his work and, in doing so, remains sympathetic but never obsequious. Fascinating to the general reader, essential for scholars. Contains bibliographic essay and index.

Hobson, J. Allen. *The Dreaming Brain.* New York: Basic Books, 1988. Masterful account of neurobiological thinking on the nature of sleep and dreams. Presents Freudian and Jungian theories of dream symbolism as nonscientific precursors and discusses the discovery of rapid eye movement sleep as the beginning of the scientific approach. To be reckoned with by any future psychology of dreams. Bibliography and index.

Jung, C. G. *Symbols of Transformation.* Translated by R. F. C. Hull. New York: Pantheon Books, 1956. Revision of the 1912 work that arguably forced Jung's break with Freud and inaugurated the distinctively Jungian style of analysis. Also contains much material regarding the development of Jung's thought after the break with Freud.

Whyte, Lancelot Law. *The Unconscious Before Freud.* New York: Basic Books, 1960. Lucidly explores the understanding of the unconscious before Freud, as reflected in the works of such poets, scientists, philosophers, and mystics as William Shakespeare, Johann Wolfgang von Goethe, Blaise Pascal, René Descartes, Jean Jacques Rousseau, and Samuel Taylor Coleridge. Indexes of names and subjects.

Charles Cameron

Cross-References

Jung Publishes *Psychology of the Unconscious* (1912), p. 309; Wittgenstein Emerges as an Important Philosopher (1921), p. 518; Sartre and Camus Give Dramatic Voice to Existential Philosophy (1940's), p. 1174; Sartre's *Being and Nothingness* Expresses Existential Philosophy (1943), p. 1262; Lévi-Strauss Explores Myth as a Key to Enlightenment (1964), p. 1994.

BROOKS BROTHERS INTRODUCES
BUTTON-DOWN SHIRTS

Category of event: Fashion and design
Time: 1900
Locale: New York, New York

Brooks Brothers' introduction of the button-down collar changed the style of men's shirts and created a classic item of fashion

Principal personages:

JOHN E. BROOKS, the oldest of Henry Sands Brooks's grandsons, designer of the button-down shirt.

HENRY SANDS BROOKS (1770-1833), the son of a Connecticut doctor, founder of a retail clothing store

THEODORE ROOSEVELT (1858-1919), the twenty-sixth president of the United States, one of the first Americans to wear the button-down shirt

WOODROW WILSON (1856-1924), the twenty-eighth president of the United States, inaugurated in 1913 in a Brooks Brothers outfit

J. P. MORGAN (1837-1913), an investment banker and owner of the Reading Railroad who wore Brooks Brothers clothing

Summary of Event

The style of men's clothing in the United States during the latter years of the Gilded Age, which began in the late nineteenth century, was similar in design to items of apparel worn by Europeans. On both sides of the Atlantic, the men's fashion industry was influenced by English designers and clothing manufacturers. Cross-Atlantic exchange did little to enhance innovativeness in the cut, color, and fabric of clothing designed, manufactured, or sold in the United States. Even though items of men's apparel extended beyond the basic utilitarian purpose of covering for a naked body into the social realm of status, they were not designed or produced for comfort, practicality, or elegance. Stiff, drab, staid, and durable constituted the standards for the tailoring or mass production of men's garments and accessories at the end of the nineteenth century.

Change in the men's clothing industry, unlike that in the world of women's fashion, rarely occurred and was slow to win acceptance. In 1900, however, Brooks Brothers, a manufacturer and retailer of men's clothing, quietly but dramatically introduced changes that set aside the physically and emotionally restrictive clothing norms of the past and established a new set of standards based on comfort, quality, and style. The fashion items that Brooks Brothers used to create a new fashion statement were the button-down shirt, or button-down polo shirt; the three-button, soft-shoulder sack suit; and the Scottish Harris tweed sport coat.

Brooks Brothers, the instigator of fashion innovativeness, was by 1900 one of America's oldest manufacturers and retailers of men's clothing. For more than eight de-

cades, the company, not especially known for its design creativity, worked to establish its high rank among men's clothiers on the bases of quality and service. With the simultaneous marketing of three newly designed items of apparel, Brooks Brothers secured a favored position within the retail trade that it would retain for most of the twentieth century. Although the sack suit and the Harris tweed coat became accepted items of men's wear, it was the button-down shirt or button-down polo shirt that proved to be one of America's most significant design and retail successes. Of the three apparel items, it was the button-down shirt that gained over time the label of classic. First worn by political and business leaders, it filtered down into the common culture of American life.

The button-down shirt was the design creation of the grandson of the founder of the Brooks Brothers company, John E. Brooks. Like his grandfather, he had a keen eye for designs that were stylish as well as potentially profitable. While traveling in England in 1900, he attended a polo match and soon became more interested in the garb worn by the players than in the activity on the playing field. Of particular interest to him were the shirts worn by the polo players. He observed that the English polo players used buttons to secure the points of their collars, keeping them from flapping in the wind. Reasoning that such accoutrements could be adapted to shirts worn by American men, he returned home and submitted a design for a shirt made of cotton, in a number of colors and colored stripes, with an attached, narrow rolled collar that included a button to hold the top of the shirt together and two buttons, one on each side of the shirt, to hold down the flaps of the collar. Company directors approved the idea. They believed that the button-down shirt was marketable, for it filled the need of the American male for garments that were stylish yet functional. They accepted the design for manufacturing and marketing because they considered it a visual representation of the Brooks Brothers philosophy of selling, at a reasonable price, quality merchandise to male customers who valued refined items of apparel.

The button-down-collar shirt was first sold at the Brooks Brothers flagship store in New York City in the fall of 1900. The comfort and tasteful yet subtle styling of the shirt quickly captured the attention of many customers. The button-down shirt quickly was deemed practical by the men who first wore it.

The button-down-collar shirt was, in its initial stage of introduction in 1900 and 1901, a success. It was more comfortable, less restricting, and less troublesome than its predecessors, with its attached, unstarched collar, and it fitted with ease under a suit coat. Furthermore, it held a necktie more securely in place and thus proved to be highly practical, especially for office-type work. Its value soon was recognized by President Theodore Roosevelt, President Woodrow Wilson, J. P. Morgan, and members of the Vanderbilt and Astor families. Both Roosevelt's and Wilson's inaugural clothing, including suits, shirts, and ties, was furnished by Brooks Brothers. Later, other presidents from Herbert Hoover to John F. Kennedy were Brooks Brothers customers. The cap that President Franklin D. Roosevelt wore was a Brooks Brothers creation.

Impact of Event

Although the button-down collar was received favorably by many American men, during the first two decades of the new century it was not the sole or the dominant style. The body of most shirts sold in Europe and the United States was altered in the 1880's. The shoulder yoke was introduced, along with proportioned sleeves with cuffs that either were curved or were in the French style, with part of a wide cuff turned back and fastened with cuff links. Shirt bodies were either white, plain colored, or striped, with collars and cuffs either the same color as the body or white. Most collars were starched and detachable. The most popular style was the high straight standing collar, a perpendicular cylinder of stiff or stiffened linen or cotton that covered the neck completely. Folded-over and wing-tipped collars also sold readily. It was not until about 1930 that the detachable shirt collar was abandoned by the fashion industry.

The body of the button-down shirt was similar to that of most tailored or manufactured shirts sold in 1900 and did not change greatly thereafter. With the introduction of the button-down collar, the body of the shirt was only slightly altered. The original button-down shirt was constructed with a shoulder yoke that was shallower, sleeves that were straighter, and a buttoned front that was plainer. The cuffs of the button-down shirt were left round. The collar and cuffs of the shirt were the same color as the body, and the colors used were the same as for past Brooks Brothers shirts, no different from those used by other clothiers. The innovation, of course, came in the collar, which was attached to the shirt body, was narrower, and had its characteristic buttonholes to allow it to be fastened to the shirt body.

The buttons for the button-down shirt were selected carefully by Brooks Brothers. Most were made of seashells, usually with two holes bored for attachment by thread to the shirt. In America, by the end of the 1890's, John F. Boepple was manufacturing buttons made of freshwater mussel shells harvested from the Mississippi River or its tributaries. Less costly than buttons made from ocean shells, mussel-shell buttons were used particularly in mass-produced, ready-made men's, women's, and children's clothing. Brooks Brothers continued to use the more expensive and more iridescent buttons made from ocean shells. Shirts could be purchased ready-made by the Brooks Brothers factory or could be made by hand.

The introduction of the button-down collar gave rise to a wider acceptance of the four-in-hand tie made in small-patterned or striped silk, introduced in 1890. The bow tie, the ascot, and a large and rather thick four-in-hand knot were all used with high collars; a smaller and less thick tie was needed to accommodate the button-down collar. Consequently, Brooks Brothers scaled the size and thickness of the four-in-hand downward so that it could be used with the button-down collar. In doing so, the company created an elegant neckwear accessory.

The button-down shirt remained, once introduced to the public, the biggest seller of all items manufactured and sold by Brooks Brothers. In the modern age of mass production and marketing, other clothiers soon adopted the style. After World War II, the button-down shirt was the most popular shirt style in America. It became a

major component, along with the sack suit, of the Ivy League look of the late 1940's and 1950's.

Brooks Brothers became a public corporation, passing out of family ownership and operation. It was purchased by Garfinckel's in 1946; by Allied Corporation in November, 1981; by Campeau Corporation in November, 1986; and by Marks & Spencer in April, 1988. It retained its reputation as a clothier of distinction, however, in part because of its continual sale and marketing of button-down shirts.

Bibliography

Ash, Juliet, and Lee Wright, eds. *Components of Dress: Design, Manufacturing, and Image-Making in the Fashion Industry.* New York: Routledge, 1988. A small, very readable volume. Short chapters on a number of topics, from World War I fashion to influences on dress styles by minorities, are interesting and informative. A picture of workers in a Brooks Brothers factory is reproduced.

Bigelow, Marybelle S. *Fashion in History: Apparel in the Western World.* Minneapolis, Minn.: Burgess, 1970. Fashion history is covered from antiquity to the modern era. Illustrated with reproductions of clothing. The various sections on men's clothing provide information on the evolution as well as the innovativeness of style.

Boucher, François. *Twenty Thousand Years of Fashion: The History of Costume and Personal Adornment.* Rev. ed. New York: Harry N. Abrams, 1987. Color plates illustrate fashion from ancient times to the modern era. Reproductions of Impressionist paintings are true to colors of the originals. The lengthy glossary of fashion terms and items is helpful.

Colle, Doriece. *Collars, Stocks, Cravats: A History and Costume Dating Guide to Civilian Men's Neckpieces 1655-1900.* Emmaus, Pa.: Rodale Press, 1972. Limited in readable material, but many drawings by the author provide precise data on collars, stocks, and cravats that can be used to date costumes and portraits. A general reference work on styles of neckwear of various eras. Appendix B contains an account of neckpieces in art. Reproductions of portraits of men from the seventeenth to the twentieth century illustrate neckwear worn.

Laver, James. *Costume.* New York: Hawthorn Books, 1964. Men's and women's fashions from early antiquity into the twentieth century are discussed. Lovely black-and-white drawings illustrate the text.

Schoeffler, O. E., and William Gale. *Esquire's Encyclopedia of Twentieth Century Men's Fashions.* New York: McGraw-Hill, 1973. Informative coverage of men's fashion up to the early 1970's. Glossary. Biographical sketches of leading designers at the end of this work are truly informative. Reproductions of ads, sketches, and drawings, along with inclusion of quotations from primary sources, add effective dimensions to this study.

Tortora, Phyllis, and Keith Eubank. *A Survey of Historic Costume.* New York: Fairchild, 1989. Very readable. Begins in 3000 B.C. and covers fashion up to 1970. Illustrated, with thorough bibliography.

Waugh, Norah. *The Cut of Men's Clothes, 1600-1900.* New York: Theatre Arts Books, 1964. Informative section on nineteenth century tailoring. Valuable information on the use of pattern blocks and measurement in producing mass-produced clothes. Patterns with measurements of different styles are included. The quotations from primary sources are insightful.

Yarwood, Doreen. *Costume of the Western World: Pictorial Guide and Glossary.* New York: St. Martin's Press, 1980. Illustrations and black-and-white drawings by the author. Concise but valuable glossary of fashion items and terms.

Loretta E. Zimmerman

Cross-References

Poiret's "Hobble Skirts" Become the Rage (1910), p. 263; Chanel Defines Modern Women's Fashion (1920's), p. 474; Jantzen Popularizes the One-Piece Bathing Suit (1920), p. 491; Schiaparelli's Boutique Mingles Art and Fashion (1935), p. 979; Dior's "New Look" Sweeps Europe and America (1947), p. 1347; Lauren Creates the "Polo" Line (1968), p. 2141.

PUCCINI'S *TOSCA* PREMIERES IN ROME

Category of event: Music
Time: January 14, 1900
Locale: Teatro Costanzi, Rome, Italy

The premiere of Giacomo Puccini's Tosca *marked Puccini's departure from lyric sentimentality and announced his adoption of the* verismo *style*

Principal personages:

> GIACOMO PUCCINI (1858-1924), a composer of Italian opera whose works became an important staple of the modern operatic repertoire
>
> VICTORIEN SARDOU (1831-1908), a French playwright whose melodrama *La Tosca* was the inspiration for Puccini's opera
>
> GIUSEPPE GIACOSA (1847-1906), one of two librettists who jointly wrote the librettos for Puccini's operas
>
> LUIGI ILLICA (1857-1919), Giacosa's cowriter for the librettos for Puccini's operas

Summary of Event

On January 14, 1900, Giacomo Puccini's opera *Tosca* made its premiere in Rome, the city in which it is set. A glittering crowd of notables took their seats for the sold-out performance. The attendance of members of the royal family and government leaders gave the evening the gloss of a near-official occasion. The glamour of the evening masked a harsh social reality, however; Italy was a political tinderbox. Strikes and riots paralyzed the nation, and rumors of disturbances and conspiracies at the opera house had nerves on edge. A delegation from the Roman police told Leopoldo Mugnone, the conductor, that in case of demonstrations or violence he was to play the royal march to calm the audience. There had already been attempts on the life of King Umberto, and there were fears for the safety of Queen Margherita, who was in the audience. Some moments after the opera began, there was a disturbance that brought the performance to a stop, but it turned out to be a quarrel over seating. After the false start, the opera proceeded. The arias were received warmly, and Puccini was called to the stage several times, but there was nothing like the unbridled enthusiasm that had been anticipated. The reviews the following morning echoed the cool audience reaction. The general theme of the critics was that the opera's plot had overwhelmed the music. Nevertheless, it had been a great moment. Critics, royals, and ordinary patrons alike had witnessed Puccini embracing *verismo*, the Italian term for realism.

By the time of *Tosca*'s premiere, Puccini was Italy's leading operatic composer. After an unsteady beginning in the 1880's with *Le Villi* (1884) and *Edgar* (1889), he established himself as a composer of the first rank with *Manon Lescaut* (1893) and *La Bohème* (1896). When Puccini turned his attention to *Tosca*, he was already re-

garded as Giuseppe Verdi's musical successor. Puccini had seen the great Sarah Bernhardt perform the title role in Victorien Sardou's play *La Tosca* in Florence in 1895, and Giulio Ricordi, Puccini's publisher, was able to secure the rights to the piece. Any doubts about the play's suitability as a subject for opera were swept away when Verdi said that if he were not so old, he would write an opera based on *La Tosca*.

Sardou said that the idea for the play was based on an incident in the French religious wars of the sixteenth century. A Catholic nobleman promised a Protestant woman that he would save her husband from execution in return for sexual favors. She complied, but she awoke the next morning to see her husband dangling from the gallows. Sardou's play is set against Napoleon's war in Italy and includes a much stronger historical element than the opera does. In Puccini's streamlined libretto, Floria Tosca is a famous diva, intensely jealous of her lover, Mario Cavaradossi, who is an artist. When Cavaradossi shields Cesare Angelotti, an escaped political prisoner, he is arrested by Rome's chief of police, Baron Scarpia. The corrupt and degenerate Scarpia sees in this arrest an opportunity to recover his prisoner, punish Cavaradossi, and seduce Tosca all at once. In the pivotal second act, Scarpia tortures Cavaradossi in Tosca's presence, but the artist steadfastly denies any knowledge of Angelotti's hiding place. When Tosca can take no more, she reveals Angelotti's whereabouts to save Cavaradossi from further torture. Police are sent to arrest Angelotti, who commits suicide, and Cavaradossi is sentenced to death for harboring a fugitive. Scarpia offers Tosca a bargain. If she satisfies his carnal desire, Scarpia will order that a mock execution take place and will provide a safe-conduct pass for Tosca and Cavaradossi to leave Rome. Tosca very reluctantly agrees. Scarpia gives the order for the mock execution, writes out the pass, and gives it to Tosca. Instead of making love to Scarpia, however, Tosca stabs him to death on stage.

In the third act, Tosca rushes to the prison with the safe-conduct pass. Since Cavaradossi's execution is to take place at dawn, she is certain that the charade will be over long before Scarpia's body is discovered and that they will be able to make their escape. In the brief moments that they have together, Tosca describes what has transpired and happily assures Cavaradossi that the firing squad will fire blanks; she even coaches him in how to make a convincing fall. The guards march Cavaradossi away as Tosca watches. Tosca is lighthearted as the volley is fired, still believing that everything is a sham. As she approaches the body, however, she realizes the truth—Scarpia had lied, and the execution was real. At that moment, Scarpia's lieutenant arrives at the fortress with the news of the baron's murder, and Tosca throws herself from the fortress tower rather than be arrested.

A familiarity with the outlines of the plot is essential to understanding the *verismo* of the opera. Grand opera of the nineteenth century tended to focus on episodes in the lives of high-born characters caught between love and duty. Further, no conventions prevented a character from singing after being suffocated or stabbed. *Tosca* examines the lives of more ordinary people who are passionate and vengeful. The murders and suicides that *verismo* plots almost invariably include are final. No

verismo character sings after being killed. Perhaps one anecdote will suffice to demonstrate Puccini's dedication to realism on the stage. Puccini often traveled around Europe to be present as his works were performed in one opera house after another. In Vienna, Puccini attended a rehearsal that solved a nagging problem for him. The opera's most famous aria comes at the moment when Tosca has capitulated to Scarpia's foul demands, and Puccini worried that the aria interrupted the action of the moment. In the Vienna production, Maria Jeritza was singing the title role. In the middle of the second act, an overzealous Baron Scarpia manhandled Jeritza and knocked her to the ground just as the introduction for the aria began. Rather than stop the rehearsal, Jeritza raised herself slightly and sang from the ground. "Exactly right," shouted Puccini. "Never do it any other way." The new staging seemed more realistic to Puccini, and the aria is still usually sung in that manner.

The premiere of *Tosca* signaled an important shift in Italian opera. The most important operatic composer of his generation had produced a full-length work in the new style of *verismo*. Puccini was to go on to hone his *veristic* skills further in such works as *Madama Butterfly* (1904), *Fanciulla* (1910), and *Turandot* (1926).

Impact of Event

Tosca was the first full-length *verismo* opera by a composer of the first rank. Realism had truly arrived in the musical world. The roots of *verismo* originated in the novels of Émile Zola, who argued that drama and musical stage works should concern themselves with directly human issues and should deal with poor, ordinary people in the midst of their miseries and joys. In Italy, Zola's ideas were first taken up by writers. Giovanni Verga, for example, wrote stories about Sicilian peasants. In music, as in literature, realism was at first embraced by the French. The depiction of a promiscuous, lawless factory worker, culminating in her on-stage murder, makes Georges Bizet's *Carmen* (1875) a departure point for the *verismo* movement. The Italians quickly followed suit.

In 1890, Pietro Mascagni's one-act opera *Cavalleria rusticana*, a tale of seduction, adultery, jealousy, and murder taken from Giovanni Verga's *Vita dei campi*, premiered in Rome. Two years later, Ruggero Leoncavallo's one-act opera *Pagliacci* was an immediate success. Again, adultery and revenge are the bases of the plot, but in *Pagliacci* two murders are committed on stage. Frequently twinned in performance, *Cavalleria rusticana* and *Pagliacci* are still a standard part of operatic repertoire. It is *Tosca*, though, that was the first full-length opera in *verismo* style to achieve an unshakable place in standard repertoire.

Other *veristic* operas that followed in the 1890's and the opening years of the twentieth century helped to confirm the style and to establish patterns in structure and plot. Some, such as Francesco Cilea's *L'arlesiana* (1897) and *Adriana Lecouvreur* (1902), Umberto Giordano's *Fedora* (1898) and *Andrea Chénier* (1896), and Leoncavallo's *Zazà* (1900), deserve notice. While these works generally continued the fascination with passion and death, they somewhat refined the *veristic* ideas for the musical stage. While Zola spoke of ordinary lives, the *verismo* composers inter-

preted that to mean artistic lives. Heroes and heroines of these operas are frequently singers (Tosca, Zazà), writers (Andrea Chenier), actors (Adriana Lecouvreur, Canio, and cast in *Pagliacci*), or painters (Cavaradossi). Yet it would be wrong to see *verismo* as merely a set of plot conventions and character occupations.

Musical elements closely associated with *verismo* include minor harmonies, wide melodic intervals, orchestral doubling of vocal lines, and the slow pace of dramatic arias. Such characteristics are exemplified by "Vesti la giubba" from *Pagliacci* and "E lucevan le stelle" from *Tosca*.

Puccini also employed the system of leitmotif (leading motive) in *Tosca*. A leitmotif is a recurrent melodic element that identifies a character. In Scarpia's case, Puccini employs a brief, carefully planned musical statement that includes an interval regarded in medieval music as sinister and demonic. One has only to hear Scarpia's musical motive to be reminded of his ominous presence or influence.

Now that the operas of Richard Strauss, Alban Berg, and Benjamin Britten are standard musical fare, it is difficult to appreciate how new and daring *Tosca* must have seemed in 1900. Contemporary critical responses reflect how novel *Tosca* seemed as it premiered around the world. In London, critics attacked the *verismo* elements of plot:

> Those who were present at the performance of Puccini's opera *Tosca*, were little prepared for the revolting effects produced by musically illustrating the torture and murder scenes of Sardou's play. The alliance of a pure art with scenes so essentially brutal and demoralizing . . . produced a feeling of nausea. . . . What has music to do with a lustful man chasing a defenseless woman or the dying kicks of a murdered scoundrel?

In Boston, critics attacked the score:

> At the first hearing much, perhaps most, of Puccini's *Tosca* sounds exceedingly, even ingeniously, ugly. Every now and then one comes across the most ear-flaying succession of chords; then, the instrumentation, although nearly always characteristic, is often distinctly rawboned and hideous. . . .

The plot and music seem conventional to modern ears, but *Tosca*'s importance remains undiminished. Berg's *Lulu* and *Wozzeck*, Dmitri Shostakovich's *Lady Macbeth of Mtsensk* (1932), and Britten's *Peter Grimes* (1945) all owe a debt to the *verismo* ideas of plot, character, and musical style that *Tosca* first fully exemplified.

Bibliography

Ashbrook, William. *The Operas of Puccini.* Oxford, England: Oxford University Press, 1985. A detailed analysis of Puccini's operas. While an excellent book, it is technical and will be useful only to someone who reads music and has some understanding of music theory.

Carner, Mosco. *Puccini.* London: Duckworth, 1974. The best and most scholarly English-language biography of Puccini. An enlarged third edition published in

1992 includes an entirely new chapter on *Tosca*.

DiGaetano, John Louis. *Puccini the Thinker.* New York: Peter Lang, 1987. DiGaetano's work assesses the dramatic and intellectual content and development in Puccini's operas. He is particularly interested in the influence of Richard Wagner's operas on Puccini's works. A useful book, although occasionally uncritical in its use of sources.

Greenfeld, Howard. *Puccini.* London: Robert Hale, 1980. A highly readable biography by an ardent fan. The book, though somewhat weak on Puccini's personal life, contains a good discussion of the works and their sources.

Headington, Christopher, Roy Westbrook, and Terry Barfoot. "Verismo." In *Opera: A History.* London: Bodley Head, 1987. An excellent general introduction to opera; particularly good on *verismo.* Although the authors are musical scholars, the language of the book is completely accessible. A fine introduction.

Osborne, Charles. *The Complete Operas of Puccini: A Critical Guide.* London: Victor Gollancz, 1990. While Osborne is not very fond of *Tosca*, his highly readable book provides an excellent act-by-act description of the action that would be of great help to someone planning to see *Tosca* for the first time. His chapter on *Tosca* also includes a detailed and interesting comparison of Sardou's play and the libretto.

Puccini, Giacomo. *Puccini Among Friends.* Edited by Vincent Seligman. Rev. ed. New York: Benjamin and Bloom, 1971. A standard English-language edition of Puccini's letters, first published in 1938. *Letters of Giacomo Puccini* (1931; reprinted in 1974) is also a useful source.

Brian R. Dunn

Cross-References

Mahler Revamps the Vienna Court Opera (1897), p. 7; Caruso Records for the Gramophone and Typewriter Company (1902), p. 69; Strauss's *Salome* Shocks Audiences (1905), p. 151; Berg's *Wozzeck* Premieres in Berlin (1925), p. 680; Berg's *Lulu* Opens in Zurich (1937), p. 1078; Britten Completes *Peter Grimes* (1945), p. 1296; *Amahl and the Night Visitors* Premieres on American Television (1951), p. 1536; Adams' *Nixon in China* Premieres (1987), p. 2599.

TIFFANY AND TIFFANY STUDIOS
DEVELOP NEW IDEAS IN DESIGN

Category of event: Fashion and design
Time: April 2, 1900
Locale: New York, New York

Tiffany Studios provided the means through which Louis Comfort Tiffany became a recognized exponent of the modern art movement in the United States

> *Principal personages:*
> Louis Comfort Tiffany (1848-1933), a leading American decorator and designer in the pre-1914 period
> Charles Louis Tiffany (1812-1902), a noted jeweler who gave his son Louis moral, artistic, and financial support
> Samuel Bing (1838-1905), an entrepreneur of the Art Nouveau movement who became an early Tiffany supporter in Europe
> John La Farge (1835-1910), an American artist who, with Tiffany, is considered to be a leading innovator in the use of stained glass
> Arthur J. Nash (1849-1922), an English-born glassmaker who helped Tiffany establish his glass furnaces and perfect Favrile glass

Summary of Event

The demise of Tiffany Glass and Decorating Company in 1900 and its succession by Tiffany Studios was a logical development in the career of one of America's most gifted and influential designers. Through his new company, Louis Comfort Tiffany hoped to realize a lifelong ambition: to promote glass as an accepted, even ideal, artistic medium and to become a trendsetter in America's artistic development.

Headstrong and volatile, Tiffany at the age of eighteen informed his father, Charles Louis Tiffany, founder of the famous jewelry concern, that he wanted neither to go to college nor to a secure position in the family firm. He wanted to be an artist. Tiffany began training in the studio of George Inness, the famous American painter, but longed to expand his horizons. At Inness' studio, Tiffany was introduced to leading artists of the day as well as to their ideas and philosophies, some of which made lasting impressions. The most influential was the Arts and Crafts movement associated with William Morris of England. It stressed honesty of craftsmanship and the importance of designs from nature. It made no distinction between artist and craftsman. Morris had also revived and improved upon the ancient art of working with stained glass as an artistic medium. Tiffany adopted so many of Morris' ideas that he became known as the William Morris of America.

Trips to France and Morocco profoundly changed Tiffany's life. Tiffany was overwhelmed by the richness of color of the stained glass windows of the great French cathedrals and equally impressed by the more earthy colors and the exotic designs found in Morocco. His experiences confirmed his belief in the primacy of color in

art, and thereafter he considered himself as much a colorist as an artist.

Potentially, glass is a superb artistic medium, offering a forum for brilliant colors. Tiffany began experimenting with glass as early as 1870. Creating more effective forms of glass became his life's work and the means through which he achieved fame.

Tiffany for a time worked as a conventional artist but found the work too limited. Inspired by examples of the Arts and Crafts movement he saw at the Philadelphia Centennial Exposition of 1876, Tiffany decided that interior decorating would offer a wider scope for his talents. He formed Louis C. Tiffany and Associated Artists, working with other artists knowledgeable in porcelains, textiles, and exotic carvings. Tiffany added his growing interest in and knowledge of the decorative possibilities of glass. Tiffany soon became America's best-known interior decorator, decorating some of the country's most famous homes, including the White House, for which he created an enormous decorative glass screen. The screen was greatly admired, with reason. It was fashioned of "opalescent," a new kind of glass Tiffany had developed in cooperation with artist John La Farge.

Tiffany became more involved in his research in glass. In 1885, he abandoned interior decorating and formed the Tiffany Glass and Decorating Company. He now could devote himself full-time to perfecting and utilizing glass as an artistic medium. Tiffany's new company was involved primarily in creating stained-glass windows. The cutting process, however, resulted in many leftover pieces of the colorful and expensive glass. Seeking ways to utilize them, Tiffany came upon the idea of piecing the fragments together with lead strips of graceful, often stylized and freeform designs to form various objects, the most notable of which were lamp shades. Through his lamp shades, Tiffany became famous as one of the first industrial designers.

Seeking further to concentrate his work on glass, Tiffany established his own furnaces in Corona, New York, in 1893. Along with skilled glassblowers, notably Arthur J. Nash, Tiffany developed a further refinement of opalescent glass. The new glass, called Favrile, was introduced to the public in 1896.

Tiffany believed that he could realize his objective of becoming an arbiter of taste, bringing color and good design to the masses. Using his glass and the objects fashioned from it as a focal point, and building on his training as an artist, craftsman, and interior designer, Tiffany founded Tiffany Studios in 1900. The studios offered complete design services ranging from interiors to architecture, from garden design to textiles and jewelry. Craft workers in the studios turned out most of the articles. What they could not produce was commissioned. Everything, however, conformed to Tiffany's ideas concerning good taste.

Tiffany's fame spread abroad, largely through the efforts of Samuel Bing, a Parisian art dealer credited with founding the Art Nouveau movement. Embracing radical new designs and the extravagant use of light and color, Art Nouveau was in many ways the precursor of modern art. Tiffany became the leader of the Art Nouveau movement in America.

In 1913, Tiffany was at the height of his career. Few artists in America had earned as much admiration, and few American artists were as well known in Europe. That year was also the year of the famous Armory Show, which exposed Americans to radical new movements in art such as Fauvism, Postimpressionism, and German expressionism. Many Americans were shocked or even outraged by what they saw. Among them was Louis Tiffany. He railed against the modernists. The master who had done so much to change taste had lost touch; the world of art in which he has been a moving force now passed him by. Tiffany clung to his theories, but his lush, extravagant designs could not survive World War I. Tiffany outlived two wives who played comparatively small roles in his life. His daughters married and left home, and his only son chose a career with the family's jewelry firm. Louis Comfort Tiffany died in the bleak Depression year of 1933. It was left to later generations to appraise his true genius.

Impact of Event

Louis Comfort Tiffany's death on January 17, 1933, was scarcely noticed. Even *Art News* had little to say about his creative life other than that at one time his designs aroused considerable controversy. The post-World War I generation forgot Tiffany; it was the post-World War II generation that rediscovered him and recognized the influential role he had played in the development of twentieth century art and design. In the decades after the 1960's, a growing field of literature has been devoted to Tiffany and his work. The influence Tiffany exerted through his studios can be divided into four general areas: influence on modern art, perfection and promotion of glass as an artistic medium, creation of new and dramatic forms of glass, and his role as a pioneer in industrial design.

The Art Nouveau movement roughly coincided with the period of the greatest productivity and influence of Tiffany Studios. The movement largely was ignored by the post-World War I generation, but later art historians saw its radical departure from late Victorian formalism, its free forms and sensuous lines, and its lavish use of light and color as major influences in the development of modern art.

Aside from the radical nature of many of his designs, what Louis Tiffany had in common with modern art movements such as Fauvism, Postimpressionism, and Abstract expressionism was his emphasis on and treatment of color. It was precisely because of their unorthodox use and exaltation of pure color that the Fauves or "wild ones" were so named. Among the more famous Fauve artists were Henri Matisse, Georges Braque, and Georges Rouault. The Postimpressionists also exalted color but arrived at it in a manner similar to that used by Tiffany in glass. Georges Seurat, a leading Postimpressionist artist, achieved his remarkable gradations of color through a process called pointillism. Dots of color were painted in juxtaposition and left to the eye to blend. Tiffany had used the same process in both his opalescent and his Favrile glass. Varying colors in the forms of particles or strands within the glass itself produced an array of iridescent colors depending upon the light. Tiffany used the same technique in his painting with mosaics, in which he arranged tesserae, or

bits of mosaic, often nearly as small as Seurat's dots in ways that achieved astonishing color effects. Tiffany's influence on Abstract expressionism in the United States was more direct. Artists such as Jackson Pollock and Robert Motherwell saw Tiffany as an early exponent of pure form and color in art expressed in glass form.

Tiffany's greatest contribution to the world of design and art was in perfecting, utilizing, and promoting glass as an artistic medium. He had no desire to imitate the techniques of the medieval masters of stained glass but rather wanted to improve upon them. Before Tiffany, virtually no important artist used stained glass as a medium. Today it is associated with a growing list of important artists including Henri Matisse, Georges Rouault, and Marc Chagall.

Although Tiffany worked on many forms of glass and patented several, the two for which he is best known and which found their fullest utilization in the products of Tiffany Studios are opalescent and Favrile. Opalescent glass was unique in that it contained color and design within it. Both effects were derived from opaque particles floating in suspension that created designs in addition to modifying the degree of transparency or opacity. The composition at the same time created color and scattered light in a unique, even mysterious, manner. Tiffany and La Farge also succeeded in achieving the iridescent quality of buried ancient glass.

Tiffany's greatest triumph was Favrile glass, with its incredible beauty and versatility. Its perfection came only after the study of glass chemistry and endless experimentation. Tiffany's skilled glassblowers, by fusing molten glass of various colors, exposing it to fumes produced by vaporizing different metals, and skillfully manipulating the molten masses, including variations in the surface areas, produced an astonishingly wide range of colors and effects, from flesh tones to foliage, flowers, and intricate folds of garments. The designs, the colors, and even the textures of Tiffany's subjects were in the glass itself.

The importance of the establishment of Tiffany Studios must be seen as part of the pioneering work in industrial design. Simply stated, industrial design is the creation of handsome and useful designs mass-produced at low cost for the general public. Although always a careful craftsman, Tiffany saw himself as an educator of the people, with a desire to bring beauty to the masses. He saw himself as among the first to design for an industrial age. The best example of industrial design was his work with lamp shades. Other items his studios produced included trays, tableware, inkstands, jardinieres, clocks, photograph frames, pincushions, goblets, plates, and plaques. For a time, no well-appointed American home would have been without objects of Tiffany design. Lamp shades were one of the few items Tiffany mass-produced, and they were what caused Tiffany's name to remain in the public mind when his more elaborate and exotic creations had been forgotten. It may be in the field of industrial design that Tiffany Studios had its greatest impact.

Bibliography

Couldrey, Vivienne. *The Art of Louis Comfort Tiffany.* Secaucus, N.J.: Wellfleet Press, 1989. A lavishly illustrated and well-presented book by a former editor of *Collec-*

tors World. The book spans Tiffany's entire artistic career and includes illustrations of his early paintings. An interesting chapter debates whether his works are "Kitsch or Genius." The author links Tiffany to some of the movements in modern art, such as Abstract expressionism.

Duncan, Alastair, Martin Eidelberg, and Neil Harris. *Masterworks of Louis Comfort Tiffany.* New York: Harry N. Abrams, 1989. Comprehensive coverage of Tiffany's works, including a series of his paintings and many of the objects he designed, such as punch bowls and jewelry. Duncan is a decorative arts consultant and approaches his subject within that framework. Both Eidelberg and Harris are historians. Included is a detailed chronology. Probably the most significant feature of the book is the splendid color photography, for which the publisher is noted.

Koch, Robert H. *Louis C. Tiffany: Rebel in Glass.* New York: Crown Publishers, 1964. Koch can be considered a pioneer in the "Tiffany revival" of the 1960's. A student of architecture, he arrived at Tiffany's works through studying armories and grew fascinated with his subject. The book is divided into four parts, including Tiffany as a painter, his work in glass, his work with the Tiffany Studios, and an assessment. The preponderance of black-and-white photographs weakens the presentation.

McKean, Hugh. *The "Lost" Treasures of Louis Comfort Tiffany.* Garden City, N.Y.: Doubleday, 1980. McKean was one of the artists invited to study at Tiffany's home and tends to be somewhat adulatory. The photographs and the chapter on the hallmarks of Tiffany's creations are two commendable features of this work.

Potter, Norman, and Douglas Jackson. *Tiffany Glassware.* New York: Crown Publishers, 1988. Probably the best introduction to Tiffany's professional career. Even though the emphasis is on Tiffany's glassware, an excellent introduction to his career is also provided. Contains short bibliographies of various people who assisted or influenced Tiffany.

Tiffany, Louis Comfort. *The Art Work of Louis C. Tiffany.* 1914. Reprint. Poughkeepsie, N.Y.: Apollo, 1987. Foreword by Alastair Duncan. A reprint of the limited edition book commissioned by Tiffany's children in 1914. Covers the range of Tiffany's creative work, including architecture and landscape, and is an interesting insight into how Tiffany was regarded at the time. The famous commercially produced lamp shades are scarcely mentioned.

Nis Petersen

Cross-References

Hoffmann and Moser Found the Wiener Werkstätte (1903), p. 79; Hoffmann Designs the Palais Stoclet (1905), p. 124; Les Fauves Exhibit at the Salon d'Automne (1905), p. 140; Gaudí Completes the Casa Milá Apartment House in Barcelona (1910), p. 257; Avant-Garde Art in the Armory Show Shocks American Viewers (1913), p. 361.

DREISER'S *SISTER CARRIE* SHATTERS LITERARY TABOOS

Category of event: Literature
Time: November 8, 1900
Locale: New York, New York

Theodore Dreiser's Sister Carrie, *published despite misgivings concerning its frank treatment of sexuality, became a beacon to later American writers intent on overthrowing literary taboos*

Principal personages:

THEODORE DREISER (1871-1945), a young novelist who would become the leading figure in American literary naturalism

FRANK NORRIS (1870-1902), a young naturalistic novelist who, as the first reader of the *Sister Carrie* manuscript, urged its publication

FRANK NELSON DOUBLEDAY (1862-1934), a partner in the firm of Doubleday, Page & Company, who tried to rescind the agreement to publish *Sister Carrie*

Summary of Event

In 1899, Theodore Dreiser was a young veteran of print journalism with experience on daily newspapers in Chicago, St. Louis, Pittsburgh, and New York. In September of that year in New York (or perhaps a few months earlier at a friend's house in Maumee, Ohio), Dreiser began writing the story of a girl from a small Wisconsin town who becomes a kept woman in Chicago and, eventually, a Broadway starlet. The novel, which Dreiser finished in March of 1900, would embroil him in one of the most famous disputes in American publishing history.

Dreiser sent the completed manuscript to a publishing house in May, but it was rejected, although an editor suggested the possibility that Doubleday, Page & Company might be interested. In doubt was the suitability of the novel's frank portrayal of sexuality in an era of Victorian literary proscriptions. The heroine, Carrie Meeber, based in part on one of Dreiser's own sisters, lives with two men without benefit of matrimony. Perhaps most dubious of all according to the standards of the day, Carrie's transgressions are not punished beyond her consignment to a vague unfulfillment at novel's end.

Despite this cause for caution, Doubleday, Page accepted the manuscript for publication. The reason was the unbridled enthusiasm for the book expressed by the publisher's first reader, the California naturalistic novelist Frank Norris. In 1899, the firm (then called Doubleday, McClure) had brought out Norris' violent tale of a brutish San Francisco dentist, *McTeague*. Norris, whose popularity with his publishers gained him substantial influence, pronounced *Sister Carrie* "a wonder" and

one of the most pleasing novels he had read "in *any* form, published or otherwise." Impressed by Norris' response, Walter Hines Page wrote Dreiser accepting the novel in the absence of his partner, Frank N. Doubleday, who was traveling in Europe. When the signed agreement arrived from Page, Dreiser had every reason to believe that his career as a fiction writer had been launched. Soon, however, Doubleday and his wife Neltje returned from Europe, where they had been trying to acquire the publishing rights to Émile Zola's novels. Doubleday, a somewhat moralistic Episcopalian in spite of his relatively liberal attitude toward *McTeague* and Zola's novels, read Dreiser's manuscript and objected to the publishing agreement on the grounds that the work was immoral and because, in any event, it was unlikely to sell. Neltje Doubleday also read the book and concurred in her husband's judgment.

On July 19, at Frank Doubleday's insistence, Page wrote to Dreiser explaining the growing misgivings at the publishing house about the manuscript and asking for release from the agreement. Dreiser decided to fight for his rights. A series of thrusts and parries ensued, with Dreiser first trying courteous insistence and finally angry threats of legal action. Doubleday, Page representatives responded with offers to find him a different publisher and other attempts to mollify. Eventually, Doubleday agreed in exasperation to honor the agreement but to commit to only one edition. In a concession bespeaking surprising goodwill under the circumstances, Doubleday put Norris in charge of publicity, and the latter sent out 127 review copies appended with promotional material and his own personal letters. By the actual day of publication, November 8, 1900, Norris and Dreiser were certain the novel would be a huge, immediate success. They were mistaken. Very few reviewers were favorable, and those that were encountered much to criticize. The overwhelming majority of reviewers found the novel's subject matter unacceptably crude according to prevailing tastes and judged the style totally graceless. The response of the public was equally disheartening. Only 456 copies had sold by February of 1902, netting Dreiser royalties of $68.40.

The effect of Dreiser's disappointment was profound and sustained. In the short run, his perceived failure in this first attempt at long fiction, added to family and marital troubles, sent his already brooding psyche into a deep depression, and he was on the verge of suicide for several months. He was rescued from this funk by his brother, the celebrated songwriter Paul Dresser, who arranged for his treatment in a sanitarium. Recovering his equilibrium, Dreiser achieved notable financial success while pursuing a career as an editor of women's magazines. He might have stayed with this work permanently had he not been made to resign his position because of an affair of the heart involving an assistant's daughter. Forced to try writing literature again as a way of making a living, he went on to become one of his nation's leading novelists and the author of one of its most important twentieth century works of fiction, *An American Tragedy* (1925). Yet he never forgot his troubles with Doubleday, Page over the manuscript of *Sister Carrie*, even though the novel's subsequent publication in England spurred the slow but steady growth of its reputation in America. Throughout his later life, he returned again and again to the story of his

tiff with his first publisher, often embellishing it with half-truths and outright false-hoods. Almost always, these elaborated stories made Neltje Doubleday the blue-nosed villainess of the piece, a bit of misinformation he apparently picked up from Frank Norris. For many years, the legends Dreiser circulated about the circum-stances surrounding the Doubleday affair were taken at face value, but later scholar-ship served to set the record straight.

Impact of Event

Because *Sister Carrie* was effectively neutralized at the time of its appearance by the combination of its less-than-enthusiastic publisher, mostly negative reviews, and negligible sales, it had no appreciable immediate impact. Not until the modest suc-cess of his second novel, *Jennie Gerhardt* (1911), did Dreiser attract the concentrated attention of important critics and writers, who then discovered the ultimately more respected earlier novel. Undoubtedly, the most important of the first literary critics impressed by Dreiser was the acerbic Henry Louis Mencken. Dreiser had published some of Mencken's early essays while working as a magazine editor. The two be-came fast friends, a circumstance that positioned Mencken to mount his famous defense of Dreiser when the latter's 1915 novel *The "Genius"* was attacked for its "lewd" and "obscene" material by the New York Society for the Suppression of Vice. The notoriety of the temporary suppression of *The "Genius,"* coupled with the growing legend of his earlier troubles with Doubleday over *Sister Carrie*, helped establish Dreiser as an antiestablishment icon for the next generation of writers, including F. Scott Fitzgerald, James T. Farrell, Richard Wright, and many others. By the time *An American Tragedy*, Dreiser's epic novel fictionalizing a famous murder case, became a best-seller following its publication in 1925, *Sister Carrie* had come to be regarded as a national classic.

What subsequent writers discovered in *Sister Carrie*, however, was not simply a novel of historic importance in the battle against Victorian literary squeamishness. Equally important were other trendsetting aspects of the work as well as its attempt to come to intellectual grips with the modern world, in which the failure of faith necessitated a search for a substitute, secular salvation. First, the novel's heroine, Carrie Meeber, is a lower-middle-class Midwesterner who speaks ungrammatically. These qualities sharply differentiate her not only from the protagonists of romantic novels but also even from the protagonists of earlier American realists such as Henry James and William Dean Howells, whose "slice of life" fiction carefully avoided such ungenteel types. Moreover, Chicago and New York, the settings of *Sister Car-rie*, are rendered so palpably that the novel is justly regarded as a pioneering picture of the newly urbanized America teeming with seeking immigrants. As such, it pro-vided a precedent for later city novelists such as John Dos Passos, Nelson Algren, and Hubert Selby, Jr.

Perhaps the most widespread and long-lasting influence *Sister Carrie* had on later writers, however, stemmed from the book's attempt to construe the meaning of mod-ern American life. In the novel, Dreiser weds the growing spiritual skepticism of the

age to a national context. He was prepared for this mission by his reading and experiences in the years preceding the novel's publication. His reading had made him, at least nominally, a philosophic naturalist who believed that God was dead, that life was meaningless, that man was a helpless victim of his heredity and environment, and that blind chance shaped events. His experience had led him to brood about the disillusionment that inevitably resulted from the attainment of his desires and about his continued longing for fulfillment in spite of the evidence of his emotions. Dreiser incorporated his reading of naturalistic philosophy into *Sister Carrie* through the voice of an omniscient narrator who comments on and assesses the heroine's development. He made use of his experience by giving Carrie the same wants and urges that had prodded his own progress through life. In the novel, Carrie achieves material, sexual, artistic, and social success as well as fame, but her ultimate dissatisfaction leads her to contemplate an alternative agenda, the subsuming of the self in devotion to the less fortunate.

The American writers who came after Dreiser were forced to face a world that *Sister Carrie* had helped to define. Whether they accepted or rejected the bleak twentieth century determinism of the novel, they had to acknowledge that the philosophy contributed mightily to the skeptical mindset dominant among American intellectuals. Succeeding writers who sought thereafter to signal the significance of contemporary American life often walked the same road taken by Dreiser. A notable example of the influence of *Sister Carrie* on a later work is Fitzgerald's *The Great Gatsby* (1925), often singled out as the finest novel about the American Dream. Its mythic hero, Jay Gatsby, tragically pursues most of the same ends that had mesmerized Carrie; moreover, Fitzgerald ends his novel with a poetic evocation of the very desire and disillusionment over which Dreiser had brooded at the close of his story. *Sister Carrie* can be seen as well as the ancestor of the many other novels that excoriate American materialism, works as diverse yet typical as Sinclair Lewis' *Babbitt* (1922) and Joan Didion's *Play It As It Lays* (1970).

In 1981, *Sister Carrie* enjoyed a second debut somewhat more auspicious than its first. The University of Pennsylvania's Dreiser Project, a scholarly endeavor aimed at providing definitive editions of the novelist's works, published a version based on the *Sister Carrie* holograph. This version restores some thirty-six thousand words deleted in the process that led to the Doubleday, Page edition in 1900. Even this later version, though, met with the seemingly inevitable controversy that plagued most of Dreiser's book launchings. The Pennsylvania edition eliminates the final scene, in which Carrie muses on her experience while rocking in her chair—a deletion justified on the grounds that Dreiser had added it a few weeks after he had ostensibly finished the manuscript.

Bibliography

Dreiser, Theodore. *Letters of Theodore Dreiser*. Edited by Robert H. Elias. 3 vols. Philadelphia: University of Pennsylvania Press, 1959. Contains scattered references to *Sister Carrie* written to correspondents over Dreiser's entire life. Many

references add to the legend surrounding the suppression of the novel by Double-
day, Page in 1900.

—————————. *Sister Carrie.* Philadelphia: University of Pennsylvania Press, 1981.
Part of a scholarly project aimed at recreating the definitive texts of Dreiser's
novels as he would have authorized them. Restores passages eliminated by a vari-
ety of participants in the process of creating and publishing the novel in 1899 and
1900. Amplifies especially the characters of Carrie and Hurstwood.

Dudley, Dorothy. *Forgotten Frontiers: Dreiser and the Land of the Free.* New York:
Harrison Smith and Robert Haas, 1932. Biography that attempts to place Dreiser
in a national context. Written in a somewhat florid style uncharacteristic of biog-
raphies. Dudley's advantage over more recent biographers was her interviews with
Dreiser. Contains no scholarly apparatus or photographs. Reissued by the Beech-
hurst Press in New York (1946) simply as *Dreiser and the Land of the Free.*

Elias, Robert H. *Theodore Dreiser: Apostle of Nature.* New York: Alfred A. Knopf,
1948. An early critical biography done as a doctoral dissertation. Elias' advantage
over straight biographers was his training in literary criticism and the availability
of resource persons just a few years after Dreiser's death in 1945. Contains an
index and a few photographs. Reissued in emended form by the Cornell Univer-
sity Press in 1945.

Hussman, Lawrence E. "Theodore Dreiser." In *Dictionary of Literary Biography,*
edited by Margaret A. Antwerp. Vol. 1. Detroit: Gale Research, 1982. An illus-
trated chronicle of Dreiser's life and art. Includes photographs and reproductions
of manuscript pages, book jackets, playbills, and more. *Sister Carrie* section in-
cludes the 1899 Dreiser entry from *Who's Who in America,* a contemporary review
of the novel, and a reproduction of the last page of the *Sister Carrie* holograph. A
selected bibliography is included.

Lingeman, Richard. *Theodore Dreiser: At the Gates of the City, 1871-1907.* New
York: G. P. Putnam's Sons, 1986. The first volume of the definitive biography. A
much more sympathetic approach to Dreiser's life than W. A. Swanberg's (cited
below) and more sensitive in its approach to the novels. Contains photographs,
index, and bibliography. The second volume, published in 1990, is entitled *The-
odore Dreiser: An American Journey, 1908-1945.*

Pizer, Donald. *The Novels of Theodore Dreiser: A Critical Study.* Minneapolis: Uni-
versity of Minnesota Press, 1976. Sets out to establish sources and elucidate the
composition process for each of the novels. Separate chapter on each novel. Dis-
cussion of *Sister Carrie* composition especially helpful. Contains index and end-
notes.

Salzman, Jack, ed. *Theodore Dreiser: The Critical Reception.* New York: David
Lewis, 1972. A collection of contemporary reviews of Dreiser's books. Includes
several of the original responses to the 1900 Doubleday, Page edition of *Sister
Carrie* and an introductory essay by Salzman that puts Dreiser's literary reception
and subsequent reputation in historical context.

Swanberg, W. A. *Dreiser.* New York: Charles Scribner's Sons, 1965. The first serious

and comprehensive biography. Swanberg's jaundiced view of Dreiser's private life did not sit well with the surviving members of the novelist's family. Reliable on factual details but deficient in literary judgment. Contains photographs and index. Superseded by Lingeman's two-volume biography cited above.

Lawrence E. Hussman

Cross-References

Joyce's *Ulysses* Epitomizes Modernism in Fiction (1922), p. 555; Woolf's *Mrs. Dalloway* Explores Women's Consciousness (1925), p. 637; Beauvoir's *The Second Sex* Anticipates the Women's Movement (1949), p. 1449; The Theatres Act Ends Censorship of English Drama (1968), p. 2131; Roth Publishes *Portnoy's Complaint* (1969), p. 2163.

THE FIRST NOBEL PRIZES ARE AWARDED

Category of event: Literature
Time: December 10, 1901
Locale: Stockholm, Sweden, and Oslo, Norway

On the fifth anniversary of Alfred Nobel's death, the first prizes that his will established were awarded—the physics, chemistry, physiology or medicine, and literature prizes in Stockholm, and the peace prize in Oslo

Principal personages:

ALFRED NOBEL (1833-1896), a Swedish chemist, inventor, entrepreneur, and philanthropist whose wealth, acquired through the manufacture of dynamite and other explosives, provided the funding for the Nobel Prizes

BERTHA VON SUTTNER (1843-1914), an Austrian writer whose dedication to the movement for international peace inspired Nobel to establish the peace prize

Summary of Event

The genesis of the Nobel Prizes has been traced to two newspaper items, an advertisement and an obituary. The advertisement, placed in a Vienna newspaper by Alfred Nobel in the spring of 1876, was for a woman with a knowledge of languages to come to Paris to serve as his secretary and housekeeper. Countess Bertha Kinsky, then a thirty-three-year-old governess to the baronial Suttner family, had mastery of German, French, English, and Italian. After corresponding with Nobel, she went to Paris and charmed him, quickly becoming not only his secretary but also his friend. Although she left his employ after only a week (to marry Arthur von Suttner secretly in Vienna), she began a correspondence with Nobel that continued while she and Arthur were estranged from his family and, after the Suttner family finally became reconciled to their marriage, when she took up her position as Baroness von Suttner at the family estate. They corresponded about literature, which, next to science, was Nobel's favorite interest (he not only read but also wrote poetry, dramas, and novels). Bertha von Suttner's linguistic talents were much greater than Nobel's, and her writings and involvement in the peace movement made her internationally famous. Through her letters, she was able to imbue Nobel with her hatred of militarism, and many scholars have seen her influence both generally in the principles underlying the Nobel Prizes and specifically in the Peace Prize.

The pacifism and idealism that Baroness von Suttner was encouraging in Nobel received an added impulse from an obituary notice that appeared in 1888. Alfred's brother Ludvig had died on April 12, but the author of the obituary confused Ludvig with Alfred, and so Alfred Nobel was able to read his own obituary. It was a disillusioning experience, for he found that people viewed him primarily as a merchant of

death—not an inventor whose discoveries had been forces for good but one whose explosives had made war distressingly horrible. He had believed that his explosives would end war long before Bertha von Suttner's peace congresses would, since these weapons would force nations to realize that increasingly horrible wars were ruinous ways of solving their problems; when he saw how the appetites of nations for wars were whetted rather than repelled by these new weapons, however, he came to agree with the baroness that more sophisticated and powerful explosives would not prevent wars. Nobel also began to think about how he could use his great fortune, amassed from selling explosives, to advance human understanding and love.

In 1889, Bertha von Suttner published a novel, *Die Waffen nieder!* (*Lay Down Your Arms*, 1892), in which she pictured the devastating effects that wars had on people's lives. Her book was second only to Harriet Beecher Stowe's *Uncle Tom's Cabin, Or, Life Among the Lowly* (1851-1852) in the influence that it exerted on people, institutions, and nations of the nineteenth century. In the years after the appearance of *Die Waffen nieder!*, Nobel, in his letters to the baroness, began referring to his weapons as "implements of hell" and calling war "the horror of horrors." Before 1889, he had derided most peace efforts, but by 1892, he was actively promoting various peace movements. In 1893, when he reached the age of sixty, his health started to deteriorate rapidly, so he hired Ragnar Sohlman as his assistant and drafted a will in which he left most of his estate to the Royal Academy of Sciences in Stockholm. Nobel's will stipulated that the academy annually use a part of the estate's income to honor the persons who had made the most important discoveries in science and, as he put it in a letter to Bertha, to reward the person who had done most to advance the idea of general peace in Europe.

While on a trip to Paris in 1895, Nobel canceled the 1893 will and wrote a new one that became the founding document for the Nobel Prizes. One of the notable differences in the new will was the provision for a literature prize (Nobel wanted to honor idealistic writings). When the contents of this will were revealed after Nobel's death on December 10, 1896, his relatives were shocked to discover that their share constituted a minuscule portion of the estate's total assets. Some of them brought suit to break the will, as did a woman who had had a relationship with Nobel, but these lawsuits never came to trial, as the claims were settled out of court through various grants. Finally, after three years of difficult negotiation, Sohlman, the chief executor, succeeded in getting Nobel's will accepted by his relatives and in moving the prize-awarding institutions—the Academy of Sciences, the Swedish Academy, the Karolinska Institute, and the Norwegian parliament—to establish specific mechanisms for nominating and selecting prizewinners. On June 29, 1900, King Oscar II approved the statutes of the Nobel Foundation and the special regulations of the prize-giving institutions, and five Nobel committees began doing their work to select the first Nobel Prize winners.

The Swedish Academy of Sciences gave the first Nobel Prize in Physics to Wilhelm Röntgen for his discovery of X rays. Although this discovery had been made in 1895 and Nobel's will stipulated that the prize be given for work done during the

preceding year, the physics committee interpreted Nobel's provision quite broadly to mean that past achievements could be rewarded, since properly assessing a discovery's importance often required tracing its influence over a period of time. The award of the chemistry prize to Jacobus van't Hoff was for discoveries in chemical thermodynamics and osmotic pressure made in the 1880's; like their comrades in physics, the committee members for the chemistry prize felt that it took longer than a year for a great chemical discovery to prove its worth. The first prize in physiology or medicine was given to Emil von Behring for his discovery, ten years earlier, of the antitoxin against diphtheria.

In the eyes of many critics and scholars, the award of the literature prize to Sully Prudhomme has proved to be the least worthy in this group of first Nobelists. The committee members mentioned Prudhomme's "lofty idealism" in their justification of the award, but people throughout the world objected to the choice, pointing out the superior literary accomplishments of Marcel Proust, Paul Valéry, Thomas Hardy, Henrik Ibsen, and others. Close to home, forty-two Swedish authors and artists signed a tribute to Leo Tolstoy (who had not even been nominated). Many members of the French Academy had nominated Prudhomme, and their advice appears to have exerted a strong influence on the members of the Swedish Academy.

Unlike the science and literature prizes, which were awarded in Stockholm, the Peace Prize was presented in Oslo by the chairman of the Peace Prize Committee in the presence of the Norwegian Royal Family. The recipients of the first Nobel Peace Prize were Henri Dunant and Frédéric Passy. In 1864, Dunant had helped create, through his writings and other efforts, the International Red Cross, and this and his work for prisoners of war were seen by the committee as important contributions to world peace. Passy had founded an influential international peace society, and the committee probably chose him along with Dunant to emphasize the international character of the Peace Prize. The surprise at the first announcement of this award was its dual nature. The idea of a divided prize was not in Nobel's will but actually originated with Nobel's relatives, who tried to break the will and compromised in an out-of-court settlement. In this settlement, they stipulated, among other provisions, that in no circumstances should a prize be divided into more than three prizes. The selection committee took advantage of this provision, which other prize committees have used many times since.

Impact of Event

When the Nobel Prizes were first awarded, they did not have the great prestige that they later acquired. To help make the prizes reliable symbols of significant accomplishment in science, literature, and peace, committee members, during the formative period of the prizes, selected scientists, writers, and peace activists whose accomplishments had already brought them great fame. In this way, they added the glory of the winners to the prize itself. This process was easier to perform for the science prizes, where some objective measures of the greatness of a discovery existed. The literature and peace awards were subject to more controversy than the

science prizes, since political factors sometimes affected decisions. Nevertheless, even for these awards, committee members saw it as their duty to recognize achievers who, according to the consensus of the best people in the respective fields, had done important, influential, and idealistic work.

The prestige of the Nobel Prizes grew rapidly, both because of the pragmatic approach of the Nobel committees and because of the genuine needs that the Nobel Prizes met. Before the Nobel Prizes, most awards were local, national, or narrowly disciplinary. The Nobel Prizes, which were intended to be truly international, thus filled a niche, and the prize committees became supranational arbiters of achievement in the sciences, literature, and peace. The Nobel Prizes, though, were not always free from provincial or disciplinary prejudices. For example, several writers of national epics seem to have been chosen for provincial reasons, and the rivalry between organic and physical chemists often played a role in the selection of winners of the chemistry prizes.

Nobel laureates have undoubtedly played an important part in the development of the sciences and humanities. In focusing on the accomplishments of a very small group of individuals and an even smaller number of institutions, however, it is helpful to be aware of the richness and complexity of the evolution of science, literature, and peace. According to many scholars, the Nobel Prizes, taken alone, actually distort the understanding of the histories of the various disciplines. In their defense, members of the various Nobel committees have stated that their awards are not intended to give a balanced picture of modern physics, chemistry, medicine, literature, or peace. If understood in terms of Nobel's intention—to honor examples of the progress of human understanding and compassion—then the Nobel Prizes do give a sense of what achievements attained the greatest international recognition in their time.

The Nobel Prizes have honored only a limited measure of pivotal work in science, literature, and peace. In itself, a prize guarantees neither the significance nor the immortality of the accomplishment honored. Indeed, in several cases the awards have been clearly wrong or wrongheaded. For example, over the years there have been many complaints about the Swedish Academy's neglect of writers of the highest achievement—from France, Marcel Proust, Paul Valéry, and Paul Claudel; from Russia, Leo Tolstoy, Maxim Gorky, and Vladimir Nabokov; from Great Britain, Thomas Hardy, Joseph Conrad, James Joyce, Virginia Woolf, D. H. Lawrence, W. H. Auden, and Graham Greene; and from Scandinavia, Henrik Ibsen and August Strindberg. Instead of choosing these preeminent writers, committee members selected such provincial writers, now largely unread and forgotten, as Rudolf Christoph Eucken, Karl Adolph Gjellerup, Henrik Pontoppidan, Carl Spitteler, and Erik Axel Karlfeldt. In response to these criticisms, committee members have defended their choices. For example, they did not choose Ibsen because of his negativism, Strindberg because of his iconoclasm, and Hardy because of his lack of ethical idealism.

Despite the infelicity of some of the choices, the Nobel Prizes have served an important social function, since they have provided the world with a way to recog-

nize achievements that have helped to advance human understanding. In addition to the honor bestowed on scientists, writers, and peace activists, the prizes have also been able to encourage the development of certain disciplines, institutions, and ideologies. In this respect, the prizes in literature and peace have fascinated the general public most strongly. Committee members in these areas have sometimes used the prizes to attack political movements they viewed as retrograde; for example, the award of the Nobel Peace Prize to the German journalist Carl von Ossietzky was seen by many as the Nobel committee's way of attacking Adolf Hitler and Nazism. In literature, committee members have often used their prize to call the world's attention to neglected writers and movements.

The durability of any achievement in science, literature, or peace ultimately depends on the depth of its influence on human progress. In a sense, the prizes embody the paradoxes that characterized Alfred Nobel's life and work. He made many important discoveries and hoped that they would be used to advance human welfare. What he witnessed, however, was the use of his discoveries by unscrupulous people and nations for ignoble and destructive ends. When he saw, particularly under the influence of Bertha von Suttner, that the evil consequences of his work seemed to outweigh the good, he resolved to set up prizes that would reward discoveries, writings, and activities that resulted in the progress of knowledge beneficial to humanity. Throughout his life, he felt that what really mattered was the quest for scientific knowledge and for creative expression in literary and human affairs. He called himself a superidealist and believed deeply that understanding would bring improvement; for him, growth in understanding and growth in love went hand in hand. Like Ebenezer Scrooge in Charles Dickens' *A Christmas Carol* (1843), Nobel was given a glimpse into the future evaluation of his life, and he was consequently able to change that life. As a result, each year on the anniversary of his death, prizes in his name are awarded that show concretely that his idealistic goals possess an enduring meliorative reality.

Bibliography

Bergengren, Erik. *Alfred Nobel: The Man and His Work.* Translated by Alan Blair. New York: Thomas Nelson, 1962. The official biography of Nobel, written with the cooperation of the Nobel Foundation. Weaves anecdotes and analyses into a mostly reliable account of the development of Nobel as a chemical inventor and industrial entrepreneur. Also deals sensitively with Nobel's relationship with Bertha von Suttner.

Crawford, Elisabeth T. *The Beginnings of the Nobel Institution: The Science Prizes, 1901-1915.* New York: Cambridge University Press, 1984. Crawford, who had access to the early papers of the Royal Swedish Academy of Sciences and its Nobel Committees for Physics and Chemistry, makes good use of the information. Gives an inside look at how academy members actually selected prizewinners during the first decade and a half of the Nobel Prizes in Physics and Chemistry.

Nobelstiftelsen. *Nobel: The Man and His Prizes.* 3d ed. New York: Elsevier, 1972.

Written with the cooperation of the Nobel Foundation to commemorate the first fifty years of the prizes, this book's editions have served as the institution's official history. In addition to histories of the individual prizes, the book also contains a biographical sketch of Alfred Nobel by H. Schück and an essay on Nobel and the Nobel Foundation by Ragnar Sohlman.

Wasson, Tyler, ed. *Nobel Prize Winners.* New York: H. W. Wilson, 1987. Profiles the 566 men, women, and institutions that received the Nobel Prize between 1901 and 1986. Selective bibliographies of original and secondary sources available in English are included at the end of each sketch. There are prefatory essays on Alfred Nobel, the Nobel Prizes, and the Nobel institutions.

Wilhelm, Peter. *The Nobel Prize.* London: Springwood Books, 1983. Presents incisive accounts of Alfred Nobel's life and work, the history of the Nobel Foundation, a description of its administrative functions, and an analysis of the nomination procedures, the selection process, and the ceremonies themselves. Also traces the personal odyssey of one of the recent Nobel Prize winners, from the announcement of his award through his reception of the Nobel Prize in Stockholm. Beautifully illustrated, with many color and black-and-white photographs.

Robert J. Paradowski

Cross-References

Bergson's *Creative Evolution* Inspires Artists and Thinkers (1907), p. 161; The First Pulitzer Prizes Are Awarded (1915), p. 407; Pasternak's *Doctor Zhivago* Is Published (1957), p. 1747; Singer Wins the Nobel Prize in Literature (1978), p. 2423; Soyinka Wins the Nobel Prize in Literature (1986), p. 2594; Mahfouz Wins the Nobel Prize in Literature (1988), p. 2625; Gordimer Wins the Nobel Prize in Literature (1991), p. 2668.

HEART OF DARKNESS REVEALS
THE CONSEQUENCES OF IMPERIALISM

Category of event: Literature
Time: 1902
Locale: Edinburgh, Scotland, and London, England

Joseph Conrad's novel revealed the horrors behind the rhetoric of nobility and idealism in which Europeans cloaked their imperialism

Principal personage:
> JOSEPH CONRAD (JÓSEF TEODOR KONRAD NAŁĘCZ KORZENIOWSKI, (1857-1924), a novelist who revealed the horrors of European imperialism in Africa

Summary of Event

In 1874, seventeen-year-old Joseph Conrad left his Polish family to travel to Marseilles, France, to become a seaman. He sailed on vessels of several nations, but he became a British citizen in 1887. In 1890, he left the high seas to travel up the Congo River into the heart of Africa. His trip into the Congo Free State (later Zaire) inspired *Heart of Darkness*, which was published as a serial in *Blackwood's Magazine* in early 1899 and in book form in 1902.

The story opens at dusk on board the yawl *Nellie*, anchored in the Thames River at London. Five men are on board, all bound together by their connection with the sea. An unnamed primary narrator repeats to the reader a story told that evening by a seaman, Marlow.

As the primary narrator looks out into the night, he thinks back to the days when men such as Sir Francis Drake sailed out from London. Suddenly, Marlow breaks into his reverie, saying: "And this also . . . has been one of the dark places of the earth." Conrad thus signals to the reader that his story is not going to be a romantic paean to empire.

Marlow goes on to recall Roman adventurers who came up the Thames nineteen hundred years before. They were only conquerors: "The conquest of the earth, which mostly means the taking it away from those who have a different complexion or slightly flatter noses than ourselves, is not a pretty thing when you look into it too much." Marlow suggests that imperial adventures are justified only if they embody "efficiency" and "an idea." Do efficiency and an idea, such as the carrying of European civilization into other areas, justify imperialism? Marlow seems to think so, but few assumptions remain unexamined as his story goes on.

Earlier in his career, Marlow had been hired to command a steamboat for a Belgian company that traded on the Congo River. As he journeyed among company stations along the river, he quickly began to be stripped of his illusions regarding

efficiency and idealism. He walked among the litter of abandoned, rusty machinery and noted the waste of aimless, inefficient railroad building. He found chain gangs of African workers dying in misery of starvation and disease. He met the company's general manager, a greedy careerist unencumbered by either efficiency or ideas. He was surrounded by rootless European "pilgrims" who spoke the word "ivory" as though they were praying to it. Company employees were empty men: "To tear treasure out of the bowels of the land was their desire, with no more moral purpose at the back of it than there is in burglars breaking into a safe."

Marlow heard people talk of Kurtz, who ran the company's Inner Station far up the river. They whispered his name in the worshipful tones they used to discuss ivory. His efficiency flooded the company with ivory, and his "idea" inspired others. Kurtz is a prodigy, a special being, one man said: "He is an emissary of pity, and science, and progress. . . ." In contrast to the company men who surrounded him, Kurtz began to appear to Marlow as a beacon on a path toward a better world.

Marlow moved on up river into the heart of darkness, toward Kurtz. His boat carried twenty cannibals, culturally rooted men with whom he worked and toward whom he felt gratitude, unlike the manager and pilgrims who also traveled with him.

As the old steamboat slowly approached the Inner Station, Marlow saw human forms moving along the tree line, decayed buildings filled with ivory, slim posts decorated by little round balls—which he belatedly realized were severed heads— and then a white man, a Russian, dressed in multicolored rags. While the company men scurried around loading the ivory, the Russian told Marlow that Kurtz was ill. The Russian was a Kurtz disciple, captivated by his ability to articulate "an idea." "He made me see things—things," the Russian said.

They brought the dying Kurtz on board. The manager was distraught, because Kurtz had organized the natives into a personal army to drain the whole district of ivory. The disruption would force the company to shut down operations there. Marlow found Kurtz horrifying—a man who pushed "the idea" to the point of insanity—but not as disgusting as the empty greed of the manager and his company.

As Marlow brought the steamer back down the river, he spent as much time as he could with Kurtz and heard his last words: "The horror! The horror!"

Marlow returned to company headquarters at Brussels, Belgium, and visited Kurtz's fiancée, the "Intended." As he rang her doorbell, he seemed to hear whisperings of Kurtz's last words: "The horror! The horror!" As he sat with her, he was aware of the death and destruction on which his civilization was built, symbolized by the ivory on the piano keys in the quiet drawing room. The Intended had known Kurtz, she said, in all of his nobility and idealism. With every word spoken, the room grew darker. She asked Marlow to repeat Kurtz's last words; though he wanted to tell the truth, Marlow collected himself and told her that Kurtz's last words had been her name.

Marlow, who detested lies, had learned on his journey into darkness that civilization was based on lies. Only a few, like Kurtz, were able to look steadily at this truth, the horror that civilization hides from itself.

The men on the *Nellie* sat quietly as Marlow finished his tale. They silently watched the heart of darkness settling on London.

Impact of Event

The twentieth century witnessed explosive change, yet Joseph Conrad's *Heart of Darkness*, written at the beginning of the century, retained its fascination for readers at the end. What readers found in it changed. The book has been interpreted as a romantic adventure story, as a slashing attack on imperialism, as a conservative political manifesto that rejected political idealism, as a manifesto for the left, as a psychological journey into the heart of the individual, as a retelling of the ancient myth of the hero's quest, as an existential study of alienation and solitude, and as a modernization of classical literature's theme of a descent into hell. One could construct a revealing intellectual trek through the twentieth century just by tracing interpretations of Kurtz's words "The horror! The horror!"

Critics often got far away from Conrad's main focus, colonialism in the Belgian Congo. Conrad was one of the first Europeans to understand what was happening in the Congo. After explorers penetrated the region, European nations scrambled for a foothold in the resource-rich basin. In 1876, King Leopold II of Belgium proposed piercing "the darkness" of the Congo and bringing there civilization and Christianity. Such noble words fit the Europeans' conception of their destiny and burden. In 1884, German Chancellor Otto von Bismarck, alarmed at the possibility of war among the competing powers, called a conference in Berlin. The conferees turned the Congo over to Leopold as his personal property in return for his promise to open the region for the trade of all nations.

Although Leopold skillfully cloaked his work in the rhetoric of humanitarian reform, he turned the Congo into a personal plantation and skimmed off such resources as ivory and rubber. He closed the region to outside competitors and used his army to reduce the Congolese to slavery. In the 1890's, stories of atrocities began to leak out. Europeans read of chain gangs and slave labor, with people's heads and hands being cut off if they failed to meet their quota of rubber or ivory. They read of a Captain Rom at Stanley Falls who used African heads to decorate his flower bed. By 1908, the Congo's population had fallen by around three million people. That year, the revelation of the horrors there finally forced Leopold to relinquish the colony to the Belgian government.

While most Europeans still regarded colonization as an honorable civilizing mission, Conrad stripped away such illusions. Edmund Morel, the leader of the Congo Reform Association, called *Heart of Darkness* the most powerful indictment ever written on the subject. Conrad provided one of the few literary attacks on imperialism in Great Britain before World War I.

As the decades passed and the European empires crumbled, critics formulated brilliant social, economic, and psychological critiques of imperialism. Yet Conrad never passed out of fashion. He seemed to have anticipated every turn in anti-imperial analysis. Each generation found inspiration and reinforcement in *Heart of*

Darkness. For example, in 1979, American film director Francis Ford Coppola used *Heart of Darkness* as the source of his anti-Vietnam War film *Apocalypse Now*, with the story moved from the Congo to Vietnam and Cambodia.

Not everyone wanted to confer anti-imperial sainthood on Conrad. One group of dissenters believed that *Heart of Darkness* was a Eurocentric work that portrayed Africans as dark and mysterious beings who threatened civilized humans. In 1975, Nigerian novelist Chinua Achebe attacked *Heart of Darkness* as racist. Another group of critics argued that Conrad, or at least Marlow, deplored only Belgian imperialism, not colonialism generally.

Conrad undoubtedly believed that Africans were inferior to white Europeans. Racism was almost unquestioned in Europe at the turn of the century, and Conrad did not completely transcend his times. Yet Conrad's indictment of European atrocities against Africans has seldom been equaled. He avoided turning Africans into stereotypical racial figures or into noble savages. Marlow saw the Africans as humans, not as criminals, enemies, or rebels. Marlow's language, too, undercut the commonly accepted racism of his time and place. For example, he described the feeling of isolation and fright he felt in Africa: "The earth seemed unearthly. . . . It was unearthly, and the men were—No, they were not inhuman." He backed away from completing the thought with the racial cliché of his day, forcing the reader also to stop and, presumably, think. Conrad was a cultural relativist who believed that all cultures had the right to exist without disruption from the outside.

Did Conrad and Marlow condemn only Belgian atrocities and support imperialism generally? That seemed to be what Marlow wanted to do as he began his story. He established efficiency and "an idea" as criteria that distinguished strong-armed conquerors from proper colonists. The Belgian company met neither criterion.

Underneath his attack on Belgian exploitation of the Congolese was an indictment of imperialism generally. Marlow interrupted the primary narrator's opening reverie about the glories of British imperialism by saying that England also had been one of the dark places of the world. Marlow later described finding Kurtz's eloquent report to the International Society for the Suppression of Savage Customs; the report was inspired by the noblest expressions of the imperialist civilizing "idea." Yet Marlow discovered that ideas (and people) uprooted from their culture become evil. At the bottom of his report, in an unsteady hand, Kurtz had scribbled: "Exterminate all the brutes!"

Kurtz was a product of all Europe, Marlow said, not just Belgium. Kurtz had a British mother and French father and had been educated partly in England. Nor is darkness found only in the Congo. Marlow ends his tale in the darkening room of the Intended in Brussels, and the primary narrator ends the story in London with the five men sitting silently in "the heart of an immense darkness."

Bibliography

Brantlinger, Patrick. "*Heart of Darkness*: Anti-Imperialism, Racism, or Impressionism?" *Criticism* 27 (Fall, 1985): 363-385. This article breaks with most critics who

read the novella as a savage attack on imperialism. Brantlinger argues that Conrad unintentionally sanctioned imperialism and racism by using an impressionistic writing style that raises the problem of imperial evil and then backs off under the cover of obscure language.

Fleishman, Avrom. *Conrad's Politics: Community and Anarchy in the Fiction of Joseph Conrad.* Baltimore: The Johns Hopkins University Press, 1967. Fleishman carefully traces the evolution of Conrad's political thinking and places it within the context of his time. Conrad valued order and community, both destroyed by the greedy, shabby imperialists.

Hawkins, Hunt. "Conrad and the Psychology of Colonialism." In *Conrad Revisited: Essays for the Eighties,* edited by Ross C. Murfin. Tuscaloosa: University of Alabama Press, 1985. Hawkins finds that Conrad anticipated brilliant studies of the psychology of colonization by such researchers as O. Mannoni and Frantz Fanon. The colonist, unable to succeed in his own society, goes to a colony where, through no merit of his own, he achieves domination over others. He is cut off from both his own society and that of "the Other" and ultimately disintegrates psychologically.

_____. "Conrad's Critique of Imperialism in *Heart of Darkness.*" *PMLA* 94 (March, 1979): 286-299. Focuses on *Heart of Darkness* as a case study of imperialism in the Congo, but goes on to argue that Conrad rejected all varieties of imperialism, efficient and inefficient, benevolent and evil, British and non-British. Conrad, the author says, believed indigenous cultures had the right to exist without disruption from outside.

Hay, Eloise Knapp. *The Political Novels of Joseph Conrad: A Critical Study.* Chicago: University of Chicago Press, 1963. Hay's interesting study distinguishes between the views of Conrad and Marlow. She suggests that though Marlow may have sincerely used efficiency and idealism as criteria for judging imperialism, Conrad's language undercuts Marlow's views to condemn imperialism generally.

Parry, Benita. *Conrad and Imperialism: Ideological Boundaries and Visionary Frontiers.* London: Macmillan, 1983. At first glance, this seems to be the kind of study that sometimes subjects literary criticism to ridicule; it is dry, abstract, and difficult to understand. Yet it rewards careful reading. Parry argues that Conrad provides a sophisticated critique of the capitalist world system.

Raskin, Jonah. "Imperialism: Conrad's *Heart of Darkness.*" *The Journal of Contemporary History* 2 (April, 1967): 113-131. Raskin describes the fever of imperialism in the Western world at the turn of the century. Raskin believes that as the text of his story, Conrad attacks Belgian imperialism in terms that his British audience could understand and accept; underneath, though, is a subtext that attacks imperialism generally.

William E. Pemberton

Cross-References

Artists Find Inspiration in African Tribal Art (1906), p. 156; Golding's *Lord of*

the Flies Spurs Examination of Human Nature (1954), p. 1585; *Things Fall Apart* Depicts Destruction of Ibo Culture (1958), p. 1763; *Apocalypse Now* Is Hailed as the Ultimate Vietnam War Film (1979), p. 2429; *"MASTER HAROLD"* . . . *and the boys* Examines Apartheid (1982), p. 2496.

LE VOYAGE DANS LA LUNE
INTRODUCES SPECIAL EFFECTS

Category of event: Motion pictures
Time: 1902
Locale: Paris, France

Distributed nearly worldwide, Georges Méliès' Le Voyage dans la lune *introduced its audiences to special effects and championed the use of film for entertainment*

Principal personages:

GEORGES MÉLIÈS (1861-1938), a French magician turned filmmaker who pioneered the use of special effects

GASTON MÉLIÈS (1852-1915), the brother of Georges, who produced their films in America

AUGUSTE LUMIÈRE (1862-1954) and

LOUIS LUMIÈRE (1864-1948), the French brothers who showed the first films to a paying audience

CHARLES PATHÉ (1863-1957), a former phonograph manufacturer who brought an industrialist's attitude to French film production

FERDINAND ZECCA (1864-1947), the director of Pathé's studios, who was accused of mutilating Méliès' films

D. W. GRIFFITH (1875-1948), a great American filmmaker who considered Méliès' work an inspiration

EDWIN S. PORTER (1869-1941), an American director who moved beyond Méliès' innovations

JOHN NEVIL MASKELYNE (1839-1917), an English magician admired by Méliès

Summary of Event

When Georges Méliès showed his latest film, the extravagant science-fiction spectacle *Le Voyage dans la lune* (*A Trip to the Moon*) to a Parisian audience in August, 1902, cinema was young and in search of its artistic identity. The international success of Méliès' well-designed, entertaining fantasy fare, of which *Le Voyage dans la lune* was the best, quickly established audience demand for narrative films. It also made its producer, director, actor, and set designer one of the founding fathers and creative shape-givers of cinema.

Méliès had attended the now-famous first film presentation to a paying audience by the brothers Auguste and Louis Lumière in Paris on December 28, 1895. Immediately, magician and theater-owner Méliès was fascinated by the new art. When the Lumières refused to sell him one of their own projector/cameras, Méliès acquired the necessary equipment from British and French inventors and started to show films in his Théâtre Robert-Houdin in April, 1896.

Unhappy with the films he had to buy, and too much a creative genius to content himself with their storyless, unadorned recordings of reality, Méliès started to make films of his own. Between September, 1896 and March, 1897, he built the world's second film studio (after Thomas Edison's Black Maria Studio in New Jersey) in Montreuil, near Paris. There, until 1914, his Star Film Company would produce about five hundred films—an output that made Méliès one of the biggest producers and directors of early films.

In 1902, *Le Voyage dans la lune* splendidly showcased Méliès successful transformation from stage magician to filmmaker. With its painted backdrops, different-scale models, trapdoors, wings, and wires, the film's studio effects complemented its creator's editing skills and mastery of photographic effects. All the special effects of *Le Voyage dans la lune* were unified by a dramatic story—the flight to the moon.

The fourteen-minute film opens with a view of the Astronomic Club, where President Barbenfouillis (played by Méliès) proposes a trip to the moon. The technology utilized—a projectile fired by a big gun—had been imagined by novelist Jules Verne in 1865 and required little explanation. The tableau of the Astronomic Club dissolves to reveal the manufacture of capsule and cannon. This filmic dissolve, like the fade-out, was first created by Méliès, who superimposed with increasing luminosity the frames of the next scene over those of the first (or else slowly closed the lens for a fade).

The technique of the painted backdrop employed in the film's total of thirty tableaux was one Méliès borrowed from theater and fine-tuned to his new medium. Such relatively conventional *trompe l'oeil* ("deceive the eye") effects as the surface of Méliès moon, which nevertheless brought new vistas to film, are adapted to the specific optical qualities of his film stock. Because he painted backdrops and props in shades of grey instead of in true colors, the scenery had a plastic look on film.

For the voyage itself, Méliès used both a model and a simulated tracking shot. Rather than moving his camera, which would become common practice with mobile modern equipment, Méliès instead moved his set to show the projectile landing, in a well-executed matte shot, directly in the eye of the "man in the moon"—an actor peeping through a painted moon. From this visual joke, Méliès dissolved to a second, "realistic" landing on the surface.

To show the scientists encountering the bellicose Selenites, or moonfolk, Méliès relied heavily on the stop-camera technique, which, according to his memoirs, he discovered quite by accident. Before Méliès, no one had realized that a camera could be stopped while filming a scene and later restarted. Characteristically, Méliès used this idea to give to the old magician's trick of substituting one object for another a new aura of fantastic realism: The scientists' umbrellas turn into mushrooms on Méliès' moon; when struck by Barbenfouillis' umbrella, the hostile Selenites disappear in a puff of smoke.

For the spaceship's return to the earth, Méliès employed the rudiments of continuity editing. Every time the spaceship disappears at the bottom of a scene, it reappears at top in the next scene, simulating a long fall viewed from different cam-

era positions. Upon their rescue from the sea, Méliès' astronauts receive a triumphant welcome and bow to the film's audience—a gesture carried over from the stage.

Ironically, the very success of Méliès films such as *Le Voyage dans la lune* contributed to his demise as a filmmaker. Cinema's undisputed leader from 1896 to 1905—even, after 1903, the owner of an American branch led by his brother Gaston—Méliès found himself unable to adapt. The industrialization of film production, led by Charles Pathé in France, spelled doom for the quality-conscious artisan Méliès. Méliès agreed to have his films distributed by Pathé in 1911; his granddaughter later charged that Ferdinand Zecca, the man Pathé put in control, deliberately mutilated Méliès' films to eliminate a rival.

Méliès was aesthetically unwilling to evolve from a position of perfection, and his films remained, up to the close of his career in 1912, filmed theater. He thus missed a crucial shift in audience demand: His static camera never changed its position—head-on to the stage. By 1909, American audiences—three-fourths of the French film industry's market—had turned away from fantasy fare and were demanding naturalistic drama.

After a bitter forced sale of his studio and the demolition of his theater in 1923, Méliès found himself reduced to selling novelties in a tiny kiosk in Paris. He was rediscovered by film historians, however, and his work was treated to a gala retrospective in 1929; he was awarded the Cross of the French Legion of Honor by Louis Lumière in 1931. With honor also came financial rescue. When Méliès died in 1938, his early contribution to the development of narrative cinema and his technical inventions were widely recognized.

Impact of Event

The international success of *Le Voyage dans la lune* not only shaped audience expectations worldwide but also brought home Georges Méliès' problems with the piracy of his films, especially in the lucrative American market. To combat this abuse, his Star Film Company established an office under Gaston Méliès in New York City in 1903. Méliès also began to submit paper contact prints to the Library of Congress to protect his copyrights in the United States. Ironically, it was there, and in a private American collection, that most of Méliès' films survived, rather than in Europe.

In addition to distributing George Méliès' films, Gaston began producing his own films for the family company in New Jersey in 1909. Yet his outfit, which was relocated to San Antonio, Texas, in 1910 and to Santa Paula, California, in 1911, produced typical "American" fare, mostly Westerns shot out of doors. Gaston's enterprise ceased operations in 1912; Gaston's presence in the United States, however, ensured that Georges Méliès' films were widely available there and were noticed by American filmmakers.

Among these, pioneer Edwin S. Porter was impressed by Méliès' emphasis on narrative and his use of special effects to propel the plot. The opening of Porter's

masterpiece, *The Great Train Robbery* (1905), for example, establishes its plot with a successful matte shot. Through the window of a railroad telegraph office that is taken over by two bandits, the target of the robbers, a train, is seen to come to a stop. Like Méliès, Porter filmed this scene by blacking out a part of the live studio action (here, the window) and superimposing on this "free" part of the frame a second film, which shows the stock footage of the train.

Once Porter's star was eclipsed for a lack of continuous filmic innovation, America's most gifted early director, D. W. Griffith, rose to prominence. Griffith's work, too, shows an indebtedness to Méliès; without the success of narrative films such as *Le Voyage dans la lune*, it is hard to imagine demand for Griffith's highly complex dramatic films.

While Griffith developed a far more dynamic style of editing and camerawork, his special effects were still firmly based on Méliès' pioneering examples, on which Griffith built his improvements. To demonstrate spatial movement, Méliès moved his set; Griffith instead changed his camera position and developed true tracking shots. To track the riders of the Ku Klux Klan in *The Birth of a Nation* (1915), his camera was even put aboard a car. Griffith nevertheless exuberantly acknowledged Méliès' influence, to the point of stating that he owed everything to his French colleague.

In Europe, the success of *Le Voyage dans la lune* and Méliès led to two startlingly different developments at the level of national cinema. In France, the freshly founded Société Film d'Art took Méliès' idea of filming action on a stage to its logical extreme and sought to appeal to intellectual taste by filming theater. Charles Le Bargy's *L'Assassinat du duc de Guise* (1908; *The Assassination of the Duke de Guise*) was the first in a series of influential hits. Yet because the Société Film d'Art's productions were so inherently stagey—and, indeed, sought to derive artistic legitimacy from their rather regressive form—French film lost its international leadership by the early 1910's.

Whereas the selective adaptation of Méliès' ideas by the French cinema lacked the artistic freshness necessary to recapture the world market from Hollywood after World War I, German cinema rose to international status by looking at Méliès' work with different eyes. After a brief flirtation with Film d'Art, directors in Germany looked to Méliès' film, from which they derived an emphasis on the fantastic. The closed world of his studio was seen as resembling the human soul—incidentally, also the reason for Méliès' appeal to Surrealist filmmakers such as Luis Buñuel. For his popular fare, Danish filmmaker Stellan Rye used Méliès' technique of superimposition in his haunting tale of a double, *Der Student von Prag* (1913; *The Student of Prague*); a huge success, the film was twice remade in Germany.

German cinematic expressionism, including Robert Wiene's masterpiece *Das Cabinet des Dr. Caligari* (1919; *The Cabinet of Dr. Caligari*), is unthinkable without Méliès. Unlike its inspiration, German cinema of the 1920's proved very adaptive. With German audiences developing an appetite for more naturalistic-looking fantasy tales, films such as Friedrich Wilhelm Murnau's vampire tale *Nosferatu* (1922) fol-

lowed another of Méliès' many leads: Special effects were used for the "realism" they gave to illusion. Fritz Lang's *Metropolis* (1927) mastered the form.

It was this "realist" approach to special effects that brought American naturalistic film back into studios once the development of sound necessitated a tightly controlled production environment. Throughout the 1930's and 1940's, Hollywood became synonymous with studio films. Special effects, however, were more commonly used to simulate car rides than to animate fantastic monsters such as the star of Willis H. O'Brian's *King Kong* (1933), a true successor of Méliès' fantasy creatures.

By the late 1950's, with a final twist of irony, French (and some American) directors and critics had turned against the studio film. Instead, they championed *cinéma vérité* ("cinema truth"), a very strict form of filming pure, unstaged reality. Jean Rouch and Edgar Morin's *Chronique d'un eté* (1951; *Chronicle of a Summer*) popularized the movement, which appeared to take film back to the Lumière brothers' original recording of reality.

The movement toward realism, of which *cinéma vérité* represented the avant-garde, turned back once more with the rise of the science-fiction film. From Stanley Kubrick's *2001: A Space Odyssey* (1968) to James Cameron's *Terminator II: Judgment Day* (1991), increasingly sophisticated special effects have become the backbone of films with an audience appeal as global as that of Georges Méliès' *Le Voyage dans la lune*, the first film to take humanity on a fantastic trip through space and time.

Bibliography

Barnouw, Erik. "The Magician and the Movies." *American Film* 3 (April/May, 1978): 8-63. Places Méliès in the context of primarily French and British magicians. Argues that the stage illusionist's traditional skills were outmoded by film's special effects and that magic did not translate successfully onto the screen. Illustrations; no notes.

Brakhage, Stan. "Georges Méliès." In *The Brakhage Lectures*. Chicago: GoodLion, 1972. Riddled with factual errors and written in a strange mock-colloquial style (refers to the director as "George" throughout). An often misleading and highly impressionistic transcription of a lecture by the American experimental filmmaker. Illustrations, but no notes or index.

Cook, David A. "The Evolution of Narrative: Georges Méliès." In *A History of Narrative Film*. New York: W. W. Norton, 1981. Useful, readable overview. Sees Méliès as having helped introduce the narrative, as opposed to documentary, use of film. Lists all thirty tableaux of *Le Voyage dans la lune*, twenty of which are reproduced in illustrations. Factually accurate, brief, and interested in Méliès's contributions to film, which Cook refers to throughout. Index, bibliography, notes, and glossary.

Frazer, John. *Artificially Arranged Scenes: The Films of Georges Méliès*. Boston: G. K. Hall, 1979. The best student's book on Méliès in English. Every known surviving film is presented through synopsis, notes on special effects, and critical analysis. Added are a biography and description of Méliès' cultural environment. Richly

illustrated; excellent filmography of all known works, good bibliography, notes, index.

Hammond, Paul. *Marvellous Méliès.* New York: St. Martin's Press, 1975. The first major study in English, superseded by Frazer. Badly written and poorly organized, but valuable for its rich accumulation of detail. Many special effects are analyzed. Stresses Méliès' background as a magician and his welcome from the surrealists. Filmography, corrected by Frazer; notes, index.

Kovacs, Katherine Singer. "Georges Méliès and the *Feerie.*" *Cinema Journal* 14 (Fall, 1976): 1-13. Persuasively places Méliès in the tradition of a nineteenth century French spectacle show, the *feerie.* Part 1 discusses this tradition, and part 2 shows how Méliès' films use it for their techniques, plots, and themes. Analyzes Méliès' special effects clearly and emphasizes their popular appeal. Notes.

R. C. Lutz

Cross-References

The Great Train Robbery Introduces New Editing Techniques (1903), p. 74; *The Birth of a Nation* Popularizes New Film Techniques (1915), p. 402; Eisenstein's *Potemkin* Introduces New Film Editing Techniques (1925), p. 615; Gance's *Napoléon* Revolutionizes Filmmaking Techniques (1925), p. 642; Kuleshov and Pudovkin Introduce Montage to Filmmaking (1927), p. 701; Lang Expands the Limits of Filmmaking with *Metropolis* (1927), p. 707; Buñuel and Dalí Champion Surrealism in *Un Chien andalou* (1928), p. 750; Kubrick Becomes a Film-Industry Leader (1964), p. 1989; The *Star Wars* Trilogy Redefines Special Effects (1977), p. 2391.

STIEGLITZ ORGANIZES THE PHOTO-SECESSION

Category of event: Art
Time: February 17, 1902
Locale: New York, New York

The founding of the Photo-Secession established the preeminent school of American art photography at the turn of the century and consolidated Alfred Stieglitz's power as leader of the pictorial movement

Principal personages:

ALFRED STIEGLITZ (1864-1946), the founder and director of the Photo-Secession and its chief spokesperson

EDWARD STEICHEN (1879-1973), a fellow of the Photo-Secession, the impetus behind Stieglitz's establishment of the Little Galleries of the Photo-Secession in 1905

FRANK EUGENE (1865-1936), a founding member and fellow of the Photo-Secession known for his hand-manipulated photographs

GERTRUDE KÄSEBIER (1852-1934), one of the original fellows and the leading female Photo-Secessionist

CLARENCE H. WHITE (1871-1925), a leading pictorialist from Ohio and an original fellow of the Photo-Secession

ALVIN LANGDON COBURN (1882-1966), a celebrated member of the Photo-Secession and a friend of George Bernard Shaw

Summary of Event

Alfred Stieglitz first experimented with photography while studying engineering in Berlin during the 1880's. Stieglitz's early work was in the "pictorial" style then popular in Europe—pastoral landscapes, rustic genre scenes, figure studies, and portraits of fashionable society types influenced by the popular painters of the day: the French Barbizon School, Camille Corot, James McNeill Whistler, and German genre painters such as Max Liebermann. By patiently submitting prints to exhibitions and competitions, Stieglitz quickly developed an international reputation as a photographer.

When Stieglitz returned to America in the 1890's, he took control of the Camera Club of New York and elevated its journal, *Camera Notes*, to international prominence as a mouthpiece for pictorial photography. Such moves created tensions within the club, most of whose members practiced the old, technically oriented style of photography, in which correct exposures and sharp focus were the principal criteria for success. The traditionalists called Stieglitz and his fellow pictorialists, most of whom suppressed detail for broad effect, "fuzzyographers." It was this growing rift within the Camera Club of New York that led Stieglitz to think about forming a new group, one more in keeping with his own sentiments. He envisioned a group of

pictorial photographers and their patrons, loosely organized and informal but in large part modeled after the British Linked Ring, an organization formed in London in 1892 by pictorialists disillusioned with the photographic establishment of their day.

Although the Photo-Secession was officially founded on February 17, 1902, it held its first exhibition at the National Arts Club in New York City from March 5 to 24 of that year. The exhibit included work by some thirty-two photographers, about half of whom never actually became members of the Photo-Secession.

The group was a rather elite body, with only those considered worthy of the honor being elected to membership. Stieglitz had complete jurisdiction; the council of the Photo-Secession simply rubber-stamped his recommendations. The Photo-Secession's purpose was to advance pictorial photography by bringing together like-minded photographers and their supporters and by holding exhibitions of the highest quality. Membership in the organization was divided into two categories: fellowship, which required acceptance based on the quality of one's prints, and associateship, which required only a general sympathy with the aims and spirit of the movement.

Among the well-known Photo-Secession fellows were Gertrude Käsebier, a professional photographer from New York known especially for her soft, evocative photographs of women and children; Edward Steichen, a trained painter as well as a photographer; Clarence H. White, a Newark, Ohio, bookkeeper; and Frank Eugene, who had studied painting in Munich. Less familiar today but also among the Photo-Secession's founding fellows were John G. Bullock, Robert Redfield, Edmund Stirling, Eva Watson Schütze, William B. Dyer, Dallett Fuguet, Joseph T. Keiley, and John F. Strauss. Several of this latter group had been connected with the Photographic Society of Philadelphia, which had organized high-quality exhibits in the 1890's that had helped to establish pictorialism in America.

Although no homogeneous Photo-Secession style was promoted or enforced, several common denominators gradually emerged: emphasis on tonalism, on a blurring or softening of outlines, and on the suppression of details. Some members of the group, including Stieglitz himself, tended toward "straight" photography, while others were dedicated manipulators, scratching or drawing on their negatives or using "painterly" photographic techniques such as the gum bichromate process. Thus, the range of styles and techniques practiced by Photo-Secessionists tended to parallel pictorial photography in general rather than to define a unique group approach.

Stieglitz was dedicated to the cause of establishing photography as a fine art, placing it on an equal footing with other printmaking methods such as etching and lithography. With this in mind, he wrote prolifically about photography and edited the journals *Camera Notes* (1897-1902) and *Camera Work* (1903-1917). He also served as the chief impresario for pictorial photography in America, organizing, under the banner of the Photo-Secession, exhibitions at important museums across the country. The critical acclaim accompanying these shows quickly established the organization's preeminence.

Prior to the Photo-Secession era, photographic exhibitions tended to be organized by categories (such as landscape or portraiture) and often awarded prizes. Stieglitz

was instrumental in bringing about shows in which works were included solely on the basis of artistic merit and were aesthetically displayed at eye level in exhibits punctuated by tasteful floral arrangements. He refused to have Photo-Secession photographs exhibited unless they were hung as a group in a setting that met his strict qualifications.

Because it was difficult to enforce these exacting exhibition standards, Stieglitz, at Steichen's suggestion, opened the Little Galleries of the Photo-Secession at 291 Fifth Avenue (later known simply as "291") in New York City in November of 1905. There, in an intimate setting, on burlap-covered walls, Stieglitz exhibited first the work of Photo-Secession members and later, beginning in 1908, the work of avant-garde painters and sculptors as well. These shows, which included works by such important European modernists as Auguste Rodin, Henri Matisse, and Pablo Picasso, provided Americans with an opportunity to see such work five years before the infamous Armory Show of 1913.

In fact, it was Stieglitz's increasing emphasis on modern painting and sculpture at "291" and in *Camera Work* that led to the unraveling of the Photo-Secession. Many members felt that Stieglitz was moving away from photography and therefore away from their interests. The last important Photo-Secession show was an exhibition organized by Stieglitz and held at the Albright Art Gallery in Buffalo, New York, from November 3 to December 1, 1910. The show included 584 prints and filled eight galleries, drawing large crowds and positive press. Stieglitz viewed it as the culmination of his dream to have photography recognized as a valid art medium by an important art museum.

The Buffalo exhibit marked the end of the Photo-Secession's major activities as a group. Opinionated and autocratic, Stieglitz quarreled with many of the photographers including Käsebier, White, and even Steichen. Although a notice calling for dues was sent out to Photo-Secession members in 1911, and no formal dissolution of the group is recorded, many of the members turned to professional photography as a livelihood and drifted away from Stieglitz. With the coming of World War I, the group effort that had been the heart and soul of the Photo-Secession perished.

Stieglitz continued to show new photographic work when he believed it was important, such as the photographs of Paul Strand, which appeared in the final issue of *Camera Work* in June, 1917. Increasingly, however, Stieglitz took over the promotion of American modernist painters such as Georgia O'Keeffe (his future wife), Arthur Dove, John Marin, and Marsden Hartley. He remained active as a photographer, however, and his work, writings, and exhibitions mark an important step in the evolution of the art of photography.

Impact of Event

Although Stieglitz and the Photo-Secession were not the lone pioneers of pictorial photography in America, they quickly became the most influential organization in the field. By the turn of the century, Stieglitz had already established himself as the leading spokesman for the promotion of photography as an art form. He was a mas-

ter of the printed word as effective propaganda. Between 1887 and 1911, he published more than two hundred articles about photography; many more were penned by those who dedicated themselves to espousing his ideals. Such wide dissemination of Stieglitz's views established his international reputation.

Stieglitz gained control of all phases of the pictorialist movement by organizing shows, having his friends review them in his own publications, and even controlling to some extent the sale of the work through "291." The impact of the Photo-Secession on art photography was, as a result, pervasive.

During the early years of the organization, many aspiring pictorialists, with varying degrees of talent, signed on with the Photo-Secession. They quickly saw that Stieglitz's group could promote them in a way no other body could. Also, there was a certain cachet involved in belonging to the exclusive society. Stieglitz spoke of his group as the "chosen few" and believed that superior work by a handful of advanced workers could change the course of photography. He was also a tough opponent, with little sympathy for those who did not follow him unquestioningly.

Stieglitz was well connected, both in America and abroad. He wielded great influence, for example, with the Linked Ring (of which he was a member) and with similar photographic organizations in France and Germany. He had set out to prove that American pictorialism was on a par with its European counterparts, and in this he fully succeeded.

Stieglitz's journal, *Camera Work*, became hugely influential despite a relatively small circulation. Noteworthy authors of the day such as George Bernard Shaw and Maurice Maeterlinck contributed essays. The photographers included in its elegant pages benefited from subsequent scholarship and are among the most well-known from the era. Stieglitz and Steichen, in particular, are considered leading figures in American photographic history.

Stieglitz's own photographic style was constantly evolving, from the soft impressionism of the 1890's to the realism commonly associated with such famous images as *The Steerage* of 1907. In 1910, he did a celebrated series of photographs depicting New York City. It was at this time that Stieglitz effectively abandoned pictorial photography and allied himself with the new practitioners of "straight" photography such as Paul Strand. Later Stieglitz projects included his close-up portraits of Georgia O'Keeffe and his series of cloud studies, *Equivalents*, executed in the 1920's and 1930's. Stieglitz managed "291" until it closed in 1917 and later directed two other galleries, the "Intimate Gallery" (1925) and "An American Place" (1929-1946). Both were known for exhibiting avant-garde art.

During World War I, Stieglitz served as chief of aerial photography in the American Expeditionary Forces. Later, between 1923 and 1937, he was a successful fashion and portrait photographer for *Vogue* and *Vanity Fair*. He was in charge of overseeing all Naval combat photography during World War II, and in 1947 he was appointed director of the photography department at New York's Museum of Modern Art, where, in 1955, he curated the celebrated "Family of Man" exhibition.

White and Käsebier also continued to be active in photographic circles. White

lectured on photography at Columbia University from 1907 on and later established the Clarence H. White School of Photography. Many of his students became prominent photographers themselves, including Margaret Bourke-White, Dorothea Lange, Paul Outerbridge, and Ralph Steiner. In 1916, both White and Käsebier became leading members of the newly formed organization Pictorial Photographers of America. For many disaffected Photo-Secessionists, White took over as leader of the pictorial movement and Käsebier was his firm ally.

Alvin Langdon Coburn, whom George Bernard Shaw considered to be the world's greatest photographer, went on to publish several series of portraits of French and English celebrities, including *Men of Mark* (1913) and *More Men of Mark* (1922). He also pioneered in abstract photography, making his famous "Vortographs" in 1917. Much of Coburn's later life was spent living and traveling in Europe, and he became a British subject in 1932. Thus, the Photo-Secession's influence continued to be an important force both in the United States and abroad.

The most lasting impact of Stieglitz's Photo-Secession was the growing acceptance of photography as an art form. Most modern museums collect and exhibit photographs on the strength of their aesthetic merits. No longer relegated to the realm of science and technology, photography—in large part because of Stieglitz's vigorous promotion—is firmly established as a creative art.

Bibliography

Doty, Robert. *Photo-Secession: Photography as a Fine Art.* Rochester, N.Y.: George Eastman House, 1960. The first important study on the Photo-Secession. Reissued as *Photo-Secession: Stieglitz and the Fine Art Movement in Photography* (New York: Dover, 1978). Contains numerous photographs, notes to the text, a selected bibliography, a chronological list of exhibitions held at "291," and a listing of Photo-Secession members. Numerous photographs.

Green, Jonathan. *Camera Work: A Critical Anthology.* Millerton, N.Y.: Aperture, 1973. A large-format book reproducing selected images and essays from *Camera Work.* Includes an introductory text, notes, brief biographies, bibliography, and various indexes to *Camera Work.*

Greenough, Sarah, and Juan Hamilton. *Alfred Stieglitz: Photographs and Writings.* New York: Callaway Editions, 1983. A lavishly illustrated oversize book published in conjunction with a major Stieglitz retrospective exhibit held at the National Gallery of Art in Washington, D.C. Includes excerpts from Stieglitz's essays and letters, notes, chronology, selected bibliography, and exhibition checklist. Best source for Stieglitz's own photographs.

Homer, William I. *Alfred Stieglitz and the Photo-Secession.* Boston: Little, Brown, 1983. One of the standard texts on the Photo-Secession. Includes a list of Photo-Secession members, notes, brief descriptions of processes used by pictorialists, extensive bibliography, and index. Photographs.

Longwell, Dennis. *Steichen: The Master Prints.* New York: Museum of Modern Art, 1978. An elegantly presented text dealing with Steichen's early years (1895-1914).

Notes, plates with commentary, catalogue of plates, brief essay on Steichen's printing techniques, bibliography, and index.

Lowe, Sue Davidson. *Stieglitz: A Memoir/Biography.* New York: Farrar, Straus & Giroux, 1983. As the title suggests, this is a somewhat anecdotal coverage of Stieglitz's life, written by a grandniece. Includes family photographs, a Stieglitz chronology, notes that draw heavily on unpublished correspondence, an extensive bibliography, a compilation of illustrations and articles in *Camera Work*, a list of exhibitions arranged by Stieglitz from 1902 to 1946, Stieglitz's family tree, and other useful appendices.

Michaels, Barbara L. *Gertrude Käsebier: The Photographer and Her Photographs.* New York: Harry N. Abrams, 1992. An exceptionally well-documented study of Käsebier's life and work, including much interesting information about her interaction with Stieglitz and other members of the Photo-Secession. Excellent notes, bibliography, and index. Photographs.

Stieglitz, Alfred. *Camera Work: A Pictorial Guide.* Edited by Marianne Fulton Margolis. New York: Dover, 1978. Includes reproductions of all 559 *Camera Work* illustrations and plates, bibliography, glossary of terms, and separate indexes of authors, titles, and sitters.

Weaver, Mike. *Alvin Langdon Coburn: Symbolist Photographer.* Millerton, N.Y.: Aperture, 1986. One of Aperture's outstanding monographs, with chronology, notes, and bibliography. High-quality, lavish illustrations.

White, Maynard P. *Clarence H. White.* Millerton, N.Y.: Aperture, 1979. Another Aperture monograph with brief text, notes, numerous plates, chronology, and selected bibliography.

Gillian Greenhill Hannum

Cross-References

Avant-Garde Art in the Armory Show Shocks American Viewers (1913), p. 361; Malevich Introduces Suprematism (1915), p. 413; Man Ray Creates the Rayograph (1921), p. 513; Luce Launches *Life* Magazine (1936), p. 1031; Mapplethorpe's Photographs Provoke Controversy (1989), p. 2636.

CARUSO RECORDS FOR THE
GRAMOPHONE AND TYPEWRITER COMPANY

Category of event: Music
Time: April 11, 1902
Locale: Milan, Italy

Enrico Caruso's first serious attempt at recording operatic songs proved an over-whelming success, launching his career as one of the world's major recording artists

Principal personages:
ENRICO CARUSO (1873-1921), an opera singer whose voice is considered one the finest of all time
FREDERICK WILLIAM GAISBERG (1873-1951), the executive for the Gramophone and Typewriter Company who persuaded Caruso to record
NELLIE MELBA (HELEN ARMSTRONG, 1859-1931), an Australian soprano who sang with Caruso in many of the world's opera houses

Summary of Event

During the early part of 1902, Enrico Caruso, a well-known tenor star of European opera, experienced a particularly successful season in Monte Carlo. Singing opposite the renowned Australian soprano Nellie Melba, Caruso sang his way through countless famous operas.

Melba had persuaded Caruso to sing at Covent Garden in London. Caruso had been reluctant to accept the engagement, which would be his first in England, but under considerable pressure from the persuasive Melba, he accepted. Before traveling to England, he returned to Milan to sing in Alberto Franchetti's new opera, *Germaine.* The opening night was a gala performance attended by royalty and aristocracy and by prominent artists of the day. Seated in the audience that night were such men as Giacomo Puccini, Umberto Giordano, and Gabriele D'Annunzio.

Of more significance, though, was the fact that seated in the audience the next evening was Fred Gaisberg, the manager of London's Gramophone and Typewriter Company. Along with his brother Will, Gaisberg had come to Milan to find new recording artists. Unable to get tickets to the premiere performance, Gaisberg was still able to hear Caruso sing the part of Federico Loewe the following night. Despite the inherent weaknesses of the opera, Caruso sang magnificently. Gaisberg knew from that one evening that he had found a singer whose voice would be perfect for the young recording industry.

Alfred Michaelis, the firm's local representative, was asked to speak with Caruso and negotiate a fee. To everyone's initial delight, Caruso agreed to make the recordings. In 1901, Caruso had briefly tried the new medium, but his first experiment was not a success. A year later, he was more than eager to try again. Caruso was also a canny businessman; in fact, one of the reasons why he had hesitated to sing at Co-

vent Garden was that the fee was less than what he had been offered to perform elsewhere. Gaisberg and Caruso agreed on a fee of one hundred pounds, for which Caruso was to sing ten arias.

Thinking that the London office would seize the opportunity to add Caruso to their list of world-class recording artists, Gaisberg was surprised with the reply to his cable announcing the agreement. Officials at the Gramophone and Typewriter Company cabled back, "Fee exorbitant, forbid you to record." Gaisberg had heard Caruso sing only once, but that was enough to convince him that he had experienced an unusual talent, and he decided to go through with the project. Years before, the celebrated Italian conductor Arturo Toscanini had remarked after hearing Caruso sing that the whole world would talk about him. Once Gaisberg had the recordings, the whole world would hear Caruso sing as well.

A number of Caruso's contemporaries tried to dissuade him from participating in such a novelty. Caruso was not of the same opinion. From the very first meeting, Caruso thought well of Gaisberg, and their friendship had much to do with Caruso's willingness to sing. During their conversations, Gaisberg cleverly remarked that the recordings would be available during Caruso's debut at Covent Garden. Caruso quickly grasped that this would widen his audience and perhaps endear him to the English audience that much quicker.

Despite this seemingly businesslike approach, Caruso treated the entire recording session with enjoyment and a certain lightness. The recording session was arranged for the afternoon of April 11 at Gaisberg's suite at the Grand Hotel di Milano. (By coincidence, the suite was directly above the one in which the famed Italian composer Giuseppe Verdi had died.)

The ten arias included selections from half a dozen well-known operas. "Questo o quella" from *Rigoletto* began the session. For the next two hours, Caruso sang with his usual warmth and vibrancy such songs as "Una furtiva lagrima," "E lucevan le stelle," and "Celeste Aida." The makeshift recording studio was primitive; the tin horn that Caruso sang into hung five feet from the floor. The accompanist had to use a packing case as a piano stool.

The primitive conditions were ignored by Caruso, and the recording session went smoothly. At the end, Caruso accepted his check, embraced the accompanist, and left hastily for a late lunch with his wife, Ada. One more crucial step still awaited Gaisberg; immediately after the session was over, he sent the waxes of the recordings to be copied. To his surprise, there was not one single failure. From this one recording session, the Gramophone and Typewriter Company would make nearly fifteen thousand pounds. When Caruso arrived in London for his debut, the recordings were selling extremely well. For many immigrant Italians who could not afford seats to Caruso's performance, the newly released recordings proved some comfort.

What had continually plagued the phonograph industry was the poor quality of the recordings of the time. The Gramophone and Typewriter Company had been experimenting with wax cylinders at the turn of the century. Caruso had already had experience with recording on wax cylinders when, in late 1900 or early 1901, he had

recorded three cylinders for the Pathé company. These recordings were far inferior to those Caruso completed for Gaisberg. After Caruso became famous, Pathé continued to keep these poorer-quality recordings in its catalog.

Caruso's rich, melodic voice seemed to have overcome much of the problem of surface noise, which had always been a concern of those trying to make accurate recordings. Whereas the technique used in the Pathé recordings was similar to that used by the Gramophone and Typewriter Company, the results were very different. Caruso's name and recordings would soon dominate classical recordings. By the time of his death, Caruso had received almost two million dollars in royalties from his extensive recordings.

The phonograph was already an important form of entertainment, and over the next thirty years this simple device would transform music and recordings. After the London debut of Caruso at Covent Garden Opera House, his success as an opera singer as well as a recording artist was assured.

Impact of Event

Caruso was unaware that this one recording session would encourage phonograph companies to concentrate more on classical music than they had done up until then. The success of the phonograph had previously stemmed entirely from recordings of popular songs. John Philip Sousa's band had experienced success recording for Berliner, and singer Harry MacDonough's renditions of "The Holy City" and "Lead Kindly Light" were two of the highest-selling recordings for Victor.

The works of the major classical composers, though, were sparsely represented in the record catalogs of the early 1900's. Because recordings had to be fitted on a twelve-inch record side, most pieces were severely truncated. By 1913, the largest classical entry in the Victor catalog, recordings of works by Ludwig van Beethoven, was limited to three short pieces.

Franz Joseph Haydn and Wolfgang Amadeus Mozart received one recording apiece. By far the largest number of recordings available were those made by operatic singers, since recording a solo voice accompanied by piano was considerably easier than trying to record an entire orchestra.

Despite Caruso's recording successes, Nellie Melba—his leading lady in so many operatic performances—began her recording career reluctantly. Prior to 1904, the only recordings Melba had made were private recordings for her father. After much persuasion, Melba agreed to release these private recordings, and she continued to record for Gramophone on a regular basis until 1926. Such stellar performers gave the recording industry a more durable appearance. Like Gaisberg before him, Alfred Clark continued to add prominent performers and composers to Gramophone's Red Label discs. Claude Debussy, Reynaldo Hahn, and Jules Massenet all became admirers of the phonograph and were pleased to record for the company.

Caruso made his first recording with orchestral accompaniment in 1906 for Victor, performing five operatic arias: "Di quella pira" from *Il Travatore*, "Spirto gentil" from *La Favorita*, "M'appari" from *Martha*, "Che gelida manina" from *La*

Bohème, and "Salut demeure" from *Faust*. Despite improvements in technology, recording conditions were still primitive; musicians were still perched on high chairs in order to allow them to be heard properly. Caruso, in spite of these spartan studio facilities, continued to make fine recordings.

Caruso's recording legacy stands as one of the finest collections of operas and operatic arias. As a musician and businessman, Caruso always seemed to anticipate future trends. Long before radio ever began to challenge the popularity of the phonograph, Caruso participated in the first wireless transmission. Just as he had with the Milan recordings, Caruso was again making history. On April 9, 1909, from the Metropolitan Opera House in New York, Caruso's voice was transmitted through two microphones placed in the footlights of the stage. The following year, Caruso gave the first radio broadcast of operatic selections, again from the stage of the Metropolitan Opera House. Radio, however, had yet to catch the imagination of the American public. The phonograph was still the dominant medium through which most listeners heard the famous voices and orchestras of the day.

Radio began to challenge the supremacy of the phonograph only at the beginning of the 1920's. Even Caruso did not broadcast a complete opera, a feat first achieved by the British Broadcasting Company in 1926, when Mozart's *The Magic Flute* was transmitted direct from a London concert hall. Spurred by the challenge of radio, recording companies continued with experimentation and research in an effort to improve recording quality. Improvement over the early wax cylinders and disc reproduction soon interested those musicians who had stayed away from earlier recordings.

One such skeptic was Arturo Toscanini. The Victor Company had approached Toscanini, who agreed to record sixteen sides. Unfortunately, Toscanini was not pleased by the results, and he wanted the recording cylinders destroyed. Working with men and women whose musical standards were extremely high further motivated Victor to seek alternative designs.

Through laborious trial and error, Victor's engineering continued to perfect the disc. By the early 1930's, records of fourteen minutes a side were created by increases in the number of grooves per inch and by reductions in the speed of revolution. The resulting records played at 33⅓ revolutions per minute (rpm) instead of at the much less reliable 78 rpm. Marketing this new disc proved difficult for Victor, though; the LP, or long-playing record, would not be commercially successful until Columbia Records launched its version in 1948.

During the Depression, the phonograph was almost abandoned. Sales of discs had dropped so dramatically that a recovery looked almost impossible. Toscanini, though still disenchanted with the quality of recordings, agreed to complete a number of works before leaving America. Technically, the recordings were judged to be the best that had ever been made. More important, these recordings became an industry standard and at the time were incomparable. This unusual turn of events brought the phonograph industry back to public awareness and ensured that music would continue to be produced on disc.

Caruso and Toscanini were close friends, and each admired the other's talent and skill. Neither man regarded himself as anything other than a committed musician performing always at maximum effort. Between them, and almost incidental to what they sought to achieve in their performance of the great operatic and symphonic works, they provided a catalyst for the emerging recording industry. Caruso's willingness to record those ten simple arias in Milan in 1902 provided the impetus to reproduce fine classical music for all to hear and enjoy.

Bibliography

Caruso, Dorothy. *Enrico Caruso: His Life and Death*. New York: Simon & Schuster, 1945. An extremely candid account by Caruso's wife about what life with the great opera singer was like. Dates and places are hardly mentioned, but the omissions are more than made up for in descriptions of Caruso and revelations about how he viewed himself as an opera singer.

Caruso, Enrico, Jr., and Andrew Farkas. *Enrico Caruso: My Father and My Family*. Portland, Ore.: Amadeus Press, 1990. A scholarly treatment of the life of Caruso written by his son. Contains a comprehensive discography and a meticulously researched chronology of all Caruso's appearances. One of the most complete biographies of Caruso.

Gelatt, Roland. *The Fabulous Phonograph, 1877-1977.* 2d rev. ed. New York: Macmillan, 1977. Much of the book discusses the rise and fall in popularity of the phonograph. All major events are cited, but there is a tendency to move back and forth between historic events. Caruso's own contributions are set in the context of the recordings of the time.

Greenfeld, Howard. *Caruso.* New York: G. P. Putnam's Sons, 1983. A straightforward account of Caruso's life and achievements. While there is very little new material, what is presented is thorough and well written.

Jackson, Stanley. *Caruso.* New York: Stein & Day, 1972. Includes no new material on Caruso's life, but the presentation is novel. Jackson has studied Caruso's career in great detail and is able to postulate some reasons as to why Caruso remained aloof. Contains a comprehensive index.

Richard G. Cormack

Cross-References

Puccini's *Tosca* Premieres in Rome (1900), p. 29; ASCAP Is Founded to Protect Musicians' Rights (1914), p. 379; Bessie Smith Records "Downhearted Blues" (1923), p. 572; *The Jazz Singer* Premieres in New York (1927), p. 734; Sound Technology Revolutionizes the Motion-Picture Industry (1928), p. 761.

THE GREAT TRAIN ROBBERY
INTRODUCES NEW EDITING TECHNIQUES

Category of event: Motion pictures
Time: 1903
Locale: The United States

Audiences and filmmakers were thrilled with Edwin Porter's film, which introduced new cinematic techniques while establishing the narrative pattern of Western films

Principal personages:
> EDWIN S. PORTER (1870-1941), the writer, director, photographer, and editor of *The Great Train Robbery*
> THOMAS ALVA EDISON (1847-1931), the owner of the company that employed Porter and produced *The Great Train Robbery*
> GEORGES MÉLIÈS (1861-1938), a Paris magician who began making motion pictures of his magic acts in 1896 and whose techniques of special trick effects caught the attention of Edwin S. Porter
> MAX ARONSON (1882-1971), an actor later known as G. M. "Bronco Billy" Anderson, who had appeared in earlier Edison films and who played several parts in *The Great Train Robbery*

Summary of Event

In the fall of 1903, Edwin S. Porter, working for the Edison Company in New Jersey, made a moving picture the likes of which had never before been seen in the United States. There were similarities in technique to some films from England and some from France, particularly those made by Georges Méliès, whose experiments in special effects and artificially arranged scenes had caught Porter's attention. Porter, however, went beyond all of his predecessors in the film medium when he recognized the narrative potential for cutting and splicing different shots—that is, editing. He had first employed this technique in making *The Life of an American Fireman* in 1903, after many years as the maker of many motion pictures for Edison. He combined stock film of a fire company in action with specially shot scenes on an artificially arranged scene. The result was to merge discontinuous action into coherent narration.

In his next significant film project, Porter calculated that he could invent his whole collection of material, not relying on stock footage at all, and thereby control his narrative even more. His plan, which included shooting interiors as well as the exteriors of the New Jersey countryside, was to produce a smoothly flowing narrative of "cops and robbers," with his characters as cowboys. In this early, if not the first, Western film, the standard plot form of the chase was embodied in the journalistic event of the train robbery. Porter's genius was to recognize the potential of the

Western genre for films. His social awareness led him to emphasize the powerful attraction of law-and-order themes.

Most important, however, was the technique he used for combining the material of his discontinuously filmed shots. *The Great Train Robbery* would, by its artistic and commercial success, establish Porter as the leading director of his time and influence all later directors in their approach to the making of motion pictures. In fourteen shots (incomplete scenes), Porter presented a story with three lines of action which, through editing by intercutting the shots, and using no dissolves or fades, he wove together to create an illusion of continuous narrative.

In the first scene, a fixed long-shot interior of a railroad telegraph office, two masked men force the clerk to stop the next train, which is seen through the window of the office. This is one of the earliest innovative features of the film. It may have been created by building the set of the office near an actual railroad, or it may be the effect of double-exposing the film, superimposing the moving train on a blank in the first exposure. It is probably an example of Porter's using back-projection, shooting the interior from one side while projecting the moving train from the other side onto the space for the window.

While the train is departing, the robbers tie up the clerk and leave to catch up with the train. The next scene is an exterior shot of the railroad water tower, where the robbers hide before jumping onto the train, which is forced to stop beneath them. This cut from interior to exterior is Porter's most creative act as director/editor. Because previous films had sought to keep narrative simple and continuous, most shots were complete scenes, with little intercutting between scenes and no intercutting between incomplete scenes (or shots). The action then shifts to a shot inside the mail car, where a clerk is accosted by the robbers, who shoot him and blow open the railroad safe, take its contents, and leave.

The fourth scene is shot from atop the moving train, in effect a "moving" camera, looking across the tender and into the locomotive cab. Intentionally or not, the scene is cinematically exciting because the camera helps to create the action, moving rather than simply showing movement. One virtue of editing through crosscutting shots is to create the illusion that widely separated actions occur at the same time. Simultaneously with the robbery of the mail car, the action of this scene shows two more robbers seizing control of the locomotive, tossing the body of the fireman from the train as they do so. Substituting a dummy for the body of the fireman is only natural (and humane), but the illusion is important for the pace of this sequence. Porter demonstrates that he will improvise in whatever way he needs to sustain the vigor of the film's fast-paced action.

The next scene is shot from beside the halting train, with the engineer uncoupling the locomotive and separating it from the rest of the train. Another exterior shot follows, showing the passengers forced from the coaches and lined up along the tracks, where the bandits rob them. There are many passengers, and Porter may have recruited local citizens as extras. Use of extras would become increasingly necessary as films lengthened their narratives and expanded the scope of their action. One of

the passengers attempts to escape, runs toward the camera, is shot, and falls to the ground. Most action was shot with actors moving from left to right or right to left, in front of a static camera. This movement directly into the camera is another mark of the film's novelty. In the seventh scene, the robbers board the locomotive and force the engineer to drive it off, away from the camera.

The next shot establishes some distance from the preceding one, as the robbers halt the engine and run off into the wooded hills. To capture the movement of the robbers, Porter's camera pans to follow their action. Again the film exploits a technique, panning, that would become standard cinematic practice, though it was far from standard in 1903. The outlaws are shown in the ninth scene running across a stream to mount their horses and ride into the woods. The action is shifted abruptly to a distant location in the next shot, inside the telegraph office again. Here the clerk is seen struggling to his feet so that he can use his chin to operate the telegraph. A little girl comes in with a pail and cuts the clerk free. He runs out of the office. The next scene takes place in a dance hall, to which the clerk has rushed to sound the alarm. He enters while a tenderfoot is dancing a jig to the tune of gunshots at his feet. When the clerk arrives, all the men grab their guns and rush out of the dance hall.

In the final sequence of the narrative, three shots are spliced together. In the first of these, the twelfth scene, the robbers ride their horses in flight from the posse, which shoots one of the robbers, who falls from his horse. The action required a stuntman, but Porter had no such trained actors to draw upon. In the next scene, the three remaining bandits believe they have escaped, dismount, and begin examining their loot. Suddenly they are surrounded and attacked by the posse; all the robbers and a few of the posse fall in the gun battle. The final shot has no narrative function in the film. It is a close-range shot of the leader of the outlaw band, who points his pistol at the audience and shoots. This shot has not been woven into the cause-effect narrative illusions created by the intercutting of the rest of the film, but it forcefully testifies to the self-conscious artistry of Porter as he learned to master this medium.

Although he went on to make other interesting films for twelve more years, Porter did not make cumulative advances on the achievement of *The Great Train Robbery*. He used contrast editing in *The Ex-Convict* and parallel editing in *The Kleptomaniac*, both produced in 1905, and he used many photographic tricks, such as double exposure, stop-motion, and dissolves, to make *The Drama of a Rarebit Fiend* (1906) in the tradition of Méliès' trick films. Porter was burdened by the pressure to produce films on schedule for a demanding market, one enlarged by the multiplication of nickelodeons for mass public viewing. He made hundreds of films, but none was as influential as *The Great Train Robbery*.

Impact of Event

Most American films before 1903, including those made at Edison's studios and by Porter, had been very brief one-shot moving pictures of such news events as the inauguration and funeral of President William McKinley. Interesting tricks of vision

such as those made by Méliès in France were not yet made for the American market, although vaudeville skits and magicians' tricks could be captured in such single-shot cinema. The first, though not the most important, influence of *The Great Train Robbery* was to show that there was a large commercial market for film narratives of all kinds, but especially for realistic Westerns. Although Edison had made some motion pictures of Western subjects, such as *Cripple Creek Barroom* (1898), there had been no genuine continuing narrative of this kind before Porter's film, which was 740 feet of visual action with no title cards, requiring a little more than twelve minutes to run.

The commercial and popular success of this film was so great that many other filmmakers sought to rival it. There were sequels, imitations, and even thefts of *The Great Train Robbery*. Among these were films titled *The Great Bank Robbery* and *The Little Train Robbery*. Investors saw that there was money to be made in films. Beginning with the proliferation of nickelodeons, permanent movie houses were built to provide mass entertainment for a potentially huge profit. *The Great Train Robbery* was long a standard film in these establishments. Indeed, the very first nickelodeon opened in Pittsburgh in 1905 with Porter's motion picture as its attraction.

The more significant effects of Porter's film were in the techniques that others borrowed to make their films, so that aesthetic form rather than the subject matter of films was influenced. Porter may have seen films made by the British directors G. A. Smith and James Williamson, who were experimenting with editing in their own ways, but it was Porter's film, with its editing for continuity, that caused Smith, Williamson, and their followers to make full and artistic use of this technique, as in Cecil Hepworth's critically acclaimed film of 1905, *Rescued by Rover.*

Porter's film conveyed aesthetic energy and integrity through attention to techniques that were derived from the structure and mechanics of the medium itself. Because he manipulated the film and to some degree the camera, as well as the subject of the filmic shots, Porter illustrated the importance of style and arrangement, thus establishing moving pictures as an art form. One could shape vision by arranging the elements of vision. Porter used this principle in the intercutting of shots for scenes. It would take D. W. Griffith to extend this by recognizing that there could be any number of shots within a single scene. It is ironically appropriate that Griffith should have had his start in motion pictures as an actor in a film directed by Edwin S. Porter, *Rescued from an Eagle's Nest*, in 1907.

Bibliography

Cook, David A. "The Discovery of the Shot: Edwin S. Porter." In *A History of Narrative Film*. New York: W. W. Norton, 1981. Emphasizing the difference between Méliès' method of arranging scenes and Porter's arrangement of shots, Cook examines the narrative artistry of both *The Life of an American Fireman* and *The Great Train Robbery.* Uses illustrative stills from the films.

Ellis, Jack C. "Birth and Childhood of a New Art: 1895-1914." In *A History of Film*.

3d ed. Englewood Cliffs, N.J.: Prentice-Hall, 1990. Emphasizing Porter's lack of experience with traditional art, Ellis explains the success of Porter's work in films as commercial expediency. Praises *The Great Train Robbery* for unlikely achievements in form still valuable almost ninety years later.

Fenin, George N., and William K. Everson. "The Primitives: Edwin S. Porter and Bronco Billy Anderson." In *The Western: From Silents to the Seventies*. Rev. ed. New York: Grossman, 1973. Focusing upon features of *The Great Train Robbery* that mark it as an early, though not the first, Western, Fenin and Everson examine strengths and weaknesses of Porter as a director.

Fulton, A. R. "Arranged Shots." In *Motion Pictures: The Development of an Art from Silent Films to the Age of Television*. Norman: University of Oklahoma Press, 1960. A discussion of significant differences between Porter's arranged shots and Méliès' arranged scenes, with focus on *The Life of an American Fireman* and *The Great Train Robbery*.

Jacobs, Lewis. "Edwin S. Porter and the Editing Principle." In *The Emergence of Film Art*, compiled by Lewis Jacobs. New York: Hopkinson and Blake, 1969. Porter's career, from handyman for Edison in 1896 to independent producer in 1911, concluded with his directing a spectacular story of Rome in 1915. Keys to Porter's success were innovative techniques, especially in editing, and sensitivity to social issues in narrative.

Mast, Gerald. "Film Narrative, Commercial Expansion." In *A Short History of the Movies*. 3d ed. Indianapolis, Ind.: Bobbs-Merrill, 1981. Analyzes Porter's work during the commercial expansion of film production, when melodrama and farce dominated theater. In *The Life of an American Fireman* and *The Great Train Robbery*, Porter's editing practice was superior to his predecessors' and prepared for more significant contributions by Cecil Hepworth and D. W. Griffith.

Richard D. McGhee

Cross-References

Le Voyage dans la lune Introduces Special Effects (1902), p. 57; Grey's *Riders of the Purple Sage* Launches the Western Genre (1912), p. 304; *The Birth of a Nation* Popularizes New Film Techniques (1915), p. 402; Eisenstein's *Potemkin* Introduces New Film Editing Techniques (1925), p. 615; Kuleshov and Pudovkin Introduce Montage to Filmmaking (1927), p. 701; Ford Defines the Western in *Stagecoach* (1939), p. 1115.

HOFFMANN AND MOSER FOUND
THE WIENER WERKSTÄTTE

Category of event: Fashion and design
Time: 1903
Locale: Vienna, Austria

Through innovative and popular designs, the Wiener Werkstätte helped to lay the basis for the establishment of modern art in Central Europe

Principal personages:
JOSEF HOFFMANN (1870-1956), an imaginative, talented architect and designer who was a founder and chief supporter of the Wiener Werkstätte

KOLOMAN MOSER (1868-1918), a designer and cofounder of the Wiener Werkstätte who was responsible for some the Werkstätte's earliest, most creative designs

FRITZ WÄRENDORF (1869-1939), a wealthy textile magnate whose encouragement and financial support helped to make the Wiener Werkstätte possible

OTTO WAGNER (1841-1918), a pioneer in modern architecture who, as head of the architectural division of the Vienna Academy, became Hoffmann's mentor

DAGOBERT PECHE (1887-1923), the second most-noted designer of the Wiener Werkstätte, whose softer lines anticipated Art Deco

GUSTAV KLIMT (1862-1918), an avant-garde artist whose breakaway group, the Secessionists, helped to end the conservative grip on Austrian art

WALTER GROPIUS (1883-1969), a German architect and founder of the Bauhaus who benefited from many of the ideas of the Wiener Werkstätte

Summary of Event

To understand the significance of the founding of the Wiener Werkstätte (Viennese Workshops) in 1903, it is necessary to trace some of the reasons for the mounting pressure to develop such an organization. In the last decade of the nineteenth century, the artistic establishment of Vienna, then the capital of a large empire, was conservative to the point of being reactionary. During the 1850's and 1860's, the medieval ramparts of the city had been demolished and replaced by a great circular avenue lined, to the dismay of progressive architects and artists, with grandiose buildings in designs lacking in originality. The Künstlerhaus (house of artists), which had been established to promote modern art, was governed by arch-conservatives hostile to innovative ideas of any kind. The Austrian Museum of Art and Industry

and its School of Arts and Crafts, created to foster an understanding between art and industry, was equally unprogressive.

A break came in 1894, when Otto Wagner, a structural rationalist, became head of the Architectural School of the Academy of Fine Arts. Among his students were Josef Hoffmann, who became one of Austria's leading modern architects, and Koloman Moser, a highly imaginative designer. Wagner encouraged both to develop in new and innovative ways.

Another break in the conservative hold on art came three years later, when the avant-garde artist Gustav Klimt headed a challenge to the monopoly the Künstlerhaus had on modern art by forming a dissident group called the Secessionists. Both Hoffmann and Moser joined the Secessionists.

That same year, the Museum of Art and Industry acquired Hofrat von Scala, a new, more liberal director who was also a member of the Secessionists. He, in turn, appointed the progressive Felician von Myrbach as director of the School of Arts and Crafts. Both Hoffmann and Moser subsequently joined the faculty.

The way was now open to change. In addition to the Art Nouveau style, another influence on the development of modern art at the time was the Arts and Crafts movement developed in England under John Ruskin and William Morris. Dedicated to craftsmanship and individual creativity, the movement's members hoped, through the creation of handsome yet simple designs using honest materials, to counter the ugliness and uniformity of the machine age. The movement had a pronounced effect on the Secessionists, who tended to divide into two groups, the stylists and the naturalists. The former were applied artists or designers; the latter, studio or fine artists. A growing animosity developed between the two groups, the more so since the studio artists considered themselves to be the superior. Hoffmann and Moser saw themselves both as designers and artists.

The need now, as Hermann Bahr, a leading journalist of the day, stated, was for an organization that would bridge the gap between art and craftsmanship, giving equality to the artist and the craftsman or artisan. Hoffmann and Moser wanted to create such an organization; Fritz Wärendorf, a wealthy textile magnate familiar with the Arts and Crafts movement from his frequent visits to England, offered financial support. The Wiener Werkstätte were quickly established, dedicated to the idea that the work of fine craftsmen equals that of fine artists.

A combination of the finest materials, superb craftsmanship, and innovative designs (largely by Hoffmann and Moser) resulted in a variety of beautiful objects by the Werkstätte that delighted a small but wealthy and influential segment of the Viennese bourgeoisie. A successful exhibition in Berlin in 1904 established the reputation of the Werkstätte outside Austria.

At first largely confined to working in precious metals, ivory, and leather, the Werkstätte eventually expanded into furniture, enamel, bookbinding, graphics, fashion, knitwear, beadwork, embroidery, woven, printed, and painted fabric, ceramics, glass, carpets, wallpaper, and lacework. The objective was the creation of the *Gesamtkunstwerk*, or complete work of art. The concept already existed in opera, es-

pecially the music dramas of Richard Wagner, which combined music, theater, dance, literature, and the decorative arts.

Hoffmann realized the objective of *Gesamtkunstwerk* between 1905 and 1911 with the building of the Palais Stoclet in Brussels. Adolf Stoclet, a wealthy Belgian industrialist, admired Hoffmann's architectural designs. Inheriting a huge fortune upon the death of his father, Stoclet was persuaded by Hoffmann to construct a house in Brussels completely designed by the Wiener Werkstätte, with no consideration given to cost. The house became a landmark in modern architecture, admired even by Hoffmann's critics. Every detail, down to the doorknobs, was designed by the Werkstätte. Some claimed it was the most perfect house ever designed.

Moser resigned from the Werkstätte in 1907, discouraged by the casual method of operation and the continued waste of expensive materials resulting from the lack of planning and supervision. Hoffmann, however, refused to put any restraint on either the artists or the artisans. Nor would he entertain the idea, despite repeated suggestions, that the Werkstätte design for the commercial market. The only exception was the Werkstätte's creation of chairs designed by the firm of Thonet. Since the cost of the items, although high, never covered the cost of production, benefactors constantly had to be found to cover the deficits. Dagobert Peche replaced Moser as chief designer. His preference for a softer, more playful and decorative style was a definite influence on the development of Art Deco.

With its creations increasingly admired and purchased, the Werkstätte might have existed indefinitely had it not been for World War I. A number of the Werkstätte's artists were killed, including Klimt. More important, the defeat devastated Austria, leaving Vienna the impoverished capital of a truncated state. An exhibition mounted in 1920 of items that seemed not only excessively costly but frivolous drew largely unfavorable comments and few customers.

Peche died in 1923. Hoffmann, although increasingly concerned with his architectural practice, insisted the customary method of operation continue even though customers who could afford the expensively crafted products grew ever fewer with the onset of the Depression. Supporters attempted to keep the Werkstätte alive by opening branches in Berlin and New York, but the effort failed. All the Werkstätte's shops closed in 1932, and the remaining stock was sold at a bankruptcy sale.

Hoffmann once commented that were its products to appear in every shop window, the Wiener Werkstätte would soon be forgotten. It is the individualistic styling, superb craftsmanship, and limited production that make the creations of the Werkstätte increasingly more valuable and appreciated and have kept its name alive. The creed of the Werkstätte translated into action gives added weight to the frequently repeated argument that the distinction between artist and craftsman is at best only blurred.

Impact of Event

A direct impact of the founding of the Wiener Werkstätte on the art world of the early twentieth century is difficult to establish. The production of the Werkstätte was

limited and followed no particular style. Its influence cannot be compared with that of movements such as Impressionism, expressionism, or Surrealism. The indirect impact of the Wiener Werkstätte, however, was considerable.

As mentioned, the art world of Vienna in the last decades of the nineteenth century was almost moribund. Such style as existed was the "Makart Style," named for Hans Makart, who specialized in exuberant and eclectic historical paintings glorifying past achievements of the Habsburg Dynasty, which still ruled in Vienna. The founding of the Secessionist movement in 1897 and the ensuing establishment of the Wiener Werkstätte, however, effected significant changes. Vienna in the decades before World War I was witness to an amazing florescence of modern art of which the Wiener Werkstätte were an integral part and to which the Werkstätte made lasting contributions felt not only in Vienna but outside Austria as well.

Among the greatest composers of the new art was Gustav Mahler, who was also director of the Vienna Court Opera. Mahler's father-in-law, Carl Moll, a member of the Secessionist movement, organized the first Wiener Werkstätte exhibition in Vienna. In 1902, Hoffmann designed a major exhibition honoring Ludwig van Beethoven for which Mahler wrote an arrangement of the Ninth Symphony and Klimt designed a frieze. Although technically sponsored by the Secessionists, the exhibition actually was the work of the Werkstätte, which was formally organized a year later.

In the fine arts, three of the greatest Viennese artists of the day were Gustav Klimt, Egon Schiele, and Oskar Kokoschka, all of whom were associated with the Werkstätte. The Werkstätte commissioned and sold Schiele's works when no other dealers would do so because of the works' sexually explicit nature. The same support was given to Oskar Kokoschka, whose agitated style and "psychological portraits" disturbed even members of the avant-garde. Kokoschka left Austria for Germany to become part of German expressionism.

The Werkstätte contributed to literature through bookbinding, lettering, and graphics; it contributed to fashion through textile, dress, and jewelry designs; it designed the first loose fitting dress to free women from corsets—a design admired and emulated by Paul Poiret, the Parisian couturier. When the playwright and librettist Hugo von Hoffmansthal wished the great Eleonora Duse to perform in his new play *Elektra*, she agreed to do so only if the Werkstätte designed both her costumes and jewelry. A connection can also be drawn between the theories of Sigmund Freud, the Viennese father of psychoanalysis, and the works of Schiele and Kokoschka. One of the reasons many of the designs of the Werkstätte were so popular was because they seemed sensuous and even mildly erotic.

The greatest impact of the Wiener Werkstätte in the field of modern art and design, however, was inadvertent. In 1907, Josef Maria Olbrich, the architect of the Secessionist headquarters, and Josef Hoffmann were among those who sponsored the Deutscher Werkbund (German craft association), the aim of which was to enhance the position of craftsmanship through cooperation among art, industry, and handicraft. Whereas the Art and Crafts movement and the Werkstätte had for the most

part rejected methods of machine production, the Werkbund embraced them whole-heartedly. Among the members of the Werkbund was Walter Gropius, a young German architect. In 1911, the same year Hoffmann completed the Palais Stoclet, Gropius designed a building with revolutionary "curtain" walls. Whereas Hoffmann's building was a magnificent private residence, Gropius' building was a factory that would serve as a prototype for what became known as the International Style in architecture, a style repeated thousands of times all over the world. In 1918, Gropius founded the Bauhaus in Weimar, Germany, with the intent of creating good prototype designs that would be mass-produced to adorn the homes of the general public. The Wiener Werkstätte, in a sense, became the link between the Arts and Crafts movement of John Ruskin and William Morris and the Weimar Bauhaus of Gropius. The Wiener Werkstätte can be said to have been the midwife to the birth of modern industrial design.

Bibliography

Adlmann, Jan E. *Vienna Moderne, 1898-1918.* Houston, Tex.: Sarah Campbell Blaffer Gallery, 1978. Basically a catalog of Wiener Werkstätte designs mounted by the University of Houston in 1979. Contains instructive short essays on the philosophy of design by authorities such as Friedrich Poppenberg and Walter Gropius. A valuable feature is a list of the initials used to identify works by the Wiener Werkstätte.

Kallir, Jane. *Viennese Design and the Wiener Werkstätte.* Introduction by Carl E. Schorske. New York: George Braziller, 1986. Kallir is codirector of the Galerie St. Étienne in New York, which specializes in the works of twentieth century German and Austrian artists, and is, understandably, knowledgeable about her subject. Some of her assertions, such as that the notion of *Gesamtkunstwerk* served as a starting point for the establishment of the Werkstätte, can be disputed. The book is divided into five parts: background, history, architecture, fashion, and the graphic arts. Detailed notes and an excellent chronology are included.

Neuwirth, Waltraud. *Wiener Werkstätte: Avantegarde, Art Deco, Industrial Design.* Translated by Andrew Smith. Vienna: Neuwirth, 1984. The principal part of the book is a catalog of designs from the archives of the Wiener Werkstätte in the Austrian Museum of Applied Art in Vienna. Affords the reader the opportunity to see the wide range of styles, from Art Nouveau to proto-Art Deco. Most, however, are uniquely the creations of the designers and artists. Included are examples of furniture, lace, pottery, jewelry, silver, enamel work, and graphics. Also given are prices of the items, the time they were offered for sale, and a formula for transposing to present-day currencies.

Schweiger, Werner J. *Wiener Werkstaette: Design in Vienna, 1903-1932.* Translated by Alexander Lieven. New York: Abbeville Press, 1984. Probably the most comprehensive work available in English on the Werkstätte. Schweiger is a native Austrian obviously enamored of his subject, which makes some of his observations open to question. An interesting feature is the book's inclusion of biogra-

phies of artists associated with the Werkstätte. Profusely illustrated both in black and white and in color.

Sekler, Eduard Franz. *Josef Hoffmann.* Translated by E. G. Sekler. Princeton, N.J.: Princeton University Press, 1985. A comprehensive study on the life, philosophy, and works of Hoffmann, who was the driving force behind the Wiener Werkstätte. The work focuses on Hoffmann's architectual creations; a catalog lists 502 items. The Palais Stoclet receives extensive coverage. Excellent appendices, including considerable primary material concerning Hoffmann. Many detailed black-and-white photographs.

Nis Petersen

Cross-References

Tiffany and Tiffany Studios Develop New Ideas in Design (1900), p. 34; Hoffmann Designs the Palais Stoclet (1905), p. 124; The Deutscher Werkbund Combats Conservative Architecture (1907), p. 181; Poiret's "Hobble Skirts" Become the Rage (1910), p. 263; A Paris Exhibition Defines Art Deco (1925), p. 654.

SHAW ARTICULATES HIS PHILOSOPHY IN
MAN AND SUPERMAN

Categories of event: Theater and literature
Time: 1903
Locale: London, England

George Bernard Shaw regarded the writing of plays as a means to communicate serious ideas as well as to entertain, and in Man and Superman *he presented to his audiences notions of human behavior based in the works of Friedrich Nietzsche*

Principal personages:
GEORGE BERNARD SHAW (1856-1950), an Anglo-Irish playwright, socialist, and social commentator
FRIEDRICH WILHELM NIETZSCHE (1844-1900), a German philosopher most widely associated with the idea of the "Superman"
HARLEY GRANVILLE-BARKER (1877-1946), the comanager of the Court Theatre, who premiered many new and controversial plays in London, including *Man and Superman*

Summary of Event

When George Bernard Shaw wrote *Man and Superman*, he found little interest among producers in London. The play was long and somewhat short on action. An actor once complained that Shaw's plays lacked entrances and exits—that is, occasions for actors to storm on and off stage in tempests punctuated by soliloquies. In 1905, however, an American, Robert Loraine, successfully produced *Man and Superman* in New York, and in 1907 it had another successful run at Harley Granville-Barker's Court Theatre in London.

With the success of *Man and Superman*, Shaw was clearly established as a playwright of some note. The play has been called one of the best comedies of the first half of the twentieth century; it was certainly the first play in which Shaw began to espouse a Nietzschean philosophy built around the ideas of creative evolution and the life force (the *élan vital* of Henri Bergson). The life force, Shaw's conception of God, permeated the universe and provided the impetus for creative development, or evolution. Shaw was also interested in biological evolution, to the point of advocating voluntary efforts at eugenics.

These ideas are also clearly related to the philosophy of Friedrich Nietzsche concerning the *Übermensch*, or Superman. Nietzsche was convinced that modern culture was decadent and that the human race was losing its genius to the mediocrity of mass production and popular culture, and he presented these ideas in works such as *Jenseits von Gut und Böse: Vorspiel einer Philosophie der Zukunft* (1886; *Beyond Good and Evil*, 1907) and *Also sprach Zarathustra: Ein Buch für Alle und Keinen* (1883-1885; *Thus Spake Zarathustra*, 1896). Driven by the life force, the Superman

would cast aside the restraints of decadent morality and custom and allow his instinctive urges to guide him to new heights of creativity. Such a person must reject all altruistic ethics, such as Christianity's "turning the other cheek," which Nietzsche regarded as weak and feminine. Ultimately, the Superman must regard his goal as too important to be compromised by concern about the means of achieving it. (Nietzsche was too sophisticated to allow this to become merely a matter of expedience, but his disciples have not always been capable of such distinctions.)

Shaw once denied even having read Nietzsche, but he published a positive review of an English edition of the philosopher's works in 1896. Nietzsche's epigrams were, Shaw said, "written with phosphorus on brimstone." In his usual deprecatory way, he added, "The only excuse for reading them is that before long you must be prepared either to talk about Nietzsche or else retire from society. . . ." Nietzschean ideas are scattered throughout *Man and Superman*, but those ideas are also parodied in the play; Shaw was unlikely to adopt anyone's ideas slavishly.

Man and Superman is a play in four acts. Acts 1, 2, and 4 chronicle the rather comical courtship and adventures of John Tanner and Ann Whitefield. Act 3, the most famous, is a dream of Hell, with Tanner and Don Juan and the other major characters as themselves or in recognizable form. It is in this act that Shaw provides a direct discussion of Nietzschean ideas, largely in dialogues between Don Juan and the Devil. While Juan sees human progress coming from the evolution of the artist and man of action into a Superman, the Devil argues that escape from the dreary world comes only in diversion. Both agree that the morality and convention of society are stultifying and must be ignored by those who expect to grow.

Nietzschean/Shavian misogyny appears in the assertion that women are dominated by the reproductive instinct. There is no thought of women fleeing motherhood or combining it with other creativity, though in Tanner's "Revolutionist's Handbook" (which is appended to the play), it is suggested that marriage and childbearing should be separated. Instincts about mating should not be blocked by convention and morality. It might be noted that Shaw's marriage was, at the insistence of his wife, Charlotte, celibate. Moreover, not only did Nietzsche regard the altruistic aspect of human nature as feminine, but he was also suffering from syphilis, a fate he seems to have blamed on the woman from whom he caught the disease and, by extension, womankind.

Ultimately, the word battle is won by Tanner, who establishes that progress depends on biological evolution. Only when that occurs can intellectual creativity move to a new paradigm. Unfortunately for him, the other characters, intent on mouthing their own views, fail to notice. This is, perhaps, Shaw's way of saying that those who saw reality at the beginning of the twentieth century were the Cassandras of the day.

Although the "Don Juan in Hell" episode is usually the part of the play that is cited as Nietzschean, Shaw uses, and in a sense sends up, the philosopher's ideas in the rest of the play as well. Superficially, acts 1, 2, and 4 are a romantic comedy. Ann rejects the idealistic Octavius Robinson, who is deeply smitten by her charms, and pursues Tanner. For most of the play, the only one who perceives Ann's inten-

tions is Henry Straker, Tanner's chauffeur. Straker clearly shares the role of Shavian hero, for he sarcastically exposes the truth and is amused by the fact that no one heeds him when he does.

Ann, however, is the true *Übermensch* of the play. She does not hesitate to scheme and lie to further her plans. She allows, even encourages, poor "Tavy" (Robinson) to think he is her choice, because she wishes to camouflage her real intentions. If the Superman casts aside convention and allows instinct, the most direct contact people have with the life force, to guide conduct, then in *Man and Superman*, Ann is the Superman. Male patronization comes through in the fact that Ann's instinct is to use any means necessary to establish a sexual relationship with the man who appears most likely to give her superior children, and her energies are not turned to any other sort of creativity. Tanner, who is often seen as the Nietzschean figure in the play, denounces convention and insists that he intends to remain free of family and sexual obligations so that he can pursue his work of revolution. When the chips are down, however, he docilely accepts not only Ann but also marriage, ignoring his own handbook, in which he rejects the connection between mating and marriage. Perhaps his surrender is really to his own instincts concerning reproduction, but if so, the fact is ignored in the play. At the end of act 4, Tanner seems to be resigned to his fate and agrees to the conventional relationship that Ann expects—as, apparently, so does he.

Impact of Event

The success of *Man and Superman* was part of a series of critical and economic successes for Shaw in the late nineteenth and early twentieth centuries. His plays of the period included *Mrs. Warren's Profession* (1898), *Captain Brassbound's Conversion* (1900), *Candida: A Mystery* (1897), *John Bull's Other Island* (1904), and *Major Barbara* (1905). This burst of success resulted in Shaw's never again having to worry about his place in the literary world or about his financial security. Shaw's marriage in 1898, which provided him with personal and economic stability, seems to have been another factor in his productivity.

Plays were becoming a means of political expression for Shaw. In 1884, he had joined the Fabian Society, a group of largely middle-class socialists who were inclined to think that the way to a socialist economy was mostly education; ultimately, the Fabian Society would be one of the major elements in the organization of the Labour Party. The elitism of *Man and Superman*, however, points up the idiosyncratic nature of Shaw's socialism. Despite the working-class character of Straker, little of the play suggests that the author had much faith in the virtues of the proletariat. Nevertheless, Shaw was an effective publicist for and supporter of the Fabians for many years.

Although the philosophy of *Man and Superman* may not have fit Shaw's socialist principles perfectly, the play did have a part in introducing Nietzsche in England and the United States. Shaw introduced the word "Superman" into English. (He first tried "Overman," which really gave a better sense of the meaning of the Nietzschean term.) Shaw was particularly attracted to the ideas of the life force and hero

in Nietzsche's work, and Tanner's "Revolutionist's Handbook" is clearly modeled on parts of *Beyond Good and Evil.* The Shavian hero is often more practical than the sort of Superman that Nietzsche seems to be describing, but he is the type who drives toward his goals with little concern for the mores and folkways of his own culture. Clearly, Nietzsche would approve.

Shaw gave the Nietzschean life force something of an English twist. In Shaw's plays, the life force is a matter of practical courage that might be founded on foolhardiness or preoccupation. Either might lead a hero to ignore danger. In neither *Man and Superman* nor his other Nietzschean play, *Back to Methuselah* (1921), does he drift into the contemplation of the eternal in the fashion of Nietzsche. Shaw's Superman is practical and draws his ideas from common sense. He may, in good British fashion, muddle through.

Man and Superman was an important work. St. John Erving suggests it may be one of the three best comedies of the first half of the twentieth century. It helped to popularize Nietzschean philosophy in the English-speaking world and was part of the beginning of a movement to translate serious philosophic ideas into dramatic form. Finally, it was part of the burst of creative activity that established George Bernard Shaw as a major playwright and social commentator; previously, he had been generally regarded as clever but superficial. The published play was his first book success, with five printings in two years. Shaw would remain a respected writer, philosopher, and critic, and by the time of his death in 1950, he had become one of the world's best-known writers. Revivals of his plays have been common, and much of his work remains widely read.

Bibliography

Bentley, Eric Russell. *A Century of Hero Worship.* Philadelphia: J. B. Lippincott, 1944. While devoting only a chapter particularly to Shaw, Bentley describes the nineteenth and early twentieth centuries' cult of admiration of great men. His comments about other English thinkers such as Thomas Carlyle are valuable for insights and background to the ideas of Shaw.

Durant, Will. "Friedrich Nietzsche." In *The Story of Philosophy: The Lives and Opinions of the Greater Philosophers.* 2d ed. New York: Simon & Schuster, 1953. Although his work is perhaps marred by occasional oversimplification, Durant is greatly skilled at presenting the ideas of his subject in a readable form. Nietzsche's thought is, to say the least, arcane, and an introduction such as Durant's chapter is welcome if not necessary.

Erving, St. John. *Bernard Shaw: His Life, Work, and Friends.* New York: William Morrow, 1956. Erving was personally acquainted with Shaw and a successful critic himself. He admires his subject but is willing to be critical. He includes significant amounts of literary criticism about Shaw's work, and his lengthy digressions into the lives of Shaw's friends are both interesting and useful background. A readable and informative biography.

Holroyd, Michael. *Bernard Shaw: The Pursuit of Power.* New York: Random House,

1989. This is the second volume of an excellent three-volume scholarly biography. Thoroughly researched, very detailed, and quite insightful. The second volume covers the years 1898-1918 and so is of particular importance to those interested in *Man and Superman.* Anyone with a serious interest in Shaw, however, should certainly see all three volumes.

Nietzsche, Friedrich. *Beyond Good and Evil: Prelude to a Philosophy of the Future.* Translated with commentary by Walter Kaufmann. New York: Vintage Books, 1966. The most accessible of Nietzsche's major works and the model for John Tanner's "Revolutionist's Handbook." The best introduction to Nietzsche's thought; provides a foundation for further study.

Shaw, George Bernard. *Man and Superman.* Vol. 3 in *Bernard Shaw: Complete Plays with Prefaces.* New York: Dodd, Mead, 1963. Any complete edition of the play will do. It must include all four acts, the "Epistle Dedicatory to Arthur Bingham Walkley," which stands as a preface, and "The Revolutionist's Handbook."

Solomon, Robert C., ed. *Nietzsche: A Collection of Critical Essays.* Garden City, N.Y.: Doubleday, 1973. A compilation of comments about Nietzsche by noted thinkers. The volume includes Shaw's review entitled "Nietzsche in English," which was published in *Saturday Review* in 1896. Although the value of the articles in this volume will vary depending on the interests of the reader, anyone interested in Nietzsche will find useful pieces included.

Fred R. van Hartesveldt

Cross-References

The Abbey Theatre Heralds the Celtic Revival (1904), p. 119; Bergson's *Creative Evolution* Inspires Artists and Thinkers (1907), p. 161; *The Playboy of the Western World* Offends Irish Audiences (1907), p. 176; Yeats Publishes *The Wild Swans at Coole* (1917), p. 440; Joyce's *Ulysses* Epitomizes Modernism in Fiction (1922), p. 555.

VAUGHAN WILLIAMS COMPOSES
HIS NINE SYMPHONIES

Category of event: Music
Time: 1903-1957
Locale: England

The nine symphonies of Ralph Vaughan Williams spanned nearly a half century and were instrumental in establishing a school of twentieth century English symphonists

Principal personages:
RALPH VAUGHAN WILLIAMS (1872-1958), an English composer of symphonies and choral works, the chief figure of the twentieth century English musical renaissance

WALT WHITMAN (1819-1892), an innovative American poet whose poetry the young Vaughan Williams frequently set to music

MAURICE RAVEL (1875-1937), an eminent French composer who taught Vaughan Williams advanced composition

GUSTAV HOLST (1874-1934), an English composer and close friend of Vaughan Williams

SIR ADRIAN BOULT (1889-1983), an English conductor whose recordings of Vaughan Williams' symphonies are considered definitive

ROY DOUGLAS (1907-), an English composer and arranger who served as Vaughan Williams' musical amanuensis

URSULA WOOD VAUGHAN WILLIAMS (1913-), an English poet who became the composer's second wife and biographer

Summary of Event

In 1903, Ralph Vaughan Williams began work on his First Symphony; his ninth and last symphony received its premiere in 1958. For more than half a century, he was the principal figure in English music, at first a new voice and at the end the conservator and transmitter of a distinguished symphonic tradition.

Vaughan Williams' first three symphonies form a kind of triptych. Their composer did not number them, but assigned them titles. The first, *A Sea Symphony*, was written between 1903 and 1909 and premiered at the Leeds Festival in 1910. The second, *A London Symphony*, written in 1912 and 1913, premiered in 1914 and was revised in 1920 and 1933. The third, *Pastoral Symphony*, was completed in 1921 and premiered the following year. The three symphonies depict, respectively, the sea, the city, and the countryside, and they are large-scale works, comparable in their variety and scope to novels by George Eliot or Thomas Hardy.

A Sea Symphony can be called a symphony only in the sense that it has four movements (the third of which is a scherzo) and is a large-scale composition. Amer-

ican poet Walt Whitman's free verse, which provided the text for the symphony, did not lend itself well to tuneful settings, and Vaughan Williams set it as a kind of musical prose. The composer eschewed use of such traditional symphonic structures as sonata form in the outer movements in order to avoid breaking the continuity of the verse.

Whitman's often overblown and pretentious language is sometimes reflected in the music. The movements are entitled, respectively, "A Song for All Seas, All Ships"; "On the Beach at Night, Alone" (the most effective movement); "Scherzo—The Waves," which can be done independently, without the chorus; and "The Explorers." Because of the large orchestra specified, the need for organ and chorus, and the length of the work, this is the least frequently performed of Vaughan Williams' symphonies.

In contrast, *A London Symphony* is the most popular of Vaughan Williams' symphonies. Though there had been many musical landscapes and seascapes written during the Romantic period, such as Ludwig van Beethoven's *Pastoral* symphony (1808) and Felix Mendelssohn's *The Hebrides* (1830-1832), urban musical portraits were rare. Frederick Delius' *Paris: The Song of a Great City* (1899) is probably the first major musical cityscape.

A London Symphony, which the composer began to sketch in 1912, follows the conventional outline of the four-movement symphony, with the first movement in sonata form and the third movement a scherzo-nocturne depicting London at night. One of the most innovative features of this symphony, and a trait that was to occur in several of Vaughan Williams' subsequent symphonies, is the epilogue at the end of the march-like last movement; the epilogue is quiet and repeats the "Westminster Chimes" harp motive of the opening of the symphony. *London Symphony* also shows to the best Vaughan Williams' artistic creed of writing music for the people, not for a highly select elite.

Vaughan Williams began to sketch *Pastoral Symphony* in 1916 in northern France, where he was serving with the British Army during World War I. The work was completed in 1921 and given slight revisions in the early 1950's. In contrast to his preceding symphonies, it is quiet, contemplative, heavily scored only in the third movement, and characterized by modal melodies harmonized by chord-streams. It has been considered a "war requiem"; many of the composer's younger musical friends were killed in the war. The first movement is in sonata form, the slow movement contains the specification for a natural trumpet (inspired by bugles heard at a distance during wartime), and the third movement corresponds to a scherzo, but the finale is a quietly pensive movement opening and ending with a distant, wordless soprano solo.

The next three symphonies in turn form a triptych. Two modern and dissonant works frame the quiet and contemplative Fifth Symphony; these works were identified by their composer by keys rather than by titles or numbers. Vaughan Williams resented the imposition of programs, and he complained when the mood of his Fourth Symphony was interpreted as rage at the rise of fascism during the 1930's, or

when the bitterness of his Sixth Symphony was seen as a reaction against the optimism of the immediate postwar period.

The *Symphony in F Minor*, better known as the Fourth Symphony, was begun in 1931 and first performed in 1935. It is surprisingly dissonant and violent to those who know only Vaughan Williams' earlier symphonies. In many respects, it resembles the Fourth Symphony of Jean Sibelius (a composer whom Vaughan Williams highly esteemed and to whom he dedicated his Fifth Symphony) in its use of concentrated germ motives out of which the symphony is built. Cast in the traditional four movements, the basic germ motives are stated at the opening of the first movement. The bumptious scherzo is connected to the ironic fourth movement, which ends with an epilogue in which the principal germ motive is treated fugally. The symphony then concludes abruptly with statements of the main germ motives. To many commentators, this is Vaughan Williams' greatest, even though not most popular, symphony.

In contrast to the Fourth Symphony, the Fifth Symphony, in D major (begun in 1938 and first performed in 1943), is a serene and contemplative work. Each of the movements bears a title: "Preludio," "Scherzo," "Romanza" (the slow movement), and "Passacaglia," the term for a Baroque form built up on a repeated bass-note pattern. Its mood of affirmation always will be associated with Great Britain during World War II, yet much of it was inspired by John Bunyan's seventeenth century morality tale *The Pilgrim's Progress* (1678); Vaughan Williams worked for thirty years on an operatic setting of Bunyan's book. One critic has compared the symphonic triptych to Bunyan's tale, with the Fourth Symphony representing Vanity Fair and the Sixth Symphony the struggle with the demon Apollyon.

The Sixth Symphony, begun in 1944 and undergoing numerous revisions until its premiere in London in 1948, is Vaughan Williams' most "modern" symphony, going beyond the Fourth in its use of sharp dissonance. The composer resented application of extramusical connotations such as "war symphony" to the work. It is not a triumphant composition, but ironic and, in places, even bitter. The four movements of the symphony are linked, with the entire fourth movement an epilogue in which the germ motives of the symphony are transformed into a highly contrapuntal work with a prevailingly soft dynamic level. This symphony received more than a hundred performances within two years of its premiere.

Vaughan Williams' final three symphonies also form a triptych, reflecting the composer's interest in film music, which he did not begin to write until 1940. The seventh symphony, *Sinfonia Antarctica*, was derived from the music that Vaughan Williams wrote for the film *Scott of the Antarctic* (1948) in 1947 and 1948. In the following year, he began turning the film score into a symphony, which was completed in 1952 and given its premiere in Manchester in the following year. In five movements, and with a large orchestra that includes organ, wind machine, and women's chorus, the symphony retains the episodic structure of the film score. In fact, it can more properly be called five programmatic movements for orchestra, each prefaced by a literary quotation, rather than a coherent symphony. The second movement, a scherzo, uses themes that were used in the film to depict whales and penguins; in this and

other ways, the work is reminiscent of *A Sea Symphony*. The wordless vocal solo in the epilogue fifth and final movement is reminiscent of that of *Pastoral Symphony*. The third movement is the desolate "Landscape," which culminates in fortissimo organ chords in alternation with the full orchestra.

In contrast with the bleakness of the preceding symphony, the Eighth Symphony of 1956, written when the composer was eighty-three, is the most classical in structure and displays a good humor rarely seen in his postwar works. The first movement, "Fantasia," is subtitled "Variations Without a Theme"; the martial second movement is scored for wind instruments alone; the third movement, "Cavatina," is scored for strings alone and is one of the composer's most peacefully expressive works, and the fourth, "Toccata," makes an extensive use of tuned percussion instruments.

The Ninth Symphony, in E minor, was finished late in 1957 and given its premiere four months before the composer's death at the age of eight-five. Coolly received at its first performance, it is perhaps his most enigmatic symphony. The orchestration is quite unusual, including three saxophones and flügelhorn as well as an enlarged percussion section. It is closest in spirit, freedom of musical structure, and compositional techniques, though less complex, to his Sixth Symphony, and resembles the earlier work in its abstract nature as well as in its use of an epilogue-like slow finale.

Impact of Event

Vaughan Williams established the twentieth century English symphonic tradition at home and abroad. The English composers of symphonies who came after him—including Arnold Bax, Edmund Rubbra, William Alwyn, and Benjamin Britten—had their paths smoothed by the precedent set by their senior colleague. His influence was felt elsewhere in more subtle ways: The American composer Aaron Copland compared Vaughan Williams' Fifth Symphony to looking at a cow for forty-five minutes, yet he used its harmonic devices in his own *Appalachian Spring* (1944) and Third Symphony (1946). The American composer-educator William Schuman (1910-1992) used some of the structural devices that unify Vaughan Williams' Sixth Symphony in his own Sixth Symphony in 1949.

Vaughan Williams' roots were not only in the Anglo-German tradition of Hubert Parry, Charles Villiers Stanford, and Edward Elgar, but also in English folk song (he was a longtime member of the English Folk Song and Folk Dance societies and attended their meetings until his eighties). He was also inspired by the traditions of English music of the Renaissance and Baroque music and by the rich tradition of English vernacular church music. His approach was evolutionary rather than revolutionary. Through his writing for amateur choirs, brass and wind bands, and school orchestras, he successfully raised the level of musical instruction.

His lifelong credo was that a nation's musical health was represented best not by its premiere musical organizations in the major metropolitan areas but by the general level of music-making throughout the country, and he conducted amateur musical groups until the state of his health no longer permitted this activity. He sought to

communicate music not merely to professionals but to unsophisticated performers and listeners as well, and he is one of the few composers of the twentieth century who completely succeeded in this endeavor.

The symphonies of Vaughan Williams, as well as such other orchestral works as *Fantasia on a Theme by Thomas Tallis* (1910) for double string orchestra and the music for *Job* (1930), have their greatest esteem in England, Australia, New Zealand, and the English-speaking nations of North America. Outside these orbits, performances of his symphonies have become infrequent, but his influence on twentieth century music is undeniable.

Bibliography

Douglas, Roy. *Working with Vaughan Williams.* London: British Library, 1988. From 1942 until the composer's death in 1958, Douglas served as Vaughan Williams' musical amanuensis by fashioning the composer's difficult-to-read musical manuscripts into proper shape. In the letters and conversations reproduced in this book, enriched with photographs and facsimiles of the composer's writings, one gets a clear view of Vaughan Williams' deep humanity.

Kennedy, Michael. *The Works of Ralph Vaughan Williams.* Rev. ed. New York: Oxford University Press, 1980. A new edition of a book originally published in 1964. Each work of Vaughan Williams is discussed in depth. Critical opinions of the time are included, and a comprehensive picture of each major work is presented. Musical knowledge is helpful but not essential for appreciating the insights of the text. The best book on the composer's music.

Mackerness, Eric D. *A Social History of English Music.* London: Routledge & Kegan Paul, 1964. The author provides a highly readable and nontechnical context for the social milieu from which Vaughan Williams' music came and of the musical life of the country for which it was written.

Schwartz, Elliott S. *The Symphonies of Ralph Vaughan Williams.* Amherst: University of Massachusetts Press, 1964. All the symphonies are discussed in detail and given musical analyses; the brief section "Structure, Style, and Meaning" will interest the general reader most. Unfortunately, the author uses outdated terminologies and seeks to force many of the movements into nineteenth century frameworks.

Vaughan Williams, Ralph. *The Making of Music.* Ithaca, N.Y.: Cornell University Press, 1955. These lectures, presented for a general audience at Cornell University in the fall of 1954, are an excellent introduction for most readers to Vaughan Williams' musical ideas and philosophy. Though several ideas were presented in earlier writings, they are brought together here in a concise and readable volume.

Vaughan Williams, Ralph, and Gustav Holst. *Heirs and Rebels.* Edited by Ursula Vaughan Williams and Imogen Holst. London: Oxford University Press, 1959. The correspondence of Vaughan Williams and Gustav Holst from their student days in 1895 to Holst's death in 1934, edited by the widows of the two composers. Includes some of Vaughan Williams' early writings on music. This volume not only

records a great musical friendship but also shows how the two composers worked and relied on each others' advice.

Vaughan Williams, Ursula. *R. V. W.: A Biography of Ralph Vaughan Williams.* London: Oxford University Press, 1964. An intimate biography of the composer by his second wife, making extensive use of letters and reminiscences by friends and colleagues. Presents a vivid portrait of the composer as a person and discusses his friendships. Especially valuable as a record of his later years.

R. M. Longyear

Cross-References

Elgar's First Symphony Premieres to Acclaim (1908), p. 214; Sibelius Conducts the Premiere of His Fourth Symphony (1911), p. 292; Mahler's Masterpiece *Das Lied von der Erde* Premieres Posthumously (1911), p. 298; Hindemith Advances Ideas of Music for Use and for Amateurs (1930's), p. 816; Britten Completes *Peter Grimes* (1945), p. 1296.

HENRY JAMES'S *THE AMBASSADORS* IS PUBLISHED

Category of event: Literature
Time: November, 1903
Locale: New York, New York

The Ambassadors was the first and greatest of Henry James's three late novels that dealt with an international theme, and the book climaxed his efforts at the subtle dissection of thought processes

> *Principal personages:*
> HENRY JAMES (1843-1916), an expatriate American writer whose long career was marked by the constant adoption of fresh literary approaches
> WILLIAM DEAN HOWELLS (1837-1920), a friend of James and one of the most esteemed American writers of his time, who helped to arrange the first publication of *The Ambassadors*
> JOSEPH CONRAD (JÓSEF TEODOR KONRAD NAŁĘCZ KORZENIOWSKI, 1857-1924), a friend and neighbor of James whose impressionistic style influenced James's late work

Summary of Event

By the time of the publication of *The Ambassadors* in 1903, Henry James had long been recognized as one of the United States' premier writers. Yet over the years his readership had been dwindling to a select coterie, while the general public was growing less inclined to support his work. Part of the reason for this disfavor was that his writing had grown increasingly intellectually challenging, but James had also lost popularity because he was unwilling to stay with the tried-and-true themes that had brought him initial success. In early novels such as *The American* (1877) and *The Portrait of a Lady* (1881), which were both popular and critical triumphs, he had described naïve, feeling Americans whose hearts were broken by scheming or class-prejudiced Europeans. When James resolutely turned to new themes, as in *The Bostonians* (1886), which satirized Boston reformist and spiritualist circles, he began losing his audience. An attempt to write for the British stage, lasting from 1890 to 1895, was equally unsatisfactory. One play, *Guy Domville* (1895), was actually booed off the stage. After this signal theatrical failure, James moved from London, where he had been living, to the English countryside and returned to composing short stories and novels. He began to pour out a remarkable series of supernatural stories, such as *The Turn of the Screw* (1898), which experimented with point of view and the rendering of delicate mental nuances. In 1900, incorporating these innovations into a longer work, he wrote a projected plan for *The Ambassadors*.

The reaction of the staff of *Harper's Magazine*, to which James submitted his plan in hopes that the book would be accepted for serialization, was a harbinger of the notice the novel would receive from the general public. The *Harper's* reader advised

against acceptance, stating, "It does not promise a popular novel. The tissues of it are too subtly fine for general appreciation." James's friend William Dean Howells, literary consultant to *North American Review*, helped James's serial to publication in that journal, which was more high-toned but less widely read than *Harper's*, in the twelve issues of 1903. The book was published the same year and, as could have been expected, did not take the world by storm. It did, however, intensely interest discerning reviewers who noted James's brilliant joining of the old and the new.

An "old" component of the novel was James's international theme of the contrasting manners of Europeans and Americans, a theme he had handled brilliantly in his earliest novels and to which he returned with increased awareness. Again a naïve American, here Chad Newsome, is made the prey of a worldly European, here Madame de Vionnet, though the moral and social issues are more complex than they had been in James's earlier treatments. The American turns out to be less naïve, the European less jaded than each had at first appeared. New to the novel was the usage of literary techniques James had been working up mainly in shorter fiction. First among these techniques was James's complex employment of a single, constricted point of view from which to tell the story. The viewpoint is not Chad's but that of a man, Lambert Strether, who is sent by Chad's mother to extricate her son from the coils of a European temptress. Before Strether can accomplish his mission, he must determine how deeply Chad is involved. Situated in Strether's perspective, the reader undergoes with him the task of trying to unravel highly veiled appearances. Strether is tremendously sensitive, and so the presentation of his consciousness entails the drawing of superfine distinctions. Such nicety, a Proustian sensitivity to delicate gradations of thought and human relationships, is a second major new element of James's late style.

The Ambassadors was to be the first in a trilogy of novels of similar themes and style that represent the crowning glories of James's career. Each deals with the clashing life-styles and philosophical outlooks of Americans and Europeans; each involves the careful investigation of moral questions; and each is told with a heightened awareness of the mind's workings. The next book, *The Wings of the Dove*, which was published in 1902 but which was written after *The Ambassadors*, concerns a young American heiress, suffering from a fatal disease, whom an impoverished Londoner woos in hopes of inheriting her fortune. The last book in the series, *The Golden Bowl* (1904), centers on the suspected infidelity of an American heiress' Italian husband. As in *The Ambassadors*, the rather uneventful plots of the novels become the basis of sometimes excruciating, often compelling explorations of human thought and motivation.

Where these two novels depart from *The Ambassadors* is in their treatment of point of view; the first book had been told exclusively from Strether's viewpoint whereas the latter novels are constructed from the intersecting viewpoints of a handful of extremely articulate characters. In one sense, then, these last two texts improve on the style of the first, in that the reader is allowed a more rounded view of the stories' situations as they are surveyed by multiple eyes. In another sense, how-

ever, as some critics have noticed, the technique makes for a diffuseness not found in the more concentrated presentation of *The Ambassadors.* Of the three novels, only the first appeared as a serial; this fact, along with the book's use of a single consciousness to filter the action, doubtless contributed to its tightness of construction.

In all three books, there is an interesting interplay of plot and observation, with a sordid and often tragic story forming a powerful contrast to the delicate sensibilities of the embroiled characters. *The Ambassadors,* though a model for the other final masterpieces in the James canon, stands out in its combination of these elements to create suspense and in the economy of means used to achieve its effects.

Impact of Event

The mannered, highly personal, almost idiosyncratic prose style of *The Ambassadors* was not one that another author would be likely to imitate. Yet the focus of James's novel on a detailed examination of the subjective states of a small collection of characters, as well as his presentation of the story from the perspective of a single, limited participant, were to become hallmarks of much modern fiction. James's one novel, of course, was not responsible for the sea change that moved the twentieth century novel away from the broader canvas and omniscient narration characteristic of its nineteenth century predecessor. *The Ambassadors,* though, was one of a number of novels of the time that shaped this change. Further, James's handling of the theme of Americans abroad in *The Ambassadors* foreshadowed and doubtless influenced the work of many post-World War I American writers.

When James moved to southern England in 1895, he settled in an area where a number of other writers, including other American expatriates, were or would soon be living. Three of these writers, Stephen Crane, Joseph Conrad, and Ford Madox Ford, exerted influence on James and on one another (although Crane died before *The Ambassadors* was published). More important, each, along with James, was instrumental in moving the craft of fiction in a subjective direction. Sharing James's interest in the refinements of psychology, Crane, for example, composed a war novel, *The Red Badge of Courage* (1895), which paid more attention to the depiction of the soldier-hero's mental states than to recording valiant deeds. Sharing James's use of a restricted point of view, Conrad presented the narrative of *Lord Jim* (1900) not only by way of the unreliable remembrance of the central character, who is the source of the tale, but also through a second, possibly faulty narrator who retells the first character's tale. These and other writers of the group, with James as the greatest virtuoso of them all, helped to shrink (in scope) and deepen (in psychological insight) the purview of the novel.

A glance at such great modern authors as Virginia Woolf, James Joyce, and William Faulkner shows how the lines set down by James and related writers were followed. Of the three, Woolf is the closest to James in technique. In her *To the Lighthouse* (1927), she created a work that, though much more concrete and tied to everyday life than *The Ambassadors,* was remarkably similar in its close scrutiny of the flittings of consciousness over a short period of time among a compact group. Joyce's

Ulysses (1922) had, as one of its many innovations, the representation of the "stream of consciousness," that is, the moment-to-moment flux of thought in the minds of leading characters. Joyce's work took the modern novel further into the exploration of psychic minutiae than even James had contemplated. Faulkner, taking much from Joyce, in *The Sound and the Fury* (1929) moved the stream-of-consciousness technique into new areas of abnormal psychology by examining such things as the minds of a mentally retarded character and of a youth on the verge of suicide. In exploring these minds, too, Faulkner limited the reader's view to what these flawed consciousnesses perceived. *The Ambassadors* had been a major precedent for the employment of the limited point of view, but James had used the technique to present the perspective of a sensitive, intelligent character; Faulkner used the method, in one case, to render, literally, the mind of an idiot.

James's novel also pioneered in the presentation of American characters in Europe. By examining Americans in foreign lands, he was able to bring out the contrasting traits of personality developed in the Old and New Worlds. It is true that a number of earlier writers, including Nathaniel Hawthorne, had studied Americans in Europe, but the theme had always held a decidedly minor place in American letters. Not only did *The Ambassadors* lift the handling of this material to a new level of excellence, making it a subject to be reckoned with, but the book also problematized conventional literary stereotypes. James did not simply compare honest Americans to dissembling Europeans but showed that each had characteristics of the other. Later writers from the United States would go even further and reverse the traditional images altogether. In Ernest Hemingway's *The Sun Also Rises* (1926), for example, the American expatriate war veterans are the ones who have seen it all and are wearied with life, while many Europeans still have the zest for living that once would have characterized Americans. For Hemingway and other American writers such as Gertrude Stein and Henry Miller, the American experience could be fathomed fully only through the use of European life as a benchmark. In this, such writers were upholding a way of looking at matters that had been most forcibly presented by James.

Literary influences proceed in various manners. The most superficial type manifests itself when one author imitates another whose prose and perspective seem congenial; Hemingway, for example, imitated Sherwood Anderson in this way at first. A more profound type of influence appears when one author sets the terms of ongoing literary discourse. This James did with *The Ambassadors*, so that many of his successors, though not touched by his prose style or his opinions on the world, felt obliged to take up his compositional methods and his major themes.

Bibliography

Blackmur, R. P. *Studies in Henry James.* Edited by Veronica A. Makowsky. New York: New Directions, 1983. An important collection of essays and prefaces to James's novels by a "new critic" who is especially interested in a number of philosophical problems raised by James's late novels. He questions how, for exam-

ple, *The Ambassadors* can be written in such an abstract, formal style and yet, at the same time, approach so near to capturing the real flavor of life. Index.

Edel, Leon. *Henry James: The Treacherous Years, 1895-1901.* Philadelphia: J. B. Lippincott, 1969.

_____. *Henry James, the Master: 1901-1916.* Philadelphia: J. B. Lippincott, 1972. These books are the last two in Edel's five-volume biography. The fourth volume covers James's first work on *The Ambassadors,* and the fifth discusses the novel's writing, serialization, and publication as a book. Gives a sense of James's numerous friendships and devotion to craft. With notes and index.

Holland, Laurence B. *The Expense of Vision: Essays on the Craft of Henry James.* Baltimore, Md.: Johns Hopkins University Press, 1982. Both an examination of the themes of James's novels and a presentation of the intellectual climate in which he worked. Looks into the complicated but discreet use of parallelism used to structure *The Ambassadors.* Contains an appendix and index.

James, Henry. *The Ambassadors.* Edited by S. P. Rosenbaum. New York: W. W. Norton, 1964. Along with the text of the novel, this edition contains extracts from letters James wrote about his work, the novel's plan, and essays from leading critics, including F. R. Leavis, E. M. Forster, and Ian Watt. Annotated, with bibliography.

_____. *The Art of Criticism: Henry James on the Theory and Practice of Fiction.* Edited by William Veeder and Susan M. Griffin. Chicago: University of Chicago Press, 1986. Includes James's appreciations of contemporary authors, his prefaces to the New York editions of his novels, including *The Ambassadors,* and his essays on fiction. Chief among the latter is "The Art of Fiction," in which James lays down his premises, involving both realism and experimentation, for judging literature. With index and bibliography.

_____. *The Complete Notebooks of Henry James.* Edited by Leon Edel and Lyall H. Powers. New York: Oxford University Press, 1987. Contains James's notebooks and diaries as well as his notes to publishers. In the notebooks is to be found his first elaborate sketching out of the story and themes of *The Ambassadors.* Here, too, is the précis of the book that he sent to *Harper's* in hopes of having the novel serialized.

Matthiessen, F. O. *Henry James: The Major Phase.* New York: Oxford University Press, 1944. Offers a sensitive assessment of James's later novels. In studying *The Ambassadors,* Matthiessen looks especially at James's use of a single character as a center of consciousness. Also explores Strether's relation to New England Puritanism. With appendix and index.

James Feast

Cross-References

Stein Holds Her First Paris Salons (1905), p. 129; William James's *Pragmatism* Is Published (1907), p. 171; Joyce's *Ulysses* Epitomizes Modernism in Fiction (1922),

p. 555; Woolf's *Mrs. Dalloway* Explores Women's Consciousness (1925), p. 637; Hemingway's *The Sun Also Rises* Speaks for the Lost Generation (1926), p. 696; *The Sound and the Fury* Launches Faulkner's Career (1929), p. 805; Miller's Notorious Novel *Tropic of Cancer* Is Published (1934), p. 963.

BARTÓK AND KODÁLY BEGIN TO COLLECT HUNGARIAN FOLK SONGS

Category of event: Music
Time: 1904-1905
Locale: Hungary

Béla Bartók and Zoltán Kodály began collecting Hungarian folk songs and were able to transcribe and analyze them accurately, initiating the scientific study of folk music

Principal personages:

BÉLA BARTÓK (1881-1945), a classical composer and pioneer ethnomusicologist

ZOLTÁN KODÁLY (1882-1967), a classical composer and pioneer ethnomusicologist

BÉLA VIKÁR (1859-1945), a Hungarian expert in folk poetry who first recorded genuine folk songs on cylinders in 1896

Summary of Event

In the summer of 1904, Béla Bartók heard a young girl singing Transylvanian folk songs in a small rural village and quickly wrote them down. A new world of sound opened up to him. Applying for a state grant to collect more songs, in 1905 he began to record on cylinders the authentic Magyar folk songs of the Hungarian people. Having fortuitously met fellow folk song enthusiast Zoltán Kodály in the same year, Bartók went out with him to collect thousands of songs and dances among the peasants of Hungary in the next decade.

Both men had been trained in the classical traditions of Western harmony and sonata form. Composers such as Franz Liszt, Johannes Brahms, and Richard Strauss had been their models in composition. The new worlds of melody and rhythm found in the Hungarian folk songs struck them like thunderbolts. Here in their own homeland was a different kind of music. As they amassed, separately and together, thousands of tunes from Hungarian, Slovak, Romanian, and Bulgarian singers and instrumentalists, they realized that they had discovered the authentic folk music of Hungary and that it operated along tonal and rhythmic lines different from both the traditional classical music they had played and composed and the so-called gypsy music that passed in Hungary and elsewhere at the time as folk music.

Kodály had interested himself in folk song a bit earlier than had Bartók. In 1905, he finished a doctoral dissertation on the structure of Hungarian folk songs. He had begun to listen to the folk songs recorded in 1896 on cylinders by ethnographer Béla Vikár. Introducing Bartók to these earlier cylinder recordings, Kodály then set about transcribing their tunes with Bartók's help. They were determined to carry on where Vikár had left off and uncover the total body of living folk song in Hungary.

They sensed that what passed for genuine folk song among the general public was

basically watered-down fragments. Whether in the music of gypsy bands playing for middle-class urban audiences in Hungary or abroad, or in the appearance of folk-derived melodies in classical music, compromises had been made to fit the folk melodies within conventional harmonic bounds. Nationalistic composers of the nineteenth century had tried to incorporate some folk songs into their works. Popular pieces such as Brahms's *Hungarian Dances* (1869) and Antonín Dvořák's *Slavonic Dances* (1878, 1886), as well as the efforts of other musical nationalists, indicated a willingness to explore roots and folk heritages, but to Bartók and Kodály, this movement was not enough. With their growing concern for establishing a distinctive Hungarian art apart from the generally accepted musical models emanating from Austria's capital, Vienna, or from Germany, new materials and new manners of composing and listening had to be forged out of field work, recording, and analysis.

For a decade, beginning in 1905, Bartók and Kodály traveled the length and breadth of Hungary, sometimes together but often separately, trying to gather as much of the music as they could before it died out among the peasants, who would soon be modernized into more passive consumers of music rather than creators and performers of it. They discovered a harsh and ancient music that to them was a pure and natural part of the lives of rural people. Pentatonic and modal scales (similar to the old medieval church scales) were dominant; only more recent, nineteenth century pieces featured conventional "Western" major and minor scales.

More rigorously than others who were starting to record folk song on cylinders, including the Englishman Ralph Vaughan Williams and the Australian Percy Grainger, they developed a method that remains the norm in the study of comparative musicology—as Bartók called it—or ethnomusicology. It was a step-by-step method that involved first collecting widely and deeply in an ethnic enclave, recording everything. The next step was to transcribe, in a notation system devised to indicate sound features beyond the standard notes on the music staff, and to systematize the collection of melodies. Finally, they analyzed melodic contours and scales, the minutely articulated rhythms and the frequent changes in them and in tempo characteristic of live folk song, in addition to analyzing the exact relation of words and melody.

Bartók further stressed in his numerous essays during this period and later that the fieldworker had to know, before entering the field, the context, including previous collections and the folk customs and rituals of the people to be studied. Photography needed to be used to record instruments and their detailed features, and ideally film would capture folk dance. As pioneers in ethnomusicology, both men advocated a gestalt approach, a complete study of a culture and its music.

They were also concerned with publishing their results so that a broad public would become aware of this heritage. In 1906, they issued piano arrangements of twenty Hungarian folk songs. Through the remainder of their lives and even after their deaths, a steady stream of essays and books flowed. A massive corpus of folk song containing more than ten thousand items began to appear in the 1920's. Kodály's later work has been appearing since World War II in volumes produced by the Hungarian Academy of Sciences.

Impact of Event

Almost immediately, Bartók and Kodály's research affected their own work and turned Hungarian music life upside down. The new harmonies and scales shocked the concert public, and their vociferous advocacy of a reform of music-making and even educational practice in the schools disturbed conventional ways of hearing music. Bartók, in particular, extended his research beyond Hungary to North Africa in 1913 and to Turkey in 1935. He was determined to trace Eastern European music styles to Asian styles, and he succeeded. In his many essays and in his own classical compositions, he fused Eastern European music with analogous Asian practice and brought to Western classical music a more worldwide sensibility. Like his contemporary Igor Stravinsky, who had delved into authentic Russian folk song, he was a revolutionary in composing tonally—but with new tonalities based on folk practice. Unlike the members of the Austrian-centered atonal and twelve-tone schools, who rigorously avoided a tonal base in their practice, Bartók and Kodály always believed that some tonal system was essential if classical music was to be renewed, so that music would remain in a sense "within" cultures. To them, that meant a kind of music-making that flowed from a people's folk culture through to the composing of concert music. Neither man eschewed altogether the standard genres of classical music: They renewed them from within.

Bartók's music from 1908 on reflects his folk song research. With the inspiration of Claude Debussy and later Igor Stravinsky, who were working with whole-tone scales and rhythms from folk music, he began in works such as the piano pieces *Allegro Barbaro* (1911), the *Fourteen Bagatelles* (1908), and *Two Rumanian Dances* (1909-1910) to use pentatonic scales, the interval of the fourth, the minor third, and folk dance rhythms (especially Bulgarian ones) to alter his earlier musical practices, which were quite conventional in the line of Liszt, Brahms, and Strauss. Even the most conventional of his six string quartets (usually considered to be the greatest set of string quartets since Ludwig van Beethoven's) reveals folk-song influence. Most significantly, between 1908 and 1909 he put together a piano manual in miniature, *For Children*, consisting of eighty-five graded pieces for students. Like Kodály, whose major interest became that of music education as reform method, Bartók committed himself to the spread of his ideas through publications for the more general public.

It was not until after World War I that Bartók and Kodály emerged as world figures and achieved mature styles and methods. Kodály wrote a number of concert works that have remained popular. His symphonic pieces based on folk tunes became world renowned. His two "folk" operas, *Háry János* (1926) and *Spinning Room* (1924-1932), were based on folk customs and used folk songs. His unyielding commitment to music education was stunning in its impact. He arranged folk songs for choruses of various types in order to revive group singing and developed what is now called the Kodály method of music instruction for schools from the elementary through secondary levels. Taught in institutes in Hungary and in other nations, his method of graded instruction in group singing and the fundamentals of music (in-

tervals, rhythms), which incorporated elements of folk music, helped to renew interest in putting music into the educational system on an equal basis with other subjects.

Both men continued their scientific analysis of folk song from the 1920's on, with Bartók balancing his touring as a pianist (one of the most brilliant of the century) and composing of large-scale works with his research, which intensified from 1934 until his death in 1945. He also contributed to Kodály's educational crusades with settings for chorus of folk songs he collected. From 1920 on, Bartók's own compositions reflected a synthesis of various folk musics with some features of other avant-garde composers. His study of baroque music and counterpoint in the 1920's contributed another strain to his own music, one not fundamentally alien to the underlying folk aesthetic he had mastered. Counterpoint and baroque motor rhythms, with the repetition and variation of small phrases and motifs, did not clash with the similar methods of folk musicians, who used repetition and variation as fundamental structural principles. Alternation of slow and fast movements as well as polyrhythmic features within movements of large-scale compositions fit with folk performance practices, especially of folk dance tunes, which he used widely. Vocal styles that included passing tones (or grace notes), melisma, and sudden leaps became part of his instrumental method. The often freely varied, essentially rhapsodic, and increasingly rapid ornamental style of folk fiddlers inspired nearly all of his mature works for orchestra. Percussive use of the piano stemmed from his knowledge of folk drumming in Africa and elsewhere. Combinations of modal scales were frequent in the vertical (harmonic) aspect of his composing, while in the horizontal (melodic) he tended to use short-phrased figures that were often in eighth, sixteenth, and dotted-note configurations. All these features imparted to his major compositions a unique sound and style.

In another light, his *Forty-four Duos for Two Violins* (1931) and the 153 pieces in *Mikrokosmos* for piano (1936-1937) reveal his concern for music education and his creation of what are in essence musical encyclopedias for a new corpus of music. In these collections, graded for teaching, he not only addressed music students in a practical way but also set forth an aesthetic rooted fundamentally in folk music. Using folk tunes he had collected as well as all the technical features inherent in required mastery of violin and piano playing, Bartók succeeded in bringing together explicit folk practice and more standard classical techniques, which are themselves derived in large part from folk practice of the past.

Bartók's double career represents a unique accomplishment for a composer. His methods are a model for the reinvigoration of twentieth century music. While other methods seem to have petered out, his legacy points a way to a more democratic and truly international idiom of making music.

Bibliography

Abrahams, Roger D., and George Foss. *Anglo-American Folksong Style.* Englewood Cliffs, N.J.: Prentice-Hall, 1968. An introduction to ethnomusicology using famil-

iar materials. Usefully illustrated to make each point with music and lyrics.

Bartók, Béla. *The Hungarian Folk Song.* Albany: State University of New York Press, 1981. A new edition of the master's 1924 book with English versions of the lyrics. Contains nearly four hundred pages of detailed analysis and classification of tunes, all reproduced in Bartók's meticulous and groundbreaking method. The book is difficult but worth study, and it is approachable by nonspecialists. A classic in ethnomusicology.

Choksy, Lois. *The Kodály Method: Comprehensive Music Education from Infant to Adult.* Englewood Cliffs, N.J.: Prentice-Hall, 1974. A lucid and thorough step-by-step explanation of what Kodály wanted in terms of understanding both the fundamentals of music, through graded group singing and rhythmic exercises, and the folk heritage of each nation and its peoples. A manual with musical samples, diagrams, and suggested selections for classroom use.

Eösze, László. *Zoltán Kodály: His Life and Work.* London: Collet's, 1962. A general coverage of his life and works, with some musical samples. Good for context and its author's Hungarian perspective.

Griffiths, Paul. *Bartók.* London: J. M. Dent, 1984. One of the moderate but thorough volumes in the Master Musicians series. Current in its understanding of the many facets of the composer's accomplishment. Contains music examples, index, and lists of key personages and all works.

Kodály, Zoltán. *Folk Music of Hungary.* Rev. ed. Budapest: Corvina Press, 1971. An enlarged edition of the 1952 original and the English version of 1960. Like Bartók's book, it is a technical study of the music but is more focused on types classified by function in the culture. Has descriptions and photos of instruments. Comprehensively illustrated with music examples.

_____. *The Selected Writings.* London: Boosey & Hawkes, 1974. Brings together many short essays on folk song and other kinds of music. The vivid pieces provide easy access to the significance of Kodály and Bartók's work and the contexts of the times.

Nettl, Bruno. *Folk and Traditional Music of the Western Continents.* 2d ed. Englewood Cliffs, N.J.: Prentice-Hall, 1973. A short but thorough study of folk musics and a good example of how ethnomusicology can be accessible. Covers some of the same folk music studied by Bartók and Kodály.

Ujfalussy, József. *Béla Bartók.* Boston: Crescendo, 1972. Translated from the original 1971 book in Hungarian. Possibly the most thorough book on Bartók's life and his music as both cultural and social phenomenon. From a native's perspective, it is always cogent and detailed and never specialist in approach. Though without musical examples, it delves into all important musical techniques.

Frederick E. Danker

Cross-References

Schoenberg Breaks with Tonality, (1908), p. 193; *The Firebird* Premieres in Paris

(1910), p. 269; *The Rite of Spring* Stuns Audiences (1913), p. 373; Schoenberg Develops His Twelve-Tone System (1921), p. 528; Guthrie's Populist Songs Reflect the Depression-Era United States (1930's), p. 810; Hindemith Advances Ideas of Music for Use and for Amateurs (1930's), p. 816.

COHAN'S *LITTLE JOHNNY JONES* PREMIERES

Categories of event: Theater and music
Time: November 7, 1904
Locale: Liberty Theatre, New York, New York

George M. Cohan's musical shows Little Johnny Jones *and* Forty-five Minutes from Broadway *helped to establish his vision of musical theater as a distinctive American art form*

> *Principal personages:*
> GEORGE M. COHAN (1878-1942), a vaudevillian who went on to write, direct, produce, and star in many Broadway musicals, infusing them with his energetic style
> SAMUEL HARRIS (1872-1941), a producer who first collaborated with Cohan on *Little Johnny Jones* and then became his partner for many years
> ABRAHAM ERLANGER (1860-1930), the financier of *Forty-five Minutes from Broadway*
> FAY TEMPLETON (1865-1939), a light-opera star around whom Cohan fashioned *Forty-five Minutes from Broadway*

Summary of Event

George M. Cohan and his family act, the Four Cohans, were a vaudeville group of national prominence when, in 1900, Cohan focused his ambitions as a playwright, songwriter, and performer on the New York theater. At the time, there were three strains of musical theater: the world of musical vaudeville (Cohan's background), European-style operettas, and musical farce. Cohan drew on expanded vaudeville sketches for *The Governor's Son* (1901) and *Running for Office* (1903), the latter of which was a musical farce that introduced the heavy use of contemporary slang in lyrics and dialogue and that incorporated colloquialisms adapted from vaudeville.

Still, these shows played at small downtown theaters. Cohan desired a starring vehicle for himself on Broadway, and the show he next designed—and produced with his new partner, Samuel Harris—signaled a coalescence of the Broadway musical as a twentieth century art form. With *Little Johnny Jones* in 1904 and then again with *Forty-five Minutes from Broadway* in 1906, Cohan merged elements of the three strains of musical theater while bringing innovations in structure, style, and focus. In so doing, he infused the work with much of his ambitious, democratic, self-aggrandizing, and flippant personality—nicely meeting the needs of an American society appreciatively reflecting on itself as it solidified its position as a world power.

Rather than developing a story around currently popular songs, as was common, Cohan sketched out the plot of his musical first. The story of *Little Johnny Jones*

combined melodrama with comedy: An American jockey in the British Isles was accused of cheating after losing the English Derby. Cleared of these charges in the drama's second act, he returned to San Francisco's Chinatown to search for his missing girlfriend, whom he believed had been kidnapped by a notorious gangster.

The subplots—disguises, machinations, intrigues—were complicated, but the play moved rapidly, with grand musical spectacles providing crescendos in each act. The first act's exposition built in anticipation of the jockey's entrance. When he appeared, Johnny Jones (played by Cohan) counseled assembled guests at the Hotel Cecil in London to bet on his horse, Yankee Doodle Dandy, a recommendation that was celebrated in a song-and-dance number. "Yankee Doodle Dandy" drew on the patriotic impulses of theatergoers and gave Cohan an opportunity to display both his nasal singing and the dancing style he had perfected in vaudeville. The number was an instant success; during the New York opening at the Liberty Theater, audience calls of "encore" necessitated the song's repetition several times.

The second act included a similarly wonderful production number, which became the dramatic climax of the entire show. Johnny stood at a Southhampton pier, bidding a ship bound for New York adieu. An undercover policeman had instructed the hero to wait for a flare from the ship as a signal that his nemesis (aboard the ship) had been exposed. Cohan, as Johnny, sang a sad, slow chorus of "Give My Regards to Broadway" as the vessel departed. The lights went down, and a miniature ship crossed at the back of the stage. When a rocket shot up from the ship, Cohan launched into a joyous, lively reprise of the memorable tune before the curtain fell to close the act. The scene, a watershed in American musical theater (the song became a staple in musical tributes to New York), was depicted in a mural in the theater Cohan himself built in 1911.

The undercover policeman was a character known as "the Unknown" and was played by Tom Lewis, half of a popular comedy team. Sam J. Ryan, the other half of the team, played an amiable Irish pal of Johnny. Using the Unknown for comic relief, Cohan gave him many of the best punch lines but no songs, a first in musical comedy. He rounded out the cast with burlesque singer Truly Shattuck and with members of his own vaudeville family, his parents Jerry and Nellie Cohan and his wife, singer and comedienne Ethel Levey.

Forty-five Minutes from Broadway followed in 1906. Although it lacked the trademark flag-waving element that appeared in Cohan's simultaneous *George Washington, Jr.* (the show that introduced the song "You're a Grand Old Flag"), *Forty-five Minutes from Broadway* still demonstrated Cohan's emerging quintessential formula for the musical: fast, flashy, funny language spoken in a slangy vernacular combined with several upbeat, exuberant songs and some sentimental ballads. Cohan wrote the musical as a vehicle for Fay Templeton, a popular light-opera star; the production was financed by Abraham Erlanger, the dominant member of the Theatrical Syndicate, which virtually controlled booking rates at almost all theaters—both on Broadway and in the provinces—from 1896 to 1910. *Forty-five Minutes from Broadway* became the biggest musical-comedy hit in New York in forty years.

Forty-five Minutes from Broadway starred Victor Moore as the sentimental, wise-cracking hero. Again, Cohan molded a hero on his own personality traits. An important factor of the musical's success was its celebration of the rural—or at least suburban—virtues of New Rochelle, New Jersey (later to be trumpeted in another medium on *The Dick Van Dyke Show*) in juxtaposition with the glamour and glitter of New York.

The show had two memorable tunes: "So Long, Mary" and "Mary's a Grand Old Name." The production used simple sets and contained only six songs, which, like those of *Little Johnny Jones*, showed the influence of the *fin-de-siècle* musical farce playwright Edward "Ned" Harrigan. Cohan later clarified his appreciation of this Irish-American in the tributary song "Harrigan" in *Fifty Miles from Boston* (1907).

Impact of Event

Little Johnny Jones and *Forty-five Minutes from Broadway* established Cohan as a force to be reckoned with in American musical theater. The title of one of his 1901 shows, *The Man Who Owns Broadway*, soon came to be a nickname for Cohan himself, who was not only writing, producing, directing, and starring in plays but also building and buying theater buildings. Responses to his forceful personality varied, and in the second decade of the twentieth century, responses of the general public and those engaged in the acting profession could vary. Cohan's composition "Over There" caught the optimistic spirit many Americans shared as the United States entered World War I; it quickly became the unofficial anthem of American involvement. His outspoken stand against unionism led the ultimately unsuccessful fight against the Actors Equity Association's summer strike in 1919. All agreed, however, what a powerful impact he had on the style of the American musical.

Oscar Hammerstein II, himself a powerful voice in the evolution of the musical as an art form, wrote that "Never was a plant more indigenous to a particular part of the earth than was George M. Cohan to the United States of his day. The whole nation was confident of its superiority, its moral virtue, its happy isolation from the intrigues of the old country, from which many of our fathers and grandfathers had migrated." Hammerstein led the successful movement in 1958 to erect a tributary statue to Cohan in Times Square.

Critics tend to agree that Cohan's lasting legacy for musical comedies was the bringing of a distinctly American quality to his productions. Important elements of Cohan's work that helped to capture his cultural moment and to create an "American" style were his use of dialogue, his creation of an archetypal hero based on his own persona, and his unabashed patriotism—which, some would argue, crossed the bounds of ethnocentrism in its celebration of perceived superiority.

The true heyday of Cohan's success in the theater coincided with the expansion of film as recreational entertainment from 1906 through 1910. Early silent films could not adequately convey song-and-dance entertainment; as films began to draw crowds away from live melodrama and comedies, sometimes replacing the very theaters where such works had been performed previously, Cohan solidified the formula of

using both strains in his musical productions.

Cohan's heavy use of slang and idiomatic expressions dated his works within twenty years; still, at the time of their origin, these shows conveyed a sense of currency and realism, a spirit of democracy and the common man. The ambitious optimism of the heroes and heroines, their nostalgic appreciation of a home in the countryside, their enjoyment of the entertainment possibilities afforded by urban life, their resolute commitment to Americanism—these were values that theater-goers identified with readily, and they would resurface again and again in American musicals of the twentieth century.

The male lead in *The Music Man* (1958), for example, displayed many of the qualities of a Cohanesque hero. *Oklahoma!* (1944) espoused a love of the land. *Guys and Dolls* (1951) affirmed that love triumphs even amid the glitter and temptations of an urban environment and also demonstrated the continuing importance of slang and dialect in American musicals. *Candide* (1957) included a pivotal use of scenery—a sheep swimming in the ocean—in the dramatic tradition of the flare in *Little Johnny Jones.* A popular 1953 song by Howard Dietz and Arthur Schwartz, "That's Entertainment," paid tribute to Cohan's penchant for incorporating patriotic pitches into musical production numbers.

James Cagney received an Academy Award in 1942 for his dramatization of Cohan's life in *Yankee Doodle Dandy*, and half a century later, the film still received wide viewership through television presentations. The day the motion picture opened in New York City was declared "George M. Cohan Day" by then-mayor Fiorello La Guardia. Eulogizing Cohan, who died in November of 1942, La Guardia noted "He put the symbols of American life into American music."

All in all, Cohan's contributions were prodigious. During his career, he wrote dozens of plays, of which twenty-eight were musicals. He collaborated on at least forty others and participated in the production of 150 more. More than five hundred songs are credited to his pen. More important than his quantity was the quality that his oeuvre conveyed, as he merged nineteenth century styles, innovating and over-seeing the genesis of the modern musical.

In recognition of his important contributions, the American Guild of Variety Artists decided in 1970 to name its honorary awards "Georgies." Perhaps the most appropriate tribute, though, occurred on Broadway itself. *George M* (1969), a flag-waving hit produced by David Black and Konrad Matthair, although fairly critical of the old master, employed the very form he helped to create over sixty years earlier.

Bibliography

Bordman, Gerald. *American Musical Comedy from Adonis to Dreamgirls.* New York: Oxford University Press, 1982. Chapter 5, "American Musical Comedy Flexes Its Muscles," historically contrasts the work of George M. Cohan with imports such as the Gaiety shows from London and operettas such as *The Merry Widow* from Vienna. Cohan's success is credited to his dynamic personality and his flag-waving, which coincided with a rise in American nationalism.

Cohan, George M. *Twenty Years on Broadway.* Westport, Conn.: Greenwood Press, 1971. Reprint. Robust, self-congratulatory, romanticized autobiography. Not the best source for all the details of Cohan's life, this volume nevertheless nicely conveys the vigor, optimism, ambition, and self-reliance that motivated Cohan and with which he imbued many of his male leads. Heavy use of slang and collo-quialisms—as in his plays—to establish himself as a true "common man."

Ewen, David. *The Story of America's Musical Theater.* Philadelphia: Chilton, 1961. Chapter 4, "Musical Comedy," credits Cohan with the creation of the American musical. A simple, concise history of his rise and fall on Broadway; the former is delineated by *Little Johnny Jones, Forty-five Minutes from Broadway*, and *George Washington, Jr.*, the latter by his struggle against the Actors Equity Association and the popularity of realism.

McCabe, John. *George M. Cohan: The Man Who Owned Broadway.* Garden City, N.Y.: Doubleday, 1973. Accessible, standard biography on Cohan that conveys his style and substance as an entertainer. No notes, but includes well-chosen snippets from a range of his works. Useful chronological appendices of all of his New York productions, stage appearances, and plays. Excellent collection of photographs. Index.

Morehouse, Ward. *George M. Cohan: Prince of the American Theater.* 1943. Reprint. Westport, Conn.: Greenwood Press, 1972. Reprint of early biography published soon after Cohan's death. Morehouse's personal admiration of the artist comes through; he draws on many personal interviews and has a fine command of both language and details. Eighteen photographs. Appendix with chronology of important dates in Cohan's life.

Vallillo, Stephen M. "George M. Cohan's *Little Johnny Jones.*" In *Musical Theatre in America*, edited by Glenn Loney. Westport, Conn.: Greenwood Press, 1984. Eloquent and detailed overview of the musical's innovative debut on Broadway in 1904, with systematic and clear explanation of how the subplots connect to the larger structure of the work. Includes four photographs from the 1904 run.

Scot M. Guenter

Cross-References

Show Boat Introduces American Musical Theater (1927), p. 745; *Oklahoma!* Opens on Broadway (1943), p. 1256; Bernstein Joins Symphonic and Jazz Elements in *West Side Story* (1957), p. 1731; Willson's *The Music Man* Presents Musical Americana (1957), p. 1752; Sondheim's *Company* Is Broadway's First "Concept" Musical (1970), p. 2213.

DUNCAN INTERPRETS CHOPIN IN HER RUSSIAN DEBUT

Category of event: Dance
Time: December 26, 1904
Locale: St. Petersburg, Russia

Audiences were startled and inspired by Isadora Duncan's first performance in Russia, in which she introduced a unique style of movement danced to the music of Frédéric Chopin

Principal personages:
ISADORA DUNCAN (1877-1927), a dancer who revolutionized the art of the dance through unconventional movement, music choice, and theatrical presentation
MICHEL FOKINE (1880-1942), a Russian dancer and choreographer whose ideas about expressive movement and its relationship to music modernized ballet
SERGEI DIAGHILEV (1872-1929), the creator and director of the legendary Ballets Russes whose innovative performances and extensive tours helped revive the art of ballet

Summary of Event

By 1904, Isadora Duncan was a riveting one-woman revolution in Europe in the art of the dance. Shamelessly rejecting traditional ballet, she shocked many conservative observers. Her style of movement, choice of music, scandalously scanty costume, and readily expounded theories on dance made her an object of acute interest. Her first performance in Russia in December, 1904, was no different. She startled and inspired those who witnessed her innovative program of dances to the music of Frédéric Chopin, including dancer/choreographer Michel Fokine and impresario Sergei Diaghilev. With these performances, Duncan emerged as a symbol of a new dance form in Russia, just as she was becoming in the West.

Since first sailing from New York to London in 1899, Duncan had toured extensively in Europe. In each new place, she had shared her theories of expressive dance and "natural" movement (as opposed to the "artificial" posturings of ballet) with initially intrigued and then adoring audiences. Her range of influence across Europe among its artistic and cultural elite was broad, as is evidenced by the prolific responses of critics and the typically sold-out concert halls in which she appeared. Indeed, her Russian debut on December 26 was met with such acclaim by St. Petersburg audiences that a second performance was added three days later.

Her arrival on the morning of December 25 followed a tearful parting from her new love interest, actor and stage designer Gordon Craig. Duncan and Craig had met earlier that month following one of her performances in Berlin. Instantly they

discovered in each other a passionate soul mate, and for Duncan, separation from Craig on this Russian trip was torture. Nevertheless, she managed to rally enough to give an impressive performance.

Her concert, which took place in the elegant Salle des Nobles (Hall of Nobles), was a benefit for the Society for the Prevention of Cruelty to Children. Hosted by Grand Duchess Olga, sister of the czar, the concert was assured patronage by St. Petersburg's artistic, intellectual, and social aristocracy. In addition, news of Duncan's astonishing dance had traveled to Russia by published reviews and word of mouth, prompting attendance by a flood of curious concertgoers. Tickets for Duncan's debut performance quickly sold out.

Her surprising use of movement, music, and decor immediately captured the attention of her audience. What she termed "natural impulses" formed the basis of her dance, as she intently explored the gestures and movements that accompany various human emotions. For Duncan, dance was an art of personal expression, free from the formalized technique and stereotypical theatrics that were common in ballet. Like many of her contemporaries, she turned to the literature and art of ancient Greece for clues to this "natural" movement. She rediscovered such unastonishing activities as running, skipping, and making modest leaps. It was Duncan's uplifting gestures and expressive face and hands that transformed the simple into the heroic.

Also startling was her choice of accompaniment, which included the classical music of Chopin and Ludwig van Beethoven and the operas of Richard Wagner and Christoph Gluck. For the St. Petersburg performance, she chose the mazurkas, polonaises, nocturnes, and waltzes of Chopin. Her daring use of classical compositions not intended for dancing caused outrage among some viewers who found her appropriation of such music to be improper. Yet Duncan's use of and deep respect for this music revealed her artistry as well as her ambition.

Interpreting music, instead of employing it as an accessory to the dance, was a concept unique to Duncan and foreign to the Russians (although Fokine was beginning to think along the same lines). Her dancing provided an additional dimension to the music's rhythm, as she used its phrasing to help structure her movements. For example, a decrescendo in the music might be accompanied by a fall to the floor. Repeated dance movements would correspond with repeated musical phrases. Duncan's new form of dance and its relationship to music clearly distinguished her from other dancers of the day.

Another distinguishing feature was her choice of decor. Her stage decorations consisted of simple blue curtains that traveled with her from stage to stage. Her costume was a flowing, transparent Grecian-style tunic that had a tendency to slip off one shoulder; gone were constricting corsets and stockings. She danced in sandals or barefoot, with bare legs, on a blue carpet.

Audiences responded to Duncan's singular expressiveness, all the more apparent because of her exposed arms, legs, and feet. Like her movement, her revealing tunic pointedly contrasted with the tights, toe shoes, and full-length dresses of her ballet counterparts. Duncan's style of dress reflected her personal philosophy of life, which

was as revolutionary as her style of dance. She lived by her own rules, constantly seeking freedom from convention and restricting traditions (as is apparent by her early avoidance of marriage and the birth of her children out of wedlock).

Observers were quick to say, however, that her dancing was not offensive or sexual. One Russian critic rationalized her physicality in this way: "This is not a *nudité* that arouses sinful thoughts but rather a kind of incorporeal nudity. . . ." Duncan's dancing was thus relegated to a spiritual, even ethereal, realm.

Most viewers were enthusiastic about her performances, although some questioned her copying of "Greek" poses or found her dancing monotonous. Even more controversial, Duncan embodied an ongoing argument between tradition and change. She represented a challenge to the sacred and idealized ballet world by presenting an alternative dance form. This challenge had long-lasting repercussions. On the whole, however, Duncan's first performance in Russia was met with loud applause.

So successful was this concert and her encore on December 29 that she was invited to return to St. Petersburg and to appear in Moscow the following February. Diaghilev later summarized the significance of her success: "Isadora gave an irreparable jolt to the classic ballet of Imperial Russia." This jolt would be felt intensely.

Impact of Event

A critic watching Duncan's interpretations that night of Chopin's music declared that she made a "shocking" first impression. With each step, however, he found the shock diminishing: ". . . as Mme. Duncan became alive and began to dance, the first impression faded away. Before us was not a woman creating a sensation. Before us was an artist."

Duncan herself realized the phenomenon she was creating, later recalling her Russian debut in her 1927 autobiography, *My Life*:

> How strange it must have been to those dilettantes of the gorgeous Ballet, with its lavish decorations and scenery, to watch a young girl, clothed in a tunic of cobweb, appear and dance before a simple blue curtain to the music of Chopin; dance her soul as she understood the soul of Chopin!

Certainly, her choices of movement, music, and decor were unusual for the time. So was such an outward display of one's innermost soul. In fact, Duncan's dance represented a dramatic departure from traditional dance of the day, dominated in European theaters by the Romantic, if formalized, ballet. It must have been strange for the Russian audience, indeed.

Classical ballet was particularly entrenched in Russian society, where the Franco-Italian traditions of the Russian Imperial Ballet were safeguarded by venerated dancemaster Marius Petipa, and the czars paid dearly for extravagant productions such as *The Sleeping Beauty* and *The Nutcracker*. When Duncan arrived, the Imperial Ballet, in its famed Maryinksy Theatre (now the Kirov), boasted such stars as Fokine, Anna Pavlova, Mathylda Kschessinska, and Tamara Karsavina. Vaslav Nijinsky would appear shortly thereafter. Closely connected with the ballets were painters Léon

Bakst and Alexandre Benois, as well as producer Sergei Diaghilev.

Against this backdrop of popular talent and established art waltzed the coura-geous Isadora. Her simple, expressive movements stood in sharp contrast to the acrobatic feats, pirouettes, and toe-dancing of the Imperial Ballet's stars. Undoubt-edly, the revelation that such simple movement could be powerful influenced Fokine and Diaghilev.

Also influential was Duncan's choice of music. Russian audiences were accus-tomed to seeing evening-long spectacles performed to music made-to-order for the dance—literally measure for measure—by Léo Delibes, Ludwig Minkus, or Peter Ilich Tchaikovsky. Duncan presented a new option and a new theory: that dance and orchestral, symphonic, or operatic music could exist side by side. Fokine and Dia-ghilev's later productions clearly reflected this new outlook.

At the time of Duncan's first Russian performance, the twenty-five-year-old Fokine was a rising young dancer in the Imperial Ballet with an agenda for change of his own. While Duncan was a revolutionary in her attempts to abandon the ballet, how-ever, Fokine wanted to reform it. The same year that Duncan jolted Russian society, Fokine wrote his famous manifesto to the Imperial Ballet inveighing against ar-tificiality and unquestioned tradition. He maintained that dancing should be inter-pretive rather than merely mimetic, and that its expressive and rhythmic qualities should be glorified.

The similarity in his thinking with Duncan's is evident. While Fokine had not seen her perform before writing his letter, it is probable that he had read of her theories or lectures as early as 1902 (the date of Duncan's first public solo appear-ance in Europe). The extent to which Fokine's initial dissatisfaction with the ballet was stimulated by what he read about Duncan prior to seeing her, however, cannot be determined.

Even if Fokine arrived at his suggestions without awareness of Duncan's work, her Russian performances certainly paved the way for his reforms. Duncan's new style of dance psychologically prepared audiences and artistic authorities for Fokine's de-sired changes. Before Duncan's December engagement, Imperial Ballet directors had not even bothered to answer Fokine's letter. Soon afterward, Fokine was allowed to present his first choreographic works, among them several that surely reflected Duncan's influence: *Les Sylphides* (1909; originally called *Chopiniana*) with music by Chopin, and *Acis et Galatée* (1905), with a Greek theme. His *Carnival* (1910), without a literary subject, and *Cléopâtre* (1909), also with a Greek theme, seemed to be directly influenced by Duncan as well. In his choreography, Fokine utilized music that had not been originally composed for dance, and he incorporated free, expres-sive movement obviously reminiscent of Duncan.

In 1907, Fokine presented his ballet *Eunice*, which ballerina Tamara Karsavina called a tribute to Duncan because of its Greek theme. (Even then, dancers were not permitted to dance barefoot as Fokine wished. Instead, they penciled in ten toes over their pink tights.) A Russian critic wrote in 1912 that "Fokine was the first independent propagator of these [Duncan's] principles on a wider scene. Fokine's

Eunice not only does not move away from Duncanism, but indeed bears manifest traces of it."

Diaghilev, creator and director of the innovative, legendary company the Ballets Russes, agreed that Duncan's influence was significant in Fokine's reforms and his own later theatrical experiments. Moreover, observer and writer Prince Peter Lieven credited Duncan with inspiring a new spirit in the Russian Ballet: "The beginning of the new outlook must be ascribed to Isadora Duncan," Lieven wrote. "She was the first to *dance* the music and not to dance *to* the music. She altered the whole direction of the dance."

Duncan's new form of movement juxtaposed on classical music, her theory that dance was an art of self-expression, and her refreshing sense of simplicity in design made her a front-runner in the revolution that was soon to be called modern dance. She dramatically set the stage for its next pioneers, Ruth St. Denis and Ted Shawn. Duncan's sweeping impact on the art and attitudes of a changing society, along with her direct influence on Fokine and Diaghilev, are significant legacies. Her vital performances, including the one in St. Petersburg's elegant Salle des Nobles, cast new light on an art form that would never again be the same.

Bibliography

Blair, Fredrika. *Isadora: Portrait of the Artist as a Woman.* New York: McGraw-Hill, 1986. A readable biography that represents current and thorough scholarship on Duncan. Blair places Duncan's debut in Russia in 1904, unlike previous accounts that use the date 1905 or later. The author chronicles the dancer's life, work, and loves; she also provides a social and historical framework for Duncan's dance and range of influence. Contains extensive notes and bibliography.

Duncan, Irma, and Allan Ross MacDougall. *Isadora Duncan's Russian Days.* London: Victor Gollancz, 1929. Cowritten by one of Duncan's adopted daughters, this lengthy book focuses on Duncan's life in Russia in the 1920's. The dancer had hoped to begin a school in postrevolutionary Russia but instead met with political turmoil and opposition to her ideas.

Duncan, Isadora. *My Life.* New York: Boni and Liveright, 1927. Duncan's autobiography, released after her tragic death by strangulation in 1927, provides a revealing and intimate description of her thoughts, theories, and love affairs. Some dates and events are obscured through recollection and may have been edited, but the whole offers valuable insight into the dancer's personality and purpose.

MacDougall, Allan Ross. *Isadora: A Revolutionary in Art and Love.* Edinburg, N.Y.: Thomas Nelson and Sons, 1960. The author, once Duncan's secretary, writes an inspiring biography. He offers the date 1905 for Duncan's first visit to Russia, moving it up from previously accepted accounts of 1907 or 1908. MacDougall places her performance in historical context and aptly describes her legacy.

Seroff, Victor. *The Real Isadora.* New York: Dial Press, 1971. A lengthy and detailed biography that includes an interesting account of Duncan's Russian performances (although this author places her Russian debut in 1905, immediately following the

tragic "Bloody Sunday"). Contains captivating photos of Duncan, her pupils, and her lovers.

Alecia C. Townsend

Cross-References

Pavlova First Performs Her Legendary Solo *The Dying Swan* (1907), p. 187; Diaghilev's Ballets Russes Astounds Paris (1909), p. 241; Fokine's *Les Sylphides* Introduces Abstract Ballet (1909), p. 247; *The Firebird* Premieres in Paris (1910), p. 269; *L'Après-midi d'un faune* Causes an Uproar (1912), p. 332; *The Rite of Spring* Stuns Audiences (1913), p. 373; The Ballet Russe de Monte Carlo Finds New Leadership (1938), p. 1088.

THE ABBEY THEATRE HERALDS THE CELTIC REVIVAL

Category of event: Theater
Time: December 27, 1904
Locale: Dublin, Ireland

After years of discussion, planning, and performing at other venues, several writers and actors dedicated to both art and Ireland founded the Abbey Theatre

> *Principal personages:*
> WILLIAM BUTLER YEATS (1865-1939), a major modern poet and a winner of the Nobel Prize in Literature
> LADY AUGUSTA GREGORY (1852-1932), an Irish patron of the arts and an author and collector of folklore
> JOHN MILLINGTON SYNGE (1871-1909), an important Irish playwright
> ANNIE HORNIMAN (1860-1937), an Englishwoman who funded the founding of the Abbey Theatre
> WILLIAM GEORGE FAY (1872-1947), an actor and manager of various Irish acting companies, most notably at the Abbey Theatre
> FRANK J. FAY (1870-1931), William Fay's brother, an authority on acting who was also active in the Abbey Theatre's early years

Summary of Event

On December 27, 1904, the Abbey Theatre opened its doors in Dublin, Ireland. The event was the culmination of years of discussions and dreams and, for many, was the capstone of what has come to be called the Celtic Revival. That movement, which included not only artistic but also political, social, economic, and even athletic aspects, saw persons of various faiths and backgrounds attempt to establish an Irish identity separate from the English civilization that seemed to them to be destroying Irish culture and thus Ireland itself. The Celtic Revival was broad-based and complex, and the establishment of a theater that would produce Irish drama was one of the movement's primary goals. The founding of the Abbey Theatre seemed to fulfill that aim.

The theater itself was less than ideal. In the past, the site had contained various buildings, including one that had served as a morgue. There had been recent renovations, but the result was not imposing. The small theater seated slightly more than five hundred persons, and the stage was so shallow that actors who needed to exit from one side of the stage and enter later from the other side had to pass along an outside lane at the back. The location was near the River Liffey, but on the north bank, the less fashionable side of the river. Originally the site of a medieval abbey, the area had become Lower Abbey Street; from the abbey and the street, the Abbey Theatre took its name.

The two plays that opened the Abbey Theatre were *On Baile's Strand*, a verse play by William Butler Yeats, and Lady Augusta Gregory's comedy *Spreading the News.*

Dublin newspapers of all political persuasions praised the opening of the theater and the productions, and it was appropriate that the first plays presented were by Yeats and Lady Gregory, since both had played major roles in establishing the theater. Yeats, already a famous poet, had been fascinated with the social and artistic possibilities of the stage for many years, particularly in portraying Irish subject matter. In 1899, his *The Countess Cathleen* (1892) inaugurated the Irish Literary Theatre, and in 1902 Maud Gonne, Yeats's unrequited love who was noted for her anti-English opinions, played the title role in his *Cathleen ni Houlihan.* Lady Gregory, like Yeats, was from the Protestant Anglo-Irish Ascendancy class and had long been interested in Irish folklore. At Coole Park, her estate in the west of Ireland, she had brought together at various times Yeats, John Millington Synge, George Russell (known as "Æ"), Edward Martyn, Douglas Hyde, and others committed to restoring Ireland's past glories through such means as fostering the Irish language, discovering and saving the folktales of Irish peasants, and rewriting the myths of heroic Ireland.

Yeats and Lady Gregory were not alone; George Moore and Edward Martyn were also committed to the idea of an Irish theater. All four had been founders of the Irish Literary Theatre, which had been established with the aim of producing Celtic or Irish drama. Martyn, a wealthy Irish Catholic, was inspired by the plays of Henrik Ibsen, whose Norway stood in the same subordinate relationship to Denmark as Ireland did to England. Moore, a versatile man of letters, was also an Irish Catholic. He had spent much of his literary career in London and on the Continent. Both men, however, played no direct role in the founding of the Abbey Theatre in 1904. Personal and artistic considerations—Yeats argued that Martyn's dramas were not sufficiently artistic and that Moore's style lacked poetic quality, while Martyn feared that Yeats's Celtic mythic dramas bordered on being anti-Catholic—saw Martyn and Moore part company from Lady Gregory and Yeats. After three years, the Irish Literary Theatre disbanded.

The Abbey Theatre is often considered a writer's theater. Not only Yeats but also Synge and, later, Sean O'Casey were publicly associated with the fortunes of the Abbey. Actors, however, were equally influential; stage drama is not only the play but also the performance. In the founding of the Abbey, Frank and William George Fay, two brothers, played major roles. Unlike their literary colleagues, the Fays had only slight formal education. Both, however, had a love of the theater. Frank, the eldest, was an accounting clerk by profession who through self-study became an authority on speech and acting styles. A part-time drama critic, in 1901 he urged the creation of a national theater using Irish actors. For many years, W. G. Fay had toured with small companies throughout the British Isles, and although he had a talent for comedy, he never had much success. Returning to Dublin, he and Frank founded several amateur acting groups. In 1902, the Fays joined with Yeats in producing his *Cathleen ni Houlihan* and Æ's *Diedre.*

The Irish National Theatre Society was established in early 1903. Yeats became president and Russell, Hyde, and Maud Gonne were vice presidents. W. G. Fay was the stage manager, and the Fays and the other actors were given a say in the running

of the society, including which plays were to be produced. In May, 1903, the as-yet-obscure company put on several plays in London to the praises of English critics. In October, 1903, Synge's *In the Shadow of the Glen* made its debut in controversy. Arthur Griffith, the founder of the Irish nationalist movement Sinn Féin, criticized the play as a slander on the Irish peasants and thus a slander upon Ireland itself. During the first performance, Maud Gonne and several others walked out; art and patriotism were not inevitably compatible.

One of the difficulties faced by the Irish National Theatre Society was the lack of a suitable playhouse. Between 1899 and 1903, Yeats and his fellow writers and the Fays and their amateur actors had resorted to at least six different Dublin halls. Having their own theater seemed a necessity; ironically, the group attained a playhouse through the financial support of an Englishwoman who loathed politics, particularly Irish politics. A member of a wealthy family, Annie Horniman had known Yeats for many years and was dedicated to furthering his art. In 1902, she told Yeats that she might finance a theater in Dublin if her economic circumstances warranted it. In early 1904, Horniman acted. She acquired a ninety-nine-year lease, paid for the remodeling herself, and in April turned over to Yeats, as president of the Irish National Theatre Society, free use of the theater. A license was obtained, and the society was warned against producing anything immoral, antireligious, or highly political. On December 27, 1904, the Abbey Theatre opened. The dream had become a reality.

Impact of Event

Dublin critics praised the opening-night productions at the Abbey Theatre. After a performance several nights later, however, an observer noted that there were fewer than fifty persons in the theater. It was several months before the Abbey again saw a capacity audience, and then it was not for a play by Yeats, Lady Gregory, or Synge, but for a less demanding and more accessible drama by William Boyle, *The Building Fund.* The play lacked the artistic metaphors and complicated language of Yeats and Synge, but the audience came in greater numbers.

Attendance continued to be sparse throughout the remainder of 1905. One reason was that Horniman had placed a requirement in her gift that there be no cheap seats in the Abbey—she believed that true art was primarily the province of the upper classes. Horniman was committed to Yeats and to art, but her definition of art did not include Irish cultural concerns. Yeats, while totally dedicated to art—one of his criticisms of Martyn's plays was that they were not art—disagreed with Horniman about Ireland. In his commitment to the drama as an art form, Yeats saw his Irish theater as emulating, and not only in literary form, the drama of ancient Greece. There—and, Yeats hoped, in modern Ireland—individuals brought together in the common environment of the theater would collectively absorb the mythic history from their common past and experience a spiritual regeneration. In addition, Richard Wagner's evocation of the Germanic heroic past in his operas served as a kind of paradigm for Yeats.

Lady Gregory, whose interest was in the Irish folklore of the peasants of western Ireland, was less knowledgeable about continental drama, past and present. Her plays, unlike the mythic histories of Yeats, were primarily comedies. Still, she and Yeats worked well together. John Millington Synge was the other major literary figure of the early Abbey years. Synge spent much time in the west of Ireland, particularly in the Aran Islands, and the results were a number of dramas, culminating in *The Playboy of the Western World*, which was first produced at the Abbey Theatre in 1907. Synge's plays were rooted in present and peasant Ireland, not in the heroic Celtic past of Yeats, and his plays were not always initially well received. When *The Playboy of the Western World* was first performed, many members of the audience vociferously objected to a play in which an Irishman could claim to murder his father and thus become a hero, and that a character in the play could refer to a woman's "shift" was regarded as an unacceptable slur on female chastity. Yeats was not present at the first performance, but he soon returned to Dublin. In a famous incident on the Abbey stage, he defended Synge and his play and condemned the audience for its intolerance (Yeats repeated the act years later, in 1926, after another Abbey audience hissed Sean O'Casey's *The Plough and the Stars*). Yeats's art was not necessarily that of either Synge or O'Casey, but he defended their works against widespread audience disapproval, whether on patriotic, religious, or moral grounds. For Yeats, Lady Gregory, and Synge, the Abbey Theatre combined both art and Irish culture, and outside forces would not be allowed to dictate what would be presented, or not presented, on the Abbey stage. Predictably, though, in 1906 the majority, including the actors, lost the right to decide what plays were produced at the Abbey. The sole criteria was to be what was good art, and Yeats and his literary colleagues would make the decisions.

The Fays and Horniman soon terminated their relationship with the Abbey. The former were interested in bringing and keeping an audience; they were less concerned about a policy of art for art's sake. In 1908, the Fays left the Abbey and its literary directors. Horniman's continued funding kept the Abbey doors open for the first several years, but in 1910 Horniman finally abandoned her commitment to the Abbey and sold her rights to Yeats and Lady Gregory. In both cases, the separation was bitter.

The Abbey's reputation for excellence and controversy continued. Yeats himself remained active in Abbey affairs as new actors and playwrights stepped onto the stage, most notably Sean O'Casey. Synge died in 1909, Lady Gregory in 1932. Yeats survived until 1939. The decline and fall of the Abbey Theatre was predicted numerous times, but like the legendary phoenix, it always sprang again from the ashes, literally so after the theater burned in 1951. In 1924, it became the first state-subsidized theater in the English-speaking world. Through the years, many non-Irish works were produced, including plays by William Shakespeare, Henrik Ibsen, Eugene O'Neill, Bertolt Brecht, Harold Pinter, and Tom Stoppard. The Abbey, though, retained its Irish roots, not only in the many revivals of plays by Yeats, Gregory, Synge, and O'Casey, but also in works by George Bernard Shaw, Oscar Wilde, Brendan Behan,

Samuel Beckett, and Brien Friel. The Abbey also remained an actors' theater; the Fays were followed through the years by Barry Fitzgerald, Siobhan McKenna, and Cyril Cusack. If the Abbey did not entirely fulfill Yeats's intentions, he never doubted the importance, for good or perhaps ill, of Irish drama. In one of his later poems, "The Man and the Echo," written after the Easter Rising of 1916 in reference to his play *Cathleen ni Houlihan*, he wrote,

> I lie awake night after night
> And never get the answers right.
> Did that play of mine send out
> Certain men the English shot?

Bibliography

Ellmann, Richard. *Yeats, the Man and the Masks.* New York: Macmillan, 1948. Ellmann, a biographer of James Joyce and Oscar Wilde, wrote one of the most important studies of Yeats's life and career.

Fay, Gerard. *The Abbey Theatre.* New York: Macmillan, 1958. The author, the son of Frank Fay, tells of the contributions of his father and his uncle to the establishment of the Abbey. Balances the traditional interpretation that the Abbey was solely the creation of the playwrights.

Flannery, James W. *W. B. Yeats and the Idea of a Theatre.* Toronto: Macmillan, 1976. This excellent study traces Yeats's long interest in the drama. Unlike some critics, the author takes seriously Yeats's commitment to the art of the drama.

Hunt, Hugh. *The Abbey: Ireland's National Theatre, 1904-1978.* New York: Columbia University Press, 1979. Authorized by the directors of the National Theatre Society. An excellent summary of the first seventy-five years of the Abbey Theatre and includes a listing of all the Abbey productions.

Kohfeldt, Mary Lou. *Lady Gregory: The Woman Behind the Irish Renaissance.* New York: Atheneum, 1985. A well-written account of Lady Gregory, her contribution to the Abbey Theatre, and her relationships with the major figures of the Celtic Revival.

Mikhail, E. H., ed. *The Abbey Theatre: Interviews and Recollections.* London: Macmillan, 1988. An excellent summary of the remembrances of many important figures in the history of the Abbey Theatre from the earliest days to the 1980's.

Eugene Larson

Cross-References

Reinhardt Becomes Director of the Deutsches Theater (1905), p. 145; *The Playboy of the Western World* Offends Irish Audiences (1907), p. 176; Yeats Publishes *The Wild Swans at Coole* (1917), p. 440; Joyce's *Ulysses* Epitomizes Modernism in Fiction (1922), p. 555; Brecht Founds the Berliner Ensemble (1949), p. 1410; Behan's *The Hostage* Is Presented by the Theatre Workshop (1958), p. 1757.

HOFFMANN DESIGNS THE PALAIS STOCLET

Category of event: Architecture
Time: 1905
Locale: Brussels, Belgium

The Palais Stoclet was Josef Hoffmann's architectural masterpiece, and the building set a precedent for domestic architecture

Principal personages:
JOSEF HOFFMANN (1870-1956), a leading Austrian architect who developed a unique Art Nouveau style
GUSTAV KLIMT (1862-1918), an Austrian artist whose talents complemented those of the architect
ADOLPHE STOCLET (1871-1949), a discerning and wealthy Belgian banker who was the ideal patron

Summary of Event

By 1905, Josef Hoffmann had become one of Vienna's more successful so-called Secessionist architects, who had abandoned the ornate and imitative styles of traditional Austrian architecture. Hoffmann's chief inspiration was his former professor, Otto Wagner, the head of the Architectural School of the Austrian Academy of Fine Arts. Wagner had developed an austere, rectilinear style that Hoffmann admired and further developed, and the style became known as the Austrian version of Art Nouveau.

Hoffmann had obtained commissions for building several villas in a fashionable suburb being developed on the outskirts of Vienna. One such villa was for the designer Koloman Moser, with whom Hoffmann had established the Wiener Werkstätte (Viennese Workshops), dedicated to creating decorative objects of original designs and the finest workmanship. Adolphe Stoclet, who was at the time living in Vienna, greatly admired the villa. Introduced to Hoffmann by Moser, Stoclet was prepared to commission the architect to design a villa for him at the same location.

In 1904, circumstances changed. Stoclet's father, a Belgian industrialist, died, leaving the son immensely wealthy. A house by Hoffmann was still to be built, but now it was to be in Brussels, where Stoclet's business was located. Hoffmann, motivated by the talent available to him through the designers of the Wiener Werkstätte and Gustav Klimt, an artist whom he greatly admired, prevailed upon Stoclet to let him design a house that would be perfect in every detail—one of the exquisite creations of the Wiener Werkstätte in macrocosm. Money was to be no object. Stoclet gave Hoffmann a free hand and carried the knowledge of the real cost of his house with him to the grave.

The house was designed as a piece of sculpture, so perfect that nothing could be added or taken away without severely altering the creation. The basic design of the

house was planar, a series of interconnecting squares and rectangles with black and white the dominant colors. The house was so placed that it presented a unified, artistic composition from wherever it was viewed.

Hoffmann employed optical illusions in the construction of the house—the most obvious being its "atectonic" appearance, which resulted in a seeming denial of the load-support relationships. The walls of the house (or "Palais," as it was soon called because of its costly construction) were covered with slabs of white Norwegian marble of crystalline purity. Carved moldings of darkly gilded bronze cascaded down from a square tower topped with an open-work design of flowers and surrounded by four Herculean figures of beaten copper. The moldings followed and delineated both the vertical and horizontal edges of the building and gave the illusion that the walls were thin sheets of marble delicately held together by the gilded moldings, which also served to protect the edges. To mask the basically heavy-masonry construction of the building further, the windows were placed flush with the outside walls. The lightweight effect was almost ethereal.

If the exterior was austere black, white, and gold, the interior glowed with rich colors. Entering the Palais Stoclet was an experience. The entrance began with a narrow covered walkway and revealed in successive stages the splendors within. The street door opened into an austere, windowless anteroom clad in white marble. This opened into a somewhat larger vestibule clad in dark-green marble and dimly lit through soft lights directed at a series of small golden urns placed on top of the marble walls. Turning left, the visitor entered the great hall—a stupendous room stretching the entire width of the house and, supported on slender honey-colored marble columns, soaring two stories to the roof level. At one end, a bay window enclosing a fountain added to the length of the hall; on the other end, glass doors extended the hall into a landscaped garden. The muted colors of the great hall provided an unobtrusive background for parts of Stoclet's famed art collection, which was placed or hung throughout the area.

The salon, or drawing room, usually the principal room in a great house, was insignificant. The two dominant rooms—both entered from the great hall, one entrance opposite the other—were the music theater and the dining room, which celebrated what the architect Peter Behrens called "life's greatest festivities." The walls of the music theater were of polished, strongly veined black marble; the floor was made of dark teak squares surrounded by coralwood; the coverings and draperies were crimson-purple. A gallery on one side permitted viewers to look down on the luxurious patterns formed below.

The dining room was the most celebrated room. It was forty-five feet in length, and its wall combined the honey-colored marble of the great hall with the black of the music theater. The glory of the room—the most costly feature of an incredibly costly house—were the great mosaics by Gustav Klimt, which almost entirely covered the two long walls; a smaller mosaic covered a third wall opposite the bay window overlooking the garden. The mildly erotic themes of the great mosaics centered on the gardens of art and of love. The small mosaic on the wall opposite the

garden windows was a stylized version of a garden that never fades.

This room, too, employed visual deceptions. The walls receded in stages, thereby achieving a three-dimensional effect and permitting the lower part to be used as sideboards, on which were displayed silver created by the Wiener Werkstätte. The mosaics, constructed of rare marbles, enamels, semiprecious stones, and precious metals, were two-dimensional in the Byzantine manner, made the more interesting by rich, raised ornamentation.

The garden, as carefully planned as the rest of the house, was an extension of the interior. The two great bays extending into the garden seemed like open arms inviting the viewer into the house through an elegant loggia opening into the great hall. On a moonlit night, the effect could be overwhelming, causing a famous museum director to exclaim that such a work of maturity and artistic grandeur as the Palais Stoclet had not been seen since the days of the Baroque.

Impact of Event

The completion of the Palais Stoclet established Josef Hoffmann as one of Europe's leading architects. Hoffmann probably would have become still better known had he written about his art. For him, though, as for the noted Catalan architect Antonio Gaudí, art was not to be intellectualized; it was to be felt. Hoffmann was to become better known as an "architect's architect," one of the founders of modern architecture and design. Walter Gropius, Peter Behrens, Hendrik Petrus Berlage, and Gerrit Thomas Rietveld, among others, all admired him. Hoffmann directly influenced Le Corbusier and Ludwig Mies van der Rohe. Frank Lloyd Wright had long conversations with Hoffmann, and the similarity of their essentially planar designs is obvious.

Although he was a prolific architect, working to the year of his death, Hoffmann never again achieved the triumph of the Palais Stoclet. Had he built it and nothing else, however, he still would have been regarded as one of the great architects of the twentieth century.

Another effect of the building of the Palais Stoclet was that, perhaps more than any other artistic creation of its time, it became the outstanding example of *Gesamtkunstwerk*, or complete work of art. Such a creation was the idealistic goal of artists ranging from the composer Richard Wagner to the architect Gaudí. Both Adolphe Stoclet and his wife were aware of the concept and purposely worked to achieve it. The house, an artistic triumph in itself, could be compared to an elegant vitrine housing a great art collection. The collection, mostly in the form of primitive art from all over the world, blended happily with the polished polychrome modernity of the house. Combining theatrical and musical production with the brilliant conversation of their guests and fine food in the fabled dining room, Adolphe and Suzanne Stoclet created artistic experiences equal to that of viewing the house and its art collection. Seldom accepting outside invitations, the Stoclets created their own world by having as guests or performers some of the greatest artists of the time, including the pianist Ignacy Jan Paderewski, the choreographer Sergei Diaghilev, the musician Igor Stravinsky, the actor and playwright Sacha Guitry, and the writer Anatole France.

The greatest impact of the Palais Stoclet was in the context of architectural, social, and intellectual history. The Palais Stoclet was the right building at the right time in the right place. The nineteenth century is sometimes referred to by intellectual historians as the "Bourgeois Century," bourgeois meaning "capitalist" in the Marxist-Leninist sense. Dominating the nineteenth century both politically and economically, the bourgeoisie had yet to develop its own cultural identity in architecture but resorted rather to borrowing from earlier styles. Although Hoffmann lived in a Vienna that was an imperial capital, he made no effort to cultivate the patronage of the nobility. His architectural designs, as well as those of the Wiener Werkstätte, were for the wealthy bourgeoisie.

The Palais Stoclet was evidence of the bourgeoisie's architectural coming of age. Their style generally was known as Art Nouveau, although the style varied greatly depending on the locale, with Hoffmann's version verging on austere classicism. Pre-World War I Brussels, flush with wealth from banking, industrial expansion, and colonial exploitation, became the site of some of the most spectacular creations in the bourgeois Art Nouveau style, and the Palais Stoclet set the ultimate example. Some cultural historians maintain that this search for a new style by the bourgeoisie was a form of escapism, as if they knew their world would end—as indeed it did in 1914, with the coming of World War I. Although he would survive the war by nearly four decades, Hoffmann would never design another Palais Stoclet. Even had he found another patron, it is doubtful that the egalitarian postwar world would have tolerated such an ostentatious display of affluence. The luxurious creations of the American designer Louis Comfort Tiffany, intended for the same upper-middle-class clientele, were to meet a similar fate. Just as Europe's great medieval cathedrals stand as expressions of the piety of their time, so is the Palais Stoclet palpable evidence of a now-vanished era of rampant capitalism. As such, the building, although influencing subsequent architectural designs, remains unique—a source of pleasure, even wonder, for those interested in architecture, but also a primary document for architectural, social, and intellectual historians alike.

Bibliography

Frampton, Kenneth. *Modern Architecture: A Critical History.* 3d ed. New York: Thames & Hudson, 1992. Just as Carl Schorske's volume sets Hoffmann's Palais Stoclet masterpiece against turn-of-the-century Vienna, Frampton sets both the architect and his architecture within the broader framework of Western architecture. The chapter relating to Hoffmann is called "The Sacred Spring," referring to the pool of artistic talent to be found in Vienna at the time. It is interesting to compare the Palais Stoclet with the Secession Building, the first structure in the austere new style that was the Viennese version of Art Nouveau.

Schorske, Carl E. *Fin de Siècle Vienna: Politics and Culture.* New York: Vintage Books, 1981. Increasingly, turn-of-the-century Vienna is being recognized for its amazing cultural and artistic achievements. With musicians such as Arnold Schoenberg, Richard Strauss, and Gustav Mahler, artists such as Gustav Klimt, Egon

Schiele, and Oskar Kokoschka, and architects such as Josef Hoffmann, Adolf Loos, and Otto Wagner, the city at the time equaled, if not surpassed, Paris, London, and Berlin as a center of Western culture. The creation of the Palais Stoclet, which Schorske calls a "Viennese house," must be seen against this richly varied cultural and artistic background. Of particular interest is a comparison of a frieze Klimt created for a Beethoven Exhibition in 1902 and the later frieze for the Palais Stoclet.

Schweiger, Werner J. *Wiener Werkstaette: Design in Vienna, 1903-1932*. Translated by Alexander Lieven. New York: Abbeville Press, 1984. No study of the Palais Stoclet could be complete without a concurrent study of the Wiener Werkstätte, the design group cofounded by Hoffmann. Indeed, the Palais Stoclet has been described as a permanent Wiener Werkstätte exhibition. Includes excellent illustraions of the Palais Stoclet and its Wiener Werkstätte creations.

Sekler, Eduard Franz. *Josef Hoffmann, the Architectural Work: Monograph and Catalog of Works*. Princeton, N.J.: Princeton University Press, 1985. The definitive work on Hoffmann. This extensively illustrated book permits the evaluation of Hoffmann as an architect and decorator. It notes the influence of classicism, cubism, and expressionism on his work. A two-hundred-page catalog lists all of Hoffmann's known works both as an architect and as a designer. Includes an index and comprehensive bibliography, mostly in German.

_____. "The Stoclet House by Josef Hoffmann." Edited by Douglas Fraser, Howard Hibbard, and Milton J. Lewine. In *Essays on the History of Art Presented to Rudolf Wittkower*, Vol 2. London: Phaidon Press, 1967. Considering the fame of the house, comparatively little literature is available on it, possibly because it was completed shortly before the outbreak of World War I. Sekler is an authority on Hoffmann, and this is undoubtedly the best individual monograph available on the Palais Stoclet. The coverage is thorough and given in loving detail; includes a precise description of the materials used in and the names of artists who contributed to the construction of the house. A number of excellent color photographs give an idea of the polychrome richness of the interior.

Nis Petersen

Cross-References

Tiffany and Tiffany Studios Develop New Ideas in Design (1900), p. 34; Hoffmann and Moser Found the Wiener Werkstätte (1903), p. 79; The Deutscher Werkbund Combats Conservative Architecture (1907), p. 181; Gaudí Completes the Casa Milá Apartment House in Barcelona (1910), p. 257; Le Corbusier's Villa Savoye Redefines Architecture (1931), p. 869; Wright Founds the Taliesin Fellowship (1932), p. 902.

STEIN HOLDS HER FIRST PARIS SALONS

Categories of event: Art and literature
Time: 1905
Locale: Paris, France

Expatriate American writer Gertrude Stein and her brothers established Paris salons at which innovative artists, writers, and musicians gathered and exchanged ideas

Principal personages:
GERTRUDE STEIN (1874-1946), a controversial, innovative writer whose chosen exile intrigued many
LEO STEIN (1872-1947), Gertrude's brother, a writer who collected art and was the first of the group to move to Paris
MICHAEL STEIN (1865-1938), an art collector and railroad manager who was the eldest of the Stein children and the most financially responsible
SARAH SAMUELS STEIN (1870-1953), another salon hostess, Michael's wife
ALICE B. TOKLAS (1877-1967), a companion and lover to Gertrude Stein

Summary of Event

Gertrude Stein is known less for her own work than for her association with the writers and artists of whom she said, according to Ernest Hemingway's epigraph to *The Sun Also Rises* (1926), "You are all a lost generation." Although her innovative style of writing has prompted numerous critical studies, her manner of living remains more intriguing, and her influence on many major figures of her era is inarguable. The salons Stein, her brothers, and her sister-in-law established were the center of artistic fusion and fission. The assemblage of the era's most avant-garde writers, artists, and musicians, and their sharing of theory and practice, was an important force in the formation of modernism.

It was Leo Stein, Gertrude's closest brother in age, who leased the apartment-studio at 27 rue de Fleurus in Paris that would become the center of so much activity. Gertrude joined him there in 1903 after failing four courses at The Johns Hopkins University and being denied her degree in medicine. Their elder brother Michael Stein and his wife Sarah also moved to Paris in 1903, renting an apartment at 58 rue Madame, near Gertrude and Leo. Later, the group was completed by Alice B. Toklas, who came to Paris in 1907 but did not move in with Gertrude and Leo until 1910.

Upon settling in at 27 rue de Fleurus, Gertrude Stein at once began the two activities that would determine the rest of her life: art collecting and writing. Over the many years of the Stein tenancy, the walls of the studio apartment displayed the works of Paul Cézanne, Pablo Picasso, Henri Matisse, Georges Rouault, Georges

Braque, and other contemporary artists, as well as paintings by Pierre Renoir, Paul Gauguin, Vincent van Gogh, and most of the other recognized Impressionists. At the same time, she began writing, at first in a relatively conventional although naturalistic style (perhaps she was still looking through the would-be doctor's eye) and then working toward her controversial, fragmented, repetitious narrative style.

Collecting paintings of current artists naturally brought the Steins into contact with the many artists based in Paris. Paris, of course, was already a center for artistic license. The Paris Salon d'Automne in October, 1905, displayed a controversial Matisse painting, *Woman with the Hat*, which was criticized by the conservative art establishment for its brashness. Gertrude and Leo's purchase of this canvas both made their reputation as art collectors and gained them the friendship of Matisse, who began visiting them at their home. Other artists came with him. The Steins followed the French custom of receiving guests on a specified day; their at-homes were held on Saturday, and these get-togethers of artistic luminaries rapidly became famous throughout the community. Sarah and Michael held similar salons and also entertained Matisse and collected his work. Popular opinion held that Sarah and Michael had better food, but the more discerning conversation and more avant-garde art were to be found at 27 rue de Fleurus. Certainly, the artists of the Paris scene attended both.

Initially, Leo Stein was the major force in the rue de Fleurus salons, giving lectures on art while Gertrude remained in the background. As Gertrude's expertise grew and her opinions became pronounced, however, she came out of the shadows. Gertrude and Leo became estranged, partly because her artistic judgments were wildly divergent from his and partly because he was never very enthusiastic about her own writings. Leo Stein moved permanently to Italy in 1912, at which time Gertrude virtually cut off her relationship with him. Gertrude remained with her lover, secretary, and friend Alice B. Toklas at the rue de Fleurus until 1938, when the owner wanted the studio apartment back for his son; the two women then moved to 5 rue Christine. All during these years, the rue de Fleurus was a center for artists and writers, and many whose names became household words passed through there.

During the Steins' tenancy, the walls of 27 rue de Fleurus were covered from floor to ceiling with paintings, many of them unframed. Friendships waxed and waned. Picasso supplanted Cézanne as favorite son when Cézanne's prices skyrocketed and the Steins could no longer afford his paintings. (Gertrude felt that Cézanne owed it to an old friend to offer old-customer prices.) All the major movements of a volatile era were exhibited and expounded at the Stein salons. Musicians and photographers were part of the circle. In fact, everyone remotely connected with the art world longed, usually in vain, to be invited. The details of Gertrude's salons were taken care of smoothly by Alice B. Toklas, spouse, secretary, and even "bouncer," who told people whose speech or behavior gave offense (Ernest Hemingway was one) that they were not welcome to come back. The salons were discussed, praised, and caricatured throughout Europe and America; Gertrude Stein was truly a legend in her time.

Impact of Event

The salons of the Steins had a major influence on Gertrude Stein's own work and on that of the artists who participated in them. Stein's first novel, *Quod Erat Demonstrandum* (written in 1903 but not published until 1950), mostly written before she became acquainted with Paris artists, was new in content but traditional in form. It told the story—her own story—of a lesbian triangle in which the main character is the loser; the book fictionalized events that took place before Stein's move to Paris. *Quod Erat Demonstrandum* was a relatively straightforward, linear narrative. After meeting Cézanne, however, Stein translated his practice into her own work. *Three Lives* (1909) puts into words a decentered reality in which no single theme, person, or idea predominates. The book is made up of three sections, each of which subtly characterizes a servant girl and shows her powerlessness in the face of her controlling environment and determining character. According to Stein, she used Cézanne's advice to painters as well as the example of his practice to create a new writing style that focused on nuances of voice and that created a flat, seamless surface. She referred to her approach as "the continuous present."

After Cézanne, Picasso became a major influence on Stein's work. At the time when he became Stein's friend, Picasso was moving toward cubism. She did not try to capture Picasso's angular style in words but rather dwelt on his method of manipulating objects to represent his vision. "I was very much struck . . . with the way Picasso could put *objects* together and make a photograph of them," she once wrote, adding that "by the force of his vision it was not necessary that he paint the picture. To have brought the objects together already changed them to other things, not to another picture but to something else, to things as Picasso saw them." She tried to achieve similar manipulations with words, through fracturing syntax and violating expectations in her bold word-portraits (one of which was called "Picasso"). Her goal was "to kill the nineteenth century," and she believed the methods of the avant-garde artists would allow her to do it.

The effect Stein's salons and her personality had on the artists she entertained is less easy to pin down than their effect on her, which she eagerly and voluminously documented. (It is, of course, true that she selected from their words and works what agreed with her own theories.) First, she was a very colorful figure, with an eccentric way of dressing and a life-style shocking to her contemporaries. Her image appealed greatly to artists, who produced numerous paintings and photographs of her. Probably the most famous of these is Picasso's portrait of her; he also painted her brother Leo. Gertrude Stein was also painted by Francis Picabia, Pierre Tal Coat, Marie Laurencin, and others. Generally, these paintings emphasize her stockiness and at the same time suggest her uncompromising intelligence. Stein seems to have achieved the status of a mythic figure among these artists.

The lively interchange among the artists and writers at the salons allowed them to share each other's techniques and attempt to apply them to different media, as Stein herself attempted to translate Matisse's and Picasso's art techniques into writing. Moreover, the concept of art itself became more plastic and flowing, as artists of

various disciplines saw parallels that eliminated barriers between them. Stein encouraged this notion of a plastic art by the various pronouncements she made on artistic subjects. Her views were generally taken very seriously, although often they were merely disguised versions of others' theories. Of course, the artistic movements from the turn of the century—Fauvism, cubism, Futurism, Dadaism, and others— were involved with fragmenting experience and demolishing traditional art forms; the desire for experiment and revolution was in the air. How much of this was actually connected with Stein's salons is open to conjecture. It can only be said with certainty that a large percentage of the early twentieth century's avant-garde artists passed through the doors of 27 rue de Fleurus.

Finally, the Stein salons were a part of the image of the art community for a number of years and were the subject of scandal, jokes, complaints, envy, and admiration. Their presence contributed to the public's growing belief that there was a vast gulf between elitist and popular art.

Bibliography

Bloom, Harold, ed. *Gertrude Stein*. New York: Chelsea House, 1986. This selection of critical essays includes writers from Stein's time as well as later ones. An essay by Judith Saunders about Paris and another by Jayne Walker about Stein's first decade as a writer are particularly useful for those interested in Stein's salons. Helpful chronology concludes the collection.

Burnett, Avis. *Gertrude Stein*. New York: Atheneum, 1972. A novelized biography for young readers, this book is a quick and easy introduction to Stein's life and times. Not for serious students, who might begin with the Bruce Kellner book.

Dubnick, Randa. *The Structure of Obscurity: Gertrude Stein, Language, and Cubism*. Urbana: University of Illinois Press, 1984. This difficult but rewarding book shows the interplay between Stein's work and avant-garde literary and art movements. Helps connect Stein with current literary theory. For advanced students of Stein and modernism. Bibliography; index.

Hobhouse, Janet. *Everybody Who Was Anybody*. New York: G. P. Putnam's Sons, 1975. Gossipy biography filled with colorful anecdotes of Stein's life and times. Good for an overall impression. Voluminous, excellent illustrations, including photographs of Stein, her literary friends, and her studio-apartment. Good color reproductions of Stein-influenced paintings. Minimal notes, useless bibliography, index.

Hoffman, Michael J. *Gertrude Stein*. Boston: Twayne, 1976. Clear, concise critical study, one of the better books in Twayne's *United States Authors* series. Most of the study analyzes Stein's writing, but the opening chapter gives an account of the Paris salons. Notes, helpful although dated bibliography, index.

Kellner, Bruce, ed. *A Gertrude Stein Companion: Content with the Example*. New York: Greenwood Press, 1988. A highly informative, strangely constructed book containing, among other things, brief analyses of Stein's writings, critical essays, thumbnail biographies of famous Stein associates, important Stein quotations, and

poems about Stein. Good photographs. Annotated bibliography in addition to works cited list. Index.

Knapp, Bettina. *Gertrude Stein.* New York: Continuum, 1990. Straightforward, well-written introduction to Stein. Divided into two parts, "The Life" and "The Work"; first part gives details of her relationships with Paris artists. Notes, bibliography, and index.

Toklas, Alice B. *What Is Remembered.* New York: Holt, Rinehart and Winston, 1963. A memoir of Toklas' life with Gertrude Stein. Impressionistic and somewhat inaccurate, as memoirs often are, this book is nevertheless worth reading for its wit and for the often astonishing vignettes of Paris life.

Janet McCann

Cross-References

Avant-Garde Artists in Dresden Form Die Brücke (1905), p. 134; The Salon d'Automne Rejects Braque's Cubist Works (1908), p. 204; The Futurists Issue Their Manifesto (1909), p. 235; Der Blaue Reiter Abandons Representation in Art (1911), p. 275; Kandinsky Publishes His Views on Abstraction in Art (1912), p. 320; Duchamp's "Readymades" Challenge Concepts of Art (1913), p. 349; Avant-Garde Art in the Armory Show Shocks American Viewers (1913), p. 361; The Dada Movement Emerges at the Cabaret Voltaire (1916), p. 419; Man Ray Creates the Rayograph (1921), p. 513; Hemingway's *The Sun Also Rises* Speaks for the Lost Generation (1926), p. 696.

AVANT-GARDE ARTISTS IN DRESDEN
FORM DIE BRÜCKE

Category of event: Art
Time: Summer, 1905
Locale: Dresden, Germany

The artists' group Die Brücke created a shocking new style, using deliberately distorted images and antinaturalistic, dissonant colors, which became known as expressionism

Principal personages:
ERNST LUDWIG KIRCHNER (1880-1938), a multimedia artist, a cofounder of the Brücke and the group's self-proclaimed leader
ERICH HECKEL (1883-1970), a founding member of the Brücke and a painter, printmaker, and sculptor, the group's business manager
KARL SCHMIDT-ROTTLUFF (1884-1976), a printmaker, painter, and sculptor who named the group
FRITZ BLEYL (1880-1966), an architect and graphic artist, a cofounder of the Brücke
EMIL NOLDE (EMIL HANSEN, 1867-1956), a painter and graphic artist who was briefly a member of the Brücke
MAX PECHSTEIN (1881-1955), a painter who joined the Brücke in 1906 and who was the catalyst for the group's dissolution
OTTO MÜLLER (1874-1930), a painter and graphic artist who joined the Brücke in 1910

Summary of Event

One of Germany's first avant-garde artists' groups, Die Brücke (the bridge) was founded in Dresden by a group of young architectural students in the summer of 1905. The group was made up of Ernst Ludwig Kirchner, Erich Heckel, Karl Schmidt-Rottluff, and Fritz Bleyl, all of whom shared an interest in art. Inspired by the writings of the German philosopher Friedrich Nietzsche, who stressed the importance of artistic creativity, Schmidt-Rottluff chose the group's name as an allusion to a passage from Nietzsche's *Also sprach Zarathustra: Ein Buch für Alle und Keinen* (1883-1885; *Thus Spake Zarathustra*, 1896): "What is great in man is that he is a bridge and no end."

The Brücke's members set out to express their creative visions and convictions by using irrational, unrealistic symbolic images in defiance of the principles of idealized, academic German art and Impressionism. Believing that art lacked a sense of passion and commitment, they rejected rigid and narrow artistic standards. They emphasized spontaneous self-expression in their work and aspired to move German art in a radical new direction. Rather than imposing any restrictions on style, the

Brücke embraced a diversity of international sources and influences. The group's members assimilated the flatness of late medieval German woodcuts, the deliberate coarseness of Paul Gauguin's woodcuts, the simplified forms of Edvard Munch's graphics, the subjectively colored and thickly painted canvases of Vincent van Gogh, and the antinaturalistic, brilliantly colored paintings of the French Fauves. They also admired African sculpture and Oceanic art, which they studied at Dresden's Ethnographic Museum, and incorporated such influences into their own work.

Rejecting middle-class values, the Brücke's members consciously detached themselves from their own middle-class backgrounds. They settled into a renovated butcher shop in a working-class section of Dresden that became their communal studio. Protesting materialism and mass-produced objects, the Brücke believed that art was too alienated from contemporary life. Wanting to incorporate art with life, they furnished their studio with handcarved items. In their studio, they employed diverse media—painting, sculpture, lithography, woodcuts, etchings, and furniture—to express their creativity. Initially, they seldom dated their works, freely painted on one another's canvases, and often shared the same models.

The Brücke's early works included portraits, cityscapes, mood-evoking landscapes, and nudes. During the summer months, the members painted by the lakes surrounding Moritzburg, near Dresden, where they painted numerous images of nudes. Their depictions of nudes frolicking in the landscape reflected their generation's interest in a more simplified life and a return to nature. The Brücke's pictorial style eliminated all extraneous details and emphasized flatness, the angular use of lines, distortion of form, and clashing, dissonant colors.

Printmaking also played an important role in the Brücke's stylistic development. Jagged patterns, diagonals, and an emphasis on two-dimensional flatness were also characteristics of the group's early graphic works. Each of the Brücke's artists contributed his knowledge of a particular printmaking technique: Kirchner of wood engraving and etching, Heckel of woodcarving, and Schmidt-Rottluff of lithography. Heckel stated that it was "difficult to determine what each of us brought to the others in stimulation, because it was reciprocal and often in common." The simplified forms of their graphic works were technically innovative and helped to affirm their position at the forefront of the contemporary German avant-garde. The members also used their graphics as a vehicle to reach out to a wider audience. For the nominal fee of twelve marks per year, passive members were allowed to join the Brücke; in return, these paying, nonactive members received a yearly progress report of the group's activities and a folder of their graphics, which later became quite valuable and highly sought-after.

The Brücke also extended membership to other artists who wished to participate in their exhibitions. In 1906, Kirchner executed a woodcut that expressed the group's desire to attract young, revolutionary artists who shared its beliefs and wished to participate in its exhibitions. In 1906, the Brücke's members were joined by the established artist Emil Nolde, who remained a member for only eighteen months. The Brücke admired Nolde's use of brilliant colors and spontaneous brushwork.

Although Nolde quickly spurned the Brücke's communal working method and lifestyle, he learned the printmaking process of etching from the group, a process that remained a staple in his oeuvre. The painter Max Pechstein also became a member in 1906. Trained as a decorator and a painter, Pechstein created work that was more naturalistic and decorative than that of the other Brücke artists. He used large, bold planes of color and did numerous paintings of nudes in the landscape. The Brücke also tried to include foreign artists, and in 1908 the members asked Kees van Dongen to exhibit with them. In 1911, the Prague artist Bohumil Kubišta joined the Brücke, but he had little contact with the other members. Cuno Amiet, a Swiss painter, became a corresponding member and contributed works to the Brücke's early exhibitions. Remaining in Switzerland, Amiet had no direct contact with the Brücke artists until 1912. In 1910, Otto Müller became the last artist to join the group. His paintings of bathers in nature were more tranquil-looking and less vibrantly colored than the works of the other Brücke artists.

When Pechstein moved to Berlin in 1908, he remained an active member of the Brücke. During summers, he continued to paint with the Brücke artists in the Dresden countryside. In 1910, the works of Pechstein, Nolde, Müller, and many other artists were rejected by the jury of the Berlin Secession, Germany's most prestigious art association. The works of the Brücke were rejected because they were deemed too shocking and modern. Angered by the Secession's rejection, Pechstein founded the New Secession and became its president. Consequently, the Brücke agreed never again to exhibit their work individually, since the welfare of the group was always to be put above that of its individual members. The following year, Pechstein ignored the Brücke's pact and showed his work independently at the Berlin Secession. By shifting his allegiance back to the more prestigious Berlin Secession, Pechstein attempted to advance his career without regard for the other Brücke artists, and Kirchner immediately expelled Pechstein from the group. Shortly after Pechstein's expulsion, the group began to drift apart. In 1913, the Brücke's members disbanded and went their separate ways.

Impact of Event

When the Brücke moved to Berlin in 1911, its members firmly established their reputations as the German avant-garde. Berlin had a wider and more sophisticated audience than Dresden, and the city became a showcase for the group's work. In Berlin, the Brücke's thematic interest shifted from the nude in nature to images of emotionally isolated people in a radically changing world. The group's artists depicted circus and cabaret performers, prostitutes, and tension-charged street scenes teeming with humanity. They participated in numerous Berlin exhibitions, and their woodcuts were used as illustrations for the pages of Hervarth Walden's influential literary journal *Der Sturm*, which helped to disseminate the Brücke's style.

The most obvious confirmation of the group's achievement came in the summer of 1912, when the Brücke was invited to participate in the large Cologne Sonderbund Exhibition. The Sonderbund was a huge gathering of Europe's vanguard artists and

presented a broad survey of modern art. The critics took notice, began to write positive reviews about the Brücke's works, and dubbed its members "expressionists."

Expressionism became a major cultural phenomenon, in part as the result of the writings of the art historian Wilhelm Worringer. Worringer argued that the expressionists' tendency toward abstraction, subjectivity, and distortion was a characteristic of all German art, both past and present. His books proposed that Northern European art was a distinctly unique phenomenon that was conditioned by its particular culture. Worringer suggested that Germanic art had always been antirealistic and anticlassical, unlike the art of Italy and Greece. Worringer argued that alienation from the harsh conditions of the real world was a major characteristic of Northern artists, who turned to their inner fantasies and expressive feelings in the creative process. Worringer's influential writings helped to define and shape the new style called expressionism. The term "expressionism" aptly described the work of the Brücke's members and of several other German artists, including the members of the Blaue Reiter group, as well as the work of Oskar Kokoschka and Egon Schiele in Austria. The term became widely used to define Northern European art that altered the world of visual appearances.

After World War I, expressionism changed dramatically. Much of postwar German art was concerned with social problems. The November Group was a radical association of intellectuals and artists who joined forces in the utopian belief that art could change society. Pechstein was a member of the November Group, and he designed posters and pamphlet covers urging workers to unite with artists in a joint endeavor to reconstruct Germany after the war.

The long-range effects of the Brücke's work can be seen in the works of such second-generation German expressionists as George Grosz, Max Beckmann, and Otto Dix. Grosz initially used the same garish colors and emotional intensity in his paintings as the Brücke artists had. Grosz, however, was more interested in social concerns than the Brücke artists had been, and he depicted the decadence and corruption of postwar German society. Grosz's 1916 painting *The Big City* shows a chaotic German city street filled with wounded beggars, prostitutes, and wealthy capitalists. Beckmann's grim reaction to war was manifested in his painting *The Night*. A brutalized depiction of human suffering and torture, it shows the violence inflicted upon a family by three cutthroats who have forced their way into the family's home. Beckmann's angular use of line, distortion, and exaggeration of detail in the painting anticipated the style known as New Objectivity, which was in theory a reaction against abstraction and expressionism. Dix's work *The Matchseller* (1920) shows a blinded and maimed war casualty slumped on a sidewalk. Stripped of his ability to earn a living, the matchseller symbolizes the indecencies of postwar life. Dix was a major figure in the New Objectivity, which retained the expressionist characteristic of distortion to emphasize a subjective view of the world.

When Adolf Hitler came to power in the 1930's, he virtually eradicated expressionism. Despising modern art, especially the works of the Brücke artists, Hitler

censored all German expressionist artists, and their works were removed from art galleries and museums. After World War II, however, expressionism gained international acceptance.

In the 1980's, a new wave of German expressionism, the third generation, was launched. The neoexpressionist artists Georg Baselitz, Jörg Immendorf, and Anselm Keifer were indebted to the Brücke's expressive, subjective style and determination to change the status quo in art. Although the neoexpressionists had different concerns than the Brücke's artists did, the influence of the earlier group was visible in the neoexpressionists' return to figurative painting and shift away from the dominant styles of abstract and minimalist art.

Bibliography

Carey, Frances, and Antony Griffiths. *The Print in Germany, 1880-1933.* New York: Harper & Row, 1984. Although limited to the prints in the British Museum, this is a good general study of German expressionist prints. One essay is devoted to the Brücke's printmaking innovations and techniques. Discusses the Brücke's graphics in relation to cultural and historical influences. Includes numerous black-and-white reproductions of Brücke graphics.

Dube, Wolf-Dieter, and Mary Whithall, trans. *The Expressionists.* London: Thames and Hudson, 1972. The first half is devoted to the Brücke, both as a group and as individual artists. Provides a general history of the Brücke and their style. One of the best short introductory books on expressionism. Recommended for students of expressionism and for the general reader.

Gordon, Donald E. *Ernst Ludwig Kirchner.* Cambridge, Mass.: Harvard University Press, 1968. Pioneering major study on Kirchner. Examines Kirchner's art in the context of the Brücke and of expressionism in general. Filled with biographical information. Includes numerous interesting photographs of the Brücke's Dresden studio. Good bibliography.

_____. "German Expressionism." In *"Primitivism" in Twentieth Century Art.* Vol. 2. Edited by William Rubin. New York: Museum of Modern Art, 1984. Gordon's excellent essay examines some of the non-Western sources that the Brücke's members incorporated in their work. Includes some interesting photographs and good color reproductions of the Brücke's work. Recommended for students as well as the novice.

Herbert, Barry. *German Expressionism: Die Brücke and Der Blaue Reiter.* New York: Hippocrene Books, 1983. The first half of the book is devoted to the Brücke. Provides a basic introduction to the Brücke artists and their work and gives a brief overview of the group's history. Primary emphasis is on the Brücke's work and stylistic characteristics. Includes many illustrations.

Lloyd, Jill. *German Expressionism: Primitivism and Modernity.* New Haven, Conn.: Yale University Press, 1991. The only book-length study that examines the impact of non-Western art on the Brücke's artists. Not only discusses the Brucke's assimilation of these images but also examines what prompted the group's interest in

non-Western art. Contains interesting photographs and numerous reproductions of the Brücke's artwork. Good bibliography.

Selz, Peter Howard. *German Expressionist Painting*. Berkeley: University of California Press, 1957. The first study of German expressionism in English that focused on the Brücke, its impact, and its critical reception. Traces the evolution of the Brücke to its demise in 1913. Important source for students of expressionist art and the Brücke. Excellent bibliography.

Carmen Stonge

Cross-References

Les Fauves Exhibit at the Salon d'Automne (1905), p. 140; Strauss's *Salome* Shocks Audiences (1905), p. 151; Der Blaue Reiter Abandons Representation in Art (1911), p. 275; Avant-Garde Art in the Armory Show Shocks American Viewers (1913), p. 361; The Soviet Union Bans Abstract Art (1922), p. 544; The New Objectivity Movement Is Introduced (1925), p. 631; Hitler Organizes an Exhibition Denouncing Modern Art (1937), p. 1083; The Nazis Ban Nolde's Paintings (1941), p. 1217; Rosenberg Defines "Action Painting" (1952), p. 1557.

LES FAUVES EXHIBIT AT THE SALON D'AUTOMNE

Category of event: Art
Time: October, 1905
Locale: Paris, France

Young artists exhibiting at the 1905 Salon d'Automne in Paris shocked the art community with their use of bright colors and aggressive painting styles, earning the nickname of Les Fauves (wild beasts)

Principal personages:
> HENRI MATISSE (1869-1954), a French artist and pioneer of Fauvism who used blazing colors to capture sensations and feelings
>
> HENRI-CHARLES MANGUIN (1874-1949), a Fauve whose lyrical painting *The Fourteenth of July at Saint-Tropez* was labeled artistically scandalous
>
> ALBERT MARQUET (1875-1947), a Fauve whose brushwork and color usage was at first marked by an aggressive violence
>
> GEORGES ROUAULT (1871-1958), a gentle humanitarian who was labeled as a mean-spirited misogynist; his *Monsieur and Madame Poulot* was rejected as outrageously ugly
>
> MAURICE DE VLAMINCK (1876-1958), an artist who, scornful of academy-trained artists, classified Fauvism as a way of life rather than an invention
>
> ANDRÉ DERAIN (1880-1954), an artist whose canvases radiated with pure color, greatly responsible for the invocation of the term "Fauve"

Summary of Event

Fauvism as a movement in painting first captured the attention of the Parisian art world in October of 1905. At the annual Salon d'Automne held in the Grand Palais, an architectural feature of the 1900 Universal Exposition, a number of young artists, most notably Charles Camoin, André Derain, Henri-Charles Manguin, Albert Marquet, Maurice de Vlaminck, and Kees van Dongen, had their works placed around those of Henri Matisse.

With the exception of Vlaminck, none of the artists intended to shock the art world with his entries. Matisse's painting *Woman with the Hat* (1905) was a regally posed portrait of his wife wearing a large hat, a type of stylish headwear worn by many women who strolled in the Bois de Boulogne. Critics considered the work to be a provocative public insult. Matisse also was accused of demeaning his wife by using her as his model.

Georges Rouault's submission, *Monsieur and Madame Poulot*, was classified by some viewers as a spitefully devised affront. *Monsieur and Madame Poulot* was a watercolor and gouache work of two stylized figures, a man and a woman, bourgeois characters of satiated smugness. The images that Rouault placed on his canvas

were invoked by literary figures in Léon Bloy's fiction. Rather than praise Rouault for his attempt to give visual life to two of his characters, Bloy was horrified when he saw *Monsieur and Madame Poulot.* He agreed with critics that the painting was an attempt to vilify French citizens by depicting them graphically as physically ugly and spiritually devoid human beings.

Vlaminck, assigned membership in the group of young painters who were judged to be conspirators in a plot to scandalize the Parisian art world, was motivated by a desire to shock the public. A self-taught artist who often did not possess the money to buy paints and canvases, Vlaminck believed that his work *Picnic in the Country* (1905) represented a personal protest against the weightiness of tradition-bound guidelines for acceptance. *Picnic in the Country* radiated with energetic slashes of shimmering vermilion, orange, ultramarine, and cobalt; rather than infuse the viewer with dispassionate serenity, the landscape inflamed and unleashed negative passions in those who paused to study it. Its emotional eloquence was lost in the rush to label it as a violently crude piece of work undertaken by a cultural nonconformist.

André Derain, Albert Marquet, and Henri-Charles Manguin were three other artists whose paintings were singled out and vigorously condemned. Derain, later to be recognized as one of the first and most artistically competent of the Fauves, was accused of producing a tasteless piece of work, his entry *Sun Reflected on Water.* The beauty created by the harmony he achieved between subject matter and color was not appreciated. Marquet's sensitively haunting cityscape, *Le Quai des Grands Augustins*, was classified as stridently unrealistic. Manguin's *The Fourteenth of July at Saint-Tropez* was rejected as artistically primitive and garish. Overlooked was his ability to blend, as Paul Cézanne was able to do, blues with reds, oranges, and greens.

The public and art critics found little of artistic value in the paintings that Matisse and his cohorts exhibited at the 1905 Salon d'Automne. Collectively labeled barbaric, the various works were subjected to detailed criticism. What was particularly noticeable in them was the brilliance of color, vigorous brushwork, similarity in subject matter, and outlining of objects. In a review of the exhibit in the November 4, 1905, issue of *L'Illustration*, a Paris newspaper, art critic Louis Vauxcelles referred to the painters as *Les Fauves*, or the wild beasts, a title that was adopted to identify the artists and the movement they invoked. Shortly thereafter, Vauxcelles identified Matisse as "Fauve-in-chief" and his cohorts as Donatellos among the Fauves.

The young Fauve painters did not consider themselves to be members of a group. Their association, in fact, was short-lived, unlike the Impressionists, and they did not publish a manifesto as did their contemporaries in Germany who were in the process of establishing Die Brücke. Many had met at the École des Beaux-Arts, where director Gustave Moreau, a Symbolist, had attempted to alter the staid and tradition-laden policy of the school and encouraged their artistic innovativeness. He introduced his students to sound techniques, such as draftsmanship, but he also encouraged their individuality and exposed them to the creative talents of contemporary artists.

One of the significant painters they met and listened to was Matisse. Older than the other students, Matisse rejected many of the norms of Mediterranean classicism and experimented with expressionism and the use of color to record reality. He saw in the work of Vincent van Gogh and Paul Gauguin artistic elements that could lead to a new direction in painting. What he constructed was an abstraction and synthesis of Gauguin's bolder color usage and van Gogh's emotional rhythmic linear concepts. Paul Cézanne's skillful use of color also did not escape his attention. Matisse's paintings, especially *Open Window, Collioure* (1905) and *Woman with the Hat*, served as models from the pre-Fauve to Fauve stages of the movement. Perhaps of all Matisse's works, it was his canvas *Joy of Life* (1905-1906), one of the 5,552 paintings exhibited at the 1906 Salon des Indépendants, that established his position as Fauve-in-chief.

Impact of Event

The many and confusing forces of the age in which Matisse and the other Fauves lived produced in them similar patterns of thought that led to an amazing commonality of responses. Each, largely independent of the others, sought to express a view of the world by the utilization of intense color and certain types of brush strokes. Sometimes referred to as the masters of tomorrow, Matisse, Derain, and the other Fauves, which now included Othon Friesz, Raoul Dufy, and Georges Braque, rebelled against the artistic parameters established by the more conservative academic art centers, but they did not attempt to disassociate themselves from the era in which they lived. None of them escaped from (nor did they desire to) the impact of the components of thought that infused their world with a heady energy and optimism. Like many of their cohorts in other fields, most notably literature, they wanted to express the richness of *la belle époque*, with its emphasis on pleasure, nature, brotherhood, and analysis of traditional ideas and concepts. Cardinal to their thought and thus to their work was their unswerving belief that humankind could grasp reality and the intricacies of its nature. They believed that they could play a role in determining the reality of the next moment in time. Although the initial reaction to their efforts was shock and outrage, they quickly won favor with the public and even critics, who perceived the meaning of Fauvism to be more than glaring colors violently brushed onto canvases. Fauve artists spoke in visual form of the aspirations of modern humankind.

The Fauve artistic expression was shaped by two other forces that had entered the world of European thought and culture by the end of the nineteenth century. The influence of African masks, as well as other objects of art often referred to as primitive works, captured the attention of Vlaminck and, shortly thereafter, Derain and Matisse. The three European painters saw in the African carvings elements that differed greatly from the form and content of traditional European art. Their investigation of African artifacts sparked in them a desire to go beyond the boundaries of European artistic legacies. The subtle and dramatic naturalism constructed in the masks by distorting the human body and at the time creating color and structural

harmonies could not be ignored. African masks, projecting a sense of mass and presence, intrigued them.

The other force that served to fuel the minds and actions of the Fauves stemmed from the discipline of psychology, especially the psychology of perception. Academicians had demonstrated by the end of the nineteenth century that humans were emotionally affected by color and structure, including color contrasts and spacing between colors. Studies of the psychology of perception were familiar to many artists; those who did not read the academic writings acquired the information, in whole or in part, from their colleagues. Such information influenced the work of the expressionists as well as many of the Fauves.

The Fauves charged themselves with the artistic task of recording on canvas the immediate emotional response to a setting, an object, or a person. The techniques they employed included use of color contrast, linear elements, and drawn elliptical and color-produced lines. What particularly distinguished the Fauve painters was their rejection of such techniques as chiaroscuro, modeling, and classical perspective. Cardinal to their work and central to their need to express reality was their use of pure color, the central feature of all their efforts. They utilized pure colors in ways very rarely used by prior painters. Pure color was energetically and boldly brushed onto the canvas to create brilliant broad expanses or what appeared to be color-infused flattened areas. Hot, blazing colors—reds, oranges, and yellows—were accented by cool colors such as greens, violets, and blues. They used purple or red for shadows. Their washes also radiated with the purity of the colors they selected. Their pallets exploded into a harmony of sensations produced by the placement of color pigments.

By 1906, a change in style was undertaken, especially by Matisse and Derain. The Fauves returned to a more precise draftsmanship, as illustrated in the use of marked contours, decorative symbols, subjective distortions, and subtle but masterfully and intriguingly executed arabesques. Matisse and Derain also began to experiment once again with color usage. Purity of color was not negated, but use was made of half-tones, shades of gray, and ocher.

Just as quickly as Fauvism surfaced in France, it began to wane. By 1907, the Fauves began to display their individuality within the movement. The artists who were instrumental in producing the movement moved on, but many others, some less talented, attempted to capture Fauvism forever in artistic law. Matisse and his cohorts made no attempt to devise a permanent system of expression, nor did they desire to establish artistic dogmas that would live on. Painting, as a visual representation of reality, they believed to be constantly evolving. Painters should distill from a style only those elements that could be used in the search for ways to express a continually changing reality.

Many European artists experimented with Fauvism on their way to other forms of expression, such as cubism. Fauvism thus gained attention and continued as a style. German and Eastern European artists such as Wassily Kandinsky, Alexej von Jawlensky, August Macke, Franz Marc, Gabriele Munter, and František Kupka entered

the movement. In 1913, duplicating the artistic effort of the French, the Germans created their own exhibition of Fauve and expressionist paintings. What had begun in France in 1905 as an artistic revolt against traditional norms and values led to the establishment of a movement out of which the varied expressions of modern art evolved.

Bibliography

Arnason, H. H. *History of Modern Art: Painting, Sculpture, Architecture.* New York: Harry N. Abrams, 1968. Although few pages are devoted specifically to Fauvism, the movement is set within the context of late nineteenth and early twentieth century art. Numerous plates, some in color, with discussion of individual works.

Diehl, Gaston. *The Fauves.* New York: Harry N. Abrams, 1975. An insightful, factual, and stylistic history of Fauvism. The varied forces that gave rise to Fauvism are discussed. Short biographical sketches of the major Fauve artists are included, as well as color plates of their drawings, watercolors, and prints.

Lynton, Norbert. *The Story of Modern Art.* Ithaca, N.Y.: Cornell University Press, 1980. An exceedingly stylistic study by an art historian who describes the many forces that gave rise to Fauvism and its place in the context of the development of modern art. The text is enriched by more than three hundred illustrations, many in color.

Muller, Joseph-Emile, and Ramon Tio Bellido. *A Century of Modern Painting.* New York: Universe Books, 1986. Fauvism is assessed in the context of the art heritage of Europe. Offers a technically clear description of the components of the Fauve style. Illustrated.

Zelanski, Paul, and Mary Pat Fisher. *The Art of Seeing.* Englewood Cliffs, N.J.: Prentice-Hall, 1988. Presents concise but insightful account of Fauvism. Illustrated. Glossary of terms and artistic movements included.

_____. *Color.* Englewood Cliffs, N.J.: Prentice-Hall, 1989. Underscores various intellectual approaches, such as scientific, aesthetic, and psychological, to understanding the use and effects of color. Comments by various artists on use of color are informative and interesting. A few of the paintings of the Fauves are used as illustrations.

Loretta E. Zimmerman

Cross-References

Avant-Garde Artists in Dresden Form Die Brücke (1905), p. 134; Artists Find Inspiration in African Tribal Art (1906), p. 156; The Salon d'Automne Rejects Braque's Cubist Works (1908), p. 204; Der Blaue Reiter Abandons Representation in Art (1911), p. 275; Kandinsky Publishes His Views on Abstraction in Art (1912), p. 320; Avant-Garde Art in the Armory Show Shocks American Viewers (1913), p. 361.

REINHARDT BECOMES DIRECTOR
OF THE DEUTSCHES THEATER

Category of event: Theater
Time: October-November, 1905
Locale: Berlin, Germany

By taking over Berlin's major theater from Adolph L'Arronge, the young director Max Reinhardt was poised to become Germany's foremost theater artist and entrepreneur

Principal personages:
 MAX REINHARDT (MAX GOLDMANN, 1873-1943), an Austrian-born actor and director
 ADOLPH L'ARRONGE (1838-1908), the theatrical author and producer who sold the Deutsches Theater to Reinhardt
 OTTO BRAHM (1856-1912), a critic, director, and proponent of naturalism

Summary of Event

The Deutsches Theater had long been the most prestigious commercial theater in Berlin. Owned by impresario Adolph L'Arronge, it had from 1894 on, under the direction of Otto Brahm, become Germany's aesthetically and socially most progressive theatrical venue, championing Henrik Ibsen and naturalist playwrights such as Gerhart Hauptmann. In 1904, L'Arronge refused to extend Brahm's contract, understanding with an infallible instinct that naturalism was giving way to a new, lusher Impressionist style associated closely with the then thirty-two-year-old director Max Reinhardt.

Reinhardt had studied acting in his native Vienna before he joined Brahm's theater in 1894. There he became steeped in Brahm's ensemble style and gained an understanding of the literary qualities of the drama. Brahm's vision was too confining, however, and in 1901, Reinhardt first branched out with a satirical cabaret called Schall und Rauch ("sound and smoke"), which in 1902 mutated into the Kleines Theater. In 1903, he found backers to buy the Neues Theater, where he began a string of successful productions as a director with Maurice Maeterlinck's *Pelléas and Mélisande* (1892).

In 1905, L'Arronge, out of commercial as much as artistic considerations, offered Reinhardt the direction of the Deutsches Theater with a long-term lease. When it became clear to L'Arronge that Reinhardt planned major renovations to update the aging theater (which was constructed in 1883) and to incorporate state-of-the-art scene technology such as a revolving stage and a cyclorama, the producer agreed to sell the property to Reinhardt. L'Arronge's condition was that Reinhardt give up his two other venues, so as to prevent the accumulation of a theater monopoly. In fact, the acquisition of the Deutsches Theater was the first step for Reinhardt in the crea-

tion of a commercial theater empire that dominated Berlin until 1932.

Although Reinhardt signed the purchase contracts on November 24, his first production at his new theater occurred on October 19, 1905. The inaugural performance, a production of a play by the Romantic dramatist Heinrich von Kleist, was not well received. Reinhardt's first great commercial success at the Deutsches Theater came later that year with a production of William Shakespeare's *The Merchant of Venice* (c. 1596) that enjoyed more than two hundred performances. Although he had been a director for only four years, by the time he took over the Deutsches Theater, Reinhardt was hailed as the next great German visionary of the theater. His reputation was by now such that audiences flocked to his productions (the auditorium had been duly enlarged as well), and he could afford to stage only five new plays during his first season. His overwhelming success as an artist was complemented by an acute business sense and the good fortune of having a younger brother, Edmund, to take care of the day-to-day running of affairs.

The remodeling of the Deutsches Theater with the addition of a revolving stage more than fifty feet across and a sophisticated lighting system bore witness to Reinhardt's innovative aesthetic concepts, in particular his insistence on plasticity instead of scene painting. Reinhardt's ideal at the time was to use the revolving stage both as an efficient means of changing scenery and as a dramaturgical tool. His aversion to painted scenery had been kindled by an exposure to the new theorists of scene design; in particular, he had been influenced by the writings of Adolphe Appia and the bold scenic experiments of Edward Gordon Craig and Georg Fuchs.

Earlier in 1905, still at his Neues Theater, Reinhardt had directed a celebrated production of William Shakespeare's *A Midsummer Night's Dream* (c. 1595) set entirely on a revolving stage. (The play became a signature piece for Reinhardt; he directed it twelve times on the stage and finally on film for Warner Bros. in 1935.) This production, which played more than three hundred times and was revived in 1913, featured a fully articulated forest set that virtually defined the early, neo-Romantic Reinhardt style: lavishly poetic and illusionistic, with a kind of magical playfulness that fused realistic and symbolistic elements.

Earlier in October, 1905, Reinhardt had opened an acting school that was physically and administratively connected to the Deutsches Theater. Himself an actor, Reinhardt always emphasized the centrality of the actor to his theater ("It is to the actor and to no one else that the theater belongs") and was acknowledged as a great teacher. At the Deutsches Theater, he succeeded in assembling Germany's best performers, including Max Pallenberg and Albert Bassermann, and in training a new generation that dominated the German stage for years: Tilla Durieux, Gertrud Eysoldt, Friedrich Kayssler, Alexander Moissi, Paul Wegener, and many others studied with him. To be a "Reinhardt actor" became an honor.

In spite of the alterations, the Deutsches Theater was a conventional proscenium stage theater that seated an audience of approximately one thousand. Although it remained the center of his growing empire (which sometimes, for its technical sophistication and sheer size, was dubbed the "Reinhardt Machine"), Reinhardt was

soon unhappy with its limitations. In 1906, he opened an adjacent three-hundred-seat chamber theater, the Kammerspiele, a concept that proved trendsetting in Europe (inspiring, for example, the creation of August Strindberg's Intimate Theater in Stockholm). In 1919, he finally realized his dream of building a "Theater of Five Thousand" with his gigantic Grosses Schauspielhaus.

After fifteen years at the helm, in 1920 Reinhardt turned over the direction of his Berlin theaters to his longtime dramaturge Felix Hollaender in order to concentrate his activities on Salzburg, Austria. Even though he regained control of the theaters nine years later (only to surrender them again to the Nazis in 1933), the formative Reinhardt era in Berlin had come to a close.

Impact of Event

The acquisition of the Deutsches Theater laid the foundation for Max Reinhardt's considerable influence upon the modern theater. Even during some of the hardest economic times, he demonstrated that challenging literary theater could exist and thrive within a commercial framework. Reinhardt took pride in never having accepted subsidies, and even throughout wartime and inflation, he never compromised his artistic standards.

Reinhardt's literary taste was eclectic, and he brought to the stage of the Deutsches Theater plays of every era and every nation, creating a veritable world theater. From the first, he provided an outlet for young and at times risqué work such as Frank Wedekind's tragicomedies of sex or Oscar Wilde's *Salomé* (1893), and he developed an audience for Maeterlinck and Strindberg in Germany. His collaboration with the neo-Romantic Austrian dramatist Hugo von Hofmannsthal was perhaps his most symbiotic and enduring.

He attended equally to the classical repertoire and to the writers of the avant-garde. In the 1913-1914 season, he directed a highly acclaimed cycle of ten Shakespearean plays (the cycle idea has since been imitated many times, for example in the 1980's by Joseph Papp in New York and Adriane Mnouchkine in France). Yet no achievement at the Deutsches Theater was more influential than Reinhardt's productions of a number of new expressionist plays under the heading "Das junge Deutschland" ("Young Germany") between 1917 and 1920. These plays, many mixing angry and feverish condemnations of war with ecstatic cries for human brotherhood, gave rise to a new, stark visual style to which Reinhardt's scenographer Ernst Stern and his actors proved more than equal. Not only was the Deutsches Theater instrumental in the breakthrough of expressionism as a theatrical form, but according to film historian Lotte Eisner (*The Haunted Screen*, 1952), the German silent films of the 1920's, from *The Cabinet of Dr. Caligari* (1920) to *Metropolis* (1927), would have been unthinkable without these Reinhardt productions.

Although Reinhardt largely followed his own instincts in matters of programming, his theaters employed an army of dramaturges (literary managers), the most important of whom were Felix Hollaender and Arthur Kahane at the Deutsches Theater. That the institution of the dramaturge has become virtually standard in the European

theater today is a consequence of Reinhardt's respect for the literary text. Ironically, some of Reinhardt's most severe later critics and directorial opponents, such as Bertolt Brecht and Erwin Piscator, briefly worked as dramaturges for him in the 1920's.

In his restless search for new venues, Reinhardt might justifiably be called a pioneer of environmental theater. In effect, he attempted to find a suitable spatial arrangement for every particular play he directed. Since the Deutsches Theater was conventionally configured, the more intimate and poetic plays were staged in the Kammerspiele, where every small gesture and whisper was perceptible. The productions calling for grand tableaux, great pathos, and surging masses, such as Greek tragedies or historical spectacles, occupied the Grosses Schauspielhaus.

Reinhardt also transcended the theater space altogether, first by letting his actors spill into the auditorium in a 1911 production of *Oedipus Rex*, then by transposing his plays into congenial settings. For example, he turned London's Olympia exhibition hall into a giant Gothic cathedral for a 1911 presentation of the pantomime *The Miracle* by Karl Vollmoeller, staged Hofmannsthal's *Everyman* adaptation in front of the Salzburg cathedral in 1920, had Johann Wolfgang von Goethe's *Faust* take place on a life-sized city set (the "Fauststadt") built into an open-air riding arena in 1933, and realized Shakespeare's *The Merchant of Venice* on a Venetian square in 1934. While such experiments were then not widely imitated, this amplification of theatrical possibilities set precedents that found their fulfillment especially in the avant-garde theater movements of the 1960's and 1970's.

Undoubtedly, Reinhardt's greatest influence has been on the idea of directing in the twentieth century. He is perceived by many as the avatar of the age of the director. Together with the Russian Konstantin Stanislavsky—whose disposition was quite different—Reinhardt set the guidelines for the profession. Though not the first director of international stature, Reinhardt became a truly European director (his productions, particularly the famed *Miracle*, traveled abroad frequently). He finally even exerted considerable influence upon the theater scene in America, both before and after his emigration to the United States in 1938. Among the theater artists directly inspired by Reinhardt were Harley Granville-Barker in England and Robert Edmond Jones and Lee Simonson in America. It is noteworthy that prior to Reinhardt's time, the name of a play's director was rarely even mentioned in theater reviews.

The complete professionalization of the directorial office is largely Reinhardt's achievement. He marks the transition from the nineteenth century "stage manager," who was concerned with little more than the technical problems of the production, to the modern day "régisseur," who exercises total artistic control; in that sense, a direct line can be construed between him and more recent directors such as Peter Brook, Peter Stein, and Peter Sellars. Reinhardt's productions were meticulously prepared and planned out. Before rehearsals began, he created a prompt book in which he set down every music and light cue, indicated every tone of voice and gesture for a speech, and sketched ground plans marking entrances and exits. These prompt books (many of which are extant) were often worked over several times and represent an inventory of Reinhardt's ideas about the play as well as a kind of "score"

of atmospheric, psychological, and technical details for its staging.

Few directors have modeled themselves explicitly on Reinhardt, who proclaimed no methodology of his own. His strength and authority as a director seemed to flow from his personality, not from theories. In rehearsal, the shy Reinhardt was often silent, but actors attested his catalytic ability to summon from them depths of feeling of which they were themselves unaware. What emerges from his scattered writings is a high regard for the theater as a place of almost religious importance in which humans are given the necessary freedom to play.

During the years at the Deutsches Theater, Reinhardt was not without his critics. The sumptuousness and unashamed theatricality of his often baroque spectacles and his distaste for politics did not sit well with those who saw the theater as a medium for ideological agitation and activism. Bertolt Brecht's famous condemnation of the "culinary" bourgeois theater and his development of an alternative, "epic" form were clearly provoked by his exposure to Reinhardt fare. Yet even Reinhardt's critics maintained a core of respect for the man who was dubbed "the great magician" of the theater.

Bibliography

Braun, Edward. "Max Reinhardt in Germany and Austria." In *The Director and the Stage: From Naturalism to Grotowski*. New York: Holmes & Meier, 1982. Braun gives Reinhardt shorter shrift than he deserves in this chapter, but taken in the context of the whole book, the essay manages to position him within the history of the profession. Recommended strictly as introductory reading.

Garten, Hugh F. *Modern German Drama*. London: Methuen, 1959. Discusses Reinhardt's work in the context of German neo-Romanticism. Gives information about the playwrights with whom Reinhardt worked.

Reinhardt, Gottfried. *The Genuis: A Memoir of Max Reinhardt*. New York: Alfred A. Knopf, 1979. Rather chatty but very readable narrative of Reinhardt's life by his son Gottfried, himself a theater and film director. Gives personal insight into Reinhardt's later career and life (Gottfried was not born until 1913), simultaneously humanizing the director and contributing to his myth.

Sayler, Oliver M., ed. *Max Reinhardt and His Theater*. New York: Brentano's, 1924. Though dated by virtue of having been published almost twenty years before Reinhardt's death, Sayler's book compiles translations of important early essays and materials on Reinhardt, mostly written by collaborators of the director and sympathetic critics. Coinciding with Reinhardt's sensational 1924 American tour of the pantomime *The Miracle*, the book was later (1926) put out in an edition that included the entire prompt book and color plates of scene and costume designs.

Styan, J. L. *Max Reinhardt*. Cambridge, England: Cambridge University Press, 1982. Styan's account is the first book-length study of Reinhardt in English. In 127 text pages, it provides a well-researched and useful overview of Reinhardt's many theatrical activities, but its brevity precludes it from doing Reinhardt's work full justice. The structure is thematic rather than chronological and touches on the

major productions. Well illustrated. Contains a complete list of Reinhardt productions.

Ralf Erik Remshardt

Cross-References

Stanislavsky Helps to Establish the Moscow Art Theater (1897), p. 1; Strauss's *Salome* Shocks Audiences (1905), p. 151; *The Ghost Sonata* Influences Modern Theater and Drama (1908), p. 199; Diaghilev's Ballets Russes Astounds Paris (1909), p. 241; *The Cabinet of Dr. Caligari* Opens in Berlin (1920), p. 486; Brecht and Weill Collaborate on *Mahagonny Songspiel* (1927), p. 724.

STRAUSS'S *SALOME* SHOCKS AUDIENCES

Category of event: Music
Time: December 9, 1905
Locale: Dresden, Germany

When Richard Strauss's one-act musical drama Salome *premiered in Dresden, it shocked many with its eroticism and took music beyond conventional tonality*

Principal personages:
> RICHARD STRAUSS (1864-1949), a composer who revitalized German opera in the first decade of the twentieth century with his two most progressive operas, *Salome* and *Elektra*
> OSCAR WILDE (1854-1900), an Irish-English playwright who scandalized England with his decadent play *Salomé*
> ERNST VON SCHUCH (1846-1914), the conductor of the Dresden world premiere of the opera *Salome*
> MARIE WITTICH, the soprano who sang the title role at the world premiere of *Salome*

Summary of Event

Richard Strauss firmly planted opera in the new century with *Salome* (1905), the third of his fifteen operas, and, in a way, the world of opera has still not recovered from the shock. Strauss opened the door to the explicit depiction of morbid psychological states, probing the dark recesses of the human mind through music. Determined to conquer the operatic stage with his first opera of the new century, Strauss boldly chose Oscar Wilde's play *Salomé* (1893) as the text with which to make his mark; in the process, he created a wholly new type of opera, drawing on the programmatic elements of his tone poems such as *Don Juan* (1889) and *Til Eulenspiegels lustige Streiche* (1894-1895) and on the Wagnerian system of leading motives, by which characters announced themselves by distinctive musical themes. To these, he added a quite un-Wagnerian urgency and speed.

Although there had already been successful operas based on biblical subjects, there had not been so provocative a setting of so audacious a topic as Salome's dance for King Herod and the subsequent beheading of John the Baptist. Strauss chose the controversial drama by Oscar Wilde, which conspicuously linked female sexuality and death. Wilde's play was perceived as immoral because of its rendering of a tale of shocking depravity in symbolist poetry, in which the cool surface of events only hinted at appalling emotions and behavior. Strauss ignored the artificial beauty of the poetry in favor of a full-blooded musical depiction of the shocking behavior at the court of King Herod. Wilde's play came to Strauss's attention some time after its German premiere in Breslau in 1901; the Breslau performance was followed by successful performances in Berlin. Strauss adapted Hedwig Lachmann's German trans-

lation (minus roughly forty percent of Wilde's original text).

At its most basic level, the opera concerns the gruesome results of the thwarted will of a spoiled adolescent female who is denied the object of her sexual desire. In the corrupt court of her stepfather, King Herod, where spiritual values are seen as incomprehensible, Salome is accustomed to the instant gratification of materialistic desires. Overwhelmed with desire for the visionary prophet, Jokanaan (the biblical John the Baptist), the spoiled Salome demands his head on a silver platter as her reward for performing a salacious dance for her lustful stepfather. Although Jokanaan rejected her in life, after his death she is determined to kiss his mouth. Horrified by her behavior, Herod calls for her death at the opera's conclusion.

Herod is in some ways the most provocative character in the opera; he is simultaneously a voyeur, aesthete, overattentive stepfather, indecisive leader, and stern man of action. In his famous cry, "Salome, tanz für mich" ("Salome, dance for me"), he speaks for the audience as well as himself in demanding instant erotic visual gratification; his mistake is in promising Salome anything she wants in exchange for the dance. Salome, who in the biblical accounts is said merely to have danced to please her mother, is rendered with deep psychological complexity. She is by turns bored, sulking, fascinated to the point of obsession, and appallingly vindictive. Strauss later told one soprano that, to play the part correctly, she should impersonate a sixteen-year-old with the voice of Richard Wagner's character Isolde from the opera *Tristan und Isolde* (1859). None of Herod's vulgarly materialistic rewards for her dancing (such as jewels and peacocks) can dissuade her from her goal, and she eventually makes seven separate demands for the head of the prophet, based on two musical themes.

The twin climaxes of the opera are Salome's notorious dance of the seven veils, in which exhibitionistic actions take the place of words, and her long concluding aria, known as the "Schlussgesang" (final song), which reflects Strauss's lifelong emphasis, as an opera composer, on the power of the female voice. The dance consists of a variety of the opera's musical motives and constitutes the work's only attempt at "orientalism," thus satisfying the period's fondness for exotic operatic ballets, and it also serves as the opera's prurient climax. The "Schlussgesang" allows Salome to explain in words her fascination with the body, and now the head, of Jokanaan. Salome assumes wrongly that "if you had seen me, you would have loved me," and she asserts the primacy of the erotic and materialistic over the spiritual. Her key words are actually the one statement upon which she and the Christian prophet might agree: "The glorious secret of love is mightier than is the secret of death."

Impact of Event

The score of *Salome* is one of the most dazzling and distinctive achievements of twentieth century music, a fact even the harshest detractors of Strauss admit. Critic Joseph Kerman has noted that "the whole is bound together with the greatest skill in a form comparable to that of the symphonic poem." Strauss's score demonstrated the ability of the operatic theater to achieve the psychological depth of the late nine-

teenth century novel and the case histories of Sigmund Freud.

The score nervously shuttles between the keys of C-sharp and C. The opera opens with a chromatic scale for the clarinet in C-sharp minor but within two measures switches to the major mode; Salome sings her long concluding monologue largely in C-sharp, but Herod's frightened condemnation of Salome and his call for her violent death are barked out in C minor. Jokanaan, with a simpler musical language that is strikingly different from that of the corrupt Herodians, stays close to his chosen key of C major. Strauss uses short, urgent motives to depict the seething psychological disturbances about to boil over in such characters as Salome and Herod. When Strauss played through the score of the opera for his aging father, the latter reportedly complained, "Oh God, what nervous music. It is exactly as if one had one's trousers full of May bugs."

The true climax of the opera coincides with Salome's successful kiss on the mouth of the severed head—a moment rendered by what has often been called the most appalling chord in all opera, a gruesomely dissonant explosion. The sound superbly renders the audience's sense of horror at Salome's misguided obsession, and it also hints at the main impression that audiences carry away from the opera: that there is a coldness, a clinical detachment, and a lack of empathy at the heart of this fascinating but oddly soulless work. This is not to deny the admiring words of one of Strauss's best critics, William Mann, who in *The Operas of Richard Strauss* (1966) commented that "*Salome* is the most brilliant and far-reaching of all Strauss's works."

Strauss began drafting the score for the opera in September, 1904, and finished the full orchestral score in June, 1905. Ernst von Schuch conducted the world premiere of the opera in Dresden on December 9, 1905. Marie Wittich, who created the role of Salome, allowed a ballerina to perform the dance of the seven veils, although at later performances she undertook the dance herself. *Salome* reached Berlin on December 5, 1906, and had its first performance outside Germany in Turin (in Italian) on December 22, 1906.

Capitalizing on the already scandalous reputation of the opera, Heinrich Conreid, the general manager of the Metropolitan Opera in New York, staged the first American performance of *Salome* as part of his own annual benefit, at doubled prices, on January 22, 1907. The outcry of the New York press, typified by the complaint of critic of the *New York Sun* that "the whole story wallows in lust, lewdness, bestial appetites, and abnormal carnality," limited the first American production to a single performance. No further Strauss operas were heard in New York for seven years, and *Salome* itself was not readmitted to the Metropolitan Opera until 1934.

The original protests against the opera were directed against its alleged tampering with the sacred biblical text, its unabashed eroticism, and the score's uninhibited expressionistic spelling out of every lurid detail of the disturbing story by advanced and dissonant musical means. There are now different complaints about the opera. Feminists now object to the opera on the grounds that it exploits and exposes the female body, and indeed sopranos with the required strong voice and lithe bodies now routinely utilize partial or total nudity for the dance of the seven veils. Au-

diences may well ask whether psychological enlightenment or mere titillation is the object of current productions of *Salome*; what seemed shocking and perhaps blasphemous to the initial audiences may seem exploitative, cold, and cynical to a modern audience.

Strauss's worldwide success with *Salome* and *Elektra* (1909) put him in the vanguard of Western music. With his decision to consolidate his style into a voluptuous but markedly more conservative form in his subsequent operas *Der Rosenkavalier* (1911) and *Ariadne auf Naxos* (1912), Strauss quickly surrendered his claim to musical progressivism to such younger composers as Arnold Schoenberg, Béla Bartók, and Igor Stravinsky. The far greater scandal attending Stravinsky's *Le Sacre du Printemps* (1913) allowed audiences to forget how richly Strauss had developed the vocabulary of the late Romantic style. If Strauss slammed the door shut on the leisurely operatic structures of the nineteenth century such as French grand opera and Wagnerian music drama, he invited further explorations of the psychopathology of the human mind such as Alban Berg's *Wozzeck* (1925) and *Lulu* (1937). Twentieth century operatic composers owe an enormous debt to Strauss, and particularly to *Salome*, for encouraging opera to explore through music the darker corners of the human experience.

Bibliography

Conrad, Peter. *Romantic Opera and Literary Form.* Berkeley: University of California Press, 1977. Provocatively uses *Salome* to support the general thesis that, rather than consolidating and merging words and music, opera demonstrates their antagonism.

Kerman, Joseph. *Opera as Drama.* New York: Alfred A. Knopf, 1956. Kerman's zestful dismissals of any number of operatic favorites still make for enjoyable reading, even when his judgments are amusingly wrongheaded. An example: "No less insensitive than Puccini, Strauss adds an intellectual pretentiousness to Puccini's more innocent kinds."

Mann, William. *Richard Strauss: A Critical Study of the Operas.* New York: Oxford University Press, 1964. The best one-volume analysis of each of Strauss's fifteen operas, written with genuine respect and affection for Strauss.

Osborne, Charles. *The Complete Operas of Richard Strauss.* London: Michael O'Mara Books, 1988. Chatty and diffuse; in no way supersedes the work of Mann, which is consistently more insightful.

Puffett, Derreck, ed. *Richard Strauss: Salome.* Cambridge, England: Cambridge University Press, 1989. Detailed technical analysis of the opera from a musicologist's viewpoint.

Schmidgall, Gary. *Literature as Opera.* New York: Oxford University Press, 1977. Includes a fine essay on the transformation of Wilde's decadent symbolist drama into Strauss's expressionistic shocker.

Byron Nelson

Cross-References

Mahler Revamps the Vienna Court Opera (1897), p. 7; Freud Inaugurates a Fascination with the Unconscious (1899), p. 19; *The Rite of Spring* Stuns Audiences (1913), p. 373; Berg's *Wozzeck* Premieres in Berlin (1925), p. 680; Berg's *Lulu* Opens in Zurich (1937), p. 1078.

ARTISTS FIND INSPIRATION IN AFRICAN TRIBAL ART

Category of event: Art
Time: 1906-1907
Locale: Paris, France

European artists in search of new means of expression discovered them in African tribal art, altering the course of twentieth century painting and sculpture

Principal personages:

PABLO PICASSO (1881-1973), a Spanish artist whose manipulation of form made him the most influential painter of the century

HENRI MATISSE (1869-1954), a French artist who integrated important elements of African tribal art into his work

ANDRÉ DERAIN (1880-1954), a member of the Fauves ("wild beasts") who helped to introduce fellow painters to African tribal art

MAURICE DE VLAMINCK (1876-1958), a member of the Fauves who helped to introduce fellow painters to African tribal art

Summary of Event

Several collections of tribal art had been established in Paris during the latter half of the nineteenth century. France owned extensive colonies in Africa and Oceania, and French expeditions had returned with statuettes, masks, headdresses, musical instruments, and other artifacts. These pieces were seen as indeed "primitive," that is, crude in conception and execution. In turn, their apparent savagery illustrated, at least to the satisfaction of most European viewers, the savagery of the groups producing them.

By the early twentieth century, examples of tribal art had thus been accessible to the public for several decades. Three factors contributed to their "discovery" about 1906 by avant-garde painters in Paris. First, dealers in antiquities and curiosities had begun featuring tribal art in their display cases and windows—in other words, at the street level, where their aesthetic qualities were more striking than in poorly arranged documentary displays in museums.

A second factor was the change in public attitudes toward colonization. By 1905, evidence of incredible brutality on the part of the French and the Belgians in central Africa had become public. Newspapers condemned the atrocities, and politically radical artists such as Pablo Picasso, Kees van Dongen, and František Kupka—some of whom drew political cartoons—joined in the attack. As a result, collecting and studying African art became a means of establishing solidarity with the oppressed.

The third and perhaps most important factor was the situation of art itself at the beginning of the century. It was felt that the movement known as Impressionism, which attempted to reproduce the actual experience of seeing, had exhausted the

possibilities of realistic painting. In this context, a retrospective exhibition of works by French painter Paul Gauguin in 1906 came at just the right moment. Gauguin had visited Tahiti in 1891 and had eventually settled and died in the nearby Marquesas Islands. The exhibition featured canvases that seemed barbaric in their bright colors and subject matter: idealized native scenes, "pagan" idols, and other exotic themes. Gauguin had rejected purely realistic art, and artists in search of new means of expression found inspiration in his work. Gauguin's insight into non-European cultures has been questioned, but he paved the way for the appreciation of African and Oceanic art by his younger colleagues.

Accounts of how European artists discovered and began acquiring African sculpture differ. French painter Henri Matisse recounted that he bought a piece from Emile Heymann's shop in Paris and that he subsequently showed it to his new acquaintance from Spain, Pablo Picasso, in 1906. The piece has since been identified with some certainty as a Vili statuette from what would become the People's Republic of the Congo. The figure, of a seated man impudently sticking out his tongue, appears in an unfinished oil painting by Matisse, *Still Life with African Sculpture*, dating from 1906 or 1907.

Another French painter, Maurice de Vlaminck, told a different story. He noticed, he says, pieces of African tribal sculpture in a bar, and he bought them for the price of a round or two of drinks. The exact date is hard to establish, and may have been anywhere from 1903 to 1906. Later, a friend gave him several more pieces, one of which, a wooden Fang mask from what would become Gabon, he sold to fellow artist André Derain. According to this story, it was this mask, which was on display in Derain's Paris studio, that constituted Matisse and Picasso's introduction to African tribal art.

Picasso himself was guarded in explaining his art and its inspiration. He once claimed complete ignorance of African art at this stage of his life, but he later stated that he had studied examples at the Musée d'Ethnographie du Trocadéro (rechristened the Musée de l'Homme) in Paris in 1907. In any case, he began buying pieces on visits to the flea market, eventually assembling a large collection that he maintained all of his life.

The influence of tribal art was far greater in some cases than others. Vlaminck and Derain seem to have found little more than confirmation of their own attitudes. As members of the Fauve movement, they painted in bright, even harsh colors, bypassing the intellect of the viewer to make a direct emotional appeal. They felt that African sculpture operated in the same fashion.

Matisse's work shows a more direct influence. In its apparent crudeness and emphasis on breasts and buttocks, his small sculpture *La Vie* of 1906 clearly recalls African models. The same influence is apparent in a larger sculpture, *Reclining Nude I* (1907), and a major painting of the same year, *The Blue Nude*. All these works show a rejection of conventional nineteenth century European standards of beauty and proportion, and they mark a clear advance over his *Still Life with African Sculpture*.

It was only when he came face to face with tribal art, said Picasso, that he realized "what painting was all about." At the time he was a successful if relatively unknown painter, and his study of ancient Spanish and Egyptian sculpture and the work of Gauguin had allowed him to move beyond the somewhat sentimentalized paintings of his Blue and Rose Periods. *Les Demoiselles d'Avignon* (1907), however, marked not only a break with his own past but also a total rejection of the European tradition. This large (almost eight-square-foot) painting of five prostitutes seemed intentionally ugly to those who first saw it. The figures' limbs are distorted and broken into planes. Their faces are as blank as masks, their lozenge-shaped eyes staring past the viewer. The faces of the figure on the left and of the two on the right are literally masklike (although experts disagree over their specific tribal prototypes) and savagely cross-hatched. Long after its recognition as a key work of the twentieth century, *Les Demoiselles d'Avignon* continues to shock.

Impact of Event

So-called primitive art was to have a major influence on Western culture during the twentieth century. As used broadly, the term has referred not only to tribal art but also to the work of children and the insane and to the output of self-taught "naïve" painters. Sometimes even a tendency to extreme simplification has been called primitive. Within this complex of factors, African and Oceanic tribal art made its influence felt widely and early. In addition to the Fauves, Matisse (who exhibited for a time with the Fauves), and Picasso, a number of other artists were affected. The Romanian Constantin Brancusi began to produce African-inspired sculpture about 1913, as did the Italian Amedeo Modigliani, better known today as a painter. Both lived in Paris and so were affected by the same conditions as other Paris-based artists.

Collections of African and Oceanic tribal art were not unique to France. Larger collections had been established in Germany, although that country had been acquiring colonies for a much shorter period of time. These collections were accessible to a major group of German-based artists, Die Brücke ("the bridge"), which had been formed in 1905. Its most important member was Ernst Ludwig Kirchner. For a while, Fauve painter Kees van Dongen and Swiss artist Cuno Amiet, who had been a friend of Gauguin, were also associated with the group. The Fauves were a major influence, as was tribal art. Kirchner was already painting from live black models when he began studying African and Micronesian (North Pacific islander) art at the Dresden Ethnographic Museum in 1910. His work is more harshly colored and far more angular than that of the Fauves, as if he were straining to express the emotional, "primitive," non-European side of his character.

It was through the work of Matisse and particularly Picasso, however, that the tribal art of Africans and other non-European peoples had its most significant impact upon the mainstream of Western painting. Matisse integrated the elements so subtly that they became difficult to identify, especially after his initial burst of interest in 1906 and 1907. Only toward the end of his life did the influence again become

obvious, in a series of "cutouts," highly decorative collages of brightly painted paper. The portfolio of these works he completed in 1947, appropriately called *Jazz* (after the popular black American music form), is the culmination of his career.

Several of Picasso's works from the period of 1907 take the experiment of *Les Demoiselles d'Avignon* a step further, especially two paintings sharing the title *Nude with Raised Arms*. Here the degree of stylization and near-abstraction is marked. Whatever minimal perspective remained in *Les Demoiselles d'Avignon* has vanished. Picasso was on the verge of forging the most revolutionary style of the century, cubism.

This new style was actually the mutual creation of Picasso and his colleagues Georges Braque and Juan Gris; Derain and Matisse took part, but less enthusiastically. In its simplest sense, cubism was a solution to the problem faced by all painters: representing three dimensions (height, width, and depth) on a surface that has only two. As Gauguin had been an influence a few years before, now French painter Paul Cézanne (1839-1906) became an important example. Cézanne had reduced objects and landscapes to their essential geometric components. To perceptive artists such as Picasso, the angularity of African tribal art, with its seemingly violent juxtaposition of stylized features, must have seemed the result of a similar process. To reduce these elements still further to the flat surface of a canvas was to carry the process to its logical conclusion.

Directly or indirectly (through the medium of cubism), tribal art has influenced almost every important European artist of the century. After *Les Demoiselles d'Avignon*, its most important manifestation may have been the 1923 Paris premiere of the ballet *La Création du monde*. This production combined numerous aspects of black culture, some more authentic than others, and capitalized on intense French interest in everything African. The score by Darius Milhaud is generally credited with being the first orchestral use of jazz (although the relationship between jazz and genuine African music has been debated). The scenario by writer and impresario Blaise Cendrars was based on African creation myths. Choreographer and principal dancer Jean Börlin adapted his movements from African models. The costumes and backdrop were designed by Fernand Léger, a painter who had taken part in the cubist movement and who now combined cubist and more obviously tribal elements into one harmonious and awe-inspiring whole.

Léger based many of his designs on illustrations from Marius de Zayas' *African Art: Its Influence on Modern Art* (1916), a pioneering work on the subject. The set featured three tall, free-standing figures representing presiding deities and illustrated the emergence of various stages of life. The costumes were highly stylized and managed to be both expressive and lighthearted. Around them all wound Milhaud's ingratiating, sinuous music.

When European artists discovered African tribal art in 1906 or 1907, they were impressed as much by its psychological aspects (its "magic") as by its aesthetic dimensions. Picasso's shocking *Les Demoiselles d'Avignon* and the lyrical collaborative effort of *La Création du monde* define the far-reaching impact of that discovery.

Bibliography

Bois, Yve-Alain. "Kahnweiler's Lesson." *Representations* 18 (Spring, 1987): 33-68. Discussion of critic and art dealer C. H. Kahnweiler's theory of the relationship between African tribal art and cubism. Kahnweiler had maintained that while African art was important to the development of Picasso and of cubism, its impact upon Picasso's painting *Les Demoiselles d'Avignon* was negligible. For the serious student of art history. Illustrations, substantial notes.

Goldwater, Robert. *Primitivism in Modern Art.* Rev. ed. Cambridge, Mass.: The Belknap Press of Harvard University Press, 1986. The classic study, discussing "primitivism" in all its manifestations. First published in 1938, and revised in 1966; the "enlarged" edition adds two supplementary chapters. Still the best introduction for the general reader. Black-and-white illustrations, detailed notes, "Summary Chronology of Ethnographical Museums and Exhibitions," index.

Le Coat, Gerard G. "*Art Nègre* and *Esprit Moderne* in France (1907-1911)." In *Double Impact: France and Africa in the Age of Imperialism*, edited by G. Wesley Johnson. Westport, Conn.: Greenwood Press, 1985. Examines the "discovery" of African tribal art by artists in Paris and compares the accounts of the various participants. The collection as a whole provides a broad context for the interested student. Maps, some black-and-white illustrations, notes, select bibliography, index.

Leighten, Patricia. "The White Peril and *L'Art nègre*: Picasso, Primitivism, and Anticolonialism." *Art Bulletin* 72 (December, 1990): 609-630. Detailed analysis of the reaction of artists to accounts of atrocities in French and Belgian colonies in Africa. Black-and-white illustrations, including reproductions of newspaper cartoons. Notes, list of frequently cited sources.

Rubin, William, ed. *"Primitivism" in Twentieth Century Art: Affinity of the Tribal and the Modern.* New York: Museum of Modern Art, 1984. A lavish, two-volume treatment for browsers and experts alike. Particularly pertinent chapters include "From Africa" by Jean-Louis Paudrat (on the arrival of African tribal objects in the West), "Matisse and the Fauves" by Jack D. Flam, "Picasso" by William Rubin, "German Expressionism" by Donald E. Gordon, and "Léger: 'The Creation of the World'" by Laura Rosenstock. Heavily illustrated, with many of the illustrations in color. Each chapter carries detailed notes, but there is no overall bibliography or index.

Grove Koger

Cross-References

Heart of Darkness Reveals the Consequences of Imperialism (1902), p. 51; Avant-Garde Artists in Dresden Form Die Brücke (1905), p. 134; Les Fauves Exhibit at the Salon d'Automne (1905), p. 140; *L'Après-midi d'un faune* Causes an Uproar (1912), p. 332; "Les Six" Begin Giving Concerts (1917), p. 435.

BERGSON'S *CREATIVE EVOLUTION* INSPIRES ARTISTS AND THINKERS

Category of event: Literature
Time: 1907
Locale: Paris, France

Bergson addressed the fact that, by the turn of the century, people were already speaking of evolution in a past sense and considering the modern human exempt from its working

Principal personages:
HENRI BERGSON (1859-1941), a French professor of philosophy whose major work on the creativity involved in evolution helped to reshape twentieth century thought
CHARLES DARWIN (1809-1882), the leading proponent of the theory of biological evolution
HERBERT SPENCER (1820-1903), an English philosopher whose mechanistic approach to evolution and its progress required critical modification by Bergson
WILLIAM JAMES (1842-1910), an American philosopher influential in making Bergson known to the English-speaking world
ÉDOUARD LE ROY (1870-1954), the author of one of the first major sympathetic analyses of Bergson's work
ARTHUR MITCHELL (1872-1953), an American professor, the authorized translator of Bergson's most influential work
THOMAS ERNEST HULME (1883-1917), an English literary critic and poet and one of Bergson's authorized translators

Summary of Event

Henri Bergson was born in Paris on October 18, 1859—the year Charles Darwin's *On the Origin of the Species* was published. Bergson was of Jewish ancestry; his father was a talented Polish musician, and his mother was a cultured Anglo-Irish woman. His education was typically Parisian French, beginning at the Lycée Fontane (subsequently renamed the Lycée Condorcet). His early education was divided between the sciences and the humanities, and he received a prize for his mathematics studies in 1876. He chose to focus his studies on philosophy, however, and he trained to become a university teacher at the École Normale Supérieure. A serious reading of the works of the English philosopher Herbert Spencer gave a mechanistic bent to Bergson's developing thought, though he also became acquainted with the sociology of Émile Durkheim.

At the École Normale Supérieure from 1878 to 1881, Bergson successively received at the end of each of his three years the licentiate, the *definitif* (diploma), and second

place in the *agrégation* (oral examinations). These enabled him to lecture, first outside Paris at Angers (1881-1883) and at Clermont-Ferrand (1883-1888), before returning to Paris and the Collège Rollin. During that time, he prepared his *Essai sur les données immédiates de la conscience* (1889; *Time and Free Will: An Essay on the Immediate Data of Consciousness*, 1910) and a dissertation, in Latin, on Aristotle, for which he received a doctorate from the University of Paris.

With the publication of his theses, Bergson became professor for advanced students at the Lycée Henri IV in Paris, and in 1891 he married Louise Neuberger, a cousin to the novelist Marcel Proust. He had also met the poet and literary journalist Charles Péguy, who established the journal *Cahiers de la quinzaine* in 1900 and who became Bergson's pupil. Research into the interrelationships of body and mind followed, and Bergson published his findings in 1896 as *Matière et mémoire* (*Matter and Memory*, 1911).

It was customary in French academia at the turn of the century for professors to name and pay by half-salary a substitute for a given year, taking thereby research leave from lecturing duties. Bergson substituted at the Collège de France from 1897 to 1898 as a professor of Greek and Latin philosophy. In 1899, Bergson was appointed as a permanent professor of Greek and Latin philosophy, and in 1904 he was able to transfer to the more appropriate post of professor of modern philosophy.

In the interim, Bergson published several books, including *Le Rire: Essai sur la signification du comique* (1900; *Laughter: An Essay on the Meaning of the Comic*, 1911) and *Introduction à la métaphysique* (1903; *An Introduction to Metaphysics*, 1912). The former illustrated Bergson's contention that laughter is a release of tension; the latter defended the use of intuition and, because it pointed to the forthcoming work for which Bergson is best known, remains the best place to begin a reading of his work. These publications provided the setting for *L'Évolution creatrice* (1907; *Creative Evolution*, 1911). What is now the book's final part developed out of a course of lectures on the history of the idea of time in which Bergson compared the mechanism of conceptual thought to cinematography. In 1905, he named his own substitute so that he might prepare *Creative Evolution* for publication.

Part 1 drew upon the discussion of evolution as it had developed up to Charles Darwin and its subjection to criticism by Darwin's successors in biology. Recalling the conclusions of *Matter and Memory*, Bergson summarized the result of the inquiry, which sought to discover both the mechanism and the purpose of evolution. He referred to this key concept as *élan vital*, or the "vital impetus."

Part 2 considered the divergent directions of evolution, with special reference to torpor, intelligence, and instinct. Bergson developed these within his concept of intuition and drew his discussion toward the apparent place of the human within the natural world through references to both life and consciousness.

In part 3, Bergson attempted to relate life and matter through common origins. Here, the culmination of the book was stated, in terms of the life of the body and the life of the spirit. Bergson developed his ideas about the inseparability of the theories of knowledge and of life in this section.

The final, fourth part sketched Bergson's and academic philosophy's interest in precedent systems, including those of Plato, Aristotle, René Descartes, Baruch Spinoza, Gottfried Wilhelm Leibniz, Immanuel Kant, and especially Spencer. Antiquity's philosophical issues of immutability, "no-thing," form, and "becoming" were placed against the seventeenth century's metaphysical foundations of modern science, thereby concluding the volume at the point from which Bergson initiated part 1.

What Bergson described in his original thought and within his eloquent and precise language were the certainty of evolution and the necessity of creativity in propelling the evolutionary process. In no meaningful sense does Bergson's *Creative Evolution* present a single systematic philosophy; rather, his work is descriptive.

Impact of Event

Biographers recall Bergson as being at odds with the philosophical establishment, especially as represented by those at the Sorbonne, across the Rue Saint Jacques from the Collège de France. Coming as he did through the École Normale Supérieure, Bergson exerted an influence on those students who had studied with him and who themselves went forth to teach. Thus, his works were being read as they appeared, and upon his appointment to the Collège de France in 1900, his lectures became an even greater draw—so much so that by 1911, students already referred to the Collège de France as "the house of Bergson."

From 1900 to 1914, Bergson lectured to packed halls. His lectures were attended not merely by academics and students but also by the general public, including members of the elite who sent their servants to keep places for them and tourists taking in the attractions of Paris. Many who wished to hear Bergson speak were turned away; others would come so early to lecture locations that they would sit through someone else's prior lecture merely to secure a seat to hear Bergson.

From 1914 until 1921, Édouard Le Roy functioned as Bergson's "permanent substitute" while Bergson served on French diplomatic missions to Spain and to the United States. Thereafter, Bergson took early retirement, partially in exasperation at his own success; his strenuous lecturing duties, he said, "demanded a great deal of meditation and a serious attempt at perfection." In 1922, he published his attempt to relate his own theory of time as inner duration to Albert Einstein's theory of relativity. He acted as president of the committee on international cooperation of the League of Nations from 1921 to 1926. He also continued his philosophical work while acting as a diplomat, and in 1932 he published his last book, *Les Deux Sources de la morale et de la religion* (*The Two Sources of Morality and Religion*, 1935).

Another measure of Bergson's impact is visible in the response of the Roman Catholic church to his work. In 1914, all of Bergson's writings, but most especially *Creative Evolution*, were placed upon the list of books devout Catholics were forbidden to read or possess. The Jesuit Pierre Teilhard de Chardin discussed physical anthropology and paleontology in terms derived from Bergson's *Creative Evolution* and was himself subjected to discipline from Rome. Yet peculiarly, Bergson helped

to provide the impetus for a Catholic revival by inspiring such Catholic intellectuals as the art critic Henri Focillon, the literary critic Charles de Bos, the poets Anna de Noailles, Paul Claudel, and Charles Péguy, and Jacques Maritain, a Protestant convert who led many intellectuals back to the Catholic tradition and who was mentor to Pope Paul VI.

Bergson's work also provided a rationale for the Surrealist movement in art, and his ideas also influenced the novelist Marcel Proust, the essayist Albert Thibaudet, the poet Paul Valéry, and the existentialists Albert Camus and Jean-Paul Sartre. Bergson's own literary genius was recognized by award of the Nobel Prize in Literature for 1927.

Two philosophical traditions of the twentieth century received their impetus from Bergson. While Bergson was not the innovator of the existentialist movement, the fourth part of *Creative Evolution*, with its stress upon the role of the philosophical concepts of "not-being" and "becoming" as well as on Bergson's pervasive concern for time as "duration," had implications that can be followed in the works of Martin Buber, Karl Jaspers, Gabriel Marcel, and Martin Heidegger. On the other hand, Bergson's concern to reclaim the validity of metaphysics within modern philosophy has made him one of the stimuli for the development of "process philosophy." Specifically, Alfred North Whitehead, who came to philosophy from mathematics and physical science, expanded Bergson's notions of duration and evolution from their original, restricted applications to organic life into the broader physical realm.

A final impact was made by Bergson's own courageous personal stand. Though intellectually long attracted to Catholicism, Bergson had remained a Jew, and after the surrender of France to the Nazis in 1940, he was required by the Vichy government to register as a Jewish citizen of Paris. Although Bergson, because of his old age, infirmity, and fame, could certainly have obtained an exemption, he insisted on registering to show his support for other Jews. Although ill, he stood in line to register on a cold, damp day, and as a result contracted a lung inflammation. He died shortly thereafter, on January 4, 1941.

Bibliography

Bergson, Henri. *Creative Evolution.* Translated by Arthur Mitchell. New York: Henry Holt, 1911. The treatise that helped set the tone for twentieth century thought. The translation was revised by Bergson. Detailed index.

_____. *The Creative Mind.* Translated by Mabell L. Andison. New York: Philosophical Library, 1946. Incorporates ten of Bergson's essays. Also includes an introduction, which serves as a brief intellectual biography.

Bowler, Peter J. *Evolution: The History of an Idea.* Berkeley: University of California Press, 1984. A survey of the idea of evolution by one of its leading scholars. Places Bergson's thought within its largest context. Extensive bibliography and index.

Bradbury, Malcolm, and James McFarlane, eds. *Modernism, 1890-1930.* Harmondsworth, England: Penguin Books, 1976. Thirty-four essays by twenty-one contribu-

tors. Useful for tracing the wider influence of Bergson upon literature and art. Includes chronology of events, brief biographies, extended bibliography, and detailed index.

Chevalier, Jacques. *Henri Bergson.* Translated by Lilian A. du Long Clare. New York: Macmillan, 1928. An extensive study that places Bergson within the intellectual developments in France during the latter half of the nineteenth century. Index.

Hanna, Thomas, ed. *The Bergsonian Heritage.* New York: Columbia University Press, 1962. Eleven essays by French and American scholars reflecting on Bergson's life and evaluating the meaning of his work. Bibliography, especially of works on Bergson in French.

Pilkington, Anthony Edward. *Bergson and His Influence: A Reassessment.* New York: Cambridge University Press, 1976. A reevaluation of Bergson from the perspective of the 1970's. Index.

Russell, Bertrand. *The Philosophy of Bergson.* Chicago: Open Court, 1912. An early, highly critical view of Bergson from an alternate philosophical perspective of logical analysis. Much of this original perspective remains in the chapter on Bergson found in Russell's idiosyncratic *A History of Western Philosophy* (1945).

Clyde Curry Smith

Cross-References

Freud Inaugurates a Fascination with the Unconscious (1899), p. 19; The First Nobel Prizes Are Awarded (1901), p. 45; Shaw Articulates His Philosophy in *Man and Superman* (1903), p. 85; William James's *Pragmatism* Is Published (1907), p. 171; Jung Publishes *Psychology of the Unconscious* (1912), p. 309; Wittgenstein Emerges as an Important Philosopher (1921), p. 518; Sartre and Camus Give Dramatic Voice to Existential Philosophy (1940's), p. 1174; Sartre's *Being and Nothingness* Expresses Existential Philosophy (1943), p. 1262.

BUSONI'S *SKETCH FOR A NEW AESTHETIC OF MUSIC* IS PUBLISHED

Category of event: Music
Time: 1907
Locale: Berlin, Germany

In Sketch for a New Aesthetic of Music, *Ferruccio Busoni was among the first to articulate a rational foundation for the dramatic changes in musical style that took place in the early years of the twentieth century*

Principal personages:
> FERRUCCIO BUSONI (1866-1924), a pianist, composer, and leading musical intellectual in turn-of-the-century Germany whose extensive prose works were among the first to address the rapidly changing and often confusing musical styles in the period preceding World War I
> HANS PFITZNER (1869-1949), an articulate composer and Germanophile who vigorously criticized Busoni's work, maintaining that it represented not an aesthetic of music but a whole new art and that it undermined the achievements of nineteenth century German composers
> ARNOLD SCHOENBERG (1874-1951), a leading composer and theorist who shared many of Busoni's fundamental values and who, with Busoni, dominated the musical avant-garde in Berlin in the early twentieth century

Summary of Event

At the turn of the century, Ferruccio Busoni was recognized as one of the world's leading pianists, a composer of substance, and a prolific writer whose ideas reflected the dissatisfaction with prevailing musical styles shared by most of his contemporaries among the musical intelligentsia. His *Entwurf einer neuen Aesthetik der Tonkunst* (1907; *Sketch for a New Aesthetic of Music,* 1911) was not so much a treatise on aesthetics as a melange of musical principles reflecting his own concerns for the present state of music and offering carefully considered ways of freeing music from lasting traditions that Busoni regarded as redundant.

Busoni maintained that the spirit of a musical artwork was ageless, its essence remaining the same throughout many years. Thus, he wrote, there is nothing properly old or new, only expressions of an enduring idea that have come into being earlier or later. The performance of music cast in the mold of another age is inherently inconsistent, for if the musical idea is indeed the enduring factor, the imposition of stereotypical forms or procedures brings forth nothing new, only a refurbishment of statements already achieved. The function of the creative artist lies in the formation of new laws rather than in following laws already made; the true creator seeks after the perfection of a musical expression that achieves a rapprochement

between the natural qualities of the basic musical idea and the composer's own individuality. A musical work is to be shaped by the natural qualities of the underlying idea (however that may be defined) and its most natural expression as perceived by the creative artist.

Busoni regarded established musical forms as strictures that impeded natural expression. In the history of music, form has served as an element of consistency, serving to establish an element of balance and order and allowing the imagination free rein. Over time, however, form came to be an end in itself; Busoni argued that fidelity to traditional forms should be set aside in favor of the expression that is the most natural to any given musical material. He pointed out the inconsistency of expecting overall originality of a composer and yet expecting conventionality in matters of form. Program music, he wrote, was equally faulty in that a story or series of events replaced form and imposed upon music a framework extraneous to the seeds of expansion inherent in each motive.

According to Busoni, musical notation, too, needed to be reconsidered. Notation had developed as an expedient means of preserving a fleeting inspiration for the purpose of later exploration and reinterpretation. Musical lawgivers, however, had required the interpreter of written music to reproduce the fixed connotation of the written symbols, confusing notation with music itself. The limitation of notation is closely allied with the instruments for which it is intended; for Busoni, the implied tonal color, range, and pitch system around which modern instruments were built imposed additional limitations on natural musical expression. Anything written for a specific instrument necessarily remains committed to a certain timbre or color. A possible solution to such difficulties might be offered by electronic tone production, and Busoni was quite interested in reports of Thaddeus Cahill's invention of the dynamophone, one of the earliest electronic musical instruments.

Busoni's concern for expanding what he considered a narrow tonal range led to a series of scales intended to replace the traditional major-minor system. The new scales were derived from a process wherein subsequent tones within the octave were systematically lowered within each permutation; Busoni's manuscript copy illustrated the 113 scales to which he referred in his text, but a logical extension of his procedure would produce at least 148 scales. These concerns led him to a refined gradation of the acoustic octave in which he described a tripartite tone (third of a tone) in place of the usual semitone, leading to a scale of eighteen pitches. Transposing this same plan to the next set of traditional tones produced another tripartite set of eighteen, or an acoustic octave encompassing a total of thirty-six pitches. For all these, he proposed an appropriate system of new musical notation.

The new scales and more minutely defined pitch materials were among the most widely discussed of Busoni's theses. He was drawn into an extended dialogue with contemporaries, during the course of which he came to be recognized as one of the leading musical intellectuals of the time. An attempt to clarify his ideas in a second, expanded edition of *Sketch for a New Aesthetic of Music* drew more commentary than the initial publication. Arnold Schoenberg, a prominent composer and theorist,

declared much sympathy with the substance of Busoni's writing if not with all of its applications. Yet German composer Hans Pfitzner attacked Busoni's work in *Futuristengefahr* (1917; the danger of futurism). Pfitzner defended the nineteenth century value system of feeling and inspiration against what he perceived as calculating intellectual processes, expressive paralysis, and a threat to the values of German music. The last charge caught the attention of German nationalists immersed in the heat of World War I. Busoni, the son of an Italian farmer and a German mother, had spent all of his adult life in Germany, but the Italian surname cast suspicion on him as a foreigner and, for those inclined to such beliefs, lent some credence to Pfitzner's charges.

Busoni's works before 1907 followed in the tradition of late nineteenth century Romanticism and, to a lesser degree, Impressionism. Starting with the *Six Elegies* (1908), however, his own style of composing turned toward a more sparse and pervasively contrapuntal texture, colored by progressive harmonies. There is no clear evidence of either the scales or tripartite tones described in *Sketch for a New Aesthetic of Music.*

Among pianists, Busoni's name always will be linked with his transcriptions of works by Johann Sebastian Bach and others. While some purists have derided these as musical transgressions, the process is very much in keeping with Busoni's premise that basic musical ideas endure and can be expressed in many ways without substantive loss, and that any notation represents but one of many ways of defining any given material.

Impact of Event

At a time of great ferment in the musical world, Busoni's essay was among the first attempts to present a rational defense for many of the extraordinary changes in music during the first two decades of the twentieth century. The exchanges generated by his ideas marked the beginning of literary explanations and justifications for new music that continued until well past midcentury. Those who saw music in a state of decadence could, with an open mind, find in Busoni reasons for and order behind what some described a cacophony. The emancipation of dissonance, a premise generally attributed to Arnold Schoenberg, found its first widely circulated expression in Busoni's work; Busoni, with some success, defined the difference between atonality and cacophony as a matter of the listener's comprehension.

The systematic approach to the creation of the 113 scales provided a point of departure for similar efforts later in the century. The scale structures of Josef Hauer and Olivier Messiaen, while not direct extensions of Busoni's plan, reflect his influence in their rational, instead of acoustical, approach to the arrangement of pitch materials; many other names could be added to such a list. The new notation Busoni proposed to accommodate his tripartite pitch series saw no direct imitators, but it did introduce the concept of new signs for new sounds. The manifestations of this approach led to many different procedures, particularly after the middle of the century. The fundamental concept is Busoni's premise that a musical idea exists on its

own and can be expressed through any pattern of notation appropriate to the material, an approach reflected in the scores of Messiaen and Krzysztof Penderecki, among others. The search for a source of more plastic and more finely graduated pitch material has been mirrored in the efforts of many composers to expand their tonal resources, not only in matters of pitch but in timbre and color as well. Edgard Varèse, who has achieved much in both percussion ensembles and electronic music, stressed his allegiance to Busoni in several lectures as well as in the very substance of his works such as *Amériques* (1926) and *Poème électronique* (1958).

Several years after the appearance of *Sketch for a New Aesthetic of Music,* Busoni referred to his ideas, in the most comprehensive vein, as a *Junge Klassizität,* a term that has been widely mistranslated as "young classicism" and, in that context, frequently misunderstood. In a letter to his son, Busoni made it clear that he had coined the term around 1919 and that he wished to distinguish between classicality and classicism as it is conventionally understood. In later attempts at clarifying "young classicality," he described it as an assimilation of all earlier experiments and their inclusion in new musical forms of greater strength. Busoni's idea has often been confused with neoclassicism as it was represented in the works of Igor Stravinsky during the decades following World War I and has been largely forgotten in the prevailing currency of the latter term. Young classicality is best viewed as a comprehensive aesthetic of music that may include a variety of styles and techniques; neoclassicism stands as one of those many styles. Thus, Busoni's concept, represented by the term "young classicality," anticipated, or at least described, the multistylistic quality of most twentieth century music.

Bibliography

Beaumont, Antony. *Busoni the Composer.* London: Faber & Faber, 1985. A thorough and comprehensive study of Busoni's work. Beaumont supplements his stylistic study with abundant photographic plates, musical illustrations, biographical and creative chronologies, a catalog of transcriptions and cadenzas, and a select bibliography. Valuable for its attention to detail and comprehensive treatment of the subject.

Busoni, Ferruccio. *The Essence of Music and Other Papers.* Translated by Rosamond Ley. London: Rockliff, 1957. A panoply of Busoni's writings, some of them addressing his concepts of music of the future and young classicality. Others discuss the composers who were central to his pianistic repertory, his piano playing, and a miscellany of his musical interests. A valuable collection of writings reflecting Busoni's intellectual fecundity.

_____. *Sketch of a New Esthetic of Music.* Translated by Th. Baker. New York: G. Schirmer, 1911. The original American version of Busoni's work. Reprinted in *Three Classics in the Aesthetics of Music* (1962) and in *Contemplating Music: Source Readings in the Aesthetics of Music* (1987).

Dent, Edward J. *Ferruccio Busoni: A Biography.* London: Oxford University Press, 1933. The early and standard English-language study of Busoni and his works by a

personal acquaintance. Valuable for personal insights and minutiae of biography, but dated in its treatment of Busoni's creative work.

Mason, Robert M. "Enumeration of Synthetic Musical Scales by Matrix Algebra and a Catalogue of Busoni Scales." *Journal of Music Theory* 14 (Spring, 1970): 92-126. A technical, systematic exploration of the scale system proposed by Busoni. Copiously illustrated by charts and diagrams exploring possible applications of Busoni's fundamental concept in matters of pitch organization.

Morgan, Robert P. *Twentieth-Century Music: A History of Musical Style in Modern Europe and America.* New York: W. W. Norton, 1991. Morgan presents one of the most succinct summaries available of Busoni's ideas on music in the modern age and offers examples of important composers who may have come under his influence.

Raessler, Daniel M. "The '113' Scales of Ferruccio Busoni." *The Music Review* 43 (February, 1982): 51-56. Devoted to a study of Busoni's proposed scale system and its musical applications, this publication is most valuable for its musical illustrations of the scales as they appear in Busoni's manuscript copy. The author expands the system to its logical conclusion of 147 scales.

——————. "Schoenberg and Busoni: Aspects of Their Relationship." *Journal of the Arnold Schoenberg Institute* 7 (June, 1983): 6-27. Based on letters exchanged between Busoni and Schoenberg between 1903 and 1919. The correspondence makes clear that both innovators shared a mutual respect and a conviction that the course of music had to change, but that neither completely understood the other's view of what the new direction should be.

Roberge, Marc-André. *Ferruccio Busoni: A Bio-Bibliography.* New York: Greenwood Press, 1991. As indicated by the title, a bibliographical reference tool more than a substantive exploration of Busoni's ideas or compositions. The annotated bibliography, by far the most extensive available, is valuable for its listing of published works by and about Busoni.

Stuckenschmidt, Hans H. *Ferruccio Busoni.* Translated by Sandra Morris. London: Calder and Boyars, 1970. A reasonably thorough overview of Busoni's ideas and influences by one of the principal commentators on modern music. The work generally deals with description more than with analysis or evaluation; most useful for its perspective of Busoni within the context of twentieth century musical styles.

Douglas A. Lee

Cross-References

Mahler Revamps the Vienna Court Opera (1897), p. 7; Schoenberg Breaks with Tonality (1908), p. 193; The Futurists Issue Their Manifesto (1909), p. 235; *The Rite of Spring* Stuns Audiences (1913), p. 373; Schoenberg Develops His Twelve-Tone System (1921), p. 528.

WILLIAM JAMES'S *PRAGMATISM* IS PUBLISHED

Category of event: Literature
Time: 1907
Locale: New York, New York

The publication of Pragmatism *was a significant event for both the personal development of William James as a philosopher and for the course of philosophy in the twentieth century*

Principal personage:
WILLIAM JAMES (1842-1910), an innovative American philosopher

Summary of Event

In November and December 1906, William James delivered a series of lectures at the Lowell Institute in Boston that he repeated in January, 1907, at Columbia University in New York City. The lectures were later published without notes or any further explanation as *Pragmatism: A New Name for Old Ways of Thinking.* It was the end of of James's development as a philosopher and the beginning of a significant departure in the history of philosophy in twentieth century America. Understanding the evolution of James's thought is made complex by the fact that James developed his theory of radical empiricism in a series of essays written in 1904 and 1905; those essays were collected and published posthumously in 1912 as *Essays in Radical Empiricism.* As James observed in the preface to *Pragmatism,* however, no logical connection existed between the two concepts; the two ideas were independent of each other.

The subtitle of James's book indicated that he believed that the pragmatic method was of long duration and that, in fact, many people used the method without recognizing it as an expression of philosophy. Truth, pragmatic style, grew out of all finite experience. It was what people had done in their daily lives for centuries.

Pragmatism was first presented to a nonprofessional audience as lectures and then as relaxed essays to popular or general readers. The book included eight lectures. Given and written in an informal style, the work was very much of that singular individual, William James. In the first lecture, "The Present Dilemma in Philosophy," James made his now-famous distinction between the "tender-minded" and the "tough-minded," a distinction which he traced to arguments between the rationalists and the empiricists. This distinction was vital to James's presentations, since he believed that every individual is a philosopher whose creed often reflects the whims of individual temperament.

"What Pragmatism Means" was the next lecture. With his usual gracious manner, James, with strong figures of speech and commonplace examples, described pragmatism as a method that can satisfy the rationalists and empiricists by its modest claim that a test of reality was possible using the pragmatic method. Belief and acting on a

particular belief were key elements in defining pragmatism. Because this belief had a religious element in James's world, the following lecture dealt with "Some Metaphysical Problems Pragmatically Considered"; in it, James rejected the argument that the existence of God could be perceived in the design of the universe. The evidence for God's existence, James argued, was in inner and personal experiences.

James's fourth lecture, "The One and the Many," discussed how philosophy historically expressed a desire for both unity and totality. The varied answers were unsatisfactory to James. Pragmatism was not a gnostic enterprise, James maintained in his fifth lecture, "Pragmatism and Common Sense."

James's point was a historical one. From their earliest history, he maintained, humans had developed the pragmatic method; the survival of the earliest humans depended upon their using knowledge of the past in conjunction with their own immediate experience. When the two elements were joined, common sense (or wisdom) was achieved.

As he explained in his next lecture, "Pragmatism's Conception of Truth," truth was expedient thinking that grew over time and with increased experience. Ideas that can be assimilated, validated, corroborated, and verified were true; false ideas cannot be used in such a manner.

For James made quite clear in his next-to-last lecture, "Pragmatism and Humanism," that an absolutely independent reality was difficult to find. People created reality. Ideas arrived at via individual and collective experience created reality against the backdrop of a morally indifferent nature. Once again, pragmatism offered a middle way between rationalism and empiricism.

In his eighth and last lecture, "Pragmatism and Religion," James returned to a concern, religious belief, that had provoked him throughout his career. His final evaluation was that pragmatism offered a solution to religious dilemmas, because people may create reality. He ended his presentation where he began it, with concluding remarks about tender-minded and tough-minded approaches to religion. Yet pragmatism came from a culture of science that offered the ideal of freedom as combined with the notion of American achievement. Despite the emergence of other philosophical positions, pragmatism endured because it was modern in its appeal to science and old in that it was the method that led to material success in the United States.

Impact of Event

The publication of *Pragmatism* was a major event for James as an individual philosopher and for the course of philosophy in the twentieth century. In an important sense, James had prepared all of his life for the book to appear.

James was born in New York City in 1842 to Mary and Henry James, Sr., well-to-do and somewhat eccentric parents. The family fortune was a gift of William's grandfather, who had made wise investments in the Erie Canal. In time, the family included three brothers, one of whom was the famous novelist Henry James. The final child was Alice James, whose health problems, real and imagined, limited her

life experiences; she did, however, keep a first-rate journal.

William's formal education was irregular, but through his father he visited with many of the outstanding writers and artists of the day. Henry James, Sr., encouraged William to find himself; therefore, any interest that the young boy expressed was encouraged by his father, who at the same time warned William not to close out any other possibilities. The results were mixed. After attending many private schools in both the United States and Europe, William studied painting, but determining that he had only mediocre talents, quit and turned to science.

By 1861, he was a member of the Lawrence Scientific School at Harvard University. After studying chemistry, comparative anatomy, and physiology, he transferred to the medical school and was graduated in 1869. He never, however, practiced medicine. Meanwhile, he toured the Amazon Basin with a scientific expedition; his eyes were weakened by the experience. He then lived for a time in Germany studying experimental physiology. After bouts of illness and retirement, William began teaching physiology and anatomy at Harvard in 1873. His teaching included psychology and, by 1879, philosophy.

His twin interests in science and religious matters guided James toward a career as professor of philosophy. The religious interest, though, was much more vital and bore directly on James's philosophy and life experience. The issues of free will and religious monism shaped his thoughts; after contemplating suicide, James decided, as an act of the will, to believe in free will. In a real sense, James's pragmatism was thus born.

His marriage in 1878 to Alice Howe Gibbens was very successful. He was a happy man; he was a productive scholar and a first-rate teacher. He published his masterpiece *The Principles of Psychology* in 1890. In 1902, he published *The Varieties of Religious Experience.* His last book was *A Pluralistic Universe* (1909), published a year before his death and based on a series of lectures given at the University of Oxford.

While James's philosophy fulfilled a personal need, *Pragmatism* over the course of the twentieth century played a key role in several areas. In the area of reform politics, the mid-century American politician John Dewey directly used James's ideas in the construction of his creed of instrumentalism. It is not an exaggeration to state that the ideas of pragmatism expressed the essence of progressivism and other twentieth century democratic creeds. Dewey's instrumentalism was a secular, social, and reform adaptation of James's pragmatism; interestingly, James came to construct his philosophy through the study of Immanuel Kant, while Dewey began his philosophical journeys with the study of Georg Hegel.

Twentieth century politicans have often misrepresented their own opportunism as expressions of tough-minded pragmatism. Italy's Fascist dictator Benito Mussolini, for example, invoked James's philosophy in seeking out intellectual support for his policies. During U.S. president Franklin D. Roosevelt's New Deal, a camp for the government-sponsored self-help organization the Civilian Conservation Corps was named after James; this second example of the political use of James's prestige,

however, was much closer to the spirit of the philosopher's thought.

Pragmatism's relationship to formal philosophical developments was more complex. James was an "antifoundational" thinker; he rejected René Descartes' effort to place philosophy on the same secure basis as mathematics. It is not unusual for more recent philosophers to be antifoundationalist and anti-Cartesian, largely because James and his early associates Chauncey Wright and Charles Sanders Peirce successfully challenged claims for philosophical certitude. The acceptance of this position meant that James's thought led to the boundaries of existentialism, but without the atmosphere of individual and cultural despair associated with that philosophical position.

During the 1930's and the 1940's, pragmatism was thought of as a protopositivism, anticipatory of the logical positivism that flourished in the 1920's and 1930's. Although this interpretation was in fact a wrong historical analysis, it did indicate the degree to which some scholars believed that pragmatism had affected later philosophical developments.

Finally, James's *Pragmatism* continued a de facto tradition of idealism in American thought, accepting the truths of science and harmonizing them with religious sentiment in an effort to create a better life and creed. Supported by science and religion, James's creed solved issues of long metaphysical concern and helped countless people to handle the immediate task of living day to day.

Bibliography

Allen, Gay Wilson. *William James: A Biography.* New York: Viking Press, 1967. A first-rate biography with an emphasis on the travels of James. The book offers little in interpretation, but its factual content is valuable.

Barzun, Jacques. *A Stroll with William James.* New York: Harper & Row, 1983. An interesting account of how James influenced the life of a leading historian. Barzun stresses the humanity of James and how pragmatism was the product of a fully realized human being.

Feinstein, Howard M. *Becoming William James.* Ithaca, N.Y.: Cornell University Press, 1983. An analysis of how James overcame his many psychological problems and concerns to become a mature and engaging human being. Rich in detail, this psychobiography connects James's life experiences to the creation of his books and philosophy. When the Allen book explores the "outer" James, this volume maps the "inner" James.

Kloppenberg, James T. *Uncertain Victory: Social Democracy and Progressivism in European and American Thought, 1870-1920.* New York: Oxford University Press, 1988. The best general history of the ideas of the period. Provides a meaningful context for pragmatism and an explanation of how and why the philosophy came into being. Provides good historical reasons why pragmatism was destined to be the creed underlying much American reform.

Kuklick, Bruce. *The Rise of American Philosophy: Cambridge, Massachusetts, 1860-1930.* New Haven, Conn.: Yale University Press, 1977. This history of the Harvard

University Department of Philosophy reveals how James came to be a professional philosopher and what his legacies were to the school. A rich account of James and his contemporaries; basic to any understanding of James and his world.

James, William. *Writings, 1902-1910.* Edited by Bruce Kuklick. New York: Viking Press, 1987. In this fine edited volume of James's writings for the last eight years of his life, the complete text of *Pragmatism* is included, along with *A Pluralistic Universe* and other occasional pieces. A good starting point in understanding James's ideas.

Lewis, R. W. B. *The Jameses.* New York: Farrar, Strauss & Giroux, 1991. A massive achievement, this book is a full treatment of the James family. Reveals how the individual members related to one another and how they turned their family experiences into the literary, artistic, and philosophical products of their adult years. Lewis gives a balanced treatment to this remarkable group of people.

Marcell, David W. *Progress and Pragmatism.* Westport, Conn.: Greenwood Press, 1974. Traces the impact and consequences of pragmatism on the thought of various reformers and reforms. The creed was often an American expression of the idea of progress. This book clearly illustrates how pragmatism was in the American grain. A clear statement about the importance of pragmatism in the history of ideas.

Myers, Gerald E. *William James: His Life and Thought.* New Haven, Conn.: Yale University Press, 1986. With a fine balance between biographical description and textual analysis, this work presents the whole man in all of his achievements. While some readers might quarrel with some of Myers' observations, the book is the best single-volume biography of James written in the last fifty years. A must source for understanding James as man and philosopher.

Murphey, Murray G., and Elizabeth Flower. *A History of Philosophy in America.* 2 vols. New York: Capricorn Books, 1977. The title is indicative of the book's contents. A solid survey, it provides the historical and philosophical background necessary to a deep understanding of James.

Donald K. Pickens

Cross-References

Freud Inaugurates a Fascination with the Unconscious (1899), p. 19; Henry James's *The Ambassadors* Is Published (1903), p. 96; Bergson's *Creative Evolution* Inspires Artists and Thinkers (1907), p. 161; Wittgenstein Emerges as an Important Philosopher (1921), p. 518; Sartre's *Being and Nothingness* Expresses Existential Philosophy (1943), p. 1262; Lévi-Strauss Explores Myth as a Key to Enlightenment (1964), p. 1995.

THE PLAYBOY OF THE WESTERN WORLD
OFFENDS IRISH AUDIENCES

Category of event: Theater
Time: January 26, 1907
Locale: Abbey Theatre, Dublin, Ireland

The first audiences to see The Playboy of the Western World *were offended by the play's language and depiction of Irish peasants, especially women, and hissed and rioted throughout its week-long run*

Principal personages:
> JOHN MILLINGTON SYNGE (1871-1909), a playwright whose dramas are among the great products of Ireland's theatrical renaissance of the early twentieth century
>
> WILLIAM GEORGE FAY (1872-1947), an Abbey Theatre actor and director who helped to stage Synge's play
>
> WILLIAM BUTLER YEATS (1865-1939), a renowned poet and dramatist and Abbey Theatre founder who defended Synge's works
>
> LADY AUGUSTA GREGORY (1852-1932), a prominent Irish patron of the arts instrumental in the creation of the Abbey Theatre

Summary of Event

By the time *The Playboy of the Western World* opened at Dublin's Abbey Theatre on January 26, 1907, the young Irish National Theatre Society already had staged three of John Millington Synge's plays, two of which provoked hostile reactions that foreshadowed the troubles that would beset his fourth work. In 1903, his first play, the one-act *In the Shadow of the Glen*, was denounced as being libelous of women and for having been derived from pagan, anti-Christian works, though it was essentially a dramatization of a story Synge had heard in the Aran Islands. The following year, *Riders to the Sea*, also a one-act work, was the only Synge play not subjected to audience attacks during his lifetime; its opening was uneventful, probably because the play does not deal with the conflicting demands of individuals and society. Irish nationalists were offended, however, by his third play, *The Well of the Saints* (1905), which was damned as un-Irish. Annoyed by the attacks on his work, Synge decided to retaliate; he reportedly remarked to a friend, "Very well, then, the next play I write I will make sure will annoy them." Actually, he had been trying for seven years to fashion a drama out of another Aran story, writing at least ten drafts and revising each many times; he went through thirteen rewrites of the third act alone before finally completing *The Playboy of the Western World*. When William Fay, an Abbey Theatre director and actor, read the finished manuscript, he thought audiences would be offended, particularly because of the depiction of women, but the play was staged as written.

The action spans twenty-four hours at Michael James Flaherty's pub (or "she-been") in western Ireland's rural County Mayo. Pegeen Mike, his daughter and pub-lican in his absence, is attractive, quick-witted, and independent. Betrothed to her cousin Shawn Keogh, a boorish farmer, she is planning her trousseau, but she treats him scornfully while they await a church dispensation to marry. Just before Flaherty and others leave for an all-night wake, a stranger arrives, "a slight young man . . . very tired and frightened and dirty." Named Christy Mahon, he claims to be a fugi-tive fleeing the authorities after having murdered his father, "a dirty man . . . old and crusty," by hitting him over the head with a club. Instead of turning on him, the men praise Christy's bravery and fearlessness, leave him with Pegeen, and go to the wake, confident that she is safe "with a man killed his father holding danger from the door." Because he has eluded the police so successfully, the authorities must fear him, Flaherty decides. So he hires Christy, ostensibly as "pot-boy" but really in hopes that his presence may deter the police from snooping into the publican's ille-gal operations. Left alone, Christy and Pegeen are attracted to each other, but the Widow Quin, a nosy harridan of about thirty, unexpectedly appears. Believed to have murdered her husband, she wants to take Christy home, ostensibly because of the impropriety of the young people being alone, but really because she has designs on him. Christy decides to remain, so Pegeen forces the widow out and then tells him she "wouldn't wed [Shawn] if a bishop came walking for to join us here." Settling in for the night, an increasingly confident Christy marvels about "two fine women fighting for the likes of me" and tells himself "wasn't I a foolish fellow not to kill my father in the years gone by."

In the morning, girls bearing gifts come to the pub to meet the "man killed his father," and they are joined by the Widow Quin, who asks Christy how he came to murder his father. Savoring the attention, he tells how his father wanted him to marry "a woman of noted misbehavior," a "walking terror" of "two score and five years." When he refused, the older man threatened him with a scythe, and Christy raised a club and "hit a blow on the ridge of his skull, laid him stretched out, and he split to the knob of his gullet." The credulous women bless him, call him a marvel, and drink to him, one of "the wonders of the western world." Obviously smitten with the newcomer, Pegeen warns Christy against bragging about the murder and reveals that the authorities have no report of it. Shawn attempts to get rid of his rival by bribing Christy with a ticket to America and sundry articles of clothing. Making no commitment, Christy borrows the clothes for the sporting events of the day and is delighted with himself, preening and strutting and convinced he has found an ideal new home.

Then he is staggered by what appears to be "the walking spirit of my murdered da." Old Mahon, his head swathed in bandages and plaster and very much alive, tells the Widow Quin about his son, the very antithesis of the swaggering ladies' man Christy has become. She does not betray Christy but sends Old Mahon on a wild goose chase. Though scandalized by Christy's unforgiving attitude toward his father, she again woos the youth, but he is determined to win Pegeen, so Quin

promises silence for a small payoff.

Later, when some of the men return from Kate Cassidy's wake, Old Mahon also comes back to the shebeen and tells his tale, but cheers for "the champion Playboy of the Western World" interrupt him. His son, it seems, is victor in the beach mule race; the others convince Christy's father that he is mad and send him away. Christy comes in, and when the crowd leaves, he proposes to Pegeen. A drunk Flaherty, supported by Shawn, finally comes home from the wake, with news that the dispensation has come from Rome. When Pegeen says she intends to wed Christy, Shawn— prodded by Flaherty—pleads his case, which provokes Christy to threaten: "Take yourself from this, young fellow, or I'll maybe add a murder to my deeds to-day." Shawn flees, and Flaherty decides that perhaps Christy would be a better son-in-law; after all, he says, a "daring fellow is the jewel of the world." This celebration ends with Old Mahon's return, followed by a crowd of supporters; in the ensuing turmoil, Christy chases his father outside, club in hand. He returns alone, in a daze, and the men confirm that Old Mahon has been killed. Pegeen, her father, and a newly emboldened Shawn tie up Christy and secure him to a table; when he protests and threatens, Pegeen tortures him with burning sod. Into this melee crawls Old Mahon, again back from the dead. He unties his wayward son, and the reconciled pair leave together, Christy pausing for a valediction: "Ten thousand blessings upon all that's here, for you've turned me a likely gaffer in the end of all, the way I'll go romancing through a romping lifetime from this hour to the dawning of the judgment day." The last words of the play, though, are Pegeen's; after dismissing Shawn (who assumed they now would marry), she breaks into wild lamentations: "Oh my grief, I've lost him surely. I've lost the only Playboy of the Western World."

Of all the characters, only Christy and Pegeen are dynamic, fundamentally changed by their experiences; the others are static. When he first arrives, Christy is shy, a frightened young man in a strange place; pressed into telling his story of patricide, he becomes a hero to the country folk, who admire, indeed envy, his daring. This first heroic pose, to be sure, is a sham, convincing though it is to the crowd; but his successive triumphs—athletic and amorous—unify appearance and reality, and when he leaves with his father at the end, Christy is a different person. He is the "gallant captain," Old Mahon "his heathen slave"; the son is "master of all fights from now." Pegeen, materialistic and realist, is the only one of the shebeen group who appreciates the dimensions of their experiences. She sees that just as Christy's arrival brought a measure of needed romance to a depressed community, so does his departure cause the debilitating despair to return. In other words, her enlightenment presages gloom, whereas Christy's circular journey from home and back is one of self-discovery and concomitant growth. As for the others, they first embrace Christy as a wayward adventurer whose story of far-off heroism is enticing, but they turn on him when he tries to kill his father again on their turf, for such a deadly reality in their midst is more than they can accept. Once he is gone, his story will be part of the local myth, a twenty-four-hour interlude to sustain their imagination but the significance of which they do not understand.

Impact of Event

"Play great success" read the telegram sent to William Butler Yeats (an Abbey director) after the first act of *The Playboy of the Western World* on its opening night, for the audience had applauded at the first curtain. The judgment was premature, however, because during the third act there was hissing, and a wire to Yeats later that night reported: "Audience broke up in disorder at the word shift." The play was scheduled for a week, and the Abbey determined to meet its commitment; according to Lady Augusta Gregory, another director, "It was a definite fight for freedom from mob censorship." Indeed, there were mobs the rest of the week.

At the second performance, an organized group of forty men with tin trumpets drowned out the actors beginning with the second act (the cast continued, unheard). Though police had been called, they merely stood by and watched. On subsequent evenings, however, supporters of the play (mainly from Trinity College) tangled with the trumpet-bearing protestors, so the police intervened, and newspapers reported each day of trials before magistrates who invariably were unfamilar with Synge's provocative play. The Dublin press clearly fanned the controversy, with one newspaper (in its review) calling the play an "unmitigated, protracted libel upon Irish peasant men and, worse still upon Irish peasant girlhood. . . . No adequate idea can be given of the barbarous jargon, the elaborate and incessant cursing of these repulsive creatures."

The audience had many problems with the play. They did not like the Widow Quin, a murderer of a different sort from Christy, though his seemingly cold-hearted second attempt to kill Old Mahon was difficult for them to accept; they also objected to Christy's biting of Shawn's leg in the third act. Pegeen's burning of Christy also bothered spectators who considered the act a meanness unbecoming a woman (and inconsistent with her character). What most provoked the audience, though, was Christy's comment that he would not "care if you brought me a drift of chosen females, standing in their shifts itself." The offensive word here is "shifts," for the reference to women's undergarments seemed to demean the traditional, idealized view of Irish womanhood. It also recalled the use of a shift as a symbol years earlier to mock Charles Stewart Parnell, the Irish nationalist leader whose political career was destroyed because of his adultery. Such objections to characterizations, language, and actions perhaps can be understood when this statement from the manifesto of the Irish National Theatre Society is considered: "We will show that Ireland is not the home of buffoonery and of easy sentiment, as it has been represented, but the home of an ancient idealism." Synge seemed to challenge this credo in *The Playboy of the Western World*, and fiercely nationalistic theatergoers were so offended that they failed to see beneath the surface to the substantive dramatic greatness of his work.

Synge, though, was not discouraged by his masterpiece's hostile reception. In a letter to his fiancée after the play's tumultuous opening night, he wrote, "It is better any day to have the row we had last night, than to have your play fizzling out in half-hearted applause."

Bibliography

Bloom, Harold, ed. *John Millington Synge's "The Playboy of the Western World."* New York: Chelsea House, 1988. Eight studies of the play follow the editor's introductory essay on the relationship between Christy's self-transformation and his language. The varied pieces are far-ranging in their approaches to character, meaning, and genre.

Gerstenberger, Donna. *John Millington Synge.* New York: Twayne, 1964. A thorough evaluation and analysis of the full range of Synge's work, including his poetry and prose as well as his drama. Also functions as a sound biography. The chapter on *The Playboy of the Western World* discusses its genesis, the first performances, later productions, and its U.S. reception.

Gregory, Lady. *Our Irish Theatre.* New York: Capricorn, 1965. First published in 1913, these reminiscences by a leader of the Irish national theater movement are useful for chapters on Synge and *The Playboy of the Western World*, including one on the 1911-1912 American performances. Of special interest is an appendix reprinting U.S. newspaper accounts of the controversial American tour.

Grene, Nicholas. *Synge: A Critical Study of the Plays.* Totowa, N.J.: Rowman and Littlefield, 1975. Introductory chapters on Ireland in general and the Aran Islands in particular provide useful background and place the plays in their proper context. The chapter on *The Playboy of the Western World* is unusually frank about ambiguities of meaning that confront a critic while at the same time being thorough and balanced.

Skelton, Robin. *J. M. Synge.* Lewisburg, Pa.: Bucknell University Press, 1972. By the general editor of Synge's collected works. This brief book, which begins with a short biographical sketch, has a helpful chapter on *The Playboy of the Western World*, which Skelton compares to other Synge plays.

Whitaker, Thomas R., comp. *Twentieth Century Interpretations of "The Playboy of the Western World."* Englewood Cliffs, N.J.: Prentice-Hall, 1969. Beginning with classic studies of Synge and his plays by William Butler Yeats and Una Ellis-Fermor as background, this collection reprints essays that present varied views of Christy, Synge's idiom, and his themes. Of special interest is the piece by Cyril Cusack, the Abbey Theatre director and actor.

Gerald H. Strauss

Cross-References

Freud Inaugurates a Fascination with the Unconscious (1899), p. 19; Shaw Articulates His Philosophy in *Man and Superman* (1903), p. 85; The Abbey Theatre Heralds the Celtic Revival (1904), p. 119; Yeats Publishes *The Wild Swans at Coole* (1917), p. 440; Joyce's *Ulysses* Epitomizes Modernism in Fiction (1922), p. 555.

THE DEUTSCHER WERKBUND COMBATS CONSERVATIVE ARCHITECTURE

Categories of event: Architecture; fashion and design
Time: October, 1907
Locale: Munich, Germany

The Deutscher Werkbund envisioned an ideal of a revitalized industrial Germany expressed through a total approach to architecture and the applied arts

Principal personages:
HERMANN MUTHESIUS (1861-1927), an architect, the primary founding father of the Deutscher Werkbund
HENRY VAN DE VELDE (1863-1957), an architect and lecturer, a principal figure in both the Jugendstil movement and the founding of the Werkbund
FRIEDRICH NAUMANN (1860-1919), an artistic and political activist and the only founder of the Werkbund who was present at the group's first meeting
PETER BEHRENS (1868-1940), an architect and designer for the Werkbund
WALTER GROPIUS (1883-1969), an architect with the Werkbund who later founded the Bauhaus
LUDWIG MIES VAN DER ROHE (1886-1969), an architect with both the Werkbund and the Bauhaus

Summary of Event

On the fifth or sixth of October, 1907, the first meeting of the Deutscher Werkbund (the name means "German alliance of craftsmen") took place in Munich. Munich was chosen as the meeting place because it was the home of the Werkbund's first president, Theodor Fischer; later, the Werkbund would be moved to Berlin. Only one of the Werkbund's founding fathers, Friedrich Naumann, was present at the organization's first meeting. The Werkbund was a society of architects, craftsmen, and manufacturers in which a new ideal of German industrial design was formed. The Werkbund was originally supposed to last eight years and was intended to raise the quality of life of the German public. The aim of the Werkbund was to promote functionalism in German life by producing designs for the newly evolving mechanized Germany. Prior to the founding of the Werkbund, the Jugendstil movement (the German version of Art Nouveau) was influential in Germany, but Jugendstil promoted an aversion to the machine. It became the mission of the Werkbund to compete with England in the production and export of industrially produced goods.

The founding of the Werkbund marked the move to combat conservative trends in architecture; however, the architects who were involved in the Werkbund dealt with architecture not only as buildings but as a total concept, including a building's inte-

rior space and the objects that would be utilized within the space. In terms of the applied arts, one only has to look at the lighting fixtures designed by Peter Behrens to discover their architectonic structure.

There were movements in Germany that preceded the Werkbund, such as the Künstler Kolonie (artists' colony) in Darmstadt, which was founded by Ernst Ludwig, Grand Duke of Hesse. The group of artists involved with the Künstler Kolonie included Joseph Maria Olbrich, from the Wiener Werkstätte (Viennese workshops), and Peter Behrens, who would later play a great role in the Werkbund. The Künstler Kolonie mainly utilized elements of Jugendstil, yet it was still a center for emerging industrial design.

The Wiener Werkstätte were important to the founding of the Werkbund as well, because the Werkstätte had direct contact with the English Arts and Crafts movement and with British Art Nouveau through the visits to Vienna of Charles Rennie Macintosh, a highly influential architect and designer from Scotland. The Werkstätte promoted experimentation and collaboration among its artists and craftsman.

Hermann Muthesius, a Prussian civil servant and architect, was the foremost spiritual father of the Werkbund. He spent much time in England practically as an industrial spy, taking notes on design, architecture, and even art education. Muthesius' activities brought about social and educational reforms in Germany, and his experiences in England were eventually published in three volumes. Muthesius foresaw the totality of design that would be a visual elevation of the German culture, an elevation in everything from architecture to table service. He wanted to form a link between German artists and industry in emulation of the English Arts and Crafts movement.

The vision of Muthesius caused artists to work together as a whole to reflect German culture. His views were well defined, and they exerted a strong presence over the fledgling Werkbund; Muthesius, however, chose to stay away from the group's first meeting in Munich for fear of unduly influencing its character.

Henry van de Velde, an architect, designer, and lecturer, was another founding member of the Werkbund. He was Belgian by birth and had come to Germany in the 1890's; he quickly became one of Germany's leading designers. Velde helped give birth to the Jugendstil movement, and he saw himself as cast from the same mold as William Morris, the founder of the English Arts and Crafts movement. He initiated reforms in Germany that dealt with art education and helped incorporate applied and decorative arts into art curricula. Velde was appointed head of the Weimar Art Academy in 1902, and while in that position, he promoted a dialogue between artisans and manufacturers. In his autobiography, however, he claimed to be the true spiritual father of the Werkbund and made no mention of Muthesius or Naumann.

Friedrich Naumann, who had been present at the first meeting of the Werkbund, was a former pastor who was politically active in the German parliament and as a founder of the National-Social Party. It was Naumann who wrote the Werkbund's first pamphlet, which laid out the Werkbund's principles.

Naumann also was a proponent of the idea that economic and political growth

increased together. It should be noted that he had artistic aspirations before the formation of the Werkbund, as he was associated with the Dresdener Werkstätte (Dresden workshops). During his time with the Dresdener Werkstätte, Naumann was in close contact with one of its members, Karl Schmidt-Hellerau. Schmidt-Hellerau had spent time in England and had come into contact with the Arts and Crafts movement; he had witnessed the progress being made in design and educational techniques. Naumann developed ideas for the Werkbund based on his dealings with Schmidt-Hellerau.

Muthesius, Velde, and Naumann were the primary founders of the Werkbund. They were strong personalities holding different points of view concerning what the Werkbund could be. Before the founding of the Werkbund, architecture was highly conservative, except for the emergence of Jugendstil. The Werkbund, though, was to break with the conservative ideas of architecture even more radically than the Jugendstil had.

Impact of Event

After the founding of the Werkbund, many exhibitions were held by the organization's members. Slowly, the targeted public began to get more and more involved.

In 1909, Behrens, the architect and designer who had been associated with the Künstler Kolonie in Darmstadt and was then a member of the Werkbund, became the artistic director for the Allgemeine Elektrizitäts-Gesellschaft (AEG), one of the world's largest manufacturing concerns. Behrens designed both applied arts and architecture for the AEG, including a large turbine factory in Berlin. The turbine factory design was initially considered a reworking of the neoclassic form, as strong, externally visual beams and concrete piers were used to support large panels of glass. Yet Behrens' design utilized glass and iron as expressive materials. The factory's interior was equally revolutionary, exemplifying a new concept of space in its use of a large, uninterrupted central hall and an overhead gantry. This engineering aesthetic meant freedom from the old tradition and was highly praised by the Werkbund.

Walter Gropius, an architect associated with the Werkbund, lauded the aesthetic vision of Behrens. Gropius finished his apprenticeship in Behrens' offices and claimed that the designs made by the members of the Werkbund helped him to grasp the nature of what a building could be. In 1911, Gropius designed the Fagus Shoe-Last factory. An internal steel-and-reinforced-concrete skeleton was visible in Behrens' turbine factory, which represented a decidedly nontraditional approach to form and construction. Gropius' Fagus factory, on the other hand, had no support visible from the exterior walls. The panels of glass appeared as though they were hanging; hence, they were called collectively a "glass curtain." In keeping with his vision of design, Gropius used no corner piers of concrete but only the simple, clean enframements of the glass panels.

The interior of the Fagus factory, like that of the turbine factory, was important to its function. The Fagus factory housed large, well-lit work areas, and there was efficient ventilation for the whole building.

Another important Gropius design for the Werkbund was the pavilion for the 1914 exhibition of the Werkbund in Cologne. The pavilion was to house examples of the new German ideals in industrial art. The entrance portion of the building reflected a neoclassic scheme, except that it was flanked by two glass-curtained staircases. Nothing like it had been designed before; the pavilion was dignified, yet it expressed the engineering aesthetic favored by the Werkbund. The central hall again was designed with an eye to emphasizing space. Attached to it, and thus breaking up the external, horizontal planes, was the Deutzer Gasmotorin pavilion, which held (as though it were a sacred object) a gas-driven turbine engine. The shape of this pavilion was a cross between a tempietto and a stepped pyramid. Once again, Gropius utilized the glass curtain.

During the Cologne exhibition, the Werkbund almost disintegrated over a debate sparked by then-president Muthesius and Velde that quickly developed into a standoff. The essence of the debate was the division of the Werkbund between the advocates of freedom of creation and experimentation, represented by Velde, and those who, like Muthesius, held that all artists and craftsmen should work together to attain greater quality of existing designs, making experimentation unnecessary. Muthesius' desire was to perfect and refine forms already in existence, whereas Velde saw Muthesius' stance as stagnation and believed that new forms and solutions were needed.

Young, vital artists such as Gropius were against Muthesius' view and found themselves in alignment with the "old guard" from the Jugendstil period such as Velde. There were calls for Muthesius' resignation and, finally, a bid for secession strongly backed by Gropius. Even Velde, however, did not want to break up the Werkbund; he merely wanted to steer it to his views. Behrens helped bring about some calm within the Werkbund, but as it turned out, what perhaps ultimately saved the Werkbund as an idea was the outbreak of World War I, which cut short the Cologne exhibition of 1914.

The formation of the Bauhaus was a direct result of the Werkbund. The Bauhaus was established at Weimar in 1919 by Gropius as a blending of two existing institutions: the Kunstgewerbeschule (industrial arts school), of which Velde was a founder, and the old Academy of Fine Arts. The Bauhaus held to the ideas of the Werkbund concerning a visual experience of the German culture; however, the Bauhaus was more realistic about pursuing its intentions, especially after World War I.

Gropius promoted the ideal of collective thought, using as an example the Gothic cathedral as a symbol for collective thought in the Middle Ages. In fact, the word "Bauhaus" originally meant a stonemasons' workshop set up at the base of a cathedral construction site. Another major aim of the Bauhaus was to unite everyday life with the industrial ideal.

One building that expresses the aims of Bauhaus architecture and functionalism is the Bauhaus building at Dessau, which opened in 1926. Gropius designed the Dessau building to encompass the variety of activities held within it, from photography to cabinetmaking. The interior space was designed with movable walls and dormitory

rooms that were studio space as well. The support structure was of reinforced concrete, and the external walls were composed of glass curtains.

In 1927, Ludwig Mies van der Rohe was appointed first vice president of the Werkbund. Under his guidance, the group participated in the Weissenhof Siedlung (Weissenhof homestead) exhibit in Stuttgart. The Werkbund section of the exhibition was called "Wohnung und Werkraum" (living and working areas).

Originally, all the areas were to flow together. Major young architects participated, including Gropius, Behrens, and Le Corbusier. Mies van der Rohe's apartment house dominated the whole area, for which he adapted the steel skeleton to the housing arena. Some of the steel supports could be seen on the interior of the apartments. Elements such as this freed the architecture of Weissenhof from the traditional. All the works at Weissenhof, moreover, were designed to be quintessentially functional and economical, as the living space in these dwellings was not great.

The Werkbund lasted until World War II, though it took a hiatus from late 1915 through 1918, during World War I. The Werkbund brought together different personalities with similar ideals; together, the artists and craftsmen of the Werkbund laid the groundwork for modern architecture and design.

Bibliography

Benevolo, Leonardo. *History of Modern Architecture.* 2 vols. Cambridge, Mass.: M.I.T. Press, 1971. Volume 1 offers a serious approach to the events leading up to the Werkbund and beyond. Contains subsections on Velde, Macintosh, and artists and architects of the Wiener Werkstätte. Volume 2 offers informative text concerning the premodern movements from the Werkbund to the Bauhaus, with good subsections concerning Behrens and Gropius. Both volumes are supplemented by black-and-white photographs and architectural drawings.

Benton, Tim, and Charlotte Benton, eds. *Architecture and Design, 1890-1939.* New York: Whitney Library of Design, 1975. An anthology of original articles including the writings of Muthesius, Velde, and Gropius. Of particular interest are the writings of Muthesius and Velde concerning the 1914 argument in Cologne. Many articles by Gropius; included are "The Development of the Modern Industrial Architecture" and "Programme of the Staatliche Bauhaus in Weimar, April, 1919."

Burckhardt, Lucius, ed. *The Werkbund: History and Ideology.* Woodbury, N.Y.: Barron's, 1980. This volume is a collection of thirteen essays on different aspects of the Werkbund such as social reform, architecture, and the group's aspirations of the Werkbund. Essays of particular note are "Between Art and Industry: The Deutsche Werkbund" by Julius Posener, which offers an overview of the Werkbund, and "The Thirties and the Seventies: Today We See Things Differently" by Burckhardt. Supplemented with black-and-white photographs and architectural drawings.

Campbell, Joan. *The German Werkbund.* Princeton, N.J.: Princeton University Press, 1978. A scholarly work detailing the history of the Werkbund from its founding in 1907 to 1934. Highly informative in terms of the political and personal struggles

that took place within the Werkbund. This volume also contains four appendices concerning leadership of the Werkbund, statistics on annual meetings and membership, and principal Werkbund publishers.

Giedion, Sigfried. *Space, Time, and Architecture*. Cambridge, Mass.: Harvard University Press, 1974. Contains a chapter that covers Gropius in the Werkbund and the Bauhaus. The author also discusses the influence of other artists such as Frank Lloyd Wright and Pablo Picasso on Gropius. The chapter on Mies van der Rohe contains solid information on the Weissenhof Siedlung.

Gropius, Walter. *The New Architecture and the Bauhaus*. Boston: Charles T. Branford, 1955. To read this informative book is to have a conversation with Gropius himself. The slant is toward the Bauhaus, but Gropius discusses the Werkbund as well. He explains his rationalization of architecture, his use of nontraditional materials, his Bauhaus curriculum, and even his views on town planning. This personal philosophy is supplemented by excellent black-and-white photographs of the Fagus factory and the Bauhaus that aid in the understanding of the impact of the glass curtain.

Sembach, Klaus-Jurgen. *Henry Van de Velde*. New York: Rizzoli, 1989. This monograph offers insight into Velde's work from the applied arts to architecture. The chapter entitled "Permanence in Changing Times" offers thorough information concerning Velde's Werkbund theater for the Cologne exhibition of 1914. Excellent photographs and architectural plans.

Tom Dewey II

Cross-References

Hoffmann and Moser Found the Wiener Werkstätte (1903), p. 79; Hoffmann Designs the Palais Stoclet (1905), p. 124; Behrens Designs the AEG Turbine Factory (1909), p. 219; Rietveld Designs the Red-Blue Chair (1918), p. 458; German Artists Found the Bauhaus (1919), p. 463; A Paris Exhibition Defines Art Deco (1925), p. 654.

PAVLOVA FIRST PERFORMS HER
LEGENDARY SOLO *THE DYING SWAN*

Category of event: Dance
Time: December 22, 1907
Locale: St. Petersburg, Russia

Anna Pavlova's memorable solo The Dying Swan *symbolized a new era in ballet to an appreciative audience around the world*

Principal personages:
 ANNA PAVLOVA (1881-1931), the legendary Russian ballerina whose many performing tours helped to spur interest in theatrical dance in the United States
 MICHEL FOKINE (1880-1942), the choreographer of *The Dying Swan*, whose ideas about expressive movement and its relationship to music modernized ballet
 SERGEI DIAGHILEV (1872-1929), the creator and director of the legendary and innovative company the Ballets Russes, with which Pavlova performed in 1909 in its debut season in Paris
 ISADORA DUNCAN (1877-1927), an American dancer who astonished Europeans with her unconventional movement, music choice, and theatrical presentation
 SOL HUROK (1888-1974), a Russian-American impresario who presented and promoted Anna Pavlova and her company in the United States
 MIKHAIL MORDKIN (1880-1944), a Russian dancer and choreographer who partnered Pavlova in her first American tours and later formed his own company

Summary of Event

On December 22, 1907, Anna Pavlova premiered *The Dying Swan*, a miniature ballet that was to influence multitudes. The two-minute solo quickly became her favorite and most successful piece. Choreographed by her colleague Michel Fokine, its expressive and lyrical choreography was a telling synthesis of the classical ballet tradition with its "modern" reforms. Pavlova's emotional interpretation of this synthesis, embodied in the Swan, is nothing short of legendary. Through her independent tours to cities across six continents between 1909 and 1931, Pavlova symbolized the New Russian Ballet in the mind of a vast, appreciative audience.

The Dying Swan was created in response to an invitation by the Imperial Opera. A benefit concert was being given in St. Petersburg's magnificent Maryinsky Theater (now the Kirov), and Pavlova was asked to participate. Fokine recommended the music—"Swan" from the 1886 work *Carnaval des Animaux* by Camille Saint-Saëns—realizing that this composition for mandolin would be an ideal vehicle for

the thin and graceful Pavlova. Excited by the suggestion, she asked him to create the dance. *The Dying Swan* was born.

The ballet's conception was simple. Wearing a traditional white tutu embellished with down feathers (designed by artist Léon Bakst) and a feathered headpiece, Pavlova portrayed the noble bird's struggle between life and death in an uncomplicated series of actions. Crossing the stage *sur les pointes* as if it were a shimmering pool of water, the Swan fluttered her arms in preparation for flight. Reaching the edge of an invisible precipice, she stopped short in the classic position of *attitude* (balancing on one pointe, the other leg extended back and bent at the knee). Suddenly, the Swan experienced sharp jolts of pain. She clasped her arms to her chest, moving haltingly to the footlights. There, she made a curving descent to the ground and, after protracted quivers, found everlasting rest.

Fokine recalled that the dance was choreographed in minutes, as he demonstrated the movements while Pavlova imitated him from behind. Then, she attempted it alone as he corrected her gestures and poses. The simple movements brilliantly combined classical ballet technique with a new emotional expressiveness. Without trying to amaze the audience with technical or acrobatic feats, the choreography instead consisted of a sequence of traditional *pas de bourrées*, or patterned steps, and sustained balletic positions.

If the movements of the feet were traditional, however, the movements of the arms were decidedly untraditional. Gone were the static and controlled arm gestures of nineteenth century ballet, devoid of meaning and corresponding only with specific positions of the feet. In their place were animate appendages that contributed to, rather than supported, the choreography. True to her character, Pavlova's arms were transformed into airy wings.

Almost improvisatory, the dance allowed Pavlova the freedom to impose her own mood on its movements, so that each performance was different and uniquely powerful. Pavlova revealed possibilities of expression through her movements hitherto unknown. Fokine remembered it this way: "It was like a proof that the dance could and should satisfy not only the eye, but through the medium of the eye should penetrate into the soul."

Unlike other ballets of the day, Pavlova's *Swan* did not depend for its effect on a sophisticated plot or lavish decor. Answering detractors who called the dance trivial, English dance critic Cyril Beaumont recalled *The Dying Swan* like this: "Those who never saw her dance may ask what she did that made it so wonderful. It is not so much what she did as how she did it. The emotion transferred was so overpowering that it seemed a mockery to applaud when the dance came to an end." Similar descriptions of *The Dying Swan* have been recorded by countless critics, observers, and fans.

Pavlova had long been known for her emotional portrayals, often being compared to the lyric Romantic ballerinas of the nineteenth century. She had been a principal dancer with the Russian Imperial Ballet since 1905, graduating from the Imperial Ballet Academy in 1899 and working her way up through the ranks of the company.

(She was allowed to bypass the *corps de ballet*, however, achieving the status of soloist from the start.) While her technical ability was limited by a frail body and weak ankles (often documented by critics as "her extreme femininity"), her reputation as a character dancer was established immediately. Clearly, she compensated for any technical deficiencies by developing and maximizing her expressive powers.

Michel Fokine was one of her childhood classmates, frequently partnering her in the traditional nineteenth century classical ballets. Typically, the choreography was designed to show off Pavlova's *pirouettes* (turns) and Fokine's grand jumps. This rigid formula emphasized fixed poses, stereotypical plots, and generally lacked dramatic unity. As in most ballets of the time, music merely signaled the starting and stopping of the dance. Rarely did it provide impetus or support for the movement itself.

Pavlova loved the applause that their duets invariably received, but Fokine was less than satisfied with the content of their performances. Gradually he began to choreograph for the Imperial Ballet on a regular basis, and his new ideas about the dance unfolded. In particular, he contemplated expressive over simply impressive movement and a more purposeful relationship to music. While Fokine's reforms were the product of careful deliberation, Pavlova instinctively unified movement and music when she danced. Because of this intuitive understanding, she was the perfect instrument with which to communicate Fokine's emerging ideas.

The premiere performance of *The Dying Swan* was the first of many. Pavlova continued to dance until her death from pneumonia at the age of forty-nine, presenting *The Dying Swan* to audiences throughout Europe, Australia, South Africa, Asia, and North and South America. Her signature piece became one of the most famous solos of the century and symbolized a new era in ballet. Although this new era began in Russia, Pavlova's inexhaustible tours introduced the possibilities for expression through dance to people well beyond her homeland. For this, Pavlova is included among the pioneers of twentieth century dance.

Impact of Event

In Russia, *The Dying Swan* was instantly recognized as a departure from traditional ballets. Its unadorned movement, its expressive use of the arms, and its use of classical, rather than made-for-ballet, music set the dance apart from well-known favorites such as *La Bayadere* or *Giselle* (two ballets with which, incidentally, Pavlova also had tremendous success in Russia). *The Dying Swan* represented a new direction for the Russian ballet, one that sought to elevate the dance to the level of symphonic music.

It is probable that these changes were inspired, or at least helped, by modern dancer Isadora Duncan's performances in Russia during the same period. Pavlova and Duncan had met and observed each other at work as early as 1904, the time of Duncan's first visit to Russia. It is likely that Pavlova and Fokine both were influenced by the American dancer's unrestricted, emotion-filled movement. In fact, writer Gennady Smakov has described the improvisatory and expressive nature of

The Dying Swan as "Duncanism on pointe."

The Dying Swan unified all aspects of its production, from music to movement, from Pavlova's costume to her hairstyle. As Fokine intended, it managed this while staying within the confines of classical technique (a difference between Pavlova's work and Duncan's). Pavlova supported Fokine's stance against the classical formula of nineteenth century ballet; more than anyone else, she was responsible for presenting his ideas of reform to early twentieth century audiences through her countless performances of *The Dying Swan*. She was less enthusiastic about the innovations of Sergei Diaghilev's Ballets Russes, however, and spent only one season with them in Paris although Fokine was then a principal choreographer for the company. She returned briefly to the Imperial Ballet, only to resign in 1913. Her real ambition was to travel alone.

Pavlova's influence ultimately extended across an estimated 350,000 miles and into the imaginations of millions of observers through some four thousand performances. In 1914, she organized and trained a small company of dancers who became her personal *corps de ballet*. The group toured regularly from then on; Pavlova's mission was to reach as many as possible with her art. "I want to dance for everybody in the world," she declared. Historian Arthur H. Franks has calculated that during one American tour in 1925, Pavlova's company appeared in seventy-seven towns during twenty-six weeks, performing a total of 238 times.

Between 1913 and 1925, her group was the only dance company regularly touring the United States. This constant visibility greatly contributed to the popularization of ballet in America. During the early years of Pavlova's travels, the United States was only beginning to accept dance as a legitimate pursuit, let alone an art form. Acceptance came only with tremendous resistance. Partly because of the country's conservative Puritan origins and partly because of the relatively recent rise of cities and towns (with their reputation for roughness and corruption), dancers in the United States were likely to be associated with saloons, gambling, and even prostitution.

In *Pavlova: Portrait of a Dancer* (1984), Pavlova herself wrote that she never realized how protected dancers were in Russia. She was astonished to discover that in the United States when people spoke of a woman becoming a dancer, "they used the same tone they would have whispered of her entrance into the oldest profession in the world." Without doubt, Pavlova stirred an appreciation and interest in ballet that contributed to a gradual change in its professional and artistic image. This paved the way for further developments in the dance of the twentieth century.

American impresario Sol Hurok promoted her in the United States, where she eventually commanded large fees for her performances. At first, though, she danced for meager crowds. Her American debut was in New York's Metropolitan Opera House with partner Mikhail Mordkin in 1910. Fearing little interest or even scorn, promoters advertised her performances as bringing "an art new to America" rather than stating outright that it was a ballet presentation. In other cities, Pavlova often performed in vaudeville houses on the same program with trained animal acts, jugglers, or comedians.

She persevered despite this indignity, certain that America would eventually respond to the ballet's enchantment. In many cases, Pavlova provided the first glimpse of ballet that her audience had ever experienced. She was the first significant ballerina to tour America since Fanny Elssler in 1841, and Pavlova's travels encompassed more ground. While Russian observers recognized radical departure from nineteenth century ballet in *The Dying Swan*, audiences in America and other parts of the world saw first and foremost the magic of ballet dance performed by a fairylike creature. Pavlova can be credited with sharing this magic with countless people who had little, if any, experience with theatrical dance. Certainly, she inspired the next generation of American ballet stars.

Pavlova changed the concept of the dance and the image of the dancer. Her ability to express the pathos of creatures such as *The Dying Swan*, her dynamic stage presence, and her compelling desire to share her dance even to her death made her one of the most famous dancers of the twentieth century. In her depiction of *The Dying Swan*, she demonstrated the expressive powers of an art form that was just beginning to be recognized in the United States, and she heralded a new era of Russian ballet to those who had long loved the old.

Bibliography

Fonteyn, Margot. *Pavlova: Portrait of a Dancer.* New York: Viking Press, 1984. A beautiful book featuring passages of Pavlova's own writing interspersed with historical commentary by dancer Margot Fonteyn. Lavishly illustrated with photographs, performance programs, and drawings from throughout Pavlova's career. Also includes a selective chronology of the dancer's life.

Franks, Arthur H., ed., in collaboration with the Pavlova Commemoration Committee. *Pavlova: A Biography.* London: Burke, 1956. This small volume contains ten selections about Pavlova written by, among others, her promoter Sol Hurok, one of her partners, Laurent Novikov, critic Arnold Haskell, and dancer and choreographer Michel Fokine. Franks's introductory biographical sketch of Pavlova's life is useful, although some dates are inaccurate.

Ivchenko, Valerian. *Anna Pavlova.* Translated by A. Grey. Paris: Brunhoff, 1922. Reprint. New York: Dover, 1974. In this elegant book, the author describes Pavlova's life and repertoire in detail and provides lengthy quotations by other observers to substantiate his own views. Also included are seventy-five photographs and drawings, some in color.

Lazzarini, John, and Roberta Lazzarini. *Pavlova: Repertoire of a Legend.* New York: Schirmer Books, 1980. Written by the founders of the Pavlova Society, this oversize book describes each dance in Pavlova's repertoire and briefly explains its historical significance. Includes a biographical sketch, an essay discussing the use of photographs as historical evidence, and an extensive bibliography representing current scholarship.

Smakov, Gennady. "Anna Pavlova." In *The Great Russian Dancers.* New York: Alfred A. Knopf, 1984. Offers a valuable historical perspective on Pavlova's life and

art. The author, a Russian émigré critic, places the ballerina in the context of other Russian dancers and achievements. The book as a whole represents current scholarship in its exploration of the lineage of Russian classical dancers of the twentieth century.

Alecia C. Townsend

Cross-References

Duncan Interprets Chopin in Her Russian Debut (1904), p. 113; Diaghilev's Ballets Russes Astounds Paris (1909), p. 241; Fokine's *Les Sylphides* Introduces Abstract Ballet (1909), p. 247; *The Firebird* Premieres in Paris (1910), p. 269; *L'Après-midi d'un faune* Causes an Uproar (1912), p. 332; *The Rite of Spring* Stuns Audiences (1913), p. 373.

SCHOENBERG BREAKS WITH TONALITY

Category of event: Music
Time: 1908-1909
Locale: Vienna, Austria

By composing Das Buch der hängenden Gärten, *Arnold Schoenberg demonstrated that melody and harmony could be liberated from traditional tonal controls.*

Principal personages:

ARNOLD SCHOENBERG (1874-1951), an Austrian composer and teacher who revolutionized the melodic and harmonic structure of classical music

ALEXANDER VON ZEMLINSKY (1872-1942), an Austrian composer who befriended Schoenberg and provided much of his formal training

GUSTAV MAHLER (1860-1911), a Bohemian-Austrian composer and patron of Schoenberg and the leading symphonist of his generation

RICHARD STRAUSS (1864-1949), a German composer and early supporter of Schoenberg

ANTON VON WEBERN (1883-1945), an Austrian composer, one of Schoenberg's pupils and a major follower

ALBAN BERG (1885-1935), an Austrian composer, another pupil of Schoenberg's and an exponent of his methods

Summary of Event

The world of classical music was ripe for revolution in the early twentieth century: Insurrections of various grades of severity broke out nearly everywhere and would continue in the years preceding and immediately following World War I. Vienna was no exception. As capital of the Austro-Hungarian Empire, it was in the vanguard of the German-speaking cultural world, the inheritor of the tradition of such great composers as Wolfgang Amadeus Mozart, Ludwig van Beethoven, Franz Schubert, and Johannes Brahms. It represented the cultural dignity of Old World Europe. Even that tradition, though, was split. Since the 1870's, patrons of music had been bitterly divided over the choice between the structurally conservative Johannes Brahms and the shockingly innovative and grandiose Richard Wagner. Disputes between the factions had led to actual brawls in the streets.

The conflict was probably more emotional than substantive, having more to do with generation gaps and changing fashions than anything else, but part of it was technical. The conservatives preferred the old-fashioned harmonic progressions supposedly practiced by Brahms; many apparently did not hear his decidedly nonstandard enhanced chords. He seemed somehow stable, like the bedrock of the old standard hymnals. Wagner's music, though, could not be related to this context at all. He seemed to wander from key to key, and his resolutions did not provide the same

sense of finality. Furthermore, since his death in 1883 things had gotten worse. New composers such as Anton Bruckner, Richard Strauss, and Gustav Mahler—to say nothing of the Frenchman Claude Debussy—aggressively sided with Wagner in expanding the standard harmonic range.

Into this rift the young Arnold Schoenberg wedged; early in his career, he would lift the conflict to a new orbit with the composition of *Das Buch der hängenden Gärten* (1908-1909; the book of the hanging gardens). The son of a Jewish shoe-seller of the Czech tradesman class, Schoenberg began violin lessons at age nine and started composing duets spontaneously, without formal instruction. At first, he was aided in this by his teacher, who used duets in lessons and encouraged the boy to bring his own. Shortly afterward, learning from a biography of Mozart that his hero composed in his head, Schoenberg began imitating this. Upon entering *Realschule* (nonclassical high school for nonprofessionals) at eleven, he found a cultural climate even more encouraging. There he met Oskar Adler, who provided lessons in elementary theory and ear-training and invited him to compose and arrange for a string trio. This trio eventually became a quartet, with Schoenberg trying all the parts and writing the group's music from encyclopedias.

Forced to leave school before graduation by the death of his father, Schoenberg began clerking at a bank (a job he hated) and continued composing and playing. In 1893, a new director, the young Alexander von Zemlinsky, took over the amateur orchestra Polyhymnia, making a lifelong friend of Schoenberg, then the orchestra's cellist. Zemlinsky was able to apply his formal conservatory training to fill in the gaps in Schoenberg's theoretical education, but the pupil soon left the instructor behind. Before long, a few commissions enticed him to devote himself to music alone; one day in 1895, he came home to announce, "My boss has gone bankrupt; I will never work in a bank again." Supporting himself by conducting various workers' choruses and by scoring operettas and arranging others' compositions, he concentrated on composing. His first major success came with a String Quartet in D of 1897-1898 that he never published, although it won widespread praise. After struggling spiritually and emotionally, he followed this with a breakthrough: *Verklärte Nacht* (1899; transfigured night), for string sextet, both transferred the symphonic poem to the chamber-music level and expanded Wagnerian tonal ambiguity.

For the next ten years, Schoenberg published a series of works that led directly to the revolutionary *Das Buch der hängenden Gärten* and the theoretical book *Harmonielehre* (1911; *The Theory of Harmony,* 1947). First came the *Gurrelieder* (1900-1911; songs of Gurre), for solo voices, speakers, choirs, and a vast orchestra. This monumental two-hour work, part song cycle, part oratorio, part melodrama, part symphonic opera, was remarkable even in its original form; Schoenberg, though, revised its orchestration in 1911 to emphasize its transition from Wagner to the new, free-tonal world of the twentieth century. This work brought him to the attention of Strauss, who both secured him his first teaching appointments and recommended that he set Maurice Maeterlinck's 1892 drama *Pelléas et Mélisande* to music. The resulting massive symphonic poem of 1903, *Pelleas and Melisande,* expanded his use

of counterpoint (the interweaving of separate melodic lines), opening new harmonic possibilities.

At that point, Schoenberg and Zemlinsky founded a Society of Creative Musicians, which included Strauss and Mahler as well as Schoenberg's new students Anton von Webern and Alban Berg and which pioneered radical new works, especially Schoenberg's own. String Quartets in D minor and F sharp minor of 1906 and 1907 provoked hostile reactions, to the point of being hissed off the stage. The final break came with the 1909 composition and 1910 performance of *Das Buch der hängenden Gärten*, a setting of fifteen poems from Stefan George's collection of the same title. In it, Schoenberg attempted to discover a musical equivalent to George's poetic expressionism, which distorted normal language to force new, otherwise unrealizable perceptions and to express extreme states of feeling. Schoenberg accomplished this by abandoning the conventional concepts of keys and tonal relationships and exploiting the potentialities for dissonance in the heretofore unused "accidental" tones within keys. He thus invented a musical parallel to George's dislocations of language. The result revolutionized music. Schoenberg followed this up by publishing *Harmonielehre* in 1911, which provided a theoretical justification for his innovations and created an unrestricted tonal basis for post-nineteenth century music.

Impact of Event

By making it possible for musicians to use the entire tonal spectrum in their compositions rather than having to restrict themselves to conventional, predetermined patterns, Schoenberg revolutionized classical music. He accomplished a break with musical traditions as radical as the parallel movements in art and literature from Impressionism to expressionism and from representation to nonrepresentation. It was a stunning feat. Like many revolutions, it transcended and repudiated what had seemed to be standards of conventional propriety. To the established, it looked like the replacement of order by chaos, and the reaction was furious. Schoenberg seemed to have destroyed the foundations of classical music and to have subverted the reassurances of traditional harmony. Dissonance (an ambiguous term) would reign; the specter of lawless atonality grinned ominously, although Schoenberg explicitly rejected the term, preferring "polytonality" to suggest the opening up of new possibilities rather than the rejection of the past.

Of all the great modernist innovators of the World War I period—T. S. Eliot, James Joyce, and Franz Kafka in literature; Marcel Duchamp and Wassily Kandinsky in painting; Frank Lloyd Wright in architecture; Schoenberg and Igor Stravinsky in music—Schoenberg has provoked the greatest and most lasting hostility, and he has gained less eventual acceptance, even among professionals. Stravinsky's *The Rite of Spring* (1913), for example, which caused a riot at its first performance, has become a modern classic; at any time in the late twentieth century, at least forty recordings of the piece have been in print simultaneously. There have never been more than two of *Das Buch der hängenden Gärten*, and sometimes none. Schoenberg's big sellers have been the late Romantic works with which he began. Similarly, al-

though *Harmonielehre* has regularly been in print, it remains a great unread testament. Schoenberg resembles a prophet without much of a following.

Part of the reason for such neglect is the lack of appeal of much of the music produced by those following Schoenberg's methods. Although in retrospect this does not hold true for his own music and that of his leading adherents, such as Alban Berg and Anton von Webern, the idea of generating music from an arbitrary sequence of tones treated as a fixed melodic and harmonic unit struck most listeners as mechanical and sterile. It looked as if it would create music that was formulaic, routine, abstract, and dead, if not officiously offensive. Furthermore, the immediate public response to the actual music was to reject it forthright. Complex historical and social reasons lay behind this reception; those on the Brahms side of the musical rift, for example, had become so entrenched that they were reacting adversely to any innovation. They had already been howling about Debussy's deviations, most of which are quite inoffensive to later ears. At the outset of World War I, much of Europe already seemed to be searching for enemies.

For all this, Schoenberg ended up affecting twentieth century music more profoundly than any other person. Even Stravinsky, who prided himself on leading in musical innovations, eventually came under the sway of Schoenberg's theories; he recognized ultimately that removing tonal limitations modified music more deeply than any other new technique. For Schoenberg had proposed the most radical change possible—the abolition of tonality-centered music. That is, he argued that the conventional theory of diatonic harmony developed since the time of Bach and ensconced in every music conservatory in the Western world should no longer be practiced. To Schoenberg, diatonic harmony had reached a dead end; within that system, little new could be done. Composers were doomed to repeat endlessly the same lifeless chordal patterns. In fact, his theory in part merely acknowledged what composers in practice had long been doing. Wagner, Mahler, Strauss, and Modest Mussorgsky, as well as the composers of the Schoenberg circle, had long exploited the so-called accidental tones of the keys, abandoning definite tonal centers and building chords on forbidden intervals.

Yet Schoenberg did more than merely legitimize experimentation; he laid a basis for a totally new kind of music, and he did this, in part, by returning to the roots of Western music. So profound was this change that it dominated the teaching and conception of classical music from 1925 to 1950. No composer working during that generation could operate without at least acknowledging Schoenberg's influence. Furthermore, no one working after that time could ignore the implications of the revolution he accomplished, for he had changed the way music was understood. By that time, it could finally be seen that he was not simply a theoretical crank promoting a freak, a lunatic scientist reborn as a monster musician. He had recognized that counterpoint, abandoned since Bach in favor of diatonic harmony, was saturated with unexplored potentialities, whereas standard harmony was rapidly running out of possibilities.

Schoenberg was undoubtedly a pivotal figure in twentieth century music. The

extent of his influence can be seen in the fact that he remained controversial and provocative several generations after his first proposals. The most profound theoretician of the century, he also created an enduring body of musical masterworks, including the much-undervalued *Das Buch der hängenden Gärten*. Ultimately, the theoretical foundation established by Schoenberg in *Harmonielehre* would be developed by him and others into the system of twelve-tone, or serial, music, an important aspect of modern music, but one tangential to the main thrust of Schoenberg's revolution.

Bibliography

Berg, Alban. "Why Is Schönberg's Music So Hard to Understand?" *The Music Review* 13 (August, 1952): 187-196. Though seemingly dated, this article provides one of the simplest and clearest nontechnical explanations of Schoenberg's ideas as reflected in his music. Pitched primarily at the lay listener, it is fresh and direct. Written by a friend, student, and colleague, it also bears the stamp of authenticity.

Grout, Donald Jay, and Claude V. Palisca. "Schoenberg and His Followers." In *A History of Western Music*. 4th ed. New York: W. W. Norton, 1988. Although formally a textbook for college music majors, this is accessible to the general reader. Grout and Palisca cover the full range of Schoenberg's innovations; their explanations are models of clarity, providing a balanced overview with examples, illustrations, and bibliography.

MacDonald, Malcolm. *Schoenberg*. London: Dent, 1976. The single best source on Schoenberg, covering all aspects of his life and work. Focuses directly on the pivotal period of *Das Buch der hängenden Gärten*, showing how his work led up to and then away from this moment. Photographs, copious musical examples, full critical apparatus.

Morgan, Robert P. "The Atonal Revolution." In *Twentieth Century Music: A History of Musical Style in Modern Europe and America*. New York: W. W. Norton, 1991. Morgan covers the musical and aesthetic aspects of Schoenberg's work and relates them to the course of the entire century. Examples, bibliography, and complete index.

Rosen, Charles. *Arnold Schoenberg*. New York: Viking Press, 1975. The standard musicological biography of Schoenberg. Rosen, however, has a knack of translating technical material into understandable terms, and he shows it here. Photographs, illustrations, musical examples, bibliography, and index.

Schoenberg, Arnold. *Style and Idea*. Edited by Leonard Stein; translated by Leo Black. London: Faber, 1975. Schoenberg's attempt to explain himself to the general reader. It has rich material and reveals why he had a reputation as a brilliant and encouraging teacher. English was not his native tongue, however, and he does not dodge difficulties.

Smith, Joan A. *Schoenberg and His Circle: A Viennese Portrait*. New York: Schirmer, 1986. The most complete account of Schoenberg's social and intellectual

relationships. Smith is particularly acute in drawing connections between musical theory and the cultural milieu. Photographs, musical examples, illustrations, bibliography, and index.

Webern, Anton. *The Path to the New Music.* Edited by Willi Reich; translated by Leo Black. Bryn Mawr, Pa.: T. Presser, 1963. Webern's version of the evolution of Schoenberg's theories, along with discussion of contributions of Berg and himself. Good anectodal and theoretical material, but not completed before his death (and not recovered until a while after), so that some aspects of the book are not complete.

James Livingston

Cross-References

Busoni's *Sketch for a New Aesthetic of Music* Is Published (1907), p. 166; The Futurists Issue Their Manifesto (1909), p. 235; Webern's *Six Pieces for Large Orchestra* Premieres in Vienna (1913), p. 367; Schoenberg Develops His Twelve-Tone System (1921), p. 528; Berg's *Wozzeck* Premieres in Berlin (1925), p. 680; Berg's *Lulu* Opens in Zurich (1937), p. 1078.

THE GHOST SONATA INFLUENCES MODERN THEATER AND DRAMA

Categories of event: Theater and literature
Time: January 21, 1908
Locale: Stockholm, Sweden

August Strindberg's The Ghost Sonata *was a critical and commercial failure when first produced, but the play was later recognized as a masterpiece and had a strong effect on the development of modern drama*

> *Principal personages:*
> AUGUST STRINDBERG (1849-1912), a Swedish novelist and playwright
> AUGUST FALCK (1882-1938), a young Swedish actor and director, co-founder of the Intimate Theater

Summary of Event

In 1907, the year in which he wrote his play *Spöksonaten (The Ghost Sonata,* 1916), fifty-eight-year-old August Strindberg was the preeminent Scandinavian dramatist alive; Henrik Ibsen had died the previous year. Strindberg's plays, like Ibsen's, had been recognized (although not unequivocally) as masterpieces by critics, but they were far from receiving equitable treatment in the theater. His early, fairly realistic plays had been produced with some success mostly in other countries—including Denmark, France, and Germany—but the plays he composed in the highly productive phase following his "Inferno" period (a period of mental breakdown between 1894 and 1897) were both more personal and theatrically more challenging. *Till Damaskus, forsta delen* (1898; *To Damascus I,* 1913) had only one (unsatisfactory) staging in 1900, and the seminal *Ett drömspel* (1902; *A Dream Play,* 1912), which was considered unstageable, was not produced until 1907.

Inspired by a European movement toward smaller, more intimate playing spaces that had begun with André Antoine's Théâtre Libre in Paris in 1887 and culminated in the opening of Max Reinhardt's Kammerspiele (chamber theater) in Berlin in 1906, Strindberg was searching for a way to produce his plays independently, and he began to develop a form of drama suited to such a confined environment: the chamber plays. At the same time, the young actor August Falck had formed a touring company and given Strindberg's controversial *Fröken Julie* (1888; *Miss Julie,* 1912) its first successful Swedish production. When he brought the production to Stockholm, Falck discussed with Strindberg the possibility of creating a small theater dedicated to the playwright's work.

In late 1907, the plans began to take shape. Falck rented a tiny space that had to be altered extensively. The theater was outfitted with 161 seats in fifteen rows and had a stage that measured approximately thirteen by twenty feet. The interior was appealingly decorated (with a large bust of Strindberg in the foyer), and the stage was framed by reproductions of Arnold Böcklin's pictures "The Island of the Living"

and "The Island of the Dead," the latter of which would become the final image of *The Ghost Sonata*. Strindberg stipulated (against the conventions of the time) that there be no bar or smoking, that performances were to last less than two hours, and that the text of plays performed be on sale at the theater. There were about twenty original actors and actresses in the Intimate Theater, among them Anna Flygare, Manda Björling, and Helge Wahlgren (who played the lead role of the student in the production of *The Ghost Sonata*). The actors, though excited about their association with Sweden's most famous author, were young and relatively inexperienced, as was Falck. Thus the Intimate Theater, the first small theater to concentrate exclusively on one playwright, opened on November 26, 1907, with a production of Strindberg's chamber play *Pelikanen* (*The Pelican*, 1962).

The immediate response was less than enthusiastic, and Falck had to substitute a revival of *Miss Julie* when two other chamber plays were also ill received. On January 21, 1908, the Intimate Theater first presented *The Ghost Sonata*. Again, critics were baffled by the play, which they found highly eccentric and even suspected of being a practical joke on Strindberg's part. A critical and commercial failure, it lasted a mere fourteen performances and was not staged again until 1916, when Max Reinhardt proved, with a boldly expressionistic production in Berlin, that it was not only highly theatrical but also one of the key plays of the modern canon.

In the play, a young student, Arkenholz, who is gifted with "second sight" and is able to see apparitions hidden to others, falls in love from afar with a young lady named Adèle, who is the daughter of a respected colonel and who lives in a house in Stockholm. (The play is set in front of and inside two rooms of this house.) An old man, Hummel, wins the young man's confidence and arranges his invitation to a supper at the colonel's house, but it soon becomes clear that the inhabitants of the house—the colonel, an old spinster, a mummy who sits in a closet and babbles like a parrot, a recently dead consul, a manservant, and others—are mutually tied together by a web of hypocrisy and lies: They are "ghosts" of their own past. As Hummel imposes himself on their "ghost supper" and proceeds to "strip" them of their self-deceptions, he himself is suddenly revealed to be not the benevolent crusader for truth he affects to be but instead a kind of monster, blood-sucking and murderous. Faced with his guilt, he is forced to commit suicide. In the final scene, Adèle and the student share a few moments of happiness, but they are interrupted by a vampiristic cook, who torments the family by depriving them of nourishment. Adèle finally succumbs to an illness, which is a reflection of the corruption surrounding her; as the student prays for her, she dies. The final image is of Böcklin's "Island of the Dead."

The Ghost Sonata rests on a syncretistic philosophy informed by the mystical theology of Emanuel Swedenborg (who saw humans as passing through a series of unmaskings or "vastations" after death) but also by the concepts of Buddhism, particularly "maya" (the veil of illusion that masks life) and "samsara" (the wheel of eternal rebirth). This "spiritual" action of the play initiates the student into the pains and mysteries of human existence and emphasizes Strindberg's belief in the

necessary reconciliation between life and death through the shedding of all illusions and guilty secrets.

Strindberg had written *The Ghost Sonata* rapidly, in about two weeks in March of 1907. It is designated as "opus three" of the chamber plays, which he consciously modeled on Ludwig van Beethoven's sonatas; *The Ghost Sonata*, accordingly, follows Beethoven's Piano Sonata No. 17 in D Minor. Indeed, the play's three movements can be shown, in mood, tempi, and thematic treatment, to possess a definite likeness to the sonata scheme of exposition, execution, repetition, and coda. Following a musical logic and a kind of dreamlike associative technique liberated Strindberg from the customary considerations of intrigue, psychology, or plot, and he created a very complex and idiosyncratic texture of experience.

Impact of Event

The failure of *The Ghost Sonata* in its first outing convinced directors that it was unstageable. In spite of Reinhardt's demonstrative rehabilitation of the play on that score, there have been few professional productions since, and very few successful ones.

Even with an unillustrious production history, *The Ghost Sonata* is one of the first truly modern dramas, and perhaps the quintessential modern play. It is not by chance coincident with other developments that were to shape modernity: Sigmund Freud's analysis of dreams and the unconscious, Pablo Picasso's experiments with cubism, and Albert Einstein's postulates for the Theory of Relativity. In *The Ghost Sonata*, a host of unconscious motivations brought to light and a kind of causal and temporal relativity that could be called "cubist" are at work. Strindberg had put it thus in his *Oppna brev till Intima Teatern* (1911-1912; *Open Letters to the Intimate Theater*, 1959): "No predetermined form is to limit the author, because the theme determines the form." This statement nonchalantly refuted a century of well-made plays and opened the path for a drama of great formal freedom, a drama of images, moods, and symbols that followed a spiritual rather than an external pattern of truth.

What is more, the chamber plays seemed to anticipate the development of film long before it was recognized as a separate form or an art. *The Ghost Sonata* is genuinely cinematic in its structure; acts 2 and 3 are set up like reverse-angle shots of each other, and the short, pointed scenes seem to anticipate film narrative. Accordingly, the Swedish film and theater director Ingmar Bergman has characterized *The Ghost Sonata* as the greatest Swedish play and one of the ten most important plays in dramatic literature; he himself has directed it three times.

Together with other Strindberg plays such as *To Damascus I* and *A Dream Play*, *The Ghost Sonata* became a decisive precedent for the German expressionist theater movement between 1910 and 1925. The play's subjective viewpoint, episodic structure, and concern with spiritual redemption closely aligned it with plays by Oskar Kokoschka, Georg Kaiser, and Ernst Toller. In its unmediated mixture of the trivial and the supernatural, the realistic and the fantastic, however, *The Ghost Sonata* also points toward the Surrealist theater (for example, the work of Guillaume Apollinaire). The great

theater theorist and visionary Antonin Artaud considered *The Ghost Sonata* one of the few plays worthy of being produced at his short-lived Théâtre Alfred Jarry.

In America, Strindberg's influence was unexpectedly profound. Eugene O'Neill was so impressed with Strindberg that many of his early plays are virtual paraphrases of Strindberg's work; later famous plays such as *The Emperor Jones* (1920) or *Desire Under the Elms* (1924) are Strindbergian in tone or 'opic. O'Neill initiated the first American production of *The Ghost Sonata* in New York at the Provincetown Playhouse in 1924. He declared Strindberg "among the most modern of moderns," and in his Nobel Prize acceptance speech in 1936, he credited Strindberg with inspiring his dramatic career. Even the plays of Tennessee Williams reflect Strindberg's heritage more than Ibsen's; Edward Albee, too, is deeply indebted to Strindberg.

Though it may be said (as Martin Esslin has argued) that *The Ghost Sonata* represents a "direct source" for the plays of the Theater of the Absurd, its metaphysical conclusion is altogether different. Read carefully, the play is not a manifesto of existential hopelessness and despair but rather an affirmation of a moral order and of spiritual transcendence. The two playwrights associated most closely with the Theater of the Absurd, Eugène Ionesco and Samuel Beckett, denied any influence from Strindberg. Strindberg, however, was highly esteemed by Albert Camus and Jean-Paul Sartre, two French authors who were the originators of the existentialist philosophy that nurtured the Theater of the Absurd; Camus and Sartre, in fact, were founders of a Strindberg society. Yet it is Harold Pinter's drama, where the irrational and inexplicable lurks under the guise of the realistic, in which one can locate the same insecurities of language and truth, the same dread notion that reality itself is inaccessible to casual perception, as one can find in Strindberg.

In spite of all overt and implied influence, *The Ghost Sonata* as such stands alone; Strindberg's vision was too personal, his style and voice too distinctive to find many direct imitators. Yet modern drama is unthinkable without it.

Bibliography

Bryant-Bertail, Sarah. "The Tower of Babel: Space and Movement in *The Ghost Sonata.*" In *Strindberg's Dramaturgy*, edited by Göran Stockenström. Minneapolis: University of Minnesota Press, 1988. Bryant-Bertail's is the standout article among several in this scholarly collection that address the play. Though not meant for the casual reader, the article repays the effort needed to read it. Offers a clear and persuasive insight into the sign systems and hidden meanings at work in *The Ghost Sonata*.

Meyer, Michael. *Strindberg.* New York: Random House, 1985. By far the most carefully researched and exhaustive of all Strindberg biographies; considered the authoritative narrative of his life. Based largely on Strindberg's voluminous output of letters, from which Meyer quotes at length. Sticks to facts and avoids speculation. Illustrations are sparse but sufficient; the bibliography rather slim.

Morgan, Margery. *August Strindberg.* New York: Grove Press, 1985. A brief but competent overview of Strindberg's life and work, best suited as introductory

reading for those unfamiliar with the author. Contains a solid ten-page discussion of *The Ghost Sonata*, its motifs, and its meanings. A good place to start before going on to Meyer's work.

Rothwell, Brian. "The Chamber Plays." In *Strindberg: A Collection of Critical Essays*, edited by Otto Reinert. Englewood Cliffs, N.J.: Prentice-Hall, 1971. One of the quintessential essays on all four of Strindberg's chamber plays; puts *The Ghost Sonata* into the context of its less successful (but equally interesting) "sister" plays. In very readable prose, Rothwell analyzes the themes of guilt and redemption and the mystic thinking that pervades Strindberg's late plays.

Stockenström, Göran. " 'Journey from the Isle of Life to the Isle of Death': The Idea of Reconciliation in *The Ghost Sonata.*" *Scandinavian Studies* 50 (Spring, 1978): 133-149. Made somewhat less than accessible only by the fact that the text is quoted in the Swedish original, this excellent essay provides a very convincing explanation of the religious and metaphysical motifs in *The Ghost Sonata* and gives an interpretation of the "spiritual" action of the play. Requires familiarity with the text.

Strindberg, August. *The Ghost Sonata*. In *Selected Plays*. Translated by Evert Sprinchorn. Minneapolis: University of Minnesota Press, 1986. One of several translations of *The Ghost Sonata*, Sprinchorn's is both readily available and quite reliable—although the tone is perhaps too often colloquial, or Americanized, to satisfy philologists.

_____. *Open Letters to the Intimate Theater.* Translated by Walter Johnson. Seattle: University of Washington Press, 1966. These letters, memoranda that Strindberg sent to August Falck and the actors at the Intimate Theater because he disliked attending rehearsals, represent the author's thinking on matters of acting, theater, and drama (his own and others) during the period of the chamber plays. Essential clues to Strindberg's mind, art, and method.

Törnqvist, Egil. *Strindbergian Drama: Themes and Structure*. Atlantic Highlands, N.J.: Humanities Press, 1982. Törnqvist's scholarly work is meticulous in its analysis of themes and references; it succeeds in decoding the complex structure of and making sense of some of *The Ghost Sonata's* darker passages. A very interesting chapter compares and evaluates the nine existing translations of *The Ghost Sonata*, an important consideration for English-language readers.

Ralf Erik Remshardt

Cross-References

Stanislavsky Helps to Establish the Moscow Art Theater (1897), p. 1; Freud Inaugurates a Fascination with the Unconscious (1899), p. 19; Reinhardt Becomes Director of the Deutsches Theater (1905), p. 145; Strauss's *Salome* Shocks Audiences (1905), p. 151; Sartre and Camus Give Dramatic Voice to Existential Philosophy (1940's), p. 1174; *Long Day's Journey into Night* Revives O'Neill's Reputation (1956), p. 1726; Esslin Publishes *The Theatre of the Absurd* (1961), p. 1871.

THE SALON D'AUTOMNE REJECTS
BRAQUE'S CUBIST WORKS

Category of event: Art
Time: Summer, 1908
Locale: Paris, France

The rejection of Georges Braque's six paintings by the Salon d'Automne led to the first exhibition of his paintings with "cubes" and to the launching of cubism, the most revolutionary art movement of the twentieth century

Principal personages:

GEORGES BRAQUE (1882-1963), a French painter whose exhibitions at Daniel-Henry Kahnweiler's gallery in 1908 and at the Salon des Indépendants in 1909 helped launch the cubist movement

DANIEL-HENRY KAHNWEILER (1884-1976), a leading German art dealer who gave Braque a chance to show the paintings rejected by the Salon d'Automne

LOUIS VAUXCELLES (1870-?), a Parisian art critic who first used the word "cubes" in reference to Braque's paintings

HENRI MATISSE (1869-1954), a leading painter and one of the Salon d'Automne jurors who rejected Braque's works, who satirically referred to the "little cubes" in Braque's paintings

PAUL CÉZANNE (1839-1906), a revolutionary Impressionist painter known for his "architectonic" landscapes, who inspired Braque to change his Fauvistic style to a more conceptual one

PABLO PICASSO (1881-1973), Braque's colleague in the founding of cubism, who had an intense creative rapport with Braque between 1909 and 1914

Summary of Event

In February of 1907, Georges Braque's work was a success when it was presented at the Salon des Indépendants in Paris. Braque caused a stir with his Fauve-like creations such as *The Port of Antwerp* (1906), *The Port of Ciotat* (1907), and *Little Bay at La Ciotat* (1907). The Fauves, or "wild beasts," a group of prominent artists including Henri Matisse, André Derain, Maurice de Vlaminck, Albert Marquet, and Othon Friesz, used pure, wild colors for expressive purposes; Braque, an admirer of the Fauves' work, emulated their style. Less than two years after Braque's success at the Salon des Indépendants, however, his newer canvases would be rejected by these same men, who objected to Braque's evolving Cézanne-influenced style. After the death of Paul Cézanne in 1906 and the exhibit of a huge number of Cézanne's works at the Salon d'Automne in 1907, Braque became a fervent disciple of the great Post-impressionist. In fact, at L'Estaque, a coastal village near Marseilles where Cézanne

had completed many of his Postimpressionistic, architectonic landscapes, Braque began emphasizing, in the manner of Cézanne, geometric construction and color not as emotive or decorative forces but as means of creating an intellectual aura through strong, simplified planes. Braque's *View from the Hôtel Mistral* (1907), for example, demonstrates his fondness for Cézanne's conception of nature as a series of planes, cones, and spheres and for the artist's use of heavily outlined forms with a great deal of height or with an upward, thrusting placement. A further influence on Braque's earlier, accepted Fauve-like style was his introduction in the spring of 1907 to Pablo Picasso at Picasso's studio in rue Ravignan, where Picasso was coincidentally completing his revolutionary *Les Demoiselles d'Avignon*. According to Jean Leymarie in *Braque* (1961), Braque was overwhelmed by Picasso's similar Cézannesque style, his decimation of a traditional, naturalistic approach to subject matter, and his stylistic influences, which included Hellenistic painting, Iberian sculpture, African masks, and works from Oceania. By the time Braque painted his *Standing Nude* in December, 1907, heavier volumes and thick outlines, foreshortened space, a toned-down palette of grays and browns, distinct anatomical distortions, and the rhythms of African art were visible in his work.

Therefore, in the early summer of 1908, when Braque returned for the third time to L'Estaque to paint landscapes, his style was radically different from the one he had demonstrated at the Salon des Indépendants in February, 1907. His *Houses at L'Estaque*, for example, reflected a structural approach to landscape, a dissociation of form and color, multiple volumes with numerous vanishing points, planes of darks truncating light areas, and a palette of muted purple-grays, greens, and warm ochres—features resembling Picasso's earlier style. Therefore, Braque was angry and disappointed when, after enthusiastically having decided to show his six unorthodox canvases at the Salon d'Automne in late summer of 1908 instead of at the Salon des Indépendants (where almost anyone could exhibit new work), he was promptly rejected. Although two paintings were "reclaimed"—the prerogative of each voting juror if he chose—Braque withdrew entirely from the Salon d'Automne. He quickly accepted the invitation of a friend, Daniel-Henry Kahnweiler, a leading German art dealer, to exhibit his works. Thus, from November 9 to November 28, 1908, Braque displayed twenty-seven works in a one-man show at Kahnweiler's gallery.

Braque's exhibition gave the French public its first glimpse of the movement that would soon be labeled "cubism." Matisse criticized Braque's strange paintings with "cubes," and Louis Vauxcelles, a famous Parisian art critic of the period, derided Braque's paintings, calling his human subjects deformed and metallic-looking. In a review published November 14, 1908, Vauxcelles remarked that Braque "despises form and reduces everything, landscapes and figures and houses, to geometric patterns, to cubes." In reviewing an exhibit of Braque's works at the Salon des Indépendants in the spring of 1909, Vauxcelles again described Braque's work in terms of "cubic oddities" and as a style of "Peruvian Cubism"—the first use of the word "cubism" itself. Braque's *Harbor in Normandy* (produced in the early spring of

1909), one of the two paintings exhibited at the show, illustrates clearly Braque's new style of cubist fragmentation. Not until later was this style associated with Picasso, although the public grew to associate cubism primarily with Picasso (probably because of the Spaniard's more dominant, aggressive nature, which tended to eclipse the more retiring, less socially forceful personality of Braque).

Impact of Event

Thanks to Braque, still life as a genre of painting regained the prominence that it had enjoyed during the period of Claude Monet and Paul Cézanne. Suddenly, the human world and humankind's needs were elevated to the status of fit subjects for art. Receptacles of food and drink, newspapers, playing cards, musical instruments, and books became prime subject matter, as they had been during the seventeenth century golden age of still-life painting and in the later works by the famous genre painter Jean Siméon Chardin. Works such as _Still Life with Musical Instruments_ (1908) and _Guitar and Fruit Dish_ (1909) are examples of Braque's revitalization of the still-life painting.

Braque's rejection by the Salon d'Automne in 1908 indirectly gave birth to cubism, especially the earlier Cézanne phase, or so-called analytical phase, which began in 1909. The analytical style is characterized by the depiction of pictorial planes that are opened, with a concomitant buildup of space and volume, by fragmentation of form (or subject matter), oftentimes with a series of criss-crossing, moving verticals and diagonals, and by an avoidance of color, with a strong emphasis on multiple perspectives of an object from diverse angles and on refracted light from multiple sources. Examples of Braque's works of this phase include _Glass on a Table_ (1910), _Violin and Palette_ (1909-1910), and _Piano and Mandola_ (1909-1910).

Budding cubism also intensified the Braque-Picasso bond, which was an unusual happening in the art world. This meeting of two great artistic minds gave birth to the painting ideology that shook the early twentieth century. Between 1909 and 1914, Braque and Picasso frequently lived near each other; in fact, both artists, upon returning to Paris in the late summer of 1909, had studios together in Montmartre. During the summer of 1910, both artists worked apart (Braque at L'Estaque again and Picasso at Cadaqués on the Costa Brava); however, their collaboration throughout the rest of the year produced works that were very similar. In the summer of 1911, both artists painted together at Ceret in the French Pyrenees. The heavily abstracted works of Braque—for example, _The Portuguese_ (1911) and _Woman Reading_ (1911)—appear almost indistinguishable from Picasso's works of the period, such as his famous painting dedicated to their mutual art dealer, _Portrait of Daniel-Henry Kahnweiler_ (1910). The only significant stylistic differences between the artists at the time concerned Picasso's emphasis on form and on the human body (unlike Braque's spatial concerns) and his love of browns and earthtones (in contrast to Braque's use of greens). Later, Braque even experimented with new materials worthy of artistic expression, creating a whole new art form, _papier colle_. Scraps of wallpaper, matchbooks, pieces of cardboard, and string intermingled with the drawing medium; real

scraps coexisted with illusory sketched objects in works by Braque such as *Fruit Dish and Glass* (1912) and *Still Life with Playing Cards* (1913). Picasso, too, sharing Braque's art ideology, created the first collage in 1912 by adding a piece of oilcloth to a painting, a technique he later extended to include the use of cards and stamps.

Important as cubism was in the art world, the movement led by Braque and Picasso was only one aspect of a broad cultural revolution that saw similar experimentation occur in almost every intellectual discipline. Cubism found parallels in the novel spatial-temporal explorations of the writer James Joyce, the composers Arnold Schoenberg and Igor Stravinsky, and even the physicist Albert Einstein. Schoenberg's adoption of the twelve-tone chromatic scale and Stravinsky's elevation of atonality and polytonality were analogous to the breaking of a traditional-historical presentation of reality in the works of Braque and Picasso. Joyce and Einstein's very different experiments with multiple time and movement were both in many ways similar to the cubists' use of simultaneity of vision (in which many facets of an object are presented simultaneously from diverse angles). Sigmund Freud's perception of divided conscience also relates well to the principles of fragmentation implicit in cubism.

According to Janet Flanner in *Men and Monuments* (1957), cubism (and the works of Braque) influenced other famous art groups and artists of the modern period. The English Cubist movement led to the formulation of vorticism; Italian artist Umberto Boccioni incorporated cubistic philosophy into his school of Futurism; and Fernand Léger experimented with pipe-shaped cubism, which he labeled "tubism." Other leading international painters and sculptors who were influenced by cubism included Paul Klee of the *Blaue Reiter* group of German expressionists; Kazimir Malevich, a Russian cubist who formulated Suprematism; Piet Mondrian, a Dutch artist whose theories introduced "neo-plasticism"; Rumanian sculptor Constantin Brancusi; and Russian sculptor Aleksandr Archipenko. Frenchman Marcel Duchamp created a scandal at the 1913 New York Armory Show with the "dynamic cubism" of his *Nude Descending a Staircase*. Furthermore, cubism seeped into other artistic media in the early twentieth century. Cubistic sets and costumes designed by Picasso became stylish, and cubism influenced much early twentieth century architecture and interior design. There evolved, too, cubistic furniture, fashions, textile designs, graphics, typography, cartoons, architectural designs, and even "cubistic" cuisine. David Smith's huge, environmental sculptural-cubism works and Andy Warhol's pop art carried Braque's ideology into postmodern times.

In 1922, Braque was finally invited to exhibit at the Salon d'Automne, fourteen years after the salon had first rejected his radical creations. In the course of those years, Braque had helped revolutionize not only the international art scene and much of modern culture but also the way in which people saw their world. His pictorial masterpieces captured the new dynamism and psychological complexity of a highly technological, multifaceted modern age and people. By the time Braque was asked to exhibit at the Salon d'Automne, the viewing audience and society were ready. Not only were all of the fourteen recent works he submitted sold, but he also became,

finally, a huge success with the ordinary French public—as well as with the citizens of the world.

Bibliography

Flanner, Janet. "Master." In *Men and Monuments*. New York: Harper, 1957. An excellent long chapter (approximately seventy pages) giving an in-depth look at Braque and biographical information concerning his art friends, French society, his major relationships, and his war service. Many little-known facts about "the master" and his works. Somewhat dated, the last decade of Braque's life is left uncovered. No color reproductions of art works; contains six black-and-white photographs of the major figures.

Leymarie, Jean. *Braque*. Translated by James Emmons. Paris: Éditions D'Art Albert Skira, 1961. A thorough, precise commentary on the diverse styles of Braque. Very fine color plates of the major works of the major phases of the artist; a useful chronological survey at the beginning of the text.

_____. *Georges Braque*. Munich: Prestel-Verlag, 1988. Text published in conjunction with the exhibition *Georges Braque* held at the Guggenheim Museum in New York (June-September, 1988). Three outstanding introductory essays, excellent color plates with accompanying critical blurbs, eighty-five paintings, twenty-five drawings, and three works of sculpture.

Richardson, John. *Georges Braque*. Greenwich, Conn.: New York Graphic Society, 1961. An inspiring introduction to Braque and his major pictorial phases. Great interjections of Braque's own comments to the author during various interviews throughout the years. Fine color plates (thirty-four) and black-and-white plates (forty-three), along with pertinent critical commentaries. A useful index of plates.

Constance A. Pedoto

Cross-References

Les Fauves Exhibit at the Salon d'Automne (1905), p. 140; Artists Find Inspiration in African Tribal Art (1906), p. 156; The Futurists Issue Their Manifesto (1909), p. 235; Apollinaire Defines Cubism in *The Cubist Painters* (1913), p. 337; Avant-Garde Art in the Armory Show Shocks American Viewers (1913), p. 361; Picasso Paints *Guernica* (1937), p. 1062.

THE CHRISTIAN SCIENCE MONITOR IS FOUNDED

Category of event: Journalism
Time: November 28, 1908
Locale: Boston, Massachusetts

The appearance of The Christian Science Monitor *marked a major effort by a religiously sponsored publishing group to report news events in a style marked by scrupulously nonsectarian objectivity.*

Principal personages:

MARY BAKER EDDY (1821-1910), the founder of the Christian Science religion and principal mover behind the *Monitor*'s establishment

ERWIN D. CANHAM (1904-1982), a correspondent for a small Maine newspaper who rose to a position as one of the *Monitor*'s best-known editors

COLONEL HERBERT JOHNSON, the *Monitor*'s circulation manager from 1927 to 1941

Summary of Event

The Christian Science Monitor published its first edition on November 28, 1908. Foremost among the paper's creators was Mary Baker Eddy, the founder of the Christian Science religion. Eddy's religious movement was based on a philosophy that exercised a significant influence on the paper's nature and evolution.

Among the key elements underlying Christian Science was the belief that humankind is created in the image of God and that this inherently spiritual human nature, being a reflection of an infinitely good Creator, is endowed with the intelligence to overcome evil and material limitation. Prayer and spiritual healing were also essential components of the church's teachings. Eddy envisioned *The Christian Science Monitor* as an important tool in fulfilling the healing mission she had established for her church by confronting and addressing the social and moral problems that faced the world. By bringing national and international events into clearer focus for its readers, the paper would combat the apathy, indifference, and despair that were common responses to world affairs through its spiritually enlightened, problem-solving journalism.

Although religious teachings per se were never considered to be among the essential goals of *The Christian Science Monitor*, its founders did, from the outset, reserve a special section of each issue, called the "Home Forum," for editorials on a wide variety of religious subjects. The first of these was written and signed by Eddy herself, but policy underwent a change almost immediately. Soon after the November, 1908, issues, this key section of the paper was published without an author's name.

In this respect, the *Monitor* was quite different from its earliest forerunner, *The*

Christian Science Journal, which had been founded in 1883 by Eddy as a monthly publication with the specific mission of airing and developing denominational questions. A second, somewhat different periodical, *The Christian Science Sentinel*, had been established by Eddy in 1898. While still devoted to religious articles, this weekly publication included a substantial number of news stories. The emphasis placed on the major issue of the day, the Spanish-American War, was an early indication of what the public at large would see when the *Monitor* appeared a decade later: a notable sensitivity to issues that had worldwide importance, especially questions of peace between nations.

One of the main problems in the expansion of journalism during the first decade of the twentieth century was the increasing sensationalism used by publishers to attract the attention of readers and to guarantee large circulation numbers. The trend was associated with two major figures in American journalism, William Randolph Hearst and Joseph Pulitzer. This phenomenon was unattractive to people who, without necessarily wishing to retreat to religiously sponsored publications to escape the sensationalism of the daily press, might be attracted to a newspaper dedicated to higher standards in the choice of subjects discussed and in methods of presenting the news.

When the idea of *The Christian Science Monitor* was first broached, therefore, the paper's primary emphasis was drawn from principles suggested to Eddy by fellow churchman John L. Wright, a Boston newspaperman, in a March, 1908, letter: "Many would like a paper that takes less notice of crime, etc., and gives attention . . . to the positive side of life, to the activities that work for the good of man and to the things really worth knowing." Wright emphasized the need for "daily newspapers that will place principle before dividends."

Given such considerations, the unique features of the first issues of *The Christian Science Monitor* are more easily understood. A considerable amount of attention was given, for example, to the issue of the U.S. arms budget and its discussion in Congress. The *Monitor* was careful to try to view this subject with attention to all of its ramifications (for employment in economic sectors that were not specifically military, for example) rather than to offer a simple journalistic summary. Similarly, the *Monitor*'s coverage of a locally vital issue—the Charles River dam project in Boston Bay—was accompanied by consideration of the wider implications of such environmental control systems; the paper also discussed the dam's effect on the river's banks, since the Massachusetts Institute of Technology was one of the first institutions to be founded on the reclaimed areas of Boston's Back Bay.

Such emphasis on major news events and their wider repercussions did not prevent the *Monitor* from providing more popular forms of information, most notably sports news. From its earliest issues and for a number of years, page three of the paper was reserved for news of sporting events.

As soon as a publication structure existed in Boston, the paper was in a position to internationalize its sources for news information through the organization of the Christian Science church. A notable example of this was the contribution of Freder-

ick Dixon, the head of the church's Committees on Publication for Great Britain and Ireland. Until the *Monitor* grew large enough to send salaried correspondents to foreign capitals, it was church committee heads such as Dixon who sent regular clippings from the foreign press that could be integrated (with acknowledgement of their sources) into the news columns of the Boston paper.

Impact of Event

The death of Mary Baker Eddy in December, 1910, posed no immediate transitional problems for the recently established newspaper. In 1914, however, it fell to Archibald McLellan, a former editor of the *Monitor* and the church's director following Eddy's death, to confront the future by confirming his support for the editorial leadership of Dixon, a man who had earlier served as an associate editor at Eddy's suggestion.

Although the paper maintained steady progress in providing quality news from different points around the world over the next few years, its second decade witnessed some tensions, particularly where questions of possible censorship were concerned. Because the *Monitor* would not limit itself to hiring only Christian Scientists to carry out the business of gathering and editing the news, some reporters objected when the paper's authorities suggested wording changes in articles in order to avoid the appearance of acceptance of "morally questionable" practices that were being reported. Specific efforts were made to make staff and higher editorial personnel maintain journalistic standards without imposing moral judgments. Nevertheless, as late as the mid-1950's, a term such as "death" was consciously avoided in the *Monitor*'s pages; "passing on" was preferred, because it reflected more closely the Christian Science religious belief concerning the end of life.

Another area that reflected the *Monitor*'s concern for maintaining different standards from those of more typical daily newspapers was its treatment of "society news." Only organizational activities of recognized social groups were considered worthy of news coverage; practically nothing appeared in the newspaper's columns about personal or family social activities or honors.

The one area in which the *Monitor*'s particular philosophy can be seen most visibly overlapping with editorial policy toward the news involves discussions of medical questions. Because Christian Science places strong emphasis on freedom of individual decision in confronting the effects of disease, the paper tended on several occasions to devote major attention to issues that might affect such individual rights. An example occurred in the early 1940's, when policymakers in the United States were considering the adoption of national medical health programs. The paper's keen interest in such subjects, and particularly in questions of medical ethics, would mount steadily as, in the last decades of the twentieth century, issues such as genetic engineering, euthanasia, and abortion became topics of international debate.

Although it would be inaccurate to suggest that church religious policies ever dominated the content of *Monitor* articles or editorials, tension sometimes occurred between church directors and those placed in the highest positions of responsibility

for the paper's management. One such case occurred less than a decade after Eddy's death and hastened the retirement of editor Frederick Dixon; another case occurred nearly seventy years later, when budgetary cuts and shifts in emphasis toward different media audiences precipitated the resignation of another highly respected editor, Kay Fanning.

Whatever effect internal debates may have had over key personnel appointments and retirements over the years, there is no doubt that *The Christian Science Monitor* succeeded in maintaining and expanding its image as a highly professional and objective newspaper. This success was marked by the pattern of its street circulation figures and, increasingly, the growth in the number of regular subscribers paying for mail delivery of the paper to their homes in many countries around the world.

The paper's first circulation records from April, 1909, showed a total of 43,000 subscribers. This figure was to nearly double by 1917 (to 81,558) and then peak at 123,080 in 1919. The immediate postwar figures were considerably lower, but growth in circulation became marked after the mid-1920's, largely because of the effective efforts of Colonel Herbert Johnson, who applied his prior experience as a business executive to the task of circulation management between 1927 and 1942. Circulation thus exceeded 170,000 in the mid-1950's and continued to expand nationally and internationally during the last four decades of the twentieth century.

Bibliography

"Downsized." *The Nation* 247 (December 5, 1988): 588. Discusses the resignation of Kay Fanning, editor of the *Monitor* and first woman president of the American Society of Newspaper Editors, over drastic cuts in the *Monitor*'s staff and the number of pages it could contain. Preference is suggested for the new magazine *World Monitor.*

Canham, Erwin D. *Commitment to Freedom.* Boston: Houghton Mifflin, 1958. This book represents a comprehensive history of *The Christian Science Monitor*, from several decades before its actual founding in 1908 to its fiftieth anniversary in 1958. By that time, Erwin Canham had served thirteen years as the *Monitor*'s editor. The book is filled with a number of vignettes concerning the personal characteristics of many of the individuals associated with the paper's first fifty years of operation.

Childs, M. W. "The *Christian Science Monitor.*" *Saturday Evening Post* 218 (September 15, 1945): 14-15. Published soon after the end of World War II, this article commended the *Monitor* for its ability to adhere to high standards of journalism in a very difficult environment for international news.

Helm, Leslie. "The Church That Would Be a Media Mogul." *Business Week*, September 26, 1988, 53-54. Discusses a major and controversial shift in publications emphasis: introduction of a Christian Science documentary information program for television and the launching of *World Monitor* as a subscription magazine.

Quint, W. D. "Telling the Good Men Do." *New England* 41 (September, 1909): 98-104. An early article about the paper, appearing in a regional magazine spe-

cializing in issues of interest to New Englanders. Covers both the founding philosophy and responsible personnel of *The Christian Science Monitor*, which was less than a year old at the time.

Byron D. Cannon

Cross-References

Lippmann Helps to Establish *The New Republic* (1914), p. 385; The First Pulitzer Prizes Are Awarded (1915), p. 407; Wallace Founds *Reader's Digest* (1922), p. 549; Luce Founds *Time* Magazine (1923), p. 577; Ross Founds *The New Yorker* (1925), p. 648; Luce Launches *Life* Magazine (1936), p. 1031; Buckley Founds *National Review* (1955), p. 1683; *60 Minutes* Becomes the First Televised Newsmagazine (1968), p. 2136; *USA Today* Is Launched (1982), p. 2507.

ELGAR'S FIRST SYMPHONY PREMIERES TO ACCLAIM

Category of event: Music
Time: December 3, 1908
Locale: Manchester, England

Edward Elgar's First Symphony premiered in Manchester, England, and provided a new foundation for English symphonic music

Principal personages:
SIR EDWARD ELGAR (1857-1934), a composer who revitalized the English symphonic tradition and inspired younger composers to follow his example
HANS RICHTER (1843-1916), an influential German conductor who championed Elgar's music in England and Germany
GENERAL CHARLES GEORGE ("CHINESE") GORDON (1833-1885), the Victorian military hero whose martyrdom at the siege of Khartoum inspired Elgar to write a suitable musical commemoration of him

Summary of Event

Edward Elgar's determination to write a symphony helped both to revitalize the nearly moribund tradition of serious English music and to inspire the next generation of English composers, which included such figures as Ralph Vaughan Williams and Havergal Brian, to follow in his steps. Still widely perceived as the composer of imperialistic England, Elgar was himself a contradictory mixture of bluff self-assurance, naïve patriotism, and Victorian heartiness on the one hand, and incisive introspection, remorseful nostalgia, and painful remorse on the other. He struggled hard to rise above neglect, class and religious prejudice, and his own quixotic personality to earn his position as the foremost English composer since Henry Purcell at the end of the seventeenth century.

Having first achieved international attention for his *Variations on an Original Theme (Enigma)* (1899), Elgar consolidated his position as a great orchestral writer with his First Symphony (1908), which confirmed his status as the greatest English composer of his time and England's first great symphonic writer. Elgar grew up in a culture that was not conducive to the writing of opera, and he poured much of his youthful creative impulse into the creation of religious and patriotic oratorios. Elgar's characteristic mood, however, was introspective and lyrical rather than extroverted and dramatic. Elgar had long dreamed of writing a symphony in commemoration of the heroic death of General Gordon at Khartoum in the Sudan in 1885. Although no explicit reference to Gordon survives in the final form of the First Symphony, it is easy to see what aspects of Gordon's character appealed to Elgar: heroism, dignity, massive reserve, and Christian suffering.

The most striking features of the symphony, such as the mercurial changes of disposition and the nostalgia bordering on melancholy, seem to owe more to Elgar's

own temperament than to the general's. As a friend of Richard Strauss, Elgar could be said to have written his own version of Strauss's *Ein Heldenleben* ("A Hero's Life") in the First Symphony, although without Strauss's swaggering and overt humor. One British critic, noting the symphony's similarity to Strauss's work, has remarked that "in both we see a personality struggling against opposing elements." Unlike Strauss, though, Elgar never was confident enough to seize the opportunity to shock and outrage; nor did he adapt on a regular basis to shifts in taste, as Igor Stravinsky did. Like Gustav Mahler, his great contemporary symphonist, he was drawn almost neurotically to nostalgia for a lost childhood and the expression of melancholy emotions.

The composition of the symphony was completed on September 25, 1908, and Elgar dedicated the score to Hans Richter. The Halle Orchestra of Manchester gave the premiere on December 3, 1908. The symphony appeared with no specific "program," or explanatory ideas, Elgar having given up any specific association with General Gordon. As he explained to a friend, "There is no programme beyond a wide experience of human life with a great charity (love) and a massive hope in the future." Elgar chose not to verbalize emotions that were clearly and artfully woven into his music.

The first movement begins quietly, with a drumroll that introduces a dignified melody in A-flat major, presented first quietly, with the simplicity of a hymn tune, and then with the volume and dignity to justify Elgar's expressive marking *nobilmente e semplice* ("nobly and simply"). Over an A-flat held by the basses, a new, vigorous tune in the contrasting key of D is introduced, and the remainder of the long first movement is, in a sense, a competition between the A-flat and D tunes, in which the initial A-flat tune prevails in the subdued conclusion.

The second movement, in F-sharp minor, has the effect of the traditional symphonic scherzo. The first violins play a sixteenth-note figure that will reappear in the third movement with a new rhythmic configuration; this is superseded by a brisk, march-like figure that has an ominous quality. This too yields to a new passage in B-flat major in which the woodwinds chirp out a more hopeful tune. The movement ends with a sustained F-sharp that leads, without interruption, into the third movement, which is one of the finest, most reflective pieces in all of Elgar's music and which constitutes a wistful, philosophical reflection. A drooping, nostalgic theme for the clarinets offers the most poignant moment in the entire symphony, as it efficiently distills the prevailing sense of nostalgia and regret.

It is fair to say that the final movement does not fully unify all the rich strands of the symphony. The first movement is unusually full of ideas, and the third movement achieves a level of spiritual resignation that makes the final movement seem slightly redundant, if not actually anticlimactic. The final movement begins in D minor and quickly switches to a brisk, rhythmically aggressive section, thus forming an obvious contrast to the philosophical mood of the third section. The symphony ends with an elaborate summing up of earlier thematic materials and a strong restatement of the original motto theme, in the symphony's opening key of A-flat major.

Impact of Event

Throughout his career, Elgar was torn between the demand for boisterous musical exercises and the nostalgic, introspective pieces he preferred. Both aspects of Elgar's stance as a professional composer are evident in the First Symphony. Elgar learned how to pour his subjective feelings into relatively strict musical genres. As one of his most sympathetic critics, Diana McVeagh, has noted, "the symphonies are his dramas." Although deeply attracted to the music dramas of Richard Wagner, with their long melodic lines and capacity for the leisurely exposition of philosophical ideas, Elgar retained the formal discipline of the great composers in the German symphonic tradition, such as Johannes Brahms and Antonín Dvořák.

The symphony's finale is undoubtedly complicated, containing references to earlier themes in the symphony and perhaps overly ambitious in attempting to work out the formal design according to the German symphonic tradition. Another friendly critic, Basil Maine, has noted that "Elgar often begins with a profusion of ideas and works towards their reconciliation." There are good reasons why Elgar opted for an elaborate finale: The work was his first and perhaps overdue contribution to the symphonic tradition, and Elgar, who was largely self-taught rather than formally trained, was eager to show his mastery of the form. Also, Elgar was a late Romantic composer, enjoying his most creative period at the very moment when contemporary composers were accustomed to working with massive forces. For example, Gustav Mahler, with his *Symphony of a Thousand* (1907), and Arnold Schoenberg, with his *Gurrelieder* (1900-1911), were simultaneously creating works that required unusually large orchestral and choral forces. Within a few years, deliberately modernist composers such as Igor Stravinsky, Eric Satie, and Edgard Varèse would make a point of replying to the lush, overlong late Romantic masterpieces with short, sardonic sketches.

Having achieved two hundred performances in the year following its premiere, Elgar's First Symphony obviously found a sympathetic audience in its composer's homeland. One of Elgar's biographers observed that "no English work had ever before received such rapturous and immediate acclaim." Remarkably, the symphony enjoyed a hundred performances in England in the first year of its existence, with eighty-two performances around the world in 1909 alone. It was acclaimed by the conductor Hans Richter, Elgar's sympathetic interpreter, as "the greatest symphony of modern times, written by the greatest modern composer." As such great symphonic writers as Mahler, Jean Sibelius, Carl Nielsen, and Sergei Rachmaninoff were all alive and active at the time, it is easy to dismiss Richter's compliment as partisan zeal. Yet Elgar's First Symphony, like his other masterworks, has a distinctive voice of its own that has kept it near the front rank of the symphonic repertory.

By his success, Elgar inspired the next generation of English composers to write symphonies and find sympathetic audiences for them. Ralph Vaughan Williams found a way to incorporate folk tunes in his nine symphonies, and Havergal Brian proved even more industrious in his symphonic output. Two other English composers who shared Elgar's birth year of 1857, Gustav Holst and Frederick Delius, were not drawn

to writing symphonies, but they certainly profited from the way in which Elgar's *Variations on an Original Theme (Enigma)* brought new prestige to the English orchestral tradition. English composers born in the twentieth century, such as Benjamin Britten and Michael Tippett, likewise profited from the audience for serious orchestral and choral music that Elgar had helped to create.

Elgar quickly began work on his Second Symphony (1910-1911). The Second Symphony does not enjoy the high critical esteem of the First Symphony, although it is possible that its finale is superior, since Elgar allowed his personal voice to take precedence over formal considerations. In the tone poem *Falstaff* (1913), Elgar discovered that William Shakespeare's fat knight was probably more liberating a role model than General Gordon had been.

Elgar himself collected sketches for yet another symphony, but he never got around to assembling them into a coherent work following the creative decline that set in after the shocks of World War I and his wife's death in 1918. George Bernard Shaw and others urged Elgar to proceed with the Third Symphony, but Elgar preferred to indulge in a new phase of his career. He concentrated on preserving performances of his great works on recordings, and he was one of the earliest of the great composers to comprehend the impact of the phonograph. He left deathbed instructions that no one should try to assemble the fragments of the Third Symphony into a performing version, and his wishes have been respected.

Bibliography

Kennedy, Michael. *Portrait of Elgar.* 2d ed. London: Oxford University Press, 1982. A substantial and sympathetic study, although largely superseded by the work of Jerrold Moore.

McVeagh, Diana. "Edward Elgar." In *The New Grove Twentieth-Century English Masters.* New York: W. W. Norton, 1986. Provides a solid, quick survey of the composer's life and work.

Maine, Basil. *Elgar: His Life and Works.* 1933. Reprint. Bath, England: Cedric Chivers, 1973. The earliest long critical analysis of Elgar's music, written in the twilight of Elgar's life and overly defensive about its subject.

Moore, Jerrold Northrop. *Edward Elgar: A Creative Life.* Oxford, England: Oxford University Press, 1984. The authoritative life of England's greatest composer after Purcell, sensitive to his artistic achievement and contradictory personality.

Simpson, Robert, ed. *Elgar to the Present Day.* Vol. 2 in *The Symphony.* Harmondsworth, England: Penguin, 1967. Provides a good overview of the historical development of the tradition. Includes a good short study of Elgar by David Cox.

Stasny, John, and Byron Nelson. "From Dream to Drama: *The Dream of Gerontius* by Newman and Elgar." *Renascence* 43 (Fall, 1990/Winter, 1991): 121-135. Gives a psychological study of Elgar's breakthrough work, in which Elgar confronted the implications of his introversion, his Catholicism, and his admiration for General Gordon.

Byron Nelson

Cross-References

Vaughan Williams Composes His Nine Symphonies (1903), p. 90; Sibelius Conducts the Premiere of His Fourth Symphony (1911), p. 292; Mahler's Masterpiece *Das Lied von der Erde* Premieres Posthumously (1911), p. 298; Hindemith Advances Ideas of Music for Use and for Amateurs (1930's), p. 816; Britten Completes *Peter Grimes* (1945), p. 1296.

BEHRENS DESIGNS THE AEG TURBINE FACTORY

Category of event: Architecture
Time: 1909
Locale: Berlin, Germany

An artist's design for a modern factory building proved that functionalism and creativity could coexist in the architecture of the industrial age

Principal personages:

PETER BEHRENS (1868-1940), an artist-turned-architect who led German architects toward a sober, nonhistorical style and identification with the industrial world

PAUL JORDAN (1854-1937), an engineer and corporate executive who brought the Deutscher Werkbund's radical approach to art and industry into the AEG corporation

WALTHER RATHENAU (1867-1922), a corporate executive and statesman who, as head of AEG, encouraged industry's involvement in culture and politics

KARL BERNHARD (1854-?), an engineer who collaborated with Behrens on the design of the AEG turbine factory

OSKAR LASCHE (1868-1923), an engineer and manager who directed AEG's turbine factories in Berlin

Summary of Event

The relation between industry and creative design was one of the most troubling problems in European culture at the start of the twentieth century. The huge scale and utilitarian motives of the age's new structures—steel bridges, railroad sheds, factories—mocked the idea that applying traditional ornament to them would humanize them. Beyond that, the mysterious processes of industry itself met no standard model for humanistic culture. Traditional designs would be out of sync with the new machine world, but that world seemed too given over to utility and exploitation to be worth celebrating with new forms. The Deutscher Werkbund, founded in 1907, declared that the problem had to be fought at its source: Workers, managers, and consumers should have their spirits elevated through factories and products designed by great artists. Peter Behrens' designs for the AEG (Allgemeine Elektrizitäts-Gesellschaft, or German General Electric Company) gave stylistic expression to the Werkbund's ambition.

Peter Behrens first thought that industrial standardization had to be fought through the bizarre, individualistic forms of Art Nouveau (called *Jugendstil* in Germany). He soon decided, though, that Art Nouveau's extremism betrayed the nature of architecture, which was based on utility, geometry, solidity, and rhythm. He also decided

(based on his reading of Friedrich Nietzsche) that it was his responsibility as an artist to seek out, embrace, and transform the most powerful force of the age. To Behrens, as to the Werkbund, that force was technology; he believed, therefore, that the great modern architect must design in accordance with industry's characteristics—matter-of-factness, forcefulness, monumental scale, standardization and repetition—without losing his identity to the machine.

The directors of the electrical conglomerate AEG accepted the Werkbund's ideas about art and industry. The corporation was so successful and powerful that its leaders felt a responsibility to make it a cultural force for good commensurate with its economic might. Paul Jordan, AEG's director of factories, thought this should be done by making AEG's products and factories works of art, spreading aesthetic awareness to their users. In 1907, AEG hired Behrens as its artistic adviser.

Behrens first brought his new, simple geometric style to AEG's brochures and casings for its small appliances. Their simplicity and unity of style, he said, were analogies for the functionalism and mass-produced repetition of the products themselves. In 1908, Behrens was invited by AEG factory director Oskar Lasche to take part in the design of a new turbine factory on Huttenstrasse in Berlin. The factory design marked the first time that Behrens could shape an AEG product from its inception. His ambition was to create a factory that would be an artistic statement without hiding its functionalism behind ornament.

The heart of the building was a pair of fifty-ton cranes, designed by civil engineer Karl Bernhard, that carried turbine components down the center of the factory. The 660-foot-long double line of supports for the cranes determined the shape of the building. Behrens incorporated the supporting frame into the exterior surface of the building, a row of load-bearing columns designed on the principle of the Greek temple. Where the row stopped at Huttenstrasse, the box shape suggested by the frame required symmetrical, monumental expression. Behrens shaped this end to suggest both the force and the smoothness of machine operations, giving it a plain, six-sided gable over a huge central window.

The barrel-vaulted roof required for the gable was Behrens' only interference in Bernhard's functional plans. The steel frame, its concrete footing, and the glass window infill determined all visible materials for the building. There would be no decorative brick or stone disguise on this factory.

Behrens' design—built in six months and completed in October, 1909—was a huge, stark-looking, but perfectly balanced expression of industrial forces. On the side elevation, exposed steel columns set thirty feet apart, resting on austerely crafted hinges on concrete bases, marched inexorably down the building's length. Their finely tuned proportions turned Behrens' image of industry—endless repetition creating a standardized world—into a dignified colonnade. The inner faces of the steel frame sloped inward to meet the crane's stresses, which Behrens expressed by setting the great windows between the columns at a slant as well. This threw the colonnade into even greater prominence, making clear that it was the building's essential structure, and brought out the horizontal sweep of the overhanging roof.

Behrens' imagery changed on the Huttenstrasse front, eighty-two feet square. The temple-like appearance of the gable end was accentuated by making the building's corners into massive, rounded concrete pylons, which were grooved with horizontal steel bands to carry the side elevation's impression of endless length around the corner. The concrete was only a curtain wall between the steel beams, and Behrens revealed this by sloping the pylons inward at the top, as he did with the side windows. Nevertheless, the pillars and the concrete gable gave a weighty dignity to the building's most visible side. The gable end was Behrens' metaphor for modern industry, transforming brutal utility into a simple, dignified shrine to humanity's powers.

The AEG turbine factory created a sensation among architects, businessmen, and the public. For the first time, a famous architect had combined forces with the Machine Age instead of trying to hide from it. For architects and critics, the lesson was of enormous importance. Peter Behrens had applied personal creativity to the impersonal demands of functionalism; he had created a building that was a servant of modern industry but that was shaped by the values of the artist.

Impact of Event

The success of the AEG turbine factory fulfilled the company directors' hopes for bringing art into industry. Peter Behrens became director of all the corporation's design projects. His work for AEG, lasting through World War I and continuing intermittently afterward until Behrens' death in 1940, extended beyond factories and consumer products to housing for company employees. Other German companies brought in avant-garde architects, notably the Werkbund member Hans Poelzig and Behrens' former assistant Walter Gropius, to design objects, shops, and factories. For the first time, radical architecture was solidly identified with the Machine Age.

Behrens' prestige meant that his work for AEG added sales value to its products. The company benefited from the increased attractiveness of the items he designed, and the reputation for cultural sensitivity that his factory designs brought to AEG made for excellent public relations. The turbine factory's fame only reinforced the idea that hiring an advanced artist or architect to apply "industrial design" to products paid off. Behrens' faithful, inspired application of Werkbund goals for the AEG brought the concept of product styling, and the notion that avant-gardism could be a life-style accessory, into the marketplace.

The other face of Behrens' success made the architect a major participant in social and cultural policy. Behrens designed employee housing because Paul Jordan's goal in hiring him was to improve the quality of life for all who came in contact with AEG. Putting workers' living space under the direction of a sensitive artist would, in theory, make employees more spiritually healthy, in the same way that turning the factory into a work of art would make them more in harmony with their labor. The idealistic notion of architecture behind this hope had implications beyond the simple fostering of good employee relations. It implied that the avant-garde architect should be the master coordinator of the new industrial world, rebuilding both its public and private sides physically and spiritually. Behrens himself constantly referred to the

philosophers Friedrich Nietzsche and Georg Hegel, with their claims that the artist gave form to the deepest impulses of the age, as his sources. Such theories combined with German architectural critics' obsession with the deeper purposes of art to encourage a messianic vision of architecture.

Behrens' example pushed Werkbund-inspired architects to test his ideas still further. The major question raised by the turbine factory was whether its success owed more to obedience to function and standardization or to personal artistic vision. Debate on the topic split the Werkbund in 1914 between the antistandardization, *Jugendstil* individualists and the profunctionalist backers of the anonymous "type" in architecture. The very success of Behrens' design forced the issue of how completely the architect could surrender to industry's needs and remain an artist. The question was revived at the end of World War I in the battles between "expressionists" and "functionalists" in modern architecture. In the end, the hope of being useful to society in a chaotic time made most radical architects embrace functionalism; however, Behrens' initial goal of transforming function into a symbolic representation of the Machine Age never fully disappeared. In addition, in the 1920's, few avant-gardists wanted to serve big business as Behrens had; it was necessary to find some more democratic purpose, such as public housing for utilitarianism.

To some architects, the AEG turbine factory was old-fashioned and dishonest in the way it placed art before function. The gabled roof was unnecessary, the concrete corners created a false image of a massive stone building, and the building sides not visible to the public had been left ugly and inharmonious. Behrens' former employee Walter Gropius applied the idea of a simple, cubic architecture based on industrial materials even more ruthlessly. Gropius' 1911 Fagus shoe-last factory was an asymmetrical complex with a flat roof and, instead of concrete pillars, sheets of glass wrapping around the corners of a light steel-frame box. The rigid, heavy industrial aesthetic discovered by Behrens became gravity-defying and free, a reflection of human potential in the new age.

The deepest lessons of Behrens' architecture came out after World War I, when the old world had been swept away. Gropius brought his vision of a new world of basic industrial shapes, directed by Behrens' vision of the architect redesigning the entire world, into the founding of the Bauhaus school in 1919. In 1926, Gropius transformed the vision of a dematerialized, abstract, steel-and-glass architecture into one of the masterpieces of the 1920's, the Bauhaus building in Dessau. Two other former Behrens employees, Le Corbusier and Ludwig Mies van der Rohe, pushed Behrens' discoveries even further to create a new style. Mies van der Rohe refined industrial building down to the classically simple steel frame; Le Corbusier applied an artist's eye to functionalist "types" to create pure forms. The idealism behind Behrens' decision to serve industry created the sense of purpose with which the Modern movement of the 1920's transformed architecture. Although the shapes and immediate ends of modern architecture became different from Behrens', its goal— to comprehend, control, and ennoble the forces of modernity—continued the lesson of the AEG factory.

Bibliography

Buddensieg, Tilmann. *Industriekultur: Peter Behrens and the AEG.* Translated by Iain Boyd Whyte. Cambridge, Mass.: MIT Press, 1984. The essential source on the subject and an invaluable guide to debate on art and industry after 1900 in Germany. Actually written by several authors, which makes the book disjointed. Excellent photos of Behrens' buildings, products, and illustrations. Catalog of designs, appendices, bibliography, index.

Campbell, Joan. *The German Werkbund.* Princeton, N.J.: Princeton University Press, 1978. History of the Werkbund's ideas, organization, and influence. Little attention to specific works of architecture or to architects except as they participated in Werkbund leadership. Clarifies the different influences on architectural avant-gardism in Germany. Chronological summary, index.

Curtis, William. *Modern Architecture Since 1900.* Englewood Cliffs, N.J.: Prentice-Hall, 1983. A textbook history that gives a chapter to the Werkbund and follows its and Behrens' later influence on Gropius, Le Corbusier, and Mies van der Rohe. A good balance of art history and the history of architectural theory. Index.

Frampton, Kenneth. *Modern Architecture: A Critical History.* New York: Oxford University Press, 1980. The author's sensitivity to the impact of industrial capitalism on architecture makes the chapter on the Werkbund outstanding. As a general textbook, too short on detail on crucial issues and burdened with sparse, small illustrations. Select bibliography. Index.

Pevsner, Nikolaus. *Pioneers of Modern Design.* Rev. ed. London: Penguin Books, 1960. Revision of a work first published in 1936 as *Pioneers of the Modern Movement.* Treats architectural and design history after 1850 as the background to Gropius' Bauhaus concepts. Dated and biased on that account, but its unity of argument and attention to the applied arts help clarify Behrens' context. More recent work on consumer-product design outstrips Pevsner in sophistication. Table of names and dates, index.

M. David Samson

Cross-References

Hoffmann and Moser Found the Wiener Werkstätte (1903), p. 79; Hoffmann Designs the Palais Stoclet (1905), p. 124; The Deutscher Werkbund Combats Conservative Architecture (1907), p. 181; German Artists Found the Bauhaus (1919), p. 463; Loewy Pioneers American Industrial Design (1929), p. 777; Le Corbusier's Villa Savoye Redefines Architecture (1931), p. 869.

PICKFORD BECOMES "AMERICA'S SWEETHEART"

Category of event: Motion pictures
Time: 1909-1929
Locale: The United States

Mary Pickford rose from anonymity to become "America's Sweetheart," Hollywood's most famous and influential female star of the silent-film era

Principal personages:

MARY PICKFORD (GLADYS LOUISE SMITH, 1893-1979), the beloved motion-picture actress and producer who epitomized the silent-film era's optimism and "Pollyanna" outlook

DAVID BELASCO (1853-1931), a Broadway playwright and entrepreneur who rechristened Gladys Louise Smith as Mary Pickford

CHARLIE CHAPLIN (1889-1977), the creator of the silent-film era's most beloved comic character, "the little tramp," and a cofounder of United Artists

DOUGLAS FAIRBANKS (1883-1939), the creator of some of the silent era's most indelible swashbuckling heros, a cofounder of United Artists, and Pickford's beloved second husband

D. W. GRIFFITH (1875-1948), the pioneering film director who guided Pickford's first film efforts and who helped to cofound United Artists

CARL LAEMMLE (1867-1939), the pioneering producer who lured Pickford to his company with money and the promise of stardom under her own name

ADOLPH ZUKOR (1873-1976), the film executive who oversaw the highly successful buildup and exploitation of Pickford's star status

Summary of Event

Mary Pickford's meteoric rise to the position of "America's Sweetheart" is one of the great sagas of the free-wheeling boom years of the silent-film era. Though a relatively brief period, 1896-1927, the silent-film era was a tumultuous period that witnessed the rapid rise of the motion picture from the lowly status of flickering, turn-of-the-century vaudeville novelty to major American industry.

The baby girl that the world would soon know as Mary Pickford was born in Toronto, Canada, on April 8, 1893, as Gladys Louise Smith. Young Gladys Louise became her family's principal breadwinner at the age of five, when an acquaintance of Charlotte Smith, the girl's widowed twenty-four-year-old mother, suggested putting Gladys, her younger sister Lottie, and her younger brother Jack on stage as a means of staving off poverty.

In spite of the young mother's initial concerns about the theater's unsavory reputation, desperation drove Charlotte to take Gladys to an audition. On September 19,

1898, the diminutive Gladys made her theatrical debut with the Cummings Stock Company at Toronto's Princess Theater. Her compensation, eight dollars a week for six evening performances and two matinees, was sufficient to turn Charlotte into one of the era's most calculating stage mothers and young Gladys into an ambitious, stage-struck child actress.

During the next decade, the Smiths barnstormed through North America in a variety of traveling theatrical troupes. For Gladys, the Smiths' main source of support, Broadway loomed as the big prize, the goal that, once achieved, would bring unqualified professional and economic success.

After the Smiths spent the summer of 1906 trying to arrange an interview with David Belasco, then Broadway's most flamboyant and prestigious entrepreneur, Belasco finally consented to hear Gladys read. The fourteen-year-old's straightforward yet winsome manner impressed the impresario, who hired her. Belasco, though, found the name Gladys Louise Smith unappealing; so, too, did Gladys. Belasco, after hearing the youngster run through a list of family names, selected Pickford; when they got to first names, Gladys offered Marie, which she had wanted to use in place of Louise. The master showman quickly changed Marie to Mary and, presto, Mary Pickford was born. After her rechristening, the excited young actress sent a telegram to her mother in Toronto: "GLADYS SMITH NOW MARY PICKFORD ENGAGED BY DAVID BELASCO TO APPEAR ON BROADWAY THIS FALL."

In 1909, at the age of sixteen, Pickford sought to supplement her stage earnings with a bit of film work. Although motion pictures were regarded as an artistically inferior medium, they nevertheless offered a bit of easy money for an actor. Therefore, when Pickford auditioned for D. W. Griffith, Biograph's principal director, it was essentially a matter of financial necessity rather than artistic compulsion. Indeed, at the time, Griffith still harbored dreams of becoming a successful playwright. That these two cinematic pioneers should link up at the beginnings of their respective film careers, just as the motion picture was about to catapult into the front ranks of the entertainment industry, remains one of show business' great strokes of happy coincidence.

Pickford, with her petite frame, blonde curls, and youthful vigor, as well as her aura of virginal purity and natural Irish spunk, was a perfect fit for Griffith's Victorian paradigm of idealized feminine beauty. It is not surprising, then, that Pickford's earliest work for Griffith, such as her portrayal of the oldest of three sisters in *The Lonely Villa* (1909), or her starring role in *The New York Hat* (1912), still resonates with freshness and dramatic power.

Although Biograph, like the other pioneering film companies, did not identify actors by name, fearing that the publicity would fuel demands for higher wages, Pickford's golden curls made her readily identifiable to film fans. Indeed, theater managers, sensing a new strategy for attracting audiences, began promoting her Biograph films by advertising "The Girl with the Golden Hair." Pickford was also known to Nickelodeon audiences as "Little Mary," an appellation derived from the name of a character that she had played in one of her earliest Biograph films.

By 1916, Pickford, now a bona-fide star and international celebrity, was making more than a million dollars a year for Adolph Zukor's Famous Players Company. Riding the waves of the rapidly evolving star system and applying her negotiating skills as well as those of her mother, Pickford was well positioned to continue her reign as Hollywood's most influential female star and producer throughout the duration of the silent-film era.

Impact of Event

Mary Pickford's career provides a salutary example of an extremely bright and talented woman who fought assiduously to maintain economic and artistic control of her various enterprises. Quite simply, she was a woman well ahead of her time. Indeed, her fierce quest for independence, while most obvious in her business dealings, also manifested itself in quite palpable form in the roles she undertook in her some two hundred films.

Pickford was ambitious, and as the industry's moguls came to rely more and more heavily on the star system's capacity to guarantee box-office returns, the "Little Girl with the Curls" instinctively knew her worth. Her ambition was further fueled by a strong sense of competitiveness; in her negotiations with Zukor, she would make it a point to underscore the latest contract coup of Charlie Chaplin as a wedge to boost her own income and control.

In 1916, Pickford was earning a handsome guaranteed salary. Zukor had also been compelled to set Pickford up as her own producer, a move formalized with the establishment of Pickford's own company, Artcraft Pictures. Pickford commanded both a $10,000 a week salary and a fifty percent take of her films' profits. As historian Richard Koszarski points out, Pickford was, in effect, Zukor's partner. Yet since everyone involved was making money, and lots of it, no one really complained.

A majority of critics now agree that Pickford's most enduring work was created during her several years at Artcraft, a productive period yielding twelve full-length releases. In the 1920's, when she and husband Douglas Fairbanks presided over Hollywood's social life from Pickfair, their Beverly Hills estate, Pickford's output had slowed to only one release per year. Though more time and budget were lavished on production values, Pickford's films of the 1920's tend to betray a sense of self-importance entirely missing from the more hastily produced and streamlined Artcraft features.

The Artcraft films benefited from the substantive contributions of directors such as Maurice Tourneur (*The Poor Little Rich Girl*, 1917), Cecil B. DeMille (*The Little American*, 1917), and Marshall Neilan (*Rebecca of Sunnybrook Farm*, 1917). Walter Stradling and Charles Rosher were among Pickford's favorite cameramen, while scripts tailored to the Pickford persona were carefully crafted by Frances Marion and Jeanie Macpherson. Pickford's films also enjoyed the production values derived from the services of Ben Carre and Wilfred Buckland, two of Hollywood's best art directors.

By late 1918, the success of Pickford's Artcraft releases led to an even bigger

contract and greater creative control, but at First National, rather than with Zukor. In 1919, Pickford helped to mastermind the organization of United Artists with her erstwhile rival Charlie Chaplin, her former boss at Biograph, the distinguished director D. W. Griffith, and her soon-to-be husband and fellow screen idol Douglas Fairbanks. United Artists would be the corporate shelter under which Pickford would operate for the duration of an eminent acting career that concluded with the desultory sound film *Secrets* (1933).

In assessing Pickford's impact as a businesswoman, it is fair to state, as Scott Eyman does in his masterful Pickford biography, that "Mary Pickford, in fact, was the first female movie mogul." The most important consequence of her keen yet always straightforward dealings was the solidification of her capacities to maintain the kind of creative control she felt necessary to her artistic as well as commercial success. Her greatest challenge, however, involved coping with the perception that the public would only be satisfied in seeing her play variations of her seminal role as "America's Sweetheart." Indeed, Pickford's love-hate relationship with the composite character of "Little Mary" gives retrospective examinations of her career a mordantly bittersweet, if not tragic, touch.

Pickford did make attempts to alter her persona by taking on more mature roles, such as those of *Rosita* (1923) and *Dorothy Vernon of Haddon Hall* (1924); these were, however, less than successful. Pickford had become an icon of American popular culture, an idealized embodiment of the cute, lovable, feisty girl-woman. This was what Pickford's public had come to expect, even in the jangling Jazz Age. Indeed, the charming, even naïve innocence of her roles in such films as *My Best Girl* (1927), by invoking the values of a rapidly fading yet still significant Victorian sensibility, helped to provide a reassuring emotional and psychological refuge for those seeking at least momentary relief from the moral ambiguities of the Roaring Twenties.

Pickford's "America's Sweetheart" was much more than a mere two-dimensional caricature. Indeed, Pickford's films almost always included working-class issues and perspectives, Dickensian qualities that were still prominent in such later works as *My Best Girl* (1927). And though Pollyannaish elements were present in her films, these were countered by an aggressive, spunky determination to right wrongs and get ahead. Indeed, as critic Molly Haskell has noted, Pickford was "no American Cinderella or Snow White" but rather a rebel who "championed the poor against the rich, the scruffy orphans against the prissy rich kids."

Bibliography

Brownlow, Kevin. "Mary Pickford." In *The Parade's Gone By.* New York: Alfred A. Knopf, 1968. Brownlow argues that Pickford's appeal was based essentially on her talents as a comedienne. An interview includes discussion of the actress' professional relationships with D. W. Griffith, David Belasco, Adolph Zukor, Edwin S. Porter, Cecil B. DeMille, and Ernst Lubitsch.

Eyman, Scott. *Mary Pickford: America's Sweetheart.* New York: Donald I. Fine,

1990. This definitive and superbly written Pickford biography successfully plumbs the psychological as well as artistic and business dimensions of the actress' tough yet vulnerable persona, revealing an individual driven by insecurities born of childhood tragedy. Includes a bibliography, filmography, and poignant photos culled from the Pickford archives.

Haskell, Molly. *From Reverence to Rape: The Treatment of Women in the Movies.* Baltimore: Penguin Books, 1974. Haskell's seminal work is a refreshingly lucid and readable account of the role of women in film.

Herdon, Booton. *Mary Pickford and Douglas Fairbanks: The Most Popular Couple the World Has Ever Known.* New York: W. W. Norton, 1977. A lively and carefully researched work. Includes a useful bibliography and a variety of revealing photographs and production stills.

Jacobs, Lewis. *The Rise of the American Film: A Critical History.* 1939. Reprint. New York: Teachers College Press, 1968. Jacobs' masterful chronicle includes repeated references to Pickford, including a compelling argument for appreciating Pickford as the primary personification of the era's "Pollyanna philosophy."

Koszarski, Richard. "Mary Pickford." In *An Evening's Entertainment: The Age of the Silent Feature Picture, 1915-1928.* New York: Charles Scribner's Sons, 1990. In this meticulously researched survey, Koszarski argues that Pickford's composite character, while radiating sweetness and light, also provided a role model for ambitious young women. Also includes discussion of Pickford's business attainments.

Niver, Kemp R. *Mary Pickford, Comedienne.* Edited by Bebe Bergsten. Los Angeles: Locare Research Group, 1969. A revealing chronicle of Pickford's apprenticeship under the tutelage of D. W. Griffith, with an emphasis on her comedic roles. Includes a careful selection of frame enlargements, a synopsis for each film, and reprints of promotional handbills sent to theater owners.

Pickford, Mary. *Sunshine and Shadow.* Garden City, N.Y.: Doubleday, 1955. A surprisingly limited account of Pickford's motion-picture experiences. Reflecting her growing postretirement conservatism and self-imposed exile at Pickfair, Pickford complains about such troublesome aspects of post-World War II society as unions, Communism, and immorality.

Windeler, Robert. *Sweetheart: The Story of Mary Pickford.* New York: Praeger, 1974. Windeler's candid and carefully researched work, the first full-scale Pickford biography, remains an invaluable and indispensable resource. Includes a number of illuminating photographs and a complete filmography.

Zukor, Adolph. *The Public Is Never Wrong: The Autobiography of Adolph Zukor.* Edited by Dale Kramer. London: Cassell, 1954. Zukor's warm recollections of Pickford's contributions to the motion-picture industry reveal a deep respect for both her artistic and business achievements.

Charles Merrell Berg

Cross-References

The Great Train Robbery Introduces New Editing Techniques (1903), p. 74; Sennett Defines the Slapstick Comedy Genre (1909), p. 230; *The Birth of a Nation* Popularizes New Film Techniques (1915), p. 402; *The Ten Commandments* Establishes Silent-Film Spectacle (1923), p. 567; Chaplin Produces His Masterpiece *The Gold Rush* (1925), p. 659; Keaton's *The General* Is Released (1926), p. 691; *The Jazz Singer* Premieres in New York (1927), p. 734; Sound Technology Revolutionizes the Motion-Picture Industry (1928), p. 761.

SENNETT DEFINES THE SLAPSTICK COMEDY GENRE

Category of event: Motion pictures
Time: 1909-1933
Locale: Hollywood, California

Mack Sennett founded Keystone Studios in a rural Southern California community soon to be known as Hollywood, where he assembled and trained a group of comedians in a frenetic style of comedy known as slapstick

Principal personages:

MACK SENNETT (MICHAEL SINNOTT, 1880-1960), a Canadian vaudeville performer who founded Keystone Studios

MABEL NORMAND (1894-1930), an actress whose work with Sennett made her the first great silent-screen comedienne

FORD STERLING (GEORGE FORD STITCH, 1883-1939), an actor who became Keystone's first comic villain as well as the leader of Sennett's Keystone Kops

CHARLIE CHAPLIN (1889-1977), an English music-hall performer discovered by Sennett who created his immortal "Tramp" character while employed at Keystone

ROSCOE "FATTY" ARBUCKLE (1887-1933), a huge, wildly kinetic vaudeville performer who became one of Sennett's most versatile and prolific screen comedians

HARRY LANGDON (1884-1944), a Keystone actor who, with his slow, infantile mannerisms and wide-eyed, baby-faced expressions, created his own endearing screen character

Summary of Event

After serving a four-year apprenticeship at New York's Biograph Studios, where he acted in, wrote, and directed short films under the guidance of D. W. Griffith, Canadian-born Mack Sennett broke with Biograph and founded Keystone Studios in August, 1912. Sennett had followed Griffith to Southern California when Griffith moved his faithful troupe of actors and technicians west from Biograph's New York studios in January of that year. When he left Biograph, Sennett took with him three of his own faithful followers: his girlfriend, actress Mabel Normand, comedian Ford Sterling, and technician Henry "Pathe" Lehrman, who became one of Sennett's early comedy directors.

While at Biograph, Sennett had learned valuable lessons in cinematic technique from Griffith, most especially in the pacing of one- and two-reel films. Sennett had learned to build suspense and excitement by increasing the frenetic intensity of a film's action with the use of quick-cut editing, leading to a spectacular, emotionally intense finale. Sennett realized that by burlesquing Griffith's morally simplistic, melodramatic storylines with exaggerated, melodramatic plots of his own and by peppering

his stories with wildly kinetic, roughhouse brawling and spectacular stunts, he could produce a type of film that used Griffith's commercially successful and cinematically innovative dramatic style for comedic effect. At that time, there was no film studio specializing in comedies. Sennett was aware of the major film studios' reluctance to indulge in comedy; by forming Keystone, he hoped to cash in on the comedic void left by the other film producers.

Sennett's estimation that there existed a wide untapped audience that would support his venture into screen comedy proved to be accurate. Although his first one-reel comedies were quite primitive, filled with hackneyed plots borrowed from melodramas, lowbrow comedy routines borrowed from burlesque, and horribly exaggerated, hammy acting by all of his cast members, the films were amazingly successful. Although the production values for his later films improved and the acting became slightly less exaggerated, the content of the films remained basically the same: wild, chaotic comedy exploits filled with surreal, out-of-control action sequences delivered at a frenetic pace that increased in intensity as the films careened to a spectacularly frenetic finale. The typical plot of a Keystone comedy revolved around a simple boy-girl relationship, with a rivalry for the girl's affections leading to all sorts of madcap confrontations, the mayhem escalating in intensity as the film progressed. The climax of each film usually involved a wild chase, with legions of figures careening across the screen until the rival was defeated or a penultimate stunt executed. Sennett himself directed many of the comedies and even appeared in several of them, usually in minor roles playing a dim-witted rube. If he was not personally involved in a film's production, he screened, critiqued, and edited nearly every film produced in order to ensure that his comedic formula was well maintained.

In addition to developing a strongly personal approach to screen comedy, Sennett also had a knack for spotting new talent. Mabel Normand, his sweetheart from Biograph, with her fearless approach to staging death-defying stunts, her expressive range of emotions, and her creative exuberance, developed into one of the most gifted screen comediennes of all time. When Sennett spotted Charlie Chaplin working in a vaudeville house playing a drunk, he signed him to an exclusive film contract, even though Chaplin had no training for film comedy. When he spotted Harry Langdon in a vaudeville troupe, Sennett believed so strongly in Langdon's potential that he assigned two of his best writers—Frank Capra and Harry Edwards—to work exclusively with Langdon. At first reluctant to sign Roscoe "Fatty" Arbuckle, Sennett eventually gave Arbuckle near-total creative control over his films, letting him direct as well as star in his own two-reelers and eventually putting Arbuckle's nephew and Arbuckle's dog on the payroll. Over the next several years, Sennett also gave other struggling newcomers their first big break in films, including such talented individuals as Chester Conklin, Ben Turpin, Slim Summerville, Charley Chase, Gloria Swanson, Wallace Beery, and Carole Lombard.

Impact of Event

While insisting that each Keystone film adhere to his formulaic, slapstick ap-

proach to comedy, Sennett also encouraged his cast and crew to invent and improvise the most outrageously creative variations to his basic approach. It was because of his tolerance for the bizarre and the spontaneous that Sennett and his troupe were able to develop such pioneering slapstick ingredients as the pie-throwing melee, the bumbling Keystone Kops, the kewpie-doll bathing beauties, the use of wildly surreal, cartoonish action sequences, and the use of nonstudio locales and actual events (including fires, parades, and amusement parks) as settings for his comedies. Sennett was also the first to produce feature-length comedies, the first of which, the hugely successful melodramatic burlesque *Tillie's Punctured Romance* (1914), featured nearly every comic he had working for him at the time. Later, after Sennett had joined with D. W. Griffith and producer Thomas Ince to form Triangle Studios, Sennett produced features starring Mabel Normand that included *Mickey* (1918), *Molly O* (1922), *The Extra Girl* (1923), and *Suzanna* (1923)—all of them box-office successes. When Griffith eventually left Triangle, Sennett founded Mack Sennett Studios and continued producing two-reelers and feature films into the late 1920's.

Sennett was a very savvy, extremely cost-conscious, businessman. At the peak of his popularity, his studio churned out, on the average, one two-reel comedy per week. When the public demand for his comedies exceeded his output, Sennett met the demand by reediting his films, taking, for example, the first reel of one film, combining it with the climax from another film, and releasing the hybrid version under a new title as a new two-reeler. As a result of Sennett's phenomenal success as a pioneer of screen comedy, his style was heavily imitated. Some of his fiercest comedy competitors were his own former employees: Henry "Pathe" Lehrman and Ford Sterling left Keystone to form their own company, producing copycat comedies that proved to be nearly as popular as Sennett's. Hal Roach, along with another former Keystone employee, Harold Lloyd, founded Hal Roach Studios and applied many of the Sennett techniques to his comedies, encouraging Lloyd to develop a Chaplin-inspired character called Lonesome Luke. Ironically, the amazing stunts and frenetic pacing found in Sennett's comedies were eventually adapted for many dramatic films produced during Sennett's heyday.

At the same time that Sennett was encouraging his employees to develop unique variations on his proven approach to screen comedy, however, he was also discouraging individuals who veered away from this approach. Sennett had some of the greatest film talents of all time working for him, and all eventually left because of Sennett's stifling insistence on adherence to his comedic philosophy (and his insistence on paying his talented employees as little as possible). Although he became known as the "King of Comedy," a more accurate title for Sennett would perhaps have been the "Carpenter of Comedy," a phrase used by film historian Walter Kerr to describe Sennett's contributions to screen comedy. Still, it is impossible to dismiss Sennett's influence, not only on early silent comedy but on sound comedy as well. The classic screwball comedies of the 1930's, the slapstick routines of such roughhouse comedians as Laurel and Hardy, the Three Stooges, and the Marx Brothers, comedy extravaganzas such as Stanley Kramer's *It's a Mad Mad Mad Mad*

World (1963) and Blake Edwards' *The Great Race* (1965), and the films of such disparate talents as Preston Sturges, Jerry Lewis, and Mel Brooks all owe a debt to Sennett.

Sennett himself continued to produce successful comedies and to develop—and then alienate—talented film newcomers well into the early days of sound films, encouraging such performers as W. C. Fields and Bing Crosby to apply their talents to film. After merging his studio with Paramount in the 1920's, Sennett was wiped out financially during the stock-market crash of 1929 and became a producer and director at Educational Pictures, a studio known for hiring Hollywood has-beens. In 1939, he appeared as himself and acted as technical adviser (along with Buster Keaton, the only major silent-film comedian Sennett did not discover) for the film *Hollywood Cavalcade*, based loosely on his experiences as a pioneer comedy producer and on his relationship with Mabel Normand.

Sennett's style has been called primitive, vulgar, lowbrow, crude, and chaotic. He has been called a penny-pinching tyrant and criticized for refusing to recognize the individual talents of the many creative people who worked for him, forcing them to either adapt to his own formulaic style or face expulsion. Sennett, however, can never be faulted for his bold decision to leave the most prestigious film studio of the early century—Biograph—headed by the most innovative American filmmaker of the period—D. W. Griffith—to found a film studio dedicated to producing comedies. It was a venture looked upon by his contemporaries as insane and doomed to fail, but it provided the birthplace of a new type of screen comedy and the training ground for some of the greatest film talents of all time.

Bibliography

Fowler, Gene. *Father Goose.* New York: Covici, Friede, 1934. A largely anecdotal biography of Mack Sennett's life and career, told in a very informal, humorous style. Although fun to read, the book should not be taken as a factual account of Sennett's life.

Fussell, Betty Harper. *Mabel.* New Haven, Conn.: Ticknor and Fields, 1982. A biography of Mabel Normand, Mack Sennett's on-again, off-again girlfriend. Contains many details of his stormy, tragic relationship with the gifted comedienne as well as in-depth descriptions of the founding of Keystone.

Kerr, Walter. *The Silent Clowns.* New York: Alfred A. Knopf, 1975. An excellent examination of silent-screen comedy, with an emphasis on the comedic contributions of Charlie Chaplin, Buster Keaton, Harry Langdon, and Harold Lloyd, all of whom—with the exception of Keaton—worked for Sennett at some point during their early screen careers. Also contains a somewhat unflattering critique of Sennett's slapstick approach to screen comedy.

Lahue, Kalton C. *Mack Sennett's Keystone: The Man, the Myth, and the Comedies.* South Brunswick, N.J.: A. S. Barnes, 1971. A detailed overview of Sennett's life: how he founded Keystone, his contributions to film comedy, and the many talented individuals who worked for him. For the most part well documented, much

more so than Fowler's book and Sennett's own autobiography.

Pratt, George C. *Spellbound in Darkness: A History of the Silent Film.* Greenwich, Conn.: New York Graphic Society, 1973. A compilation of articles, reviews, and profiles written during the silent-film period. Gives a detailed history of silent film from its inception to the advent of sound. Contains several reviews of Sennett-produced films plus a lengthy interview with Sennett conducted by novelist Theodore Dreiser, who was a big fan of Sennett.

Sennett, Mack, and Cameron Shipp. *King of Comedy.* Garden City, N.Y.: Doubleday, 1954. Journalist Cameron Shipp interviewed Sennett over a two-year period and also interviewed many of Sennett's former employees. The resulting book is hardly factual, yet it is still a wonderful account from Sennett's humorous point of view of his struggles to found his own film studio and of his dealings with some of the famous talents he helped to discover. It is also a heartbreaking—though, again, not altogether accurate—account of his relationship with Mabel Normand.

Jim Kline

Cross-References

The Birth of a Nation Popularizes New Film Techniques (1915), p. 402; Chaplin Produces His Masterpiece *The Gold Rush* (1925), p. 659; Keaton's *The General* Is Released (1926), p. 691; *The Jazz Singer* Premieres in New York (1927), p. 734; Sound Technology Revolutionizes the Motion-Picture Industry (1928), p. 761; The Classic Screwball Comedy Reaches Its Height in Popularity (1934), p. 951.

THE FUTURISTS ISSUE THEIR MANIFESTO

Category of event: Art
Time: February 20, 1909
Locale: Paris, France

Futurism established itself as the most aggressive artistic movement of its age, and its manifesto, which proclaimed that art can only be violence, cruelty, and injustice, provoked attention on a truly international front

Principal personages:

FILIPPO TOMMASO MARINETTI (1876-1944), an Italian poet who wrote the founding manifesto of Futurism

GIACOMO BALLA (1871-1958), an Italian artist and teacher of the younger generation of Futurist painters

UMBERTO BOCCIONI (1882-1916), an Italian artist who took a leading role in the Futurist movement

CARLO CARRÀ (1881-1966), an Italian artist active among the Milanese Futurists

FRANCESCO BALILLA PRATELLA (1880-1955), an Italian composer who wrote "The Technical Manifesto of Futurist Music"

LUIGI RUSSOLO (1885-1947), an Italian artist who developed "The Art of Noise"

GINO SEVERINI (1883-1966), an Italian artist influential in the Paris art world

Summary of Event

Filippo Tommaso Marinetti was a well-known literary figure in France and Italy among avant-garde poets and artists when his "Manifeste de Futurisme" (futurist manifesto) was published on February 20, 1909, on the front page of *Le Figaro*, the paper that served as the battleground of artistic theories and allegiances in Paris. "Manifeste de Futurisme" is a prose poem describing an intellectual journey that is separated into three parts, each symbolic of a different stage of artistic development in modern Italy. The first part is designated as the pseudoscientific, from which the artist escapes at dawn in an automobile; the second represents the immediate future and announces the Futurist program; and the third looks forward to the more distant future, when a new generation of artists will repeat the ruthless emancipatory process of the present Futurists.

Marinetti's manifesto established the general terms for the theory and practice of the entire Futurist movement and became a rallying cry for artistic revolutions among artists of the younger generations. Though "Manifeste de Futurisme" had a bombshell effect, it was based on traditional aspects of artistic rebellions as well. In the appeal to the young artists of the day, Futurism followed many of the precepts of

Romanticism, particularly in its challenge to the artist to seek inspiration in contemporary life. The manifesto demanded emancipation from the crushing weight of tradition, the so-called graveyard of culture, and exhorted the artist to reject existing academies, museums, libraries, and all similar institutions devoted to maintaining traditional values in art. Not only was Marinetti's disdain for the status quo apparent in his rejection of tradition, but it was also evident in his inciting the artist to show contempt for prevailing middle-class values and standards of taste.

Though the manifesto's call for young artists to shake the foundations of tradition-based cultural institutions was itself revolutionary, the most significant contribution on the part of the Futurist agenda lay in its articulation of the concept of dynamism, which, according to Futurist dogma, was to be the basis for the arts. In fact, initially Marinetti wavered between "Dynamism" and "Futurism" as potential names for the new art movement. As a concept, dynamism represented a rejection of static, changeless reality. Futurism urged artists to abandon the life of passive contemplation and to take a place in the center of the universe's ceaseless activity. Movement, activity, and change were to supplant the static representation of realism and Impressionism in order to project the dynamic movement and rapid locomotion of the new age of the automobile and aeroplane. Not only did Futurism address itself to the physical realm, but it also glorified intellectual exertion and agitation. Conflict, violence, misogyny, anarchism, and, ultimately, even war were viewed as positive examples of universal dynamism. At the same time, the strong language, harangues, changes of images, exaggerations and insults gave Marinetti's manifesto the sense of vitality related to the spirit of dynamism. In Marinetti's vision, the artist was to become an agitator who was not only to overthrow the cultural institutions of society but was also to participate in the agitation for political change. Thus, in his choice of a manifesto as the form calling for an artistic revolution, Marinetti used the methodology of propaganda in order to politicize the arts.

"Manifeste de Futurisme," while it addressed itself to all aspects of creative endeavor, concentrated primarily on the effect of Futurism in literature. Consequently, Marinetti extended the range of the Futurist program by publishing more specific statements such as a 1910 manifesto of Futurist painters signed by the Italian artists Giacomo Balla, Umberto Boccioni, Carlo Carrà, Luigi Russolo, and Gino Severini. The painters' manifesto appealed to artists to adopt a more honest and aggressive approach to art and focused on the rejection of representation. Artists were encouraged to provide fresh angles of perception in their work to break down the traditional psychological distance between the aesthetic object and the spectator. The Futurists drew much of their inspiration from psychophysics and the psychophysiology of visual perception, which provided analogues that were to represent the dynamism of movement and change.

Marinetti and the other Futurists extended their efforts to revitalize the other arts as well with the issue of additional manifestos. In a 1913 manifesto, Marinetti urged dramatists to abandon traditional aspects of theatrical representation such as logical plot development and believable characters in order to foreground the illogical and

absurd. Since the plays written by the Futurists were concerned with speed and motion, the proper work of the playwright was seen as the synthesizing of facts and ideas in the least number of words. Brevity, distillation, and condensation were encouraged; Marinetti approved the staging of Richard Wagner's opera *Parsifal* (1882) in forty minutes. He also suggested presenting in a single evening all the Greek, French, and Italian tragedies as fragments and the whole of William Shakespeare's work reduced to a single act. Similarly, an attempt was made to alter structure in music, and a 1911 manifesto issued by Francesco Balilla Pratella promoted music that exploited small changes in pitch and complicated, changing, and subtle rhythms in order to crush the domination of dance rhythm. In a 1913 manifesto discussing "the art of noise," Luigi Russolo took Pratella's demands for nonharmonic music as a point of departure and extended the limits of traditional music to include all of the sounds of everyday life. In order to realize the new music, Russolo invented new instruments and a new kind of musical notation. Ultimately, the Futurists also extended their demands for dynamism, condensation, and simultaneity into experiments in the cinema and radio. As a result, the Futurists' all-encompassing program for dynamic change in the arts had an incalculable impact on international artistic movements.

Impact of Event

Once the Futurists issued their manifestos, they attempted to put the new aesthetics into practice, and their experiments culminated in the 1912 Exhibition of Futurist Painters in Paris. Since widespread publicity accompanied the exhibition, many of the paintings were reproduced in newspapers and art journals as examples of Futurist notions of movement and simultaneity. The exhibition was supplemented by a whole range of other events: discussions, press conferences, concerts, and encounters with rival art movements. In addition, the publicity events were accompanied by Futurist Evenings, during which Marinetti incited audiences by hurling insults at them. Usually, the evenings ended in riots, as spectators attempted to attack the Futurists, and the rioting and brawling frequently spread out into the streets and bars. Because of the notoriety resulting from the events in Paris, the reception of the Futurists was surrounded with even more provocations when the exhibition toured Brussels, London, and Berlin. The media attention that the events generated gave a sense of urgency to the concepts of the Futurists, and the speed of the publicity surrounding the Futurist escapades brought their ideas almost simultaneously to the attention of all countries.

The concepts of universal dynamism and simultaneity emphasized in the 1912 Futurist exhibition were also explored in the early works of the cubist painters Georges Braque and Pablo Picasso, whose work would in time modify some of the wildly exaggerated claims of the Futurists. At the same time, the focus of the Futurists on movement affected the work of Marcel Duchamp and Robert Delaunay, who went on to synthesize Futurist aesthetics in their work. Consequently, the Futurists influenced a variety of approaches in art by calling attention to the disjointed feelings and

chaotic sensations inherent in rapidly changing twentieth century society. Though Marinetti did not visit Russia until 1914, the ideas of the Futurists stimulated such Russian artists as David Burliuk and Kazimir Malevich and the poet Vladimir Mayakovsky, who responded by generating their own Futurist-inspired programs. Malevich was ultimately to pass beyond Futurism to the absolute abstraction of Suprematism, but his awareness of Futurist images of movement and flight contributed to his explorations of nonobjective space. Burliuk and Mayakovsky, on the other hand, presented Futurist-inspired recitals that took on similar patterns of provoking spectators. In particular, the Russian constructivists decorated public squares, trains, and theaters with agitprop decorations using dynamic forms similar to those in the paintings of Boccioni, Balla, and Russolo. Ultimately, the spectacle of the Russian Revolution seemed to the Futurists to be the culmination of their agitation for a total destruction of tradition and order, a realization of their dreams.

Though, on the surface, Futurism appeared to prosper in terms of the influence it generated on other movements, after three years of feverish activity, the Italian Futurists showed signs of exhaustion from the demands of collective activity. At the same time, jealousies and conflicting interests split the group into new alignments with redefined goals. The outbreak of World War I further jeopardized the cohesiveness of the Futurist cause, particularly since Marinetti's manifestos became increasingly nationalistic, thereby subverting the very nature of Futurist universality. In 1920, Marinetti, despite the defection of many of the most talented Futurists, generated a Second Futurism, which lasted until the outbreak of World War II. This movement, despite its explorations of tactile art and radio theater, was not to have the notoriety whipped up by the original Futurists. Instead, it was left to other movements to engender new ideologies in art.

While Futurism itself expired as an international movement, Dadaism, the disruptive antiart phenomenon born in Zurich in 1916, appropriated a number of Futurist techniques. Though the first issue of the Dada review *Cabaret Voltaire* contained a free-word poem by Marinetti, Dada did not merely reject the past; it was also uninterested in the future, and Marinetti's violent optimism was totally negated. Yet the influence of Futurism can be traced not only in the irreverence of the Dadaists but also in their approach toward the disruption of perception by means of nonsense poetry, collage, chaotic performances, and subversive satire. Ultimately, almost every twentieth century attempt to subvert representation in art and language from traditional conventions and restrictions can be traced back to the original manifestos of the Futurists. In particular, the attention paid by the Futurists to speed, absurdity, and disruption in order to dislocate the spectator and break down traditional modes of perception had in it the germs of contemporary street theater, pop art, "happenings," and antitheater.

Bibliography

Clough, Rosa Trillo. *Futurism: The Story of a Modern Art Movement.* New York: Greenwood Press, 1961. A two-part analysis of the history of Futurism, featuring

sixteen black-and-white illustrations and an extensive bibliography. The first part traces the aims, methods, and theories of the Futurists in literature, painting, architecture, and music. The second part analyzes the influence of Futurism on the arts from 1942 to 1960. Clough's book is highly informative but is directed toward an informed reader.

d'Harnoncourt, Anne. *Futurism and the International Avant-Garde: Essays.* Philadelphia: Philadelphia Museum of Art, 1980. A catalog of the exhibition of Futurism held in Philadelphia from October 26, 1980, to January 4, 1981. The Philadelphia Museum of Art's curator of twentieth century art, d'Harnoncourt provides a comprehensive overview on the role of Futurism within the avant-garde. Included are an essay, "Futurism as Mass Avant-Garde," by Germano Celant, color and black-and-white reproductions from the exhibition arranged according to nationality, and examples of Futurist-inspired art by non-Futurist Italian, French, German, Russian, British, and American artists.

Kirby, Michael, and Victoria Nes Kirby. *Futurist Performance.* New York: PAJ Publications, 1986. Provides a twelve-chapter analysis of the origins of Futurist performance, with discussions on theoretical foundations as well as more practical information on scenography, acting, costumes, and Futurist cinema and radio theater. The appendix provides translations of manifestos and playscripts and includes a chronology of Futurist performances and an extensive bibliography.

Kozloff, Max. *Cubism/Futurism.* New York: Charterhouse, 1973. Discusses cubism and Futurism as parallel movements. Kozloff provides a lengthy, well-illustrated exploration of cubism and its heritage, its relevance as an avant-garde movement, and its characteristics. The discussion of Futurism develops theory and practice, and the conclusion provides an overview of similarities and differences. Includes a brief bibliography and illustrations.

Markov, Vladimir. *Russian Futurism: A History.* Berkeley: University of California Press, 1968. Deals extensively with Russian Futurism and its variants. Markov explores the influence of the Futurist manifestos on Russian art and poetry and describes Marinetti's visit to Russia in 1914. The historical perspective traces Futurism from its beginnings through its flowering and decline and provides parallels to the history of Italian Futurism. Extensive notes and a bibliography of sources in English and Russian included.

Martin, Marianne W. *Futurist Art and Theory: 1909-1915.* Oxford, England: Clarendon Press, 1968. Provides a historical perspective of Italian Futurism, tracing its roots from the painting and sculpture in Italy during the later nineteenth century to the decline of Futurism at the outbreak of World War I. Martin explores the relationship between Marinetti's life and his launching of Futurism. Includes individual overviews of Boccioni, Carrà, Russolo, Severini, and Balla. Excellent bibliography, index, and appendix. Black-and-white reproductions provided.

Tisdall, Caroline, and Angelo Bozzola. *Futurism.* New York: Oxford University Press, 1978. A comprehensive historical perspective on Futurism. Tisdall and Bozzola explore provocative aspects in the theory and practice of Futurism and provide

discussions of Futurism and women and Futurism and Fascism. Includes a brief bibliography and 169 plates.

Christine Kiebuzinska

Cross-References

Avant-Garde Artists in Dresden Form Die Brücke (1905), p. 134; Les Fauves Exhibit at the Salon d'Automne (1905), p. 140; The Salon d'Automne Rejects Braque's Cubist Works (1908), p. 204; Der Blaue Reiter Abandons Representation in Art (1911), p. 275; Kandinsky Publishes His Views on Abstraction in Art (1912), p. 320; Apollinaire Defines Cubism in *The Cubist Painters* (1913), p. 337; Duchamp's "Readymades" Challenge Concepts of Art (1913), p. 349; Malevich Introduces Suprematism (1915), p. 413; The Dada Movement Emerges at the Cabaret Voltaire (1916), p. 419; Man Ray Creates the Rayograph (1921), p. 513; The Soviet Union Bans Abstract Art (1922), p. 544; Surrealism Is Born (1924), p. 604.

DIAGHILEV'S BALLETS RUSSES ASTOUNDS PARIS

Category of event: Dance
Time: May 19, 1909
Locale: Théâtre du Châtelet, Paris, France

From its inception, Sergei Diaghilev's Ballets Russes revitalized the art of ballet through revolutionary innovations in choreography, set design, and musical scores

Principal personages:

SERGEI DIAGHILEV (1872-1929), a Russian impresario who created the Ballets Russes

MICHEL FOKINE (1880-1942), a choreographer who created several important ballets for Diaghilev's Ballets Russes

LÉON BAKST (LEV ROSENBERG, 1866-1924), a painter who helped revolutionize stage set and costume design through his vibrant and original work for the Ballets Russes

ALEXANDRE BENOIS (1870-1960), a painter and early member of Diaghilev's "World of Art" whose costumes and set designs demonstrated his belief in the importance of historical veracity and artistic synthesis

VASLAV NIJINSKY (1890-1950), a celebrated dancer and choreographer who epitomized the genius, virtuosity, and brilliance of Diaghilev's Ballets Russes

NIKOLAY KONSTANTINOVICH ROERICH (1874-1947), a Russian painter who designed the sets and costumes imbued with a pagan mystery that Parisian audiences found fascinating

TAMARA KARSAVINA (1885-1978), a ballerina of great beauty and talent who was a principal dancer in most ballets of the Ballets Russes repertory

Summary of Event

On May 19, 1909, in the newly refurbished Théâtre du Châtelet in Paris, the curtain rose on the premiere performance of Sergei Diaghilev's Ballets Russes. The audience, made up of the city's dignitaries, artists, and social elite, was astounded by the spectacular decor and costumes, the passionate bravura dancing, and the atmosphere of exoticism that enveloped the performance. The "wild Asiatic horde" electrified Parisian audiences and began a twenty-year assault on every artistic convention associated with theatrical dance presentation. The guiding force and creative center of this artistic phenomenon was Sergei Diaghilev.

Diaghilev's early education provided him with an appreciation of the arts, and although he enrolled in the law school of St. Petersburg University, his ambition was to become a singer or composer. Through his association with his cousin Dmitry

Filosov, Diaghilev was accepted into a group of young men who shared similar viewpoints about art and the world. First called the "Nevsky Pickwickians," the group formed the nucleus of Mir Iskusstva ("world of art").

A strong voice in Russian art criticism, Mir Iskusstva produced a journal of the same name, which Diaghilev edited. In his essay "Complicated Questions," Diaghilev stated the group's views: Art should be expressive, synthetic, and individual. It should communicate "higher truths" and express the elusive ideal of beauty. Mir Iskusstva was critical of the narrow, canon-based art of the academies and of the prevalent "social realism" style of painting. Through the collaborative efforts of Diaghilev, Michel Fokine, Léon Bakst, and Alexandre Benois, the aesthetics championed by Mir Iskusstva were soon applied to the presentation of ballet.

The 1909 premiere season of the Ballets Russes marked the fourth time Russian art had been presented by Diaghilev to Parisian audiences. In 1906, he had organized an exhibition of Russian art that toured Paris, Berlin, and Venice. In 1907, he had brought Russian music to Paris in the form of five historical concerts that included the music of Nikolay Rimsky-Korsakov, Sergei Rachmaninoff, and Aleksandr Scriabin. His next venture was a 1908 production of Modest Mussorgsky's *Boris Gudunov* (1874) at the Paris Opera featuring the famous Fyodor Chaliapin. Each presentation was a triumphant success, whetting the European taste for Russian spectacle. Diaghilev cultivated his audiences, creating an obsession for things "à la Russe."

Ever a perfectionist, Diaghilev insisted that the Théâtre du Châtelet be completely overhauled prior to opening night. His concern for perfection in even the smallest production details was at once a measure of his genius and a major contributing factor to the economic peril that constantly threatened the company. New crimson carpet was laid, the foyers and auditorium cleaned and repainted—all without regard to cost. Even the audience on opening night was not left to chance; fifty-two of the most beautiful actresses in Paris were invited to sit in the dress circle in the first balcony. Blondes were alternated with brunettes; theater manager Gabriel Astruc claimed that upon seeing these women, "the whole house burst into applause."

The ballets performed that first season were *Le Pavillon D'Armide*, the "Polovtsian Dances" (from the opera *Prince Igor*), *Le Festin*, *Les Sylphides*, and *Cléopâtre*. Choreographed by Fokine, the ballets featured music by predominantly Russian composers: Nicholas Tcherepnine, Aleksandr Borodin, Rimsky-Korsakov, Mikhail Glinka, Peter Ilich Tchaikovsky, and Mussorgsky. Costume designs and set decor were created by Diaghilev's Mir Iskusstva companions Alexandre Benois, Léon Bakst, Konstantin Korovin, and Nikolay Roerich.

Accustomed to the banal and effete lethargy of European ballet, Parisian audiences went wild over the virtuosic, athletic vigor of Vaslav Nijinsky, the delicate beauty of ballerinas Tamara Karsavina, Anna Pavlova, and Ida Rubinstein, and the innovative choreography of Fokine. They were equally stunned by the vibrantly passionate, hauntingly pagan, and radically new set decor and costume designs for the ballets. Two ballets in particular captivated the audiences: the "Polovtsian Dances" and *Cléopâtre*.

The "Polovtsian Dances" represented a true novelty for the jaded Parisian audiences. Fokine's innovative use of the corps de ballets as a living ensemble of individuals replaced the conventional static posing, and Roerich's lyric, brooding decor and costumes evoked an aura of pagan mystery. Audiences were swept up in the frenzied finale; one historian has written that "at the end, when Sophia Fedorova led the dance like one possessed, her companions, too, [were] utterly in the grip of the music's frenetic rhythm . . . while the audience jumped and shouted for joy."

Cléopâtre introduced the exotic Ida Rubinstein and the artfully authentic decor and costumes of Bakst and created a passion for everything Egyptian. With *Cléopâtre*, Fokine created a concise choreographic drama in one act, integrating pantomime with the dancing; in combination with Bakst's carefully researched design, Fokine achieved a "scenic realism" that stunned the audience.

The total effect of Diaghilev's Ballets Russes presentations on Parisian audiences was overwhelming. The combination of innovations in choreography, set decor and costume design, brilliant dancing, and exotic music took Paris by storm and began two decades of artistic innovation that revolutionized theatrical dance presentations worldwide.

Impact of Event

When Sergei Diaghilev presented his "saison Russes" in Paris in 1909, he not only created an appetite for Russian ballet, but he also began a revolution in choreography, scene design, musical composition, and ballet technique. More important, that first season changed forever the way audiences perceived dance and dancers, established a completely new process of and standard for artistic collaboration, and thrust dance into a vanguard position among the arts. That first season had both immediate and long-lasting effects on a variety of artistic, social, and cultural spheres.

In much the same way that Diaghilev and Mir Iskusstva condemned Russian art for being overly academic and parochial, Fokine's choreographic reforms were aimed at liberating ballet from its academic straitjacket. Fokine jettisoned the formulaic conventions of his predecessor, Marius Petipa, and created ballets that were concise, with costuming, design, and movement appropriate to their setting, and forged a new ensemble to replace the static and merely decorative corps de ballet of Petipa. Fokine's interest in individual expression can be seen in his transformation of the corps de ballet into a moving, liberated group of individuals with their own personalities, gestures, and emotions. While not abandoning classical technique as did his contemporary Isadora Duncan, Fokine revitalized and expanded the classical vocabulary, freeing the dancer's arms from static conventional poses and their spines from a rigid adherence to the vertical. Many of his innovations, while present in the season of 1909, were not fully realized until such ballets as *Schéhérazade* (1910), *The Firebird* (1910), *Petrushka* (1911), and *Le Dieu bleu* (1912). Fokine's choreographic reforms substantially influenced Nijinsky, Diaghilev's next choreographic protégé.

In the realm of art, Diaghilev's influence spread from his immediate circle of Mir Iskusstva friends to the major painters of the twentieth century. Natalya Goncharova,

Mikhail Larionov, Robert Edmond Jones, Giacomo Balla, Pablo Picasso, Andre De-
rain, Henri Matisse, Juan Gris, Maurice Utrillo, and Joan Miró all created set and
costume designs for Diaghilev's Ballets Russes. Picasso's designs for *The Three-
Cornered Hat* (1919), *Pulcinella* (1920), and especially *Parade* (1917) are considered
masterpieces. In the program notes for *Parade*, Guillaume Apollinaire wrote, "Until
now, scenery and costumes on the one hand, and choreography, on the other, have
had only an artificial connection, but their fresh alliance in *Parade* has produced a
kind of Surrealism . . . [which] promises utterly to transform arts and customs
alike. . . ." Before Diaghilev, scene painting and costume design were primarily in the
hands of professional craftsmen, who worked according to conventional formulas.
With the artistic collaboration of easel painters, the Ballets Russes' productions cata-
pulted stage-decor reforms into the public eye, making the design an integral and
unified part of the production and transforming into reality the aesthetics of Mir
Iskusstva and Richard Wagner's concept of *Gesamtkunstwerk*, or total work of art.

Diaghilev's dedication to novelty guaranteed that the Ballets Russes would be in
the forefront of artistic expression. Nowhere was that more visible than in the roster
of composers invited by Diaghilev to create new scores for his new ballets. Diaghilev
had a genius for recognizing new currents in artistic expression and an instinct for
selecting artistic pioneers. From its inception, the Ballets Russes embodied the pi-
oneering, modern spirit and bold confidence of its founder.

The popularity of the Ballets Russes transformed public opinion about Russian
music and rescued ballet scores from the antipathy of composers. Diaghilev's com-
mitment to a unified and balanced production, with each component of equal artistic
caliber, led him to commission music that could match the spectacular dancing,
choreography, and decor of his ballets. Occurring simultaneously with a rising neo-
nationalist sentiment among Russian composers, Diaghilev's desire for novelty, unity,
and artistic collaboration connected him irrevocably and providentially to the young
Igor Stravinsky.

In collaboration with Diaghilev, under the auspices of the Ballets Russes, Stravin-
sky went on to create masterpieces of musical composition. *The Firebird, Petrushka*,
and *The Rite of Spring* (1913) attest to the brilliant outcome of this partnership. As
radical and uncompromisingly original as Stravinsky's scores were, the nature of
Diaghilev's collaboration with Stravinsky led to an even more important transforma-
tion: the upgrading of the role of the ballet composer, which influenced the genre to
such a degree that, one historian has noted, it led to the "miraculous and altogether
unexpected resurgence and its dramatic upgrading in the twentieth-century scale of
values." In addition to Stravinsky, Diaghilev commissioned scores from a multitude
of history's most celebrated composers, including Maurice Ravel, Erik Satie, Claude
Debussy, Richard Strauss, Manuel de Falla, Sergei Prokofiev, and Darius Milhaud.

The 1909 season of the Ballets Russes fundamentally changed the way audiences
perceived ballet and ballet dancers. Instead of an endless display of stilted positions
and static groupings, the ballet ensemble of Diaghilev's company pulsed, swirled,
and leapt. Gone were the symmetrical groupings of identically clad women who did

nothing more than frame the stage. Absent too were the listless young men who appeared as occasional supports for their balancing partners. Nijinsky, Adolph Blom, Léonide Massine, and Mikhail Mordkin reestablished the primacy and splendor of the male dancer at a time when men were all but extinct from the stage. The overall effect produced a completely different kind of dance drama, one that left the audience demanding more.

As influential as the Ballets Russes was on the individual careers of the artists, dancers, choreographers, and composers who were directly associated with it, its legacy can be seen other ways as well. Diaghilev's insistence on the highest standards of all the artistic components of production elevated ballet and theatrical dance presentation to the equal of theater, visual arts, and music. No longer the inferior stepchild of opera, dance became recognized as legitimate artistic expression. Additionally, Diaghilev's process of collaboration (carried forth from the early Mir Iskusstva days), which illustrated that superb artistic work could be created outside the academy, opened doors for many independent artists. Without Diaghilev's model of a touring company with new repertory each season, it is doubtful that many of the fine ballet companies of today would have come into existence. Indeed, American ballet owes a tremendous debt to the Ballets Russes, from which it received not only dancers, teachers, and choreographers but also the vision of what twentieth century ballet could be.

Bibliography

Garafola, Lynn. *Diaghilev's Ballets Russes*. New York: Oxford University Press, 1989. Scholarly, well-written and thorough book that examines the entire enterprise of the Ballets Russes from a broad and fresh perspective. Analyzes the concurrent artistic, economic, social, and cultural trends and conditions that influenced and were influenced by Diaghilev and the Ballets Russes.

Fokine, Michel. *Fokine: Memoirs of a Ballet Master*. Translated by Vitale Fokine. Edited by Anatole Chujoy. Boston: Little, Brown, 1961. Fokine's account of his early life, ballet training, and rise to stardom as a choreographer.

Haskell, Arnold Lionel. *Diaghileff: His Artistic and Private Life*. New York: Simon & Schuster, 1935. Written in conjunction with Diaghilev's contemporary Walter Nouvel. Dated, romantic, and gossipy; interesting (if suspect) details of Diaghilev's private life and the behind-the-scenes drama at the theater. Appendices include catalog of productions and company roster through the years.

Kochno, Boris. *Diaghilev and the Ballets Russes*. Translated by Adrienne Foulke. New York: Harper & Row, 1970. An oversized book containing photographs, excerpts from letters, program notes, and unpublished essays by Diaghilev and his contemporaries, including Benois, Jean Cocteau, Picasso, and Stravinsky. Excellent resource for information about the specific ballets, dancers, designers, and musicians from 1909 to 1929. Amazing photographs, sketches, and anecdotes about every ballet produced under the auspices of the Ballets Russes.

Pozharskaia, Militsa, and Tatiana Volodina. *The Art of the Ballets Russes*. Translated

by V. S. Friedman. New York: Abbeville Press, 1990. A beautifully photographed oversized book with many color plates. Arranged chronologically to display the productions of the Ballets Russes in their Paris seasons from 1908 to 1929. Emphasis is on costume, set, and stage design rather than on choreography or dancing. Includes a foreword by Clement Crisp, an annotated list of artists, and a minimal but informative text.

Van Norman Baer, Nancy, comp. *Art of Enchantment: Diaghilev's Ballets Russes, 1909-1929.* New York: Universe Books, 1988. Catalog of an exhibition of Ballets Russes artifacts at the Fine Arts Museum of San Francisco. Excellent articles by ten different authors accompany photographs of the exhibit material. Elena Bridgman's essay on the Mir Iskusstva origins of the Ballets Russes and Joan Aceola's essay on Nijinsky are exceptional. The chronologic table of Ballets Russes productions is a very handy quick reference guide.

Cynthia J. Williams

Cross-References

Duncan Interprets Chopin in Her Russian Debut (1904), p. 113; Pavlova First Performs Her Legendary Solo *The Dying Swan* (1907), p. 187; Fokine's *Les Sylphides* Introduces Abstract Ballet (1909), p. 247; *The Firebird* Premieres in Paris (1910), p. 269; *L'Après-midi d'un faune* Causes an Uproar (1912), p. 332; *The Rite of Spring* Stuns Audiences (1913), p. 373; The Ballet Russe de Monte Carlo Finds New Leadership (1938), p. 1088.

FOKINE'S *LES SYLPHIDES* INTRODUCES ABSTRACT BALLET

Category of event: Dance
Time: June 2, 1909
Locale: Théâtre du Châtelet, Paris, France

Michel Fokine took ballet into new dimensions by elevating the male role and showing that ballet could be beautifully abstract

Principal personages:
MICHEL FOKINE (1880-1942), a Russian ballet dancer and choreographer, a founder of modern ballet
VASLAV NIJINSKY (1890-1950), the greatest Russian dancer of his time, especially noted for his powerful yet beautiful leaps
ANNA PAVLOVA (1881-1931), the greatest Russian soloist of her time, whose performance in *Les Sylphides* is thought to be unequaled
TAMARA KARSAVINA (1885-1978), a leading ballerina who partnered Fokine and Nijinsky at various times
SERGEI DIAGHILEV (1872-1929), the impresario who managed the Ballets Russes, the company that staged *Les Sylphides*
OLGA PREOBRAJENSKA (1871-1962), one of the principals in Diaghilev's Ballets Russes
ALEXANDRE BENOIS (1870-1960), a painter and designer primarily associated with the Ballets Russes

Summary of Event

While browsing through some pieces at a music shop, Michel Fokine found a suite entitled "Chopiniana," orchestrated by Alexander Glazounov. Fokine considered arranging a ballet to the suite, but he first decided to add a waltz to the piece, and he asked Glazounov to orchestrate this as well. Fokine's resulting ballet, *Réverie Romantique*, which was performed by the Russian Imperial Ballet in 1907, was an attempt to return ballet to the conditions of its highest development. The ballet's first piece, a polonaise, was performed in a ballroom setting by dancers in rich Polish costumes. The second piece, a nocturne, was turned into a scene from the life of Frederick Chopin in which the composer (portrayed by Alexei Bulgakov) was shown working at a piano in a deserted monastery. Ill and assailed by vague fears, Chopin was suddenly tormented by the ghosts of dead monks. Recoiling in terror and then collapsing in a half faint on the keys, he was rescued by his muse, a dancer in white who appeared out of the darkness to drive away the haunting visions and ease him back to his piano, where he resumed his composition. The third piece, a mazurka, portrayed the interruption of a young peasant girl's wedding to an old man, and her flight from the scene with her former lover. The waltz, a classical *pas*

de deux, followed; the final piece, a tarantella, was an ensemble dance set in a square somewhere in Naples, with Mount Vesuvius looming in the distance.

On April 6, 1908, Fokine presented a new version, *Second Chopiniana*, at the Maryinsky Theater in St. Petersburg. Glazounov's waltz was retained in the new production, but the rest was now orchestrated by Maurice Keller. Part of a double bill with a ballet that showcased the dancers' use of profile positions, angular lines, and flat palms throughout, *Second Chopiniana* was deliberately different in style. Dissatisfied with irrelevant acrobatic feats and toe dance in ballet, Fokine in his new work sought to create a romantic mood piece that was plotless but at the same time infused with emotion. He also wanted to show that he was not destroying the old ballet styles but was, rather, interpreting them differently from his contemporaries— one of whom, Marius Petipa, had succeeded in creating a dominant fashion. Sergei Diaghilev rechristened the work *Les Sylphides* in homage to *La Sylphide* (1832), the first of the great Romantic ballets, and he chose it to be part of the repertory for his first Ballets Russes season in Paris.

In its final form—which took only three days to choreograph—*Les Sylphides* premiered in Paris in 1909. A plotless, abstract piece with a delicate suite of music, the ballet looked deceptively simple, though this was primarily because of the exceptionally talented leads—Anna Pavlova, Vaslav Nijinsky, Tamara Karsavina, and Olga Preobrajenska—whose innate musicality, lightness afoot, and soft arm movements created an elegiac, wistful poetry. Scenarist Alexandre Benois had designed a mournful, romantic setting, a deserted, ruined place. The nocturnal darkness was relieved by a glowing dark green hue and quivering patches of moonlight.

The ballet's dominant mood was set by the overture, which evoked a haunting tenderness. The ballet proper began with a nocturne danced by the whole company, their hair adorned with white flowers and their chests decorated with small posies of forget-me-nots. This female corps de ballet looked like soft white anemones or, alternately, like snow flakes gathering into cool masses of deliquescent beauty. Next came a valse executed by Karsavina with a rare romanticism and beautiful extensions. Pavlova flew across the stage in the first mazurka, and although her leaps were not particularly high, her slim body and midair positions created the impression of light, lyrical flight. Nijinsky, the sole male dancer, shone next in his mazurka. Clothed in black and white and wearing a blond wig that hung down to his shoulders, he seemed to be almost weightless, and he demonstrated his extraordinary ability to seem to pause in mid-flight. With exceptional speed, yet enviable lightness, he moved from the front of the stage to the back at a single bound, and he fused pauses and successive movements into a vibrant whole. His dancing had a continuous, weaving rhythm, and although his technique was meticulously worked out, his dance instinct and imagination made the choreography seem beautifully natural.

The prelude was danced by the diminutive Olga Preobrajenska, who demonstrated an exceptional sense of balance. Her dancing on point was virtually ethereal— especially her ability to freeze on the toes of one foot—and although she was a champion of the style of dancing extolled by Marius Petipa, she put her sense of

traditionalism at Fokine's revolutionary service.

The waltz's *pas de deux*, performed by Nijinsky and Pavlova, ended with Pavlova performing a *pas de bourrée*, a running step, on her toes. The ballet concluded with a final waltz danced by the entire company in an expressive play of configurations.

The huge ovation that greeted the conclusion was a tribute to Fokine's pure vision and to his dancers' creation of a fantastic atmosphere. The dancers were not simply exhibiting themselves; they were, instead, expressing a spiritual mood that grew out of Chopin's pieces.

Impact of Event

Les Sylphides crowned the 1909 season of Sergei Diaghilev's Ballets Russes. It was close enough to the tradition of French ballet so as not to surprise the Parisians, and its exceptional execution delighted critics and audiences alike. The production also offered a series of revelations.

Audiences attending *Les Sylphides* discovered that a ballet did not have to be more than one act in length. Moreover, the work demonstrated that ballet's subject matter could be abstract so long as a dancer's whole body (rather than merely legs or torsos) moved to convey emotion or sensation. The corps de ballet was part of the plastic sequence of movements, and their varied groupings were more than simply decorative. Music, it was also discovered, could have a more intimate relationship to dance than ever before. The participation of Nijinsky as a soloist was another novelty and a revelation all its own, for he created a different image for the male dancer: No longer merely a partner for the ballerinas, he could display his own acrobatic and athletic virtuosity without feeling apart from the thrilling whole.

Les Sylphides quickly lent justification to Fokine's new tenets of ballet. A dancer in his own right who had partnered Pavlova, Karsavina, and other noted ballerinas, Fokine sought to have dance keep up with the changing tenor of the times. Classical dance seemed far too static for his liking; he believed that dance tradition subjugated all periods, styles, and characters to its own imperious decrees. As he complained in his memoirs, "Everything was sacrificed for one form, one style, so that the artists might display the dance, the technique, in the manner in which it had been prepared—once and for all." In such old-style performances, Fokine wrote, everything was focused on the dancer's personal appearance and technique instead of on the dancer's ability to express emotion. In short, Fokine wrote, many traditional ballets of the time were marked by stale self-exhibitionism instead of by creative energy. He also decried the fact that such ballets had no real unity of action, for performances could be interrupted by applause and a dancer's grateful bows. Moreover, Fokine complained about prevailing techniques of dance expression (some dancers would interpret stories with their hands, others with their feet) and about lapses in costume style; some ballets used historically correct costumes, while others would have special ballet attire.

Taking advantage of his special position as a teacher at the Imperial Ballet School in St. Petersburg, Fokine was gradually able to introduce his views of ballet to those

who would be the Russian ballet's future. It was really as a choreographer, however, that he was most successful in promulgating his views. Fokine's ideas met with contempt from the conservative Maryinsky Theater authorities, and it was really only after he joined forces with Diaghilev in 1909 that Fokine's views received their proper due. Through a series of classic productions with the Ballets Russes, Fokine demonstrated his principles in action. Dance steps and movements corresponded to the period and character presented. Dancing and mimetic gesture expressed the dramatic action and were directly connected to theme. The whole body was used as an instrument of expression, and this expression extended from the individual to the ensemble. Every element on stage—decor, costuming, lighting, choreography, mime, music—harmonized into an integral whole.

Les Sylphides quickly became part of every major ballet company's repertoire, and yet has not always had successful presentations. *Les Sylphides* is dance for its own sake, yet it is delicate, precise dance that cannot be successful if the performing ensemble is not tremendously skilled. Only the very greatest ballet companies with the greatest stars (such as Margot Fonteyn, Lynn Seymour, Rudolf Nureyev, and Mikhail Baryshnikov) have managed to evoke the beauty of the work.

Fokine was not the first to use Chopin's music for ballet; Isadora Duncan had danced to Chopin in 1904 during her Russian tour. Yet ever since Fokine, other choreographers and dancers have exploited Chopin. Anna Pavlova used Chopin's music in 1918 for her *Autumn Leaves.* Nineteen years later, Bronislava Nijinska created a performance to a Chopin concerto. Fokine continued to inspire American and English choreographers well into the second half of the century. Jerome Robbins has gone to Chopin for several ballets, particularly for *Dances at a Gathering* (1969), a suite of plotless dances growing out of eighteen piano pieces that is directly linked to *Les Sylphides*. Frederick Ashton's *A Month in the Country* (1976), a supremely bittersweet drama about the foibles of the human heart, used John Lanchbery's arrangements of Chopin. John Neumeier's full-length *Lady of the Camellias* (1978) also used Chopin's music.

Les Sylphides was not the last word on the subject of abstract dance. Future choreographers carried forward the innovations of Fokine's work and added their own, and by the late twentieth century, many of the elements that had seemed revolutionary in Fokine's time had begun to seem almost quaint. Yet there is no denying the powerful effect of *Les Sylphides* on modern ballet, and the work has assumed an honored place in the classical repertory alongside the other masterworks of twentieth century choreography.

Bibliography

Balanchine, George, and Frances Mason. *Balanchine's Complete Stories of the Great Ballets.* Garden City, N.Y.: Doubleday, 1977. Standard, classic reference, with stories of more than four hundred ballets. Also gives Balanchine's personal thoughts on dancing, careers in ballet, and ballet for children. Contains a brief history of ballet, with a chronology of outstanding events from 1469 to 1976, an illustrated

glossary, and more than seventy-five photographs.

Beaumont, Cyril W. *Complete Book of Ballets: A Guide to the Principal Ballets of the Nineteenth and Twentieth Centuries.* New York: Grosset & Dunlap, 1938. Contains a very brief biographical sketch of Fokine's career, a list of his productions all over the world, and synopses of his major ballets, along with cast lists and brief commentaries.

Fokine, Michel. *Fokine: Memoirs of a Ballet Master.* Translated by Vitale Fokine. Edited by Anatole Chujoy. Boston: Little, Brown, 1961. Posthumously published, translated from journals in Russian. Gives an account of Fokine's early years, his training at the Imperial Ballet School, and his own sense of his awakening genius.

Robertson, Allen, and Donald Hutera. *The Dance Handbook.* Essex, England: Longman, 1988. A practical guide that provides entries on influential works, choreographers, dancers, and companies. Includes essential facts and critiques. Illustrated. Glossary, index, and sources.

Sokolova, Lydia. *Dancing for Diaghilev: The Memoirs of Lydia Sokolova.* Edited by Richard Buckle. New York: Macmillan, 1961. A fascinating record of the Diaghilev Ballet, written by the principal character dancer. Vignettes of Nijinsky, Karsavina, Léonide Massine, Fokine, and many other famous ballet figures.

Keith Garebian

Cross-References

Pavlova First Performs Her Legendary Solo *The Dying Swan* (1907), p. 187; Diaghilev's Ballets Russes Astounds Paris (1909), p. 241; *The Firebird* Premieres in Paris (1910), p. 269; *L'Après-midi d'un faune* Causes an Uproar (1912), p. 332; *The Rite of Spring* Stuns Audiences (1913), p. 373; The Ballet Russe de Monte Carlo Finds New Leadership (1938), p. 1088.

HANDY USHERS IN THE COMMERCIAL BLUES ERA

Category of event: Music
Time: The 1910's
Locale: The United States

W. C. Handy transformed the native music of the Southern backwoods, work camps, and cotton fields into a commercial craze

Principal personages:
 W. C. HANDY (1873-1958), an originator of popular blues and a leading American composer
 "BLIND LEMON" JEFFERSON (1897-1929), a leading blues man and authority on the blues
 BESSIE SMITH (1894-1937), the greatest of the early blues singers
 MA RAINEY (1886-1939), a great blues singer
 BERTHA "CHIPPIE" HILL (1905-1950), a Ma Rainey protégé
 "BIG BILL" BROONZY (WILLIAM LEE CONLEY, 1893-1958), a famed blues singer and guitarist

Summary of Event

Along the Lower Mississippi from Memphis down to New Orleans, the blues evolved during the post-Civil War years. At a train station in Tutwiler, Mississippi, a black musician named William Christopher Handy "rediscovered" the blues in 1903 while listening to a guitarist use a knife to strum a song that Handy subsequently wrote as his own "Yellow Dog Blues." The occasion reminded him that, eight years before, he had heard another lone singer "hollering" his blues. Handy's full enlightenment about this aspect of the Delta cultures surrounding him came as his Knights of Pythias band was playing for a Cleveland, Mississippi, dance later in the year. As bandleader, he was asked to perform "native" music—that is, to play blues. Unable to comply, he allowed three ragged local musicians to do so; when they brought the house down, he realized the music's commercial value. The event changed his career. Inspired by such incidents, Handy later laid legitimate claim to the title "Father of the Blues," and the rest of the nation, within a few decades, would embrace the music.

While in future the blues would be identified accurately as part of jazz, its provenance historically, although murky, was separate. Jazz represented a Southern confluence of multiracial and multiethnic urban influences that initially were geographically specific to cities of the South Atlantic and Gulf coasts. The spread of jazz and its fusion with other musical forms was another continuing story.

Blues music, as recent studies confirmed, is of African origins. The music underwent transformation in the rural areas and small towns of the Lower Mississippi; by the late 1890's, the music was specific to people who performed harsh physical labor,

and lived accordingly hard lives, in cotton fields of the large Delta plantations, in mining, logging, and work camps, in levee and railroad construction, in freight loading, and in the perpetually debt-ridden, segregated, unlettered, and depressed worlds of crop-lien and sharecrop farming. Thus, blues were powerfully emotive, and the sole instrument capable of rendering their "blue notes" (sung usually between the third and seventh degrees of the scale) was the human voice. Accompaniment, when there was any, was generally by guitar, which merely filled in as a second voice. In their archaic forms, the blues' twelve-bar stanzas of three lines each did not even lend themselves to musical notation; the rhythm, rhyme, and subtle poetry were the singer's to provide.

Raw, rural, and steeped in subsistence-level living—although their range of subjects was vast—the blues dealt mainly with inevitabilities: hard labor, death, bad crops, sex, loss of a lover, sickness, low wages, scarce money, drink, jail, and a world awash in other troubles. Nevertheless, there sometimes was an implicit and wry shared humor in the music, as well as sadness, nostalgia, and lament. For the blues' purpose was to alleviate distress by means of the traditional open and candid vocal expression especially common to isolated, segregated, and—in formal terms— unschooled people.

Handy's background was unlike that. Born in Florence, Alabama, the son of a Methodist minister, he was reared in a household that discouraged music and condemned the life of musicians. Nevertheless, thanks to his teachers, he had by the age of ten shown some musical precocity. Following high school, he spent a year as a coronet player with several bands and with Chicago's Mahara Minstrels; he also spent two years as an instructor at Huntsville, Alabama's Teacher's Agricultural and Mechanical College for Negroes. After this came the revelations of Tutwiler and Cleveland and several more years as a bandleader in Mississippi and Tennessee.

As late as 1907, when Handy and the lyricist-singer Harry Pace started a music-publishing business near Memphis' thriving black music center on Beale Street, Handy had still refrained from publishing his own compositions, although he had behind him a quarter century of acquaintance with all types of music and was enamored of the blues. His "Memphis Blues," written upon request expressly for the Memphis mayoral campaign of flamboyant Ed Crump in 1909, however, rocked the city and established Handy's songwriting reputation. It was while he was reminiscing about an earlier visit to St. Louis' notorious Targee Street that he then composed what proved to be his world-famous "St. Louis Blues" in 1914. As a sophisticated and urbane musician, Handy had effectively added the fruits of his own experience to the archaic rural blues that had captured his imagination in the Mississippi Delta. When he and Pace moved their business to New York in 1918, Handy ranked as the first man to compose the blues formally as well as the first to popularize them commercially.

Impact of Event

The excitement attending Handy's "Memphis Blues," the influence of which was

initially local, by 1912 swept New York. His spectacularly successful "St. Louis Blues," which enjoyed an even more fervent reception in Harlem and soon became nationally popular, introduced the American public to a second-hand and sophisticated blues removed from its rural origins. Blues such as Handy's that represented the compositions of rather worldly musicians and vaudevillians became popular throughout the United States. Such music was sung by urbanized cabaret and torch singers, including Ohio's Mamie Smith, whose origins were neither rural nor Southern.

What mattered most in catapulting the blues into general recognition and popularity was their recording, and Handy's successes unquestionably encouraged his imitators to move in that direction. Perry Bradford, who had moved from Alabama to Harlem, was foremost in persuading the General Phonograph Company to record Mamie Smith singing his "Crazy Blues" in 1920. The first vocal blues recording, Smith's record, which sold more than a million copies in six months, is regarded as a milestone by music historians. Reaching an immense audience, it constituted a cultural event. Instantly, it brought forth from black communities across the country, where superb music had flourished locally for years, a host of blues composers, singers, and bands for the enjoyment of eager audiences. Smith's recording further encouraged recording companies with labels such as Brunswick, Columbia, OKeh, and Victor to tap the hunger of American blacks for reproductions of their authentic music. The subsequent spate of "race records"—a designation that carried proud, rather than pejorative, connotations for the increasingly self-conscious blacks of the 1920's—not only whetted racial pride but also stimulated a search for more genuine blues songs and singers.

No one filled the latter bill better than Chattanooga's magnificent, if tragic, Bessie Smith, soon to reign as "Empress of the Blues." Before her death in an auto accident (ironically near Clarksdale, Mississippi, where Handy had discovered the blues), Smith sang with her uniquely poignant voice among a constellation of singers and performers who made the blues a national treasure. Among these personalities were Gertrude "Ma" Rainey, several of her protégés, including Bertha "Chippie" Hill and Ida Cox, and a number of young jazz musicians who would use blues as a base for their idiom, including Fletcher Henderson, James P. Johnson, and Louis Armstrong. In addition, Smith and her blues interpretations were direct inspirations to later great blues, jazz, and gospel singers such as Janis Joplin, Billie Holiday, and Mahalia Jackson.

Bessie Smith's "downhome" genius also focused attention upon rediscovering the original and authentic forms of rural, or archaic, blues and their variations, including the field "hollers," while they could still be recorded. A major catalyst in this quest was Texas' remarkably knowledgeable Blind Lemon Jefferson, who moved from regional to national fame by way of Paramount and OKeh recordings. Efforts such as Jefferson's brought recognition to musicians such as Daddy Stovepipe and Pappa Charlie Jackson—both of whom recorded in 1924—as well as to Delta bluesman Charley Patton, to the unaccompanied field hollerer Texas Alexander, to Ragtime Henry Thomas, to gospel blues performer Blind Willie Johnson, and not least

to Jefferson's proclaimed protégés Huddie (Leadbelly) Ledbetter, Josh White, and Sam "Lightning" Hopkins. Others to record their way to prominence during the 1920's were Mississippi's Lonnie Johnson and Big Bill Broonzy, hillbilly bluesman Coley Jones, and Jelly Roll Morton, who composed his "New Orleans Blues" in 1902 and subsequently gained fame for melding blues, ragtime, and brass band music. Such performers composed, played, and sang more than two thousand variously styled blues recording during the blues boom that followed Handy's "St. Louis Blues" in 1914 and soared to a peak during the 1920's.

By the 1930's, the blues in their variety had launched the careers of numerous outstanding singers, composers, and musicians and had been intensively recorded. The blues had likewise served as vehicles for bringing black music into the American mainstream, simply because the emotions the music conveyed had been felt and appreciated. Equally important, as the blues live on in their original forms, they have also been woven into the fabric of jazz, rhythm and blues, country, and rock and roll.

Bibliography

Charters, Samuel Barclay. *The Bluesmen: The Story of the Music and the Men Who Made Blues.* New York: Oak Publications, 1967. Author concentrates on the blues' origins and on musicians and songs from Alabama, Mississippi, and East Texas, with such material specifically on blues masters Charlie Patton, Skip James, Robert Johnson, Bukka White, Blind Lemon Jefferson, Henry Thomas, and Texas Alexander. Many fine illustrations and photos. Brief notes and usable index. Must reading.

──────────. *The Roots of the Blues: An African Search.* Boston: Marion Boyars, 1981. Charters describes his search for sources of blues: men, instruments, and songs from portions of West Africa from which slaves were taken to the United States. Augmented by two volumes of recordings. No notes or bibliography, but many photos. An easy, interesting read, though hardly definitive.

Dale, Rodney. *The World of Jazz.* Oxford, England: Phaidon, 1980. Chapter 3 deals specifically in survey fashion with the evolution of the blues and provides thumbnail biographies of some of the great blues singers and players, with accompanying photos. Good introduction to the subject. Deals well with the blues' integration into jazz. Many fine photos, appendices, notes on musicians' specialties, and a brief index.

Ferris, William R. *Blues from the Delta.* New York: Da Capo Press, 1984. A Yale University folklorist and musician, Ferris places Delta blues and personalities associated with them in social and historical perspective, from the early days through to B. B. King, Muddy Waters, and Howlin' Wolf. Based on personal visits and stays in the Delta. Many blues lyrics, conversations, letters, and marvelous photos providing a feel for the region's blues folk. Notes, useful bibliography, extensive discography, filmography, and useful index. Colorful reading.

Handy, William Christopher. *Father of the Blues: An Autobiography.* New York:

Macmillan, 1941. Interesting and useful, if only because it is one of the lengthiest and most detailed autobiographies of its kind. A better composer by far than a writer, Handy nevertheless presents a fascinating life story. There is a chronological list of his compositions, arrangements, and books along with a brief index.

Malone, Bill C. *Southern Music, American Music.* Lexington: University Press of Kentucky, 1979. A fine study, engagingly written, broad in range, and rich in detail. Blues are well-integrated into discussion of the evolution of all Southern music—hillbilly, Cajun, gospel, country, rock, and soul. Chapters proceed chronologically, so there is a sense of the historical relationships among these various musical forms. Good notes, a fine critical bibliographical essay, an extensive double-columned index, and eight pages of photos. Excellent read.

Southern, Eileen. *The Music of Black Americans: A History.* New York: W. W. Norton, 1971. A chronological historical account of the subject. Excellent both for background and important detail. Scholarly, well-written, and an easy read. A splendid critical bibliography and discography are included for each chapter, plus numerous selections from scores and an extensive double-columned index. Must reading.

Clifton K. Yearley

Cross-References

Joplin Popularizes the Ragtime Style (1899), p. 13; ASCAP Is Founded to Protect Musicians' Rights (1914), p. 379; Bessie Smith Records "Downhearted Blues" (1923), p. 572; Gershwin's *Rhapsody in Blue* Premieres in New York (1924), p. 598; Armstrong First Records with His Hot Five Group (1925), p. 670; Ellington Begins an Influential Engagement at the Cotton Club (1927), p. 739; Billie Holiday Begins Her Recording Career (1933), p. 930.

GAUDÍ COMPLETES THE CASA MILÁ APARTMENT HOUSE IN BARCELONA

Category of event: Architecture
Time: 1910
Locale: Barcelona, Spain

With a design totally modern yet free of eclecticism, Antonio Gaudí established a controversial prototype for regional architecture

Principal personages:
ANTONIO GAUDÍ (1852-1926), an innovative architect whose bold designs set a precedent for Catalan regional architecture
EUSEBIO GÜELL (1846-1918), a cultured Barcelona textile magnate who gave Gaudí needed spiritual and financial support
EUGÈNE-EMMANUEL VIOLLET-LE-DUC (1814-1879), a French architect whose theories on architecture and admiration for the Gothic style deeply influenced Gaudí
JOHN RUSKIN (1819-1900), an English art critic whose ideas on the architect as artist and the national character of good architecture inspired Gaudí

Summary of Event

The completion of the Casa Milá apartment house in 1910 was for Antonio Gaudí the logical culmination of a career that had started when he was a boy in the provincial town of Reus, south of Barcelona, where he was born. Gaudí knew even then that he wanted to be an architect and viewed his chosen profession almost as a religious calling. He would be the consummate architect: theoretician, artist, engineer, designer, and master builder. He would develop a style that would be completely his; a style that would benefit his fellow citizens, for Gaudí had a deep-seated social consciousness; a style and designs that would add to the cultural heritage of Catalonia, for Gaudí was an ardent nationalist. Catalonia, located in northeastern Spain, is generally considered to be Spain's most progressive and prosperous region. Despite Madrid's repeated attempts to assimilate Catalonia into a greater Spain, the Catalans have fought stubbornly to retain their identity.

With a delicate constitution that would plague him his whole life and with limited resources, Gaudí had to focus on his objectives. At the Architectural School of the University of Barcelona, he studied only what was of interest and what he thought would be of benefit. An architect whose theories he found fascinating was Eugène-Emmanuel Viollet-le-Duc, who was at the time restoring some of France's ancient monuments, including the City of Carcassone, which Gaudí visited. Viollet-le-Duc advised would-be architects to look to the past for inspiration rather than for designs. A freethinker, he saw medieval cathedrals not primarily as places of worship but

rather as marvels of engineering. Gaudí shared this admiration but saw the Gothic arch as too weak, needing support. He developed in its stead the parabolic arch, which had virtually no lateral thrust and was therefore more versatile.

To supplement his income while a student, Gaudí worked as a draftsman for local builders. The experience was invaluable. He developed a thorough knowledge of materials, of tools, and of construction devices such as the tiled laminated arch traditionally used in Catalonia. It was lightweight and inexpensive yet amazingly strong. More important, Gaudí developed a deep compassion for the humble artisans among whom he worked.

One of Gaudí's first commissions upon graduation was a plan for a workers' cooperative. He exhibited the plan at the Paris Exposition of 1878. It attracted the attention of Eusebio Güell, a local textile magnate, who was cultured, had a social conscience, and was, like Gaudí, an ardent nationalist.

Güell gave Gaudí a number of important commissions, including one for an elaborate town house for himself. More important, Gaudí was introduced in the Güell home to a number of new ideas, including those of John Ruskin, an influential English art critic, as well as to the music of the German composer Richard Wagner, whom Güell greatly admired.

From Ruskin, Gaudí gained the idea of seeing architecture as essentially organic, related to nature through its play of light and color. Ruskin also stressed the national content of good architecture. It was, he said, expressive of race. Wagner, as a librettist, composer, conductor, and producer, was a model of a well-rounded artist.

Reflecting the influence of Viollet-le-Duc, Gaudí's designs for buildings were inspired by those of the past but adapted, such as Moorish designs with brilliantly colored tile work or Gothic ones with a parabolic arch substituted for the traditional pointed arch. A significant commission from Güell was for a garden complex of twenty houses to be located on a barren hillside. To support the numerous necessary terraces, Gaudí used the tilted column, another of his architectural innovations. The vast central terrace was supported by columns in the Greek Doric manner. The columns also served as conduits for water that was collected on the terrace and was filtered by the sand that was used instead of paving. Surrounding the terrace was a sinuous border of multicolored tile fragments set in mortar. As a housing complex, the project was a failure, but it became a brilliant success as a public park.

By the time Gaudí received the commission for the Casa Milá apartment complex in 1906, he believed that he had developed fully as an architect. There would be no traces of the Moorish, the Gothic, or the Greek in his design. Casa Milá was pure Gaudí, but it was also Catalan in spirit, in harmony with the undulating shoreline on one side and the rugged serrated mountains that served as a background to Barcelona.

The façade of Casa Milá was of massive undulating stone cut through by windows and balconies; the whole is in a constant play of light and shadow. The stone also served as insulation against the blazing Mediterranean sun. The façade was apart from the freestanding building, attached to it by rods. The building in turn was

supported by pillars, from which was suspended a framework of trusses and girders. The arrangement permitted a fluidity in arrangement, with each apartment different from the next. Two generous interior patios served as sources of light and air. Gaudí paid meticulous attention to both the cellar and the roof. Ramps led down to the cellar, giving Casa Milá one of the first underground garages. The roof, supported by Gaudí's lightweight tiled arches, boasted probably the largest collection of freestanding Surrealist sculptures in the world in the form of its numerous chimneys.

Casa Milá was Gaudí's last secular assignment. Had he built nothing else, it still would have caused him to be ranked among the leading architects of the twentieth century.

Impact of Event

Gaudí never completely finished Casa Milá, as he had become increasingly engrossed in his greatest project, the Expiatory Church of the Holy Family (Sagrada Familia), to which he devoted all of his energies until his tragic death in 1926. Casa Milá, however, remained one of Barcelona's most controversial buildings, and its impact ranged far beyond the Catalan capital. A true assessment of that impact is difficult to make because so little is known of the architect and his relation to what many consider to be his most significant building. Gaudí sought no recognition. He seldom gave interviews and left no writings. Such plans and other architectural drawings as existed were largely destroyed during the Spanish Civil War. Because attitudes toward architecture have changed since Gaudí's time, an assessment of the impact of Casa Milá must be made in terms of both immediate and long-term effects.

As an immediate effect, the Casa Milá apartment house, with its undulating lines, its asymmetry, and its emphasis on light and shade, came to be regarded as an extreme example of the Art Nouveau style popular between 1900 and 1914. The categorization is simplistic. Although related to Art Nouveau, Casa Milá is part of the Catalan interpretation of Art Nouveau known as *modernismo* or modernism. Gaudí's *modernismo*, however, is more than surface decoration. Organic in nature, for the body and façade of Casa Milá can be equated to a body and its skin, Gaudí's outward forms are a manifestation of forces at work below the surface.

The second immediate effect involved the relationship of Casa Milá to an emergent art form called Surrealism. Surrealism attempts to transpose absolute reality into superreality by resolving the contradictory conditions of dream and reality. Casa Milá, with its amazing roof sculptures, was considered to be the result of such a resolution in the opinion of many of the Surrealists, including Salvador Dalí, a fellow Catalan. The Surrealists fought most strongly to keep Gaudí's memory alive.

By the time of Gaudí's death and even before, his intensely personal, regional style was being replaced by what became known as the International Style. Originating in Germany with the Bauhaus group, the style was rectilinear, impersonal, and devoid of ornamentation. Preferring steel, lightweight metals, and glass over masonry, it placed primary emphasis on function. Divorced from tradition, the style sought to be universal.

Although the communist and fascist dictatorships of Spain tended to favor a ponderous neoclassicism, elsewhere the spread of the new style was phenomenal. Whole sections of cities were leveled to be replaced by glassy, boxlike structures. The rebuilding of the devastated cities of Europe after World War II hastened the utilization of the International Style, for among its advantages were ease of construction and economy.

Gradually, a reaction began to set in from persons unhappy living and working in these buildings and from architects who had begun to see themselves as little more than designers of containers. The centennial of Gaudí's birth in 1952 witnessed a growing desire for more personal styles such as that represented by Casa Milá. Ornamentation began to reappear. A group of architects calling themselves the postmodernists saw ornamentation as a means of enriching architecture.

There was renewed interest in the works of Antonio Gaudí, and the list of publications on the Catalan master grew. Rediscovering Gaudí also meant becoming aware of his regionalism, his relation of buildings to their environment, as well as his commitment to a versatile urban design. Casa Milá embodied all of these characteristics.

Architects began to become uncomfortably aware that an architectural design suitable to northern Europe was not suitable to a tropical climate. In addition, the phenomenon of universalization that the International Style represented meant the subtle destruction of traditional cultures and a loss of human values. Increasingly, attention focused on what became known as critical regionalism in architectural design, with awareness of and attention to traditional regional models, building materials, and construction methods.

Concomitant with the growing disillusionment with a standardized design in urban architecture was unhappiness with the destruction of the urban fabric that often resulted from use of this design. What resulted, with depressing regularity, were whole sections of cities consisting of impersonal high-rise buildings at odds with the environment and often even hostile to it, separated by highways and parking lots. These replaced the traditional closely knit neighborhoods, fostering a sense of isolation rather than of community. With all of his urban buildings and especially with Casa Milá, Gaudí was careful to relate to the environment. Although unconventional in design, Casa Milá harmonizes with the adjoining buildings and follows the contours of the streets.

Probably the outstanding feature of Casa Milá as it relates to urban design is its versatility. The numerous balconies, one concealed from the other, foster the solitude humans often crave, while the roof and the patios foster the equally necessary social interaction. The design itself permits the rearrangement of space to suit changing demands. In 1923, Le Corbusier (Charles-Édouard Jeanneret), one of the best-known modern architects, called for nonmonumental buildings that would be "machines for living." Casa Milá can be considered to be such a machine. By using the traditional monumentality as a façade, Gaudí provided the best of both the traditional and the new.

Bibliography

Collins, George R. *Antonio Gaudí.* New York: George Braziller, 1960. Collins is considered by many to be the leading American authority on Gaudí. The book is divided into three parts: Gaudí's life, his works, and an evaluation. The last part is particularly valuable. The book has many photographs and some architectural drawings. The text is supplemented with copious notes.

Hitchcock, Henry-Russell. *Gaudí.* New York: Museum of Modern Art, 1957. Hitchcock, a prolific writer on architectural history, was one of the early promoters of the International Style; the Museum of Modern Art, more than any other institution, fostered growth of the style. Hitchcock stresses Gaudí's uniqueness and seemingly cannot relate him to the growing disillusionment with the International Style. Black-and-white photographs.

Kostof, Spiro. *A History of Architecture: Settings and Rituals.* New York: Oxford University Press, 1985. Kostof, a noted professor of architectural history, has spent his life making architectural theory comprehensible. This book is his masterpiece. The last chapter, "At Peace with the Past, the Last Decades," is a well-written exposition on the changes in architectural theory during the last decades of the twentieth century, changes that helped reinvigorate Gaudí's ideas.

Martinell, Cesar. *Gaudí: His Life, His Theories, His Work.* Translated by Judith Rohrer and edited by George R. Collins. Cambridge, Mass.: MIT Press, 1975. The most detailed and complete study on Gaudí. The author, who knew Gaudí in the last decades of his life, is both an architect and a historian. The work is divided into three sections: Gaudí's life, his theories, and his work. The appendices contain a number of valuable primary documents, including Gaudí's earliest architectural plans, his school transcript, and an early essay by him on ornamentation.

Mower, David. *Gaudí.* London: Oresko Books, 1977. An excellent, comprehensible survey of Gaudí's career. Two valuable features are a series of quotations from prominent figures such as Walter Gropius, Salvador Dalí, Louis Sullivan, and Albert Schweitzer on Gaudí and chronologies dealing with the career of Gaudí and the history of Catalonia. Photographs are interspersed with text.

Solà-Morales Rubió, Ignasi. *Gaudí.* Translated by Kenneth Lyons. New York: Rizzoli International Publications, 1983. Divides Gaudí's professional life into three phases: early eclecticism; the period of equilibrium, which includes Casa Milá; and the architecture of destruction, which includes the monumental Church of the Holy Family.

Zerbst, Rainer. *Gaudí, 1852-1926.* Translated by Doris Jones and Jeremy Gaines. Cologne, Germany: Benedikt Taschen Verlag, 1988. Possibly the best book for someone wishing an easy introduction to Gaudí and his works. The author, an art critic, is a Gaudí devotee. Gaudí's works are treated separately. The photographs, all in color, are outstanding and include examples of Gaudí's furniture and interior decorations.

Nis Petersen

Cross-References

Hoffmann Designs the Palais Stoclet (1905), p. 124; German Artists Found the Bauhaus (1919), p. 463; Surrealism Is Born (1924), p. 604; Le Corbusier's Villa Savoye Redefines Architecture (1931), p. 869; Kahn Blends Architecture and Urban Planning in Dacca (1962), p. 1919; The AT&T Building Exemplifies Postmodernism (1978), p. 2407.

POIRET'S "HOBBLE SKIRTS" BECOME THE RAGE

Category of event: Fashion and design
Time: Spring, 1910
Locale: Paris, France

Fashion designer Paul Poiret altered the way women dressed by his elimination of the corset, but he also restricted their freedom of movement with his hobble skirt

Principal personages:
> PAUL POIRET (1879-1944), the first modern designer and creator of women's clothing that emphasized the natural shape of the body
> LÉON BAKST (LEV ROSENBERG, 1866-1924), a designer for the Ballets Russes who collaborated with Poiret
> ERTÉ (ROMAIN DE TIROFF, 1892-1990), an artist employed by Poiret as an assistant designer
> RAOUL DUFY (1877-1953), an artist who provided Poiret with designs for textile manufacturing

Summary of Event

Paul Poiret was employed as a designer at the House of Worth during the last decade of the nineteenth century. As a result of a dispute, Poiret resigned his position and established his own house of design on September 1, 1903. As a result of his creativity and business acumen, he quickly became one of France's most successful couturiers. From 1904 to 1914, his fashion and design innovations had a pronounced effect on the way women dressed. He was the most significant of early twentieth century French designers; he demonstrated that astute business practices and fashion were not incompatible.

Poiret first gained attention for his determination to dress women in a natural manner, according to the way that they were constructed by nature. He rejected the use of the restrictive corset worn by most women, which produced an S-shaped form that emphasized the hips and bosom and prevented women from assuming an upright posture. He replaced the corset with a girdle and a brassiere, an item of apparel that was first advertised in 1907. The brassiere designed by Poiret was a modification of the bust bodice, or "improver," of the late nineteenth century. Poiret also set aside the stiff crinoline petticoat, which often called for the use of fifteen or more yards of taffeta and possessed a circumference of six or even seven yards. He introduced a plainer item made of crepe de chine or linen that became known as a "slip." The interest group that most vigorously protested the substitution of the slip for the petticoat was the silk industry, the members of which blamed Poiret for the loss of business and profits.

In his search for newness, Poiret also set aside the pale, diluted colors of the

Edwardian period and, like the Fauve painters, employed vibrant and pure color; he referred to his fabrics as "cloths of fire and joy." He generously utilized orange, yellow, and red; other colors such as emerald green, cerise, vermillion, royal blue, and purple also became identified with his work. Often, too, he imposed his Fauvist colors on a black background. He drew upon the creative skills of artists such as Raoul Dufy and Erté to provide him with color designs, which he then had imprinted on fabric. For evening wear, he used exquisite fabrics such as silver and gold lamés interwoven with silk, damask, brocade, and brocatelle; gold and silver thread and beads were added as decorative features. His search for the right fabric to execute his creations in part was responsible for the renewal of the French textile industry and the revitalization of the art of applied design. Other Poiret fashion statements were coils of flashing pearls worn under stoles of white fox, cockades of multicolored feathers, and turbans as appropriate and stylish headwear. Furthermore, he was the first couturier to develop and market a line of perfumes, which he called "Rosine" after his oldest daughter. Success led him to add other items to the "Rosine" line, including colognes, toilet waters, soaps, powders, lotions, creams, talcums, and cosmetics.

For inspiration, Poiret drew upon the ideas of designers Léon Bakst and Alexandre Benois of the Ballets Russes. Poiret, however, always contended that he employed Asian influences in design and the use of pure and vibrant color before the Russian ballet was accepted in Paris by 1909 and even before the Fauve artists made their mark upon the world of painting in 1905.

In a contradictory vein, Paul Poiret was the creator of the natural-form silhouette of the modern woman, yet he was also responsible for arresting, with his introduction of the hobble skirt, the freedom of movement that he pioneered. He once noted, "I freed the bosom, shackled the legs, but gave liberty to the body." It was the hobble skirt, though, that kept his name alive across the pages of modern fashion history.

The hobble skirt was a garment with a high waistline, sometimes belted under the breast, and narrow from the knees to the ankles. The hemline circumference was less than thirty-six inches. Some skirts were decorated with a wide band or sash at the hemline, which created a strong fabric restriction that further reduced the ability of the women who wore the style to walk. The skirt gave the appearance that wearers had only one leg; some observers commented that the image produced was that of a skittle.

The hobble skirt first appeared as an item of fashion in Paris in the spring of 1910. It is frequently contended that the skirt first appeared as a costume for an actress who wanted a dress that would provide a pleasing contrast to a pillar that she had to lean against in a play. In fact, Poiret initially designed the skirt in order to achieve the new look that he envisioned for women, a look that would be dramatically different from that of the ample-skirted woman that had dominated women's fashion for decades. The hobble skirt blended the designer's straight look with his interest in classical style. Although it inhibited women's freedom of movement (they were forced

to hobble rather than walk), it was accepted and even sought after because of Poiret's status in high couture. If the skirt had been introduced seven years earlier, when Poiret was just beginning to establish himself professionally, it might well have been rejected. Women in search of the new wore the skirt, regardless of discomfort, in large measure because Poiret told them it was the apex of style.

When women wearing the hobble skirt first appeared on the streets of Paris in late spring and early summer of 1910, journalists vigorously attempted to persuade women to reject it. City officials also entered the fray, since women in hobble skirts created traffic delays when they slowly crossed a street or stepped into a carriage or vehicle. Women hobbling down the street were jeered or verbally chided by many males for wearing such fashion foolishness. At a performance of a play at the Théâtre Michel, colored slides of the hobble skirt were projected onto a screen during the intermission; when the eighth slide was shown, many of the theater patrons began loudly to complain about the presentation. The outcry reached such an intense pitch that a number of patrons attempted to assault Poiret as he sat in his theater box.

Strident public rejection of one facet of his design efforts did not deter Poiret. In a new collection displayed six months after the original showing of the hobble skirt, he introduced it again. This time, the pope was persuaded by some citizens to denounce the skirt, and priests were ordered to refuse absolution to any woman wearing one. As Poiret surmised, though, outcry against the style did not adversely affect sales. The number of his clients increased; other designers began to copy the style, and copies were sold in department stores around the world. During the late fall of 1910, one of Poiret's German customers, the owner of a department store in Berlin, requested that the couturier personally show his collection, including the hobble skirt, in the German capitol. Poiret did so with enormous success. The next year, Poiret and his wife drove throughout Europe presenting shows of his designs. His models and his trunks of clothing followed by train. While well received in various European cities, it was in Moscow and St. Petersburg that they were jubilantly welcomed. It was in Moscow that Poiret met Romain de Tiroff, later to be called Erté, a young artist who sketched some of the couturier's creations and was hired by Poiret as an assistant designer. Poiret's fashion, and business instincts, proved correct. The hobble skirt was universally accepted by women interested in a new look.

Impact of Event

Various modifications, some subtle and others dramatically visual, were quickly introduced by Poiret. On Poiret's personally selected models, who usually wore large hats with wide brims that were decorated with large ribbons or feathers, the image was that of a T-shaped silhouette. Since the skirt was so slim, Poiret eliminated pockets and reintroduced the handbag. Like the hats, Poiret's handbags were quite large. He also offered muffs made of swansdown or fur as an alternative accessory to the handbag. When swans became a protected species and the cost of fur increased, use was made of lamb, sealskin, or mink. Other accessories utilized by the designer to underscore his T-shaped silhouette were gloves—usually long and white—and

umbrellas and parasols that were long and tightly furled. Shortly after the first hobble skirt appeared, Poiret issued a skirt with a slit added at the side or front of the garment to allow more mobility. Since a small portion of a wearer's legs were thus made visible, Poiret, quickly followed by other designers, set aside the extensively decorative stockings of the nineteenth century and encouragd his clients to wear plain stockings made of either lisle or, for the very wealthy, silk, with a small decorative design on the sides.

In 1912, Paul Poiret once again modified the hobble skirt. This change was made more for visual effect than for practicality. He placed over the skirt a tunic of various materials, including lace; over hobbles worn in the evening, the tunic was often made of gold lace. By the end of 1912, the couturier modified the tunic twice. It was first shortened and made fuller, especially at the hips, and was referred to as a "pannier." The silhouette thus achieved was that of a peg top, and the style bore that name. Within a year, the tunic was allowed to drop down the length of the skirt in a sloping fashion to the ankles. Another change evolved from the costumes that Poiret designed for a theatrical show. He retained the hobble design, but the tunic became a knee-length, belted affair that was wired at the hemline to produce a flare. The wired tunic was adopted for use by his clients, and it became as popular as the peg-top version. By 1914, the style was referred to as the "lampshade tunic."

Modification of the hemlines of his fashions also led Poiret to alter the neckline of his blouses and dresses. The V-neck was introduced to replace the high Edwardian collars that dominated nineteenth century styles. Once women began to appear in V-necked garments, many clergy declared their disapproval and condemned the style as immoral. Numerous physicians joined the protest, arguing that wearing the V-neck would adversely affect a woman's health. Rejecting the religious and medical remonstrances, women accepted, wore, and by demand perpetuated the style.

The popular vertical-line garment that created the T-shaped silhouette was, by 1914, deemed no longer suitable for the work that women were called upon to perform during World War I. Although Poiret adamantly refused to accept the changes that a world at war unleashed upon Europe, he had, unknowingly, established a baseline from which new and often more practicable fashion evolved. All that other designers had to do was to discard the hobble and add length to the tunic for a seemingly new and more utilitarian style to emerge. By 1915, the hobble skirt was past fashion. The tunic became a dress or was dissected to become a blouse and a skirt with a hemline that ended six or more inches from the ankle; by 1916, hemlines were ten inches from the ground.

After World War I, Poiret continued to create new designs, but he was unable to recapture the imagination and thus the support of modern women, who reflected the legacies of the couturier not only in the image of physical form but in the manner of dress as well. During the later years of his life, he devoted his time to painting and to making plans for an institute of design. He died April 28, 1944, an innovator who had established the direction for modern women's fashion but who had rejected the nature of its progression.

Bibliography

Byrde, Penelope. *A Visual History of Costume: The Twentieth Century.* New York: Drama Book Publishers, 1986. Primarily the presentation of sketches, paintings, and photographs of men's, women's, and children's fashions from 1900 to 1984, with captions describing styles across the twentieth century. On page thirty-six is a reproduction of the T-shaped silhouette, a model wearing a hobble skirt and large hat and carrying a tall umbrella. The sketch, a lithograph, appeared in 1911 in *Chic Parisien.* A short introduction offers informative fashion data. The author refers to the hobble skirt as the "tubular line."

Ewing, Elizabeth. *History of Twentieth Century Fashion.* 3d ed. London: Batsford, 1992. Contains useful information on the hobble skirt and Poiret. The text is tastefully supported with drawings and reproductions of illustrations from fashion magazines. An account of the experiences of workers in the fashion industry and statistics on their earnings are included.

Langner, Lawrence. *The Importance of Wearing Clothes.* New York: Hastings House, 1959. Insightful information on the cultural forces that gave rise to various fashions, one of which was the hobble skirt. The introduction was written by James Laver of the Victoria and Albert Museum in London. Illustrations included.

Laver, James. *Costume.* New York: Macmillan, 1956. Interesting and detailed data on the hobble skirt and Poiret. Illustrated with reproductions of fashion sketches.

——————. *Costume Through the Ages: 1000 Illustrations.* New York: Simon & Schuster, 1963. A volume of fashion sketches. The illustrations of the T-shaped silhouette and the hobble skirt provide an informative image of a significant aspect of women's fashion.

Nunn, Joan. *Fashion in Costume, 1200-1980.* New York: Schocken Books, 1984. Valuable information on the hobble skirt. Descriptions given of the hobble and the tunic are worthy of note. Interesting information on fabrics and furs used by early twentieth century fashion designers. Black-and-white sketches are elegantly presented.

Poiret, Paul. *King of Fashion: The Autobiography of Paul Poiret.* Philadelphia: J. B. Lippincott, 1931. An interesting and informative autobiography. Must be read with care, always keeping in mind the time and the background of the writer; his racist sentiments can catch the reader unprepared.

Tortora, Phyllis, and Keith Eubank. *A Survey of Historic Costume.* New York: Fairchild Publications, 1989. A detailed account of all aspects of fashion from ancient times to the present. Illustrations are many and presented in black-and-white and color. On page 282 is a lovely reproduction of the hobble skirt from a 1913 French fashion magazine.

Waugh, Norah. *Corsets and Crinolines.* 2d ed. New York: Theatre Arts Books, 1970. A detailed history of the corset and the petticoat is afforded. Illustrations include reproductions of different patterns used to make corsets and petticoats.

White, Palmer. *Poiret.* New York: Clarkson N. Potter, 1973. An interesting, informative, readable, and graphically pleasing biography of Paul Poiret. The full-page

color reproductions are exquisite. The text is also enhanced by photographs of Poiret and his family and friends. The author does not explore Poiret's racist sentiments.

Wilcox, R. Turner. *The Mode in Costume.* New York: Charles Scribner's Sons, 1942. Chapter 42 deals with French fashions from 1910 to 1920. Informative account of the work of Poiret.

Yarwood, Doreen. *Costume of the Western World: Pictorial Guide and Glossary.* New York: St. Martin's Press, 1980. Materials on Poiret and the hobble skirt are insightful. Glossary gives a concise description of the hobble skirt. Black-and-white sketches inserted throughout text.

Loretta E. Zimmerman

Cross-References

Brooks Brothers Introduces Button-Down Shirts (1900), p. 24; Les Fauves Exhibit at the Salon d'Automne (1905), p. 140; Diaghilev's Ballets Russes Astounds Paris (1909), p. 241; Chanel Defines Modern Women's Fashion (1920's), p. 474; Jantzen Popularizes the One-Piece Bathing Suit (1920), p. 491; Schiaparelli's Boutique Mingles Art and Fashion (1935), p. 979; Dior's "New Look" Sweeps Europe and America (1947), p. 1346.

THE FIREBIRD PREMIERES IN PARIS

Category of event: Dance
Time: June 25, 1910
Locale: Théâtre Nationale de l'Opéra, Paris, France

Sergei Diaghilev's Ballets Russes returned to Paris for their second triumphal season, performing original ballets by Michel Fokine, including The Firebird

Principal personages:
MICHEL FOKINE (1880-1942), a ballet dancer and choreographer who created several important ballets for the Ballets Russes
SERGEI DIAGHILEV (1872-1929), a Russian theatrical impresario whose Ballets Russes dance company revolutionized classical ballet
LÉON BAKST (LEV ROSENBERG, 1866-1924), a Russian painter whose spectacular sets and costume designs were an important component of the Ballets Russes' success
ALEXANDER GOLOVIN (1863-1930), a Russian painter who created set and costume designs for the Ballets Russes
TAMARA KARSAVINA (1885-1978), a leading ballerina in the Ballets Russes who pioneered many of its principal roles, including the Bird of Fire in *The Firebird*
IGOR STRAVINSKY (1882-1971), a Russian-born composer of exceptional renown who scored *The Firebird* and other ballets for the Ballets Russes

Summary of Event

In 1909, a touring ensemble of Russian dancers under the direction of Sergei Diaghilev astonished Parisian audiences with their exquisite dancing, innovative choreography, and vibrant set decor and costumes, and with the aura of pagan exoticism that surrounded them. That first season introduced the choreography of Michel Fokine, the dancing of Vaslav Nijinsky, Tamara Karsavina, Anna Pavlova, and others, and the colorful designs of Léon Bakst, Alexandre Benois, and Nikolay Roerich. Music for the ballets was equally nationalistic, featuring Russian composers Aleksandr Borodin, Mikhail Glinka, Nikolay Rimsky-Korsakov, Peter Ilich Tchaikovsky, and Nicholas Tcherepnine. A brilliant artistic and cultural success, the Ballets Russes' 1909 premiere season set the stage for subsequent triumphs.

Diaghilev's second Parisian season had even more emphasis on the exotic East and mysterious Russia. Of five ballets presented in 1910, three featured Russian or Oriental themes, music, and decor: *Schéhérazade, L'Oiseau de feu* (known in English as *The Firebird*), and *Les Orientales.* Only *Giselle* and *Carnaval* were in the Romantic tradition. Though all five ballets displayed the celebrated technique of the company's Maryinsky-trained dancers, ballet technique, no matter how exquisite,

was not the appeal of the Ballets Russes. It was the transformation of the stage into an exotic world awash with color, motion, and brilliance, where music enveloped the senses and dancers exuded an aura of sensuous liberation that captivated the Parisian public.

The Firebird featured the choreography of Fokine, set decor and costumes by Alexander Golovin and Léon Bakst, and the music of Igor Stravinsky. The cast included Tamara Karsavina as the Bird of Fire, Fokine as Ivan Tsarevitch, Enrico Cecchetti as the evil Kostchei the Immortal, and Fokine's wife, Vera Fokina, as the beautiful Tsarevna. The libretto, created by Fokine, is an amalgam of several Russian fairy tales. A ballet in one act and two scenes, *The Firebird* presents a fairy tale for adults. The story concerns the young Prince Ivan, his encounter with the glorious, magical Bird of Fire, and his battle with Kostchei, an evil magician. The plot is an allegory of heroism overcoming political tyranny, and the Tsarevitch is rewarded by marriage to the Tsarevna and the obeisance of adoring subjects.

The Firebird opens with a musical overture; as one critic has described the work's beginning, "There are low mutterings, mysterious long-drawn wails as of one unknown creature calling to another, the tramp of gnomes underground, strange rustlings, moans . . . and above all can be heard, at first faintly . . . the tremulous whirr of the wings of a bird soaring in circular flight." Stravinsky's music and Golovin's set combined to create an atmosphere of mystery; Karsavina's shadowy entrance completed the illusion.

Fokine's choreography explores the precariousness of individual freedom and the conflict of freedom and authority which is represented both by Ivan, who will one day be a king, and by Kostchei, an evil tyrant who is forced from his throne. Critic Lynn Garafola has observed that when alone, "the Firebird gleams with the power of a fully realized being; captive, she reflects the tenuousness of individualism itself."

Fokine was an innovative choreographer who liberated classical ballet from its academic straitjacket. *The Firebird* is especially noteworthy for the use of both classical ballet technique and nontraditional movement styles. Fokine's interest in the individual, expressivity, and naturalism are clearly evident in *The Firebird*. His unconventional aesthetic was matched and supported by Bakst's designs, which bared the torsos and midriffs of the dancers. By allowing dancers to move freely, Bakst's costumes, one critic has noted, "brought a greater psychological naturalism to the ballet stage."

A musical masterpiece, Stravinsky's score for *The Firebird* marked his first composition for Diaghilev. The music incorporates traditional Russian folk songs, modified and orchestrated in a manner that presages Stravinsky's later compositions of *Petrushka* (1911) and *Le Sacre du printemps* (1913; *The Rite of Spring*). Stravinsky worked in close collaboration with Diaghilev and Fokine who, Stravinsky later wrote, created the ballet's choreography "section by section, as the music was handed to him." Stravinsky was later critical of Fokine's choreography, which he claimed was complicated and overly detailed, thus making it difficult for the dancers to coordinate their movements and gestures with his music. Nevertheless, in his 1962 biogra-

phy, Stravinsky credited the success of the ballet as "equally due to the spectacle on the stage in the painter Golovin's magnificent setting, the brilliant interpretation by Diaghileff's artists, and the talent of the choreographer."

After the ballet's premiere, the French critic Henri Léon lavished praise on the production. Noting the unusually close collaboration of Fokine, Stravinsky, Golovin, Léon applauded their attainment of an equilibrium of motion, sound, and form. Léon commented that

> The backdrop, shot with darker tints of gold, seems to be woven of the same yarn as the fabric of the orchestra. In the sounds of the instruments you hear the living voices of the sorcerer, raving witches and gnomes. When the bird is flying by, it makes an impression of being carried by music. In all of them—Stravinsky, Fokine and Golovin—I see one author.

It was precisely this synthesis that was the strength of the Ballets Russes and the source of the exceptional appeal of *The Firebird*.

Impact of Event

With the success of *The Firebird* and the entire 1910 season, the Ballets Russes established itself as the dominant force in the realm of the ballet and its allied arts. The name Ballets Russes became synonymous with innovations in choreography, musical composition, and stage design. The vogue for things "à la Russe" was considerable; the influence of Bakst, Benois, and Golovin was visible in everything from ottomans to evening gowns. *The Firebird* and subsequent "Oriental" ballets such as *Petrushka, Le Dieu bleu* (1912), *Thamar* (1912), and *Sadko* (1911) came to represent the Ballets Russes. The effects of the Ballets Russes on developments in the arts, society, and culture were far-reaching and long lasting.

To understand the significance of *The Firebird*, it is important to acknowledge the unique characteristics of the Ballets Russes' artists and the philosophic antecedents of the ensemble. In the prewar seasons of the Ballets Russes (1909-1914), Diaghilev engaged Russian artists exclusively as his designers. All had been members of Mir Iskusstva ("world of art"), a group of Russian artists who shared a similar, progressive aesthetic. These artists believed that Russian folk arts and crafts should be supported and used to revitalize the visual arts and in order to create a modern, truly Russian style. They also believed in the necessity of an artistic synthesis of elements within a production, a concept that composer Richard Wagner had earlier popularized with the idea of the *Gesamtkunstwerk*, or total work of art. Influenced by the Symbolist movement, the group saw in ballet productions the possibility for a true unity of design. The early Ballets Russes productions, in fact, were Symbolist experiments in which, as Elena Bridgman has noted, "The constituent parts—movement, costumes, decor, and music—worked *en ensemble* to induce specific emotional states." Many of the principles adhered to in the early Ballets Russes productions had their origins in the art colonies established by Russian neonationalists Savva Mamontov at Abramtsevo and Princess Maria Tenisheva at Talashkino. Diaghilev borrowed

the collaborative method of scenic design first established at Abramtsevo and also employed easel painters, rather than professional decorators, as stage designers. Diaghilev's presentation of Russian culture as exotic and alien to the Western World— an approach that was enormously successful with audiences and critics, who raved about the "wild Asiatic horde"—was one of Mamontov's important legacies.

From this aesthetic perspective, Diaghilev's productions can be viewed as visible symbols of the *Gesamtkunstwerk* ideals that Mir Iskusstva championed. *The Firebird*, praised for its artistic harmony and collaborative unity, was the prototype for future collaborations and provided validation for the aesthetic philosophies of its artists. According to Garafola, *The Firebird* was the Ballets Russes' only true example of collaborative process; Garafola suggests that "far more than collaboration, what held together the pieces of Diaghilev's best works was the community of values to which their contributing artists subscribed." Both the Mir Iskusstva ideals and method of process were validated through the success of the Ballets Russes' 1910 season.

In *The Firebird*, Fokine's revolutionary choreographic aesthetic continued to develop. He attacked the stale, academic conventions of the Russian Imperial Ballet and created new forms of movement that were expressive and reflective of the time, place, and ethos of each ballet. He brought new life and enhanced expressiveness to the use of the arms and torso in dance, discarded the artificial geometry of a regimented corps de ballet, and democratized and humanized his dancers by insisting that they move as a collective of individuals. His reforms paralleled those of Konstantin Stanislavsky and the Moscow Art Theater; both believed in the principles of scenic realism and worked to promote reform from within their disciplines.

It is ironic that the very success of *The Firebird* presaged the beginning of Fokine's choreographic decline. Locked into the creation of exotic pagan extravaganzas by their popularity, Fokine's work (with the exception of his masterpiece *Petrushka*) became increasingly formulaic. Diaghilev's enthusiasm for sensationalism and for his young protégé, Vaslav Nijinsky, made further difficulties for Fokine. Fokine was expected to create ballets that would feature Nijinsky, even though he preferred to choreograph for women. Fokine left the company in 1912, returning only briefly in 1914.

Stravinsky's association with Diaghilev, by contrast, propelled him to the vanguard of modern art. Following *The Firebird* he composed *Petrushka, The Rite of Spring*, and *Les Noces* (1923) for Diaghilev productions. His ballets, operas, and many compositions brought him international renown. Diaghilev's (then uncommon) insistence that musical scores be of the highest quality for ballets elevated both arts to new heights.

The success of *The Firebird* and other ballets of the early seasons provided visual artists wide exposure and freedom to experiment. Bakst, for example, brought to his stage designs for the Ballets Russes the influence of numerous movements in contemporary European painting—including Symbolism, Art Nouveau, expressionism, and Fauvism. Some historians have speculated that the presentation of such designs

in Ballets Russes performances may have encouraged the general acceptance of such artistic currents. The powerful effect of the Ballets Russes designs on the evolution of the visual arts is evident in the list of artists who chose to work with Diaghilev; after the tremendous success of Bakst, Benois, Golovin, Roerich, and Natalya Goncharova, such distinguished artists as Giaccomo Balla, Juan Gris, Henri Matisse, and Pablo Picasso made history with their designs for the company.

The Firebird's impact on choreography, music, scenic design, and the visual arts was immediate and profound. It was, however, only a harbinger of the artistic revolution that would take place during the next few seasons of the Ballets Russes: Beginning with *L'Après-midi d'un faune* (1912), quickly followed by *Jeux* (1913) and *The Rite of Spring*, the Ballets Russes would catapult ballet into the modern age.

Bibliography

Fokine, Michel. *Fokine: Memoirs of a Ballet Master.* Translated by Vitale Fokine. Edited by Anatole Chujoy. Boston: Little, Brown, 1961. Fokine's account of his early life, dance training, and rise to stardom as a choreographer.

Garafola, Lynn. *Diaghilev's Ballets Russes.* New York: Oxford University Press, 1989. Exceptionally well-written and thorough book that analyzes the Ballets Russes from artistic, social, economic, and aesthetic perspectives. The information on Fokine, although not copious, is rich and thought-provoking.

Kochno, Boris. *Diaghilev and the Ballets Russes.* Translated by Adrienne Foulke. New York: Harper & Row, 1970. An oversized book containing photographs, excerpts from letters, program notes, and unpublished essays by Diaghilev and his contemporaries. The early seasons of the Ballets Russes are not as well documented as the later ones, but the illustrations are beautiful, and the book covers every ballet produced by the Ballets Russes from 1909 to 1929.

Pozharskaia, Militsa, and Tatiana Volodina. *The Art of the Ballets Russes.* Translated by V. S. Friedman. New York: Abbeville Press, 1990. A beautifully photographed oversized book with many color plates. Arranged chronologically by Parisian season, 1908-1929. Emphasis is on costume, set, and stage design rather than choreography or dancing. Includes a foreword by Clement Crisp, an annotated list of artists, and a minimal but informative text.

Van Norman Baer, Nancy, comp. *Art of Enchantment: Diaghilev's Ballets Russes, 1909-1929.* New York: Universe Books, 1988. Catalog of an exhibition of Ballets Russes artifacts at the Fine Arts Museum of San Francisco. Excellent articles by various authors accompany photographs of the exhibition material. Nancy Van Norman Baer's article on design and choreography and Dale Harris' article "Diaghilev's Ballets Russes and the Vogue for Orientalism" are helpful in understanding the exotic ballets of the prewar seasons. The chronologic table of Ballets Russes productions is a handy quick reference.

Cynthia J. Williams

Cross-References

Diaghilev's Ballets Russes Astounds Paris (1909), p. 241; Fokine's *Les Sylphides* Introduces Abstract Ballet (1909), p. 247; *L'Après-midi d'un faune* Causes an Uproar (1912), p. 332; *The Rite of Spring* Stuns Audiences (1913), p. 373; The Ballet Russe de Monte Carlo Finds New Leadership (1938), p. 1088.

DER BLAUE REITER ABANDONS REPRESENTATION IN ART

Category of event: Art
Time: 1911
Locale: Munich, Germany

A group of artists disenchanted with traditional art and contemporary European culture formulated an abstract approach that celebrated the inner, spiritual dimension of humanity

> *Principal personages:*
> WASSILY KANDINSKY (1866-1944), a Russian artist widely acknowledged as a founder of modern abstract art who cofounded Der Blaue Reiter with Franz Marc
> FRANZ MARC (1880-1916), a German painter best known for his paintings of animals
> GABRIELE MÜNTER (1877-1962), an original member of Der Blaue Reiter who saved and donated many works and writings of Der Blaue Reiter artists
> ALFRED KUBIN (1877-1959), an Austrian writer and artist who was an original member of Der Blaue Reiter
> AUGUST MACKE (1887-1914), a German painter who participated in creating the almanac of Der Blaue Reiter

Summary of Event

Der Blaue Reiter (the blue rider) was among the first major artists' associations dedicated to abandoning representational art in favor of an abstract style. Founded by Wassily Kandinsky and Franz Marc, who were its "editorial board," Der Blaue Reiter was not an actual organization but a diffuse community of artists with common interests. Blaue Reiter artists staged several exhibits, published two editions of an almanac (a second volume was prepared but never published), and individually advocated a new abstract and expressionistic art. While numerous sources inspired and nourished Der Blaue Reiter, Kandinsky was its prime mover, and the group's history is truly the story of a crucial period in Kandinsky's development as a painter and theorist.

In 1909, Kandinsky founded and became president of the Neue Künstlervereinigung (NKV), a Munich artists union. The NKV staged two exhibits, the first in 1909, at which Kandinsky showed paintings and woodcuts. During 1909, he also began work on a series of musical "color-poems" to be performed on stage and started work on a series of paintings he called "Improvisations." While not abstract paintings per se, Kandinsky's Improvisations, with their progressive abandoning of objective referents, were a move toward abstractionism. In 1910, Kandinsky began

another series he called "Compositions," which too moved toward abstraction. He showed *Composition II* (1910) and *Improvisation X* (1910) at the second NKV exhibition in 1910, and both works, along with the progressive works of other NKV artists, were ridiculed, scorned, and even spat upon. Such protests by the public and critics were not uncommon, though, given that the NKV represented the same avant-garde spirit of change as did the earlier Die Brücke and Berlin Secession movements, with which Kandinsky also exhibited.

Franz Marc, whom Kandinsky had not met, wrote a very favorable commentary on the exhibit that led to the pair's first meeting. Their friendship quickly deepened. In 1910, Kandinsky also produced *First Abstract Watercolor*, considered by many to be the first abstract painting (some argue, though, that the painting was actually a study for 1913's *Composition VII* and has been incorrectly dated).

First Abstract Watercolor was momentous for Kandinsky; it expressed his realizations not only that objects are not necessary for painting (an insight he first had when viewing Monet's *Haystack in the Sun* in 1896) but also that hidden secrets within objects are their essence and true contents. It is in this essence, Kandinsky reasoned, that the "spiritual" resides, and he believed that such spiritual truth was what modern art should pursue. Through abstraction, he maintained, one could encounter a realm where the human soul would be transfigured as colors, these colors being the language or music by which the artist would summon forms immanent in the cosmos. These forms, as "art," would also operate to elevate human beings to a new spiritual way of living in which ethics and aesthetics would redeem them from the materialistic alienation of modern progress. *Über das Geistige in der Kunst, insbesondere in der Malerei* (1912; *Concerning the Spiritual in Art, and Painting in Particular*, 1912), Kandinsky's manifesto, explained his thoughts on such issues.

In 1911, Kandinsky and Marc's friendship continued to blossom, and Marc joined the NKV. At the time, Kandinsky was writing reviews for the Russian journal *Apollon* and other periodicals in which he critiqued traditional European art, especially that of conservative Munich. In place of such art, he advocated the creation of a freer, more expressive and abstract art that would display the "inner sound" of the spiritual as experienced by the artist. Marc also advocated these views and Kandinsky and Marc joined with other artists and dealers to protest the publication of an ethnocentric diatribe against foreign artists written by conservative members of the German art establishment. In the meantime, preparations were being made for the third NKV exhibition, and it was clear by then to Marc and Kandinsky that the NKV would not remain intact. Kandinsky resigned as president and told Marc of his desire to create a new almanac that would promote both modern, abstract art and art from other cultures and times, all of which would manifest the inner life of the artist.

In August, Kandinsky met Marc's friend August Macke, who became active in planning the almanac and whose uncle financially supported Der Blaue Reiter. In September, Marc and Kandinsky whimsically decided upon the name "Der Blaue Reiter." Kandinsky had made a painting with a similar name in 1903, both he and

Marc loved the color blue, and Marc loved horses and Kandinsky riders. When Kandinsky's *Composition V* (1911) was rejected in early December for the third NKV exhibit, ostensibly because it was too large but more probably because Kandinsky was a foreign artist, Marc, Kandinsky, Gabriele Münter, and Alfred Kubin promptly left the NKV and formally dedicated themselves to Der Blaue Reiter. Marc immediately led the effort to stage the first Blaue Reiter exhibit simultaneously with the NKV show. In addition to the founding group's works, Robert Delaunay, Henri Rousseau, and the composer Arnold Schoenberg also showed paintings. While Alexey von Jawlensky and Paul Klee did not exhibit with the group at the time, their membership and participation were imminent. In his brief introduction to the first exhibit, Kandinsky wrote of a desire to promote not one pictorial style but rather a diversity of forms by which an artist could individually express his or her inner desire. *Concerning the Spiritual in Art* was published simultaneously with the exhibit by Piper, a small publishing house sympathetic to the new art.

Impact of Event

A recurring image in Kandinsky's work is the rider on horse. More than merely a lyric icon, the image symbolized his personal stance, and that of Der Blaue Reiter, in respect to the art and society of the time. The rider is a messenger bringing forth transformative ideas and images. In esoteric theories, as interpreted by Kandinsky, blue is a heavenly color, one that touches the soul in such a way as to induce the divine music of spiritual rebirth. Moreover, the rider is a heroic or messianic figure. In the spirit of Kandinsky's many renderings of St. George slaying the dragon and overcoming its terrors and evils, Der Blaue Reiter railed against the materialism and positivism that produced blindness and complacency in bourgeois culture. The many commentaries and critiques written by Blaue Reiter artists in journals, pamphlets, letters, and elsewhere articulated the struggle of the new art to create a wholly different aesthetic and ethical environment for modern humanity.

In developing such a stance, Der Blaue Reiter drew on a broad base of resources. Symbolists, theosophists, mystics, anthroposophists, Johann Wolfgang von Goethe, the Gospels, Friedrich Nietzsche, Richard Wagner, and the insights of modern physics, among others, influenced the writings and art of Der Blaue Reiter. The group's goal was nothing less than the destruction of forms of thinking that were tied so closely to material reality and objects that "inner necessity," which made such things possible and was their true content, was considered nonexistent or irrelevant. In addition to promoting the significance of esoteric knowledge, Der Blaue Reiter also took a strong stance against another growing ideology of modern society, individualism. While Blaue Reiter members were very supportive of individualistic expression in art and life, they emphasized that, although it is the artist/individual who does things, such actions and works can always be traced back to the mysterious, transcendent, life-giving spirit of inner necessity. The spirit animates and inspires the individual and steers the artist away from the illusions of objective reality toward a synthesis with the immutable laws and truths of the cosmos. In this sense, certain

constraints were placed on purely personal expression, for such expression, Blaue Reiter adherents believed, could easily be contaminated by worldly concerns and was constantly in need of a rigorous path to truth. Only such a path could guide humanity. Der Blaue Reiter thus advanced not only an approach to art but also an esoteric humanism that was a guide for living.

With such a vision of a grand synthesis of new aesthetic and ethical sensibilities within existing culture, Blaue Reiter members promoted a rebirth of society. Der Blaue Reiter pushed art into abstraction, and though there were differences between them, Kandinsky and Marc, along with Kazimir Malevich, Piet Mondrian, Paul Klee, and kindred artists, formed a powerful avant-garde that celebrated the spiritual and abstraction in art. In doing so, they also helped promote the writings of Wilhelm Worringer, which proved crucial to understanding not only abstraction but also the ways in which expressionism, surrealism, existentialism, and other subsequent avant-garde movements struggled with spiritual alienation and metaphysical anxiety. Abstraction in art, for Der Blaue Reiter, was a response to the fragmentation, isolation, and mechanization of modern life.

The spiritual quest of Der Blaue Reiter was not confined, however, to matters of liberating the soul. In addition to creating new understandings of how color and form, like music, resonate with the soul, and how art could be directed away from a reliance on external necessity (objects, representation) toward inner necessity, Der Blaue Reiter was also very much an ecumenical movement. Der Blaue Reiter's ecumenical nature was manifested on two fronts, one embracing ethnic and national diversity and the other encompassing multiple forms of art.

The almanac of Der Blaue Reiter, completely compiled by artists, contained highly varied subject matter. In addition to criticism, commentaries, and artwork by Blaue Reiter and other European avant-garde artists, the almanac included reproductions of cave drawings, Chinese paintings, Japanese drawings, Egyptian shadow figures, medieval gravestones, Etruscan reliefs, sixteenth century German woodcuts, children's drawings, musical scores, and works from Mexico and Malaysia. The aims of such variety were to counter the ethnocentric protectionism of the German art establishment (which later manifested itself in Adolf Hitler's nationalism) and to stimulate the observer to experience the multiple forms by which the inner calling of the artist expresses itself.

Also reflected in the almanac was Kandinsky's notion of a grand synthesis of the arts. Perhaps inspired by the theories of musicians such as Richard Wagner and Alexsandr Scriabin, Der Blaue Reiter made an effort to draw all forms of artistic expression—music, theater, folk art, sculpture, architecture, and more—into play. The influential Bauhaus school that began in 1919 was inspired by Der Blaue Reiter's synthetic approach.

The impact, then, of Der Blaue Reiter was that it stimulated modern art to look to other cultures for inspiration. The movement also advocated that the ideas of modern art, which had typically been associated with the visual arts, especially painting, should be extended to all areas of art. In promoting modern art, Der Blaue Reiter

reflected a widespread exploration of inner experience that was already taking place in literature, philosophy, psychology, and other disciplines. In the long term, the spirit that inspired Der Blaue Reiter also inspired Walt Disney's 1940 film *Fantasia*, Frank Lloyd Wright's design for the Guggenheim Museum, and American abstract expressionist painting. It can even be argued that modern interests in occult wisdom and the spiritual, as well as romantic critiques of materialistic, technological culture, owe much to Der Blaue Reiter's celebration of art and life.

Bibliography

Cheetham, Mark A. *The Rhetoric of Purity: Essentialist Theory and the Advent of Abstract Painting.* New York: Cambridge University Press, 1991. A serious discussion of the theory and philosophy of abstraction in painting. Includes an insightful treatment of Kandinsky.

Kandinsky, Wassily. *Kandinsky in Munich: 1896-1914.* New York: Solomon R. Guggenheim Foundation, 1982. A highly informative text with numerous reproductions and photographs chronicling Kandinsky's years in Munich, where his abstract style blossomed.

Roethel, Hans K. *The Blue Rider.* New York: Praeger, 1977. Roethel visited Gabriele Münter frequently and was the director of the Stadtische Galerie in Munich, to which Münter donated a massive collection of Blaue Reiter works and writings. His book contains an informative text with anecdotal and biographical data, letters, photographs, and plates.

Vogt, Paul. *The Blue Rider.* Woodbury, N.Y.: Barron's, 1980. A small book with an instructive text and a highly useful documentary appendix of letters, exhibition catalog introductions, and prefaces to and excerpts from the Blaue Reiter almanac.

Weisberger, Edward, ed. *The Spiritual in Art: Abstract Painting, 1890-1985.* Los Angeles: Los Angeles County Museum of Art, 1986. Lavishly filled with striking plates and superb essays on expressionism, abstract painting, mysticism, esoteric and occult wisdom and their bearings on the spiritual in modern European and American art, and a glossary of spiritual terms. A joy to experience.

Zweite, Armin. *The Blue Rider in the Lenbachhaus, Munich.* Munich: Prestel-Verlag, 1989. A beautiful book with historically relevant text, factual data, photographs, and numerous plates focusing exclusively on Blaue Reiter works in the Stadtische Galerie in Munich.

Marc J. LaFountain

Cross-References

Avant-Garde Artists in Dresden Form Die Brücke (1905), p. 134; Les Fauves Exhibit at the Salon d'Automne (1905), p. 140; Scriabin's *Prometheus* Premieres in Moscow (1911), p. 286; Kandinsky Publishes His Views on Abstraction in Art (1912), p. 320; Avant-Garde Art in the Armory Show Shocks American Viewers (1913), p. 361; Malevich Introduces Suprematism (1915), p. 413; *De Stijl* Advocates Mon-

drian's Neoplasticism (1917), p. 429; German Artists Found the Bauhaus (1919), p. 463; The Soviet Union Bans Abstract Art (1922), p. 544; The Formation of the Blue Four Advances Abstract Painting (1924), p. 583; *Abstract Painting in America Opens in New York* (1935), p. 1001.

RILKE'S *DUINO ELEGIES* DEPICTS ART AS A TRANSCENDENT EXPERIENCE

Category of event: Literature
Time: 1911-1923
Locale: Trieste, Italy, and Muzot, Switzerland

During a critical twelve-year period of his life, the German poet Rainer Maria Rilke composed ten highly influential elegies that revolutionized the poetic process

Principal personage:
RAINER MARIA RILKE (1875-1926), a poet, essayist, and prolific letter-writer

Summary of Event

In 1910, Rainer Maria Rilke, already a well-known writer and familiar figure on the European art scene, visited his friend Princess Marie von Thurn und Taxis at Duino, her remote and strangely beautiful castle on the coast of the Adriatic, near Trieste. He returned again to Duino in the winter of 1911 and, in one of those rare moments in the history of artistic composition, fell under a kind of aesthetic trance or spell, during which time he conceived the work that would become *Duineser Elegien* (1923; *Duino Elegies*, 1930). He would brood over the project for the next twelve years, experiencing several false starts before finishing the entire work during a brilliant explosion of creativity that took place during the month of February, 1922, while he was living in a chateau in Muzot, Switzerland. During that same month, Rilke also managed to complete the masterful *Die Sonette an Orpheus* (1923; *Sonnets to Orpheus*, 1936). In the following months, he was to see both of these masterpieces come off the press at almost the same time.

In many ways, *Duino Elegies* and *Sonnets to Orpheus* represent the capstone of Rilke's artistic career. *Duino Elegies*, in particular, stands as one of the magisterial works of twentieth century art, a unique synthesis of poetic vision and linguistic creativity. In *Duino Elegies*, Rilke expanded the possibilities of the German language for the writing of poetry while offering a new idiom and a revolutionary attitude toward the making of art. Rilke created his own idiom, one that differed markedly from the prevailing style of leading German poet Stefan George and his followers.

Rilke was certainly well prepared for these undertakings; he did not come to this formidable task as a neophyte but as an accomplished author of such major works as *Das Buch der Bilder* (1902; the book of pictures) and *Auguste Rodin* (1903), as well as a number of other books of lesser importance. Indeed, Rilke belonged to the last magnificent generation of the old Austrian-Hungarian Empire, a generation that produced a virtual renaissance of the arts in the German-speaking Central European countries.

This German arts movement, which had its focal points in Prague, Munich, Vienna, Zurich, and Berlin, gave the world many lasting treasures in the decades preceding and following World War I. The symphonies of Gustav Mahler, the radical physics of Albert Einstein, the psychoanalytical theories of Sigmund Freud, the nightmarish fiction of Franz Kafka, the new philosophy of Ludwig Wittgenstein, the mythological studies of Carl Jung, and the geometric furniture designs of the Bauhaus movement are only some of the more notable high points of this period of cultural enlightenment. Even World War I, with its prolonged and bloody trench warfare, could not completely extinguish the gleam.

Rilke was able to assimilate this culture and, in the process, find his own poetic voice largely because of his many close contacts in the arts world. He married the artist Clara Westhoff, and during the first months of their rather casual marriage, they lived near the arts colony of Worpswede, near Berlin. Before and after his marriage to Westhoff, Rilke had profound contacts with Lou Andreas-Salomé, a brilliantly creative woman who took Rilke to all the important arts centers of Europe and also introduced him to the Russian landscape, culture, and language. Rilke was also on close personal terms with the greatest sculptor of the period, Auguste Rodin, whom he served briefly in the capacity of private secretary. It is no exaggeration to state that Rilke could enter any capital city in Europe and call upon a good friend who was well connected in the artistic or literary life of the country.

Clearly, many other artists had similar opportunities. What made Rilke a genius was the unique vision he brought to his writing. *Duino Elegies* belongs to the great body of visionary poetry that includes the work of Dante Alighieri, William Blake, William Butler Yeats, and Hart Crane. Like those poets, Rilke saw poetry as an outgrowth of his own spiritual life. Rilke was an intensely meditative poet who believed in the coexistence of the material and spiritual realms. For this basic reason, he must be considered a mystical writer; he populated *Duino Elegies* with "angels," the perfect beings of this spiritual realm. His elegies can be read, then, as the records of his most important imaginary contacts with these transcendent creatures.

In the ten elegies, Rilke meditates on a few profound themes: time and eternity, life and death, art versus ordinary things, the mortal poet versus the immortal angel, and the need to lament but also to celebrate or praise existence in primal sound. There is no recognizable locale or time for these poems; conceivably, they could have been written almost anywhere or at any time. As such, they possess genuine universality.

A tone of melancholy, at times bordering on unbearable pain and sadness, dominates *Duino Elegies*. In the tenth elegy, for example, Rilke imagines day-to-day life as a kind of grotesque circus in which happiness is an elusive target in a sideshow and everyone becomes a juggler and acrobat. Money is featured as a monster whose organs are put on display. Yet an even deeper sadness permeates these works, as in the eighth elegy, where human beings are shown to be mere spectators in life, grasping its beauties momentarily only to lose them again and again.

The angels exist both to mock the insufficiency of human efforts and to inspire

greater achievements. Liberation from this cycle of human limitation occurs through the process of transformation—looking into the ordinary pleasures of the world so profoundly as to transcend them and to approach the angelic state. Transformation occurs as human beings begin to love both one another and the things of the world. Through language, the poet is redeemed; the world itself exists through the simple act of naming.

Impact of Event

One way to define a literary classic is to identify it as a work that has never gone out of print. By that measure, *Duino Elegies* is certainly a classic, a book that continually attracts new generations of readers, both in the original German text and in the many translations into other languages. Clearly, then, *Duino Elegies* has had a broad international influence. There are also many concrete and specific instances of the powerful influence of the book's ten poems.

In England, France, and America—as well as in Germany—Rilke's work has been absorbed by a variety of poets, critics, and translators. In some instances, one person has functioned brilliantly in all three of those roles. The English poet W. H. Auden, for example, not only wrote passionately and insightfully about Rilke but also patterned significant images and attitudes in his own poems after those he found in *Duino Elegies*. These tendencies are most apparent in Auden's sonnet sequence entitled *In Time of War* (1939), in which Rilkean angels appear, along with a reference to Rilke himself. Auden also wrote an important essay on the effect of Rilke's verse on poets writing in English. Entitled "Rilke in English," this essay appeared in 1939 in the widely read magazine *The New Republic*.

Another British poet of the same period who also exhibited Rilkean flourishes in his verse and who actually echoed some of the opening lines of *Duino Elegies* was Sidney Keyes. Unfortunately, Keyes was killed during military action in North Africa during World War II, but the very fact that he was imitating a German poet while fighting German soldiers speaks eloquently about the power of Rilke's poetry to transcend the narrow confines of national boundaries. During this same period, in the year 1939, a team of British translators, J. B. Leishman and Stephen Spender, completed their translation of *Duino Elegies*. Spender was a famous poet in his own right, and the Leishman-Spender translation established a standard of literary accuracy and fluency that few succeeding translators have been able to match.

Rilke's international influence is also evident in the enthusiastic response of French writers and critics to his work. This approbation is especially noteworthy in light of the violent hatred often displayed by the French toward the Germans and vice versa. It is a testimony to the spiritual power of Rilke's poetry that it somehow overcame the rancorous feelings caused by the Franco-Prussian War, as well as the enormous bitterness generated by both world wars.

During the midst of World War I, the eminent French writer André Gide tried to recover some of Rilke's manuscripts, which had been left behind in Rilke's Paris apartment after the outbreak of the war. Although the landlord had apparently auc-

tioned off most of Rilke's personal effects, Gide personally recovered a few precious remains and returned them to the German poet at the end of the war. In 1926, the French magazine *Les Cahiers du Mois* devoted an entire issue to the work of Rilke; during some of the worst fighting of World War II, Gide again paid homage to Rilke in an essay published in 1942.

American writers may not have come as close to Rilke initially, simply because they were not members of the close-knit European literary community. Yet word of Rilke's accomplishments, especially *Duino Elegies*, spread quickly to the shores of America. During the 1940's, a great deal of criticism of Rilke's poetry as well as translations of his most important German texts appeared in American literary magazines. Famous literary figures such as Herter Norton, C. F. MacIntyre, and Babette Deutsch were actively involved with Rilke's work. MacIntyre, in particular, went on to establish himself as one of the premier translators of Rilke's poetry, as shown by his volumes entitled *Rilke: Selected Poems* (1940) and *Rilke: Sonnets to Orpheus* (1960). Other noteworthy translators have included Stephen Garney and Jay Wilson, who produced a very colloquial translation of *Duino Elegies* in 1972, and Elaine Boney, whose translation of the same poems was entitled *Duinesian Elegies* (1975).

Translations aside, the most important influence of *Duino Elegies* was on the kinds of poems writers began to undertake. It is impossible to imagine a poet such as Robert Bly, for example, writing without Rilke's influence. Bly placed high value on translating and assimilating non-English poets, an approach he explained in numerous essays.

Even more telling, however, is the Rilkean voice, the voice of meditation on the things of this world and the deeper realities of the "other" world, a voice that readers can clearly detect in such poets as W. S. Merwin (another translator-poet) and John Ashbery. In this connection, Merwin's volume *Writings to an Unfinished Accompaniment* (1973), with its series of poems on irreducible things (such as a tool, bread, a door, horses, rain, or flies), is a beautifully successful example of Rilkean technique expressed in contemporary American English. In like manner, John Ashbery's poetry, especially his early volumes, *Some Trees* (1956) and *Rivers and Mountains* (1966), reveals a similar preoccupation with transforming everyday things into transcendent objects, a Rilkean use of the ordinary world as a springboard to the extraordinary.

It is only fair to note that Rilke himself would probably have been horrified that his poetry exerted such influence after his untimely death from leukemia in 1926. Before his death, in fact, he scolded the young German poets who were trying to copy his verse. His final words on the subject can be found in *Briefe an einen jungen Dichter* (1929; letters to a young poet), in which he stresses the necessity of individuality as the starting point of all genuine poetry.

Bibliography

Brodsky, Patricia Pollock. *Rainer Maria Rilke*. Boston: Twayne, 1988. Written in clear, journalistic style; presents the life and work of Rilke in a straightforward

chronological manner. An excellent introduction to his life and work. A chronology of Rilke's life and a brief selected bibliography will also prove invaluable to the beginner.

Mandel, Siegfried. *Rainer Maria Rilke: The Poetic Instinct.* Carbondale: Southern Illinois University Press, 1965. The first chapter of this superbly insightful study, "Between Day and Dream," is mandatory reading for any student of Rilke's work because it delineates the numerous tragedies of his early life. Mandel is particularly effective in showing Rilke's growth and evolution as a poet. The index to this book provides an invaluable checklist of names and titles.

Peters, H. F. *Rainer Maria Rilke: Masks and the Man.* Seattle: University of Washington Press, 1960. Anyone interested in Rilke's influence on other poets of the twentieth century should read at least the chapter of Peters' book entitled "Tonight in China," which covers the topic in great detail. Peters writes more for the professional critic than for the general reader, but a careful reading will yield rich insights. His chronology of Rilke's life is easily the best in print.

Rilke, Rainer Maria. *Duinesian Elegies.* Translated by Elaine E. Boney. Chapel Hill: University of North Carolina Press, 1975. A literal, academic translation of the elegies that offers an excellent starting point for the nonreader of German.

―――――――. *Duino Elegies.* Translated by J. B. Leishman and Stephen Spender. New York: W. W. Norton, 1939. The definitive and most widely used translation, with excellent commentary.

Daniel L. Guillory

Cross-References

The Futurists Issue Their Manifesto (1909), p. 235; Der Blaue Reiter Abandons Representation in Art (1911), p. 275; Jung Publishes *Psychology of the Unconscious* (1912), p. 309; German Artists Found the Bauhaus (1919), p. 463; Gide's *The Counterfeiters* Questions Moral Absolutes (1925), p. 620; *Poems* Establishes Auden as a Generational Spokesman (1930), p. 857.

SCRIABIN'S *PROMETHEUS* PREMIERES IN MOSCOW

Category of event: Music
Time: March 15, 1911
Locale: Moscow, Russia

Aleksandr Scriabin's Prometheus: The Poem of Fire, *was an attempt to expand traditional tonal relationships and to blend music with other arts through the use of a keyboard that projected colored light*

Principal personages:
ALEKSANDR SCRIABIN (1872-1915), a Russian pianist and composer whose visionary approach to music stretched tonality and technology to its limits
HELENA PETROVNA BLAVATSKY (1831-1891), the Russian-born mystic whose writings influenced Scriabin's orientation to Theosophy
VLADIMIR SOLOVYOV (1853-1900), a Russian philosopher from whom the mystic Russian symbolists derived their aesthetic ideas
TATIANA SCHLOEZER (1883-1922), Scriabin's mistress during his most musically productive years

Summary of Event

Aleksandr Scriabin's *Prometheus: The Poem of Fire* received its premiere in Moscow on March 15, 1911, in a performance conducted by Serge Koussevitzky. The work was scored for immense resources, including not only a large orchestra but also an extensive obbligato piano solo (played by the composer), parts for organ and chorus, and especially the use of a "light keyboard" to project colored lights onto a screen. Unfortunately, the latter instrument was not yet ready, and the premiere had to take place with only standard illumination. The "mystic chord" that underlies the work (consisting of the pitches C, F-sharp, B-flat, E, A, and D on the piano) is seemingly an attempt to replace the tonal organization that had governed music from the time of Johann Sebastian Bach with a new system; in reality, though, the mystic chord is a supercharged version of colorful chords that Frédéric Chopin, Franz Liszt, and Richard Wagner (the three composers who most strongly influenced Scriabin) had frequently used in their music. A program was loosely discernible: The sole piano represented Prometheus, who was punished by the gods for giving fire to man (Scriabin had been especially influenced by the ancient Greek Aeschylus' depiction of this event), and the arrival of fire was heralded by the choral epilogue, in which the chorus sang only vowel sounds and not words.

The work soon received performances abroad, especially in London under Sir Henry Wood and Amsterdam under Willem Mengelberg. Some conductors would even do the work twice on the same program so that the audience could absorb its

full impact. It was not, however, done with a color organ as Scriabin intended until 1915, when the Russian Symphony Orchestra under Modest Altshuler performed it at Carnegie Hall in New York. At this performance, streaks or spots of light illuminated a sheet placed above the heads of the performers.

Scriabin devoted himself to two musical media: the piano and the orchestra. His earlier piano works are in direct line of descent from the études, preludes, and stylized dances of Frédéric Chopin, but with highly enriched harmonies. At the same time, he was writing opulent symphonies with a highly musical content, culminating in a third symphony, *Le Divin Poème* (*The Divine Poem*), performed in 1905. This period saw his resignation from the piano faculty of the Moscow Conservatory; his move to Western Europe (primarily Switzerland); his abandonment of his wife for Tatiana Schloezer, a piano student at the conservatory who was his companion for the rest of his life; and his discovery of the philosophy of Friedrich Nietzsche, who enunciated the doctrines of the eternal return and the superman who could transcend ordinary limitations of morality with the power of his will.

Two works mark Scriabin's full maturity as a composer: the *Poème de l'extase* (*Poem of Ecstasy*), a large-scale orchestral work completed in 1908, and his Fifth Piano Sonata of that same year. Both were based on a poem that Scriabin had written around 1905, after he had abandoned Nietzsche's philosophy for the writings of Helena Petrovna Blavatsky. He regarded her book *The Secret Doctrine* (1888), a mixture of occultism and Indian religious thought, as important to his thinking; he later came to use Blavatsky's "theosophical" ideas as formulas to describe his own experiences and thoughts.

Both *Poem of Ecstasy* and the Fifth Piano Sonata are extensive one-movement works, based on musical motives that are constantly transformed. *Poem of Ecstasy* requires a large orchestra, including eight horns, five trumpets, and an organ for the grand apotheosis at the end; it is the most erotic musical composition since Wagner's 1859 *Tristan und Isolde.* Scriabin perceived ecstasy as a state in which the consciousness of self disappeared into a superpersonal, nearly divine oneness.

Among the most original elements of Scriabin's style are his extravagant expression markings. In contrast to the detailed performing instructions that his contemporary Gustav Mahler inserted into his symphonic scores, Scriabin sought to influence the mood of the performers. His instructions, in French, go far beyond any of Claude Debussy's. Those in *Prometheus* are representative: "Delicate, crystalline," "with an intense desire," "suddenly very sweet and joyful," "with emotion and rapture, and then mysteriously veiled," "ecstatic," "increasingly luminous and flamboyant." What these directions have in common is an intense subjectivity, akin to Scriabin's custom of playing only his own music in his piano recitals and, according to many witnesses, never playing a given piece the same way twice.

Extramusical influences on *Prometheus* had been building for several decades. Several writers of the nineteenth century, including E. T. A. Hoffmann, Charles Baudelaire, and Joris-Karl Huysmans, had been affected by the idea of synesthesia (the mixing of perceptions of musical sounds with colors or words), and the French

Symbolists of the late nineteenth century had given musical titles to poems or paintings. Similarly, composers such as Emmanuel Chabrier give pictorial titles to piano pieces, and Claude Debussy chose a woodcut of a wave for the title page of his symphonic poem *La Mer* (1905). Scriabin esteemed Wagner for seeking a synthesis of all the arts in his music dramas, but he felt that Wagner had had the arts develop along parallel lines rather than merged them into an integrated whole.

Impact of Event

Prometheus was regarded as the most extended, ambitious, and imaginative of Scriabin's completed compositions. Combining characteristics of both symphony and concerto with an orchestration that reinforced motivic development and counterpoint, it also promised to be that synthesis of all the arts toward which the French and Russian Symbolists had aspired. Scriabin associated at this time not primarily with fellow musicians (he disdained nearly all other composers) but with a small group of poets and painters who experimented with language and colors. The period immediately preceding the outbreak of World War I in 1914 was one of intense and even violent experimentation in artistic Russia as well as in other European cultural centers such as Paris and Vienna. From a later perspective, *Prometheus* thus came to be viewed in two ways: as a harbinger of the atonality of the later twentieth century and as a work that stretched the tonal system to its farthest possible limits. Both interpretations are plausible and have been supported with musical evidence, although Scriabin never discussed his technical principles of musical composition.

Scriabin's interests returned to the piano with his last five piano sonatas. Mystical connotations have been given to two of them: The Seventh Sonata has been called the "White Mass" and the Ninth the "Black Mass." The Tenth Sonata of 1913 represents Scriabin's closest approach to atonality.

The project that occupied most of Scriabin's interest during his last years was even more grandiose than Wagner's ambitious cycle about the ring of the Nibelungs. The *Mysterium*, as Scriabin's project has been called in Western countries, was to be enacted in India (originally in the Himalayas) and was to include not only music but also art, dance, recitations of theosophical poetry, the burning of incense, and even the giving of caresses, thus involving senses of sight, smell, and touch as well as hearing. *Mysterium* was to accomplish no less a goal than the unification of humankind in a single instant of ecstatic revelation; its finale was to culminate in a vision of apocalyptic ecstasy and the end of the world. Scriabin even welcomed the outbreak of World War I as a means of hastening this end. Realizing that his grandiose goal needed preparation, he sketched a "Preliminary Act," a musical tragedy concerning a hero who would bring joy and ecstasy into the world before his death. Some of Scriabin's last piano pieces may have been destined either for this work or for *Mysterium*. Financial support for this undertaking was not forthcoming, and Scriabin's death from blood poisoning in 1915, at the age of forty-two, ended whatever hopes were existing for his grandiose work. Scriabin's visions, as in *Prometheus*, outran the technology then in existence.

For several decades, Scriabin's *Prometheus* had to wait for a performance as the composer had intended. To begin with, the musical aesthetic that prevailed for several years after the end of World War I was hostile to his opulent and intensely personal musical style; a work such as Igor Stravinsky's Wind Octet of 1923—with its adherence to classical and musical forms, its stripped-down instrumentation, its astringent sonorities, and its allusions to everyday music, was the exact musical antithesis of Scriabin's *Prometheus.* The music of Arnold Schoenberg and his disciples (especially Anton von Webern) made a much sharper break with tonality, and Paul Hindemith's "New Objectivity" repudiated the hyper-Romanticism associated with Scriabin. Even before the outbreak of World War I, Jean Sibelius' Fourth Symphony (which also premiered in 1911) represented in its uncompromising austerity a reproach to Scriabin's self-indulgently opulent musical style. At least some of Scriabin's visionary ideas, however, were continued by such mystical composers as Cyril Scott (a theosophist like Scriabin) and the Catholic Olivier Messaien, who developed a similar but much more intricate system of musical composition.

To the general music lover, *Prometheus* was for many years a work that was discussed in textbooks on musical history rather than one that was performed. To some conductors in the 1970's, however, the work became a challenge, because it was a multimedia work that would incorporate color as well as music. Scriabin had wanted colors provided by concealed lamps that would flood the concert hall with light, not colors projected on a screen as in the first performance (in New York in 1915), and in his manuscript score for the color keyboard there were two "voices," one slower than the other. Scriabin did not describe any apparatus for projecting the colors (technology was not his forte), but in his sketches, he had worked out equivalents of colors and pitches (F-sharp was violet, for example). He changed some of these ideas in his later annotations to the score.

Beginning in the early 1970's, interest in multiple media, improvements in technology (especially lasers), and the revival of many post-Romantic works led to renewed attempts to perform *Prometheus* with colored lights. In Scheveningen, The Netherlands, in 1973, the auditorium was filled with an inflatable balloon, with lights projected from its surface to the inside. At Oxford, England, in 1979, the chorus was draped in white, and the colored lights were projected on the singers. In Louisville, Kentucky, in 1990, the effect of two lines of color was achieved by projecting one set of colors on the backdrop of the stage while the orchestra was suffused with lights of another hue. *Prometheus* would seem to be an ideal work for videocassette, with music, colors, dance, and even some kind of action. At any rate, performances of this work, with or without lights, are rare because of the resources that Scriabin specified, and reactions to the multiple media in simultaneous effect vary. Some in the audience are entranced by the interplay of sound and light, whereas others feel that the light show detracts from the performance. Scriabin's feeling that the integration of colored light within a symphonic work would be "a powerful psychological resonator for the listener" was realized in *Prometheus*, but not fully until several decades after his death.

Bibliography

Baker, James. *The Music of Alexander Scriabin.* New Haven, Conn.: Yale University Press, 1986. Though his musical analyses are highly technical, Baker provides the clearest assessment of Scriabin's most important twentieth century works.

Bowers, Faubion. *Scriabin: A Biography of the Russian Composer.* Tokyo: Kodansha International, 1969. An extensive biography that, as some reviewers have advised, should be used with caution. An update, *The New Scriabin: Enigmas and Answers,* (1973), contains some additions and information about researches on the "mystic chord."

Brown, Malcolm. "Skriabin and Russian 'Mystic' Symbolism." *Nineteenth-Century Music* 3 (July, 1979): 42-51. Presents the case that Russian Symbolist philosophers and writers had a strong influence on Scriabin's musical mysticism, especially after his return to Russia.

De Schloezer, Boris. *Scriabin: Artist and Mystic.* Translated by Nicolas Slonimsky. Berkeley: University of California Press, 1987. Originally published in Russian in 1923, this book by one of the composer's intimate friends (the brother of his mistress Tatiana Schloezer) gives many accounts of the development of Scriabin's mysticism, his concepts of ecstasy, and the development of *Mysterium.*

Macdonald, Hugh. "Alexander Skryabin." In *The New Grove Russian Masters 2,* edited by Stanley Sadie. New York: W. W. Norton, 1986. The most recent biography of Scriabin, with a detailed list of the composer's works. Also the best short source of information about both the composer and his music.

_____. "Lighting the Fire: Skryabin and Colour." *The Musical Times* (October, 1983): 600-602. Describes the various attempts to perform *Prometheus* with colored lighting and how Scriabin changed his color equivalences.

Meade, Marion. *Madame Blavatsky: The Woman Behind the Myth.* New York: G. P. Putnam's Sons, 1980. An overly detailed and personal biography of the woman whose books had a strong influence on Scriabin's theosophical thought. Though the author mentions Theosophy's effect on some writers, she ignores its influence on musicians.

Peacock, Kenneth. "Synesthetic Perception: Alexander Scriabin's Color Hearing." *Music Perception* 2 (1985): 483-506. Traces the history of synesthesia among several writers and in the medical literature before discussing Scriabin's *Prometheus* and his projects for *Mysterium.*

Rudakova, Yevgeniya, and A. I. Kandinsky. *Scriabin.* Translated by Tatyana Chistyakova. Neptune City, N.J.: Paganiniana Publications, 1984. Mostly a documentary and pictorial biography, with reproductions of Scriabin's manuscripts and concert programs. An interesting sidelight is the constantly favorable attitude displayed toward Scriabin by Soviet critics from 1918 onward.

R. M. Longyear

Cross-References

Schoenberg Breaks with Tonality (1908), p. 193; Sibelius Conducts the Premiere of His Fourth Symphony (1911), p. 292; Malevich Introduces Suprematism (1915), p. 413; Stravinsky Completes His Wind Octet (1923), p. 561; Messiaen's *Quartet for the End of Time* Premieres (1941), p. 1206.

SIBELIUS CONDUCTS THE PREMIERE OF HIS FOURTH SYMPHONY

Category of event: Music
Time: April 3, 1911
Locale: Helsinki, Finland

The Fourth Symphony of Jean Sibelius is considered his most modern and one of his finest, yet it was a reaction against many modern trends by this essentially conservative composer

Principal personages:
JEAN SIBELIUS (1865-1957), a Finnish composer of Swedish origins who was Finland's leading composer
ELIAS LÖNNROT (1802-1884), the compiler of the Finnish folk epic *Kalevala*
MARTIN WEGELIUS (1846-1906), the director of the Helsinki conservatory and Sibelius' composition teacher
ROBERT KAJANUS (1856-1933), a Finnish conductor and composer, the earliest champion of Sibelius' music
ROSA NEWMARCH (1857-1940), an English writer who explained Sibelius' music to England and Germany
RICHARD STRAUSS (1864-1949), a German composer and conductor, one of the first to conduct Sibelius' music in Germany
FERRUCCIO BUSONI (1866-1924), an Italian-German pianist and composer, Sibelius' piano teacher and subsequent supporter
HERBERT VON KARAJAN (1908-1989), an Austrian conductor whom Sibelius considered to be the best interpreter of his music

Summary of Event

The Fourth Symphony of Jean Sibelius was not a success at its first performance in Helsinki on April 3, 1911. Its unrelieved austerity and uncompromising nature aroused puzzlement and even hostility there and at subsequent performances. Sibelius' English friend Rosa Newmarch was commissioned by Sibelius' publisher, the German firm of Breitkopf and Härtel, to write an explanation of the work for German audiences. Later, the work was to receive slow and grudging recognition as one of the seminal musical compositions that—like Arnold Schoenberg's *Pierrot Lunaire* (1912) and Claude Debussy's *Jeux* (1913)—proclaimed that the nineteenth century was irretrievably over and that a new century in music had definitely begun.

Sibelius studied music with the composer, pianist, and conductor Martin Wegelius and made a study trip to Vienna, where he met Johannes Brahms and was particularly influenced by the music of Anton Bruckner. His musical development was slow, and he often revised his compositions after their first performances. He

showed a flair for dramatic orchestral composition with soaring themes in his First Symphony (1899), a flair he retained, although with new ideas of formal structure, in his Second Symphony (1901). These two works, along with *Finlandia* (1899; revised 1900, his most popular composition), his Violin Concerto (1903; revised 1905; Richard Strauss conducted the premiere of the revised version), and the symphonic poems based on the Finnish folk epic *Kalevala* achieved for Sibelius an international reputation, especially in England and Germany. Sibelius had shown himself to be an inspired melodist whose orchestral works contained a cool scoring in which many saw a reflection of Finland's sub-Arctic scenery and climate. Others saw Sibelius as a representative of Finland's struggle for liberation from Russian domination (Finland had been awarded to Russia at the Congress of Vienna in 1815). Sibelius himself was of Swedish descent, but he had attended a Finnish-language high school and was fluent in both languages.

Sibelius began to change his musical style with his Third Symphony (1907), still one of his least appreciated works. Although he retained his reliance on melody in the work, which is almost neoclassical, the Third Symphony made more use of an austere scoring and a striving for organic unity than did his previous works.

The austere tone of the Fourth Symphony (1911), which took Sibelius nearly two years to write, may have been caused by reflections over a potentially life-threatening illness. A tumor in his throat was at first thought to be cancerous. Several operations, and abstaining from tobacco and alcohol for a decade, led to its cure, but the future of his health and even survival were uncertain for a few years, and he was concerned for the welfare of his wife and children.

The form of the symphony is the conventional four-movement structure of the Ludwig van Beethoven symphony; Sibelius esteemed Beethoven above all other composers. Yet there are several critical deviations from the conventional symphony within the individual movements. The first movement, in A minor, is in sonata form, but an extremely condensed and compressed variety; some of the themes are fragmentary gestures rather than soaring melodies such as he had hitherto written. The second movement, in F major, occupies the place of a scherzo, but its pastoral quality is overridden by a menacing coda. The slow movement, in C-sharp minor, contains near its end a soaring melody that is soon defeated.

The finale, in A major, is the negation of the optimistic finale of most nineteenth century works from Beethoven onward; it is in a condensed sonata form, like the first movement, but with a particularly bleak and quiet coda in A minor in place of the triumphant conclusion that most audiences expected. There had been pessimistic finales in nineteenth century music, such as to Frédéric Chopin's B-flat minor sonata or Peter Ilich Tchaikovsky's Sixth Symphony (the *Pathétique*), but none of comparable austerity until the lunar landscapes of Dmitri Shostakovich's Eighth String Quartet of 1960.

A remarkable feature of Sibelius' Fourth Symphony is its reliance on a basic interval and motive. The symphony is held together by the interval of the tritone (A to D-sharp) and by a motive that often consists of the notes C, D, F-sharp, and E.

This motive is often transposed, altered, or permutated or serves as the skeleton of a given theme.

For the orchestral player, many rhythmic intricacies in all parts require much rehearsal; it is probably the most difficult Sibelius symphony to put together and demands a conductor of consummate musicianship. Not only the austerity and bleakness of the symphony but also its difficulty have contributed to its lack of popularity and its relative infrequency of performance. The premiere in Vienna in 1912 had to be canceled because the members of the Vienna Philharmonic refused to perform the piece.

Sibelius wrote to his English friend Rosa Newmarch that the Fourth Symphony was "a protest against the compositions of today" with "absolutely nothing of the circus about it." He was reacting chiefly to the opulent and lengthy symphonies of Gustav Mahler and the later symphonic poems of Richard Strauss. The conservative symphonies of Aleksandr Glazunov and the melodious concertos of Sergei Rachmaninoff, Russia's leading symphonists at the time, and the Impressionistic works of Claude Debussy and Maurice Ravel may have been other works that Sibelius rejected. Certainly, this symphony is the antithesis of the two large-scale symphonies to receive their premieres in 1911: Mahler's Ninth and Edward Elgar's Second.

Impact of Event

Two immediately following major works of Sibelius retained his technique, shown in the Fourth Symphony, of composing works built up from small germ motives and a somber atmosphere: the symphonic poem *The Bard* (1913, revised 1914) and a symphonic poem for voice and orchestra, *Luonnotar* (begun 1910 but not published until 1914), a setting of the creation legend in the *Kalevala*. Neither work became popular, although they are highly esteemed by lovers of Sibelius' music.

Despite these apparent setbacks, honors flowed toward Sibelius. In 1912, he was offered a position as professor of composition at the Imperial Academy of Music in Vienna, which he declined. In 1914, he was invited to the United States, where he received the honorary degree of doctor of music from Yale University. His symphonic poem *The Oceanides*, combining a composition technique of using motivic gestures rather than themes with a very lavish orchestration, received its premiere and immense acclaim at a festival in Norfolk, Connecticut.

The Fifth Symphony, Sibelius' largest work since the Fourth Symphony, was hastily composed for a concert honoring the composer's fiftieth birthday in 1915 and then extensively revised in 1919. Though it retains an experimental character and continues many of the rhythmic difficulties of the Fourth Symphony, it belongs to a world quite different from the earlier work. If the Fourth Symphony represents ice, granite, and leaden winter clouds, the Fifth Symphony depicts forests, lakes, and summer sunlight. The bleak conclusion of the Fourth Symphony is replaced by the optimistic, heroic ending of the Fifth, which remains one of his most popular works.

Sibelius was somewhat isolated by World War I; he was unable to obtain royalties from his German publisher, since Russia, which still occupied Finland, was an en-

emy country. He now submitted his compositions to the Wilhelm Hansen company in Copenhagen. After the end of the war, Finland became independent, and Sibelius was esteemed as a national treasure, a prominent figure of international renown, the recipient of government grants and of subsidies to permit the recording of his symphonies.

With the Sixth Symphony of 1923, Sibelius set out along a new path, retaining his concept of themes growing from organic cells but adhering to the concept of key-centers, which had been abandoned by Arnold Schoenberg and his school. Sibelius' key-centers, however, are treated with ambiguity: In the first movement, for example, there is the constant ambiguity between the keys of D minor and F major, both with B-naturals (in the style of the old church modes) instead of B-flats. His orchestration became more sparse, returning to the austerity of the Fourth Symphony. Sibelius himself commented that instead of offering the world highly spiced cocktails (probably an allusion to the works of Strauss and Ravel), he was providing "pure cold water."

His final symphony, the Seventh, was originally premiered in Stockholm in 1924 as a "symphonic fantasia," and only in the following year was it numbered as a symphony. In one movement, the entire work grows out of the germ motives stated in the introduction, but the piece does not follow traditional symphonic form except in the recurrence of themes and contrasts of tempos. The symphonic poem *Tapiola* of 1926, a pantheistic evocation of the Finnish forests and their spirit denizens, was to all practical purposes Sibelius' valedictory work, except for a few minor ephemeral compositions.

Many of Sibelius' biographers have tried to explain his thirty-year silence after *Tapiola*. An eighth symphony was reported to be in various stages of composition; by all accounts, Sibelius worked on it but destroyed it, and, after his death, his widow and eldest daughter insisted that it did not exist. Publishers, performers, and orchestras sought additional works from him, to be acknowledged with tactful refusals. Explanations for his silence include a slight stroke that he suffered shortly after finishing *Tapiola* and alcoholism; the most likely reason is that he had said all that he had to say in his chosen musical style. He did not approve of the new musical trends in composition that arose after World War I, especially the later styles of Schoenberg and Igor Stravinsky, both of whom he esteemed at first but later deprecated. Béla Bartók and Ernest Bloch were the only postwar composers whom he seems to have respected.

Sibelius did attempt to write popular works in the style of his early *Valse triste* (1904) and thus assure himself a steady stream of royalty checks, but without success. His last datable composition is from 1938. He was happiest in occupying his villa at Järvenpää, north of Helsinki, where he had lived since 1904 amid his beloved forests. There death claimed him in 1957, in his ninety-second year.

Sibelius founded no school of composers, accepted few pupils, and left no legacy other than his music. The phonograph and radio, even more than concert performances, were to contribute to the growth of the audience for his music. After 1920,

England and America contained his staunchest admirers, and as late as the 1950's foreign musicians visiting the United States were surprised at the esteem given to Sibelius. Yet with the eclipse of neoclassicism and serial composition in the 1970's, new respect began to be accorded to the school of conservative symphonists of the first half of the twentieth century, including not only Sibelius but also Carl Nielsen, Ralph Vaughan Williams, Howard Hanson, and Dmitri Shostakovich. Among their works, Sibelius' Fourth Symphony represents a unique contrast of modernism within a traditional symphonic framework, but a modernism that does not seem outdated to the listeners of the late twentieth century.

Bibliography

Abraham, Gerald. "The Symphonies." In *The Music of Sibelius*, edited by Gerald Abraham. New York: W. W. Norton, 1947. The starting point for all subsequent analyses of the symphonies of Sibelius, even though several later students of these works have disagreed with some of Abraham's conclusions.

Hannikainen, Ilmari. *Sibelius and the Development of Finnish Music.* Translated by Aulis Nopsanen. London: Hinrichsen Edition, 1948. This brief volume is chiefly useful in providing a background to Sibelius, discussing his Finnish precursors, and introducing the younger Finnish composers in Sibelius' shadow.

James, Burnett. *The Music of Jean Sibelius.* Rutherford, N.J.: Fairleigh Dickinson University Press, 1983. The best short study of Sibelius' music for nonspecialists. Makes much use of Erik Tawaststjerna's researches before their publication in English.

Johnson, Harold E. *Jean Sibelius.* New York: Alfred A. Knopf, 1959. The author sought to write an unauthorized biography, in contrast to the glowingly eulogistic studies that had previously appeared. The analyses of the works are rather simplistic.

Layton, Robert. *Sibelius.* New York: Farrar, Straus & Giroux, 1965. An older biography of the composer. Organized according to genres, with the symphonies discussed in chapters 5 through 7. The concluding chapter provides a fine summary of the composer's achievement.

Levas, Santeri. *Jean Sibelius: A Personal Potrait.* Translated by Percy M. Young. 2d ed. Provoo, Finland: Werner Söderstrom Osakeyhtiö, 1986. This memoir, by Sibelius' private secretary for more than twenty of his last years, gives an intimate portrait of the composer as a person. Included are his often sharp observations about his musical contemporaries and extensive illustrations, including paintings by the composer's Finnish contemporaries and neighbors.

Parmet, Simon. *The Symphonies of Sibelius.* Translated by Kingsley A. Hart. London: Cassell, 1959. This study of the composer's symphonies is focused more on their performance, especially involving questions of rhythm and tempo, rather than on the structure of these works. The author had conducted these symphonies in consultation with their composer.

Tawaststjerna, Erik. *Sibelius.* Translated by Robert Layton. 2 vols. Berkeley: Univer-

sity of California Press, 1976-1986. Two volumes in English of Tawaststjerna's monumental and definitive study have appeared, covering the composer's life to 1914. This study makes extensive use of the composer's diaries and correspondence, which were not available to previous writers, and gives thorough analyses and discussions of all his major works. This biography supersedes all earlier studies.

R. M. Longyear

Cross-References
Vaughan Williams Composes His Nine Symphonies (1903), p. 90; Busoni's *Sketch for a New Aesthetic of Music* Is Published (1907), p. 166; Mahler's Masterpiece *Das Lied von der Erde* Premieres Posthumously (1911), p. 298; The Art of Radio Develops from Early Broadcast Experience (1920's), p. 469; Shostakovich's *Lady Macbeth of Mtsensk* Is Condemned (1936), p. 1042.

MAHLER'S MASTERPIECE *DAS LIED VON DER ERDE* PREMIERES POSTHUMOUSLY

Category of event: Music
Time: November 20, 1911
Locale: Munich, Germany

Six months after Gustav Mahler's death, Bruno Walter conducted Das Lied von der Erde, *a symphony of songs that embodied the composer's farewell to life*

Principal personages:
GUSTAV MAHLER (1860-1911), an Austrian composer and conductor whose symphonies and songs have come to be recognized as pivotal creations bridging the Romantic and modern periods of music
ALMA MAHLER (1879-1964), an Austrian composer whose marriage to Mahler in 1902 significantly influenced his ensuing career and creations
BRUNO WALTER (BRUNO SCHLESINGER, 1876-1962), a German conductor who became Mahler's disciple, friend, and coworker as well as an ardent promoter of his compositions

Summary of Event

Gustav Mahler saw his songs and symphonies as spiritual adventures, milestones in the history of his soul, and in *Das Lied von der Erde* (*The Song of the Earth*) he sought to communicate to others his highly charged emotional experiences as he wrestled with the abiding verities of life and death. In an irony the grim import of which he would readily have grasped, Mahler did not live to conduct the premiere of *Das Lied von der Erde*. Throughout his life he had endured many heart-wrenching ordeals, including the premature deaths of several of his brothers and sisters, and these traumas had taught him both of life's transience and of the evil that dwells beneath life's surface, always threatening to destroy human happiness. In 1907, he received further confirmation of these convictions when his five-year-old daughter died of scarlet fever and when, two days after her death, he learned of his own fatal heart disease. From 1901 to 1904, he had composed *Kindertotenlieder* (songs on the deaths of children), the chamber orchestration of which anticipated *Das Lied von der Erde*'s, and after his daughter's death he could not escape the feeling that he had taunted fate into taking his child away from him. These shocks, which had transformed Mahler's physical and emotional life, also transformed his spiritual and musical life, thus preparing the ground from which *Das Lied von der Erde* would grow. As he wrote to Bruno Walter, his daughter's death and his heart disease had made him "thirstier than ever for life," and he wanted to express these feelings in music.

A friend of his wife's father had given Mahler a collection of Chinese poems that Hans Bethge had translated into German. Several of the poems expressed bitter and

melancholic feelings that echoed Mahler's own, and in 1907 he started sketching melodies for those texts that he found most meaningful. He worked assiduously on ways to unify the songs, at first glance so dissimilar in meaning and mood, into a symphonic world in which the Earth's ephemeral beauty was interrelated with the transitoriness of human life.

In *Das Lied von der Erde*, Mahler created an eclectic blend of Eastern and Western music. He deftly wove such Orientalisms as the pentatonic scale into orchestrations evocative of the disembodied beauty of a Chinese watercolor. Unlike the deeply Christian vision of his Eighth Symphony (1910), the world of *Das Lied von der Erde* exhibits a pantheistic feeling for nature. Indeed, Mahler depicts a world in which God seems absent, and the composer agonizes between affirming and negating the poles of several basic conflicts: life and death, joy and sadness, love and separation. These struggles sharpen his taste for nature's beauty and heighten his passionate joy at being alive.

Before he died, Mahler allowed Bruno Walter to study the manuscript of *Das Lied von der Erde*. Walter was so moved by the piece that he could scarcely utter a word when he handed it back to Mahler, who turned to the last movement and expressed his concern that experiencing its anguish might drive members of the premiere audience to "make an end of themselves." Mahler's widow Alma chose Walter to conduct the premieres of her husband's posthumous works; Walter, in turn, selected Munich for the premiere of *Das Lied von der Erde* because it had been the site of Mahler's final triumph, the premiere of his Eighth Symphony. The time for *Das Lied von der Erde*'s premiere was also propitious: a two-day festival in Mahler's honor.

Even though Walter had earlier conducted a stirring rendition of Mahler's Second Symphony, the premiere of *Das Lied von der Erde* was clearly the highlight of the festival. The orchestra for *Das Lied von der Erde* was large, including, in addition to the usual strings, winds, and brasses, such unusual instruments as the celesta, glockenspiel, tam-tam (gong), and mandolin. Mahler made use of the full power of the orchestra only sparingly; for most of the work, the singers are supported by a solo instrument or a small group of instruments. For Walter, *Das Lied von der Erde* was the most Mahlerian of all the composer's works, and its psychic key was Mahler's proximity to death. Walter therefore saw that the work's basic tension was between existence and extinction, both of which Mahler, through his music, had been able to reconcile.

This song symphony, which listeners in Munich heard for the first time on November 20, 1911, had six movements. As in several of Mahler's earlier symphonies, he used long first and last movements to frame the inner movements. In *Das Lied von der Erde*, the outer movements give extended expressions of the theme of acceptance of life's paradoxes, whereas the inner movements depict the fleetingness of life's joys.

At the end of Walter's first performance of *Das Lied von der Erde*, a silence of several seconds followed, since the audience was too moved for an immediate reaction. One eyewitness saw some people, the blood drained from their faces, trembling

with emotion; many others were in tears. After these moments of silence, the audience erupted in ecstatic cheers, as Bruno Walter, his face radiating profound appreciation for the creation of his absent friend, returned to the stage again and again to bow. Although some critics in the audience agitatedly discussed faults in the score, other critics shared the audience's overall mood of elation and gratitude for what they said was Mahler's most moving composition. For once, he had created a symphony in which form and emotion were ideally matched. The genuine melancholy and otherworldliness of the music did not sound artificial or forced. Unique among the arts, music is able to express several conflicting emotions simultaneously, and in *Das Lied von der Erde* Mahler had been able to blend sadness and joy into an affirmation of life as well as death.

Impact of Event

Gustav Mahler passionately believed that God had chosen him to enrich humanity by creating new worlds of music, and he suffered deeply when his works met with incomprehension and vilification. Like the premieres of Mahler's previous symphonies, the first hearing of *Das Lied von der Erde* generated much critical comment. Mahler, in the course of his career, had made many enemies—for example, anti-Semitic critics who found his compositions bombastic, even decadent. As he would have expected, the reviews of the premiere of *Das Lied von der Erde* were not as enthusiastic as the initial reaction of the audience. One reviewer wrote that the orchestra had been emphasized to the disparagement of the singers, who had to overcome great difficulties merely to make themselves heard. Other critics worried about the weaknesses in structure of this symphony of songs, in particular the great disparity in the lengths of the movements. These criticisms did not bother Bruno Walter, who believed that Mahler had written about his own destiny and for this new experience he needed a symphony new in structure, instrumentation, and invention.

After the premiere, the story of *Das Lied von der Erde*'s influence was not smooth and untroubled. The division of opinion—either ardently enthusiastic or angrily antagonistic—that was present at the start continued through the early decades of the twentieth century. Walter was certainly convinced of the greatness of the piece and championed it by playing it whenever he could. When he conducted it in Munich again in 1915, one critic noted that, because of the astonishing amount of negative criticism directed against the work, the public had been deprived of its beauty for more than four years.

Mahler's late compositions, especially *Das Lied von der Erde*, probably had their most detailed musical influence on the members of the so-called Second Viennese School, that is, Arnold Schoenberg and his disciples Alban Berg and Anton von Webern. For them, Mahler was a musical Moses, leading them from the desert of a barren Romanticism into the promised land of a fertile modernism. *Das Lied von der Erde* influenced several of Schoenberg's compositions, especially his *Gurre-lieder* (songs of Gurre). Just as Mahler had combined the song cycle with the symphony in *Das Lied von der Erde*, so Schoenberg fused the song cycle and the can-

tata. During World War I, Webern composed some songs for voice and small orchestra based on the Chinese poems that had inspired Mahler.

In the period before World War I, *Das Lied von der Erde* had premieres in various European countries, creating the same division of opinion that had characterized the premiere in Germany. Mahler had his defenders who found his song symphony deeply moving, but others found it pretentious and prolix with its gloomy message and disproportionately long final movement. World War I hindered performances in many European concert halls, but in the United States, Leopold Stokowski was able, in December, 1916, to conduct the Philadelphia Orchestra in the piece's American premiere.

Bruno Walter continued to promote Mahler's symphonies after World War I. He then witnessed music passing through a crisis: It was either intellectualized into arid atonality or popularized into shallow entertainment, both of which alienated large segments of the traditional audience. For Walter, Mahler's music was the solution to this crisis, since his music had both modern harmonic and polyphonic ideas and a profound depth of feeling. In *Das Lied von der Erde*, Walter believed, Mahler had extended music's power so that it was now able to express the full longings and aspirations of humanity. He hoped to increase *Das Lied von der Erde*'s influence by allowing an actual concert of the work to be recorded in Vienna on May 24, 1936.

With Adolf Hitler's ascent to power in Germany and with the annexation of Austria to Nazi Germany in the late 1930's, performances of Mahler's works, including *Das Lied von der Erde*, were put to an end in these countries, and the Nazis began a policy of defaming the composer and his music. Walter continued to play Mahler's symphonies in countries not controlled by the Nazis, and after 1939, when he settled in the United States, he often conducted Mahler's works.

Despite Walter's successes, it was really not until after World War II, particularly with the advent of the long-playing record, that Mahler's music became widely popular. Indeed, the belated recognition of Mahler as one of music's great composers is one of the most remarkable features in the history of twentieth century music. Bruno Walter again played an important part in this phenomenon. From 1947 on, he made return visits to Europe, where he was able to play Mahler's works in various concerts. His recordings, too, contributed to the acceptance of Mahler's symphonies.

As *Das Lied von der Erde* became more widely known, its influence spread to other arts. For example, Antony Tudor choreographed a ballet based on its music that the Ballet Theatre first presented in 1948 at the Metropolitan Opera House in New York. The choreographer Kenneth MacMillan also used *Das Lied von der Erde* as the basis of a ballet; MacMillan interpreted the piece as being about Death, whom he personified by a figure with a half-mask, which set him off from the other dancers. In MacMillan's ballet, Death takes a man away from a woman, but both Death and the man return to her, and at the ballet's end the audience finds that in Death there is the promise of renewal.

Ballets and increased record sales were indications of Mahler's increasing popularity in the 1950's and 1960's. During his life, Mahler had conducted premieres of

his works, but they always provoked the fierce hostility of critics. Nevertheless, during the postwar decades, his symphonies began to be played regularly by most conductors, and the best of his works gradually became an important part of the standard repertoire. In America, Leonard Bernstein's advocacy of Mahler's symphonies through his concerts, records, and lectures did much to make them an integral part of modern musical life.

This recent transformation of Mahler's reputation raises a question: Why did so many people find that Mahler's compositions were an essential part of their musical life? In *Das Lied von der Erde*, he was able to create a new kind of symphony by wedding the lyric and the dramatic; in general, he took the traditional symphony and enlarged it until it was able to encompass the marvelous musical worlds he envisioned. These new worlds entranced people, as did Mahler's ability to embody in his creations some of the basic contradictions of the twentieth century. In an age made increasingly anxious by fiercely contending ideologies and horrific wars, many people turned to art to find meaning in their lives, and Mahler's music, which plumbed emotional depths and soared to spiritual heights, helped to satisfy their emotional and spiritual yearnings. At the end of his own troubled life, Mahler composed *Das Lied von der Erde* to find peace in the midst of his tragedies. This work certainly had immense significance for him, as it has had for countless listeners; when Jascha Horenstein, a great conductor of Mahler's music, was near to his own death, he said that for him one of the saddest things about leaving this world was that he would not hear *Das Lied von der Erde* again.

Bibliography

Cooke, Deryck. *Gustav Mahler: An Introduction to His Music.* Cambridge, England: Cambridge University Press, 1980. Discusses systematically the songs and symphonies (*Das Lied von der Erde* is part of Cooke's treatment of Mahler's last period). Texts of the songs are given (along with translations). Index.

Gartenberg, Egon. *Mahler: The Man and His Music.* New York: Schirmer Books, 1978. Gartenberg wrote this book for the general listener of Mahler's music as well as for the student and scholar. Instead of interweaving biographical and musical material, he divides his volume into a biography and musical analyses of Mahler's compositions. Includes biographical sketches of the principal personages mentioned in the text, a bibliography, and an index. Illustrated.

La Grange, Henri-Louis de. *Mahler.* Vol. 1. Garden City, N.Y.: Doubleday, 1973. A definitive three-volume life of the composer. The first volume, which covers the years 1860 to 1901, has been translated into English (the second volume, covering 1902-1907, appeared in French in 1983, and the third, covering 1907-1911, in 1984). The English version of the first volume is illustrated with forty-eight pages of photographs, and one of its four appendices is an extensive and detailed analysis of all Mahler's works composed up to 1901. Comprehensive notes, bibliography, and index.

Mahler, Alma. *Gustav Mahler: Memories and Letters.* Translated by Basil Creigh-

ton. Revised and edited by Donald Mitchell. New York: Viking Press, 1969. Alma Mahler's reminiscences of her husband, first published in 1946, have, in this book, been revised, edited, and enlarged. The book has two sections: one a memoir of Alma's marriage to the composer and the other a section of letters. Includes a biographical list and an index.

Mitchell, Donald. *Gustav Mahler.* Vol. 3. *Songs and Symphonies of Life and Death: Interpretations and Annotations.* Berkeley: University of California Press, 1985. This third volume of Mitchell's trilogy on Mahler centers on *Das Lied von der Erde.* Heavily illustrated with musical examples, and some sophistication in musical matters is necessary to follow some of the analyses. Bibliography, index of Mahler's work, and a general index.

Walter, Bruno. *Gustav Mahler.* New York: Alfred A. Knopf, 1972. This brief book, translated into English from the German, is an affectionate portrait of the composer by a conductor who was his good friend. Not a systematic biography but a memoir of their first meetings and other encounters and a series of reflections on Mahler as an opera director, conductor, composer, and personality. Index.

Robert J. Paradowski

Cross-References

Mahler Revamps the Vienna Court Opera (1897), p. 7; Schoenberg Breaks with Tonality (1908), p. 193; Webern's *Six Pieces for Large Orchestra* Premieres in Vienna (1913), p. 367; Schoenberg Develops His Twelve-Tone System (1921), p. 528; Berg's *Wozzeck* Premieres in Berlin (1925), p. 680; Tudor's *Jardin aux lilas* Premieres in London (1936), p. 1036; Berg's *Lulu* Opens in Zurich (1937), p. 1078.

GREY'S *RIDERS OF THE PURPLE SAGE* LAUNCHES THE WESTERN GENRE

Category of event: Literature
Time: 1912
Locale: The United States

Zane Grey combined the excitement of the frontier and a stirring human-interest story to capture an ongoing fascination with life in the nineteenth century American West

Principal personages:
ZANE GREY (1872-1939), the author of fifty-six popular novels about the American West
LOUIS L'AMOUR (1908-1988), a later Western writer who continued the tradition of Zane Grey
FREDERIC REMINGTON (1861-1909), a writer, artist, and sculptor who vividly portrayed the life of the Western frontier
FREDERICK FAUST (1892-1944?), a prolific writer who wrote Western novels under the pen name of Max Brand

Summary of Event

The exploration, taming, and settlement of the West is one of the most exciting phases of American history. The saga began with the United States' purchase of the Louisiana Territory from France for fifteen million dollars in 1803. The purchase doubled the size of the United States; however, the northern and western boundaries of the territory acquired were vague, and the purchase actually paved the way for settlement of North America west to the Pacific Ocean.

This vast region offered numerous challenges to the bold and adventurous. Many indigenous tribes roamed the Great Plains, following the enormous buffalo herds. Both the tribes and the buffalo had to be reduced and controlled before the American settlement could succeed. In his novels, Zane Grey vividly described these and other challenges.

President Thomas Jefferson was responsible for the Louisiana Purchase, and he soon authorized an expedition to explore the territory and to cultivate friendly relationships with the indigenous tribes. Meriwether Lewis and William Clark were approved by Congress to lead the expedition, which began its ascent of the Missouri River on May 14, 1804.

Lewis and Clark did make successful contact with several indigenous tribes, including the Mandan Sioux, Blackfoot, and Shoshone; the aid of these tribes was vital to the success of the expedition. After arriving within sight of the Pacific Ocean, Lewis and Clark returned to St. Louis. Their work had proved the value of the Louisiana Purchase and also proved the feasibility of an overland route to the Pacific. Although the expedition had touched only the northern edge of the vast fron-

tier, Lewis and Clark's experiences were extremely valuable to the later settlements that would be portrayed so vividly in the novels of Zane Grey.

Throughout the nineteenth century, many attempts were made to give Americans a clear perception of life on the Western frontier. One of the most successful such attempts was made by Frederic Remington. Beginning in 1880, Remington made many journeys into the Western territories, witnessing Indian battles and the slaughtering of buffalo herds. His stories and drawings soon began appearing in *Harper's Monthly, Century*, and other magazines and newspapers.

Into this historical setting came Zane Grey, whose novels depicted the adventure, the hardships, and the rewards of life on the frontier. Born Pearl Zane Grey in Zanesville, Ohio, in 1872, Grey was graduated from the University of Pennsylvania and became a dentist in New York City in 1898. He soon began writing stories about the frontier. Grey's first novel was *Betty Zane*, based on the journal of one of his ancestors on the Ohio frontier. After this book was published in 1904, Grey ended his dental career and became a full-time writer.

Grey's second novel was *The Spirit of the Border*, also based on the journal of Betty Zane. Published in 1905, this adventure story was a best-seller. The most popular of Grey's novels, and one of the earliest about the Far West, was *Riders of the Purple Sage*, published in 1912. This publication completed the process that Grey began eight years earlier. He almost single-handedly had created a new style in American literature: the Western novel. It came at a time when firsthand accounts of the West were abundant, when the stories of Frederic Remington were still being published and the frontier theory of historian Frederick Jackson Turner was still being debated.

Riders of the Purple Sage is based on the conflict in Utah between the Mormons and the region's other settlers during the 1870's. One of the leading characters is Jane Withersteen, a young Mormon woman who has inherited her father's vast wealth. The book's basic conflict revolves around a struggle to remain loyal to her Mormon beliefs while at the same time trying to change the attitudes of Mormon men toward their women and toward non-Mormons.

Like most of Grey's Western novels, *Riders of the Purple Sage* is a result of the author's many trips through the area involved. His vivid description of the rugged terrain and miles of sagebrush in southern Utah creates an extremely realistic geographic setting. Grey also appreciated the value of horses to the successful conquering of the West. The two horses immortalized in *Riders of the Purple Sage*, Black Star and Night, were real horses that Grey found and bought in Arizona.

Grey's abundant traveling and contact with people from many backgrounds gave him the ability to portray human nature and human emotions in a realistic way. In *Riders of the Purple Sage* and his other Western novels, he used that ability to depict the conflicts involved in carving a way of life from a rugged frontier setting.

Impact of Event

Beginning with *Riders of the Purple Sage*, Zane Grey's output of successful West-

ern novels was amazing. From 1915 to 1924, one of his books was in the top ten of the best-seller list nine times. This streak began with *The Lone Star Ranger: A Romance of the Border* in 1914. In 1918, his *The U.P. Trail* was number one on the list. At a time when it required at least 100,000 copies sold to be on the best-seller list, Grey's *Man of the Forest* (1920) topped the list with more than 700,000 copies sold. The best-selling of Grey's novels, however, is *Riders of the Purple Sage*, which has sold more than one million copies in hardback editions alone.

Grey was writing as prolifically at the time of his death in 1939 as he had at any time in his career. Of his total of eighty-nine books, fifty-six were Western novels. Four were other sorts of novels; the remainder were books of short stories, hunting and fishing books, juvenile books, and books of baseball stories.

The impact of Grey's novels was multiplied many times when they began to be serialized in magazines and newspapers. A total of fifty of his novels were serialized in national magazines; the *New York Daily News*, with a circulation of more than two million, serialized the last three Zane Grey novels. By 1970, Grey's books had sold more than 100,000,000 copies. They had also been the basis for more than one hundred films, including several in which Grey himself appeared.

The tremendous popularity of Grey's Western novels, in all sections of the country and with all age groups, inspired other writers to enter the field. Most sought to follow Grey's example of historical and geographical accuracy. One of the earliest to enter the field, but one who did not have the same zeal for accuracy, was Frederick Faust. Faust, a prolific writer, became a successful author in 1917, and he was soon writing Western novels under the pen name of Max Brand. His first major work was *The Untamed*, which was serialized in *All-Story Weekly*, a pulp magazine, beginning in December, 1918.

Faust wrote *The Untamed* in the phenomenal time of ten days. He did so after reading, at the request of pulp editor Robert Davis, a copy of *Riders of the Purple Sage*. Davis was a Westerner who had lived on the frontier. He regretted an earlier decision not to serialize Zane Grey's most famous novel, and he was looking for a new writer comparable to Grey. It was Davis who gave Faust the more suitable Western name of Max Brand.

Although Faust was influenced by Grey's style, there is a vast difference between Zane Grey Westerns and Max Brand Westerns. Faust never explored the West as Grey did. Grey's West was real, and his stories about it were realistic. The West of Brand was imaginary and lacked that realistic touch. Like Grey's novels, though, Brand's were made into many Western films, the most famous of which was the 1939 classic *Destry Rides Again*.

Another early Western novelist was Ernest Haycox. Although he never gained the popularity of Grey or Brand, he is sometimes linked with them as the "Big Three" of early Western writers.

A later and very colorful author about the West was Louis L'Amour. Born about the time that Grey began his writing career, L'Amour refined the methods and principles of his famous precedessor.

L'Amour received his education by traveling around the world and by reading hundreds of books, including many about the West. In his autobiography, *Education of a Wandering Man* (1989), L'Amour specifically mentions reading two of Grey's books. Although he did not copy Grey's style of writing, L'Amour did emulate Grey's zeal for knowledge of his subject. In *Education of a Wandering Man*, L'Amour stated that a writer about the West must have a more accurate knowledge of his subject than a writer on almost any other topic. He also took issue with the notion that a good Western could be written in a few days. These ideas placed Louis L'Amour much more in the company of Grey than in the company of Faust, who never explored the West and who wrote *The Untamed* in ten days.

Even more than Grey, L'Amour became famous for historical accuracy and detailed descriptions of geography and wildlife. Like Grey, he supported strong family ties and gave sensitive portrayals of Indians and Mexicans.

Louis L'Amour's first Western novel was *Westward the Tide*, published in 1950. In 1960, he began the celebrated saga of the Sackett family in *The Daybreakers*. Among L'Amour's other well-known Westerns are *Hondo* (1953) and *The First Fast Draw* (1959). L'Amour, like the earlier Western authors, saw several of his novels made into films.

Grey established a tradition for accuracy and for excellence as he created the Western novel. In launching a genre that would prove a staple of popular fiction and film throughout the twentieth century, he left a lasting mark on American culture.

Bibliography

Brown, Dee. *Bury My Heart at Wounded Knee.* New York: Holt, Rinehart and Winston, 1970. A detailed and moving account of the effect of American westward expansion on indigenous tribes. Brown supports his evaluation of the events with direct quotes from witnesses and from participants in the events. An interesting view of the historical West from a different perspective than that of most popular fiction and film.

Easton, Robert. *Max Brand: The Big Westerner.* Norman: University of Oklahoma Press, 1970. A biography of Frederick Faust. Easton emphasizes the influences that led Faust into a career as a writer. Includes a good evaluation of Faust's most famous Western, *Destry Rides Again* (1930). Also describes the Doctor Kildare stories of Faust and gives a complete Faust bibliography.

Gruber, Frank. *Zane Grey.* New York: World Publishing, 1970. An excellent biography of Grey. Includes a pictorial section on Grey and his family. Also has a complete bibliography of Grey's books and major articles. Gruber lists the Zane Grey books that were made into films.

Karr, Jean. *Zane Grey: Man of the West.* New York: Greenberg, 1949. A biography of Grey that describes interesting accounts of his childhood and later travels. The best feature of Karr's book is a complete annotated bibliography of Grey's writings. Also includes interesting photographs.

L'Amour, Louis. *Education of a Wandering Man.* New York: Bantam Books, 1989.

An autobiographical account of the life of Louis L'Amour. The author vividly emphasizes the importance of books to his own education. L'Amour describes his own writing as a natural result of his traveling, working, and reading. Also has a good pictorial review of L'Amour's life. An introduction by David Boorstin presents an interesting description of L'Amour's reading habits.

Remington, Frederic. *Selected Writings.* Secaucus, N.J.: Castle Books, 1981. A collection of real-life stories about the West, illustrated vividly by the drawings of the author. Many are written in the first person, as the author experienced the events. Includes an excellent insight into the real West and its indigenous tribes.

Glenn L. Swygart

Cross-References

The Great Train Robbery Introduces New Editing Techniques (1903), p. 74; Ford Defines the Western in *Stagecoach* (1939), p. 1115; Westerns Dominate Postwar American Film (1946), p. 1313; *Gunsmoke* Debuts, Launching a Popular Television Genre (1955), p. 1668; Seven of the Top Ten Television Series Are Westerns (1958), p. 1768; *Bonanza* Becomes an American Television Classic (1959), p. 1800; Leone Renovates the Western Genre (1964), p. 1984.

JUNG PUBLISHES *PSYCHOLOGY OF THE UNCONSCIOUS*

Category of event: Literature
Time: 1912
Locale: Zurich, Switzerland

Publication of Carl Jung's first major work marked his break with Sigmund Freud and introduced new notions of the basis of the imagination and creative activity

Principal personages:
CARL JUNG (1875-1961), the Swiss psychiatrist and disciple of Freud whose notions of a "collective unconscious" led to his founding of the school of analytical psychology
SIGMUND FREUD (1856-1939), the founder of psychoanalysis, who wished his disciple Jung would inherit his mantle and carry his doctrine of the sexual origins of neurosis into the wider world
BEATRICE MOSES HINKLE (1874-1953), a physician who translated *Psychology of the Unconscious* into English
WILLIAM BUTLER YEATS (1865-1939), the Irish poet whose own investigations into mythology, alchemy, magic, and the creative process led him to conclusions startlingly parallel to those of Jung

Summary of Event

Sigmund Freud and Carl Jung were about to part company when Jung's *Wandlungen und Symbole der Libido* (1912; *Psychology of the Unconscious*, 1916) was published in two parts in Freud's newly established journal, the *Jahrbuch*, in 1911 and 1912. The break was perhaps inevitable, given the nature and relationship of the two men. Freud looked to Jung to be his successor, the man who would carry his own brilliant insights into sexuality and the unconscious into the wider world; he had even nicknamed Jung his "crown prince." Jung regarded Freud as his teacher and quoted Friedrich Nietzsche to him: "One repays a teacher badly if one remains only a pupil."

Freud's doctrine centered on his use of the term "libido," the Latin word for "wish" or "desire." In Freud's technical vocabulary, libido is always sexual. At the start of his *Drei Abhandlungen zur Sexualtheorie* (1905; *Three Essays on the Theory of Sexuality*, 1910), he wrote:

> The fact of the existence of sexual needs in human beings and animals is expressed in biology by the assumption of a "sexual instinct," on the analogy of the instinct of nutrition, that is of hunger. Everyday language possesses no counterpart to the word "hunger," but science makes use of the word "libido" for that purpose.

The concept of libido was central to Freud's understanding of unconscious processes. "My dear Jung," he admonished his pupil, "promise me never to abandon

the sexual theory. That is the most essential thing of all. You see, we must make a dogma of it, an unshakable bulwark."

It was precisely on this point that Jung was to differ so strongly from his teacher. Addressing the members of the New York Psychoanalytic Society in September, 1912, he declared: "I do not think I am going astray if I see the real value of the concept of libido not in its sexual definition but in its energetic view." Jung added that, in his view, "libido" was simply "a name for the energy which manifests itself in the life-process." In the second part of *Psychology of the Unconscious*, Jung began to explore that difference in print.

Freud was torn; it is difficult to support intellectual freedom while maintaining a dogma. In the event, Freud held to his position, and Jung continued to explore his own. In January, 1913, Freud and Jung agreed to part company, and Jung began to refer to his own method of analysis as "analytical psychology," in contrast to Freud's "psychoanalysis."

In 1916, Jung's book appeared in English in a translation by Beatrice Hinkle under the somewhat misleading title *Psychology of the Unconscious* (the book's German title literally translates as "transformations and symbolisms of the libido"). The book had a mixed reception, one reviewer describing it as "five-hundred-odd pages of incoherence and obscenity." Virtually unaltered German editions followed in 1925 and 1938; in 1952, Jung issued a comprehensive revision that was translated by R. F. C. Hull as *Symbols of Transformation: An Analysis of the Prelude to a Case of Schizophrenia* and issued as volume 5 of Jung's *Collected Works* in 1956.

Jung's thought had come a long way between the original 1912 edition and the revision of 1952, and the shift in his thought is perhaps best reflected in one of the subtitles given to the book. The 1912 edition was subtitled "A Contribution to the History of Evolution of Thought"; in Jung's personally annotated copy used in preparing the 1952 revision, this subtitle had been corrected to read "A Contribution to the History of Evolution of Spirit." It was psyche, soul, spirituality which Jung had been bringing back into the discourse of science over the intervening years—and which his work allowed to reemerge as a strand in the great conversation between men and women of genius that informs and forms the thoughts of entire cultures down the centuries. If Freud had opened the doors to the unconscious in 1900 with the publication of *Die Traumdeutung* (*The Interpretation of Dreams*, 1913), Jung ushered the gods back into human experience and discourse.

Most notably, he identified a series of psychic motifs, which he called "archetypes," that organize the stuff of the unconscious and find expression in "archetypal images" in dreams and elsewhere. It was Jung's great insight that there are many archetypal motifs, that they belong to humanity as a whole rather than to the individual, and that there must therefore exist a "collective unconscious" containing these motifs common to all humankind.

Jung came by these insights through his early studies in mythology—the first fruits of which were published in *Psychology of the Unconscious*—and his later immersion in the study of alchemy. Yet it was the correspondence between the im-

ages he found in his wide reading and those found in his own and his patients' dreams that was significant for him. For example, Freud's formulation of the Oedipus complex would seem, from a Jungian viewpoint, an expression (in psychoanalytic terms) of one such archetype, which had earlier expressed itself in the Greek myth of Oedipus' killing his father and sleeping with his mother and in the tragedies of Sophocles—but also in Freud's own dreams.

Further, the Buddhist scripture known as *Bar-do Thödol* (the *Tibetan Book of the Dead*) contains a passage describing a soul, approaching the moment of conception, seeing visions of males and females in union. The passage continues, saying that if the soul is about to be born as a male, "the feeling of itself being a male dawneth upon the Knower, and a feeling of intense hatred towards the father and of jealousy and attraction towards the mother is begotten." From the Freudian perspective, this passage would support the idea of the universality of the Oedipus complex. To Jung, who wrote an introduction to a 1938 edition of the *Tibetan Book of the Dead*, it must have seemed a strangely ironic confirmation of the existence of the collective unconscious. Even old father Freud could not escape the Jungian archetypes.

Impact of Event

"Before the mind's eye whether in sleep or waking, came images that one was to discover presently in some book one had never read, and after looking in vain for explanation to the current theory of forgotten personal memory, I came to believe in a great memory passing on from generation to generation." The writer of these lines was not Carl Jung but the Irish poet William Butler Yeats, Jung's contemporary— and yet, word for word, they could have been penned by Jung himself, and indeed contain the essence of everything that Jung was to say about psychology. Yeats's "images" seen "in sleep or waking" are Jung's "archetypal images"; Yeats's "great memory" is Jung's "collective unconscious" under another name.

The parallels go even further. Yeats continues:

> If no mind was there, why should I suddenly come upon salt and antimony, upon the liquefaction of the gold, as they were understood by the alchemists, or upon some detail of cabalistic symbolism verified at last by a learned scholar from his never-published manuscripts, and who can have put together so ingeniously, working by some law of association and yet with clear intention and personal application, certain mythological images.

Yeats's sense of the purposiveness of certain seemingly random events of daily life—happening to pick up a book one had never read only to find references to images one had seen in sleep or reverie only a few days before—corresponds exactly to Jung's notion of synchronicity. Moreover, the particulars that Yeats cites, alchemical and cabalistic symbolism, are also the particulars of Jung's own archetypal explorations, while Yeats's "law of association" cannot be far removed from Jung's own studies in word association.

It is true that alchemy and cabala were territories explored by others at the time,

notably the mystical philosopher Arthur Edward Waite, and it could be argued that Yeats and Jung shared many common authors in their readings and many premises in their respective philosophies. The detailed analogies between their thoughts, in other words, could be the result of external factors. From a Jungian perspective, however, they point to something deeper: the truth and reality of the imaginal world Yeats calls the "great memory" and Jung the "collective unconscious." Either way, the two men now stand among the premier exponents in modern times of that philosophy (Aldous Huxley termed it "the Perennial Philosophy") whose lineage can be traced in the West through Plato and the alchemists, and which can be found alike among the shamanistic traditions of tribal peoples and in the great religions of the East.

Jung was at pains to make it clear that he did not espouse a particular religious belief—and for his pains, he was commonly regarded as an atheist. When his patients appeared to be imprisoned by their opinions, he helped them free themselves from those shackles, steering some patients away from the churches toward an agnostic position, and others away from a rigid atheism and toward religion.

What Jung did espouse was the possibility of numinous experience, an experience of the power of the archetypes as mysteries in the full religious sense of the word. While this strand in his thinking carried him ever further from Freud, it brought him closer to those poets, artists, mythographers, and theologians who were themselves in search of a new language for spirituality, one that would avoid the pitfalls of local usage and the dead hand of dogma.

Over the years, Jung gained a coterie of ardent admirers. One of them, Mary Mellon, the wife of American financier Paul Mellon, formed the Bollingen Foundation to print Jung's collected works and any other works deemed likely to interest students of archetypal thinking. Jung's early friendships with the Sinologist Richard Wilhelm, for whose translation of the *I Ching* ("classic of changes") he wrote an introduction, and the Indologist Heinrich Zimmer, from whom he learned about mandalas, were followed by many more friendships with scholars of non-Western thought, many of whom joined him for the yearly Eranos Conferences held in his honor.

Within Christianity, the Protestant cleric Hans Schaer rightly termed Jung's therapy a "cure of souls," while the Dominican Victor White's book *God and the Unconscious* (1952) explored Jung's contribution to theological thinking in positive terms. Scholars in other fields began to apply his insights to their own disciplines. Maud Bodkin's *Archetypal Patterns in Poetry* (1934) and Erich Neumann's essay on Henry Moore were among the notable applications of Jung's analytical psychology to artistic fields, while artists themselves, from Hermann Hesse (briefly) to Jackson Pollock and Sam Francis, found in Jung's writings a key to their own experiences of the creative process.

Jung's work was to have an impact beyond academic and intellectual circles. The 1960's witnessed a widening interest in Jung's work, as thousands of hippies "tuned in" to synchronistic coincidences. Jung's thought had become a part of the general

atmosphere, and his coinages such as "introvert" became a part of everyday speech. Meanwhile, Jung's younger colleague Joseph Campbell was making world mythology accessible to a wide readership in a series of encyclopedic works, from *The Masks of God* (1968) to *The Historical Atlas of World Mythology* (1983). The mythic and imaginal world was once again open territory.

Bibliography

Donn, Linda. *Freud and Jung.* New York: Charles Scribner's Sons, 1988. Warmly human account of the relationship between Freud and his disciple Jung that documents Jung's early admiration for Freud, Freud's enthusiastic acceptance of Jung as his "crown prince," the abrupt parting of their ways, and the feelings each retained for the other to the end of their lives. Annotated, indexed.

Jaffé, Aniela. *The Myth of Meaning.* Translated by R. F. C. Hull. New York: Putnam, 1971. Written by a close associate of Jung; the simplest and best of the popular introductions to Jung's thought and work. Geared to the general reader's wish to make sense out of life rather than to the specialized needs of those who seek Jungian analysis. Useful bibliography, no index.

Jung, Carl Gustav. *Psychology of the Unconscious.* 1916. Reprint. Princeton, N.J.: Princeton University Press, 1991. Reprint, with historical introduction, of the first English translation of the first work in which Jung broke from Freudian orthodoxy. Compare Jung's much-revised 1952 version of the work, translated by R. F. C. Hull as *Symbols of Transformation* (1956). Difficult but fascinating reading; indexed.

Olney, James. *The Rhizome and the Flower.* Berkeley: University of California Press, 1980. Masterful treatment of the extraordinary similarities between the works and worldviews of Jung and Yeats that tends to corroborate the belief of both men in the existence of a "world imagination."

Wehr, Gerhard. *Jung: A Biography.* Translated by David M. Weeks. Boston: Shambhala, 1987. Definitive modern biography of Jung that complements with detailed historical research Jung's own autobiographical work *Memories, Dreams, Reflections* (1973), which fascinatingly records Jung's inner life. With useful chronology and index of names.

Charles Cameron

Cross-References

Freud Inaugurates a Fascination with the Unconscious (1899), p. 19; Rilke's *Duino Elegies* Depicts Art as a Transcendent Experience (1911), p. 281; Yeats Publishes *The Wild Swans at Coole* (1917), p. 440; Borges' *Ficciones* Transcends Traditional Realism (1944), p. 1268; Lévi-Strauss Explores Myth as a Key to Enlightenment (1964), p. 1995.

HARRIET MONROE FOUNDS *POETRY* MAGAZINE

Categories of event: Literature and journalism
Time: 1912
Locale: Chicago, Illinois

Poet Harriet Monroe, the founder and editor of Poetry, *played a critical role in the renaissance and development of modern American poetry*

Principal personages:

HARRIET MONROE (1860-1936), a Chicago-born poet who founded *Poetry* in 1912 to recognize and encourage the work of young poets and who edited the magazine until her death

HOBART C. CHATFIELD-TAYLOR (1865-1945), a wealthy novelist and man of culture who helped Monroe to secure pledges from prominent Chicagoans to publish *Poetry*

EZRA POUND (1885-1972), an American poet and promoter of new poetry who became an early and important ally for Monroe

Summary of Event

When she established *Poetry: A Magazine of Verse* in 1912, Harriet Monroe chose as the journal's motto a line from Walt Whitman: "To have great poets we must have great audiences too." She was dismayed that of all the arts in America, poetry received the least attention, and she maintained that American poets suffered from having no outlet for their work. The main outlets of the day were *The Atlantic,* *Harper's,* and *Scribner's* magazines; these, however, were publishing only the most conventional verse. Monroe called the poems in the current American press "piles of rubbish" and warned that American poetry was losing vitality. Not that great poets did not exist: "A Milton might be living in Chicago today and be unable to find an outlet for his verse," she announced in the *Chicago Tribune* on the eve of publishing the first issue of *Poetry.*

Monroe, herself a modestly successful poet, stated that the aim for her magazine would be to develop a public "interested in poetry as art." Charming and strong-willed, she deeply believed in the importance of poetry. She intended to provide her fellow poets with a forum and a place to share their work. Most important, she aimed to correct an imbalance she perceived in the arts that cast poetry as unfashionable. *Poetry* would be the poets' magazine.

Harriet Monroe, the daughter of a prominent, erudite lawyer, was a native Chicagoan who worked as an art and drama critic for the *Chicago Tribune* and who had had a volume of her own poetry published in 1891. When Chicago was chosen as the site for the World's Columbian Exposition of 1892, she offered to write a dedication poem for Chicago's new auditorium, an endeavor that suited her intention of creating a place for poetry alongside the arts of music, painting, and architecture. After

working for nearly three years on "The Columbian Ode," a verse celebration of her love for her native city, she was rewarded by seeing her ode recited by a chorus of five thousand voices during the auditorium's dedication. Monroe became a local celebrity. Writers and journalists including Margaret Sullivan and Eugene Field became her friends and sponsors.

For getting her magazine launched, her most important friend was Hobart C. Chatfield-Taylor, a wealthy and socially prominent philanthropist and novelist. Her choice of sponsor was crucial and well made; *Poetry*'s longevity can be in part attributed to his simple idea for laying a financial foundation that would last—an unusual success in the history of little magazines (those literary periodicals that exist outside the field of the commercial or "established" press). Chatfield-Taylor proposed to get one hundred of his Chicago friends and contacts to donate fifty dollars a year for five years. He predicted five thousand dollars would cover printing and office expenses, allowing the editors to use money from subscriptions to pay contributors for their work. Chatfield-Taylor made the calls himself and raised the cash in less than a year.

By June, 1912, Monroe had an office and was preparing a circular to announce *Poetry* as "this first effort to encourage the production and appreciation of poetry, as the other arts are encouraged, by endowment." She had spent hours in the Chicago Public Library poring over English and American poetry magazines to compile a list of poets to solicit. She rejected poets who wrote "in the same old academic way" in favor of those who dealt with modern subjects and experimented with form. The eager responses of her selected poets began pouring in within weeks. In September, the most zealous reply of all arrived from Ezra Pound, who had established himself in London as a talented young poet and as a scout and supporter of poets whom he considered talented.

Monroe was impressed with Pound and agreed with his suggestion that he keep her in touch with "whatever is most dynamic in artistic thought, either here or in Paris." She offered him the post of foreign correspondent, and he accepted just in time for his name to appear on the masthead of the first issue, dated October, 1912. Monroe contributed an expected editorial on the status of poetry and a complaint against its neglect. As editor, she also offered some mainly stiff and archaic poems from Grace Howard Conklin and Emilia Stuart Lorimer, among others.

The immediate response to *Poetry*'s first issue was amused condescension in the East. A Philadelphia headline smirked "Poetry in Porkopolis," explaining that Chicago's proceeds from pork were promoting Chicago's poetry; the *New York World* snickered that the "slender wooers of the muse" would now "wend their way Chicagoward." Some angry correspondents wrote in to express patriotic indignation over Pound's "To Whistler, American" (one of two poems he gave the first issue), which contained the lines "You and Abe Lincoln from that mass of dolts/ Show us there's chance at least of winning through." Monroe defended her contributor rather uneasily, since while she agreed with Pound that poets had been doltishly ignored in her country, she intended to make *Poetry* first of all an American magazine.

The first few issues made it apparent that Monroe was still figuring out just what kind of poetry she really was seeking. Her choices were traditional in taste, and three free-verse pieces by Richard Aldington in the second issue were also far from modern or experimental in subject. By *Poetry*'s third issue, though, Pound had moved toward center stage, supplying contributions by the great Irish poet William Butler Yeats and poems by the Imagist H. D. for issue four. The assistant editor, Alice Corbin Henderson, claimed the new *vers libre* as an American phenomenon. Issue number six, the high point of Pound's influence on the magazine, contained F. S. Flint's historic note on the history of Imagism and its three golden rules, as well as Pound's famous "A Few Don'ts by an Imagiste."

Monroe, meanwhile, was steadily coming into her own as a creative and outspoken editor whose vision guided *Poetry* through the next few years, even though her magazine came to be known by some as Pound's mouthpiece. She continued to print more accessible American poetry and traditional pieces despite his rebuke. She adopted two homegrown American heroes of poetry, Carl Sandburg and Vachel Lindsay, neither to Pound's taste. A final division between Pound and Monroe occurred in 1915 over her slowness to accept T. S. Eliot's "The Love Song of J. Alfred Prufrock," which Pound had sent to her with his most emphatic praise. Although she recognized the poem's great power—if not its greatness—the work repelled her. Pound continued in his post as foreign correspondent until 1919, although his involvement with the magazine was never again exclusive. He supplied *The Little Review*, *Poetry*'s main rival, with the best of Yeats and Eliot and reserved his own work for Monroe.

During the World War I years, Monroe's taste became increasingly provincial, although she campaigned against patriotic verse and "war songs." Instead, she published Rupert Brooke's *War Sonnets*, some trench poems by Isaac Rosenberg, and Joyce Kilmer's "Trees." Nevertheless, she seemed more comfortable printing cozy, sentimental verse than she was publishing antiwar poems. D. H. Lawrence (whose antiwar poem "Resurrection" appeared in June, 1917) wrote to say that he found the "glib irreverence" of some of her contributors offensive.

In the postwar years, Monroe's patriotism became more pronounced. She announced that the new mission of *Poetry* would be to articulate the imaginative life of the American nation, not the cosmopolitan and "superintellectualized" concerns of expatriate groups in London and Paris. She became fond of poems celebrating the land and of American Indian dialogues and chants. Although she still included the work of intellectual poets such as Wallace Stevens and William Carlos Williams and published good poems by Robert Frost and Marianne Moore in the 1920's, her patriotic course led her to champion many mediocre and forgotten poets—including her favorite, Lew Sarett.

In her later years, she devoted less and less time to the magazine and threw her energies into foreign travel. She died in Peru in 1936 while crossing the Andes enroute to an international writers' congress in Buenos Aires.

The December, 1936, issue of *Poetry* carried tributes from friends and colleagues.

An accurate and heartfelt tribute from Ezra Pound credited Monroe with the achievement of having made *Poetry* the most "durable" of the little magazines as a result of her staunchly inclusive editorial policy. As he pointed out, the other little magazines of the twenty-four-year period of her editorship, however brilliant they might have been, "were all under sod in the autumn of 1936."

Impact of Event

Many literary historians consider the October, 1912, publication of *Poetry*'s first issue the beginning of a poetic renaissance in America. It was the start of a new era in modern American poetry, fueled by the existence of a magazine that Monroe vowed would encourage, support, and inspire poetry for its own sake. She was determined to avoid a condescending attitude bent on "delivering great poetry on high to a skeptical and unwilling audience." Her willingness to accept submissions from anyone as long as the poetry was good allowed her magazine to deliver to the widest possible audience a monthly sampling of what poets far and wide were writing.

While the poets' concerns, talents, and approaches varied greatly, Monroe believed that "diversity of presentation" would be the life of the magazine. She intended to judge each work by its own specific merit. While she never hid her prejudice against poems that were "cryptic" in thought, she was willing to print an experiment if she believed the poem had integrity. Her liberal editorial policy led to much criticism. *Poetry*'s conventional rival, *The Dial*, considered her policy bizarre and even shocking. As critic Horace Gregory pointed out, though, her open-mindedness was sometimes mistaken for haphazardness by those unable to see that she chose as her task to incite and encourage poetic revolution. Often her theoretical support of the new was betrayed by a fondness for tradition, but Monroe did much to defend the controversial and previously unacceptable in poetry.

An editorial innovation begun by Monroe and still followed by many contemporary little magazines was the special issue. Special issues focused on the poetry of geographical regions or on certain schools of poetry. Monroe edited an issue on the American Southwest, for example, and another on India. This innovation was extremely successful, because it allowed work of a certain style or cultural background to be displayed to its best advantage. Another editorial innovation credited to Monroe was the inclusion of book reviews and editorials that made worthy but obscure works and writers better known. Gerard Manley Hopkins and Robinson Jeffers were introduced to the American public in *Poetry* by sympathetic fellow poets who reviewed their work.

At Pound's urgings, *Poetry* began early to publish translations of poetry from other languages. During Karl Shapiro's tenure as editor in the 1950's, the emphasis on translations reached a peak with special issues on Greek and postwar French poetry. Shapiro introduced Max Jacob, Rainer Maria Rilke, and Stephan George to *Poetry*'s audience.

Monroe believed that an extremely important but rarely recognized element of *Poetry*'s leadership was that it paid—promptly—for contributions even in times of

financial difficulty. The awarding of yearly prizes was a tradition begun by *Poetry*'s first editor which is still followed; the first annual award of $250 went to Yeats for his poem "The Grey Rock."

The most remarkable feat of *Poetry*'s long career is its history of having consistently published the work of the most prominent poets alongside the work of those who would become prominent in the future. The magazine can be credited with discovering many leading modernist and contemporary poets. Monroe introduced Eliot, Yeats, Sandburg, Frost, Amy Lowell, and Marianne Moore to the American public; subsequent editors published works by Stephen Spender, Robert Penn Warren, Paul Engle, Conrad Aiken, Dylan Thomas, James Merrill, John Ciardi, Robert Lowell, Muriel Rukeyser, Elizabeth Bishop, Stanley Kunitz, W. H. Auden, John Berryman, Robert Graves, W. S. Merwin, Theodore Roethke, Robert Creeley, and Denise Levertov, among others.

The balance of newness and tradition that Monroe established as *Poetry*'s hallmark has continued to be reflected in succeeding decades. Monroe's life's work endures in *Poetry*. After more than three-quarters of a century, *Poetry* continues to be a respected forum for talented poets and a source of energy and innovation in the field of contemporary poetry.

Bibliography

Cahill, Daniel J. *Harriet Monroe*. New York: Twayne, 1973. This study assesses the value of Monroe's contribution to the modern poetry movement by presenting examples of her own work and by examining the significance of her editorship of *Poetry*. Includes an annotated bibliography and full index.

Hamilton, Ian. *The Little Magazines: A Study of Six Editors*. London: Weidenfeld and Nicolson, 1976. Hamilton writes about three little magazines from America and three from England chosen as the most memorable of the century. The lively chapter on *Poetry* discusses in depth Pound's involvement with and influence on the early issues, as well as Monroe's initial conservatism.

Monroe, Harriet. *A Poet's Life: Seventy Years in a Changing World*. New York: Macmillan, 1938. Monroe's autobiography, unfinished at the time of her death, is the most complete document outlining the history of her magazine.

University of Chicago Library. *Poetry Magazine: A Gallery of Voices*. Chicago: University of Chicago Library, 1980. The catalog of an exhibition from the Harriet Monroe Modern Poetry Collection at the Joseph Regenstein Library, University of Chicago, May through October, 1980. It includes a preface, a brief discussion of Harriet Monroe, and facsimiles of poetry manuscripts.

Williams, Ellen. *Harriet Monroe and the Poetry Renaissance: The First Ten Years of Poetry, 1912-22*. Urbana, Ill.: University of Chicago Press, 1977. Williams' detailed account of the first ten years of *Poetry* describes the literary scene that spawned it and Monroe's friendships, correspondences, and literary battles. Has appendix on *Poetry*'s income, expenditures, and circulation during that decade.

_____. *"Poetry."* In *American Literary Magazines: The Twentieth Century*,

edited by Edward Chielens. Westport, Conn.: Greenwood Press, 1992. Presents a history of *Poetry* from its founding through 1989, describing how changes in editorship have shaped the magazine and how it has managed to survive financially. With notes and bibliography.

JoAnn Balingit

Cross-References

The Imagist Movement Shakes Up Poetry (1912), p. 326; Yeats Publishes *The Wild Swans at Coole* (1917), p. 440; Pound's *Cantos* Is Published (1917), p. 445; Eliot Publishes *The Waste Land* (1922), p. 539; *Poems* Establishes Auden as a Generational Spokesman (1930), p. 857; Pound Wins the Bollingen Prize (1949), p. 1443; Dickinson's Poems Are Published in Full for the First Time (1955), p. 1662.

KANDINSKY PUBLISHES HIS VIEWS ON ABSTRACTION IN ART

Category of event: Art
Time: 1912
Locale: Munich, Germany

Wassily Kandinsky explained his theory of abstraction in art as a need to reject natural images to impress industrial, secular society with the coming of a new spiritual age

Principal personages:

WASSILY KANDINSKY (1866-1944), the first painter seriously to engage in nonobjective art

HELENA PETROVNA BLAVATSKY (1831-1891), a Russian émigré to America who launched Theosophy

KAZIMIR SEVERINOVICH MALEVICH (1878-1935), a Russian artist and founder of the school of Suprematism

RUDOLF STEINER (1861-1925), the German founder of Anthroposophy, a variant of Theosophy

DAVID DAVIDOVICH BURLIUK (1882-1967), an artist who promoted Kandinsky's abstract work

VLADIMIR DAVIDOVICH BURLIUK (1886-1917), David's brother, also a promoter of Kandinsky

HENRI MATISSE (1869-1954), a French painter who influenced Kandinsky's use of color

FRANZ MARC (1880-1916), an associate of Kandinsky in Der Blaue Reiter who adopted his faith in abstraction

ANATOLY LUNACHARSKY (1875-1933), a Bolshevik commissar for enlightenment who used Kandinsky's talents for reorganizing the arts in Russia

Summary

In various ways, the publication of *Über das Geistige in der Kunst, insbesondere in der Malerei* (1912; *Concerning the Spiritual in Art, and Painting in Particular,* 1912) was the culmination of Wassily Kandinsky's personal and professional development. Trained as a lawyer in Moscow, where he was born, Kandinsky left that profession and his native land when he was thirty-one years of age. In 1897 he went to Munich, Germany, to take up studies in painting. Art Nouveau and the Jugendstil movement of craft artists attracted him with their stress on nonrepresentational art, but he found unsatisfying the decorative purpose of the art of those movements. He began to paint in the Fauvist style for exhibitions and to write about the theory of

art. For several years, he wrote articles for *Mir Iskusstva* (*World of Art*) in St. Petersburg, Russia, from his home in Germany.

The most important influence upon his development was that of the German mystic, Rudolf Steiner, founder of a variant of Theosophy, which itself had been founded in 1875 by Helena Petrovna Blavatsky and Henry Steel Olcott in America. This new religious movement as a whole suggested a hidden meaning within all material culture. Blavatsky's Anglo-American sector stressed the unity of the world's religions, whereas Steiner believed in the centrality of Christ. As early as 1909, Kandinsky was editing some of the writings of Steiner. All theosophists adhered to the notions that the spiritual world was in reach of the average person and that artists were charged with aiding people to contact the "vibrations" of that other world. The materialistic culture was certain to give way soon to a higher, spiritual stage of human development.

Concerning the Spiritual in Art, and Painting in Particular explained Kandinsky's rationale for abandoning representational painting. He described his commitment to the values of Theosophy and his rejection of materialistic principles. He also provided a unique conception of the use of colors and a new method of space and form in art.

Kandinsky completed this work in December, 1911, and it was published the following year, at about the same time that his artistic work began reflecting his new abstraction. Making analogies to the writing of Maurice Maeterlinck, the music of Claude Debussy, the dance of Isadora Duncan, the colors of Henri Matisse, and the forms of Pablo Picasso, Kandinsky explained his notion of abstract value by looking for hidden meaning in art, meaning not found simply in the external expression. Viewers of art, he argued, should allow the work to speak for itself in order to understand its abstract effect.

Kandinsky noted Maeterlinck's opinion that elaborate scenery was unnecessary for his plays because audiences could image the settings, in much the same way that a child can imagine a horse while pretending to ride a stick. Even more important, Maeterlinck knew that words, when repeated, lose their symbolic, material representation and take on meanings and emotional content of their own, divorced from the original representation. Turning to music, Kandinsky indicated that the impressionistic music of Debussy (like the painting of Matisse) is never very explicit, that sudden leaps into dissonance show that conventional beauty is not the same as internal beauty. In painting, Picasso departed from conventional beauty by annihilating materiality, fragmenting objects into separate parts. Duncan's dance was in part an attempt to explore commonality with the primitives, a transitional stage to new kinds of movements that could be divorced from conventional story telling and that would spring solely from the inner spirit.

In *Concerning the Spiritual in Art, and Painting in Particular*, Kandinsky referred to the spiritual triangle. At the bottom of this figure stand the broad masses, for whom realistic representation is a comfort, but comfort without a soul. Barely above this broad stratum are those artists who appear to be avant-garde because they adopt

some peculiar style without real meaning; they pretend to have captured some hidden significance but in reality only court the devotees of the newly fashionable. Higher on the triangle (and therefore lesser in number) are those who recognize uncertainties, who question the assertions of positivism and science but are at a loss to provide new answers. Those at the top of the triangle, the least numerous and least popular, are the spiritual leaders who recognize that an era of spiritual darkness has descended. It is this group, often artists, who provide a glimmer of light from which the new age can ripen. Kandinsky saw the prophetic role of the artist, whether literary, visual, or musical, as helping to save civilization from material degradation. He perceived merit in the thoughts of Blavatsky, Steiner, and other theosophists, as well as in others who examined "nonmatter."

This spiritual dimension of art is extended to Kandinsky's detailed discussion of color and form. Certain colors are apt to cause a defined impression in limited use but then grow stale. The task of the artist is to render colorful impressions with deep and lasting meaning. Soft blue was a color accented by the Symbolist movement. Kandinsky founded Der Blaue Reiter (the blue rider) school with Franz Marc and certain émigré Russian artists in Germany. Kandinsky developed the same argument with respect to forms. All forms say something, even if it is not immediately understood by the artist. In any case, the union of color and form must never be merely decorative, an empty response to the need for nonrepresentational art. The future of art lay precisely in the harmony between form and color, divorced from material objects.

Impact of Event

Attracted by the new schools of painting in Russia as well as in Germany, Kandinsky returned to Russia in 1914, shortly after he committed himself to this new abstract style of art. Like painter Marc Chagall, who returned to Russia at about the same time, Kandinsky involved himself in the political life of the nation. He was no Marxist, because he rejected materialist philosophy, but he was probably close to the syndicalists or anarchists.

Kandinsky stayed until 1922, until it was clear that there was no future for his ideas in his homeland. He was personally and professionally close to the two Burliuk brothers, David and Vladimir. David, who asked Kandinsky to become godfather to his second son, arranged for the blue rider group to exhibit their works in Moscow for the Jack of Diamonds exhibits in 1911 and 1912. After his return to Moscow, Kandinsky actively pursued his new style of painting and aggressively exhibited his works in Russia during the war years.

Mysticism flourished in Petrograd and Moscow during the war. Composer Aleksandr Scriabin, an early convert to Theosophy and an exemplar of the new faith in Kandinsky's book, was planning his magnum opus, an opera to be performed in the Himalaya Mountains in 1915. It was to be an open-air performance to demonstrate the divine experience of ecstasy. Theosophist Peter D. Uspensky wrote an influential book on the fourth dimension, time, which would enable humankind to free itself from

death. This work was known to Kandinsky and greatly influenced fellow painter Kazimir Severinovich Malevich.

During the revolutionary year of 1917, Kandinsky married Nina Andreevskaya and painted several of his most famous works. Several of his abstract paintings were exhibited at the Fifth State Exhibition in 1919 in a show entitled "The Trade Union of Artist-Painters of the New Art: From Impressionism to Abstract Painting." The exhibit was held in the Museum of Fine Arts (now the Pushkin Museum) in Moscow.

Kandinsky was appointed professor at the Moscow Academy of Fine Arts in 1918 and was made director of the Museum for Pictorial Culture the following year. In 1920, he was made professor at the University of Moscow and was appointed to the new Institute of Artistic Culture. The latter was organized around a theoretical program drawn up by Kandinsky and was based on an explication of many of his ideas in his publication of 1912. This program was published in two parts: the theory of separate branches of art and combinations of separate arts to create monumental art. The first part, in particular, included an examination of color in its absolute and relative values and in relationship to forms. The synthesis and interrelationship among the arts was a theme of the Symbolists and was shared by Kandinsky for many years, as evident in his *Concerning the Spiritual in Art, and Painting in Particular.* The spiritual union of poetry, drama, music, dance, and painting would also form the core of Kandinsky's Bauhaus course in Weimar after 1922.

The revolutionary era in Russia generated debates in the arts as well as in politics. Members of the Institute of Artistic Culture debated the central proposition of Kandinsky and Malevich that art is a spiritual activity. Kandinsky refused to accede to the supporters of what was called the New Objectivity movement, that art could be organized practically by an engineer.

In 1921, Kandinsky founded the Russian Academy of Artistic Sciences with the encouragement of Anatoly Lunacharsky, the Bolshevik head of culture and education. Lunacharsky approved of Kandinsky's ideas of art as psychic and intuitive, but other Bolshevik colleagues thought the ideas were un-Marxian. When Kandinsky feared that his ideas were not going to be implemented, he decided to take a promising offer to return to Germany. After seven years in Russia, he left for his adopted homeland in 1922 to work at the Bauhaus school in Weimar, then in Dessau, and then finally in Berlin. In his writings at that time, he as well as other art writers reaffirmed the position taken in *Concerning the Spiritual in Art, and Painting in Particular*, that the birth of a new spiritual era was at hand.

In 1928, Kandinsky painted the settings for Modest Mussorgsky's *Pictures at an Exhibition.* In 1933, the new political leaders of Germany found his works unsuitable, and he was forced to leave his adopted country for Paris, France. He worked in Paris until his death on December 13, 1944.

If Kandinsky was not the first artist to adopt nonrepresentational art, he was nevertheless the first to do so without qualifications and the first major artist to popularize the concept. Among those influenced by Kandinsky's writing was painter Kazimir Malevich, also a disciple of Theosophy. Although the two painters never had

direct contact, their ideas had much in common. Theosophic ideas were most certainly the basis for the nonrepresentational school of Suprematist painting that Malevich launched. By 1920, Suprematist geometrical forms were evident in Kandinsky's work.

Perhaps most important was Kandinsky's influence on a younger generation of painters worldwide, such as the Czechoslovak František Kupka, the French painter Francis Picabia, and the Dutch painter Piet Mondrian. All of these artists, and countless others, were drawn to abstraction by Kandinsky; some, as in the case of Mondrian, were even drawn to Theosophy.

Bibliography

Barron, Stephanie, and Maurice Tuchman, eds. *The Avant-Garde in Russia, 1910-1933: New Perspectives.* Los Angeles: Los Angeles County Museum of Art, 1980. Beautifully illustrated, this work is devoted to the first major exhibition of the Russian avant-garde at the Los Angeles County Museum of Art, from July 8 to September 20, 1980.

Bowlt, John E. *The Silver Age: Russian Art of the Early Twentieth Century and the "World of Art" Group.* Newtonville, Mass.: Oriental Research Partners, 1979. The best general work that puts into perspective the many disparate schools of artistic expression that arose in Russia in response to Western stimuli. It suffers from lack of color illustrations, but is replete with black-and-white photographs.

Gray, Camilla. *The Russian Experiment in Art, 1863-1922.* New York: Abrams, 1962. The first book in English to survey the era of revolutionary art in Russia and to place previously little-known artists in perspective. Gray demonstrates that Kandinsky's *Concerning the Spiritual in Art, and Painting in Particular* was linked directly to the "World of Art" spiritual mode of thinking and to the Symbolists before 1912, as well as to his involvement with the proletarian and then the Bauhaus periods later.

Kandinsky, Wassily, *Concerning the Spiritual in Art.* Translated by Michael Sadlier and Francis Golffing. New York: Wittenborn, Schultz, 1947. This edition of the work includes notes on his painting by his widow, an essay on Kandinsky's personality by Julia and Lyonel Feininger, and an essay on Kandinsky's language by Stanley William Hayter.

Long, Rose-Carol Washton. *Kandinsky: The Development of an Abstract Style.* Oxford, England: Clarendon Press, 1980. Concerns Kandinsky's attempts to resolve the philosophical dilemma of his desire to renounce material values via abstract art and the conflict of that desire with a fear that he would not communicate to the masses if recognizable content disappeared from his canvases.

Overy, Paul. *Kandinsky: The Language of the Eye.* New York: Praeger, 1969. Although he acknowledges the influence of Theosophy on Kandinsky's thought, Overy believes that overemphasis on influences leads to ignoring the paintings themselves. He finds more interesting the painter's discussions of color and forms in *Concerning the Spiritual in Art, and Painting in Particular,* areas that continued to evolve

in Kandinsky's compositions, especially after 1915.

Williams, Robert C. *Artists in Revolution: Portraits of the Russian Avant-garde, 1905-1925.* Bloomington: Indiana University Press, 1977. Although scholars once disputed the religious influence upon Kandinsky's conversion to abstraction, Williams notes that since 1960 writers have recognized this influence. Williams shows that Theosophy influenced not only Kandinsky but also Malevich.

John D. Windhausen

Cross-References

Avant-Garde Artists in Dresden Form Die Brücke (1905), p. 134; Les Fauves Exhibit at the Salon d'Automne (1905), p. 140; The Futurists Issue Their Manifesto (1909), p. 235; Der Blaue Reiter Abandons Representation in Art (1911), p. 275; Apollinaire Defines Cubism in *The Cubist Painters* (1913), p. 337; Avant-Garde Art in the Armory Show Shocks American Viewers (1913), p. 361; Malevich Introduces Suprematism (1915), p. 413; *De Stijl* Advocates Mondrian's Neoplasticism (1917), p. 429; Man Ray Creates the Rayograph (1921), p. 513; The Soviet Union Bans Abstract Art (1922), p. 544; The Formation of the Blue Four Advances Abstract Painting (1924), p. 583; *Abstract Painting in America* Opens in New York (1935), p. 1001; Hitler Organizes an Exhibition Denouncing Modern Art (1937), p. 1083.

THE IMAGIST MOVEMENT SHAKES UP POETRY

Category of event: Literature
Time: 1912-1917
Locale: The United States and Great Britain

The Imagist movement attempted to simplify the language and structure of poetry by ridding it of excess verbiage and by calling for "direct treatment of the thing"

Principal personages:
> EZRA POUND (1885-1972), the American poet who was the guiding force behind Imagism
> RICHARD ALDINGTON (1892-1962), an American poet and theorist of Imagism
> H. D. (HILDA DOOLITTLE, 1886-1961), the American poet whose poems most clearly define Imagism
> AMY LOWELL (1874-1925), an American poet and sometime leader of the Imagist movement
> T. E. HULME (1883-1917), a leading theorist of modernism and of the Imagist movement

Summary of Event

The Imagist movement was not created by the consensus of a group of poets during a specific period or out of a variation in style or form. It was, instead, created by fiat one day in the spring of 1912 by Ezra Pound. On that day, after reading the poems of two of his protégés, Richard Aldington and Hilda Doolittle (better known as H. D.), Pound announced that they were "Imagistes." The birth of Imagism was followed a few months later by a more formal presentation to the public. Pound sent five poems by H. D. and a few of Aldington's poems to Harriet Monroe, the editor of *Poetry*, with instructions to publish them as quickly as possible. The poems were published in *Poetry* in January of 1913 with a note by Pound on the new "school" of poetry. Later, in March of that year, he published "A Few Don'ts by an Imagiste" in *Poetry*. Among Pound's pronouncements were a few important ones for the development of the Imagist movement, including "Use no superfluous word, no adjective, that does not reveal something" and "Either use no ornament or good ornament." F. S. Flint added a more precise list of rules in an accompanying article, which called on Imagist poets to undertake direct treatment of the "thing," whether subjective or objective; to use absolutely no word that did not contribute to a poem's presentation; and "to compose in sequence of the musical phrase, not in sequence of the metronome."

The Imagist movement had been officially born, although the definitions of an Imagist poem remained incomplete. For example, neither Pound nor Flint mentioned

the use or presence of images in Imagist poetry; their prescriptions were stylistic and not structural.

While the movement seems to have sprung from the brain of Ezra Pound, it had some important predecessors, especially the theories of T. E. Hulme. From 1910 to 1912, Hulme gathered a group of writers and poets to discuss some of his theories and to examine some poems. Hulme's theories stressed the necessity for the artist both to provide a true perception of the nature of things and to do it in a fresh language that would break through conventional expressions. Hulme also set up a dichotomy between romantic and classical. The romantic was sentimental and vague, while the classical was precise and recognized the limits of the poet to perceive the universe. Hulme's stress on the perception and presentation of an object or event and his insistence on clarity of style did contain the seeds of Imagism, but it took Pound to attach such precepts to a specific group of poets and turn theory into practice. Hulme published only five poems in his lifetime, while Pound was a genius who created new movements, helped poets get support and a publishing outlet for their work, and continued to create new poems.

The Imagist movement developed in 1913 and 1914 by finding further outlets for its poems and doctrine. *Poetry* continued to be an outlet for Imagist works, and *The New Freewoman* (later *The Egoist*) began publishing Imagist productions. A 1914 anthology of Imagist poetry included poems by Aldington, H. D., Pound, Flint, William Carlos Williams, James Joyce, and Amy Lowell. Lowell had been taught the doctrine of Imagism by H. D. and Aldington, and she changed her earlier, more formal style and began to be both a practitioner of and advocate for the new school and the new poetry. She would, however, in a short while become a disruptive force.

In 1914, Pound began to become interested in vorticism, and he soon lost his interest in and commitment to the Imagist movement, although he did see the image as central to vorticism. Amy Lowell appeared once more in London and began to gather together some of the early Imagists, H. D. and Aldington. She resisted the demands by Pound that she contribute $5,000 to a new anthology that he would edit. Matters finally came to a showdown in which H. D., Aldington, Flint, and Ford Madox Ford sided with Lowell against Pound; there was to be a new anthology of Imagist poems backed by Amy Lowell and an editorial board to edit and select the poems. Imagism became, in Pound's phrase, "Amygism."

After Lowell became the patron of the Imagist movement, a few anthologies of Imagist poetry were published, and the movement seemed to be flourishing. Lowell, however, seemed to have trouble in defining Imagism and in limiting her own poetry to any set of Imagist doctrines. She relied on Aldington to provide a theoretical basis for the movement, but he could not improve upon the earlier statements by Pound and Flint. Lowell's own attempts to define Imagism became so general and inclusive that it became difficult to differentiate between Imagist poems and Symbolist or Impressionist poems. In addition, Lowell tended to see the images as static elements within poems, while Pound always insisted on the presentation of active and moving images. Finally, without Pound's guidance or example, and as the practitioners of

Imagism became aware of its restrictions, the movement dissolved into other, more forceful movements such as Symbolism and Futurism. The poets involved in the movement would continue to use the image in their later poems, but they could not or would not rely exclusively on it.

Impact of Event

Imagism was a short-lived movement that produced a few excellent modern poems, but it could not provide many poets with guiding principles for a body of poetry. The reduction of the poem to an image placed serious limitations on poets; no one could write a long poem using the principles of Imagism. The most prominent Imagist poems were short, striking lyrics that conveyed an impression and an emotion. These poems were impressive, but nearly all the poets involved in the movement felt a need to go beyond its boundaries. Imagism was by its nature unable to deal with ideas or do much more than present fleeting impressions. William Carlos Williams, for example, later modified and expanded the Imagist doctrine by demanding that there be "no ideas but in things."

Some examples of the best Imagist poems will help point out the strengths and weaknesses of Imagism. Pound's "In a Station of the Metro" is perhaps the best-known and most celebrated Imagist poem:

> The apparition of these faces in the crowd;
> Petals on a wet, black bough.

The first line sets the scene for the observer, who perceives the fleeting impression, or ghostlike "apparition," while the second line provides the defining image. The faces within the urban and mechanical subway car are transformed suddenly by the natural image of petals on a bough. Furthermore, beauty and value is found in the least likely place, the urban landscape. It is a brilliant poem, but it is not one that can be expanded or repeated very often; it is a tour de force rather than a sustainable form. Another example of Imagism is H. D.'s "Oread":

> Whirl up, sea—
> whirl your pointed pines,
> splash your great pines
> on our rocks,
> hurl your green over us,
> cover us with your pools of fir.

The poem connects two images, as the waves of the sea are metaphorically connected to the pines of the shore. The pictured impact of the sea is quite interesting; the sea is ordered to "cover us," to overcome the land and its inhabitants with the green of the "firs." The poem is similar to the one by Pound in that one image overcomes another. The mechanical subway is displaced by the beautiful natural image in Pound, and H. D.'s pinelike sea overcomes the land.

The Imagist movement was a part of the modernist attempt to supplant the out-worn language of late Romantic and Victorian poetry. The demand that poetic language be more concrete and use more precise words in Imagism was repeated by other movements and became part of the poetics of modernism. For example, T. S. Eliot demanded that modern poetry "recover the accents of direct speech." The "direct speech" and concentration on an object that so many modern poets urged was an essential part of Imagism. In addition, the Imagist movement was strongly associated with free verse, another important technique of modernist poetry. Nearly all the important Imagist poems used free verse and rejected rhyme. As Flint demanded and Pound suggested, the Imagist poet should not use the traditional meters but should compose in the style of the musical phrase. Imagism thus contributed to the modernist assault on sentimental and sloppy language in poetry. The stress on seeing an object distinctly is very similar to Pound's famous dictum "make it new" and may even have led Eliot to formulate the principle of the objective correlative. The image of the poem was to be, as Eliot said, the equivalent of the emotion it evoked.

Some critics have seen the Imagist movement as the beginning of modernism and the source of a number of movements that followed. Graham Hough, for example, blames the Imagist movement for departing from the old tradition and failing to provide a new one. In the movement's wake, poets were left without the guidelines that only tradition could provide; they were faced with the necessity of making it new every time they created a work. There was then, according to Hough, no continuity, and there were no examples that could be followed. Others have seen the Imagist movement as having helped to destroy outdated forms and styles that could no longer touch a reader.

Imagism died of its limitations, but it survived as parts of larger structures within a number of major modernist poems. Some of the most important modernist poems show traces of Imagism's influence. For example, Eliot's "The Love Song of J. Alfred Prufrock" contains a number of startling images, such as the simile comparing the evening sky to "a patient etherised upon a table." The poem is, in effect, a stitching together of associated images. Examples of Imagism also abound in Pound's later poems and in William Carlos Williams' *Paterson* (1946-1958).

The Imagist movement is, in many ways, hard to define. There was never any agreement on exactly what an Imagist poem was or what the rules of its production were. In the midst of such confusion, it became harder for those involved in the movement to limit their poems to any doctrine of Imagism, and so the brief but significant Imagist movement had died by 1917 for lack of practitioners. Remnants of Imagism, however, can be found in Pound's group of Chinese poems called *Cathay* (1915). The setting is different, and the type of image may be different, but there is an obvious connection between these poems and Imagism. For example, "Fan-Piece, For Her Imperial Lord" is a perfect Imagist poem written in a different idiom. The poem's beginning, "O fan of white silk,/ clear as frost on the grass-blade," relates two very unlike elements, a silk fan and frost; the connections are expanded and

resolved in the last line, "You also are laid aside." A brief revival of Imagism took place in 1930 in an anthology edited by Glenn Hughes that contained recent work by some of the important Imagist poets, including Aldington, Flint, D. H. Lawrence, and William Carlos Williams. The anthology gave evidence that their work of the late 1920's and early 1930's was still indebted to Imagism.

Bibliography

Aldington, Richard, et al. *Imagist Anthology, 1930: New Poetry.* Edited by Glenn Hughes. Reprint. New York: Kraus, 1970. Originally published in 1930. A fascinating attempt to redo the earlier Imagist movement. The poems are longer and more sustained, but they do use the image as a central device. Includes an essay by Ford Madox Ford on some of the controversies within the Imagist movement and a brief foreword by Glenn Hughes.

Coffman, Stanley K. *Imagism: A Chapter for the History of Modern Poetry.* New York: Octagon Books, 1972. An indispensable source for Imagist theory and practice. Coffman is especially good on the many theories underlying Imagism. In contrast to most critics, Coffman is sympathetic to Amy Lowell in her controversy with Ezra Pound. Coffman, however, includes no examples of Imagist poetry to illustrate the principles he establishes; there is also no bibliography.

Hough, Graham G. *Reflections on a Literary Revolution.* Washington, D.C.: Catholic University of America Press, 1960. Contains two long essays on the Imagist movement and its consequences. Hough sees Imagism as a necessary but destructive movement that purified the language of poetry but destroyed the tradition and "rational order" that any true work of literature needs.

Kenner, Hugh. *The Poetry of Ezra Pound.* Lincoln: University of Nebraska Press, 1985. Includes two excellent chapters on Pound's theories and practice of Imagist poetry. Kenner is especially good at linking the theories of Imagism to Pound's overall criticism. He blames the failure of Imagism on the "diluters" of Pound's guidelines. Kenner sees Pound as always demanding praxis rather than decoration.

Pratt, William, ed. *The Imagist Poem.* New York: E. P. Dutton, 1963. Contains a brief and useful introduction to the Imagist movement and an anthology of Imagist poems. The poems are excellent examples of the various aspects of the movement; H. D.'s Greek Imagist poems, John Fletcher's urban poems, and a fine selection of the early poems of Wallace Stevens and William Carlos Williams are included. There is an excellent bibliography of both primary and secondary sources. The best available introduction to the Imagist movement.

Quinn, Vincent G. *Hilda Doolittle (H. D.).* New York: Twayne, 1967. A life and works study of one of the most important Imagist poets. Quinn is more interested in the biographical than in the critical aspects of H. D.

Tytell, John. *Ezra Pound: The Solitary Volcano.* New York: Anchor Press, 1987. A critical biography of Pound that stresses his life more than his work. Contains an excellent section on Pound's involvement with the Imagist movement. Tytell sug-

gests that what Pound was aiming for in Imagism was a revival of the presentation he found in such poets as Catullus and François Villon. Extensive sources, but no bibliography.

James Sullivan

Cross-References

Harriet Monroe Founds *Poetry* Magazine (1912), p. 314; Yeats Publishes *The Wild Swans at Coole* (1917), p. 440; Pound's *Cantos* Is Published (1917), p. 445; *Poems* Establishes Auden as a Generational Spokesman (1930), p. 857; Pound Wins the Bollingen Prize (1949), p. 1443; Dickinson's Poems Are Published in Full for the First Time (1955), p. 1662.

L'APRÈS-MIDI D'UN FAUNE CAUSES AN UPROAR

Category of event: Dance
Time: May 29, 1912
Locale: Théâtre du Châtelet, Paris, France

Vaslav Nijinsky's first work of choreography, with its use of impressionistic music, decor, and movement, altered forever the course of ballet

Principal personages:
VASLAV NIJINSKY (1890-1950), the greatest dancer of his time and an innovative choreographer
SERGEI DIAGHILEV (1872-1929), an elegant dandy and ballet impresario who helped found the Ballets Russes
LÉON BAKST (LEV ROSENBERG, 1866-1924), a painter who created most of the decor and costumes for Diaghilev's company
CLAUDE DEBUSSY (1862-1918), the composer of *Prélude à l'après-midi d'un faune*, the music to which Nijinsky's ballet was set
MICHEL FOKINE (1880-1942), a ballet dancer, choreographer, and founder of modern ballet

Summary of Event

Vaslav Nijinsky, who almost from the very outset of his ballet career had surpassed standards and expectations for dancers, had long rebelled against academic classicism and romanticism. Trained at the Imperial School of Ballet in St. Petersburg, he drew attention for his spectacular jumps, in which he appeared to pause at the apex before landing with exquisite grace and power. He partnered Anna Pavlova briefly in Sergei Diaghilev's Ballets Russes, but his chief partner was Tamara Karsavina in such outstanding works as *Le Pavillon d'Armide* (1909), *L'Oiseau de feu* (1910; *The Firebird*), *Les Sylphides* (1909), *Schéhérazade* (1910), *Le Spectre de la rose* (1911), and *Petrushka* (1911), all innovatively choreographed by Michel Fokine. Controversy followed Nijinsky throughout his career. Dismissed from the Maryinsky Theater in 1911 for appearing in *Giselle* in trunk hose and short jerkin (without regulation trunks), he lived and worked in an atmosphere of hysteria, glamor, and intrigue. Dissatisfied with old conventions and even with Fokine's revolutionary unification of music, painting, and dance, Nijinsky was invited by his mentor and lover, Diaghilev, to invent his own choreography after the triumphant 1911 Ballets Russes season.

Nijinsky devised a style of walking with his torso turned full on to the audience and his head, arms, and legs in profile. This deliberate dehumanization (following upon Émile Jaques-Dalcroze's system of eurythmics) made for a new mode of composition in which dance could be performed in opposition to music. In Paris, with the help of a pianist and dancer Alexandre Gavrilov (his occasional stand-in), he tried out his first choreography. All available evidence indicates that Nijinsky in-

vented his choreography before he had even found the musical background for it. Diaghilev, himself seeking an alternative to Fokine's choreography, was delighted and suggested the use of Claude Debussy's *Prélude à l'après-midi d'un faune* (1894), inspired by (but not a synthesis of) Stéphane Mallarmé's symbolic eclogue *L'Après-midi d'un faune* (1876; *The Afternoon of a Faun*). While it is true that Debussy's impressionistic music, with its ravishing suggestions of revitalized sensations, virtuosic instrumental character, subtle motives, and supple compositional structure, stirred Nijinsky's imagination, the fact remains that it was Nijinsky who capitalized on the musical atmosphere to express his own—not Mallarmé's or Debussy's—fantasy of sexual discovery and gratification.

Mallarmé's poem was originally a recitation for the great actor Benoît Coquelin; the poem expresses the reveries and frustration of a faun rejected by beauty (symbolized by nymphs). Debussy borrowed Mallarmé's poetic method, evoking its themes by allusion rather than by direct statement. Nijinsky interpreted the music and narrative sexually (he never read the poem), and the entire ballet became a daring depiction of something hitherto unmentionable in the theater, let alone portrayed sensually in dance.

Nijinsky's version of *L'Après-midi d'un faune* was a choreographic tableau in one act influenced by Nijinsky's knowledge of Greek and Egyptian vases and stone reliefs. It required some 120 rehearsals, though it was barely ten minutes long, and Nijinsky spent ninety of those sessions teaching his dancers (including his sister, Bronia) a new system of walking backward or forward in profile, on the heel, with slightly bended knees. The rehearsals cut into Fokine's own rehearsals for three different ballets, and the difficult choreography upset Ida Rubinstein, who turned down Nijinsky's invitation to perform the part of the ballet's principal nymph (although one of her motives was surely her desire not to ruin her friendship with Fokine, her teacher and an arch foe of Nijinsky).

In telling the simple story of a boy-faun disturbed from his lazy reveries on a hot afternoon, Nijinsky choreographed explicit sexual images. After frightening away the seven nymphs, including the boldest one, who had engaged in some teasing byplay with him, the faun picked up the principal nymph's fallen scarf, caressed it tenderly, and then thrust his body into it as if taking possession of the nymph and orgasmically relieving his sexual frustration.

Every element of the production worked—from Léon Bakst's extraordinary speckled, striped decor, lush with russets, greens, and grays, to the nymphs' costumes and Nijinsky's own dancing as the half-animal, half-human creature.

Nijinsky made his ballet represent the initial stirrings of sexual and emotional instinct and, consequently, made the work a metaphor for the first impulses of creation. He himself at the time felt the first awakenings of his own creativity, for now he was not merely an obedient servant of Fokine but a choreographer in his own right, wholly responsive to the possibilities of his art.

The audience sat motionless throughout the work—even through Nijinsky's suggestion of masturbation at the end—but as the curtain fell, a storm of applause and

disapproval broke out. Bravos rang out amid catcalls and whistles. Fights erupted in the audience. Diaghilev was visibly upset and so was Nijinsky, but as supporters yelled for an encore, Diaghilev ordered a reprise of the complete ballet, as if to appease Nijinsky and convince him that his work had earned more applause than rejection.

Impact of Event

The immediate impact was a scandal. Instead of running his regular dance critic's review, Gaston Calmette, the powerful editor of *Le Figaro*, printed his own attack in a front-page editorial on May 30, 1912, condemning Nijinsky for his depiction of an "incontinent" faun of "erotic bestiality and gestures of heavy shamelessness." Nijinsky's choreography, it was claimed, was an affront to public morality. There was a political motive for Calmette's action; in attacking the Ballets Russes, he was really targeting the Franco-Russian alliance, to which he was vehemently opposed. A rumor spread that the prefect of police would stop the next performance of the ballet, and the whole city was in a hubbub.

Diaghilev prevailed upon Nijinsky to change his last movement for at least the next few performances. The renowned sculptor Auguste Rodin, a septuagenarian, wrote an article on the editorial page of *Le Matin* the day after Calmette's furious denunciation; in it, Rodin praised Nijinsky's ability to use his body as an expression of his mind. What particularly impressed Rodin was Nijinsky's attitudes—his bendings, stoopings, and crouchings, all done with nervous angularity and yet possessing the beauty of antique frescoes and statues. To Rodin, this sort of dancing—developing the freedom of instinct expressed earlier by Loie Fuller and Isadora Duncan—was a "perfect personification of the ideals of the beauty of the old Greeks."

Calmette immediately attacked Rodin as a scandalous exploiter of public funds, prompting eminent figures from the French artistic, literary, and political worlds to begin a campaign of support for Rodin. Parisians tried to cram into a performance of Nijinsky's ballet to judge for themselves who was right, the Faunists or the anti-Faunists. The controversy thus created both a box-office bonanza and international notoriety for Diaghilev's Ballets Russes. The time and attention spent on Nijinsky infuriated Fokine, whose ballet *Daphnis et Chloë* (1912) was the last of the season and suffered in comparison with Nijinsky's. Fokine first accused Nijinsky of stealing his choreography and then choreographed a mocking travesty of Nijinsky in *Daphnis et Chloë*. He also resigned from the Ballets Russes and went over to the rival Maryinsky Theater as first ballet-master.

Nijinsky's choreography, however, transcended the politics of the dance world. To be sure, the Greek and Egyptian background influences were not unprecedented; Fokine, for example, had used Greek and Egyptian angularity since *Eunice* (1907). Nijinsky's choreography, however, was radically different for several reasons. It made heavy walking a form of dance, with the walking not done strictly to the music and sometimes being opposed to it. Nijinsky's new technique meant that the dancer's feet no longer turned out as in the classical positions. Now the positions were re-

versed, and deliberately crude movements (once thought to be ugly and primitive) were made perfectly justifiable. The motion of dancers in straight lines and angles, in opposition to spirals and serpentine undulations, showed that any line or angle could be good in its proper place. Ballets had long had irrelevant decorations for a repertoire of steps, and Nijinsky, rebelling against beauty and grace for their own sake, treated dance as an absolute medium. Unlike Marius Petipa's ballets, in which settings explained the dancing, Nijinsky's ballet made setting, costuming, lighting, music, and choreography one complete whole—a total art form in which all the arts combined inseparably.

The choreography of *L'Après-midi d'un faune* led to the composite sport movement of Nijinsky's next work, *Jeux* (1913), a modern-dress ballet about flirting tennis-players, and then, climactically, to *Le Sacre du printemps* (1913; *The Rite of Spring*), in which powerful, grotesque movements conveyed a startling interpretation of a Russian folk myth about renewal and sacrifice.

Nijinsky was a precursor of such choreographers as Jerome Robbins, Roland Petit, and Maurice Béjart. *L'Après-midi d'un faune* has been danced by numerous virtuoso performers, including Léonide Massine, Serge Lifar, David Lichine, Igor Youskevitch, Leon Danielian, and Jean Babilée. It has even inspired a Jerome Robbins version, first presented by the New York City Ballet on May 14, 1953, as a stripped-down but fascinatingly suggestive *pas de deux* set in a dance studio about nascent love competing with narcissism.

Bibliography

Balanchine, George, and Francis Mason. *Balanchine's Complete Stories of the Great Ballets.* Rev. ed. Garden City, N.Y.: Doubleday, 1977. Has stories of more than four hundred ballets, with personal thoughts on choreography, careers in ballet, ballet for children, and a brief history of ballet. Includes a chronology of outstanding dance events from 1469 to 1976. Descriptions include commentary by critics, choreographers, and composers. Photos, illustrated glossary, and notes.

Buckle, Richard. *Nijinsky.* London: Weidenfeld & Nicolson, 1972. Many years of painstaking research (including access to Nijinsky's diary and conversations with people who knew and worked with him) resulted in an authoritative biography that spans the dancer's complete life. Detailed and vivid descriptions of the significant ballets. Twenty-two line drawings and forty-eight pages of half-tone illustrations.

Kirstein, Lincoln. *Movement and Metaphor: Four Centuries of Ballet.* New York: Praeger, 1970. Surveys choreography, gesture, mime, music, costume, and decor as they have developed in the West. Interprets fifty seminal ballets and looks at social, historical, and philosophical influences on dance. More than four hundred illustrations.

Nijinska, Bronislava. *Nijinska: Early Memoirs.* Edited and translated by Irina Nijinska and Jean Rawlinson. New York: Holt, Rinehart and Winston, 1981. Nijinsky's sister provides interesting reminiscences of the Imperial Russian Ballet

and Diaghilev's seasons in Western Europe before 1914. The first book to offer a picture of Nijinsky's parents and to reveal the early life of Nijinsky and his sister. Her idolization of him is strong and warm. Sixty-four pages of photographs.

Nijinsky, Romola. *Nijinsky and The Last Years of Nijinsky.* London: Victor Gollancz, 1980. This volume by Nijinsky's wife contains the text of two books: The first (published in 1933) was a best-seller about Nijinsky's early life, their courtship, his career, and his breakdown. The second (published in 1952) concerns the years between 1919 and Nijinsky's death.

Keith Garebian

Cross-References

Duncan Interprets Chopin in Her Russian Debut (1904), p. 113; Pavlova First Performs Her Legendary Solo *The Dying Swan* (1907), p. 187; Diaghilev's Ballets Russes Astounds Paris (1909), p. 241; Fokine's *Les Sylphides* Introduces Abstract Ballet (1909), p. 247; *The Firebird* Premieres in Paris (1910), p. 269; *The Rite of Spring* Stuns Audiences (1913), p. 373; The Ballet Russe de Monte Carlo Finds New Leadership (1938), p. 1088.

APOLLINAIRE DEFINES CUBISM
IN *THE CUBIST PAINTERS*

Category of event: Art
Time: 1913
Locale: Paris, France

Guillaume Apollinaire presented a rationale for cubist practice by laying down the three main tenets of cubist aesthetics

Principal personages:
GUILLAUME APOLLINAIRE (GUILLAUME ALBERT WLADIMIR ALEXANDRE APOLLINAIRE DE KOSTROWITZKY, 1880-1918), a French poet, playwright, novelist, journalist, and cultural activist and one of the most important art critics of his time
PABLO PICASSO (1881-1973), a Spanish-French artist who became the leading cubist painter and who dominated the visual arts during the first half of the twentieth century
GEORGES BRAQUE (1882-1963), a French artist who became closely associated with Picasso and with him became a leader of the cubist movement
JEAN METZINGER (1883-1956), a French painter and critic who exhibited with the cubist group in 1910 and 1911
ALBERT GLEIZES (1881-1953), a French painter and critic who exhibited with the cubists in 1910 and 1911
JUAN GRIS (JOSÉ VICTORIANO GONZÁLEZ, 1887-1927), a Spanish-French painter who exhibited with the cubists in 1912 and who achieved a personal style that has been judged to rival those of Picasso and Bracque
ANDRÉ SALMON (1881-1969), a French poet, novelist, and art critic who was a close friend of Apollinaire
ROBERT DELAUNAY (1885-1941), a French painter much interested in color
MAX JACOB (1876-1944), a French poet, novelist, and art critic who was a close friend of Apollinaire
FERNAND LÉGER (1881-1955), a French painter who became associated with the cubists in 1909

Summary of Event
In 1913, Guillaume Apollinaire published several of his articles in a booklet, *Peintres cubistes: Méditations esthétiques* (an English translation, *The Cubist Painters: Aesthetic Meditations*, was published in 1944). The book's subtitle is an apt description of the manner in which Apollinaire treats his two principal subjects: the theory

behind cubist practice during the period 1907-1912 and the psychological analysis of the chief cubists and their works. Apollinaire does not approach his subject through logical analysis and plain expository prose. Instead, as a poet as well as a critic, he seeks to penetrate into the essence of things, and he renders his sharp impressions with sensitivity and feeling. Hence his treatment is meditative, imaginative, freely associative, and poetic; it shows serious, concentrated, and continual reflection concerning his goals. *The Cubist Painters* is truly the product of Apollinaire's aesthetic meditations.

Apollinaire begins his booklet by citing what he considers the three "plastic virtues: purity, unity, and truth." He holds that these virtues, from an artistic standpoint, "keep nature in subjection." By "nature," he means the ordinary reality perceived by means of the senses. For him, though, this reality is not true, because it consists of mere appearances, which are continually undergoing change. Therefore, in Apollinaire's view, nature is not a worthy subject for art. Although cubist artists "look at nature," Apollinaire noted, they do not imitate it. As art is not a mirror held up to nature, so cubism is basically conceptual rather than perceptual. It is a matter of intellect, and hence of the "categories"—the universal modes of development and determination. Among such categories are content and form, time and space, quality and measurement, and essence and appearance. By means of mind, then, according to Apollinaire, one can know the essential or transcendental reality that subsists "beyond the scope of nature."

Having rejected the spirit of the *fin de siècle*, the cubists pursued the new spirit of the machine age and its dynamic concept of reality. They were fascinated by the new structures and the new machines: the Eiffel Tower, the motor car, the wireless, the airplane, the telephone, the phonograph, and the cinema. They paid spectator attention to the new mathematics and the new physics: non-Euclidean geometry and topology, radiation, atomic structure, optics, light, color, quantum mechanics, relativity, and the fourth dimension. Above all, they searched for new lines and forms, both concepts not found in nature. They became interested in ancient Egyptian, African, and Oceanic sculptures. They were attacked for their geometry; they no longer limited themselves to the "dimensions of Euclid" but indulged in a "fourth dimension" and presented perspectives "in the round" from a series of station points.

Above all, they sought to achieve "purity, unity, and truth." According to Apollinaire, "purity" is practically a synonym for "originality." It is the state of an artist who, after studying tradition thoroughly, rejects it to start out on his own path of creativity. The term "unity" refers to the successful full completion of the artist's vision, when his picture "will exist ineluctably." Apollinaire says, though, that "Neither purity nor unity count with truth." Truth cannot be found in appearance, or ordinary reality; it is to be found in essence, or ultimate reality. The truth of ultimate reality, however, "can never be definite, for truth is always new." The social role and end of art is always "to keep it new." Such an aim, Apollinaire asserts, gives it "the illusion of the typical," and "all the art works of an epoch end by resembling the most energetic, the most expressive and the most typical work of the period."

According to Apollinaire, the idea of cubism was first suggested in derision by the Fauve painter Henri Matisse. The "new aesthetics," Apollinaire claims, was first thought out by André Derain, another Fauve painter. Derain himself was never a cubist, however, and the first cubist paintings were the work of the great Spanish artist Pablo Picasso, a resident of France, and his masterful French contemporary Georges Braque. Another important early contributor to the cubist movement was Jean Metzinger. In addition to his brilliant comments on these pioneers and their works, Apollinaire also comments on the following artists and their works: Albert Gleizes, Marie Laurencin (Apollinaire's mistress from 1907 to 1912, whose work was but peripheral to that of the genuine cubists), Juan Gris, Fernand Léger, Francis Picabia, Marcel Duchamp, and Raymond Duchamp-Villon, a sculptor.

Impact of Event

By the autumn of 1912, Apollinaire recognized that although cubism had become a powerful force in the art world, it had also provoked divergent aims among its practitioners. In *The Cubist Painters*, he sees four trends developing concurrently in cubism. He calls them "scientific-geometric," "physical," "instinctive," and "orphic" cubism. Of these trends, he says, two are "pure"—the scientific-geometric and the orphic. They are pure because they take nothing from visual reality and present "essential reality" in a pure manner. In addition, Apollinaire points out, Orphism depicts a "subject" conveying some "sublime meaning" despite its non-representational character. Indeed, ten days after the appearance of *The Cubist Painters*, Apollinaire deserted cubism for Orphism, although he considered Orphism within the scope of the cubist movement. He had first used the term "Orphism" to distinguish the paintings of Robert Delaunay being shown at the *Section d'Or* exhibition in 1912. Delaunay had recognized that color, if identified as light, keeps moving and changing to form abstract shapes and patterns. Delaunay also noted that certain colors, when combined in harmonic contrast with other colors, produce light movements. Léger and Picabia also went over to Orphism. Another prominent Orphicist was the Czech occult painter František Kupka, who had certain ideas about color of his own.

The *Section d'Or* group was founded in 1912 by the cubists Jean Metzinger and Albert Gleizes. This group was not, however, inspired by the expressive color theories of Delaunay or Kupka but by the interest the 1890's group called the Nabis (Symbolist disciples of Paul Gauguin) had taken in forms or compositions based on mathematical proportions. Some art historians have considered the *Section d'Or* exhibition held in Paris in October, 1912, to constitute the climax of the first, or analytical, phase of the cubist movement. During the analytic phase (1907-1912), it became cubist practice to fragment three-dimensional objects and view them simultaneously from a variety of points, everything being presented on a flat two-dimensional surface. During the synethic phase (1913-1921), forms were simplified, brighter colors came into use, and illusion, collage, and *papier collé* (patterned collage) were employed. From 1910, the cubist movement began to have international effects on such

foreign movements as Italian Futurism, the German Der Blaue Reiter group, Russian Cubo-Futurism and Rayonism, Franco-Spanish *Creacionismo*, English vorticism, Dadaism, and Surrealism.

Italian Futurism began as a revolutionary program in literature and art. Futurism soon developed far broader aims, however, and became an extensive social plan that supported Italian nationalism, gloried in action and warfare, and thrilled at the power and speed of technology and the machine. In effect, the Futurist program was preparing the way for the Fascist state. In expressing itself in literature and art, Futurism was at first tongue-tied; when it discovered the cubist idiom, it found its own voice. Although never a Futurist, Marcel Duchamp, in *Nude Descending Staircase No. 1* (1912), rendered the idea of motion in a more complex style than the Futurist Giacomo Balla did in *Dynamism of a Dog on a Leash (Leash in Motion)*, painted in the same year.

Cubo-Futurism and Rayonism were both Russian styles of painting that lasted only a few years. Cubo-Futurism was originated in Moscow in 1909 by Natalya Goncharova and Mikhail Larionov and lasted to 1914. This style took the form of combining cultivated primitivism based on Russian peasant art with cubist mannerisms. The name "Cubo-Futurism" was conferred on this style by Kazimir Malevich in 1913 in reference to his own works, in which he had combined cultivated primitivism with treatment in the manner of the early "tubular" works of Léger. In his painting *Knife Grinder* (1912) are displayed both cubist and Futurist features. Rayonism was another style practiced by Goncharova and Larionov during the same period. A synthesis of cubism, Futurism, and Orphism, Rayonism was based on the theory that all objects emitted rays; by taking the radiance of objects into consideration, artists could manipulate it for their own aesthetic purposes.

Creacionismo (creationism), essentially an aesthetic of poetry, arose for a short time in France. *Creacionismo* was apparently sponsored by Pierre Reverdy in conjunction with the Chilean poet Vicente Huidobro. After quarreling with Reverdy, Huidobro went off in a huff to Spain, where he introduced *Creacionismo*, and it flourished there for a short time. A "cubist notion" and antimimetic, *Creacionismo* maintained that a poem was a creation in its own right—that it was not an imitation of nature but a supplement to nature. This view harks back to Apollinaire, who wrote, "Poetry and creation are one and the same thing; he alone must be called poet who invents and creates. . . ."

Vorticism was an art movement started in England in 1913 by the painter and writer Wyndham Lewis and the sculptor Jacob Epstein. It was associated with Futurism and Cubism, and its founders hoped to awaken England to the twentieth century. In practice, vorticism tried to operate somewhere between the Futurist obsession with speedy motion and the cubist preoccupation with fragmented geometrical objects. Other prominent vorticists were the American poet Ezra Pound, the English writer T. E. Hulme, and the French sculptor Henri Gautier-Brzeska.

Cubism was introduced to the United States with the New York Armory Show of 1913. The most prominent American cubists were the Russian-American painter Max

Weber, who had been influenced by cubism at least a year earlier, and Stuart Davis, who was not affected by the idiom until the 1920's.

Although Picasso and Duchamp-Villon made one or two experiments in sculpture earlier, no significant cubist sculpture was created before 1914, when Duchamp-Villon's *The Horse* and Alexandr Archipenko's *Woman with a Fan* appeared. When the sculptors got going, they tended to take their cues from the cubist painters, and some sculptures show their derivation plainly. On the other hand, some sculptors who utilized cubist elements were able to create exciting new forms. During the period 1914-1920, two major sculptors emerged in Paris who worked in the cubist idiom: the Lithuanian Jacques Lipshitz and the native Frenchman Henri Laurens.

Literature, especially poetry, showed the effect of cubist philosophy and technique. Of course, Apollinaire himself and several other writers, including Max Jacob, André Salmon, Pierre Reverdy, and Gertrude Stein, were intimately connected with the cubist painters. Apollinaire's second major volume of poems, *Calligrammes* (1918), sounds a quite different aesthetic note than his first major volume, *Alcools* (1913). In the latter, the influence of Symbolism is clear, whereas in the former the poetic structure is dislocated and fragmented in cubist style. Critics have noted technical correspondences between Jacob's poetry and cubist paintings, in particular the prose-poems of his *Cornet à dés* (1917; *Cup of Dice*, 1979). Apollinaire's Swiss friend Blaise Cendrars (who wrote in French) was even more vigorous than Apollinaire in modernist poetics, liking the kinetic speed and rhythm of the modern world, which he projected in telegraphic syntax. Pierre Reverdy's poetry, too, is considered by critics undeniably cubist. Like his Chilean acquaintance Vicente Huidobro, he held a poem to be an independent object; in his poetry, he searched for essential reality. He managed to combine a number of perspectives on his own situations while excluding his own presence. Cubist influence is also discernible in the work of the Americans Wallace Stevens, William Carlos Williams, and Hart Crane. In prose, critics have seen cubist aesthetics in André Gide's novel *Les Faux-monnayeurs* (1925; *The Counterfeiters*, 1927) and in some of the work of the American Gertrude Stein.

In sum, Apollinaire's *The Cubist Painters* was a major event in the cultural history of the modern world. With his poetry, his activist leadership, and his art criticism, Apollinaire helped to give the twentieth century a new conception of representation in poetry and the plastic arts.

Bibliography

Adéma, Marcel. *Apollinaire.* Translated by Denise Folliot. New York: Grove Press, 1954. A scholarly biography of a man whose character was misunderstood and maligned. Succeeds in recovering the real person. Although largely uncritical, presents Apollinaire's life in a clear and orderly way. The basis of the studies that have followed.

Barr, Alfred H., Jr. *Cubism and Abstract Art.* New York: Museum of Modern Art, 1974. A general survey of the cubist and abstract art movements. Written in a scholarly manner and thoroughly documented. A valuable reference source.

Bates, Scott. *Guillaume Apollinaire.* Rev. ed. Boston: Twayne, 1989. A general intro-
duction to Apollinaire as poet, novelist, and art critic. Bates's method is novel: In
an effort to clarify Apollinaire's works, he relates them to their author's imagina-
tive and spiritual life. In this way, Bates finds that Apollinaire expresses himself
by means of such symbolic themes as "Christ and Antichrist," the "Phoenix,"
and the "New City." The book contains much valuable information.
Cooper, Douglas. *The Cubist Epoch.* New York: Praeger, 1971. Not merely a general
survey of the period but a highly intelligent analysis and description of cubism, its
aesthetic principles, its genesis and development, and its widespread influence.
Cooper emphasizes that cubism cannot be defined as one thing and that it was a
reaction against outworn conventions in favor of a "new realism." A worthwhile
book.
Davies, Margaret. *Apollinaire.* Edinburgh: Oliver & Boyd, 1964. A combined bio-
graphical and critical study. An authoritative work of scholarship noted for its
complete coverage. An unusual feature of Davies' study is her use of Apollinaire's
creative writing to throw light on biographical facts. She deals especially well
with her subject's modernist period and discloses his relationship to the various
painters and movements of the time. The literary criticism, although perceptive in
spots, is sparse in development.
Gray, Christopher. *Cubist Aesthetic Theories.* Baltimore: The Johns Hopkins Univer-
sity Press, 1967. Sketches the genesis and development of cubism. Also describes
both the philosophical and aesthetic ideas cubism reacted against and those it
adopted for its own use. Gray divides the development of cubism into two phases.
The first phase dealt with the issue of the true nature of reality and of human-
kind's ability to know it. The second phase displayed a rising consciousness of
painters and poets of the new developments in the sciences, especially physics and
mathematics, and in regard to the wonders of the machine.

Richard P. Benton

Cross-References

Stein Holds Her First Paris Salons (1905), p. 129; Avant-Garde Artists in Dresden
Form Die Brücke (1905), p. 134; Les Fauves Exhibit at the Salon d'Automne (1905),
p. 140; Artists Find Inspiration in African Tribal Art (1906), p. 156; The Salon
d'Automne Rejects Braque's Cubist Works (1908), p. 204; The Futurists Issue Their
Manifesto (1909), p. 235; Der Blaue Reiter Abandons Representation in Art (1911),
p. 275; Kandinsky Publishes His Views on Abstraction in Art (1912), p. 320; Du-
champ's "Readymades" Challenge Concepts of Art (1913), p. 349; *De Stijl* Advo-
cates Mondrian's Neoplasticism (1917), p. 429; The Formation of the Blue Four Ad-
vances Abstract Painting (1924), p. 583; Picasso Paints *Guernica* (1937), p. 1062.

BAKER ESTABLISHES THE 47 WORKSHOP AT HARVARD

Categories of event: Theater and literature
Time: 1913
Locale: Harvard University, Cambridge, Massachusetts

George Pierce Baker, a teacher and writer, opened his celebrated, noncredit 47 Workshop, a forum for aspiring playwrights that became an important creative incubator for modern American drama

Principal personages:
GEORGE PIERCE BAKER (1866-1935), a writer, editor, and Harvard University scholar who, in his famous 47 Workshop, became one of America's most creative teachers of other writers
PHILIP BARRY (1896-1949), a playwright best known for his comedies dealing with society's upper crust
S. N. BEHRMAN (1893-1973), a writer of plays, film scripts, and short fiction known largely for his comedies of ideas
JOHN MASON BROWN (1900-1969), a drama critic, lecturer, essayist, and war correspondent who wrote influential critical essays on theater
JOHN DOS PASSOS (1896-1970), a novelist, poet, essayist, and playwright remembered principally for his fiction
SIDNEY HOWARD (1891-1939), a playwright critically praised for his dramas of social realism
EUGENE O'NEILL (1888-1953), America's premier dramatist and Baker's most important student in the 47 Workshop
EDWARD SHELDON (1886-1946), a dramatist and collaborator whose play *The Nigger* created a furor because of its thematic focus on miscegenation
ROBERT E. SHERWOOD (1896-1955), a Pulitzer Prize-winning playwright, critic, and biographer
THOMAS WOLFE (1900-1938), a writer of fiction and plays best known for his sprawling novels

Summary of Event

In 1905, George Pierce Baker, a professor of English and forensics, began offering a course in dramatic composition at Harvard University, from which he had himself graduated in 1887. The course, English 47, was first offered at Radcliffe College and was added to the curriculum at Harvard College two years later. That Baker was able to offer the course at all was a minor miracle. Higher education at the beginning of the twentieth century, especially in private colleges, remained rather rigidly classical, and the idea that the teaching of drama writing had a proper place in the halls of academe was, to some of Harvard's more traditional administrators, anathema. Had

Baker not already established a reputation as a fine scholar and teacher and as the inspirational force behind Harvard's formidable debating teams, he most certainly would not have been allowed to try his unusual experiment. As it was, he had to make concessions, including the noncredit, extracurricular status of the 47 Workshop, which he added to the basic drama writing course in 1913.

Although Baker advanced his theory of dramatic composition in the course, its success ultimately depended on the practical application of that theory, which became the crux of the 47 Workshop. To some of his befuddled colleagues, Baker's evolving method seemed to have more in common with laboratory courses in science than with typical courses in literature or drama, which conventionally took a historical approach. He insisted that his students prepare plays for the stage, an insistence stemming from the strong conviction that a play text was not a play until it was transformed into a live production utilizing the skills of various interpretive artists. Conversant with both stagecraft and the realities of commercial theater, Baker was tough-minded and pragmatic. He required his students to write for actual audiences, not for a literate elite prone to favor poetic dramas that would never be produced. Among other things, he preached the idea that dramatic characters should talk and act like real people. Thus, from the first, English 47 involved both readings and performances of student works, initially in the theater at Agassiz House on the Radcliffe College campus. There, Baker's students were afforded the valuable opportunity of seeing their plays performed by fellow students, providing an important test of the works' stageability.

Baker's 47 Workshop, the English 47 laboratory, was to become highly selective in its enrollment. Normally, it was not even open to the younger undergraduate student body, because, in Baker's opinion, typical baccalaureate students had too little worldly experience to write with understanding or conviction. He preferred to enroll students who had either already graduated or had worked for a living, or who, like Eugene O'Neill, his most celebrated student, had roamed for several years. Prospective students were also required to submit plays, to earn their seats by virtue of their writing promise. Baker would then make his selection from among the writers of the best submitted works.

The workshop was also limited to only twelve students, which enabled Baker to give each of his writers a great deal of individual attention. In addition, a few volunteers from outside the university audited the workshop sessions and attended the stagings, which they critiqued in writing and discussed with Baker and his student playwrights. Thus, in this invaluable practicum, the aspiring playwright could write and revise works under Baker's guiding hand, then stage them and have them reviewed by qualified critical jurors. Because Baker's students had to prepare their works for performance and participate in their staging, they also had to learn the essentials of various theater arts, including acting, scene design, lighting, and costuming. The 47 Workshop was thus partly a course in theater arts.

Within three years of its inception, admission to English 47, the parent course of the 47 Workshop, became intensely competitive. Edward Sheldon's *Salvation Nell*,

which was written while Sheldon was Baker's student, partly accounted for its growing appeal. In 1908, Sheldon's play had a very successful commercial staging starring the popular and progressive actress Minnie Fiske. Sheldon's next work, *The Nigger* (1909), had a daring and controversial plot that brought some helpful notoriety to Baker's Harvard program; by the time the 47 Workshop was added, Baker's program had become a principal enticement for several students enrolling at the school. Some of these, notably O'Neill, went to Harvard solely to learn the craft of playwriting or to become better at it.

Before leaving Harvard in 1925, Baker nurtured the writing and critical acumen of dozens of important figures in American belles lettres. In addition to Sheldon and O'Neill, Baker's graduates included playwrights George Abbot, Philip Barry, S. N. Behrman, Sidney Howard, and Robert E. Sherwood. Others who studied under Baker earned their fame in other genres, notably fiction, including novelists Rachel Field, John Dos Passos, and Thomas Wolfe (who would later caricature Baker as Professor Hatcher in his 1935 novel *Of Time and the River*). Other important students from English 47 or the 47 Workshop would gain renown as critics, journalists, teachers, editors, essayists, or associates of the theater, including Robert Benchley, Van Wyck Brooks, John Mason Brown, Walter Pritchard Eaton, Theresa Helburn, Robert Edmond Jones, Frederick H. Koch, Kenneth Macgowan, Hiram Moderwell, Lee Simonson, John V. A. Weaver, and Maurice Wetheim. Many of Baker's students, most notably O'Neill, came into prominence in the 1920's, when the American theater itself finally came of age.

Despite Baker's great success, Harvard never became entirely hospitable toward his program, and he left for a more promising arrangement at Yale University. There, with a fully equipped theater donated by Edward S. Harkness, he taught playwriting, dramatic criticism, and courses in technical theater to, among others, Elia Kazan, the eminent director and cofounder of the famous Actors Studio. Before his death in 1935, he helped to establish the growing reputation of Yale's highly regarded graduate school of drama.

Impact of Event

In a letter written to *The New York Times* shortly after Baker's death, Eugene O'Neill credited his teacher and mentor with having been one of the prime movers in bringing the American theater out of its "dark age," claiming that his influence "toward the encouragement and birth of modern American drama" was "profound." That praise, coming from America's first great dramatist, himself a major force in maturing the national drama, emphatically stated what O'Neill and other students of Baker knew was true: that Baker had been an extremely important catalyst in the process.

Before World War I, despite some promising exceptions, theatrical productions in America lacked vigor and freshness and, at least in their play texts, revealed few sparks of true creative genius. Although realism in theater had been advocated by various writers, notably William Dean Howells, it had made slow progress in the

face of the popularity of melodramas, with their outlandish, contrived plots, artificial language, and simplistic morality. For new writers wishing to experiment, the commercial theater was, as O'Neill noted, a "closed shop." It was dominated by star actors and actresses who, often with their own traveling troupes, engaged in what O'Neill derided as the "amusement racket."

O'Neill's own father, James, was one of these stars, and James's career reflected the system. Like most other stars, he became known for his interpretation of a specific role, that of Edmund the Count of Monte Cristo. For him and for other headliners of the day, plays were merely vehicles for their acting, and their chief task was to thrill an audience, not to raise its consciousness or make it think. The younger O'Neill's work, some of which James had an opportunity to see staged just prior to his death in 1920, simply dismayed him. He found its brooding intensity and naturalistic bias distressing. For him, theater had no business depicting ugly truths or depressing its audience.

Baker's efforts to make playwrights move away from a romantic escapism toward a more honest depiction of life bore full fruit by the early 1920's, when Eugene O'Neill's meteoric career was on the rise. Yet Baker's 47 Workshop, although a major influence, was not the solitary springboard to the radical change in the American theater. The foreign influence of, among others, Henrik Ibsen, George Bernard Shaw, Anton Chekhov, August Strindberg, and Émile Zola, the scenic design of David Belasco, earlier plays by Americans such as James A. Herne's *Margaret Fleming* (1890) and *Shore Acres* (1892), the impact of World War I, the theories of Charles Darwin and Sigmund Freud, the conversion of many theaters that formerly hosted traveling stock companies into motion-picture houses, the development of the little-theater movement and of such groups as the Provincetown Players, the Washington Square Players, and the Theatre Guild—all made important contributions to the new American theater. So many strains, in some cases mutually reinforcing each other, make moot the question of which one should be given the primary credit for the American theater's evolution.

More clearly, Baker's teaching methods exerted an important influence that can be directly traced to his famous course. He legitimized the workshop approach to playwriting and pioneered other practical courses in theater, providing models that began to be emulated at various schools in the United States. For example, in 1918, Frederick Koch, a graduate of the 47 Workshop, started a playwriting course at the University of North Carolina and, in 1919, established the renowned Carolina Playmakers. A creative teacher who stressed the use of folk materials in drama while using some of Baker's workshop techniques, Koch was also important in the growth of the little-theater and regional-theater movements.

Others, too, followed in Baker's pedagogical track, including Walter Eaton at Yale and Kenneth Macgowan at the University of California. Within a generation, they helped to broaden college and university curricula, putting in place courses that provided practical training not merely in playwriting but in all the theater arts. Central to their philosophy was the belief that plays should be interpreted for perfor-

mance, not just as fossilized pieces of dramatic literature. At Yale, in addition to playwriting, Baker himself taught courses in stage design, costuming, lighting, and theater criticism, all stressing a practical, problem-solving approach. Thus, right up to 1933, when sickness forced his retirement, Baker continued to play a vital role in the creation of departments of theater, as distinct from such traditional disciplines as literature or speech.

It was, however, Baker's great energy and enthusiasm for theater that mattered most. His true gift lay in his ability to infuse that same enthusiasm in others, to inspire them. Looking back from the perspective of the 1950's, John Mason Brown noted that it was in such intangible contributions that Baker had a truly durable impact. According to Brown, most of the plays written in the 47 Workshop classes were actually very bad, even the ones written by playwrights who would later become very good at their craft; but Baker's great patience and encouragement helped his charges through a painful artistic infancy and left them with a lasting faith in themselves. In his earlier eulogy on Baker, O'Neill made a similar assessment. In addition to giving O'Neill and his fellow students a belief in their work, Baker gave them hope, for which, O'Neill wrote, "we owe him all the finest we have in memory of gratitude and friendship."

Bibliography

Baker, George Pierce. *Dramatic Technique*. Boston: Houghton Mifflin, 1919. A handbook for playwrights, stressing techniques learned from studying established works and their compositional design. Still regarded as a classic, it has influenced many succeeding guides to the playwright's craft.

Kinne, Wisner Payne. *George Pierce Baker and the American Theatre*. 1954. Reprint. New York: Greenwood Press, 1968. The only book-length study of Baker and his significance in the development of the American theater, written by one of his students. Includes an important introduction by George Mason Brown, the texts of several letters, and a bibliography of Baker's works.

Meserve, Walter J. *An Outline History of American Drama*. Totowa, N.J.: Littlefield, Adams, 1965. A good, expanded checklist of playwrights, works, trends, and influences in the history of American drama, placing Baker's contributions in the larger context of theater in America from its beginnings forward. Excellent for reviewing the history of drama in the United States. Minimal bibliography.

Sarlós, Robert Károly. *Jig Cook and the Provincetown Players*. Amherst: University of Massachusetts Press, 1982. An account of the founding and history of the theater in which Eugene O'Neill first gained recognition. Serves as an informative parallel study to Kinne's book. Includes an index to the persons involved and a chronology of works staged between 1915 and 1922.

Wilson, Garff B. *Three Hundred Years of American Drama and Theatre, from "Ye Baare and Ye Cubb" to "Hair."* Englewood Cliffs, N.J.: Prentice-Hall, 1973. An overview of the development of drama and theater in America to the 1960's, but in greater depth than Meserve's work. A recommended guide for serious students of

American drama, also placing Baker and the 47 Workshop in proper focus. Includes a helpful selective bibliography.

John W. Fiero

Cross-References

Stanislavsky Helps to Establish the Moscow Art Theater (1897), p. 1; The Group Theatre Flourishes (1931), p. 874; The Federal Theatre Project Promotes Live Theater (1935), p. 989; Kazan Brings Naturalism to the Stage and Screen (1940's), p. 1164; *A Streetcar Named Desire* Brings Method Acting to the Screen (1951), p. 1487; *Long Day's Journey into Night* Revives O'Neill's Reputation (1956), p. 1726.

DUCHAMP'S "READYMADES" CHALLENGE CONCEPTS OF ART

Category of event: Art
Time: 1913
Locale: Paris, France

Marcel Duchamp's elevation of everyday objects to the status of art sparked controversy but proved enormously influential

Principal personages:
> MARCEL DUCHAMP (1887-1968), a painter and sculptor whose radical approach to art would have a profound influence on twentieth century art
> RAYMOND DUCHAMP-VILLON (1876-1918), the brother of Marcel Duchamp and one of the first exponents of cubist sculpture
> JACQUES VILLON (GASTON DUCHAMP, 1875-1963), another of Marcel Duchamp's brothers who achieved fame as a cartoonist, etcher, and painter
> FRANCIS PICABIA (1879-1953), a prolific painter who had affinities with both Dadaism and Surrealism but constantly clung to his own freedom as an artist
> MAX ERNST (1891-1976), an important exponent of Dadaism and a pioneer of Surrealism
> MAN RAY (1890-1976), a painter, photographer, and writer who was an important member of both the Dadaist and Surrealist movements

Summary of Event

"As early as 1913, I had the happy idea to fasten a bicycle wheel to a kitchen stool and watch it turn." In that one act, Marcel Duchamp originated two of the most significant approaches to modern sculpture: the mobile (sculpture involving actual movement) and the "readymade" (sculpture made from ordinary, existing objects). Of even more importance was his challenge to traditional concepts and definitions of art.

Duchamp was one of the most influential artists of the twentieth century—and also one of the most fascinating and problematical, because there is so much in his art that resists explanation. He began his career as a conservatively trained artist in 1902 and, within a period of less than ten years, worked his way through the most advanced movements in pre-World War I art, including cubism, Fauvism, and Futurism. In 1913, he created an international sensation when his cubist *Nude Descending a Staircase, No. 2* was exhibited at the Armory Show in New York. By 1923, however, he had abandoned his painting career altogether. Although he had phased himself out of the making of art in the traditional sense, he continued to be an important figure in the international art world until his death in 1968. Duchamp's career raised

a series of intriguing questions: Why did he quit making art? Why did he remain an inspiration to so many artists, from the Dadaists and Surrealists of the 1920's and 1930's to young artists in the 1950's and 1960's? Was he, as some hostile critics have suggested, simply pretending to take an antiart stance to cover up his own failures as an artist? Or had he really found a new expressive activity that took him beyond art in its historical sense?

From 1910 to 1913, Duchamp made some drastic changes in his work. In a series of nudes done in 1909 and 1910, he progressed from an Impressionist approach to pose, gesture, and brushstroke to a representation in which the gestures of the figures and their relationship to one another were not explicit; each figure was painted in a dry, precise style, with even some indication of internal organs beneath the surface of the skin. He had put formal precision of statement at the service of ambiguity or mystery of content.

Then, in 1911, he did a number of cubist-inspired works, which led to two versions of *Nude Descending a Staircase*, works that illustrated successive stages of movement of a single figure. At the same time, he did his first work involving the machine as subject. Choosing a commonplace household item—a coffee grinder—he created the illusion of motion by using graphic devices (arrows and dotted lines) to indicate the turning of the grinder's wheel. This painting marked the beginning of his fascination with objects.

In 1913, having painted two versions of *Nude Descending a Staircase*, Duchamp next painted *Bride* and *Passage of the Virgin to the Bride*. In these two works, the directions he had taken in such earlier works as *Bush*, *Nude Descending a Staircase*, and *Coffee Grinder* seemed to come together. He combined his interest in both the human figure and machines to produce two works in which a "machine" became a metaphor for the human. In other words, he stripped the bride of all of her historical, sentimental associations—wedding gown, veil, bridal bouquet, something old and new, borrowed and blue. He even removed her face and all external aspects of her body, imaging her as a complex combination of tubes, valves, slots, cones, and gears— in other words, as a machine. The various parts were painted in a careful and precise way, with all evidence of brushstroke removed. As he stripped down the bride on the physical level, there was also certain psychological or mental associations of which she was stripped—the ideas of beauty and femininity, for example. The disenchantment that Duchamp evidenced for the subject also existed for art itself. He was now taking a serious antiart position; with the precision of his drawing and painting, he was moving away from the traditional concept that tangible evidence of the artist's hand in a work is an integral part of the aesthetic experience.

Duchamp was determined to break away from "retinal" art—art for the eye alone—which, as he observed, had led to the glorification of the craft aspect of painting, to an enormous regard for the virtuosity of the artist's hand. He dismissed such work as the "olfactory" art of painters who, being in love with the smell of paint, had no interest in re-creating ideas on canvas.

Duchamp's next paintings, done in late 1913 and early 1914, were of a chocolate

grinder—a machine he saw in a shop window. Again, his approach was to be as dry and as precise as possible in order to emphasize the object itself and its mystery, not the facility of his own hand. In the second version, he took the machine out of the illusionistic setting of the first painting in order to further emphasize the object character of his motif, and he also fastened pieces of thread onto the canvas to represent the teeth of the three drums that revolved in the machine as the chocolate beans were ground.

In his thinking and in his art, Duchamp had moved away from the avant-garde (cubism and abstraction) and had achieved identifiability of the object and elimination of virtuosity in the making. Having gone as far as possible in terms of creating the illusion of an object in his work, his next logical step was to involve himself directly with objects. In so doing, he was declaring that creation did not reside in making but in seeing. Duchamp stated that one important aspect of his "seeing," or selection of objects to be used as readymades, was the absence of aesthetic delectation. As he said, his choices were based on a reaction of visual indifference, with a corresponding total absence of good or bad taste. The truth of that claim was evidenced by *Fountain* of 1917—a porcelain urinal that he signed with the pseudonym "R. Mutt" and submitted to an exhibition sponsored by the Society of Independent Artists. The exhibition committee, finding the piece obscene and morally offensive, refused to display it.

Duchamp sometimes inscribed a short sentence on his readymades that, rather than being a title, he wrote, was meant to "carry the mind of the spectator towards other regions, more verbal." When he added graphic details to satisfy his craving for alliteration, the object became "ready-made aided"; to expose the basic antinomy between art and readymades, he imagined a "reciprocal ready-made: use a Rembrandt as an ironing board." Realizing that the readymade could be repeated indiscriminately, he decided to limit the number he made each year. For viewer even more than for artist, he noted, "art is a habit-forming drug," and he wanted to protect the readymades against such contamination.

Impact of Event

In his creation of the readymades, Duchamp raised—and answered—the question, who determines whether or not something is art? This question has provoked much heated debate through the centuries, with scholars arguing about the extent to which a work of art must be aesthetic, must be shaped by human hands, must be original (to distinguish it from craft), or must have a meaningful subject. Needless to say, little agreement has been reached on any of these aspects. With the readymades, though, Duchamp presented his own answer: It is the artist who determines whether or not something is art.

The readymades expressed Duchamp's penchant for paradox, for the play of visual against verbal, for alliteration, and for both visual and linguistic puns. The readymades also illustrated another major aspect of Duchamp's thinking about art, his courting of chance or accident. *Three Standard Stoppages*, for example, consist-

ing of three mystical, personal units of measure, was created by allowing three pieces of thread to fall upon three pieces of black paper, to which the threads were then affixed; the result was then carefully preserved in a wooden croquet box. The irony is that measure is usually identified with precision, but Duchamp's measure was achieved by chance.

All these characteristics of Duchamp's work—along with his antiart stance—had a great influence on the Dadaists. The Surrealists, too, were significantly influenced by Duchamp's love of paradox, wordplay, and—in particular—his involvement of the artist with chance and accident. In the works of Francis Picabia and Max Ernst, for example, there is the same use of both visual and verbal language to create witty, satirical, punning references to the foibles of society, as well as the same use of the machine as a metaphor for the human. Man Ray, the American painter and photographer, was another who was fascinated by what Duchamp and Picabia were doing to minimize the role of the hand in art.

When Duchamp incorporated movement into *Bicycle Wheel*, he pioneered kinetic sculpture. In the 1920's, he experimented further with motion in *Rotative Glass*, which was based on the phenomenon that when two spirals revolve on a common axis but slightly off-center, one appears to come forward and the other to go back. To demonstrate this, he built an apparatus consisting of five rectangular glass plates of graduated lengths, each with black lines painted at each end and attached to a metal rod that was turned by a motor. In the 1930's, he created the *Rotoreliefs*—six round cardboard disks, each stamped with what appeared to be an abstract design; when "played" on a phonograph turntable, the disks gave the illusion of a three-dimensional object. When Alexander Calder's first kinetic sculptures were exhibited in 1932, it was Duchamp who christened them "mobiles." Calder's wind mobiles, especially, relied on chance (moving air currents) for their effects. Most of the kinetic sculptors of the later twentieth century have been ardent admirers of Duchamp—in 1960, for example, when the Swiss sculptor Jean Tinguely came to New York to build his self-destructing sculpture *Homage to New York* at the Museum of Modern Art, he immediately consulted with Duchamp.

Twentieth century sculpture has, from the beginning, contained a strain of fantasy, resulting from the fact that most sculptors continued to use the human head and figure as subjects—and no matter how much they transformed the head and figure by every sort of reformation, deformation, stylization, or manipulation imaginable, some sense of human presence remained. The first twentieth century work in which fantasy appeared explicitly was Umberto Boccioni's *Unique Forms of Continuity in Space* (1913). This was followed by Duchamp's even more significant invention of the readymade. The Duchamp-inspired "object sculptures" created by the Dadaists reached a culmination in such pop art productions as Jasper Johns's cast-bronze beer cans and coffee cans filled with paintbrushes.

Duchamp was the guiding light and a great influence on both pop art and the New Realism. Many terms that have special significance to later twentieth century art were his—readymade, assemblage, mobile. As several scholars have pointed out,

his last painting, *Tu m'* (1918), was almost a dictionary of postwar directions in art—from pop and op to color field to conceptualism.

Duchamp has been one of the most important influences upon the development of conceptual art. When he invented the readymade, he reduced the creative act to the elementary level of selecting or designating an object as art. By implication, then, art was more concerned with the artist's intentions than with craftsmanship or style. Furthermore, he challenged the entire art establishment; art critics and professional arbiters of taste who dictated to the galleries, museums, and art-buying public were no longer needed, as the artist, who decided what was or was not art, became both creator and critic. Also, if art inhered not in form but in the artist's conception, then it was no longer an object for commercial, profitable speculation in the art market. The conceptualists—believing that formalism was dead and that art could only survive as idea—looked to Duchamp's readymades as the beginning of modern art and of conceptualism itself.

In the final analysis, however, the art establishment won out. As Duchamp himself later declared, "I threw the urinal in their faces and now they come and admire it for its beauty."

Bibliography

D'Harnoncourt, Anne, and Kynaston McShine, eds. *Marcel Duchamp.* New York: Museum of Modern Art, 1973. The catalog for a comprehensive exhibition of Duchamp's work. Contains essays on various aspects of his work by some of the leading Duchampian scholars. Also features a chronology, an excellent bibliography, and illustrations throughout.

Duchamp, Marcel. *Salt Seller: The Writings of Marcel Duchamp.* Edited by Michel Sanouillet and Elmer Peterson. New York: Oxford University Press, 1973. The editors have attempted to collect and publish all of Duchamp's written work. Includes an English translation of Duchamp's notes for his painting *The Large Glass.* Also contains the text of a lecture Duchamp gave in 1961, discussing his creation of the readymades.

Duve, Thierry de, ed. *The Definitively Unfinished Marcel Duchamp.* Cambridge, Mass.: MIT Press, 1991. Contains eleven essays that were first presented at a colloquium at the Nova Scotia College of Art and Design in 1987. After each essay, there is a transcription of the discussion that took place at the colloquium. Three of the essays are specifically concerned with the readymades.

Marquis, Alice Goldfarb. *Marcel Duchamp: Eros, c'est la vie, a Biography.* New York: Whitston, 1981. The author has consulted a wide variety of sources: many unpublished materials held by various libraries and universities, interviews with those who knew Duchamp, and countless articles, journals, lectures, and books. Fully documented and illustrated with black-and-white plates.

Richter, Hans. *Dada: Art and Anti-Art.* New York: Harry N. Abrams, 1965. The author uses original manifestos and other documents to re-create the times and events of Dada. He emphasizes Duchamp's influence on the development of Dada

and discusses some of the leading artists, such as Tristan Tzara, Francis Picabia, Max Ernst, and Man Ray.

LouAnn Faris Culley

Cross-References

Kandinsky Publishes His Views on Abstraction in Art (1912), p. 320; Avant-Garde Art in the Armory Show Shocks American Viewers (1913), p. 361; The Dada Movement Emerges at the Cabaret Voltaire (1916), p. 419; Man Ray Creates the Rayograph (1921), p. 513; Surrealism Is Born (1924), p. 604; Minimalism Emphasizes Objects as Art (1963), p. 1949; Laurie Anderson's *United States* Popularizes Performance Art (1983), p. 2517.

PROUST'S *REMEMBRANCE OF THINGS PAST* IS PUBLISHED

Category of event: Literature
Time: 1913-1927
Locale: Paris, France

The seven volumes of Proust's masterwork lent a new direction to psychological realism in fiction

Principal personage:
MARCEL PROUST (1871-1922), a social dilettante who devoted ten years of his life, virtually without interruption, to the creation of this work

Summary of Event

In March, 1913, *Du côté de chez Swann* (*Swann's Way*, 1922), the first volume of *À la recherche du temps perdu* (1913-1927; *Remembrance of Things Past*, 1922-1931, 1981), was published by Bernard Grasset, at the author's expense, after being rejected by several publishers. This work, with its fluid, overwrought style, mystified many readers who perhaps expected another effort in the manner of *Les Plaisirs et les jours* (1896; *Pleasures and Regrets*, 1948) a whimsical collection of poems and sketches.

Since 1907, Marcel Proust had been organizing material for a work envisioned as a lyrical synthesis of *belle époque* manners and mores, with a title referring to the collective reconstruction of reality through a process of involuntary recollection of experiences. Proust originally delineated a triad formation to include Age of Names, *Swann's Way*; Age of Words, *Le Côté de Guermantes* (*The Guermantes Way*); and Age of Things, *Le Temps retrouvé* (*Time Regained*). Although these last two parts were complete in 1913, they were published in expanded form between 1918 and 1927, along with four additional volumes that Proust created during the war years.

In 1919, *À l'ombre des jeunes filles en fleurs* (1919; *Within a Budding Grove*, 1924) received Le Prix Goncourt after it was published by Gallimard, the publishing house of the *Nouvelle Revue Française*. The critical reaction to this work was highly charged and quickly transformed Proust from a curiosity into a literary giant. Despite the increasing popularity of his work, Proust lived a reclusive life, enlarging and revising his novel until it had seven major divisions, some of which first appeared in two or three volumes, amounting to a text with a million and a half words and more than two hundred characters.

The period between 1896 and 1906 consisted of years of intellectual wandering for Proust. He wrote an unfinished novel of one thousand pages entitled *Jean Santeuil* that anticipates, in narrative structure and thematic development, parts of *Remembrance of Things Past*. He completed two translations of aesthetic essays by John Ruskin: *Le Bible d'Amiens* (1904; *The Bible of Amiens*) and *Sésame et les lys* (1906;

Sesame and Lilies). He began an unfinished critical study, published posthumously as *Contre Sainte-Beuve* (1954; *By Way of Sainte-Beuve*, 1958) in which he explored the psychological laws governing personality and behavior. Proust's work suggests that humans respond instinctively to social forces; this challenges Charles Augustin Sainte-Beuve's reliance on a rational interpretation of reality.

Remembrance of Things Past also reflects the systems of philosophers Arthur Schopenhauer and Henri Bergson. Proust's approach is based on Schopenhauer's concept that social reality is determined by the idea that each individual forms of that reality. Memory fuses elements of a dormant past, giving time the qualities of a Bergsonian continuum. Proust also read the memoirs of the Duc de Saint-Simon, covering the last part of the reign of Louis XIV. Saint-Simon's interest in etiquette and in the exact pedigrees of aristocrats contributed to Proust's nostalgia for a deeply layered hierarchical society, around which his narrator spins as a bourgeois satellite.

Lastly, Proust's concern for homosexual relationships within the contexts of love, friendship, and jealousy reflects the anxiety of social reformers during France's embattled Third Republic who vividly remembered Oscar Wilde's 1895 trial for homosexual offenses in England and who were aware that the French police maintained files on anyone suspected of deviant behavior. Proust was galvanized by the Dreyfus Affair. The climate of anti-Semitism in France led him to reflect on his own Jewishness (on his mother's side) as a form of exclusion and exclusiveness. One of his main characters, Charles Swann, is Jewish. Thus, Proust imagined a world of emotions and experiences that he attempted to understand through an exquisite examination of consciousness. This sets him squarely in the tradition of nineteenth century naturalists but also places him among modern advocates of psychological realism.

Remembrance of Things Past, a long, complex novel, reveals Proust's dual approach to narration. The central character, Marcel, relives his life from childhood. At the same time, his actions are interpreted by other characters. In this role, he absorbs experiences with little idea of their ultimate significance. As the middle-aged actor in his own drama, he attempts to clarify his own sensations as he recovers time through memory. At the end of the novel, as Marcel reflects on the unique identity of past as present, he realizes that the creative writer alone can express this transcendental nature of reality. Writing, then, is the vocation for which his entire life has been a preparation. Because he is chronically ill, however, his urgent task is to chronicle time's disintegrating and transforming function before he dies. The illumination of art is conveyed hauntingly through references to the fictional trio of Elstir, a painter; Vinteuil, a musician; and Bergotte, a writer.

Early in the morning on the day he died, Proust dictated to his housekeeper several passages later included in the narrator's portrait of Bergotte on his deathbed. In this scene, the writer's books are displayed in groups of three, like angels' wings, the symbol of the artist's resurrection.

Impact of Event

Remembrance of Things Past was conceived at a transitional moment in European

history, when nineteenth century middle-class values were confronted by the ramifications of socialism, Darwinism, and modern science. In literature, the realistic novel was trying to recover its balance as it came out from under the spell of Symbolism, which tended to transform hard-edged prose into hazy, ethereal poetics. Proust enlarged the scope of the *roman-fleuve* (cyclic novel) tradition by emphasizing the importance of the imaginative chronicler drawing on his own experience and background to convey the spirit of an age more faithfully than a strictly accurate record could achieve. In doing so, Proust glorified the near past and, for this reason, there is a valedictory element in the novels of his successors, among them Jules Romains, Roger Martin Du Gard, and Georges Duhamel. In their attempts to express the collective spirit of pre-World War I communities, along with the psychology of individuals, these writers owed a considerable debt to Proust.

Since the 1930's, each successive generation has added to the Proust bibliography. From Paul Valéry to Michel Foucault, the representatives of new waves of literary criticism have found in Proust's work a rich mine of metaphorical language and crystallized moments. Most critics have praised Proust's architectural finesse. Indeed, *Remembrance of Things Past* resembles a Gothic cathedral with a host of stained-glass windows like illuminated manuscripts in a Bible of stone. This evokes a comparison with Dante Alighieri's *Divine Comedy* (c. 1320); some critics have articulated the similarities between Marcel and Dante (narrators) and Swann and Vergil (guides through the underworld).

The world of the Middle Ages is transmitted brilliantly in the numerous references to the lengendary Geneviève de Brabant and other figures from medieval Europe who appear in the lantern slides that Marcel watched as a child in his room at Combray, or in the stories that his mother read to him before bedtime. Proust's attempt to remount the stream of time imparts a curious dreamlike quality to parts of the text. This effect is heightened by the exoticism produced by a kaleidoscopic series of perfumes and colors attached to objects, people, and events.

Many of Proust's admirers assiduously follow the two "ways," Méséglise and Guermantes, offered to the protagonist from doors opening on opposite sides of his Aunt Léonie's house at Combray, which was the crucible of Marcel's consciousness. The Méséglise path leading to Swann's house at Tansonville is an open plain covered with lilac and hawthorne. The Guermantes path is a river valley with water lilies and violets. The Guermantes family represents a lineage dating from the Middle Ages, and Marcel associates this name with societal aspirations.

Through family conversations and isolated details, Marcel learns of Swann's courtship and marriage to Odette de Crécy, a former prostitute with whom Swann became obsessed. Their marriage elevates her status, but Swann is eventually spurned by his peers until he becomes a forlorn and pathetic aesthete. Odette and Gilberte, her daughter by Swann, become objects of Marcel's fascination and, through the end of the novel, their lives continue to be linked by a series of gratuitous coincidences.

Marcel is introduced to another realm when, escorted by his grandmother, he visits the seaside town of Balbec, in Normandy, the Grand Hotel of which is later

referred to as a Pandora's box. There he makes the acquaintance of Albertine Simonet, Robert de Saint-Loup, and the Baron de Charlus, each of whom teaches him about the intermittences of the heart that undermine genuine human love. The Guermantes way leads to a number of revealing and often grotesque incidents in which Marcel witnesses erotic activities and liaisons that perturb him as he slowly acknowledges his own homosexual inclinations. In classic Freudian terms, Marcel seeks maternal affection in most of his relationships, and this virtually unattainable desire ends in various forms of compensation, jealousy, and narcissism.

Swann's pursuit of Odette represents a central feature that is extrapolated in subsequent phases of Marcel's development. His frustrations reach a climax in his affair with Albertine, with whom he briefly shares a hotel room in Venice, where he observes her in a trancelike sleep in this subterranean city. Soon after, he attempts to hold her prisoner in his Paris apartment. She escapes to her home in Balbec and dies as a result of a riding accident. This leads Marcel to conclude that love is an illusion that exists only in the mind of the lover. He lapses into habit, a form of inaction and neurotic passivity.

Marcel's redemption is distilled through art. Proust's characters appear as figures on tableaux, frescos, and tapestries in an endless succession of mirrored rooms. Albertine resembles women in paintings by Giotto and by Pierre-Auguste Renoir. Odette possesses a Botticelli beauty, and Gilberte is compared to Daphne from classical mythology. At the end of the novel, Marcel finally is able to enter the salon of the elusive Duchesse de Guermantes; he observes the vicissitudes of time, mutable in society but immortalized in art. He breaks out of habit and enters the plenitude of memory, located in privileged moments such as the enjoyment of a madeleine cake dipped in tea, the church steeples of Martinville, and a reading of George Sand's *François le champi* (1850; *Francis the Waif*, 1889).

Proust's technical innovations are similar to those found in modern art: near and far are pushed together; perspective is flattened out so that movement seems horizontal across zones of turbulence; and there is no specific beginning, middle, or end with respect to time, which is often considered to be a fourth dimension in surface reality. Furthermore, despite the length of the novel, there is an extraordinary process of psychic compression at work in the introspective landscape that Proust created. As Joseph Conrad suggested, it might prove difficult to find another novel in which artistic vigor, emotional amplitude, and linguistic splendor are so fully integrated.

Bibliography

Brée, Germaine. *Marcel Proust and Deliverance from Time.* Translated by C. J. Richards and A. D. Truitt. New Brunswick, N.J.: Rutgers University Press, 1969. This insightful work by a distinguished critic presents nine chapters that focus primarily on feminine influences on the protagonist. Connects Proust to aesthetic theories proposed by other writers.
Bucknall, Barbara J., ed. *Critical Essays on Marcel Proust.* Boston: G. K. Hall, 1987.

These fourteen essays are highly theoretical and, although each is relatively short, there is a great deal of minutiae to absorb. Some of the comparisons are far-fetched, and many of the authors depend too much on critical interpretations drawn from secondary sources. Has a fairly extensive index.

Girard, René. *Proust: A Collection of Critical Essays.* Englewood Cliffs, N.J.: Prentice-Hall, 1962. These fourteen essays cover a wide range of themes, among them Proust's notion of time as a plurality of isolated moments, the three-dimensional novel, memory as a form of spiritual grace, and Proust's belief in intuitive criticism. Contains a chronology of important dates.

Maurois, André. *Proust: A Biography.* Translated by Gerard Hopkins. New York: Meridian Books, 1958. Considered by many critics to be the definitive biography of Proust, this carefully documented work relies on factual data to present the evolution of Proust's career. Excellent use of correspondence provides keys to many of the characters. Has notes, bibliography, and index.

Moss, Howard. *The Magic Lantern of Marcel Proust.* New York: Macmillan, 1962. This short but illuminating study is a reliable introduction to Proust's main themes, represented by the metaphorical concepts of windows, gardens, parties, and steeples.

Painter, George. *Marcel Proust: A Biography.* 2 vols. New York: Vintage Books, 1978. This set studies the early years and later years of Proust's life with an almost Freudian reverence for the effects of childhood phenomena. Carefully reviews the Dreyfus Affair and painstakingly forms composite sketches of Proust's main characters. Contains a multitude of photographs and prints, copious notes, bibliography, and index.

Quennell, Peter, ed. *Marcel Proust, 1871-1922.* New York: Simon & Schuster, 1971. This centennial volume presents ten essays depicting the cultural atmosphere of Proust's novel, with an emphasis on fashions, food, and flowers. With many unique and original photographs and sketches in addition to a serviceable index.

Rivers, J. E. *Proust and the Art of Love: The Aesthetics of Sexuality in the Life, Times, and Art of Marcel Proust.* New York: Columbia University Press, 1980. The author uses behaviorist and physiological research into human sexuality to contend that Proust was misled by the sexual theories and homophobia of his generation. An unorthodox but challenging treatment of Proust. Extensive notes, bibliography, and index.

Shattuck, Roger. *Proust's Binoculars: A Study of Memory, Time, and Recognition in "A la recherche du temps perdu."* New York: Random House, 1963. The author, an esteemed critic, studies the narrative structure and comic spirit of Proust's novel. An entertaining presentation of Proust's contribution to literary history. With notes, chronology, bibliography, and index.

Wilson, Edmund. "Marcel Proust." In *Axel's Castle: A Study in the Imaginative Literature of 1870-1930.* New York: Scribner's, 1959. This fifty-eight-page essay is a refreshing and effervescent analysis of the symphonic structure and architectural unity of Proust's work. Wilson's usual command of the subject is evident as he

emphasizes Symbolist influences and other literary, artistic, and historical connections.

Robert J. Frail

Cross-References

Bergson's *Creative Evolution* Inspires Artists and Thinkers (1907), p. 161; Rilke's *Duino Elegies* Depicts Art as a Transcendent Experience (1911), p. 281; Jung Publishes *Psychology of the Unconscious* (1912), p. 309; Kandinsky Publishes His Views on Abstraction in Art (1912), p. 320; Joyce's *Ulysses* Epitomizes Modernism in Fiction (1922), p. 555; Gide's *The Counterfeiters* Questions Moral Absolutes (1925), p. 620.

AVANT-GARDE ART IN THE ARMORY SHOW
` SHOCKS AMERICAN VIEWERS

Category of event: Art
Time: February-May, 1913
Locale: New York, New York; Chicago, Illinois; and Boston, Massachusetts

The Armory Show—not the largest, but without doubt the most significant art exhibition ever held in the United States—jarred American artists and public alike out of decades of complacency

> *Principal personages:*
> WALT KUHN (1880-1949), an American painter who was one of the original group who conceived the idea of the Armory Show
> ARTHUR B. DAVIES (1862-1928), the president of the Association of American Painters and Sculptors (AAPS) who, along with Kuhn, selected the European art for the show
> WALTER PACH (1883-1958), an American painter who guided Kuhn and Davies through the Parisian world of the avant-garde
> MAURICE BRAZIL PRENDERGAST (1859-1924), an American painter who helped to select the American works and hang the exhibition
> MARCEL DUCHAMP (1887-1968), a French painter whose work provoked the greatest amount of outrage and ridicule from viewers and critics alike

Summary of Event

The International Exhibition of Modern Art—the Armory Show—formally opened on the evening of February 17, 1913, in New York City at the 69th Infantry Regiment Armory on Lexington Avenue. Four thousand guests strolled among the eighteen specially constructed rooms within the armory, viewing the thirteen hundred or so works by both European and American artists, while the 69th Infantry's regimental band provided musical entertainment.

The Armory Show was the brainchild of a small group of American artists who, as early as 1911, had met to discuss the problems of the visual arts in the United States—such as limited exhibition opportunities, the general lethargy of American art, and the lack of effective leadership from the National Academy of Design. They discussed the possibilities of forming an artists' organization through which they might work to correct some of these conditions. As the talks continued, on December 14, 1911, the original four—Henry Fitch Taylor, Jerome Myers, Elmer MacRae, and Walt Kuhn—recorded in their first official minutes that they intended to organize a society, consisting of sixteen charter members, that would exhibit the works of progressive painters, both American and foreign, that would be especially inter-

esting and instructive to the public. All the new members—among whom were Arthur B. Davies, Robert Henri, William Glackens, Ernest Lawson, George Luks, and Gutzon Borglum—tended to be antiacademy in either an artistic or an organizational sense and had been involved in earlier efforts to arrange exhibitions outside the academic system. At its first meeting in January, 1912, the group named itself the Association of American Painters and Sculptors (AAPS) and stated that its purpose would be to develop a broad interest in American art activities by holding exhibitions of the best contemporary work that could be secured, representative of American and foreign art. This statement, recorded in the official minutes, is the guiding principle of both the AAPS and the Armory Show and refutes later charges by some members that Davies and his group, by including so much European art in the show, had distorted the organization's original intention to sponsor American art exclusively.

Ultimately, there were twenty-five members in the AAPS, all of whom had achieved various degrees of recognition in the arts. Davies and Borglum, for example, were two of the best-known artists in America; some were members of "The Eight" or the Ash Can School; and seven were, in fact, members of the academy itself. In light of the critics' later negativism, it is important to emphasize that these members of the AAPS were not outsiders or incompetents but were, instead, a very distinguished group of artists who were dissatisfied with the academy's stagnation and the public's apathy toward the arts and who wanted to do something positive.

The first step taken was the acquiring of exhibition space. The National Academy of Design had always complained that New York had no adequate space for a large show, and several earlier attempts at independent exhibiting had failed because of limited facilities. As several possibilities were discussed, someone suggested an armory. Kuhn then visited the new armory of the 69th Regiment of the National Guard and, finding it had promise, agreed to a rental fee of fifty-five hundred dollars for the month of February 15 to March 15, 1913.

In the late summer of 1912, as the AAPS considered various proposals concerning the nature of the exhibition, Davies and Kuhn saw a catalog for the Sonderbund Show in Cologne, Germany, which presented a large and varied selection of contemporary works along with some of their historical precedents. The two agreed that this was exactly the type of show they and their colleagues wanted, and Kuhn left immediately for Cologne, arriving on the last day of the Sonderbund Show. He was overwhelmed by what he saw; all the leading avant-garde artists and movements in Europe were represented—from the Postimpressionists and Neoimpressionists to the Fauves, the cubists, and the German expressionists.

Determined to reproduce or even to rival the Sonderbund Show, Kuhn visited The Hague, Munich, and Berlin, where he contacted dealers to arrange for the loan of works. In Paris, he solicited the help of an American painter and critic, Walter Pach, who introduced him to the most important artists, collectors, and dealers there. In early November, Davies arrived in Paris to help Kuhn and Pach finalize their arrangements. Then, leaving Pach in Paris as the European representative of the AAPS,

Davies and Kuhn went on to London to see the exhibition of modern art organized by Roger Fry at the Grafton Galleries. Although this was not as comprehensive a show as the Sonderbund, the Americans especially liked the works of Henri Matisse, which were featured in the exhibition, and made arrangements to borrow them.

Their arrival back in the United States in late November was accompanied by a public announcement that the following February the AAPS would present, for the edification of the American public, an exhibition of the most radical avant-garde art in Europe. The twenty-five members of the AAPS then went to work at a feverish pace to accomplish all that had to be done to mount such an exhibition—preparing the exhibition space, receiving shipments of foreign works, collecting the American works, writing and printing a catalog, publicity brochures, and invitations to the opening and, finally, hanging the exhibition.

Converting the huge, cavernous space of the armory into a facility appropriate for the exhibition of painting and sculpture was an almost Herculean task. The presentation was designed as a coherent explanation of the development of modern art. Davies intended to stress the inevitability of revolution and the continuity of tradition—that is, since art is a living thing and since life presupposes change, art must change; even though these changes may seem strange at first, eventually they will be accepted and will finally become traditional. To demonstrate this, twenty-four hundred running feet of wall was hung with paintings, and hundreds of sculptures—many life-size or larger—were placed on pedestals. Partition walls built on casters were used to divide the armory into eighteen octagonal rooms, with streamers of cloth suspended from the rafters to create a lower false ceiling. A system of arc lighting to illuminate the interior adequately was also installed.

Within two days, approximately thirteen hundred works of art were hung or mounted. Of these, about two-thirds were the works of American realists. Although some critics tried to maintain that the American works were better, or at least saner, than the "crazy" art of the foreigners, it was the work of the European avant-garde that captured all the attention and caused all the commotion—painters such as Vincent van Gogh, Paul Gauguin, Paul Cézanne, Georges Seurat and the Neoimpressionists, Henri Matisse and the Fauves, Pablo Picasso and the cubists, Marcel Duchamp, Wassily Kandinsky, and the sculptors Auguste Rodin, Aristide Maillol, Constantin Brancusi, Elie Nadelmann, and Wilhelm Lehmbruck. As the controversy intensified, the art critic of the *New York Globe* declared, "American art will never be the same again."

Impact of Event

First reactions to the Armory Show were positive, with both public and press labeling it "magnificent," "sensational," and "the most important exhibit ever held in New York." The New York press, critical in the recent past of the National Academy of Design's lack of active leadership in the art world and opposed to its constant demands for public funding, now delighted in pointing out that a small group of artists, privately funded, had managed to stage such a significant exhibition.

It was not long, however, before the show was being savagely attacked by the critics and by some artists. There followed what several scholars have characterized as an "aesthetic witch hunt," with the critics and the press turning public opinion against the European works in the show. Now the public came to jeer and ridicule— and the critic Kenyon Cox, in *The New York Times*, took the position that, rather than being a milestone in the progress of art, the show was simply full of "junk." Vicious comments by Cox and other critics, together with the good-natured jibes of some of the less conservative journalists, made the Armory Show seem more like a three-ring circus than an art exhibit. To some extent, however, all this negative publicity backfired on its perpetrators, as larger crowds than had ever before attended an American art exhibit rushed to see what the furor was all about. Seventy-five thousand people saw the show in New York, while two hundred thousand crowded into the Art Institute of Chicago, where all the European works and half the American section were exhibited from March 24 to April 16. In Boston, where only two hundred fifty of the European works were shown from April 23 to May 14, attendance was down to thirteen thousand.

Certainly the critical focal point of the show in New York was Duchamp's *Nude Descending a Staircase, No. 2* (1912). Reaction to this painting ranged all the way from amusement to puzzlement to anger. Some saw it as a crazy, irresponsible joke, while others protested in frustration that they could not find the "nude" and that, anyway, it looked more like an "explosion in a shingle factory" than art. Extremist critics saw the painting as the ultimate in moral degeneracy.

The circus atmosphere that had pervaded the armory continued when the exhibition moved to Chicago, but the charges that the works were lewd, indecent, and morally degenerate increased greatly. Clergymen and schoolteachers led the attack, declaring the exhibit off-limits to innocent children. H. E. Webster of the *Chicago Examiner* claimed that the institute had been desecrated by the pollution and the blasphemous innovations exhibited in its galleries. Charles Browne, president of the Society of Western Artists, declared to an Evanston ladies' club that, since the body was the temple of God, the cubists had profaned the temple; the president of the Chicago Law and Order League hysterically called for the suppression of the exhibit on grounds that the law prohibited the hanging of such pictures in saloons. Finally, the students at the Art Institute, encouraged by an academically oriented faculty, burned Matisse and Brancusi in effigy. The reaction in Boston was mild, but attendance was fairly good, and the AAPS made a profit.

In the final analysis, the Armory Show was a more serious threat to traditional art than to modernism. As time passed, it became obvious that the public had not been deluded or corrupted by the art of degenerates, lunatics, and political subversives, as the conservatives had claimed would happen. On the other hand, these champions of the status quo were unable to develop positive artistic alternatives to the avant-garde art they had attacked so violently, and eventually their own art became a pale academic imitation of those very avant-garde forms.

Without doubt, the Armory Show was a remarkable achievement and a turning

point in the history of American art. Related to past, present, and future, it was both an ending and a beginning. It brought to fruition the efforts of two earlier groups to upset the status quo of American art—the Independent movement of Robert Henri and the realists and the modernist movement led by Alfred Stieglitz at his "291" Gallery. Almost immediately, the Armory Show had a direct effect upon established values in the art world. Three hundred paintings had been purchased directly from the show, and prices for European avant-garde art rose rapidly. There were many evidences of change in American art and collecting, as new galleries dealing in modern art began to appear. Major collectors such as John Quinn, Katherine Dreier, Walter Arensberg, and Arthur Jerome Eddy focused on modern art, developing private collections that eventually became the nuclei of America's great public collections. The more progressive American artists, whose works would previously have been exhibited only by "291," now found it much easier to gain acceptance. Moreover, before travel and communications were disrupted by World War I, more American artists than ever before went to Europe to study.

The full impact of the Armory Show was not felt for another thirty years, perhaps, as it continued to have a profound effect on artists, collectors, and the art market. The very character of American art was transformed by the winds of change that arose from the Armory Show, and it can now be said that "American art never was the same again."

Bibliography

Brown, Milton. *The Story of the Armory Show.* New York: Abbeville Press, 1988. Brown covers the founding of the AAPS, the history of the organization of the exhibit, the critical reactions, and the influences that the show had. Also contains a catalog, the constitution of the AAPS, and a list of backers, lenders, and buyers. The most complete history of the show.

Green, Martin. *New York, 1913: The Armory Show and the Paterson Strike Pageant.* New York: Charles Scribner's Sons, 1988. Discusses the Armory Show and the strike of the textile workers in Paterson, New Jersey, which occurred at the same time. The author attempts to relate these two events in spirit, as well as in time, but admits that it is difficult to find a point of view and set of terms that apply equally to both.

Henry Street Settlement, New York. *The Armory Show: Fiftieth Anniversary Exhibition, 1913-1963.* New York: Author, 1963. Contains the complete catalog of the 1913 show, with full documentation of works. Also includes letters, essays, articles, photographs, and cartoons from 1913, statements by artists, and an analysis of the 1913 show written by Milton Brown.

Schwartz, Constance H. *The Shock of Modernism in America.* Roslyn Harbor, N.Y.: Nassau County Museum of Fine Art, 1984. The catalog of an exhibition featuring works by "The Eight" and some of the artists represented in the Armory Show. Accompanying essays characterize American art in the early twentieth century and discuss the influence of several independent exhibitions and developments

leading to the Armory Show. Also contains a brief history of the Armory Show and an epilogue.

Young, Mahonri Sharp. *American Realists, Homer to Hopper.* New York: Watson-Guptill, 1977. Discusses the works of many of the American artists represented in the Armory Show. Gives the reader an excellent understanding of the tradition of realism in American art. Well illustrated throughout.

LouAnn Faris Culley

Cross-References

Avant-Garde Artists in Dresden Form Die Brücke (1905), p. 134; Les Fauves Exhibit at the Salon d'Automne (1905), p. 140; Artists Find Inspiration in African Tribal Art (1906), p. 156; The Salon d'Automne Rejects Braque's Cubist Works (1908), p. 204; The Futurists Issue Their Manifesto (1909), p. 235; Der Blaue Reiter Abandons Representation in Art (1911), p. 275; Apollinaire Defines Cubism in *The Cubist Painters* (1913), p. 337; Duchamp's "Readymades" Challenge Concepts of Art (1913), p. 349; Malevich Introduces Suprematism (1915), p. 413; The Dada Movement Emerges at the Cabaret Voltaire (1916), p. 419; *De Stijl* Advocates Mondrian's Neoplasticism (1917), p. 429; New York's Museum of Modern Art Is Founded (1929), p. 782; The Whitney Museum Is Inaugurated in New York (1931), p. 885; *Abstract Painting in America* Opens in New York (1935), p. 1001.

WEBERN'S *SIX PIECES FOR LARGE ORCHESTRA* PREMIERES IN VIENNA

Category of event: Music
Time: March 31, 1913
Locale: Vienna, Austria

The 1913 premiere of Anton von Webern's Six Pieces for Large Orchestra, Op. 6, on a program with pieces by Arnold Schoenberg and Alban Berg caused a scandalous riot

Principal personages:
> ANTON VON WEBERN (1883-1945), the most radical and advanced of the three central members of the Second Viennese School of composers
> ARNOLD SCHOENBERG (1874-1951), the composer who was the leader and teacher of the younger members of the Second Viennese School
> ALBAN BERG (1885-1935), a composer and the third major member of the Second Viennese School
> GUSTAV MAHLER (1860-1911), the great conductor and composer who was an inspiration and model for the members of the Second Viennese School

Summary of Event

Perhaps they should have known better. Certainly, Arnold Schoenberg should have; he had witnessed milder versions of the riot that broke out at the March 31, 1913, concert in Vienna's major music hall. Hisses, boos, laughter, and the noise of whistles mingled with the applause for the "new" music of Schoenberg, Alban Berg, and Anton von Webern featured at the concert. Eventually, complete chaos broke out, and the hall was filled with fistfights, shouting, and challenges to duels. Even the police could not restore order; it took half an hour to clear the hall. Later, several of the combatants were fined in the court case that ensued.

Schoenberg, the leader and teacher of a new school of composers who were turning their backs on the overripe harmonies of late Romantic music like that of Richard Wagner and Richard Strauss, organized and conducted the concert as a showcase for Berg and Webern, his best pupils. Studying with him since 1904, they were eager to have the public hear what were really their first orchestral compositions in the new atonal idiom, with which Schoenberg had been experimenting for several years. Eschewing the conventional major/minor key system that had dominated Western music for several hundred years, Schoenberg experimented with ambiguous harmonies and dissonance, with music that had no tonal center and hence was called "atonal."

Since 1906, Schoenberg had written and had performed—often to derisive hisses and laughter—a series of compositions, for orchestras smaller than the conventional

symphony orchestra, that used the voice in angular and expressive ways, valuing words and meaning over sweetness and flowing melody. He became an *enfant terrible* for a large segment of the Austrian and German public. Between 1906 and 1913, he had set forth onto new paths in music, overturning accepted conceptions of harmony and composition. With his followers—particularly Berg and Webern—he aggressively pursued his goals and fought for respect and recognition. It would never be easy.

Most important, perhaps, for Webern's own development was Schoenberg's 1909 work Five Pieces for Orchestra, Op. 16, which first clearly demonstrated the concept of tone-color melody. In the third piece of this set, "Colors" (later entitled "Morning by a Lake"), Schoenberg experimented with tone-colors between instruments as a means of creating melody. Schoenberg soon articulated this idea in a 1911 book on harmony; Webern, with his interest in medieval and Renaissance polyphony and contrapuntal practice, was intrigued. After all, in finishing his doctorate in musicology at the University of Vienna in 1906, he had edited and studied the complex vocal music of the fifteenth and sixteenth century Flemish composer Heinrich Isaac. Webern wanted to try to combine Schoenberg's own interest in reviving the art of canon and counterpoint (neglected in nineteenth century classical music, with its emphasis on the sonata form and increasingly rich triadic harmonies) with tone-color melody, so that linear (melodic) and vertical (harmonic) aspects of composition could be viewed as a single dimension.

This young group of experimental musicians became known as the Second Viennese School, in contradistinction to the line of great Viennese masters of the nineteenth century. Yet the new composers had strong links to the past and tradition and did not really think of themselves as revolutionaries. Rather, they thought of themselves as extending tradition or reviving older modes. In this effort, they did have the support of some of their older contemporaries—most notably Gustav Mahler. Mahler went to their concerts and encouraged their experiments until his sudden death in 1911. Indeed, his later compositions heralded the methods of Schoenberg, Berg, and Webern in many respects. In spite of Mahler's employment of large orchestral forces, he often broke these forces down into chamber groups and experimented with unusual timbral effects. In the song cycle *Kindertotenlieder* (1901-1904; songs on the deaths of children) and in the large symphonic song cycle *Das Lied von der Erde* (1909; The Song of the Earth), Mahler used chamber groupings and solo instrumental timbres as well as vocal lines of an intense expressiveness, which greatly impressed the members of the Second Viennese School. The three inner movements of Mahler's Seventh Symphony (1905) became models for tone-color experiments. These movements featured "coloristic" sounds from such instruments as guitar, mandolin, and cowbells within the compass of a large orchestra. Impressionistic and finally expressionistic, these experiments excited the young. Mahler became a hero to them, a foward-looking figure in the staid and conservative musical life of Vienna. Indeed, *Kindertotenlieder* was planned as the final piece for the March 31, 1913, concert, but because of the riot after the orchestral songs by Berg, it never was played.

The concert opened with Webern's new orchestral pieces. Although employing a large orchestra, Webern used his forces sparingly. Each piece was short, and the whole composition took about ten minutes. Textures were spare; short phrases and motifs shifted from instrument to instrument, and the sound level rarely went above some sort of pianissimo. After the second piece—lasting slightly longer than a minute—laughter erupted in the hall, countered by partisan applause. Such conciseness of form and coloristic use of instruments—as well as a lack of a clear tonality—put off much of the audience. Some songs by a more conservative contemporary, Alexander von Zemlinsky, calmed things down. The playing of Schoenberg's own Chamber Symphony, though, occasioned hissing and fistfights, even though this work from 1906 was less radical than Webern's work. After an intermission, two of Berg's new orchestral songs were performed to growing restiveness. In fact, their performance set off the complete chaos that terminated the concert.

Berg had set to music poems by Viennese poet Peter Altenberg, who specialized in aphoristic, Symbolist verse that confused many. The combination of Altenberg's verse, Berg's pared down, chamber-like orchestral forces, and an angular, atonal, and expressionistic vocal line was too much for established tastes. The first song elicited laughter. Schoenberg had to stop midway through the second song to demand silence. Webern chimed in, yelling that the disrupters should be ejected, and the disorder began in earnest. Fistfights, applause, whistling, and the suggestion that admirers of the music should be committed to the local insane asylum brought the concert to an end.

Impact of Event

Both Berg and Webern were devastated by the concert and fled Vienna. It was in many ways a turning point. Obviously, many of the concert disrupters came prepared to deride the new music. For Schoenberg, it was a common kind of response to his experiments, but for the younger pupils it was a shock. For the rest of their lives, they were to receive varieties of such abuse and misunderstanding.

Webern, in particular, withdrew into himself and became for the rest of his life a semirecluse who earned his living from the 1920's on by conducting orchestras and choruses. Because in many ways his music was the most radical and offered the most stunning break with convention, it was the least accepted. Even today, Webern is thought to be the most "difficult" of the three major figures for concertgoers.

Webern, though, had no intention of changing his unconventional approach to composition; he had, in fact, already extended his experiments in composition beyond the manner of the Op. 6 pieces by the time they had their premiere. His Five Movements for String Quartet, Op. 5, of 1909 lasted about twelve minutes and was even more concentrated and elliptical than the orchestra pieces. Marked by rapidly shifting tempos and dynamics, an avoidance of repetition except in brief ostinati, and tremendous technical difficulty, this work presaged Webern's later work. Other compositions of the period from 1909 to 1914 showed Webern's interest in small motives that were constantly varied and passed from instrument to instrument in the

manner of tone-color melody.

The Six Bagatelles for String Quartet, Op. 9 (1911-1913) and the Five Pieces for Orchestra, Op. 10 (1911-1913) represented the summation of this first truly original phase of Webern's career. In both compositions, he stressed transparency of texture: The instrumental forces designed for specifically chamber-music compositions and for "orchestral" pieces became closer in size, as Webern as well as Schoenberg and Berg continued to turn away from the huge orchestras of late nineteenth century music-making. Webern also started to use rests and silences as part of the fabric of his music; activity and its suspension became normative. Instruments of the woodwind family were given new prominence, and all instruments had solo roles, one instrument to a part. The frequent use of the celesta, harp, mandolin, guitar, and various percussion instruments for tone-color melody effects began to dominate Webern's compositional practice. His use of the glockenspiel, xylophone, and harmonium recalled some aspects of Mahler's instrumentation, and he began to strive more and more for clarity and openness of texture, so that every line could be heard.

After World War I, Schoenberg devised what he called the twelve-tone method of composition. Using all twelve of the notes in the regular chromatic scale in a predetermined sequence gave the composer his model, or tone row, for a whole piece. Thus, a composition would be ordered not by major or minor key progressions and harmonies but by the tone row and various technical transpositions and reversals of it. Berg and Webern adopted this new method from Schoenberg, although they had both been working along similar lines even before 1920.

Webern's later works extend the methods he had developed before World War I, but within the more controlled twelve-tone format. Pieces such as the String Trio, Op. 20 (1926-1927), the Symphony, Op. 21 (1927-1928), the String Quartet, Op. 28 (1937-1938), and the Variations for Orchestra, Op. 30 (1940) extended his methods so that he scarcely seemed to be concerned with melodic ideas that had any definable rhythmic characteristics. Medieval canonic procedures still were a feature at times in these later compositions, but they showed an even greater concern for creating a sort of mosaic of sounds or tone colors through experiments with instrumental combinations from piece to piece. Timbral matters dominated, and the transformation of instrumental colors, a true tone-color melody approach, became central. Isolated units of rhythm were contrasted carefully for textural and timbral reasons. Extreme condensation and abbreviation of motives allied with silences and a sense of an acoustic space between notes and across the score brought an atomistic feel to these compositions. Webern's soundscape came to have a sense almost of stasis, a frozen and abstract quality.

After his death in 1945, Webern became the preferred model among the three major figures of the Second Viennese School for the young composers emerging in the early 1950's. Webern to them was the most radical and future-oriented. He most decisively rejected Romanticism in music, with its sweet and aching melodies, heavy orchestrations, and rich triadic harmonies. His spareness of texture and interest in extremes of instrumental tone color and playing practice (noted so carefully in his

scores) meant, for the young "serialists" who took the twelve-tone method and applied it rigorously, that they had a mentor who had thought through his music-making with a keen logic. His use of a minimum of notes and unusual groupings of instruments and sounds appealed to them, since they wanted to redirect Western music even farther away from its past. Whether their estimate of Webern was entirely accurate remains open to question. In one sense, he was the futurist in music; in another, he was a renovator of tradition. In either case, he was a seminal figure in twentieth century music.

Bibliography

Kolneder, Walter. *Anton Webern: An Introduction to His Works.* Berkeley: University of California Press, 1968. Offers discussion of all works with some technical matters and musicological illustrations. Understandable for the generally informed reader, and a good way to get used to some score reading even if the reader is not a musician. Bibliography and index.

Moldenhauer, Hans, and Demar Irvine, eds. *Anton von Webern: Perspectives.* Seattle: University of Washington Press, 1966. Papers from a conference that offer interesting personal and musical insights into less-known aspects of Webern's life and work. Comments by Igor Stravinsky, Ernst Krenek, and Egon Wllesz are useful, as is the exploration of Webern's early late-Romantic compositions.

Moldenhauer, Hans, and Rosaleen Moldenhauer. *Anton von Webern: A Chronicle of His Life and Work.* New York: Alfred A. Knopf, 1979. A massive book that is richly rewarding in its coverage of the contexts for Webern's work. All works covered, but not a close musical or technical study. Good use of manuscript and unpublished music. Illustrated. Bibliography, index, list of works in detail.

Neighbour, Oliver W., Paul Griffiths, and George Perle. *The New Grove Second Viennese School.* New York: W. W. Norton, 1983. Taken from the *New Grove Dictionary of Music and Musicians* (1980) and revised, these short essays are excellent introductions to Schoenberg, Berg, and Webern, with detailed lists of works, illustrations, musical examples, and index.

Rosen, Charles. *Arnold Schoenberg.* New York: Viking, 1975. A hundred-page essay that helps the reader understand the significance of the composer's work. Useful chronology, no index.

Slonimsky, Nicolas. *Music Since 1900.* 4th ed. New York: Charles Scribner's Sons, 1971. This massive book covers all key events in (mostly) classical music, along with Slonimsky's descriptive comments on the pieces and often witty appraisals of the concert scene. Included are documents and letters focusing on the new directions (including the Second Viennese School) of music in the twentieth century. A detailed "Dictionary of Terms" is also helpful. Index.

Wildgans, Friedrich. *Anton Webern.* London: Calder and Boyars, 1966. A useful short study of the music, less technical than Kolneder's. Brief index.

Frederick E. Danker

Cross-References

Mahler Revamps the Vienna Court Opera (1897), p. 7; Strauss's *Salome* Shocks Audiences (1905), p. 151; Schoenberg Breaks with Tonality (1908), p. 193; Mahler's Masterpiece *Das Lied von der Erde* Premieres Posthumously (1911), p. 298; Schoenberg Develops His Twelve-Tone System (1921), p. 528; Berg's *Wozzeck* Premieres in Berlin (1925), p. 680; Berg's *Lulu* Opens in Zurich (1937), p. 1078; Messiaen's *Quartet for the End of Time* Premieres (1941), p. 1206; Boulez's *Le Marteau sans maître* Premieres in Baden-Baden (1955), p. 1656.

THE RITE OF SPRING STUNS AUDIENCES

Categories of event: Music and dance
Time: May 29, 1913
Locale: Théâtre des Champs-Élysées, Paris, France

The first performance of The Rite of Spring *startled the music and dance worlds with aggressive rhythms, cacophonic sounds, primitive, sexually oriented dance, and stark sets*

Principal personages:

IGOR STRAVINSKY (1882-1971), the composer of the music for *The Rite of Spring* and other Ballets Russes productions

SERGEI DIAGHILEV (1872-1929), the impresario who founded the Ballets Russes company and commissioned the production

VASLAV NIJINSKY (1890-1950), the famed dancer who choreographed the ballet

PIERRE MONTEUX (1875-1964), the orchestra conductor for many of Stravinsky's premiere works, including *The Rite of Spring*

NIKOLAY ROERICH (1874-1947), the principal set and costume designer for the ballet production of *The Rite of Spring*

Summary of Event

In 1897, a former law student, Sergei Diaghilev, brought organizational talents to the Russian artistic society Mir Iskusstva ("world of art"). He sponsored the society's painting exhibitions and edited its controversial journal. When the journal ceased publication in 1904, he continued to sponsor the exhibitions. Between 1906 and 1908, Diaghilev presented a series of Russian cultural exhibitions—concerts, paintings, and operas—in Paris. When interest exceeded his expectations, he invited stars from the Russian Imperial Ballet—including Anna Pavlova, Tamara Karsavina, Michel Fokine, and the soon-to-be-legendary Vaslav Nijinsky—to dance in Paris.

In 1909, Diaghilev organized the Ballets Russes, a company that presented Russian dance styles to Paris audiences and, in the process, revolutionized ballet. The repertoire of the Ballets Russes included *L'Oiseau de feu* (1910; *The Firebird*) and *Petrushka* (1911), with music by Igor Stravinsky, and *Schéhérazade* (1910), performed to the music of Nikolay Rimsky-Korsakov. The company's chief set designer was Léon Bakst, whose sense of color influenced not only stage designs but even women's fashions. Diaghilev's other artists from Russia, Alexandre Benois and Nikolay Roerich, like Bakst, were members of Mir Iskusstva. Diaghilev also employed illustrious Western painters such as Pablo Picasso, Joan Miró, and Henri Matisse and the composer Claude Debussy.

The most dramatic moment in the history of the Ballets Russes was the premiere

of *Le Sacre du printemps* (*The Rite of Spring*) in Paris on May 29, 1913. The idea for the ballet came to Stravinsky when he was finishing *The Firebird* in 1910. Both Roerich and Diaghilev were excited by the concept and encouraged Stravinsky to write it, but shortly after beginning work on the project, he hit upon the idea for another ballet that became *Petrushka*. He did not finish the score for *The Rite of Spring* until 1912; the ballet's production was then delayed by Diaghilev, who wanted Nijinsky to complete the choreography for the ballet *L'Après-midi d'un faune*. This permitted Stravinsky time to alter the orchestration while he was also working on other projects.

Following the Ballets Russes Paris season of 1912, Stravinsky went to London in June for the English premiere of *The Firebird* and then returned to Russia to do more work on *The Rite of Spring*. In the autumn, he went to Berlin with the Ballets Russes to attend a performance of *Petrushka*. In Berlin, Stravinsky met Arnold Schoenberg, Anton von Webern, and Alban Berg, the famous trio of modern German composers.

The Paris season of the Ballets Russes opened in May, 1913, in a new venue, the Théâtre des Champs-Élysées, and the first week was devoted to the ballet *Jeux*, with music by Claude Debussy; the second week was the opera *Boris Godunov*. The third week introduced *The Rite of Spring*. It is difficult to say whether the music or the dance was responsible for most of the controversy that took place on the ballet's opening night. Nijinsky's choreography of Stravinsky's work, in which Marie Piltz danced the leading role, demonstrated spasmic and frenzied motions that were ill-understood even by Nijinsky's followers. The cacophonous music caused some derisive laughter during the introduction. Indignation increased when the dancers appeared and increased again when supporters retaliated against the protesters. The uproar was such that hardly a note could be heard, and the noise continued unabated throughout the entire presentation. The event nearly caused a riot in the newly built theater. Many of the people, in fact, were fighting to keep order and to restrain the protesters; others were literally engaged in fisticuffs. The company was able to stage two more performances of *The Rite of Spring* before going to London.

Based on a pagan story from ancient Russia, *The Rite of Spring* consisted of thirteen episodes in two parts, the "Adoration of the Earth" and the "Sacrifice." The bassoon solo that opened the piece was the only folk theme employed by the composer. Although evoking faint images of Russian folk ideas, the remainder of the music was purely original. In the ballet's closing scene, a group of elders sat in a circle while a chosen maiden (Piltz) danced to total exhaustion and death to ensure that the god would allow spring to emerge once more from the bowels of the earth. Stravinsky's music was designed to convey turmoil and dissonance rather than the idyllic image of spring so often depicted by artists. The composer was immensely aided in his libretto by Roerich, who was also an archaeologist of the ancient Slavs. Fittingly, the thirty-four-minute work was dedicated to Roerich.

Unfortunately, Stravinsky was unhappy with Nijinsky's choreography. Whereas Stravinsky had conceived his music for simple, mass movements, Nijinsky forced the dancers to experiment with complicated styles that seemed unnatural. Stravinsky

recognized that Nijinsky was the most exciting dancer that he had seen but that he knew almost nothing about music and had been forced into the role of choreographer by his patron, Diaghilev. Consequently, Nijinsky's difficult steps in *The Rite of Spring* could not be completed without a slowing of the music, a development that could not but displease the composer. Finally, for a passage which Stravinsky had imagined as a scene of nearly motionless young dancers (the "Danses des Adolescents"), Nijinsky employed what the composer characterized as a jumping competition.

Stravinsky's cataclysmic score, with its complex rhythms and changing meters (not one bar was followed or preceded by a similar meter) led Nijinsky to choreograph dances that audience members saw as mere frenzy—hence the near-riot conditions. When Stravinsky went backstage, he saw Nijinsky yelling out the beat by numbers so that the dancers could continue. Nijinsky was so furious at the crowd's behavior that Stravinsky had to hold him back to keep him from darting out onto the stage. In short, the event may have been the most thunderous outburst in musical history.

Diaghilev, who may have been pleased with the reaction, had a premonition of the strong reaction to Stravinsky's music. Despite a successful dress rehearsal that went smoothly before invited guests, Diaghilev warned the dancers to concentrate on their movements and not on the reactions of the audience, and gave orders to conductor Pierre Monteux and the orchestra to complete the music without interruptions at all costs. When the commotion did break out, Diaghilev ordered the theater's electricians to turn the lights off and on in a desperate attempt to calm the storm.

Impact of Event

When the company opened in London, news of the Paris event was well known. To forestall another riot, Edward Evans, a critic for the *Pall Mall Gazette*, delivered a short introduction to the audience. The reception in London was much better; the reaction was mixed, but at least half the audience applauded through six or seven curtain calls. Shortly after the Paris opening, Stravinsky became ill with typhoid fever that kept him in a nursing home for six weeks; Monteux wrote to the ill composer that he was ashamed of his own countrymen and pleased at the reaction in England.

The Rite of Spring was performed as a concert piece in Moscow and St. Petersburg in February, 1914. Stravinsky's friend and fellow artist Alexandre Benois told the composer that he longed to hear it again, but Benois confessed that he was "completely bewildered" by the music and wondered whether it had been conducted correctly. About half the audience in St. Petersburg walked out near the beginning, but most of the remainder applauded with enthusiasm. Sergei Prokofiev wrote that he was so moved by the music that he was unable to recover from its effects. Stravinsky's own mother did not hear the music until a twenty-fifth anniversary performance in 1938; when she did, she admitted that it was not her type of music.

Monteux returned to Paris to conduct an April 5, 1914, concert version of *The Rite*

of Spring and *Petrushka* in the Casino de Paris. The 1914 Paris concert was so enthusiastically received that Stravinsky was carried from the hall on the shoulders of the audience; he later wrote to Monteux praising his expert rendering of the two pieces. On June 7, Eugene Goossens conducted the works in Queen's Hall in London to an appreciative audience. In 1924, Monteux introduced *The Rite of Spring* to audiences in Boston and New York with great success in both cities. Stravinsky was somewhat displeased with Monteux's recording of *The Rite of Spring* in the 1930's, but their relationship was not damaged. On the occasion of Stravinsky's seventy-fifth birthday in 1957, Monteux sent him a letter expressing his appreciation for the composer's confidence in him when he was young and noting that his own performances of those early ballets had enabled him to rise from the ranks. In 1963, a year before his death, the elderly Monteux again conducted *The Rite of Spring* for a fiftieth anniversary concert.

Stravinsky made a few revisions of the piece. In March, 1913, before the premiere, Monteux suggested a number of changes in orchestration when it was clear to him that several times the flutes or the horns could not be heard clearly. In 1921, Stravinsky made a few more changes and was pleased when a new choreography was designed by Léonide Massine. Ernest Ansermet conducted the new version in Paris in December of that year, with Lydia Sokolova dancing the part of the sacrificial maiden. In 1943, Stravinsky made further revisions of the last part of the composition.

Critics disagree on how much Stravinsky revolutionized music in the twentieth century. Certainly, he raised rhythm to a degree hitherto unknown. Commentators note that where melody dominated the era of classicism, harmony overshadowed rhythm and melody in the Romantic period. What Stravinsky did in *The Rite of Spring* was to raise rhythm to the point where it subordinated both harmony and melody, confining the latter to small, constantly repeated motifs. In fact, in *The Rite of Spring*, the whole orchestra became for long stretches a kind of sustained percussion instrument. The rhythmic fury of the piece, devoid of symmetry, was intended to reflect the savage, even brutal eruption of the new season, like the joy experienced from the pains of labor in childbirth.

The controversy surrounding *The Rite of Spring* certainly did not harm the Ballets Russes. Bolstered by emigré dancers from the Russian Imperial Ballet, the company continued its spectacularly successful Paris run until Diaghilev's death in 1929.

Bibliography

Buckle, Richard. *Diaghilev*. New York: Atheneum, 1979. A thorough and readable account. Especially useful is the section "The Fokine-Nijinsky Period," in which the author explores the reasons for Diaghilev's separation from Nijinsky and also from his sister, Nijinska. The documentation in this and the following work is exhaustive.

_____. *Nijinsky*. New York: Simon & Schuster, 1970. Presents the most complete information about Nijinsky and his contemporaries. A standard, reliable work, revealing especially the shocking sources of the dancer's inspiration and his

difficult relationship with his patron. Especially useful are the voluminous explanatory endnotes.

Petrov, Vsevolod N., and Aleksandr Kamenskii. *The World of Art Movement in Twentieth Century Russia.* Leningrad: Aurora, 1991. A truly magnificent work consisting of separate historical essays by the two authors. Biographical articles on Benois, Bakst, Diaghilev, and Roerich. A color photograph of one of Roerich's sets for *The Rite of Spring*, "The Kiss to Earth," is included. A separate chapter covers Diaghilev's musical productions from 1907 to 1924. Replete with reproductions of photographs and color paintings.

Stravinsky, Igor. *Stravinsky: An Autobiography.* New York: Simon & Schuster, 1936. Because so many of his thoughts and statements had been disfigured, Stravinsky stated, it was necessary for him to tell the story of his life clearly and accurately, even if he was rather young to write such a work. He notes that he did not consider himself a revolutionary and that the inspiration for *The Rite of Spring* was a special case of the music flowing from the conception of the story.

_____. *Stravinsky: Selected Correspondence.* Vol. 2. Translated and edited by Robert Craft. New York: Alfred A. Knopf, 1984. Edited by a conductor, music historian, and close friend of Stravinsky. Particularly relevant are sections of the book covering extensive correspondence with Diaghilev and Monteux and letters from Nijinsky. The letters to and from Diaghilev are remarkably short; those with Monteux, most revealing.

Stravinsky, Igor, and Robert Craft. *Memories and Commentaries.* Garden City, N.Y.: Doubleday, 1960. Consists of Stravinsky's responses to Craft's questions as they rehearsed his childhood experiences in Russia, the concerts and dancers in St. Petersburg, and the Diaghilev years. The composer's comments on his contemporaries are fresh, warm, and amazingly candid.

Strobel, Heinrich. *Stravinsky: Classical Humanist.* Translated by Hans Rosenwald. 1955. Reprint. New York: Da Capo Press, 1973. Strobel provides a short, readable text for the nonspecialist who wishes to understand the musicality of the early Stravinsky pieces. He argues also that Stravinsky was less of a revolutionary than imagined.

Vlad, Roman. *Stravinsky.* 3d ed. New York: Oxford University Press, 1978. A short but useful analysis of the composer that was originally a series of Italian television broadcasts in 1955 and 1956. Reviews the arguments about whether Stravinsky was a reactionary, classicist, or revolutionary while noting that *The Rite of Spring* featured the dominance of rhythm to an extent not heard in six hundred years.

White, Eric Walter. *Stravinsky: The Composer and His Works.* 2d ed. Berkeley: University of California Press, 1979. The biographical half of the book provides the most detailed account of the events leading up to the production of *The Rite of Spring*; the second half is an examination of the basic data relating to all of Stravinsky's compositions.

John D. Windhausen

Cross-References

Duncan Interprets Chopin in Her Russian Debut (1904), p. 113; Strauss's *Salome* Shocks Audiences (1905), p. 151; Pavlova First Performs Her Legendary Solo *The Dying Swan* (1907), p. 187; Schoenberg Breaks with Tonality (1908), p. 193; Diaghilev's Ballets Russes Astounds Paris (1909), p. 241; Fokine's *Les Sylphides* Introduces Abstract Ballet (1909), p. 247; *The Firebird* Premieres in Paris (1910), p. 269; *L'Après-midi d'un faune* Causes an Uproar (1912), p. 332; Stravinsky Completes His Wind Octet (1923), p. 561; Stravinsky's *The Rake's Progress* Premieres in Venice (1951), p. 1514.

ASCAP IS FOUNDED TO PROTECT MUSICIANS' RIGHTS

Category of event: Music
Time: February 13, 1914
Locale: New York, New York

The founding of the American Society of Composers, Authors, and Publishers (ASCAP) was a turning point in the effort of those who create and distribute music to earn decent livings

Principal personages:

VICTOR HERBERT (1859-1924), a composer and classical musician best known for his operettas who was one of the founders of ASCAP

NATHAN BURKAN (1878-1936), a copyright lawyer instrumental in the founding of ASCAP

GEORGE MAXWELL, a music publisher who helped to found ASCAP and who became the society's first president

Summary of Event

Early in February, 1914, the American Society of Composers, Authors, and Publishers (ASCAP) was founded, and the new group held its first general meeting on February 13. The organization's purpose was to ensure that songwriters and publishers would receive compensation (royalties) when their music was publicly performed in such venues as theaters, restaurants, and cabarets, as mandated by a 1909 U.S. copyright law. When radio became a major venue for musical performances after 1920, it, too, became a central source of revenue, as did motion pictures, which even in the silent era were accompanied by live music. With the advent of sound films after 1927 and, later, television, ASCAP assured itself—after much legal hassle—of new domains to monitor.

ASCAP and later performing-rights organizations such as Broadcast Music, Incorporated (BMI, founded in 1939) and the Society of European Songwriters, Authors, and Publishers (SESAC, founded in 1931) are essentially centralized clearing houses that hold catalogs of thousands of songs from thousands of publishers. These organizations monitor the performances of their catalog items and collect royalties through a complex system of licensing fees.

According to legend, the popular turn-of-the-century composer Victor Herbert sparked the formation of ASCAP. Having heard what he thought a wretched performance of his hit song "Kiss Me Again" in a New York City cabaret, he was determined to help set up some kind of control over what he considered to be the "piracy" of his music. After the passage of the copyright law of 1909, which contained a clause that gave copyright holders (both writers and publishers) control of their works of music, a group of interested parties, including Herbert, sat down at a New

York City restaurant in late 1913 to formulate their plans.

After ASCAP was officially founded in February, 1914, copyright owners could join together and combine their individual catalogs into a single catalog and force anyone who wanted to use their music to take out a license for that whole catalog. People were hired to administer this single catalog, monitor its use, and collect fees. Songwriters and publishers would divide up the revenue among themselves based on set formulas. Thus, a private organization was set up to enforce a public law.

Acting as a mediator between individuals, publishers, and the live media, ASCAP was always attentive to the bringing of new technologies into its domain. Though especially tough legal battles were involved, radio broadcasters, the motion-picture industry, and television eventually proved to be great sources of revenue. With more than thirty thousand writers and about twelve thousand publishers by the 1990's, ASCAP grew to share with BMI the dominance of the performing-rights field.

Thus, the evolution of copyright law and rapid changes in technology saw a creative activity transformed into a profit-making enterprise; the legal system came to legitimize a domain that involved the mass production of popular culture. The context of such a situation is important to understand.

By 1900, America was quickly urbanizing—especially in such cities as New York and Chicago—and industrializing. The music industry was growing just as quickly. Sheet music sold in increasing volume, with sales reaching a peak in 1918. Since Thomas Edison's invention of the phonograph in 1877 (in the cylinder format) and Emile Berliner's subsequent invention of the flat disc, millions had come to listen to recorded music. Player pianos became popular in the early twentieth century; sales of these pianos peaked in the 1920's. Clearly, rapid changes in music-delivery systems were taking place. Indeed, another clause in the 1909 copyright law (a revision of much older British and American laws) provided the legal basis for collecting fees on "mechanical rights." Since the performing-rights societies did not involve themselves directly in monitoring recordings, the Harry Fox Agency, founded in 1927, came to license recordings.

Impact of Event

The creation of ASCAP and other performing-rights agencies ensured that composers and lyricists—including the many ASCAP members who wrote classical music—could earn a living by their craft. The twentieth century witnessed a great growth in creative activity in American music and entertainment, especially on the East and West coasts. The American musical theater centered on Broadway became a world-renowned contribution to the arts only after 1900. The talents of newer immigrants to America shone there; Jewish immigrants, in particular, brought their rich folk and musical heritage with them from Europe and wrote a major portion of the popular songs and musical shows of the first half of the century. Hollywood represented the other great flourishing of American entertainment talent.

By helping many creative artists working on Broadway, in Hollywood, and in the young recording industry to reap financial rewards for their labors, ASCAP and the

other performing-rights organizations played a key role in the development of a more democratic world of popular art.

The significance of ASCAP as a watchdog for creative artists and their publishers became especially apparent after 1920, when the radio industry became an increasingly important source of public performances and the motion-picture business became a mass industry. Home performances from sheet music declined as a large nonparticipant audience emerged. With the arrival of sound films after 1927 and the interest of Hollywood studios in controlling the increasing amounts of music used in films, problems arose with ASCAP's monopoly on the domain of popular music, and the studios bought up music publishers who were still independent of ASCAP.

Many legal battles ensued, and by the 1930's, complex definitions and subtle resolutions of what constituted use and public performance of music resulted. In some cases the federal government had to intervene, with new laws and decrees setting forth limits and boundaries. The Department of Justice and Congress got involved in disputes over performance rights.

ASCAP has continually expanded its boundaries and domain as newer technologies and forms of mass media have forced redefinitions of public performances, and such expansion has often caused friction among writers, publishers, and others involved in the music business. The formation of rival BMI in 1939 reflected much of this dissatisfaction; at the same time, BMI's founding symbolized both the expanding scope of the mass-media use of music and the very democratic spread of popular culture beyond the two coasts. ASCAP's failure, at first, to comprehend the very size of the creative surge it had originally harnessed was as much a part of the problem as was its somewhat biased attitude toward music that came from sources outside the cultural mainstream.

Simply put, most ASCAP members had little knowledge of or interest in what was then termed "race" and "hillbilly" music. These indigenous forms of American music were not really part of the catalog ASCAP featured; ASCAP music was largely from New York and was aimed at the middle class and the lovers of Broadway songs. ASCAP tunes were mainstream standards offered to mainstream people and sung by middle-of-the-road singers. Early jazz and blues music was not considered worthy of much attention; for the most part, such music was performed in out-of-the-way places for less affluent audiences, and it did not find its way onto network radio shows. Records were important for race and hillbilly performers, but recordings did not yet dominate the world of these indigenous artists. In the early years, most jazz, blues, folk, and folk-derived music was simply beyond the purview of the majority of ASCAP members.

Two instances stand out to illustrate the problem: the cases of Jelly Roll Morton and Gene Autry. Although jazz became part of the musical mainstream in the 1930's, many of its early practitioners had difficulties in working with the established music industry. Racial bias was doubtless in part to blame. In addition, much instrumental jazz and many songs in the blues vein stemmed from black folk sources and expressed a worldview quite different from that of the mass of ASCAP material. By the

1930's, there was censorship of material on records and pressure to tone down live performances.

Jelly Roll Morton was one of the founders of jazz as a composer, pianist, and leader of small bands. A footloose man in the tradition of the folk itinerant, Morton was seemingly quite casual about his copyrights and relations with publishers. Most black and rural white musicians did not and could not easily keep abreast of the latest legal and technical aspects of the music business, which was centered in New York; small radio stations, small clubs, and the road were the norm for most such performers. By the late 1930's, Morton felt that his publisher had not been fair with him and that the powers at ASCAP had neglected him when he applied for membership in 1934. He was not allowed to join ASCAP until 1939, just two years before his death. He died still planning to sue his publisher and ASCAP for back royalties.

Both black and white musicians who worked in such genres as early jazz, blues, polka, Latino, and country music often sold away their copyrights to small-time publishers, who often promised to do wonders recording or promoting their songs. Many times, that was the last such artists heard of their material; many saw no royalties at all and did not even know about ASCAP.

The experience of country star Gene Autry was perhaps even clearer evidence of ASCAP's predilections. Autry became a popular singer after 1930, first as a star of Chicago's WLS National Barn Dance, then as cowriter and singer of the hit "Silver-Haired Daddy of Mine," and finally and most spectacularly as a singing cowboy from 1934 on in Hollywood. He wrote songs, and all his films featured several. Yet he felt that ASCAP looked askance at him and his music. He claimed that he approached ASCAP for membership in 1930 and that the organization paid him no attention. Not until 1938, when he was among the most popular Hollywood box-office attractions, did ASCAP grant him membership; Autry has maintained that it was his motion-picture fame that caused ASCAP to capitulate.

Distinguished black musicians including Eubie Blake, Fats Waller, Louis Armstrong, and Cab Calloway did not receive ASCAP membership until mid-career. Although Duke Ellington became a member near the start of his career, he claimed as late as 1973 that he had a difficult time in convincing ASCAP of his worthiness. Autry and Jimmie Davis, another country singer and songwriter who later was twice governor of Louisiana, argued before Congress that ASCAP simply did not understand their kind of music and, in that sense at least, discriminated against them.

Times have changed. In 1939, ASCAP's attempt to impose higher rates on broadcasters as their contracts came up for renewal led to a boycott of all ASCAP music on network radio. Before the issue was resolved, a group of those broadcasters got together and decided to form another performing-rights organization, and BMI was born. After 1940, ASCAP did continue to flourish, but BMI managed to collar the minority music creators whom ASCAP had neglected. With the ban on ASCAP material, this more indigenous music made it to the air and found success. Radio continued down the years in tapping into what had been to ASCAP an untapped vein of music, including such forms as blues, jazz, rhythm and blues, and rock and roll.

Those forms largely became the new mainstream, and ASCAP and BMI have both benefited from the development.

When rhythm and blues experienced growth in the early 1950's, BMI was ready: It had had an open-door policy toward black musicians. When rock and roll burst upon the scene in the mid-1950's, BMI was there again to sign up the writers and publishers. By the 1990's, BMI, with some sixty-five thousand writers and thirty-seven thousand publishers, stood shoulder-to-shoulder with ASCAP.

ASCAP learned from these circumstances, and now it too encourages writers and publishers in country, rock, and various ethnic music fields. Established now even in Nashville, the historic home of much of the music it once ignored, ASCAP celebrated the opening of a new building on Music Row there in early 1992. As a result, performing-rights are more secure than ever before for creative artists in the United States.

Bibliography

Jasen, David A. *Tin Pan Alley: The Composers, the Songs, the Performers, and Their Times.* New York: Donald I. Fine, 1988. A study of American popular music from 1886 to 1956. Focuses on songs and songwriters and the role of the big publishers. Provides the reader with a picture of the musical world in which ASCAP thrived.

Ryan, John. *The Production of Culture in the Music Industry: The ASCAP-BMI Controversy.* Lanham, Md.: University Press of America, 1985. Wonderfully informative about all aspects of the popular music business. Includes anecdotes, charts, figures, and a fine overview that is able to encompass theory and practicality in its handling of complex matters.

Sanjek, Russell. *From Print to Plastic: Publishing and Promoting America's Popular Music, 1900-1980.* Brooklyn: Institute for Studies in American Music, Conservatory of Music, Brooklyn College, 1983. Based on lectures, this seventy-page book offers Sanjek's insights into the business. Less full on ASCAP, but a better read, than the volume below. Good supplement.

Sanjek, Russell, and David Sanjek. *American Popular Music Business in the Twentieth Century.* New York: Oxford University Press, 1991. A comprehensive and exhaustively detailed history of the subject, by an insider who was there through much of the period. Not an easy read in its attention to business complexities, but a definitive summary of events.

Shemel, Sidney, and M. William Krasilovsky. *The Business of Music.* Rev. ed. New York: Billboard Books, 1990. A bible for the music business. A fine encyclopedia, with many well-written and lucid guides to all aspects of the music industry, historical and contemporary. Chapters on copyright, performing-rights organizations, and mechanical rights provide the best introduction to the topics for the beginner.

Frederick E. Danker

Cross-References

Joplin Popularizes the Ragtime Style (1899), p. 13; Caruso Records for the Gramophone and Typewriter Company (1902), p. 69; Handy Ushers in the Commercial Blues Era (1910's), p. 252; The Art of Radio Develops from Early Broadcast Experience (1920's), p. 469; Sound Technology Revolutionizes the Motion-Picture Industry (1928), p. 761.

LIPPMANN HELPS TO ESTABLISH *THE NEW REPUBLIC*

Category of event: Journalism
Time: November 7, 1914
Locale: New York, New York

Designed to stimulate liberal Progressive reform, The New Republic *became an important vehicle for young Walter Lippmann's evolving public philosophies*

Principal personages:
> WALTER LIPPMANN (1889-1974), a distinguished journalist, editor, publicist, and, in time, America's preeminent public philosopher
> WILLARD STRAIGHT (1880-1918), a wealthy financier and diplomat who subsidized *The New Republic*
> HERBERT CROLY (1869-1930), an influential Progressive author, an organizer-editor of *The New Republic*, and a cosmopolitan political philosopher
> WALTER WEYL (1873-1919), a prolific Progressive author and original contributor to *The New Republic*

Summary of Event

Appearing on November 7, 1914, *The New Republic* loosed a stream of liberal social, political, and cultural analysis and criticism that continued into the 1990's. The inspiriting force behind inception of the journal, which was swiftly to become the flagship of American moderate liberal commentary, was the seemingly unlikely pair of Willard and Dorothy Straight. Each was wealthy and each was identified socially with the old-style capitalist establishment that their journal would seek to restructure. Willard Straight's wealth and notoriety came first from his association with the House of Morgan, then the nation's premier banking firm, as well as from his subsequent diplomatic services in China. Despite their wealth, the Straights' political dispositions were generously liberal. Accordingly, from its conception, *The New Republic* was bounteously subsidized by the Straights.

New York-born, a Harvard University graduate, and by 1909 renowned for his polemical *Promise of American Life*, Herbert Croly provided the executive and intellectual linkage between the Straights and *The New Republic*'s editorial and writing staff. Croly immediately enlisted the writing and editorial abilities of a fellow Harvard graduate and New Yorker, Walter Lippmann. Young, brilliant, idealistic yet practical, already widely traveled and well connected, Lippmann was steeped in the political, cultural, and intellectual currents of his age: Croly's "New Nationalism" (which became the battle cry of Theodore Roosevelt's Progressivism), William James's pragmatic psychology, John Dewey's programs for social and educational reform, Henri Bergson's intuitive philosophy, Friedrich Nietzsche's affirmation of the will,

Herbert George Wells's scientific utopianism, and the novel and exciting theories of Sigmund Freud. In sum, Lippmann had creatively exploited every advantage afforded him by his birth and education among the elite of New York's cosmopolitan Jewish community.

When he agreed to join Croly on *The New Republic*, Lippmann already enjoyed the esteem won him in intellectual circles by his *A Preface to Politics* (1913), and he further augmented that reputation with *Drift and Mastery: An Attempt to Diagnose the Current Unrest* in 1914. Both works reflected Lippmann's admiration for Theodore Roosevelt's brand of political Progressivism and his perception of Roosevelt himself as a model statesman. Like Roosevelt, Lippmann too favored strong political leadership, the fostering of a sense of civic responsibility, sympathetic address to the plight of labor and of the poor, and extensive federal regulation of the country's great corporate enterprises. Though Lippmann's reformism was heady stuff, he also shared with Croly and many other Progressives a more conservative interest in deflecting what were depicted as the nation's revolutionary currents. Avowedly contemptuous of Victorian traditions, disdainful of popular sentimentality about the political wisdom of majorities, dubious about the efficacy of electoral reforms, skeptical of the touted glories of free competition on the one hand and of socialist orthodoxies on the other, the acute and eclectic Lippmann championed reform and governance by scientifically trained experts who could seize control of events, then set and guide the public agendas at home and abroad.

Lippmann's informed enthusiasms were held in common not only with Croly but also with a host of prominent American and European progressives who reveled in the prospects of peacefully revolutionizing society. Lippmann was to be one of *The New Republic*'s conduits to these political reformers, artists, poets, professionals, and assorted intellectuals. Always ambitious, he was assiduous in effecting personal exchanges with prominent people whose views mattered. Among those whom he found weighty presences in the United States were muckraking reformers such as Lincoln Steffens and Walter Weyl, politicos such as Cleveland's Tom Johnson and the new and relatively unknown president, Woodrow Wilson, jurists such as Learned Hand, Oliver Wendell Holmes, Jr., and Louis D. Brandeis, social workers (principally Jane Addams), and presidential advisers such as Colonel Edward House and ascendant cabinet officers such as Newton Baker. Abroad, Lippmann numbered many productive contacts among Great Britain's fractious socialists such as Graham Wallas, Beatrice and Sidney Webb, George Bernard Shaw, Herbert George Wells, and John Hobson, in company with additional hosts of the most vital personalities among Great Britain's artistic, literary, social, and intellectual elites. Nearly a fourth of *The New Republic*'s early articles, commentaries, and reviews were to spring from this remarkable reservoir of British talent.

For *The New Republic*'s staff, Lippmann in addition corralled a number of his former Harvard friends. Hiram Moderwell provided contributions on music. Lee Simonson contributed on the fine arts, while Kenneth Macgowan furnished commentaries on the expansive new art form of film. Alfred Kuttner was invited to write

on the latest revelations afforded by psychoanalysis, and leftist John Reed, soon to be made famous by his observations on the Russian Revolution, explored the plight of the poor.

The quality of its overwhelmingly liberal staff and of its domestic and foreign essayists, commentators, and reviewers made *The New Republic* an important publication. Ronald Steel, Lippmann's ablest biographer, noted that the journal was first among the forums "for the most serious and original minds writing in English."

Impact of Event

The appearance of *The New Republic* and the burgeoning careers of Lippmann, Croly, and other staffers were synonymous with an era marked by exuberant cries for cultural and political change. Such reformist urges, or "progressivism," manifested themselves in Europe during the 1880's and 1890's—a decade before they became apparent in America—and, though not destroyed, were thrown into disarray by the cataclysmic events of World War I. American progressive reform was later to develop and was more parochial than its European counterparts; thus, superficially, it appeared more timid. Yet the movement was in full flood in 1914 as *The New Republic* went to press.

The provocative journal was almost instantly successful. Anticipating fewer than a thousand subscribers, the eager staff watched circulation rise to twenty-five hundred within a few months and to more than forty thousand by the end of World War I—by which time American progressivism also was entering into a conservative eclipse. Although Lippmann had hoped that *The New Republic* would stimulate a series of minor insurrections, and although the journal was left of the American liberal consensus, its general tone was restrained and responsible, whether its subjects of discussion were the arts or politics.

Explanations for *The New Republic*'s successful reception lay both in the spirit of the times and most assuredly in the quality of the magazine's contributors. Unquestionably, the timing of the journal's introduction was propitious. Late nineteenth century architectural, artistic, musical, and political forms were being altered in response to new visions and styles. In architecture, for example, Barcelona's Antonio Gaudí had designed seemingly bizarre structures that laid the basis of Art Nouveau; in Germany, the seeds of Walter Gropius' Bauhaus school had been sown in the first decade of the twentieth century. Radical departures in the fine arts were evidenced by Wassily Kandinsky's abstractions, Georges Braque's and Pablo Picasso's cubism, and the avant-garde contributions of Marcel Duchamp and others to New York's 1913 Armory Show, an exhibit that regaled Americans with striking new emotional and visual perceptions. In similar fashion, the new music of Gustav Mahler, Ralph Vaughan Williams, Aleksandr Scriabin, Arnold Schoenberg, and Edward Elgar, among others, was paving the way for fresh tonal and compositional creativity. Motion pictures had also begun transforming recreational patterns and opening vast prospects for artistic communication. In nearly every sphere touching people's daily lives—from cheaper newspapers to novel understandings of the composition or

character of man, matter, and the universe—fresh precepts, approaches, and techniques were demanding the attention of thoughtful publics.

A principal function of *The New Republic* was to initiate thinking Americans into the latent possibilities opened by these and analogous developments. Attainment of that goal rested on the shoulders of a staff and contributors whose collective quality and brilliance were unprecedented in American journalism. In addition to the contributions of Lippmann, Croly, Weyl, and other insiders, essays and comments featured during the journal's first year of publication were signed by some of the finest intellects in the Anglo-American world. Historian Charles Beard addressed the task of placing history at the service of society. James Harvey Robinson reviewed major Western intellectual currents. Social philosopher and educator John Dewey dealt with the pragmatic breaking of traditional educational molds. In his ruminations, Dewey was joined by Harvard's great philosopher, essayist, poet, and novelist George Santayana. Van Wyck Brooks, Ralph Barton Perry, and Randolph Bourne variously dealt with literary matters, and their work sometimes appeared together with that of George Bernard Shaw and Rebecca West. Politics, inclusive of foreign affairs, solicited the observations of a galaxy of intellectuals and insightful polemicists: Great Britain's rising leftist economist Harold Laski; the former British ambassador to the United States—and distinguished author of *The American Commonwealth* (1888)— James Bryce; and England's leading socialists, such as Norman Angell, Graham Wallas, and H. G. Wells. Rising stars of poetry and literature were also given exciting exposure: Amy Lowell, Robert Frost, Alan Seeger, Edwin Arlington Robinson, and Conrad Aiken, along with Theodore Dreiser.

While *The New Republic* brought American intellectuals into close contact with one another as well as with their foreign counterparts, its contributors—Lippmann notably—had some immediate effect upon the nation's politicians and political discourse. Although Lippmann was enamored of Theodore Roosevelt, neither he nor Croly spared their criticism of the former president. In fact, Roosevelt, who had been one of the journal's staunch fans, acerbically broke with its editors when they rebuked him for overreacting to Wilson's intervention in Mexico. Similarly, while the editors had generally supported Wilson, they likewise challenged his "New Freedom," believing it represented a throwback to the nineteenth century; their stance was much the same in regard to Wilson's Mexican adventure as well as to the president's version of World War I neutrality. Watched closely by other opinionmakers throughout the nation and abroad, *The New Republic* quickly developed a stature and a voice with which to be reckoned. After seven years, Lippmann, well-established as a major publicist, left the journal to pursue his own evolving career of public commentary.

Bibliography

Blum, D. Steven. *Walter Lippmann: Cosmopolitan in the Century of Total War.* Ithaca, N.Y.: Cornell University Press, 1984. Concentrates on synthesizing Lippmann's theoretical writings, which were aimed at devising a cosmopolitan public

philosophy appropriate to twentieth century problems. Very interesting and informative; scholarly, yet eminently readable. Not redundant of other works, and a fine complement to Ronald Steel's biography. Notes and useful index.

Lippman, Walter. *Public Philosopher: Selected Letters of Walter Lippmann.* Edited by John Morton Blum. New York: Ticknor & Fields, 1985. Arranged chronologically by a distinguished historian, these letters—in company with the editor's informative introduction, identifications, and annotations—provide fascinating insights into Lippmann's intellectual evolution. Lippmann's own writings are as good as anyone's writings about him. A Lippmann chronology is appended. Excellent index.

Steel, Ronald. *Walter Lippmann and the American Century.* New York: Vintage Books, 1981. Deservedly the standard biography of Lippmann. Interesting, scholarly, and intelligently critical, in addition to being a pleasant read. Affords a fine three-dimensional picture of Lippmann's personality and career. Twenty-five instructive photos and illustrations. A brief chronology, extensive notes, a short bibliographical essay, and a detailed index. The best work with which to begin an understanding of Lippmann.

Wellborn, Charles. *Twentieth Century Pilgrimage: Walter Lippmann and the Public Philosophy.* Baton Rouge: Louisiana State University Press, 1969. An insightful effort to define Lippmann's view of "political realities" as consisting of tensions between the human condition and what he understood as a world of underlying essences. Lippmann's impressive publications allow such analysis. Footnotes throughout; select bibliography and a detailed index. A slim, thoughtful volume.

Wright, Benjamin Fletcher. *Five Public Philosophies of Walter Lippmann.* Austin: University of Texas Press, 1973. Intelligent, scholarly, and readable, Wright's study proceeds on the assumption that Lippmann's estimates of the world and its changing realities inevitably caused adjustments in his public philosophy. Unlike many political theorists who maintained their central positions while altering minor points, Lippmann altered his basic position at least five times through his career. This is a slim volume with footnotes, a select bibliography, and an extensive index. Very informative. Contains details on the origins and aims of *The New Republic.*

Clifton K. Yearley

Cross-References

The Christian Science Monitor Is Founded (1908), p. 209; Wallace Founds *Reader's Digest* (1922), p. 549; Luce Founds *Time* Magazine (1923), p. 577; Luce Launches *Life* Magazine (1936), p. 1031; Buckley Founds *National Review* (1955), p. 1683.

THE DENISHAWN SCHOOL OF DANCE
OPENS IN LOS ANGELES

Category of event: Dance
Time: 1915
Locale: Los Angeles, California

American modern dance blossomed when Ruth St. Denis and Ted Shawn established a school that fostered the talents of the first generation of great modern dancers and helped to establish American dance as a legitimate art form

Principal personages

RUTH ST. DENIS (1879-1968), a highly theatrical dancer who toured on the vaudeville circuit and created exotic dances based on ethnic themes

TED SHAWN (1891-1972), a performer, educator, and author who created an audience for American dance among the middle-class theater clientele

MARTHA GRAHAM (1894-1991), a modern dance pioneer who received her initial dance training as a member of the Denishawn School and company

DORIS HUMPHREY (1895-1958), an American modern dancer who studied and performed with Denishawn from 1917 to 1928

CHARLES WEIDMAN (1901-1975), a modern dance performer and choreographer who studied at Denishawn from 1920 to 1928

LOUIS HORST (1884-1964), a musician and teacher of dance composition who served as musical director for the Denishawn School from 1915 to 1925

Summary of Event

The marriage of Ruth St. Denis to Ted Shawn in 1914 began a partnership that significantly contributed to the development of American modern dance. The institution of Denishawn, created from the collaboration of these two dancers and their respective surnames, emerged in the first few decades of the twentieth century as the impetus for a dance school, a pedagogic theory, and a performing company.

Ruth St. Denis and Ted Shawn officially acquired the name Denishawn on February 6, 1915. A theater manager ran a promotion in which contestants competed to name a ballroom dance that the couple performed on the vaudeville circuit. The winning name, Denishawn, then became the official title of the dance school directed by St. Denis and Shawn. The first Denishawn school was established in Los Angeles during the summer of 1915 as the Ruth St. Denis School of Dancing and Its Related Arts. In the summer of 1916, however, the school underwent a name change and became known thereafter as the Denishawn School.

Known for her exotic and highly theatrical dances, St. Denis supplied inspiration

and an image of glamour and spirituality to the Denishawn School. She emphasized the dance techniques of the East and included the history and philosophy of dance within her classes. St. Denis also experimented with music visualization at Denishawn. In this method, the movements and rhythms of each dancer directly corresponded with a specific instrument in the orchestral score. The dancers became physical manifestations of the musical notation.

Her husband and collaborator, Shawn, offered a more systematic approach to movement. Shawn maintained respect for formalized technical dance training and helped to create a curriculum of study at the Denishawn School. Although he did not view it as an exclusive form of training, Shawn felt that classical ballet was indispensable to the dancer, as long as the instructor taught with wisdom and discrimination. The Denishawn system of training included an adaptation of ballet instruction executed while barefoot. The curriculum included ethnic and folk dance, in addition to training in eurythmics, in which the dancer enhanced rhythmic sense and expression through a progression of physical exercises that were originally formulated by Swiss music teacher Émile Jaques-Dalcroze. Denishawn also offered beginning German modern dance as well as training derived from the work of François Delsarte. Delsarte, a French teacher of music and acting, developed a complex system of gesture in relation to human expression. Shawn maintained that Delsarte's teaching was the first to incorporate the concepts of tension and relaxation, or contraction and release, which still serve as a foundation for much of modern dance. A disciple of Delsarte was hired by St. Denis and Shawn to bring this training to Denishawn.

The Denishawn system of training was eclectic, yet energetic and colorful. A typical dance class at Denishawn began with stretching exercises performed with one hand on the ballet barre for support. The dancer performed a basic ballet warmup at the barres (which circumscribed the periphery of the studio) and then progressed to the center of the floor. Arm exercises were executed next, in addition to a series of balletic dance combinations designed to promote strength, flexibility, and coordination. After these initial exercises, the student performed an array of ethnic dance styles, including dances of Spanish, Hungarian, Japanese, and East Indian derivation. As a closure to classwork, dancers often learned an excerpt from the Denishawn repertory. A dance called *Tunisienne* promoted the dexterous use of finger cymbals. Japanese dance forms were taught via repertory dances such as *Lady Picking Mulberries*. Several other dances, such as *Serenata Morisca*, *Maria-Mari*, *Gnossienne*, and *Invocation to the Thunderbird* originated as classroom exercises; thus, performance repertory also emerged from the classroom dance combinations that St. Denis and Shawn taught at the school.

As a result of the Denishawn School, a dance company evolved that was destined to nurture some of the greatest names in modern dance. St. Denis and Shawn had performed together since 1914, and with the establishment of the school in 1915, the couple began training other dancers to perform with them. The Denishawn dancers performed a repertoire that was as eclectic and vigorous as was their classroom training. In a typical Denishawn concert, the company of from seven to twelve danc-

ers performed St. Denis' music visualizations, Spanish dances, Japanese pieces, dances sharing an Egyptian motif, and dances based on American themes. Most of the pieces were not authentic ethnic dances reflecting traditional cultural forms but were dances that retained a flavor of foreign lands. St. Denis, for example, incorporated authentic costumes and music for her Egyptian-based ballet *Radha*; however, the music was played on Western instruments.

Denishawn fostered and refined the talents of several dancers who would later become prominent figures in the field of modern dance. Martha Graham, Doris Humphrey, and Charles Weidman were among the early Denishawn dancers and teachers, fulfilling dual roles as performers with the company and instructors within the school. For a decade following the opening of the Denishawn School, musician and composer Louis Horst accompanied dance classes and served as musical director. Accompanied by a staff of talented artists, St. Denis and Shawn expanded Denishawn, opening an additional school in New York City and mentoring teachers of the Denishawn method in many small towns across the country.

Impact of Event

The partnership of St. Denis and Shawn that propagated the Denishawn School and company lasted for eighteen years. Between 1914 and 1932, the duo completed thirteen major tours of the United States and emerged as pioneers of American dance, creating an audience for the art form among the middle-class theater clientele much as the tours of Sergei Diaghilev did for ballet.

St. Denis and Shawn were advocates of diversity within the education of the dancer. They believed that a dancer must study a multitude of techniques and styles in order to become a more proficient performer. During the 1930's, Denishawn sponsored the first course in America that incorporated the dance technique created by German modern-dance pioneer Mary Wigman. Both Shawn and St. Denis continued to study dance forms themselves in an attempt to enhance their art, and while on tour in the Far East, the couple studied dance in Japan, China, Burma, India, and Ceylon.

Between August, 1925, and November, 1926, the Denishawn company toured the Far East and became the first American dance company to perform in the Orient. The company also performed in Great Britain, and Shawn presented a solo program during a three-month tour of Germany. St. Denis, Shawn, and the Denishawn dancers completed five individual concerts at the Lewisohn Stadium in New York City, the last of which marked the final performance of Denishawn on August 28, 1931. After this concert, the partnership of St. Denis and Shawn dissolved, and each followed an individual career in the dance world. Shawn toured with a group of male dancers and wrote several books on dance, including *Dance We Must* (1940) and *Fundamentals of a Dance Education* (1937). He taught dance at a number of colleges, thereby helping to establish and legitimize dance in academe.

In the latter part of the 1930's, Shawn formed a famous group of male dancers that toured the United States. He worked to dispel ideas of dance as solely a feminine activity and championed the cause of dance as a worthy occupation for men. Shawn

consistently commissioned original music scores for his choreography and began the practice of collaboration with composers. Much of his choreography explored specifically American themes, including themes concerning early pioneers, Native Americans, and African Americans. Later, Shawn founded and directed Jacob's Pillow School of Dance in Lee, Massachusetts, which continued after his death as a prestigious summer dance program.

St. Denis focused her attention on the development of Denishawn House in New York City and continued to perform solos of a multicultural nature, including her interpretation of biblical psalms that utilized the Indian gesture language of mudras. St. Denis' major contributions to the dance world include her experimentation with music visualization and her choreography, which often accentuated mystical or religious themes. Although she was not known as a technically proficient dancer, St. Denis brought to the general populace the essence of exotic lands via her dances.

Perhaps the greatest contribution of Denishawn was in its presentation of contemporary American dance as a legitimate art form. Prior to the establishment of Denishawn, dance in the United States largely consisted of performances by vaudevillians, acrobatic and novelty dancers, "hoofers," and skirt dancers. Exponents of European dance were the only dancers seriously regarded by the American public, and many talented young American performers, such as ballerina Augusta Maywood and modern dancer Isadora Duncan, pursued careers in Europe. Denishawn helped to convert theatergoers to American dance and assisted in establishing it as a serious art form.

As pioneers of modern dance, St. Denis and Shawn tilled the fertile ground for the first generation of great modern dancers. Martha Graham, Doris Humphrey, and Charles Weidman were all leading dancers in the Denishawn company. In 1916, Graham entered the Denishawn School and studied almost exclusively with Shawn. Graham performed with the Denishawn company from 1919 to 1923, after which she embarked on an independent dance career that spanned almost seventy years and established her as one of the greatest figures in American modern dance. Humphrey began studies at Denishawn in 1917 and subsequently danced with the company from 1918 to 1928. In 1928, Humphrey and her partner, Weidman, left to found a school and dance company in New York City. Weidman had performed with Denishawn for the previous eight years.

Each of these modern dancers was greatly influenced by the training and theatrical experience offered at Denishawn; however, these paramount figures of American dance left the Denishawn company when their original ideas and independent ambitions were stifled. Critic John Martin has stated that modern dance originated more as a rebellion against the Denishawn system rather than as an outgrowth of it. Nevertheless, as a direct result of Denishawn and the pioneering efforts of St. Denis and Shawn, modern dance came into existence during the 1920's.

Bibliography

Kraus, Richard G., Sarah Chapman Hilsendager, and Brenda Dixon. "Modern Dance:

The Beginning Years." In *History of the Dance in Art and Education.* 3d ed. Englewood Cliffs, N.J.: Prentice-Hall, 1991. Brief overview of Denishawn. Includes information on early influences of Denishawn as well as brief biographies of Ruth St. Denis and Ted Shawn. Discusses other early modern dancers, including Martha Graham, Doris Humphrey, and Charles Weidman. Places Denishawn in context with other events and personages involved in the development of modern dance. Photographs, bibliography, excellent notes, and indexes.

McDonagh, Don. *Complete Guide to Modern Dance.* Garden City, N.Y.: Doubleday, 1976. McDonagh provides a brief but concise overview of the development of Denishawn within historical and cultural context. Also included are biographies of both St. Denis and Shawn as well as descriptions of nine Denishawn dances. Chronology of the choreography of St. Denis and Shawn supplements the text. Annotated bibliography and index. Limited photographs.

Shelton, Suzanne. *Divine Dancer: A Biography of Ruth St. Denis.* Garden City, N.Y.: Doubleday, 1981. Provides an extensive account of the Denishawn School and company. Focuses on Ruth St. Denis and includes much information on her early life and career. Interesting section on St. Denis' dance *Radha.* Includes excellent photographs and notes. Bibliography and index.

Sherman, Jane. *Denishawn: The Enduring Influence.* Boston: Twayne, 1983. Features nine chapters that focus on the Denishawn School and company rather than on St. Denis and Shawn. Author was a former Denishawn dancer. Interesting chapter on the Far East tour. Additional information on Graham, Humphrey, and Weidman. Chronology of pertinent dates, bibliography, index, and some photographs. Includes excellent appendices of Denishawn choreography.

_____. *The Drama of Denishawn Dance.* Middletown, Conn.: Wesleyan University Press, 1979. Describes specific Denishawn dances from 1914 to 1926. Offers intriguing accounts of actual choreography. Excellent introduction and appendices of choreography. Includes many photographs never before published. Anecdotal information from Sherman is interesting and effective. Descriptions of dances are clear and informative. Bibliography, index, and chronology of Denishawn tours.

Terry, Walter. *Miss Ruth: The "More Living Life" of Ruth St. Denis.* New York: Dodd, Mead, 1969. Offers a complete biography of Ruth St. Denis, including excellent photographs of her in later years. Includes an interesting epilogue of quotations from St. Denis. Focus is on a comprehensive overview of St. Denis' life more than on an account of the Denishawn School and company.

John R. Crawford

Cross-References

Duncan Interprets Chopin in Her Russian Debut (1904), p. 113; Pavlova First Performs Her Legendary Solo *The Dying Swan* (1907), p. 187; Diaghilev's Ballets Russes Astounds Paris (1909), p. 241; Fokine's *Les Sylphides* Introduces Abstract Ballet

(1909), p. 247; *The Firebird* Premieres in Paris (1910), p. 269; *L'Après-midi d'un faune* Causes an Uproar (1912), p. 332; *The Rite of Spring* Stuns Audiences (1913), p. 373; Jooss's Antiwar Dance *The Green Table* Premieres (1932), p. 920; Graham Debuts *Appalachian Spring* with Copland Score (1944), p. 1284; Taylor Establishes His Own Dance Company (1954), p. 1602; Ailey Founds His Dance Company (1958), p. 1774.

THE METAMORPHOSIS ANTICIPATES
MODERN FEELINGS OF ALIENATION

Category of event: Literature
Time: 1915
Locale: Prague, Czechoslovakia, formerly in the Austro Hungarian Empire

Franz Kafka, an obscure writer and lawyer working for a Prague insurance company, published The Metamorphosis, *a seminal work of surrealistic fiction focusing on a modern, alienated, and angst-ridden antihero who cannot adapt to his grotesque, inexplicable transformation into an insect*

Principal personages:

FRANZ KAFKA (1883-1924), a fiction writer and diarist best known for his short novels of existential despair and helplessness, most of which were published, unfinished, posthumously

MAX BROD (1884-1968), a German novelist and Kafka biographer who, as Kafka's literary executor, defied that writer's request that his unpublished manuscripts be burned

RAINER MARIA RILKE (1875-1926), a major German poet whose admiration for Kafka's work helped to establish the credibility of the novelist

THOMAS MANN (1875-1955), a celebrated German fiction writer whose stories Kafka admired and with whose works Kafka's have sometimes been compared

GUSTAVE FLAUBERT (1821-1880), a French novelist and an important influence on Kafka primarily known for his realistic fiction

JOHANN WOLFGANG VON GOETHE (1749-1832), a German poet and dramatist whose Romantic works profoundly influenced Kafka

Summary of Event

By 1912, Franz Kafka had completed *The Metamorphosis* and was reading it to his narrow circle of friends, but it was not until 1915 that he agreed to publish the story, which was issued in a minor serial publication, *Die Weissen Blätter*, under the German title *Die Verwandlung*. The haunting, nightmarish piece, destined to become a modern classic, tells the story of a self-effacing salesman named Gregor Samsa, who wakes one morning to discover that he has been transformed into a "monstrous vermin," a large, cockroach-like insect. Unable to adapt to his circumstances, Gregor finally, and willfully, dies of disillusionment and starvation.

Despite its somewhat repulsive predication, *The Metamorphosis* is an intriguing modern allegory. Gregor, a hardworking, respectful young man, simply accepts the grotesque change as his lot. In fact, he is anxious only about its impact on his ability to meet his obligations to his employer and his family. The metaphysical implications of his fantastic transfiguration concern him not at all.

In the insect's body, Gregor calmly attempts to meet or evade his humdrum re-

sponsibilities as if he were suffering from nothing worse than the flu or the common cold. How to get out of bed, how to move across the room, how to get to work on time, how to explain his failure to get there when it becomes obvious that he will be late—these and myriad other banal problems are what he mulls over.

A decent man, Gregor is particularly concerned about the impact he will have on others, especially his sister, Grete. He worries about how his family will manage without the income he had long provided, and he is especially cautious about staying out of sight, knowing that his appearance is offensive to everyone. He stays primarily in his room; when he needs to venture out, he is careful to scuttle into dark corners or hide under furniture in a deferential attempt to avoid confrontations with his family and the household servants. Unable to communicate his feelings or concern to anyone, Gregor slowly becomes totally alienated from the human world.

He also becomes a major liability. Without Gregor's income, the family faces increasing hardships. First his father is forced out of retirement to go to work as a bank messenger; then Grete and her mother find menial work. Eventually, the family has to take in boarders. Resentment toward Gregor quickly mounts. At first kind and solicitous of Gregor's welfare, even his sister begins to turn against him when, inadvertently, he appears before his mother and shocks her into a life-threatening swoon. The father, who was harshly critical of Gregor even when he was in his human form, is wholly unsympathetic. He takes to throwing things at Gregor, and at one point hits him with an apple that leaves a deep, festering wound—a recurring symbol in Kafka's fiction—that seems to drain from him the will to live.

As Gregor's appetite wanes, the troubles of the family intensify. As if to express its resentment at Gregor's failure to fulfill his responsibilities, the family eventually neglects him altogether and turns his room into a depository for the household's refuse. The three boarders, fastidious gentlemen obsessed with cleanliness, catch sight of Gregor when he tries to approach Grete while she is playing her violin. Using Gregor's appearance as an excuse, the three boarders give notice and refuse to pay for the time already spent in the house. Even Grete then concludes that the family must rid itself of the unwanted vermin. His sister's total rejection is the fatal blow for Gregor. He stops eating and dies, dispirited and totally alone.

In his story, Kafka was undoubtedly exorcising some personal devils, notably his ambivalent feelings toward his father, Herrmann, an overbearing, intemperate, and tyrannical man whose worldly values repeatedly collided with his son's aesthetic interests. A shrewd, self-made entrepreneur and owner of a wholesale luxury-goods business, Herrmann Kafka was an unmerciful taskmaster who treated his servants and employees abysmally. Kafka's reaction to his father's behavior was both to turn inward and to nurture a basic kindness and decency in his dealings with others, behavior for which his father found him weak and irresponsible.

While the equation of Gregor with Kafka and the senior Samsa and Gregor's boss with Herrmann Kafka is of speculative interest, it is of less importance than the particular modern themes that evolve from such character contrasts. Gregor is victim—a hapless, antiheroic protagonist who, hamstrung by his own decency, is un-

able to cope in a world that is at best indifferent and at worst deliberately hostile and cruel. Furthermore, he becomes totally alienated from those whose love and loyalty he should command. Turned into an insect, lacking the physical capacity for speech but still endowed with human longing and rational powers, Gregor is literally unable to communicate with his family. As metaphor, Gregor, despite his limited spiritual vision, is the sensitive but ineffective man isolated and alone in a brutal, depressing world that relentlessly progresses along Darwinian and Freudian lines.

The dominant mood of *The Metamorphosis* is one of gloom and despair. Life for the Samsa family is dreary and largely uneventful. If there is any hope for anything other than an empty, time-serving existence ending in an obscure grave, it lies in Grete's potential as a violinist or, for the author, in his own art. It had been Gregor's hope to fund his sister's training at a conservatory, but with his metamorphosis, that hope is crushed. Ironically, as the story progresses and Gregor becomes more adept as an insect, he also becomes increasingly sensitive to Grete's playing, with the allegorical implication that in order to develop fully an aesthetic sensibility, modern man must withdraw from or be ostracized by a society that no longer cares about what he thinks, much less what he feels.

Although there is an apparent kinship between Kafka's fiction and that of Russian writers from Nikolai Gogol to Anton Chekhov, the writers Kafka admired most were Johann Goethe and Gustave Flaubert. The latter has been credited with having prompted Kafka to use antiheroic protagonists treated with scientific detachment, the former with having instilled in him an abiding sense of *Weltschmerz*, or "world sorrow." Kafka, a Jew, filtered these influences through a consciousness acutely sensitive to social victimization and familial obligation. What evolves from that confluence of ethnic and literary heritages is the "Kafkaesque" tale, a story told in straightforward, simple prose that deals with a hapless protagonist who, while maintaining a cringing respect for authority, suffers anxiety and depression from a failure to measure up to its demands. Ironically, that authority, in whatever form, is often illogical or inscrutable and is invariably dehumanizing.

It is that irony that gives *The Metamorphosis* its disquieting and provocative power. After his transformation, Gregor, although powerless to meet his obligations to job and family, develops a maturing, humanizing self-awareness. In addition to becoming increasingly sensitive to the feelings of others, he begins to appreciate his sister's music, that form of human expression that impinges most directly on man's soul. Meanwhile, the authoritarian figures, Gregor's loutish father and the bullying office manager, both reveal a total insensitivity and mounting hostility toward Gregor—particularly the parasitical father, who resents having to return to work and holds Gregor responsible for all ills that befall the family. Clearly, the real vermin of the piece are the selfish exploiters who treat others without a shred of human compassion or respect.

Impact of Event

General recognition of the literary achievement of Franz Kafka did not come until

after his death from tuberculosis in 1924, in part because Kafka himself had been reluctant to publish more than a small sampling of work. Although he had early champions among a small coterie of German-language literati—in Rainer Maria Rilke and Thomas Mann, for example—it was not until the posthumous publication of his unfinished novels in the late 1920's that Kafka's reputation began to grow and his works, in translation, broke geographical and language boundaries. Had his friend and biographer Max Brod not chosen to ignore Kafka's dying wish that his unpublished works be burned, Kafka would probably have remained an obscure and largely ignored writer.

Brod was the first important critical interpreter of Kafka's fiction, and although many of his opinions have been discredited, he played an extremely important role in bringing Kafka to an international audience. That was paramount for Kafka's artistic survival, for in the 1930's, despite Kafka's early espousal of atheism and socialism, the Marxist critics of East Europe rejected his works as nihilistic and defeatist, while in Nazi Germany they were suppressed as the irrelevant whinings of an effete, intellectual Jew. By then, much of Kafka's work had been translated into both English and French, and by the 1940's, West European and American scholars and critics began to herald both his finished and fragmentary works as major contributions to modern fiction. Thereafter, he was rediscovered in the German-speaking nations of Europe and became a major influence on contemporary German fiction. In the 1960's, he gained belated recognition in the intellectual and literary circles of his native Czechoslovakia, then under Communist rule.

By mid-century, Kafka's name had become synonymous with the modern theme of alienation, and *The Metamorphosis*, his first important published work, was often singled out as the seminal piece of fiction developing that theme. Less perplexing and more tightly structured than more ambitious works such as *Der Prozess* (1925; *The Trial*, 1937) and *Das Schloss* (1926; *The Castle*, 1930), *The Metamorphosis* quickly gained a reputation as Kafka's most approachable work, and it was widely read and discussed. Since then, it has continued to enjoy a reputation as a modern classic, a brilliant tour de force embodying in mode and manner Kafka's artistic genius and his dominant themes and technique.

The general influence of Kafka's work, directly or indirectly, is both diffuse and pervasive in modern literature. Although his work's greatest impact is on fiction, his influence cuts across literary genres and is particularly visible in drama. In *The Theatre of the Absurd* (1961), Martin Esslin credits Kafka with having had a formative influence on the absurdist playwrights of the 1950's and 1960's, including Kafka's fellow countryman Václav Havel and the English playwright Tom Stoppard, who was born in Czechoslovakia. In general, existentialist playwrights and novelists, notably Albert Camus, were drawn to Kafka's work, seeing in his protagonists the plight of the existential hero who somehow must plod on in the face of cosmic insignificance and personal despair.

The theme of the individual's alienation from an increasingly impersonal and mechanistic world will always be associated with Kafka, but of equal importance

and lasting influence is the technique he developed in *The Metamorphosis* and other fictional works. Although he dealt with mostly mundane human activity, he filtered it through the crazy-quilt world of the dream, rich with symbolism subject to a wide range of psychological and critical interpretations. In fact, few modern writers have inspired as much controversy as Kafka, and the academic interest in his work remains intense. About one thing, however, there has long been a lasting scholarly consensus: that Kafka was a prescient visionary who left behind an important literary legacy.

Bibliography

Corngold, Stanley. *The Commentators' Despair: The Interpretation of Kafka's "Metamorphosis."* Port Washington, N.Y.: Kennikat Press, 1973. For further study of *The Metamorphosis*, this is an important critical bibliography on the work. Digests the content of several English and foreign-language articles and reflects the great range in critical interpretations of the story.

Gray, Ronald D., ed. *Kafka: A Collection of Critical Essays.* Englewood Cliffs, N.J.: Prentice-Hall, 1962. Included in this anthology of critical pieces are important articles by such influential thinkers as Friedrich Beissner, Albert Camus, Erich Heller, Martin Buber, and Edmund Wilson.

Hayman, Ronald. *Kafka: A Biography.* New York: Oxford University Press, 1982. One of several significant biographies of Kafka, this study is thorough, well researched, and well documented. Contains a useful chronology, photographs, selective bibliography, and glossary of German and Czech names.

Kafka, Franz. *The Metamorphosis.* Translated and edited by Stanley Corngold. New York: Bantam Books, 1972. This highly regarded and readily available translation and critical edition includes excellent explanatory notes, a selective bibliography, relevant Kafka letters and diary entries, and excerpts from important critical articles.

Kuna, Franz, ed. *On Kafka: Semi-Centenary Perspectives.* New York: Barnes & Noble, 1976. A collection of papers originally presented at a 1974 Kafka symposium. Addresses major problems in interpreting Kafka's work, including the enigmatic nature of his fiction and his status as a writer.

Spann, Meno. *Franz Kafka.* Boston: Twayne, 1976. An excellent starting place for assessing Kafka's importance, this critical overview of the author's works includes a useful chronology, a brief biography, a survey of his style, and interpretive sections on each of his principal works. Selective but dated bibliography.

John W. Fiero

Cross-References

Freud Inaugurates a Fascination with the Unconscious (1899), p. 19; Joyce's *Ulysses* Epitomizes Modernism in Fiction (1922), p. 555; Mann's *The Magic Mountain* Reflects European Crisis (1924), p. 588; Surrealism Is Born (1924), p. 604; Sartre

and Camus Give Dramatic Voice to Existential Philosophy (1940's), p. 1174; Sartre's *Being and Nothingness* Expresses Existential Philosophy (1943), p. 1262; Esslin Publishes *The Theatre of the Absurd* (1961), p. 1871; Havel's *The Garden Party* Satirizes Life Under Communism (1963), p. 1967.

THE BIRTH OF A NATION POPULARIZES
NEW FILM TECHNIQUES

Category of event: Motion pictures
Time: March 3, 1915
Locale: Liberty Theater, New York, New York

D. W. Griffith's The Birth of a Nation, *a huge commercial success, was hailed as a great achievement of art but assaulted as a vicious distortion of history*

> *Principal personages:*
> D. W. GRIFFITH (1875-1948), the director of *The Birth of a Nation* and other significant films
> THOMAS DIXON (1864-1946), the author of the novel *The Clansman: A Historical Romance of the Ku Klux Klan* (1905), the basis for *The Birth of a Nation*
> BILLY BITZER (1872-1944), the photographer for *The Birth of a Nation* and other Griffith films
> LILLIAN GISH (1896-1993), the actress who played Elsie Stoneman in *The Birth of a Nation*
> MAE MARSH (1895-1968), the actress who played Flora Cameron
> HENRY B. WALTHALL (1878-1936), the actor who played Colonel Ben Cameron
> RALPH LEWIS (1872-1937), the actor who played Austin Stoneman
> WALTER LONG (1879-1952), the actor who played Gus
> RAOUL WALSH (1887-1980), the actor who played John Wilkes Booth in *The Birth of a Nation* and later directed numerous films

Summary of Event

D. W. Griffith took more than two months in late 1914 to shoot scenes for *The Birth of a Nation*, at first called *The Clansman* (the title of the novel from which the story was taken). He had twelve reels of film after spending about three months of editing, with more than fifteen hundred shots. He gave a private showing in February, 1915, after which he issued the film for the general public as *The Birth of a Nation* on March 3 at the Liberty Theater in New York City. It ran twice daily for almost a year and was distributed throughout the United States, Europe, and Asia.

The film's story is about courtship, love, and marriage for two couples: Ben Cameron, from the South, and Elsie Stoneman, from the North, as one couple; Margaret Cameron and Phil Stoneman as the other. Their trials of love are offered as parallels to the events of the American Civil War and its aftermath of Reconstruction in the South. The Cameron family suffers terribly from the devastations of these events. Two sons are killed in battles, a third son is wounded and nearly executed by his Union captors, and one daughter (the youngest, Flora) leaps to her death rather than

submit to the embrace of a black Union soldier known as Gus.

Flora's suicide is symbolic of the consequences to family values and the social integrity of the South after President Abraham Lincoln's assassination by John Wilkes Booth. The era of Reconstruction that followed the president's death is shown to be one of social disintegration, terrorism, and black reprisals against Southern whites, encouraged by white and mulatto carpetbaggers from the North. Political power was transferred to African Americans in the South under the leadership of a Northern abolitionist, Austin Stoneman, and his mulatto henchman, Silas Lynch. When Lynch lusts after Stoneman's daughter, Elsie, and is about to force her into marriage, the plot lines merge in a climactic ride to the rescue, conceived and organized by Ben Cameron, by the heroic Ku Klux Klan.

Flora's death set the Klan into action, pursuing, capturing, trying, and executing Gus. Silas Lynch responded with orders for his black followers to attack whites everywhere. When black soldiers arrest Ben Cameron, his family rescues him, and all escape to a lonely cabin where they are besieged by black Union soldiers. Meanwhile, the Klan gathers, and Lynch assaults Elsie after she refuses his marriage proposal. After the Cameron family is nearly captured by soldiers and Elsie is nearly raped by Lynch, the Klan arrives to rescue all and then parades in victory through the streets of Piedmont, South Carolina.

The multiple scenes of siege and assault, with simultaneous rides to the rescue, are narrative achievements of Griffith's masterful editing. They highlight his ability to give exciting form through intercutting of shots of varying length, gradually diminishing as the climax of each sequence is approached. The film is marked throughout by this technique and others, such as close-ups for symbolic purposes (plates of parched corn, the portrait of Elsie), night photography (of the burning of Atlanta), dissolves (of the black-dominated South Carolina legislature), split screens, and iris shots (as in the juxtaposition of the desolate mother and children with a scene of General William Sherman's army marching through Georgia).

To get his battlefield shots composed as he wished them, Griffith and his cameraman, Billy Bitzer, studied the Civil War photographs of Matthew Brady. The most impressive features of Griffith's battle scenes are the movement of the camera in panning shots and moving shots and the arrangement of objects in the scenes to include distant, middle, and close details. Griffith showed himself to be a master of composition of elements in the scenes he photographed, and he was careful with details of both setting and acting. One of the most highly acclaimed scenes is that of the assassination of President Lincoln. The set was built and designed according to minute specifications of the scene in Ford's Theater, and the movements of the actors were directed in accordance with witnesses' accounts. These actions include the way Booth caught his spur in a balcony scarf as he leaped to the stage after shooting the president.

These technical and stylistic achievements were testimony to Griffith's artistry. They made the narrative powerful and instilled imaginative energy in the film's audiences. The director controlled spectators' vision, manipulated emotions, and drew

viewers into the action of the film, practically eliminating the critical distance that ordinarily separated audience from art object. Precisely because the film was so powerful, however, it was condemned by many as a manipulation of minds for political purposes and according to racist ideas. The event of the film's showing, repeated many times, was sometimes a riotous political event as well as an aesthetic triumph.

Impact of Event

As *The Clansman* the film was impressive, but as *The Birth of a Nation* it was wildly controversial. The new title captured the political point of the film's interpretation of its historical events. The nation of the United States could come into being only after the Civil War, but a more important point in the film was that it could become one nation only after it reduced the threat of political power from its black citizens, who were as dangerous to morals as they were to political justice. The newly formed National Association for the Advancement of Colored People and many other groups and individuals attacked Griffith's film as a cruelly racist misrepresentation of the truth about national historical events. Some have argued, moreover, that the film also was directly responsible for the revival of the Ku Klux Klan in the years that followed its premiere showing.

Because of this criticism, Griffith removed some scenes, so that the original showing of fifteen hundred shots was reduced to thirteen hundred. Although those shots became unavailable for viewing, reports indicate that they included scenes of black assaults on whites as well as close-up views of Gus being tortured by the Klan. The removal of scenes in response to political criticism indicated the film's impact on the public, showing censorship driven by moral and political interests. Griffith published a spirited written defense of his work and produced another film, *Intolerance* (1916), as an aesthetic answer by the artist. Other films were made to correct Griffith, such as the all-black *The Birth of a Race* in 1918.

For the history of the development of film art, however, it was in aesthetic and technical accomplishments that *The Birth of a Nation* had its greatest and most lasting impact. Griffith later extended his method of intercutting shots in *Intolerance*. In that film, Griffith created parallels among four different stories of intolerance, each representing tragic, or near-tragic, consequences from intolerance in the lives of individuals throughout history: from ancient Babylon to biblical Judea to medieval France to modern America.

Rescue scenes were intercut according to Griffith's principle of film lengths. In the exciting rush to rescue the hero from execution in the story line set in modern America, Griffith used the same moving camera technique as used to photograph the ride of the Klan in *The Birth of a Nation*, mounting the camera on a moving automobile with a view of the characters' faces coming toward the audience. In addition, Griffith created links between the stories with a repeated image of a mother rocking a cradle to the words of a poem by Walt Whitman.

Griffith continued after *Intolerance* to make films that showed the impact of his

experience with *The Birth of a Nation*, although none achieved the financial and popular success of that film. *Orphans of the Storm* (1922) imitated the narrative scheme of telling a story about individual fates in the swirl of great national and epic events, in this case the French Revolution. Both *Broken Blossoms* (1919) and *Way Down East* (1920) were limited in scope to the problems of women preyed upon by brutal men and harsh reality. The first was a successful venture into domestic violence made visually more painful by editing techniques and beautiful use of lighting; the second is famous for another of Griffith's great rescue scenes, as the heroine is saved from death on a floating cake of ice in a raging river. The director's repetition of skillful stylistic techniques such as this and his penchant for melodramatic stories of sentiment marked his films as distinctly his own. This has made Griffith an early example of what have been called "auteurs" in film theory.

The Birth of a Nation also encouraged big-budget, epic films of grandeur, such as James Cruze's *The Covered Wagon* (1923) and King Vidor's *The Big Parade* (1925) in the United States, Abel Gance's *Napoleon* (1927) in France, and Sergei Eisenstein's *The Battleship Potemkin* (1925) in the Soviet Union. Both Cruze and Vidor imitated Griffith's film, with their pictures composed along vertical lines to show a wagon train or truck convoy moving toward the audience as in the ride of the Klan. Griffith's film was especially influential among Soviet directors, impressing them with the effective power of editing techniques. This led to narratively exciting events in Eisenstein's *Alexander Nevsky* (1938) and Vsevolod Pudovkin's *Storm over Asia* (1928). These films and others developed the artistic device of montage.

Although Griffith's editing techniques were imitated by many who saw his film, the film's main impact as a cultural event was to raise the entertainment value of narrative films. At this new level, motion pictures could make money and also endure as aesthetic objects. They could equally well become instruments for political propaganda, as many viewers would remember after having felt the power of *The Birth of a Nation*.

Bibliography

Cook, David A. "D. W. Griffith and the Consummation of Narrative Form." In *A History of Narrative Film*. New York: W. W. Norton, 1981. Analyzes Griffith's crafting of detailed arrangements within film frames, including rehearsals, camera placement, and location shooting. Examines some of Griffith's other films as preparation for filming *The Birth of a Nation*, which receives respectful critical attention.

Ellis, Jack C. "Rise of the American Film: 1914-1919." In *A History of Film*. 3d ed. Englewood Cliffs, N.J.: Prentice-Hall, 1990. Focusing on *The Birth of a Nation*, Ellis analyzes the film as one of the masterpieces, along with *Intolerance*, of early film art. Griffith's technique and style set the pattern for classic Hollywood films. While praising the director's art, Ellis condemns the racism of his films.

Fulton, A. R. "Editing." In *Motion Pictures: The Development of an Art from Silent Films to the Age of Television*. Norman: University of Oklahoma Press, 1960. From

the use of crosscutting and still shots in 1909, with *A Corner in Wheat*, Griffith moved toward *The Birth of a Nation*. This film is analyzed for its parallelism, contrasts, and symbolism, achieved as effects of skillful editing.

Henderson, Robert M. *D. W. Griffith: His Life and Work*. New York: Oxford University Press, 1972. In fifteen balanced chapters, Griffith is presented as rising from playwright to screen actor to film director. Central chapters focus on the making of his major films. Includes a filmography, notes, index, and illustrations.

Jacobs, Lewis. "D. W. Griffith: New Discoveries." In *The Emergence of Film Art*, compiled by Lewis Jacobs. New York: Hopkinson and Blake, 1969. Griffith was innovative from the beginning of his career. He used double exposure, camera mobility, full shots, close-ups, lighting, and, most important, intercutting. Griffith's need for innovation increased with his desire to tell longer stories.

Mast, Gerald. "Griffith." In *A Short History of the Movies*. 3d ed. Indianapolis, Ind.: Bobbs-Merrill, 1981. Strong survey of Griffith's career in developing film art. After sketching Griffith's apprenticeship at Biograph, Mast focuses on *The Birth of a Nation* and *Intolerance* to discuss Griffith's mastery of technique, narration, and moral themes. A brief survey of Griffith's career from 1916 to 1931 suggests that it had a long decline.

Stern, Seymour. "*The Birth of a Nation*: The Technique and Its Influence." In *The Emergence of Film Art*, compiled by Lewis Jacobs. New York: Hopkinson and Blake, 1969. Technical triumphs included night photography, panoramic landscapes, thematic iris and still shots, tinting, various camera movements and angles, close-ups, vignettes, dissolves, linear composition, subtitles for a variety of functions, and intercutting for narrative climax. The film greatly influenced Soviet directors Eisenstein and Pudovkin.

Watts, Richard, Jr. "D. W. Griffith: Social Crusader." In *The Emergence of Film Art*, compiled by Lewis Jacobs. New York: Hopkinson and Blake, 1969. Griffith is discussed as an innovator of films for social commentary. Controversy over the racial interpretations of the Civil War in *The Birth of a Nation* led Griffith to make *Intolerance* as an answer to critics. Social concerns in *Broken Blossoms* were nearly overwhelmed by sadism, but the film survives because of its aesthetic power.

Richard D. McGhee

Cross-References

Le Voyage dans la lune Introduces Special Effects (1902), p. 57; *The Great Train Robbery* Introduces New Editing Techniques (1903), p, 74; Eisenstein's *Potemkin* Introduces New Film Editing Techniques (1925), p. 615; Keaton's *The General* Is Released (1926), p. 691; Kuleshov and Pudovkin Introduce Montage to Filmmaking (1927), p. 701; Lang Expands the Limits of Filmmaking with *Metropolis* (1927), p. 707.

THE FIRST PULITZER PRIZES ARE AWARDED

Categories of event: Journalism and literature
Time: May 24, 1915
Locale: New York, New York

Authorized by the bequest of Joseph Pulitzer, the Pulitzer Prizes established standards of excellence, becoming the most famous prizes awarded to American journalists and authors

Principal personages:
JOSEPH PULITZER (1847-1911), the publisher of the *New York World* and *St. Louis Post-Dispatch*
NICHOLAS MURRAY BUTLER (1862-1947), an educator and the president of Columbia University from 1901 to 1945
FRANK DIEHL FACKENTHAL (1883-1968), the secretary of Columbia University and the school's president after Butler
TALCOTT WILLIAMS (1849-1928), the first director of Columbia University's School of Journalism

Summary of Event

On May 24, 1915, Nicholas Murray Butler, the president of New York's Columbia University, met with the advisory board of Columbia's school of journalism. The purpose of the meeting was to verify that the terms set down in the will of Joseph Pulitzer had been faithfully followed and to approve plans for awarding prizes in journalism and letters that were to be awarded in Pulitzer's name and through his financial bequest. Butler's relations with Pulitzer, who had died in 1911, had often been difficult, and the Columbia president had been required to follow Pulitzer's expressed intentions carefully. Prior to the May 24 meeting, Butler had Frank Diehl Fackenthal, the university's secretary, draft a plan of award for the prizes. It was envisioned that in each of the prize areas, eminent experts in the field would make the initial determination and give their recommendations to the advisory board, which would in turn send their selections to the trustees of Columbia University; the prizes would then be awarded under the auspices of the trustees. There were seeds of future controversy in this plan, but Fackenthal's proposal has remained the basic structure used in allocating the Pulitzer Prizes.

Yet there were difficulties over the prospective prizes long before 1915, in large part because of the personality and accomplishments of Joseph Pulitzer, one of the most powerful persons in the United States in the late nineteenth and early twentieth centuries. Born in Hungary in 1847, Pulitzer migrated to the United States and fought for the Union during the Civil War. After the war, he became a newspaper reporter in St. Louis, as well as a political reformer, first supporting the Republicans and later the Democrats. He acquired two St. Louis newspapers and formed the *St. Louis*

Post-Dispatch; in 1883, he bought the *New York World* from the controversial financier Jay Gould. Pulitzer's newspapers became extremely profitable. Through a brilliant combination of reform advocacy and sensationalism, Pulitzer, along with William Randolph Hearst, created a new and controversial type of journalism. Pulitzer was committed to reaching the democratic majority, not simply the governing elite, and in creating his mass-circulation newspapers, he added entertainment—sports, comics, illustrations—to information. Seeing himself as a crusader on the side of the people, Pulitzer supported labor, attacked trusts and monopolies, and pilloried political bosses. The more papers he sold in the process, of course, the higher his profits were.

If Pulitzer's accomplishments were a paradoxical combination of high-minded reform and journalistic sensationalism, his personality was equally a study in contradictions. The poor immigrant became a millionaire. The spokesman for democracy had extravagant aristocratic tastes and ran his newspapers like a dictator. He was generous with his employees, but he was a tyrant toward his managers. Because of declining health, he was forced to give up day-to-day operation of his newspapers in 1889, but he autocratically ruled them from a distance. Finally, the purveyor of sensationalism was committed to raising the standards of journalism to that of a true profession, and one of his chief desires was to establish a school of journalism.

In the early 1890's, he offered Harvard University and then Columbia University one million dollars to establish such a school, but neither institution showed interest—a fact not surprising in the years when Pulitzer and Hearst were supposedly lowering newspaper standards through their "yellow journalism" techniques. In 1902, Pulitzer returned to his "grand scheme," as he called it. He wrote a memorandum about using his wealth to establish a school to raise the prestige and professionalism of journalism to the level of law and medicine. Alfred Nobel had endowed the famous prizes under his name that were first awarded in 1901; the Nobel Prize may have been an inspiration to Pulitzer, for in that 1902 memorandum and as a part of his proposed bequest, he suggested awarding annual prizes in journalism.

Pulitzer again contacted Columbia, this time with an offer of two million dollars for a journalism school, with five hundred thousand dollars of that amount to be set aside for journalistic and literary prizes. The university authorities were cautious. Journalism was not a respectable profession, and a too-close identification with it, and with Pulitzer, might damage Columbia's reputation. Pulitzer persisted, however, and this time was successful. In 1901, Seth Low, who had rejected Pulitzer's first offer, resigned as Columbia's president when he was elected mayor of New York. The new president was Nicholas Murray Butler. A graduate of Columbia, Butler was not yet forty years old when he became president. He had been involved in the university's recent building project, and as president he was committed to making Columbia one of America's great universities. "Nicholas Miraculous," as Theodore Roosevelt referred to him, became almost as much of a household name as Pulitzer himself. A professional academic as well as a prominent Republican, Butler was in many ways a contrast to Pulitzer, a self-made businessman and Democratic pub-

lisher who had doubts about the value of a higher education. They differed even in appearance: Pulitzer was lean and bearded, Butler heavy and bald. Both men, however, combined ambition, autocratic tendencies, and a desire for excellence, and after long negotiations an agreement was struck in the summer of 1903. Yet old difficulties had not been fully resolved.

Pulitzer refused to give the university an entirely free hand. His 1902 memo envisioned an advisory board drawn from the executives of New York's newspapers, and the authority of that board had been a contentious matter throughout the discussions. Pulitzer held fast, and Butler accepted the advisory board, but then Pulitzer's conception of the makeup of the board changed. Newspapermen were not enough: In order to give the proposed school and awards greater standing, he demanded that the presidents of Harvard and of Cornell University be included. That was too much for Butler; he refused to allow other universities to become involved in Columbia affairs. As a result, in 1904 Pulitzer announced that both the establishment of the journalism school and the prizes would not be implemented until after his death.

In his will, he established the primacy of the advisory board in the awarding of the prizes, so much so that if there was an attempt to reduce the powers of the board, the funds would be shifted to Harvard University. The will also described the prizes to be awarded: Four were to be in journalism; prizes were also to be awarded in fiction, drama, history, and biography. The monetary awards varied from five hundred to two thousand dollars. For the literary prizes, the qualifications mirrored the times, and the prizes were to be given to authors demonstrating morality, good taste, and patriotic values. These requirements were to lead to difficulties in the future.

Pulitzer died in 1911. According to his will, the prizes could not be awarded until the journalism school, which was established in 1912, had been in operation for three years. By the spring of 1915, that requirement had been met, and in May of that year, Butler and Fackenthal presented their plans for the prizes to the advisory board. The plan was accepted, and it was announced that the first Pulitzer Prizes for work published in 1916 would be announced at the university's commencement in June, 1917, six years after Pulitzer's death.

Impact of Event

The first Pulitzer Prizes could not have been awarded at a more inauspicious time. In April, 1917, the United States entered World War I against Germany, and in that climate the initial Pulitzer Prizes received only limited attention (and that primarily from the Pulitzer newspapers). Nevertheless, choices were made. The journalistic prizes were recommended by juries made up of staff from Columbia's school of journalism. Talcott Williams, the first director and a strong supporter of the awards, took an active role, sitting on all the recommending juries. Given the patriotic atmosphere surrounding the first year's prizes, it is understandable that the initial awards in journalism went to the *New York Tribune* for an editorial condemning Germany on the anniversary of the sinking of the *Lusitania* and to Herbert Bayard Swope of Pulitzer's own *New York World* for his reports "Inside the German Em-

pire." In time, critics complained that there was too much bias toward Eastern newspapers; it was not until 1924 that a West Coast newspaper was awarded a Pulitzer Prize.

Fackenthal's 1915 plan for the awards in letters envisioned that the American Academy of Arts and Letters would select juries to make the recommendations. No prizes were awarded for a novel or drama in the first year, perhaps because of some confusion in getting the jury system under way, possibly because no works in 1916 were judged to be of sufficient quality. The first history and biography awards, like the prizes in journalism, reflected the spirit of the times. The French ambassador to the United States, Jean Jules Jusserand, received the history prize for a study of Americans, and a book about Julia Ward Howe, the writer of the "Battle Hymn of the Republic," won the prize in biography.

It was not until the 1920's that the Pulitzer Prizes made a significant impact on the public. The 1920's differed radically from the war years and before, creating difficulties for those charged with choosing whom to honor with Pulitzer awards. Pulitzer himself was a product of the nineteenth century, and Butler, a conservative Republican, also generally supported the standards, artistic and moral, of an earlier day.

There was less controversy in the journalism awards. Issues of war and peace and other international concerns reaped recognition during that decade as they had during World War I. Pulitzer had been a reformer, and his newspapers were noted for their attacks on the perceived evils of the times. New ground was broken, however, when Pulitzer Prizes were awarded for exposing the nefarious practices of the Ku Klux Klan, which had become a powerful force during the 1920's. Reports of dehumanizing prison conditions and the problems faced by labor during a national coal strike also received Pulitzer Prizes. Coverage of the infamous Tea Pot Dome scandal, which saw a former secretary of the interior going to prison, received an award, as did an editorial criticizing the lack of justice accorded Nicola Sacco and Bartolomeo Vanzetti, two anarchists sentenced to death after a travesty of a trial. Discussions of social problems and defenses of the rights of the underdog became staples of Pulitzer Prizes.

Literary awards during the first decade of the Pulitzer Prize were dogged by controversy, primarily because of Pulitzer's instructions. The wording of the history prize was to cause the least trouble; Pulitzer wanted the award to go to the "best book of the year upon the history of the United States." Later, "best" was changed to "a distinguished," and the general wording avoided controversy. The biography description was more restrictive, requiring the award to be given to a work "teaching patriotic and unselfish service" but excluding biographies of George Washington and Abraham Lincoln as too obvious. The drama and the novel were even more problematic. For the drama award, the play honored had to have been performed in New York and had to also assist in "raising the standard of good morals, good taste, and good manners." The novel prize was to be given only to a work "which shall best present the whole atmosphere of American life, and the highest standard of American manners and manhood." Prewar attitudes on such matters came under

attack in the 1920's and after. Butler created an additional difficulty. In 1915, when the plan of award was presented to the advisory board, Butler changed Pulitzer's wording for the novel prize from "whole atmosphere" to "wholesome atmosphere," an even more restrictive defense of earlier values.

Eugene O'Neill was awarded three Pulitzer Prizes during the 1920's, for *Beyond the Horizon* in 1920, *Anna Christie* in 1922, and *Strange Interlude* in 1928. He was something of an unknown in 1920, and the jury was divided. One juror argued that O'Neill's play was not sufficiently "ennobling"; however, the majority felt otherwise. The advisory board accepted their recommendation, and O'Neill, one of America's greatest playwrights, received his first Pulitzer. In 1921, there was opposition to Sinclair Lewis' *Main Street*, which was alleged to be too satiric of small-town values. Although the jury decided to recommend the work, the advisory board, perhaps under Butler's guidance, unanimously turned down *Main Street*, selecting instead Edith Wharton's *The Age of Innocence*.

In time, Pulitzer Prizes were given in other areas. The first editorial cartoon prize was awarded in 1922, and the initial prize for photography was given in 1942. E. A. Robinson was honored in 1922, the first in a long line of distinguished poets. In history and biography, later awards were given more often to academics than in the earliest years, but those honored have generally well deserved their recognition. The novel award, which was changed to an award in fiction in 1948, proved to be the most controversial. Neither Ernest Hemingway nor William Faulkner, both of whom published significant works in the 1920's, was honored until the 1950's.

In time, the Pulitzer Prizes were not the only literary or journalistic prizes to be awarded to American writers and journalists, and some of the other prizes carried a much higher financial award. Nevertheless, the Pulitzer Prizes continued to hold a high place not only in the public's perception but also among writers themselves. Pulitzer's "great scheme" endured.

Bibliography

Hohenberg, John, ed. *The Pulitzer Prize Story.* New York: Columbia University Press, 1959. In this volume, Hohenberg presents a number of significant news stories, editorials, cartoons, and photographs that received Pulitzer Prizes from the earliest years until the 1950's.

_____, ed. *The Pulitzer Prize Story II.* New York: Columbia University Press, 1980. A selection of prize-winning stories, columns, editorials, cartoons, and photographs from 1959 to 1980. Both volumes are an excellent summary and cross-section of the first sixty years of the Pulitzer Prizes.

_____. *The Pulitzer Prizes.* New York: Columbia University Press, 1974. The standard history of the Pulitzer Prizes. Hohenberg was the secretary to the advisory board for twenty years, but the work is not merely a defense of decisions made. It is both critical and entertaining.

Stuckey, W. J. *The Pulitzer Prize Novels.* Norman: University of Oklahoma Press, 1966. The prizes given to novels have generally been the most controversial of the

Pulitzer Prizes. In this work, the author gives an insightful account of the issues and controversies involved.

Swanberg, W. A. *Pulitzer.* New York: Charles Scribner's Sons, 1967. The classic biography of Pulitzer. Swanberg had also written a major biography of Pulitzer's chief journalistic rival, William Randolph Hearst.

Eugene S. Larson

Cross-References

The First Nobel Prizes Are Awarded (1901), p. 45; *The Christian Science Monitor* Is Founded (1908), p. 209; Lippmann Helps to Establish *The New Republic* (1914), p. 385; Luce Founds *Time* Magazine (1923), p. 577; Luce Launches *Life* Magazine (1936), p. 1031; Trudeau's *Doonesbury* Popularizes Topical Comic Strips (1970), p. 2223; Joplin's *Treemonisha* Is Staged by the Houston Opera (1975), p. 2350.

MALEVICH INTRODUCES SUPREMATISM

Category of event: Art
Time: December 17, 1915
Locale: St. Petersburg, Russia

Kazimir Malevich exhibited thirty-nine paintings to which he attached the subtitle of "Suprematism"; critics saw the abstract forms as a direct challenge to realism and responded with insults and verbal fireworks

Principal personages:

KAZIMIR MALEVICH (1878-1935), a Russian artist who introduced Suprematism and formulated its doctrines

ILIA CHASHNIK (1902-1929), a Russian artist, one of Malevich's closest collaborators in promoting Suprematism through architectural constructions

VERA ERMOLAEVA (1893-1938), a Russian artist who played an active role in promoting the principles of Suprematism

VELEMIR KHLEBNIKOV (1885-1922), a Russian poet who collaborated with Malevich in the staging of *Victory over the Sun*

IVAN KLIUN (1873-1943), a Russian artist who was inspired by Malevich into experimentation with compositional complexity

IVAN KUDRIASHEV (1896-1970), a Russian artist who was influenced by Malevich and who practiced an eclectic type of Suprematism

EL LISSITZKY (1890-1941), a Russian artist who extended Malevich's Suprematist principles in art toward utilitarian ends

IVAN PUNI (1894-1956), a Russian artist and cosigner of the "Suprematist Manifesto"

NIKOLAI SUETIN (1897-1954), a Russian artist who applied Suprematist forms to functional objects

VLADIMIR TATLIN (1885-1953), a Russian artist and promoter of constructivism

Summary of Event

The movement known as Suprematism had its birth at a 1915 art exhibition in St. Petersburg, Russia, that was promoted as the "last Futurist exhibition." The focal point of the exhibition was the display of thirty-nine Suprematist paintings by Kazimir Malevich, who, in calling the new movement Suprematism, appeared to be designating the total nonobjectivity of Suprematism as the last stage of his progress as an artist. The first of the paintings by Malevich listed in the exhibition catalog is the famous *Black Square on White*. The painting consists of two shapes, a black square set in a larger white square; the contrast between the black and white presents composition at its most economical. In particular, the painting calls attention to the

effect of spatial infinity opening into the nothingness of the black square. Despite the total abstraction of the painting, the tactile quality of the surface of the canvas tended to overcome the viewer's impulse to regard the painting merely as an arrangement of basic forms. Similarly, Malevich's other paintings, with titles such as *Eight Red Rectangles* or *Painterly Realism: Boy with Knapsack—Colour Masses of the Fourth Dimension*, called attention to constructed, painted geometric forms. Malevich, however, undermined the organized nature of such concepts by giving each rectangle its own orientation within the spatial composition, thereby denying the imposition of a predetermined or expected design, pattern, or structure. In particular, the paintings stretched the limits of representation because of their total abstraction and lack of any allusions to reality, despite such allusive titles as *Boy with Knapsack* or *Red Square: Painterly Realism of Peasant Woman in Two Dimensions.* Malevich also installed his paintings so that their deliberate proximity extended the space of each painting beyond its individual frame and consequently informed viewers of the intended spatial relationship between separate works.

Since most critics judged art according to traditional values of locating meaning in art, Malevich's *Black Square on White* became the focal point of attacks against the notions of the Suprematists. *Black Square on White* was described as nothing but a void and the embodiment of emptiness, and art critics regarded this work and the others in the exhibition as degenerate examples of the destructive rejection of tradition. More positive critics likened the total abstraction of Malevich's Suprematist paintings to the recent efforts of theoretical physicists Albert Einstein, Werner Heisenberg, and Niels Bohr to define noneuclidean space. New scientific concepts required articulation in a new scientific syntax; Malevich and poets such as Velemir Khlebnikov attempted to extend the limits of the language of the arts in the same manner in order to express the alteration of perception caused by the new explorations of space and time. Consequently, in bringing art to the edge of innovation, Malevich's Suprematist paintings can be regarded as directly reflecting the dialectic between language and thought. In his exploration of the changing nature of art, Malevich wrote that "characteristic signs which distinguish the new painting from representative painting . . . are reflected in painters' differing perceptual conceptions of the world and attitudes regarding it." Since Suprematism was not concerned with the reflection of everyday life, Suprematist art was not bound to representation but instead sought to establish its freedom to represent the abstraction of infinity. For Malevich, color became a means of creating form and structure, of creating a language "composed of special words . . . an aid with which one can talk about the universe or about the state of our inner animation, something one cannot express by means of words, sounds."

To appreciate Malevich's Suprematist period, one needs to consider the period of his artistic maturation from Impressionism to Suprematism as an attempt to achieve the maximum of artistic freedom. Malevich rejected the broken brushwork of Impressionism to concentrate on the static quality of the surface plane; he further developed this static quality in paintings he displayed at a 1910 exhibition of neo-

primitivists. In his paintings of peasants, he heightened the static quality even more by presenting the peasants working in the fields as shapes whose heads, instead of being individualized, had the abstract quality of icons. Shortly thereafter, in a 1911 exhibition at the Moscow Salon, Malevich attempted to integrate the color experiments of his neoprimitivist paintings into works that reflected the influences of cubism and Futurism. His *Knife Grinder* (1912) reflected the evolution of Malevich's individual style as he adjusted it to the theories of the Italian Futurists, who advocated the representation of velocity and dynamism. In paintings shown at a 1913 exhibition in Moscow, Malevich continued to experiment with Futurism; his painting *Peasant Woman with Buckets* suggested movement by showing cones broken into almost unrecognizable shapes. Influenced by Khlebnikov's experiments in creating disjunctions between sound and meaning in language, Malevich joined the First All-Russian Congress of Poets of the Future in the production of *Victory over the Sun*, staged at the Luna Park Theater in St. Petersburg in 1913, for which he designed the costumes and stage decor. Khlebnikov and Malevich advocated the destruction of language as well as the "antiquated movement of thought based on laws of causality." From these experiments, as well as from the statements published in Malevich's brochure "From Cubism to Suprematism in Art, to the New Realism of Painting, to Absolute Creation," it became evident that Malevich's paintings mirrored the development and the formulation of personal creative principles. Ultimately, Malevich's personal explorations in art also reflected the experiments of the Russian avant-garde, and consequently, his theoretical writings influenced not only the development of Suprematism but contributed to the explorations of constructivism as well.

Impact of Event

Malevich's introduction of Suprematism had a profound effect in that it released art from the constraints of easel painting. As part of his program to alter the conceptual frame of art, Malevich began experimenting in three-dimensional architectural drawings, which he called "architectonics," and he inspired his fellow Suprematists to proclaim a transition from painting toward a universal system of art headed by architecture. In addition, Malevich devoted himself to working out his pedagogical method and to writing treatises on the history of the modern art movements and on the nature of art for the Vitebsk UNOVIS, a new kind of art school that was conceived to function not only as a teaching institute but also as a scientific research institute and workshop engaged in practical work to promote the program of the Suprematists and to train succeeding generations of Soviet artists. Consequently, all Malevich's paintings and architectural constructions from this period served as illustrations of his theories and were meant to stimulate his colleagues and students to extend their experiments into both the decorative and applied arts. Ultimately, the Suprematist experiments outlined a new field of activity for art in which painting, experiments in architecture, furniture, ceramics, polychrony, scientific experimentation, and theoretical statements were closely interlinked.

The impact of the UNOVIS program in Vitebsk is particularly evident in the work of Malevich's closest collaborators, Ilia Chashnik and Nikolai Suetin. Chashnik co-founded the journal *Unovis*, assisted Malevich with architectural constructions, and worked on ceramic designs as well as on his own Suprematist paintings. Chashnik's contributions to Suprematism were, however, cut short by his untimely death at the age of twenty-seven. Suetin's contributions to Suprematism related to his applications of Suprematist forms to functional objects. Since Malevich was interested in the conceptual framework for design, he left the actual execution to Suetin and Chashnik, and Suetin concentrated on porcelain design and decorations of porcelain with highly colored, asymmetrical patterns. Perhaps the most influential of Malevich's followers was Vera Ermolaeva, the director of the Vitebsk Art School, who played a significant role in promoting Suprematism; it was at her invitation that Malevich established the UNOVIS program at Vitebsk. Along with Chashnik and Suetin, Ermolaeva, who managed the color laboratory at Vitebsk, formed the original core of Malevich's collaborators and practioners of Suprematism. In addition to Chashnik, Suetin, and Ermolaeva, Ivan Kudriashev represents the generation of artists who came to maturity in the transitional period in the history of the Russian avant-garde. Though Kudriashev was trained as a Suprematist, by the time he had an opportunity to develop as an artist, the Soviet government had restricted artistic freedom in the promotion of the doctrine of Socialist Realism. Consequently, Kudriashev's Suprematism is highly eclectic, since he had to adhere to the new restrictions but nevertheless showed his loyalty to Suprematism by using clear, bright, unmodulated color applied to simple geometric shapes. The last tribute to Suprematism occurred long after abstract art was banned in the Soviet Union when Suetin organized the last Suprematist event, the painting of the Suprematist coffin for the funeral of Malevich.

Malevich's influence is also evident on a number of artists who were later to search for different approaches. Among these was Ivan Puni, one of the earliest followers of Malevich's Suprematism. Puni's work during his Suprematist phase offers the only example of Suprematist painting extended into actual three-dimensional space through the use of real objects, attached wooden pieces that were incorporated with the illusionistically painted objects into a spatial composition. Ivan Kliun, one of the oldest members of the Russian avant-garde, represents the intersection between adherence to cubist fragmentation and Suprematist assertion of flat, geometric shapes. Ultimately, Kliun was to draw inspiration from both Suprematism and the constructivism of Malevich's ideological opponent, Vladimir Tatlin. Similarly, El Lissitzky, who had a longstanding commitment to the Suprematism of Malevich, his mentor, was to extend the application of Suprematist theory toward utilitarian ends, and his contributions to the Russian avant-garde encompassed a wide range of activities, including painting, architecture, book design, photomontage, city planning, teaching, and theoretical explorations. His "Prouns" project (an acronym for "Project for the Affirmation of the New") represents a cross between constructivist and Suprematist ideals. Though Tatlin, as the founder of the constructivist movement, fought

longstanding ideological and aesthetic battles with Malevich regarding the function of art, Tatlin's constructions and systems of design were to polarize and clarify the position of Malevich's Suprematism. Consequently, when one views the impact of Suprematism, one must also examine the mutual impact of parallel movements. The combination of Suprematist and constructivist ideals was to influence the Bauhaus movement, and the most telling examples of the wide-ranging influence of Suprematist architectonics on Western architecture is clearly evident in the style of such artist-architects as Theo van Doesburg, Le Corbusier, Gerrit Thomas Rietveld, and Walter Gropius.

Bibliography

Barron, Stephanie, and Maurice Tuchman, eds. *The Avant-Garde in Russia, 1910-1930.* Cambridge: MIT Press, 1980. Provides biographical data, essays, and chronologies of the leading Russian artists. This well-illustrated and well-documented volume, collected from the exhibition of the Russian Avant-Garde at the Los Angeles County Museum of Art in 1980, represents an invaluable introduction to both the period and to individual artists. The section devoted to Malevich and Suprematism includes plates of representative paintings.

Bowlt, John E., ed. *Russian Art of the Avant-Garde: Theory and Criticism.* Rev. ed. New York: Thames and Hudson, 1988. Introduces in translation significant essays from the theory and criticism of Russian art movements of neoprimitivism, Cubo-Futurism, Suprematism, constructivism, and Socialist Realism. Includes Malevich's influential "From Cubism and Futurism to Suprematism: The New Painterly Realism." With 105 illustrations, notes, and extensive bibliography.

Crowe, Rainer, and David Moos. *Kazimir Malevich: The Climax of Disclosure.* Chicago: University of Chicago Press, 1991. Situates Malevich's experiments in art in contemporary critical theory and provides a scholarly exploration of Malevich's theory and practice. More suited to the scholar than to the novice. Color plates illustrate each stage of Malevich's artistic progress, and extensive notes and bibliography are provided.

D'Andrea, Jeanne, ed. *Malevich.* Los Angeles: Armand Hammer Museum of Art, 1990. Catalog from a 1990 exhibition held by the National Gallery of Art in Washington, D.C. Provides introductory essays, catalog illustrations, supplemental essays by contemporary Malevich scholars, endnotes, and selected bibliography. An excellent and comprehensive introduction to Malevich's work.

Lodder, Christina. *Russian Constructivism.* New Haven, Conn.: Yale University Press, 1983. Provides parallels between Russian constructivism and Suprematism. Though devoted to examples of the theory and practice of the constructivists, Lodder's work contributes to the awareness that many of the Suprematists also participated in the experiments of constructivism. Serves as an excellent supplemental text. Well-illustrated texts, biographical sketches, notes, and bibliography.

Zhadova, Larissa A. *Malevich: Suprematism and Revolution in Russian Art, 1910-1930.* New York: Thames and Hudson, 1982. Devoted to exploring Malevich's

contributions to Suprematism. Covers a wide range of material, including documents by Malevich and articles on Malevich and Suprematism by representative Russian artists and critics. With 445 illustrations (eighty-four in color) and index. A significant contribution to Malevich scholarship.

Christine Kiebuzinska

Cross-References

The Salon d'Automne Rejects Braque's Cubist Works (1908), p. 204; The Futurists Issue Their Manifesto (1909), p. 235; Der Blaue Reiter Abandons Representation in Art (1911), p. 275; Kandinsky Publishes His Views on Abstraction in Art (1912), p. 320; Apollinaire Defines Cubism in *The Cubist Painters* (1913), p. 337; Duchamp's "Readymades" Challenge Concepts of Art (1913), p. 349; The Dada Movement Emerges at the Cabaret Voltaire (1916), p. 419; *De Stijl* Advocates Mondrian's Neoplasticism (1917), p. 429; Man Ray Creates the Rayograph (1921), p. 513; The Soviet Union Bans Abstract Art (1922), p. 544.

THE DADA MOVEMENT EMERGES
AT THE CABARET VOLTAIRE

Category of event: Art
Time: 1916
Locale: Zurich, Switzerland

Dada demanded liberation from outmoded social conventions and challenged the traditional role of art, its subject matter, its modes of representation, and its boundaries

Principal personages:
> HUGO BALL (1866-1927), a German writer, social critic, and philosopher, the co-owner of the Cabaret Voltaire and a founding member of the Dada movement in Zurich
> TRISTAN TZARA (SAMI ROSENSTOCK, 1896-1963), a Romanian writer, one of the movement's most important propagandists
> HANS ARP (1887-1966), a painter, sculptor, and poet from Strasbourg, a cofounder of Dada in Zurich, and later in Cologne
> MARCEL JANCO (1895-), a Romanian artist, a cofounder of Dada in Zurich
> RICHARD HUELSENBECK (1892-1972), a German psychiatrist, poet, and writer, a cofounder of Dada in Zurich and Berlin
> EMMY HENNINGS (1855-1948), a German cabaret artist and co-owner of the Cabaret Voltaire

Summary of Event

In the winter of 1915, the German writer Hugo Ball opened the Cabaret Voltaire in Zurich, Switzerland. Having fled war-torn Germany in 1914 with his girlfriend, Emmy Hennings, Ball established a gathering place for writers, artists, and intellectuals to converse and perform impromptu dances, music, and poetry readings. He enlisted the help of several of his friends in this endeavor, including Marcel Janco, Tristan Tzara, Hans Arp, and Richard Huelsenbeck, who became the nucleus of the Cabaret Voltaire group. According to Huelsenbeck, the Cabaret Voltaire was named "out of veneration for a man [Voltaire] who had fought all his life for the liberation of the creative forces from the tutelage of the advocates of power." The Cabaret Voltaire opened on February 5, 1915, and every evening it featured a hybrid form of entertainment that included skits, lectures, poetry readings, music and dance recitals, and, later, art exhibitions. Ball and his collaborators at the café wanted to unite music, dance, poetry, and art in a combined *Gesamtkunstwerk*, or total work of art.

The first few performances at the Cabaret Voltaire were relatively mild. Ball played the piano, Hennings sang folk songs, and Tzara recited Romanian poetry. Janco

decorated the café with semi-African masks that he made and painted blood red. Arp, who renounced traditional illusionistic painting, contributed pictures with undefinable subject matter. The small café immediately became popular with students and soon attracted a diverse clientele. Janco later recalled that it was a place where "painters, students, revolutionaries, tourists, international crooks, psychiatrists, the demimonde, sculptors, and polite spies . . . all hobnobbed with one another." The Cabaret Voltaire became a platform for artists in exile, and the entertainment there became progressively more extreme and avant-garde. It was in this tiny café in 1916 that Dada, the most aggressively radical movement in art history, was born.

The Dadaists rebelled against bourgeois values and rejected all principles upon which society was founded. Their ambition was to create a new world out of chaos and confusion by negating the past and annihilating the present. In Zurich, Dada was initially a literary phenomenon, and poetry was the first of the arts to come under Dada's attack. Ball bewildered the audience at the Cabaret Voltaire with his "sound poems," which abandoned all preconceived systematic thought. Dressed in a cardboard cubist costume, Ball slowly recited such lines as "gadji beri bimba glandridi laula lonni cadori." Huelsenbeck, a young German poet and medical student from Berlin, introduced the practice of simultaneous readings, a technique that created utter chaos with the simultaneous recitation of different poems. The concept of simultaneity was borrowed from the Italian Futurists, who had first used the technique in their work to celebrate speed and modern technology. Huelsenbeck also read "sound poems," similar to Ball's, which emphasized dissonant sounds and were meant to be evocative of magical or primitive chants. Ball and Huelsenbeck were both interested in the irrational and the primitive as potential creative sources for producing paradoxes and complexities in art and language. Tzara's work entitled "Roar" consisted of this single word repeated 147 times. All the Dadaists stressed irony and nihilism in their work, an emphasis prompted by their desire to negate conventional values in a world whose values were rapidly collapsing.

Although Dada was not a unified art movement, it was conditioned by the social and historical atmosphere in which it originated, including the existing international movements in the arts. Dada and the artists associated with international modernism were both seeking alternatives to established artistic conventions. One year after the Cabaret Voltaire opened, Ball and Tzara established a Dada gallery and organized avant-garde art exhibitions featuring works by an international lineup of artists, including Pablo Picasso, Paul Klee, Wassily Kandinsky, Janco, Arp, Auguste Macke, Amedeo Modigliani, and many other artists who rejected conventional academic art.

Impact of Event

In 1917, Huelsenbeck returned to Germany and sparked the inception of Berlin Dada. He introduced the manifestations of Zurich Dada in his article "The New Man." In this stream-of-consciousness essay, Huelsenbeck called for the modern "New Man" to be anarchistic, to welcome chaos, and to create new ideas. Huelsenbeck advocated radical action and revolutionary change, and under his tutelage,

Dada became more aggressive and political in Berlin than in Zurich.

In Berlin, there were two Dada factions: those who banded around Huelsenbeck, including Raoul Hausmann, Hannah Höch, and Johannes Baader, and those who were associated with the Malik Publishing Company, including John Heartfield and George Grosz. The Dadaists that formed around Huelsenbeck were more interested in intellectual issues than in aesthetic concerns. They consciously emphasized a lack of obvious content in their work, strove to negate all previous aesthetic values, and challenged the outward appearances of the external world in their work.

Influenced by his Cabaret Voltaire association, Huelsenbeck also stressed the irrational in his writings, and this became one of the major characteristics of German Dada. Hausmann and Heartfield both independently developed the medium of photomontage, using randomly cut out mass-media topography, magazine illustrations, and photographs. By juxtaposing these already-existing objects in unfamiliar ways, they created irrational, sometimes shocking, visual images. Heartfield's politically oriented photomontages lampooned Prussian militarism and later criticized Weimar culture and National Socialism. Grosz also engaged in leftist satire in his works, which brutally scrutinized the irrational attitudes of German society. Grosz's work emphasized the ugliness, the grotesqueness, and the social decay of Berlin society.

The Hanover artist Kurt Schwitters was not accepted by the Berlin Dadaists. In 1919, Schwitters founded his own apolitical brand of Dada, which he called "Merz." He developed the idea of using "found" objects, or discarded visual debris from the urban environment, in his pictures and constructions. Schwitters created collages with found objects such as used ticket stubs, postage stamps, cigarettes, and other discarded scraps. He also built multimedia assemblages, called "Merzbau" constructions, from nontraditional materials. For the Dadaists, the discovered or found object became the elevated object for art, and the content of a work of art became the material itself.

A major independent, undeclared Dada artist in France was Marcel Duchamp, who also challenged the viewer's preconceptions about what constituted a work of art. In 1913, Duchamp elevated a common, mass-produced object, a bicycle wheel, to the status of fine art. Duchamp called his bicycle wheel attached to a wooden stool a "readymade." Duchamp and the Dadaists rejected the traditional definitions of art and extended art beyond the artist's canvas to encompass one's entire environment. The impact of Dada could be seen in such later movements as Surrealism, abstract expressionism, and pop art.

In Paris, Dada transformed itself into Surrealism, which also glorified the irrational. Although André Breton, the leader of Surrealism in France, deplored the nihilistic and destructive characteristics of Dada, the Surrealists shared many of Dada's concerns and concepts. Surrealism, like Dada, was essentially a revolt against traditional, established art ideals. In the 1920's and 1930's, Surrealism was the dominant avant-garde art in Europe. Surrealist artists and writers were interested in tapping the potential creative impulses derived from recollected dreams and the unconscious. Automatism, or writing and painting in an unconscious, trancelike state,

became a major interest for many of the Surrealists, who valued automatism for freeing their painting from any representational style.

The American abstract expressionist painter Jackson Pollock later used the Surrealist's device of automatism in his famous "drip" paintings of the late 1940's and early 1950's. Pollock's brand of automatism consisted of the production of squiggly lines through agitated movements over a canvas's painted surface. His technique resulted in a layered, calligraphic complexity in his work. Pollock's abstract painting *Autumn Rhythm* is an example of this use of automatism.

In the 1950's and 1960's, pop art challenged some of the same assumptions about art that Dada had earlier challenged, but pop art did not have the same satirical or anarchistic edge to it as Dada. Pop art, however, also rebelled against traditional artistic modes of expression and representation. Inspired by Duchamp and the Dadaists, pop artists used everyday objects in their paintings and constructed assemblages. The American pop artist Robert Rauschenberg used a real pillow and quilt in his work *Bed*, which he hung on the wall as though it were a conventional stretched painting. Placing the work on the wall contradicted the bedding's original function and confounded viewers. Rauschenberg also incorporated junk materials from a consumer-oriented society. In his 1959 assemblage *Monogram*, Rauschenberg used a stuffed goat, a rubber tire, newspaper, and hand-painted typography. Jasper Johns also elevated commonplace objects to the status of fine art in his series of mixed-media flag paintings, target assemblages, and *Painted Bronze* beer cans. These works, however, were not "readymades" but pristinely constructed, reproduced objects from the everyday American environment.

"Happenings" and performance art are also distant heirs of Dada. Happenings relied on the element of chance and the spontaneous, but unlike Dada, they also followed a specific, basic program. Many happenings, such as Allan Kaprow's *Soap*, also emphasized the irrational. In *Soap*, several participants smeared jam all over a car. Performance art frequently employs the fusion of all the arts in keeping with the concept of the *Gesamtkunstwerk*. The German artist Joseph Beuys staged happenings in the 1960's with mystical overtones in which he often took on the role of a shaman or high priest. In *How to Explain Pictures to a Dead Hare*, Beuys sat in a chair, his face covered with gold paint, and talked to a dead hare. Like the original Zurich Dadaist performances, these theatrical modes of expression also aimed to dissolve the barriers between various art disciplines. The Zurich Dadaists inspired future generations of artists to challenge the traditional role of art, its subject matter, its mode of representation, and its boundaries.

Bibliography

Ball, Hugo. *Flight Out of Time: A Dada Diary.* Translated by Ann Raimes. Edited by John Elderfield. New York: Viking Press, 1974. Ball's diary, spanning the years 1914 to 1921, provides a fascinating account of the Cabaret Voltaire. Contains an excellent introduction by Elderfield that provides much in-depth biographical information on Ball as well as a history of Dada in Zurich. Recommended for

students of Dada literature and art and those interested in Ball.

Coutts-Smith, Kenneth. *Dada.* New York: E. P. Dutton, 1970. Small, popular paperback book about Dada. Provides a brief overview of the Dada movement. Short history included of Cabaret Voltaire and the artists involved there. Contains some reproductions of Dadaist works and a short bibliography for further reading. Easy to read; a good source for beginners.

Foster, Stephen C., and Rudolph E. Kuenzli, eds. *Dada Spectrum: the Dialectics of Revolt.* Iowa City: University of Iowa Press, 1979. Twelve essays that discuss works by Dadaists, earlier books on the movement, and the viewpoints of other artists on individual Dada artists. Intelligently written and compiled. Good for different views on Dada movement; recommended for students of Dada art.

Huelsenbeck, Richard. *Memoirs of a Dada Drummer.* Translated by Joachim Neugroschel. Edited by Hans J. Kleinschmidt. Berkeley: University of California Press, 1969. A good, interesting book about Dada and its beginnings in Zurich and Berlin. Filled with Huelsenbeck's personal recollections. Contains a few photographs of the Dadaists, but very few reproductions of their artwork. Includes a good, informative introduction by Kleinschmidt. Recommended for students as well as others who are interested in Huelsenbeck.

Lippard, Lucy R., ed. *Dadas on Art.* Englewood Cliffs, N.J.: Prentice-Hall, 1971. A reconstruction of the Dada movement that provides samples of the Dadaists' prose, poetry, and essays. Lippard made many of these works available in English for the first time. Also examines how Dada continued to influence the arts in the 1960's and 1970's. Includes a good general introduction and biographical commentary.

Motherwell, Robert, ed. *The Dada Painters and Poets: An Anthology.* 2d ed. Cambridge, Mass.: The Belknap Press of Harvard University Press, 1989. Well-researched and well-documented major study of Dada, from its inception in Zurich to its aftermath in Germany and its demise. Contains some interesting photographs, but few reproductions of Dada artwork. Includes Dada manifesto by Huelsenbeck and an extensive annotated bibliography.

Richter, Hans. *Dada: Art and Anti-Art.* New York: Harry N. Abrams, 1965. Richter, a pioneer avant-garde filmmaker, was loosely associated with Zurich Dada. In this book, he recreates the history of Dada from its beginnings in wartime Zurich to its collapse in Paris in the 1920's; however, he does this from a highly subjective point of view. Includes quotations from manifestos and other documents of the time.

Rubin, William S. *Dada and Surrealist Art.* New York: Harry N. Abrams, 1969. A major study of Dada and Surrealism. Traces the evolution of Dada in Zurich, Germany, and Paris, and focuses on the artists who participated in the movement. Contains numerous color reproductions of Dadaist artworks and an extensive bibliography.

Willett, John. *Art and Politics in the Weimar Period: The New Sobriety, 1917-1933.* New York: Pantheon Books, 1978. Scholarly endeavor that examines the artistic and political activities at the time of the Weimar Republic. Segment of the book focuses

on Berlin Dada and the artists Heartfield, Grosz, and Hausmann. The author's main emphasis is on the political aspects of Berlin Dada. Good bibliography.

Carmen Stonge

Cross-References

The Futurists Issue Their Manifesto (1909), p. 235; Der Blaue Reiter Abandons Representation in Art (1911), p. 275; Jung Publishes *Psychology of the Unconscious* (1912), p. 309; Baker Establishes the 47 Workshop at Harvard (1913), p. 343; Man Ray Creates the Rayograph (1921), p. 513; Four Modern Masters Affirm Germany's Place in the Art World (1980), p. 2464; Laurie Anderson's *United States* Popularizes Performance Art (1983), p. 2517.

IVES COMPLETES HIS FOURTH SYMPHONY

Category of event: Music
Time: 1916
Locale: Danbury, Connecticut

Charles Ives completed his Fourth Symphony, which typified his unique approach to music as a combination of heterogeneous elements

Principal personages:

CHARLES IVES (1874-1954), an American musician widely regarded as the most significant composer of serious American music

HENRY COWELL (1897-1965), an American composer and critic who championed Ives's music

EUGENE GOOSSENS (1893-1962), an English conductor who directed the first public performance of a portion of the Fourth Symphony

LEOPOLD STOKOWSKI (1882-1977), the American conductor who led the world premiere of the Fourth Symphony in 1965

Summary of Event

Charles Ives's career is so filled with distinctively American touches as to make him seem almost a textbook example of an American composer. Ives's work was almost completely neglected during his most creative period, 1908-1917; even at the time of his death in 1954, his music had only begun to generate professional respect and had not aroused any substantial popular interest. Yet by the time of the premiere performance of the entire Fourth Symphony in 1965, eleven years after his death, Ives had become something of a popular icon, and his music today enjoys the kind of respect and enthusiasm that is rarely granted to a serious American composer.

From his father, George Ives, who was the most important influence in his creative life, Charles Ives learned a deep respect for musical experimentation, such as the playing of pieces in remote harmonies simultaneously. From Horatio Parker, his composition professor at Yale University, Ives gained respect for the European symphonic tradition and learned well the academic rules of music, which in some of his compositions he nevertheless violated. Although he spent years as a hardworking church organist, Ives did not aspire to pursue either an academic career in music, like his mentor Parker, or a professional career as a composer or performer. As his early biographer and friend, Henry Cowell, noted in *Charles Ives and His Music* (1955), "The period of Ives's most strenuous devotion to his business was also the period of his most energetic creative production of music."

Critics agree that Ives enjoyed his period of maximum creativity in the years 1908 to 1917, beginning with his marriage to Harmony Twichell in June, 1908, and ending when the composer suffered the first of a series of heart attacks. Ives composed his last works in the years after World War I, from 1918 to 1926, and then spent the rest of his long life "tinkering" (as J. Peter Burkholder describes it in his 1985 study

Charles Ives: The Ideas Behind the Music) with the vast amount of music he had already produced. Ives ceased composing, but he did not stop refining and advocating his works.

Ives composed his Fourth Symphony over the years 1910 to 1916, neatly coinciding with the period of his greatest musical creativity. The symphony utilizes nearly all the characteristics that have come to be celebrated in Ives's music: powerful contrasts and mood changes, collages, multiple tempi, improvisation, and indeterminacy (in which some orchestral voices enter and keep time at a pace independent of that of the other instruments), polyharmonies, and microtones. Possibly the most famous characteristic of Ives's music is abundantly evident in the symphony: the use—and collision and transformation—of hymn tunes and popular songs.

The Fourth Symphony opens with a choral statement of a Protestant hymn that begins, "Watchman, tell us of the night/ What the signs of promise are." The short first movement, which really functions as a prelude to the remainder of the symphony more than as the traditional first movement of a European symphony, poses a metaphysical question: When is the night coming, and what are the signs of promise? As the symphony progresses, the existential depth of this initial question becomes more pronounced. Yet the work also contains quotations from or references to at least thirty other identifiable sources, from Protestant hymns such as "Beulah Land" and "Nearer My God to Thee" to popular songs such as Stephen Foster's "Massa's in the Cold, Cold Ground." Like Claude Debussy, his French near-contemporary, Ives sought to paint a musical portrait of life as it is actually experienced, with the mind assailed by a variety of sounds and musical impressions. Ives never got over the excitement of hearing two bands in a parade playing at once, with the subsequent overlap and spontaneous harmonic possibilities. He sought to convey how the mind is filled with snatches of ideas and memories and is constantly assailed by new sensations.

As is often the case with Ives's larger works, the Fourth Symphony features a variety of contrasts, in volume, mood, rhythm, and deployment of musical forces. The first and fourth movements serve as the question and a tentative answer; the first movement is interrogatory and chromatic, while the third movement is restrained and diatonic. The second and fourth movements are highly complicated and require huge orchestral forces, while the third movement is relatively simple and musically conservative.

The third movement is largely a fugue, based on "The Missionary Hymn" ("From Greenland's Icy Mountains") and concluding with an unexpected quotation of "Let heaven and nature sing" from "Joy to the World." The third movement serves as a moment of religious introspection amid the swirl and anxiety of the second and fourth movements. The second movement is a ferocious assault on the capacity of the listener to catch multiple musical quotations and to reconceive them as part of a harmonious, challenging whole. The fourth movement, which requires an even wider variety of instrumental forces, has the effect of a deeply considered reflection on the initial question about "what the signs of promise are," and both the second and fourth movements require the services of a second and possible third conductor to

manage the dizzying rhythmic complexity of the score. The final effect of the Fourth Symphony is that of a profoundly exhausting but exhilarating spiritual struggle, in which the complex musical quotations finally yield to an impression of renewal and reinvigoration.

Impact of Event

In a way, Ives seems too exemplary to have been real. Like a Romantic poet feverishly tossing pages over his shoulder, Ives has proven to be an inspirational figure to American composers. He is seen as an archetype of the rugged American individualist (he was a life insurance executive with a totally unpredictable alternative life as an experimental composer) and as the last New England Transcendentalist. He was a prodigiously gifted composer of some watershed works in the history of European and American music, and he composed works with rapidity and skill.

American audiences tend to respond enthusiastically to Ives's obsessive use of musical quotations, pointing out the phrases as they occur; European critics, by contrast, often criticize Ives's use of this material, hinting that it reveals a lack of imagination on the composer's part. The English critic Peter Jona Korn, writing as late as 1967, argued that "the quality of Ives's music is, to say the least, highly inconsistent. He mixes many techniques, and he masters none." Yet composers still profit from Ives's experiment, and the integrity of his musical vision has made him an exemplary figure of the disciplined, incorruptible, visionary artist. What Ives's music supplies to his American audiences is the nostalgic pleasure of past memories as retrieved through his artistry.

Ives made few efforts to have his work performed in his lifetime. When he did take the trouble to have his work edited and published, as with his *114 Songs* (1922), he was emphatic that it was not with the intention of making money. When the second movement of the Fourth Symphony appeared in the musical journal *New Music* in January, 1929, it was the first time a composition of Ives's had been published, as opposed to printed and distributed privately. Because this movement is one of the most complex and difficult of Ives's scores, it is hard to imagine the impression it must have left in 1929. Yet it was performed, under the direction of the distinguished British conductor Eugen Goossens, in January, 1927, at Pro Musica's International Referendum Concert. The piece was reviewed, with some incomprehension and some enthusiasm, by the major music critics of the time, such as Lawrence Gilman and Olin Downes.

The premiere of the entire work did not take place until more than a decade after Ives's death, when Leopold Stokowski was encouraged to conduct the Fourth Symphony at a triumphant performance by the American Symphony Orchestra in New York on April 26, 1965. When recorded by Stokowski, the work generated a new admiration for Ives and new enthusiasm for a hitherto unknown American musical masterpiece.

The award to Ives of a Pulitzer Prize for his Third Symphony in 1947, almost a half century after its composition, now seems like an embarrassment, so belated was

the recognition for America's greatest serious composer. By the mid-1960's, after Stokowski's premiere performance of the Fourth Symphony and his recording of it in 1965, Charles Ives became something of a cultural icon. The prestige of Ives continued to climb, as the importance of his musical experiments were increasingly recognized and made part of the familiar idiom of serious American music.

The scope and complexity of the Fourth Symphony are also seen as part of the late Romantic effort to capture the range and variety of the human experience in musical terms. Thus, the affinity of the Fourth Symphony to such other monumental late Romantic scores as Arnold Schoenberg's *Gurrelieder* (1900-1911) and Gustav Mahler's *Symphony of a Thousand* (1907) is becoming clearer. Ives is increasingly honored for having subsumed the finest aspects of the European musical tradition into the American experience and for having recognized and honored the American roots of his aesthetic experience with honesty, vigor, and no trace of sentimentality. It is sad to reflect that Ives's music was virtually unknown during the most creative phase of his long career, and it is poignant to think of the missed opportunities for growth suffered by the serious music tradition because of its indifference to Ives's genius.

Bibliography

Burkholder, J. Peter. *Charles Ives: The Ideas Behind the Music.* New Haven, Conn.: Yale University Press, 1985. Interesting defense of Ives the thinker; takes seriously Ives's elaborate statements of his theories of music and places Ives squarely within the tradition of New England Transcendentalism.

Cowell, Henry, and Sidney Cowell. *Charles Ives and His Music.* Rev. ed. London: Oxford University Press, 1969. Provides the most sympathetic assessment of Ives's music. First published just after the composer's death, the book helped to spark an initial interest in Ives's music that blossomed into a remarkable enthusiasm in the 1960's.

Korn, Peter Jona. "The Symphony in America." In *Elgar to the Present Day.* Vol. 2 in *The Symphony,* edited by Robert Simpson. Harmondsworth, England: Penguin, 1967. Typifies the all too common British and European incomprehension of the nature of Ives's musical experimentation. Unfortunately located in an influential standard guide to the symphonic tradition.

Slonimsky, Nicholas. "Working with Ives." In *South Florida's Historic Ives Festival, 1974-1976,* edited by F. Warren Reilly. Coral Gables, Fla.: University of Miami, 1976. The Ives centennial brochure; contains essays on a variety of topics, from Ives's innovations as an insurance broker to his use of popular songs.

Byron Nelson

Cross-References

Mahler Revamps the Vienna Court Opera (1897), p. 7; Schoenberg Breaks with Tonality (1908), p. 193; Mahler's Masterpiece *Das Lied von der Erde* Premieres Posthumously (1911), p. 298; Schoenberg Develops His Twelve-Tone System (1921), p. 528; *U.S. Highball* Premieres in New York (1944), p. 1279.

DE STIJL ADVOCATES MONDRIAN'S NEOPLASTICISM

Category of event: Art
Time: 1917
Locale: Amsterdam, The Netherlands

Although Mondrian's neoplasticism did not succeed in establishing a new, universal style for art and architecture, it did have a marked influence on the development of both

Principal personages:
PIET MONDRIAN (1872-1944), a Dutch artist whose concept of neoplasticism carried abstraction in art to its logical conclusion
THEO VAN DOESBURG (CHRISTIAN EMIL MARIE KÜPPER, 1883-1931), a versatile Dutch artist and critic whose enthusiasm and untiring efforts helped to promote and popularize the new style of neoplasticism
BART VAN DER LECK (1876-1958), a Dutch artist whose use of geometric forms and primary colors was a major source of inspiration for Mondrian's development of neoplasticism
JACOBUS JOHANNES PIETER OUD (1890-1963), a Dutch architect who modified neoplasticism to adapt it to viable architectural models
M. H. J. SCHOENMAEKERS (1875-1947), a Dutch mathematician and philosopher whose theories enabled Mondrian to convert abstract theological theory into the neoplastic style
GERRIT THOMAS RIETVELD (1888-1964), a Dutch architect and early convert to *De Stijl* who was among the first faithfully to adapt neoplasticism to furniture design and architecture.

Summary of Event

When the magazine *De Stijl* (The Style), recently and jointly founded by Piet Mondrian and Theo van Doesburg, advocated in 1917 Mondrian's new style of neoplasticism, the magazine was promoting a style that had been long in developing and to the perfection of which Mondrian would devote his artistic life. Basically, neoplasticism was the reduction of art to its basics through the rejection of any representational reference, individualism, or subjectivity. The objective was a picture language, universal rather than individualistic in spirit and, ultimately, universally comprehensible.

Neoplastic paintings were compositions of straight black lines of varying width that intersected to form rectangular shapes, which were filled in with the primary colors, supported by white and gray. Although Mondrian's "constructions," as he called them, seemed simplistic, they were amazingly complicated in their subtle structures and inherent spiritual quality.

Mondrian came to his style of neoplasticism in slow stages, markedly influenced by his background. He was born in Holland, a flat, man-made country that can seem almost two-dimensional with its squared-off polders, roads, and canals intersecting at right angles. The most dominant feature of the landscape is the sharply delineated straight line of the horizon.

Mondrian's schoolmaster father was a Calvinist who instilled in his son the idea of a chosen people destined to lead austere, useful lives imbued with social purpose. Although Mondrian later abandoned Calvinism for the more personal religion of theosophy, the Calvinist idea of duty remained. His motto was "Always Further!" Indeed, Mondrian's entire artistic career was a constant evolution into a more and more sharply defined personal style, one he believed would benefit humankind.

Mondrian showed artistic talents as a child and was encouraged by his father, who was a talented amateur artist. After securing certificates to teach drawing in primary and secondary schools, Mondrian enrolled in the Amsterdam Academy of Fine Arts, his tuition paid by an unknown benefactor.

His first paintings were representational, mainly landscapes influenced by tonalism. Even in these early paintings, though, the emphasis is on composition rather than on effects and details.

A marked change occurred in Mondrian's painting style between 1903 and 1909. In 1903, he went to live and work among the peasants of Dutch Brabant; through their simple and uncomplicated lives, he became aware of a collective, universal human spirit. A stay by the sea in 1907 and 1908 reinforced his feeling for infinity. The ocean's endless expanse, so different from the closed world of his childhood, made a marked impression, as did the abstract formation of sand dunes, which contrasted sharply with the precisely constructed canals and roads he had known. Mondrian's painting now attained a monumental quality—great towers, windmills, and trees, increasingly painted in primary colors.

In 1909, Mondrian converted to theosophy, which would have an even greater effect on his artistic style than Calvinism. Theosophy assumes the absolute reality of the essence of God and the essentially spiritual nature of the universe. Mondrian's objective was to perfect an art form in harmony with, if not part of, the spiritual structure of the universe. Since the nature of such a form was necessarily collective, the starting point would be the rejection of all forms of individualism, both human and natural.

His recent conversion to theosophy was probably the reason why the cubist works of Pablo Picasso and Georges Braque made such an impression on Mondrian when he saw them for the first time at an art exhibit in 1911. He was fascinated by an art form that appealed to the mind more than it did to the emotions. The same year, he left for Paris, and the period between 1911 and 1915 is known as Mondrian's cubist period. Again, the evolution of his style can be seen, as he increasingly moved toward abstraction. Mondrian, though, found the cubist style too representational and subjective. Cubism was a means, not an end.

When World War I broke out in 1914, Mondrian left Paris for neutral Holland.

Flanders, where some of the most appalling butchery of the war occurred, was a geographic and cultural extension of Holland, and Mondrian's faith in the world he had known was severely shaken. It was a world that championed individuals, and the senseless war seemed to him to be a clash of nationalities that was merely individualism writ large. Increasingly, he sought the company of a group of avant-garde artists and critics with whom he became acquainted. Three of them would help Mondrian to effect the style he had been seeking.

The artist Bart van der Leck worked with geometric forms and primary colors. The clarity and strength of his compositions fascinated Mondrian. Theo van Doesburg, a versatile artist and critic, advocated a universal style applicable to all the arts and adaptable to the machine age. He was especially interested in possible changes in architecture. It was the theologian and mathematician M. H. J. Schoenmaekers who provided both the spiritual inspiration and the mathematical formula for the new style that would lead, Mondrian hoped, to an understanding of how the universe worked and that would enable humankind to live in harmony within it.

It was also Schoenmaekers who provided the rationale for neoplasticism. The new style was to be limited to the three primary colors, red, blue, and yellow; the three primary values, black, white, and gray; and the two primary directions, horizontal and vertical. The analogy with yellow, the vertical line, and the sun's rays was obvious. Just as obvious was the blue and the horizontal. Together, they formed red. The primary values could represent the cosmos in its formative stage. Mondrian called the new style "neoplasticism," or a new form of creativity. It was adopted by the other artists, and the manifesto proclaiming its validity was made in 1917. Van Doesburg became the chief promoter of the new style, with Mondrian continuing to be the chief source of artistic inspiration, although he withdrew from active participation.

Impact of Event

The style Mondrian advocated did not materialize as the familiar precisely delineated geometric forms in blue, yellow, red, black, white, and gray until 1921. Meanwhile, van Doesburg's hope of adapting the principles of the neoplastic style to all the arts never materialized. The concept was too utopian. Mondrian returned to Paris and single-mindedly worked on making his compositions ever more refined and luminous. The impact of his art was to be left to others.

The impact of neoplasticism on the arts was considerable, although largely indirect. One direct influence was felt in America by a group of abstract artists that included Josef Albers, Burgoyne Diller, and Fritz Glarner. A direct influence can also be seen in the art of the minimalists. Indirectly, Mondrian's emphasis of structure and form, the clarity and asymmetry of his compositions, had a marked influence on many artists, including Jean Arp, Alexander Calder, Willem de Kooning, and Mark Rothko. Even more important was the legitimacy Mondrian gave to total abstraction in art, the best-known examples of which were provided by the abstract expressionists such as Jackson Pollock. The abstract expressionists, like Mondrian,

searched for universal values that might lend sanity to a world seemingly going berserk.

The greatest impact of neoplasticism, though, was on architecture and industrial design. Adhering closely to the principles of neoplasticism, Gerrit Rietveld in 1924 designed the Schröder House in Utrecht, a Mondrian composition in three-dimensional form. Even the windows opened at ninety degree angles. Rietveld also designed his famous red-blue chair (more interesting than useful) in the neoplastic style. About the same time, J. J. P. Oud designed the facade for the Café de Unie in Rotterdam.

Geometry did not hold for Oud the mystical connotations it did for Mondrian. Working with van Doesburg, he made modifications to the neoplastic style but used the spatial relationships in Mondrian's compositions to create houses and housing developments that were both handsome and economical. For a demonstration housing exhibition held in Germany in 1927, Oud achieved striking beauty through a series of carefully proportioned syncopated geometric forms. Oud, too, restricted himself to primary colors, using them not as decoration but as an ancillary to special definition.

Through his compositions and following the initiative already established by the American architect Frank Lloyd Wright, Mondrian helped architects to escape from the "box" that was the basic unit of traditional architecture and to move into new spatial relationships. Devices such as cantilevering and achieving an effect of weightlessness by placing houses on stilts, as was done by the Swiss-French architect Le Corbusier, give evidence of Mondrian's influence.

Mondrian's greatest impact was to come through the merging of many of his basic ideas with those of the architects and designers of the Bauhaus in Germany, where van Doesburg went to teach in 1925. That same year, the Bauhaus published a series of Mondrian's essays on neoplasticism. German architects such as Walter Gropius and Ludwig Mies van der Rohe, leaders of a trend in Germany that had been combating conservative trends in architecture, were already working with straight lines, right angles, and minimal uses of color. Influenced by the philosophy of New Objectivity, which asserted that the development of architecture is determined by social and technological factors, Gropius and Mies van der Rohe, like Oud, sought to create, through the use of new technologies and materials, handsome constructions at minimal cost. Mondrian, together with Oud, can be considered to be among the creators of the International Style that was to become universal, dominating the field of architecture for the next fifty years. Mondrian's single greatest influence can be seen in the dominance of the straight line in much modern architecture.

The Bauhaus was among the pioneers in industrial design, in new forms of poster art, and in advertising layout. In the United States, the influence of the Bauhaus and the clean lines and precise spatial relationships of Mondrian can be seen in the work of Walter Dorwin Teague and Rayond Loewy, pioneers in industrial design.

In 1938, Mondrian left Paris for London; in 1940, he left war-torn London for New York and was overwhelmed by the vitality of the great metropolis. His neoplas-

tic style, to which he had rigidly adhered for nearly two decades, underwent marked changes, notably in the replacement of black lines with lines of dancing colors. The unfinished *Victory Boogie-Woogie* (1942-1943) was painted in the new style anticipating the Allied victory in World War II he did not live to see; Mondrian died in 1944. Had he lived longer, he might have had a still greater impact, for he died in a city he helped to make the art capital of the world.

Bibliography

Dunlop, Ian. *Piet Mondrian.* Bristol, England: Purnell & Sons, 1967. A good introduction to the fairly complicated subject of Mondrian's change of styles. The fifteen color plates are outstanding examples from each of his major periods, beginning with landscapes and seascapes and progressing through cubism and total abstraction before reaching his final style. Highly readable text. A précis accompanying each of the paintings makes the transitions easy to follow.

Jaffé, Hans L. C. *"De Stijl," 1917-1931.* Introduction by J. J. P. Oud. Cambridge, Mass.: Belknap Press of Harvard University Press, 1986. Treats neoplasticism in minute detail; the three main parts of the book deal with the style's origins, character and development, and influence on various artistic domains. *De Stijl* magazine advocated a complete artistic environment, and Jaffé details its unsuccessful attempts to move into areas such as literature and music. Interesting is the introduction by Oud, who frankly admits the movement was part of the idealism of his youth but that he felt he had to leave it even though its principles still influenced his work.

_____. *Piet Mondrian.* New York: Harry N. Abrams, 1970. Probably the definitive work on Mondrian as an artist. The forty-eight color plates, each accompanied by a detailed text, provide a useful overview on Mondrian's artistic development. One of the more interesting paintings is a self-portrait done in 1918. The work has a useful bibliography divided into primary and secondary sources.

Mondrian, Piet. *Mondrian, 1872-1944.* Introduction and notes by David Lewis. New York: George Wittenborn, 1957. Contains only ten color plates of Mondrian's outstanding works, starting with the sea scenes and ending with *Broadway Boogie-Woogie* (1942-1943). Lewis is a lucid writer; perhaps the most valuable features of the work are its discussions of Mondrian's relationship to the de Stijl group and his influence on other artists.

_____. *Piet Mondrian: The Earlier Years.* Introduction by George Schmidt. Basel, Switzerland: Galerie Beyeler, 1956. Begins with Mondrian's earliest paintings in 1898 done in the manner of the so-called Hague School. One notes the remarkable transition to total abstraction; the last painting shown was completed in 1935. Paintings are accompanied by commentary by Mondrian—much of which is fairly obscure, because of his spiritual orientation.

Russell, John. *The Meaning of Modern Art.* Rev. ed. New York: HarperCollins, 1991. Probably the best introduction to the subject in print. Russell gives Mondrian extensive coverage, although he is sparing of commentary on the de Stijl move-

ment, apparently not considering it to be overly important. The bibliography is extensive and detailed, especially as to the availability of works in English.

Nis Petersen

Cross-References

The Deutscher Werkbund Combats Conservative Architecture (1907), p. 181; The Salon d'Automne Rejects Braque's Cubist Works (1908), p. 204; Rietveld Designs the Red-Blue Chair (1918), p. 458; German Artists Found the Bauhaus (1919), p. 463; The New Objectivity Movement Is Introduced (1925), p. 631; Loewy Pioneers American Industrial Design (1929), p. 777; Le Corbusier's Villa Savoye Redefines Architecture (1931), p. 869; Wright Founds the Taliesin Fellowship (1932), p. 902.

"LES SIX" BEGIN GIVING CONCERTS

Category of event: Music
Time: 1917
Locale: Paris, France

The formation of "Les Six," a loose confederation of French composers, diminished the influence of such figures as Richard Wagner and Claude Debussy and inaugurated an era of more direct and accessible music

Principal personages:

DARIUS MILHAUD (1892-1974), a prolific member of Les Six whose innovative works earned him international fame

FRANCIS POULENC (1899-1963), a member of Les Six whose witty, sophisticated music made him the most representative member of the group

ERIK SATIE (1866-1925), an avant-garde composer whose unconventional attitudes and works made him a hero to his younger colleagues

JEAN COCTEAU (1889-1963), a writer, artist, and filmmaker who served as an unofficial spokesman for Les Six

GEORGES AURIC (1899-1983), a member of Les Six best known for his many film scores

BLAISE CENDRARS (FRÉDÉRIC SAUSER, 1887-1961), a writer whose wide-ranging knowledge of other cultures inspired Les Six

ARTHUR HONEGGER (1892-1955), a member of Les Six who actually had few musical interests in common with the rest of the group

LOUIS DUREY (1888-1979), a member of Les Six

GERMAINE TAILLEFERRE (1892-1983), a member of Les Six

Summary of Event

The young composers who were to be dubbed "Les Six" in 1920 had appeared together on musical programs for several years and four of them—Darius Milhaud, Georges Auric, Germaine Tailleferre, and Arthur Honegger—had known one another for a decade as students at the Paris Conservatory. Although they may have shared some aesthetic principles, it was chance that brought them together and friendship that bound them for a few crucial years in postwar Paris.

The single most important event leading to the group's formation was the premiere of *Parade* on May 18, 1917, in Paris. This ballet was the creation of writer and impresario Jean Cocteau and featured sets and costumes by painter Pablo Picasso. Its deliberately aimless scenario follows the antics of barkers and acrobats in front of a fair booth. Composer Erik Satie provided a score that was repetitious and disarmingly naïve, qualities that made the use of such "instruments" as roulette wheel, pistol, typewriter, and siren all the more striking. The audience felt itself insulted and erupted into near-riot. Cocteau and his collaborators had clearly intended to be

provocative, but they seem to have underestimated the uproar the production would cause.

The event solidified the admiration younger musicians felt for Satie. A fifty-one-year-old composer of almost crippling modesty, Satie produced pieces that were brief and droll, in direct contrast to the solemn, massive works of German composers such as Richard Wagner. During World War I, works by Germans were suspect in France in any case, but Satie also rejected the colorful, atmospheric compositions of French composers such as his near-contemporary Claude Debussy. Both Wagner and Debussy had been revolutionary in their time, but music such as Satie's constituted a direct challenge to their continued influence.

Another writer who shared both Cocteau's interest in new art and music and his talent for publicity, Blaise Cendrars, organized a concert on June 6, 1917, in honor of *Parade.* The scene was the Salle Huyghens in Paris, formerly an art school but subsequently the site of many informal concerts. A number of promising composers were invited to participate, among them Auric and Honegger and another potential member of Les Six, Louis Durey. Satie himself took part, and afterward he proposed an informal grouping of his young admirers, "Les Nouveaux Jeunes," that in addition to Auric, Durey, and Honegger would eventually include Tailleferre and Milhaud. They appeared frequently in concerts at the Salle Huyghens and at another Paris music hall, the Théâtre du Vieux-Colombier.

It was there on December 11, 1917, that Francis Poulenc, destined to become the final member of Les Six, appeared with a work called *Rapsodie nègre.* This series of songs is one of the first works clearly typical of the style associated with Les Six. Scored for baritone voice accompanied by flute, clarinet, piano, and string quartet, the songs took their lyrics from a collection of nonsensical, pseudo-African poems. Like *Parade, Rapsodie nègre* combined innocence and mockery; appropriately enough, it was dedicated to Satie.

By the beginning of 1918, Les Six existed in all but name. They gathered at Milhaud's and Tailleferre's apartments, dined together, went to the circus together, and performed together. Later that year, Cocteau provided them with a kind of manifesto in book form, *Le Coq et l'Arlequin* (1918; *Cock and Harlequin,* 1921). He praised music halls and jazz bands, attacked Wagner, and called for a music that was purely French. The book was dedicated to Auric and published by Les Éditions de la Sirène, a joint venture of Cocteau and Cendrars.

The six became Les Six on January 16, 1920, when critic Henri Collet published an article in the magazine *Comoedia* entitled "Les Cinq russes, les six français et Erik Satie." Taking the Russian group of composers known as "The Five" as his reference, Collet identified six French composers who had "by their splendid decision to return to simplicity, brought about a renaissance" in their country's music.

The label caught on, despite the differing temperaments of the figures involved. As Milhaud noted later in talking about the more important members of the group, only Auric and Poulenc were followers of Cocteau. Honegger (whose parents were Swiss) took his inspiration from the German Romantics. Milhaud himself had been

born in southern France and traced his musical roots to the Mediterranean. Nevertheless, the group gave "Concerts des Six," published a set of piano pieces, *Album des Six* (1920), and collaborated on another of Cocteau's leg-pulling ballets. *Les Mariés de la tour Eiffel* was presented on June 18, 1921, at the Théâtre des Champs-Élysées. It concerns a wedding party repeatedly interrupted by such unlikely figures as a bicyclist and an ostrich hunter. The production brought together a number of typical elements: love of technology, from the simple (the bicycle) to the complex (the Eiffel Tower); a rejection of grandiose themes; and a delight in nonsense.

The production was significant in another way: Durey chose not to take part. Les Six remained friends but went their own ways artistically. Aside from concerts, there were to be no more joint projects.

Durey and Tailleferre did not achieve further prominence. Honegger came to be regarded as a major composer, but his work shows few traces of his early association with the group. Only Poulenc and to a lesser extent Auric and Milhaud were to shape their careers according to the tenets championed by Satie, Cocteau, and Collet.

Impact of Event

The most important achievement of Les Six was to blur the distinction that had grown up between "serious" and "popular" music. They did this in a number of ways.

First of all, they rejected the examples of composers whose works were, they felt, far removed from the realm of everyday experience. Instead, they borrowed freely from the circus and the music hall, incorporating folk music from as far away as Latin America and—filtered through the medium of jazz—black Africa. Although Poulenc had based his *Rapsodie nègre* of 1917 on mock-African material, it was Milhaud who made the most creative use of folk and popular elements. The young composer had spent two years in South America as a diplomatic secretary, and he mixed tangos and sambas and similar dances into a bubbly and irreverent orchestral piece called *Le Boeuf sur le toit* (1920).

Milhaud's score to *La Création du monde* (1923) was to prove far more significant. The idea of dramatizing an African version of the creation belonged to Blaise Cendrars, who had visited Africa and produced an *Anthologie nègre* (1921; *The African Saga*, 1927) celebrating the continent's art and folklore. Milhaud, on the other hand, had visited Harlem; his orchestration for the piece called for the same seventeen instruments he had heard played in jazz bands there.

La Création du monde is generally credited with being the first symphonic use of jazz, and yet the interest in jazz in Europe and America was so great that other composers were bound to take it up sooner or later. In the years following, George Gershwin used jazz in his *Rhapsody in Blue* (1924), Aaron Copland in his Piano Concerto (1927), and Maurice Ravel in his two piano concertos (1931 and 1932). Not only was Milhaud first, however, but his work was freer in spirit. While most other composers adapted jazz elements to existing musical forms, Milhaud developed his forms to fit his material.

Interest in jazz was part of a larger and growing fascination among Americans and Europeans with the culture of black Africa. The German expressionists and the French painters known as the Fauves ("wild beasts") were influenced by the African masks and sculpture that had begun to appear in Europe after the turn of the century. Critic Marius de Zayas published *African Art: Its Influence on Modern Art* in New York in 1916, and Blaise Cendrars issued his *Anthologie nègre* five years later. The movement culminated in France with the Colonial Exposition of 1931, which highlighted the art of France's predominantly African and Oceanic empire.

Unlike many other artists, composers, and writers, Les Six welcomed the technological developments that were changing the lives of ordinary individuals. In its own lighthearted way, *Les Mariés de la tour Eiffel* had celebrated the enormous steel structure built for the World's Fair of 1889. Inspired by a catalog of farm machinery, Milhaud wrote *Machines agricoles* in 1919. Even Honegger, who often differed with his colleagues, composed a famous musical description of one of the locomotives he loved so well, *Pacific 231* (1923).

Another technological development of growing popularity was the motion picture. Before Cocteau created a ballet scenario around it, Milhaud had envisioned *Le Boeuf sur le toit* as an accompaniment to one of Charlie Chaplin's early comedies. Honegger wrote more than thirty film scores, but it was Auric who embraced the new medium wholeheartedly, eventually producing scores to about one hundred films. His greatest popular triumph was the theme song to *Moulin Rouge* (1952), a dramatization of the life of painter Henri de Toulouse-Lautrec.

Fascination with technology was in the air, and interest in science and machinery manifested itself in other art forms and in other countries. Painter Robert Delaunay produced vibrantly colored canvases of the Eiffel Tower, and he and his wife Sonia Delaunay-Terk painted enormous abstract works celebrating the principles of motion and dynamism. Fellow artist Raoul Dufy (who had designed the scenery for *Le Boeuf sur le toit*) went on to assemble one of the world's largest paintings, a sixty-by-ten-meter work illustrating the history of electricity, for the Paris World's Fair of 1937. Commercial artist A. M. Cassandre immortalized locomotives and elegant passenger ships in posters that remain popular. The artistic movements known as Futurism in Italy and vorticism in Great Britain celebrated motion and technology.

The music of Les Six has come to characterize the Paris of the 1920's. With the end of World War I, many thought a new age had dawned. Old orders of politics and culture seemed to have been swept away, and technology appeared to be transforming the world for the better. The best musical tribute to the period is Poulenc's only large-scale symphonic work, his *Sinfonietta*. Written in 1947, it is a kind of farewell to youth, mixing the gaiety and impudence of the 1920's with a melancholy realization that the new age did not last after all.

Bibliography

Cocteau, Jean. "Cock and Harlequin." In *Cocteau's World: An Anthology of Writings by Jean Cocteau*. Translated and edited by Margaret Crosland. London: Owen,

1972. A translation of Cocteau's manifesto for Les Six in its later, 1926, version. Aphoristic and jumpy, and hard to follow for those not in the know. Readers will find this volume the most accessible source.

Collaer, Paul. *Darius Milhaud.* Edited and translated by Jane Hohfeld Galante. San Francisco: San Francisco Press, 1988. A detailed though approachable study of the music. Includes catalogs of Milhaud's work arranged chronologically by category, opus number, and title; a discography; and a short bibliography. Contains many musical examples. For students.

Hansen, Peter S. "Paris After World War I" and "Les Trois." In *An Introduction to Twentieth Century Music.* 4th ed. Boston: Allyn & Bacon, 1978. A discussion for the general reader covering Cocteau, Satie, and Les Six. Les Trois are the composers Hansen considers "France's leading composers of the second quarter of the century": Milhaud, Honegger, and Poulenc. Some musical examples.

Harding, James. *The Ox on the Roof: Scenes from Musical Life in Paris in the Twenties.* 1972. Reprint. New York: Da Capo Press, 1986. The only book in English devoted to Les Six, although Harding casts his net widely enough to include Satie as well as a number of figures peripheral to the group. Begins with the premiere of *Parade* and ends in 1929; an "Envoi" brings the story up to 1961. Very readable. Photographs, general and individual bibliographies, index.

Keck, George R. *Francis Poulenc: A Bio-Bibliography.* New York: Greenwood Press, 1990. A brief biography followed by a list of works and premiere performances, a discography, an annotated bibliography, alphabetical and chronological lists of compositions, and an index. The starting point for any extended study of Poulenc.

Milhaud, Darius. *Notes Without Music: An Autobiography.* Translated by Donald Evans. Edited by Rollo H. Myers. 1953. Reprint. New York: Da Capo Press, 1970. An amiable autobiography mixing the minutiae of daily life with important cultural events. Ends in 1947, by which time Milhaud had composed most of his important work. The lack of an index limits its usefulness.

Rorem, Ned. "Cocteau and Music." In *Jean Cocteau and the French Scene.* New York: Abbeville Press, 1984. An informal but perceptive consideration by a noted contemporary composer. Finds Cocteau "a shrewd layman who somehow belonged to the world of sound." Concludes with a list of works by Cocteau on which Les Six and other composers collaborated. The book itself contains numerous illustrations, a chronology of Cocteau's life, and a detailed index. A good introduction to the cultural world in which Les Six flourished.

Grove Koger

Cross-References

Stein Holds Her First Paris Salons (1905), p. 129; Les Fauves Exhibit at the Salon d'Automne (1905), p. 140; Artists Find Inspiration in African Tribal Art (1906), p. 156; The Futurists Issue Their Manifesto (1909), p. 235; Gershwin's *Rhapsody in Blue* Premieres in New York (1924), p. 598.

YEATS PUBLISHES *THE WILD SWANS AT COOLE*

Category of event: Literature
Time: 1917
Locale: Dublin, Ireland

The major poetic voice of his age, William Butler Yeats consolidated the style and themes of his mature work, bridging the divide between nineteenth century sensibilities and twentieth century concerns

Principal personages:

WILLIAM BUTLER YEATS (1865-1939), the most influential poet of his generation and one of the most important modern poets

LADY AUGUSTA GREGORY (1852-1932), the owner of the Coole Park estate and Yeats's most important patron

ROBERT GREGORY (1881-1918), Lady Gregory's only son, shot down over Italy in World War I

MAUD GONNE MACBRIDE (1866-1953), an Irish revolutionary and a major emotional landmark in Yeats's life and imagination

Summary of Event

In *The Wild Swans at Coole*, William Butler Yeats produced the second in the series of volumes of poetry upon which any serious evaluation of his reputation must be based. Critical opinion will differ as to the extent and regularity of this series. It has its origins, however, in *Responsibilities* (1914), the book of Yeats's poetry that immediately preceded *The Wild Swans at Coole*. The shift of emphasis in *Responsibilities* constituted a watershed in the development of Yeats's comprehension and acceptance of his poetic and personal preoccupations. In *The Wild Swans at Coole*, this new phase, characterized by increased candor, a more spare poetical style, a greater formal sophistication, and a more explicitly philosophical dimension, is consolidated and extended. Yeats's effective revaluation of his imaginative origins in late Romantic verse is confirmed by the sheer range of *The Wild Swans at Coole* and the poet's command of this range. If Yeats's career as a whole is characterized by his ability to remake continually his poetic presence while at the same time preserving that presence's continuity, this ability is nowhere more in evidence than in the variety of work in *The Wild Swans at Coole*.

A large number of the changes in tone and subject matter in Yeats's verse from *Responsibilities* to the end of his career may be classified under the general heading of realism. In the context, this term attains a somewhat specialized meaning, since Yeats did not by any means forego the passionate, visionary energy that he derived from reading such English Romantic poets as William Blake and Percy Bysshe Shelley. In addition to identifying sources of this energy in his own imagination, however, Yeats began to develop a critical sense of its power. This sense led him, on the one hand, to develop an elaborate codification of this visionary power's substance and usefulness,

an ambition that receives expression in the complex and daunting poem "The Double Vision of Michael Robartes," with which *The Wild Swans at Coole* concludes. On the other hand, Yeats intensifies the expression of his awareness that ideals are both necessary and virtually impossible to attain. It is in his increasingly painful awareness of the latter fact of life that a realistic quality may be said to enter the verse. This quality gives the verse a greater dialectical impetus and sets forth more clearly than ever the poet's emotional and psychological engagement with the antithetical nature of human existence and his impassioned articulation of that engagement.

The effect of the realistic component on Yeats's verse can readily be appreciated through an account of the title poem of *The Wild Swans at Coole*. It is clear from the poem's title that the poet's realistic tendencies are not merely confined to matters of theme and tone, even if their expression has its most significant impact in those two areas. The poem itself, however, has the real-life setting of the Coole Park estate of Yeats's friend and patron Lady Augusta Gregory, a notable dramatist and author in her own right as well as the single most important material contributor to both Yeats's career as a poet and his career as a public man of letters. Coole Park, then, is specifically at odds with the largely mythological landscapes, drawn largely from Irish mythological literature, in which Yeats initially attempted to secure his poetic identity. The scenic effects, including the swans, also faithfully reflect Coole Park, and the walk that is the poem's ostensible occasion is based on Yeats's familiarity with the park's grounds.

In addition, the poet delves into his own past in order to address the poem's subject, illustrating from his own experience the interest and urgency of the poem's ultimately abstract considerations. As though to underwrite the documentary character of this material, the poem proceeds in a meditative tone the principal inspiration of which is human speech. The reflective, confiding, deliberate tone brings the reader into intimate association with the poet's thought. Yet at the same time, Yeats retains his sense of large questions. For all the poem's occasional character and almost conversational address, it finally addresses issues that, however intensely they preoccupy the poet, cannot be of concern only to him. Matters of youth and age, the effects of time, an awareness of transience in the presence of permanence, and the recollection of human emotional uncertainty in the light of the swans' embodiment of fidelity both define the scope of Yeats's personal experience and give a sense of the representative nature of experience.

This strategy of drawing on the emblematic potential of his own and others' experience underlies many of the most important poems in *The Wild Swans at Coole*. The collection's notable elegies, and the fact that it is in this collection that Yeats adds an important new form, the elegy, to his artistic repertoire, is perhaps the most obvious demonstration of the strategy in operation. In addition, however, Yeats continues to address with increasing candor the complexities of his emotional life. It might be thought that the poet is, in effect, elegizing his emotional life in the title poem. If he is, other poems reveal some of the reasons why this may be the case. The collection registers the emotional impact of the death of such beloved friends as Robert Gre-

gory (Lady Gregory's only son, whose death in action informs the background of three poems in the volume, "In Memory of Major Robert Gregory," "An Irish Airman Foresees His Death," and "Shepherd and Goatherd") and Mabel Beardsley (sister of the English artist Aubrey Beardsley), whose passing is the subject of the sequence "Upon a Dying Lady." Yeats also confronts once more what was arguably his greatest source of emotional conflict, his relationship with Maud Gonne.

The presence of Maud Gonne in Yeats's poetry continues to be paradoxically inspirational. Out of his personal distress at her rejection of his love comes poetry that, in a typical Yeatsian maneuver, hymns the unattainable. The poet's sense of his beloved's vital personality and his complicated attitude to the thoughts and causes that animate her is debated again in such poems as "The People" and "His Phoenix," to mention the most notable instances. Yeats's attitude toward Gonne is further complicated by the brief, though prominent, presence in his life of her daughter, Iseult, to whom he confides in "The Living Beauty," "To a Young Beauty," and "To a Young Girl." It would be facile and simplistic to suggest that the personal turbulence that underlies much of *The Wild Swans at Coole* is the reason the volume closes with complex poems such as "The Phases of the Moon" and "The Double Vision of Michael Robartes," which attempt to map in verse the poet's private philosophical system of reconciliation and stability. The presence of these poems at the conclusion of the volume, however, offers an additional, and significantly impersonal, optic through which the human issues and the idealizing mind that addresses them may be retrospectively assessed and appreciated.

Impact of Event

The impact of *The Wild Swans at Coole* can be assessed from a number of different standpoints, including that of contemporary Irish culture, in the formation and direction of which Yeats continued to play an active and increasingly critical role. The volume's impact can also be evaluated from the standpoint of the development of poetry that would articulate the tensions of the modern age. In addition, the volume announces in clear form the interest in intellectual and philosophical synthesis that the poet would continue urgently to address, in poetry and prose, until his death in 1939. Fresh technical considerations of language and form also arise from *The Wild Swans at Coole* and constitute the area where the reader of Yeats will most vividly encounter both the volume's continuity with Yeats's earlier work and new developments within the prosodic continuum of Yeats's poetic achievement as a whole. These considerations find a focus in the flexibility and range of voice that the volume possesses and in the increasing confidence with which the poet deploys the discursive person of his mature verse. Noteworthy examples of the resourcefulness, ease, and control of the vocal component of Yeats's compositional technique may be found in the volume's title poem and in the long opening sentence of "The Fisherman."

It is to "The Fisherman," also, that the reader initially must turn to acquire a sense of Yeats's developing conception of Irish culture in *The Wild Swans at Coole*. The poem draws on some staple elements in the poet's imaginative repertory: the

western Ireland location of Coole Park, the peasant cloth from which the clothes of the fisherman are made, and the figure's solitariness and his association with nature. Yet the poet's deliberately iconographic intention with regard to the figure, the elevation of the fisherman above the concerns of the mean-spirited and opportunistic vulgarity of cultural politics in "the town," and the frank avowal of the figure's visionary character give the poem an ideological weight that is much more covert in Yeats's earlier work.

Similarly, the poems about Robert Gregory do not merely articulate the burden of their unhappy occasion but also use that occasion as a pretext to strike a triumphal note. The qualities of Robert Gregory's life and character are preserved by the poems, so that the subject is turned into a repository of enduring values. According to "In Memory of Major Robert Gregory," the most important of the three Gregory elegies, these values are best appreciated in a cultural context. For that reason, Yeats devotes the poem's opening verses to the creation of a pantheon of artistic friends in whose company Robert Gregory properly belongs—despite the meager record of Gregory's actual artistic achievements.

The poem's emphasis on the force of personality, an emphasis underlined in the conception of the heroic embodied by Gregory in "An Irish Airman Foresees His Death," is additionally noteworthy for occurring in a volume of poems in which the development of Yeats's own poetic personality is a striking feature. Moreover, as though to confirm that his concern is for the exemplary power of the individual value rather than for the context that throws that power into tragic relief, Yeats includes the brief, occasional, but telling "On Being Asked for a War Poem." Rather than offer Robert Gregory as a martyr for any of the causes for which the conflict that took his life was being fought (and which were dear to many Irishmen of Gregory's class), Yeats re-creates Gregory in the name of a different dispensation. Yeats installs his hero in cultural, rather than military, history, rendering him representative of a specifically aristocratic tradition, a tradition that Yeats long admired and sought to persuade the Irish people to retain.

The response to the unprecendented conditions and consequences of World War I in terms of projecting codes and emblems of physical mastery and spiritual passion is not unique to Yeats. Yet his rehearsal of such a projection by his recuperation of the hero type, and by his formally locating that type in a volume of poems that is otherwise rather disquieted by life's painful transitions and imperfections, sounds a distinctly modern—and modernist—note. Younger poets, particularly Ezra Pound (who was Yeats's secretary while some of the poems in *The Wild Swans at Coole* were written), had their sense of the dislocation of historical continuity and cultural tradition endorsed by Yeats's evolving vision. The philosophical idiolect that Yeats produced as the underpinning of this vision, and which is invoked in the poems that conclude *The Wild Swans at Coole*, may have proved too idiosyncratic to influence permanently the younger generation of poets. Nevertheless, the reformulations of tradition, and the revaluations of the European literary heritage that became a persistent preoccupation of Pound and of T. S. Eliot, may be seen to have been encour-

aged by Yeats's example. From both an international and an Irish perspective, therefore, as well as from the standpoint of Yeats's own poetic development, *The Wild Swans at Coole* is a landmark publication.

Bibliography

Bradford, Curtis. *Yeats at Work.* Abridged. New York: Ecco Press, 1978. The study bases its account of Yeats's methods of composition by comparing various manuscript versions of a selection of his poems. "The Wild Swans at Coole" is one of the poems selected for discussion, and various drafts of it are reprinted.

Donoghue, Denis. *Yeats.* London: Fontana, 1971. The best single brief survey of the subject. The author is the leading Irish literary critic of his generation. Yeats's life, work, and thought are clearly presented in their many complex interrelations. The study's unifying argument is based on an interpretation of Yeats's conception of power. Contains a useful chronology and succinct bibliography.

Ellmann, Richard. *Yeats, the Man and the Masks.* New York: Macmillan, 1948. The first biography to make use of unrestricted access to Yeats's posthumous papers. The poet's doctrine of the mask is adopted as a biographical trope, so that the dialectic between Yeats's life and work is fully recounted. In many ways, the most satisfactory biographical treatment of Yeats.

Jeffares, A. Norman. *A New Commentary on the Poems of W. B. Yeats.* London: Macmillan, 1984. Comprehensive annotations of each of Yeats's poems and other very helpful scholarly material. An indispensable student's guide.

_____. *W. B. Yeats.* London: Hutchinson, 1988. A reworking of this noted Yeats scholar's earlier biographical studies of the poet. Making extensive use of Yeats's unpublished papers, the author provides some new information in a work that combines scholarship with general reader accessibility.

Longenbach, James. *Stone Cottage: Yeats, Pound, and Modernism.* New York: Oxford University Press, 1988. A detailed study of the artistic and personal relationship between two of modernism's major figures. The work covers the period when a number of the poems in *The Wild Swans at Coole* were composed.

Whitaker, Thomas. *Swan and Shadow: Yeats's Dialogue with History.* Chapel Hill: University of North Carolina Press, 1964. A sophisticated and comprehensive analysis of one of the key areas of Yeats's imagination. In particular, the poet's visionary sense of history is addressed. The study surveys its theme through all phases of Yeats's career.

George O'Brien

Cross-References

Shaw Articulates His Philosophy in *Man and Superman* (1903), p. 85; The Abbey Theatre Heralds the Celtic Revival (1904), p. 119; *The Playboy of the Western World* Offends Irish Audiences (1907), p. 176; The Imagist Movement Shakes Up Poetry (1912), p. 326; Pound's *Cantos* Is Published (1917), p. 445; Eliot Publishes *The Waste Land* (1922), p. 539.

POUND'S *CANTOS* IS PUBLISHED

Category of event: Literature
Time: 1917-1970
Locale: Great Britain, France, Italy, and the United States

With the publication of "Three Cantos" (1917), Pound launched his modernist epic, the Cantos, *a project that absorbed most of his creative career*

Principal personages:
> EZRA POUND (1885-1972), a major American poet, prose writer, and translator
> H. D. (HILDA DOOLITTLE, 1886-1961), an American Imagist poet who was also a strong classicist, a friend of Pound
> WILLIAM CARLOS WILLIAMS (1883-1963), an American poet, prose writer, and practicing physician, a fellow student of Pound
> WILLIAM BUTLER YEATS (1865-1939), a major Irish poet and playwright
> FORD MADOX FORD (FORD MADOX HUEFFER, 1873-1939), an English novelist, poet, critic, and editor
> T. S. ELIOT (1888-1965), an American-born poet, playwright, editor, and critic
> T. E. HULME (1883-1917), an English critic, poet, and philosopher who was the most outspoken anti-Romantic in Pound's London circle
> WYNDHAM LEWIS (1882-1957), an English novelist, painter, prose writer, and avant-garde polemicist
> HENRI GAUDIER-BRZESKA (1891-1915), a French sculptor in the Pound circle in London
> JAMES JOYCE (1882-1941), an Irish fiction writer and poet whom Pound assisted

Summary of Event

Ezra Pound's *Cantos* is a modernist verse epic. It is a very long poem, at 802 pages, with 116 complete cantos and four fragments at the end. A lifetime effort on the part of the poet, this ongoing work was published in ten sections between 1925 and 1969, then as a one-volume collected edition, *The Cantos of Ezra Pound I-CXVII* (1970). Cantos LXXII and Canto LXXIII did not appear in any of the collections, having been suppressed because of the fascist sympathies they expressed.

Although the *Cantos* has an epic basis, except for its length it does not conform to the main features of the classical epic. It is not a progressive narrative describing the actions of a mythical hero; Pound himself defined an epic simply as "a long poem about history." He referred to his *Cantos* as "a tale of the tribe." When he began this work, he had in mind the actions not of one hero but of many who would be presented as personae. He realized that his verse would have to be something new, that

he would have to invent for himself a new poetics and a new language.

Instead of providing a principal hero and his actions, Pound wished to present in his long poem many heroes and each one's particular actions. He tried to present them objectively by presenting them dramatically, at the same time having them expose themselves through their own actions and voices, often through documentation. In projecting his own self into his characters, he hoped that their personae would disguise his own subjectivity. Since each hero would be presented in this manner, Pound saw Robert Browning's long, personal, confessional blank-verse poem *Sordello* (1840) as a model for what he wanted to do. In Canto II, Pound writes: "Hang it all, Robert Browning, there can be but the one "Sordello."/ But Sordello, and my Sordello?" After long and tiresome work, Browning had made himself master of the dramatic monologue, and Pound admired the Victorian romantic for his vitality and gusto.

At the same time, Pound saw his many heroes as representatives who merged into "man" (humankind), whom he saw as basically good but capable of being corrupted by the power of money. A person's life, Pound believed, is a struggle to resist temptation, to pass through the darkness of suffering and sadness until he or she sees the radiant light of the Godhead.

The structural model Pound chose for the *Cantos* was the fourteenth century epic *La divina commedia* (c. 1320, *The Divine Comedy*) by Dante Alighiere. *The Divine Comedy* sets forth its narrative in vernacular Italian (Tuscan) in hendecasyllabic verse. In 100 cantos, it describes the journey of Dante, guided by the Roman poet Vergil, through the nether worlds of Hell and Purgatory and then upward into Paradise, where Dante has a radiant vision of God.

Dante's long poem was designed for educational purposes, to convey the kind of knowledge he thought would bring about a renewal of a better life for humankind. Pound also intended to educate, although in a quite different way. The *Cantos* presents an unorthodox curriculum, a result of Pound's personal unorthodoxy in pursuit of his studies. There was nothing parochial about his outlook. Literature concerned him as a whole, without regard to nation or language. He wanted "to learn and propagate the best that is known and thought in the world" and believed in the comparative method and the close observation of an individual specimen. Pound saw history as a matter of motion, of the rise and fall of civilizations, of order and disorder, of cultural values, of personalities righteous and unrighteous. History also included economics. He stated bluntly, "History that omits economics is mere bunk, it is shadow show." Finally, he was not content to know one or two foreign languages, for languages were the keys to cultures, and he preferred to read texts in their original language. He was critical of the narrow range of education in his day. He remarked sternly, "A sane university curriculum would put Chinese where Greek was." The *Cantos* contains words, phrases, or passages in some sixteen foreign languages, including Chinese (in both romanization and original characters), romanized Japanese, romanized Hebrew, Russian, Arabic, and Greek (both romanized and in the original). The difficulty of reading the *Cantos* for the average educated reader stems not from the work's obscurity per se but from the disadvantage of not having

studied Pound's unorthodox curriculum, which he outlined in his *Guide to Kulchur* (1938).

Although Pound found the Dante and Browning models useful in projecting the shape of his long poem, unlike them he did not plan to contain his poetry in the traditional narrative frame. Because he planned to present numerous persons and actions scattered in time and space, his idea of the "repeat of history" came in handy. This idea amounted to a doctrine of correspondences whereby, as time went on, persons, events, and actions were repeated. He called each such recurring pattern in history a "subject-theme." He derived his cyclical theory of history from Brooks Adams' *The Law of Civilization and Decay: An Essay on History* (1895). Adams postulated that society oscillates between barbarism and civilization in a process that goes through definite stages. When society concentrates into nations, greed dominates the economy. Usurers weaken the people by constricting the money supply, causing nations to fall. Pound's objection to usury is a persistent leitmotif throughout the *Cantos*.

Pound saw each cultural stage of society reflecting a complex of ideas and energy, expressed in thought, action, and art forms. In studying the ethnologist Leo Frobenius, Pound found a term for this complex in the word "paideuma." In the *Cantos*, he sought to reveal such composites. The perspective he chose to do so was partial rather than complete, an examination of parts and specimens rather than of wholes.

Pound deliberately lost his self in the many-voiced cantos written prior to *The Pisan Cantos* (1948), in an effort to conform to Homeric objectivity. At the prison camp near Pisa where he was held, pending trial on charges of treason after World War II, his humiliation and suffering restored his self and voice. This revival, reflected in *The Pisan Cantos*, disclosed that the poet's struggle against the evil forces of usury always had been a personal struggle and also revealed that the essential tension in the *Cantos* is the opposition between objectivity and subjectivity. This personal struggle may be the most dramatic part of the *Cantos* and is in large part responsible for its unity.

The *Cantos* is wide ranging in terms of persons, places, and times. It consists of a miscellany of single cantos together with important groupings concerning persons and subjects. Two important single cantos are Canto I, introducing the Greek hero Odysseus, and Canto XIII, introducing the Chinese sage Confucius. Of the groupings, Cantos VIII-X are the "Malatesta Cantos," featuring the Italian Renaissance hero Sigismundo Malatesta, the lord of Rimini. Cantos XIV-XVI are the "Hell Cantos," showing the just punishment of usurers. Cantos XXI-XXIV are the "American History Cantos," in which appear Pound's American heroes Thomas Jefferson, John Adams, James Madison, and John Quincy Adams. Cantos XLII-LI are the "Bank Cantos," in which are discussed the evils of banking and monetary policy. Cantos LII-LXI are the "Chinese History Cantos," in which Confucian principles are upheld. Cantos LXXIV-LXXXIV are the "Pisan Cantos," which concern Pound's imprisonment and personal failure. Cantos LXXXV-XCV are the "Rock-Drill Cantos," which attack usury but end on a personal note. Cantos XCVI-CIX are the

"Thrones Cantos," in which the poet proclaims the need for social order and right action. Cantos CX-CXII are drafts and fragments. There is no settled conclusion to Pound's epic, and it is regarded as not having been complete at the time of Pound's death.

Impact of Event

The first three of Pound's *Cantos* were published in 1917. Later, these initial cantos were almost completely revised. The first collection of cantos appeared in the volume *A Draft of XVI Cantos*, published in Paris in 1925. Pound then brought out successive volumes of cantos. The last one, *Drafts and Fragments of Cantos CX-CXVII*, appeared in 1968. The *Cantos* as a whole appeared for the first time in one volume in 1970, containing Cantos I-CXVII. The effects and impact of the epic are therefore spread over a lengthy period. For practical examination, this period can be divided into two parts, prewar and postwar. The critical attitude toward Pound's lengthy poem differed radically during the prewar and postwar periods.

The controversy over Pound's epic is partly a result of the character of the work itself. In studying China's history and literary classics, Pound had become a Confucian. Confucius, the son of a magistrate, had become a teacher of government and ethics. He sought a prince who would give ear to his principles of good government and the virtues of the exceptional man. Pound apparently sought to be such a prince and to pass these principles on as well. The contentiousness is also a result in part of Pound's political actions in Italy, actions that resulted in indictment and arrest for treason. He was accused but never tried and convicted.

In considering the effect of the *Cantos* on critics and other literary persons (the general public was little involved in such appraisal), it is noteworthy that none of Pound's friends pulled punches when criticizing Pound's writing. For instance, Wyndham Lewis in 1927 attacked aspects of Pound's style in the *Cantos*. He alleged that Pound's addiction to "clipping and stopping" produced a "melodramatic, chopped, 'bitter tone'" he found undesirable. He charged that Pound's characterizations were "made up of well-worn stage properties." According to Lewis, Pound's "comic reliefs" amount to caricature of his efforts "to deal with real life—they are Pound at his worst."

William Butler Yeats complained that the *Cantos* has "more style than form." Pound's "raging at malignants" he presents in grotesque shapes indicates a "loss of control." This is shown by the "unbridged transitions" and "unexplained ejaculations." These faults, Yeats contended, contributed to the poem's unintelligibility.

In reviewing *The Fifth Decad of Cantos* (1937), Edwin Muir recorded that it dealt with "usury, banks, scarcity, and their consequences," together with a variation on the descent-into-hell theme. Muir reported on the powerful and strange effect this installment had on readers' emotions. It develops a pattern that conveys the feeling "that all the events in the poem are contemporaneous, that they are all together in one place." Indeed, Muir contended, "everything in the poem tends to be archetypal and fixed; everything is on the same plane and in the same time, a prolonged pres-

ent." In sum, Muir held, there is "little doubt that it is one of the most remarkable poems of our time." In 1940, Muir commented on *Cantos LII-LXI* (1940, "The Chinese Cantos") as political, having to do with "the ways in which societies are ruled, well or badly." He believed that Pound had "a clear idea of good rulership and bad; the first thing being to him in accordance with nature, and the second against it." According to Muir, the Chinese cantos "are vivid and condensed," presenting history skillfully "in a series of concrete images." The American section, however, to Muir "reads like a prolonged footnote to a detailed history" and requires knowledge that most readers are unlikely to possess.

While Pound was incarcerated from 1946 to 1958 in St. Elizabeths Hospital in Washington, D.C., after being declared mentally unfit to stand trial for treason, it was announced by the Library of Congress on February 20, 1949, that his book, *The Pisan Cantos* (1948) had won the prestigious Bollingen Prize in Poetry, which carried a monetary award of $1,000. This prize was to be awarded annually by a jury of selection of the Fellows in American Letters of the Library of Congress in recognition of the highest achievement in American poetry in any one year. In making the award for 1948, the jury stated: "The fellows are aware that objections may be made to awarding a prize to a man situated as is Mr. Pound." Indeed, a volatile controversy took place immediately following announcement of the prize. The controversy focused largely on the question of "pure poetry" versus "impure politics." The debate raged wildly throughout the 1950's. Although the debate became less heated and less often voiced, no reconciliation had been accomplished by the time of Pound's death.

Critics have varied in the manner in which they have treated Pound. Peter Viereck dismissed both the man and the *Cantos* as satanic and repugnant. Randall Jarrell accepted the poetry but condemned the man. A third approach was employed by Max Wykes-Joyce, who made a sympathetic attempt to understand Pound's behavior in terms of his upbringing, his education and social experience, and his personal character. Wykes-Joyce acknowledged the poet's unwise support of Benito Mussolini, whose character Pound completely misjudged, and Pound's selective anti-Semitism. Wykes-Joyce argued that Pound's "view of the function of banks" and "his pleasure at a ruler who ruled" accounted for his praise of Mussolini.

As a man of letters as well as a brilliant poetic technician, Pound influenced two other great poets who had become his friends, Yeats and Eliot. Pound introduced Yeats to the Japanese Nō drama, with influences appearing in Yeats's play *At the Hawk's Well* (1916) and several others. As for Eliot, Pound helped him with *Prufrock and Other Observations* (1917) and carefully tidied up the long poem *The Waste Land* (1922), for which tasks Eliot always remained grateful. Pound also helped in the poetic training of Hart Crane, who eventually composed the long poem *The Bridge* (1930). Crane never met Pound but did correspond with him and became both his and Eliot's disciple.

Pound and William Carlos Williams met in college in Philadelphia. Williams might never have made it as a poet if Pound had not critically abused him; Williams'

long poem *Paterson* (1946-1958) shows Poundian influence. Pound thus influenced perhaps the three greatest long poems in English, other than his own, of the twentieth century. Pound also influenced the work of other distinguished poets, including E. E. Cummings, Marianne Moore, H. D. (Hilda Doolittle), and Archibald MacLeish. His influence continued with Charles Olson and the Black Mountain poets of the 1940's and 1950's.

Bibliography

Alexander, Michael. *The Poetic Achievement of Ezra Pound.* Berkeley: University of California Press, 1979. An appreciation of Pound's poetry as a whole but with the main focus on the *Cantos.* Although the author is an admirer of Pound's poetry, he does not avoid critical judgment. A useful introduction to Pound's poetic achievements.

Bell, Ian F. A. *Critic as Scientist: The Modernist Poetics of Ezra Pound.* London: Methuen, 1981. Argues that Pound's critical terminology was derived from analogy to the scientific disciplines.

Edwards, John Hamilton, and William V. Vasse. *Annotated Index to the Cantos of Ezra Pound, Cantos I-LXXXIV.* Berkeley: University of California Press, 1957. Both an index to the *Cantos* and an annotation of the materials indexed. The general index contains the names of persons, places, and things, quotations in English, and all foreign language expressions except those in Greek and Chinese scripts, which appear in the appendices.

Flory, Wendy Stallard. *Ezra Pound and the Cantos: A Record of a Struggle.* New Haven, Conn.: Yale University Press, 1980. The author argues that in 1938 Pound envisioned the central theme of the *Cantos* as the struggle he and like-minded others engaged in against the obstructors of knowledge (the academies) and of the distribution of wealth (the banks), but that in 1945, at Pisa, Pound entered into a personal struggle against the moral authority of his own government, with this struggle giving the *Cantos* its unity.

Kayman, Martin. *The Modernism of Ezra Pound: The Science of Poetry.* New York: St. Martin's Press, 1986. This study, a historical and formal analysis of the Poundian discourse as it is related to the central issues of modernism, is designed to evaluate Pound's importance as a modernist—in a tradition he himself helped to establish—and to examine the relation of art to politics. The analysis is pursued from the perspective of dialectical materialism and the Marxist ethic.

Knapp, James F. *Ezra Pound.* Boston: Twayne, 1979. Part of Twayne's United States Authors Series, this study is accurate as to facts and is perceptive in its criticism. Serves as a useful introduction to the development of Pound's thought and art. The author avoids spending too much time on Pound's biography and keeps literary criticism to a minimum.

Pound, Ezra. *Guide to Kulchur.* Norfolk, Conn.: New Directions Books, 1938. An indispensable guide to the *Cantos.* Discloses the unorthodox curriculum Pound pursued.

Redman, Tim. *Ezra Pound and Italian Fascism.* Cambridge, England: Cambridge University Press, 1991. A carefully muted inductive examination of Pound's relationship to Italian Fascism, with the goal of discovering whether Pound's political activity squares with what his critics allege he did. The study covers Pound's actions from the early 1930's to the end of World War II. Particularly valuable is the author's tracing of the course and development of Pound's economics.

Terrell, Carroll. *A Companion to the Cantos of Ezra Pound.* Berkeley: University of California Press, 1980. An updating and supplement to Edwards and Vasse's *Annotated Index to the Cantos of Ezra Pound.* Designed not for Pound scholars but for those beginning the study of Pound's epic. Includes sources, background, exegeses, and glosses.

Richard P. Benton

Cross-References

Harriet Monroe Founds *Poetry* Magazine (1912), p. 314; The Imagist Movement Shakes Up Poetry (1912), p. 326; Yeats Publishes *The Wild Swans at Coole* (1917), p. 440; Eliot Publishes *The Waste Land* (1922), p. 539; Joyce's *Ulysses* Epitomizes Modernism in Fiction (1922), p. 555; Crane Publishes *The Bridge* (1930), p. 851; *Poems* Establishes Auden as a Generational Spokesman (1930), p. 857; Pound Wins the Bollingen Prize (1949), p. 1443.

CATHER'S *MY ÁNTONIA* PROMOTES REGIONAL LITERATURE

Category of event: Literature
Time: 1918
Locale: Boston, Massachusetts

Willa Cather's My Ántonia *opened new possibilities for regional literature and expanded alternatives for plotting*

Principal personages:
> WILLA CATHER (1873-1947), a journalist, novelist, and winner of the 1922 Pulitzer Prize for fiction
> WLADYSLAW THEODORE BENDA (1873-1948), a painter and illustrator who made the drawings that Cather wanted to appear in all published editions of *My Ántonia*

Summary of Event

In October of 1918, when Willa Cather was forty-four years old, she was considered a promising "young" novelist by critics and reviewers such as H. L. Mencken. She was by then the author of an unheralded collection of poems, *April Twilights* (1903), a collection of short stories, *The Troll Garden* (1905), and three novels: *Alexander's Bridge* (1912), *O Pioneers!* (1913), and *The Song of the Lark* (1915). Though she had been publishing short fiction in magazines since 1892 and by 1918 usually was able to sell her stories for good prices, she was not yet very strongly established as a fiction writer. She had begun her professional career in journalism and eventually served as managing editor at the muckraking magazine *McClures* (1908-1911). Yet she had long aspired to write fiction. Her brief acquaintance with Sarah Orne Jewett in 1908-1909 brought her advice that she gradually took to heart: to seek to write truly about the Nebraska experiences that clearly were so important to her.

Cather had moved with her family to the area of Red Cloud, Nebraska, when she was ten years old, and she lived there until after her graduation from the University of Nebraska in 1895. After moving to Pittsburgh and then to New York, she returned home often to visit with her family and many friends, especially among the immigrants. In *O Pioneers!*, she was notably successful in making use of late nineteenth century Nebraska and its pioneer farming culture, made up of a diversity of immigrants, and this novel earned for her the recognition that led reviewers such as Mencken to pronounce her promising. *My Ántonia* (1918), like *O Pioneers!*, is set in southeastern Nebraska in the second half of the nineteenth century and vividly presents the unique rural and small-town culture of that period. Upon its publication, it was immediately recognized as a masterpiece.

My Ántonia is a complex novel simply told, accessible to younger readers yet challenging and provocative for professional scholars. It is constructed as a memoir in five books. The introduction presents Jim Burden, author of the memoir, for whom Ántonia Shimerda, an immigrant Bohemian girl, has become a symbol of the whole meaning of his experience of growing up in and around the Nebraska prairie town of Black Hawk. Jim's youth exactly parallels Cather's, and most of the characters are based on people Cather knew in Red Cloud. Ántonia is based on Cather's friend Annie Sadilek. Book 1 tells of Jim's move to Nebraska and his early friendship with Ántonia; book 2 recounts Jim's adolescence in Red Cloud as he prepares for college and Ántonia prepares for becoming a rural wife and mother; book 3 covers Jim's college days, when he sees little of Ántonia; and book 4 tells the story of Ántonia's hard life after she is deserted by the man who promised to marry her and she bears an illegitimate daughter. The final book shows Jim returning after twenty years without seeing Ántonia. She has married and reared a large family, while he has become a corporation lawyer and has made a bad marriage. He finds her still a vital person and a dear friend who has preserved their youthful friendship in the stories she tells her children. Though the overall plot of the novel is governed by a pattern of separation and return that emphasizes a kind of nostalgic treasuring of a beautiful shared past, the novel is not simply nostalgic, nor is it sentimental. Jim treasures the moments of communion with friends and the landscape, but he does not forget the pains and horrors of hard and greedy people, the often forbidding landscape, and the narrow-mindedness and materialism that tend to dominate his rural culture. The novel forms a moving, realistic portrait of its setting and time.

Upon its publication, *My Ántonia* was reviewed enthusiastically, and positive evaluation of the novel continued even through the 1930's, when Cather's apparent lack of direct concern for social and political issues brought her much negative criticism from reviewers. Critics praised Cather for bringing to vivid life the people of the American West and showing them to be worth knowing. Sophisticated readers noted the apparent artlessness of her technique, especially the power of giving subtle unity and epic scope to a work that appeared episodic in plot. Such readers also recognized the hard-edged realism behind Jim Burden's somewhat romantic nostalgia and emphasized that the overall portrait was not an idealized one. Cather was seen as moving beyond the local-color writers who preceded her by giving universal significance to local settings and characters.

My Ántonia established Cather as one of the most respected writers of her generation. After 1918, each of her novels was eagerly awaited and reviewed by senior reviewers in all the important national magazines and newspapers. Magazines clamored for her short stories, offering very high prices, though she preferred to write novels and resorted to stories mainly when she needed more money than her novels earned. Her next novel, *One of Ours* (1922), was inspired by the loss of a relative in World War I. Though usually considered not among her best works, *One of Ours* was very popular and won a Pulitzer Prize. The encouragement of fame led her to bold experimentation in her writing, though she always strove for a clarity of style and

representation that would make her work appealing to general readers. Among her most highly regarded works that followed *My Ántonia* are *A Lost Lady* (1923), *The Professor's House* (1925), *Death Comes for the Archbishop* (1927), and a collection of three short works, *Obscure Destinies* (1932).

Impact of Event

The importance of *My Ántonia* may be seen best, perhaps, in the context of the general movement in U.S. cultural history to produce great literature that proceeded from and represented the unique localities and cultures of the nation. Cather's most famous predecessors in fiction tend to be best known for works that vividly represent a unique locale and tell a moving, universal story that seems to belong to and grow naturally out of its setting, works such as Nathaniel Hawthorne's *The Scarlet Letter* (1850), Herman Melville's *Moby-Dick: Or, The Whale* (1851), Mark Twain's *Adventures of Huckleberry Finn* (1884), and Theodore Dreiser's *Sister Carrie* (1900).

Cather began her literary career as a disciple of Henry James. An enthusiastic admirer of the Greek and Roman classics, Cather sought to bring to her own fiction the aesthetic principles she associated with classical art and with James. Her heart and imagination, though, were most impressed by the life and culture she experienced growing up in rural Nebraska, a locale that might not seem to lend itself easily to her artistic ambitions. Her best success as novelist seemed to come when she brought these devotions together: the realism and artfulness of James, the simplicity, clarity, and universality of the classical, and her deep love for the people and places among which she was reared. Cather had to distinguish herself from the cosmopolitan James if she was going to make fiction out of her rural background. As a woman, moreover, she found herself inclined to focus more on women's experiences and to create structures rather unlike those that tended to dominate in the realistic fiction of famous male predecessors.

In *My Ántonia*, she moved decisively away from the quest as a dominant plot form, and her subsequent experimentation with fictional plots is largely a search for alternative structural forms to the quest narrative. Several of Cather's contemporaries, notably Sherwood Anderson, were also experimenting with alternative forms, and one important influence on Cather's experiments was local-color writing, especially that of Sarah Orne Jewett. "Local color" is a term used to describe the works of a group of post-Civil War authors who sought to preserve in fiction unique regional cultures that began to disappear as the nation was unified by industrialization, mass communication, rapid transportation, and urbanization after the war. Though this literature, often written by women, tended to be considered ephemeral despite its popularity, it became one foundation for the realistic and naturalistic movements in United States literature and produced such illustrious writers as Mark Twain. Cather saw in women writers such as Jewett ways of structuring plots that would allow the unification of a substantial novel without recourse to romance, action, and adventure. Certainly, a key example for her was Jewett's *The Country of the Pointed Firs* (1896), which pretends to be the journal of a summer spent by a city

writer in a rural town, much as *My Ántonia* pretends to be an unstructured memoir, a collection of a middle-aged man's memories of a childhood friend. Scholars also have documented Cather's indebtedness to European Impressionist and Symbolist writers and painters.

As a result of her success with *My Ántonia* and her subsequent experimentation, Cather became an important influence on younger writers. She continued a trend, most visibly begun by James Fenimore Cooper and Twain, of making widely appreciated fiction out of local and Western materials, helping to earn worldwide respect for American authors. Her work contributed to the later success of authors such as William Faulkner and Flannery O'Connor, who also drew their fiction from regions that could have been considered remote and unimportant. Cather also continued and brought more decisively into the mainstream of modern fiction what might be considered feminine alternatives to the traditional quests for love, enlightenment, and power that tended to dominate in popular and successful fiction, helping to make way for the acceptance of later experiments in plot form such as Faulkner's *The Sound and the Fury* (1929) and *Go Down, Moses* (1942), Eudora Welty's *The Golden Apples* (1949), Louise Erdrich's *Love Medicine* (1984), and Ursula K. Le Guin's *Always Coming Home* (1985) and *Searoad* (1991).

My Ántonia continued important traditions and helped to open up new ideas for fictional structure. The novel also dealt with and questioned traditional American themes. Jim Burden's relationship with Ántonia parallels Huck Finn's relationship with the slave Jim. As in several ways opposites to their observers, Ántonia and slave Jim seem capable of giving their friends, who represent the more powerful and dominant cultural values, a wisdom they lack, a wisdom that calls into question seemingly pervasive American values such as materialism, commercialism, and overconfidence in moral systems and technology. Jim Burden seems to see negative values triumphing in North American culture, and his nostalgia reflects a general theme of U.S. literature during and after World War I: the sense that a sort of innocent idealism has passed from the scene with the closing of the frontier and the entrance of the United States into world politics. Another main theme of *My Ántonia* is the importance of cultural diversity to the richness of a community. One of the negative developments in the novel is the town of Black Hawk's insistence upon conformity to a set of "American" values that devalues the rich contributions of the diverse European cultures that Cather herself experienced and treasured in Nebraska. This theme echoes through all Cather's works, notably *Death Comes for the Archbishop*, and it helped to make her an especially important example to ethnic writers at the end of the twentieth century.

When literary critics look back upon the first half of the twentieth century in America fiction, two authors, Willa Cather and William Faulkner, tend to stand out. Each produced short stories (such as Cather's "Neighbor Rosicky," which first appeared in *Obscure Destinies*) that are studied by almost every college student who takes a modern American literature course, and each produced several novels that are widely recognized as belonging to world literature.

Bibliography

Arnold, Marilyn. *Willa Cather: A Reference Guide.* Boston: G. K. Hall, 1986. Includes a discussion of Cather's literary reputation, followed by a bibliography of writings by Cather and an annotated bibliography of writing about Cather from 1895 to 1984. Also includes author and subject index. This is an excellent source for gaining an impression of how each of Cather's novels was reviewed when it appeared as well as for surveying literary criticism on her work.

Bloom, Harold, ed. *Willa Cather's* "My Ántonia." New York: Chelsea House, 1987. Collects eleven discussions of the novel by literary historians and critics such as James E. Miller, Jr., David Stouck, Blanche Gelfant, and Evelyn Helmick. Includes a variety of approaches to structure and theme, with emphasis on Cather's concept of time and on the representation of gender and sexuality. Includes a chronology of her life and a bibliography.

Gerber, Philip. *Willa Cather.* Boston: Twayne, 1975. A biographical and critical study of Cather's literary career. Less detailed than James Woodress' biography, this volume offers an informative introduction to Cather and her works. After a chronology of her life, Gerber presents chapters on her journalism career, two chapters on her fiction, a chapter on her literary values and beliefs, and a final overview of her career. Includes an annotated bibliography.

Murphy, John J. *Critical Essays on Willa Cather.* Boston: G. K. Hall, 1984. The valuable introduction traces the progress of Cather's critical reception. Includes essays and reviews from 1912 to 1984 and five new essays on Cather's career. Provides a good mixture of contemporary reviews and later interpretations of Cather's major work.

_____. "My Ántonia": *The Road Home.* Boston: Twayne, 1989. A book-length study, emphasizing the novel's realism and the complexity of its narrative construction. After summarizing historical context, literary importance, and critical reception, Murphy looks closely at the historical and biographical sources, discusses how Cather composed the novel, comments on major aspects of the story, and then presents his conclusions, comparing Cather to Walt Whitman. Also includes two related documents and a selected, annotated bibliography.

Rosowski, Susan J. *Approaches to Teaching Cather's* "My Ántonia." New York: Modern Language Association, 1989. Though designed for college teachers, the short essays in this volume provide a broad range of ways of looking at and thinking about the novel, making this a primary source of stimulating ideas for further thought.

Woodress, James. *Willa Cather: A Literary Life.* Lincoln: University of Nebraska Press, 1987. A detailed and readable account of Cather's life and works, with many photographs and a good index. Includes a chapter on each of Cather's books, telling about her activities and research during the period of composition, describing the novel, detailing biographical elements she included, and summarizing how the book was received by reviewers.

Terry Heller

Cross-References

Henry James's *The Ambassadors* Is Published (1903), p. 96; Hemingway's *The Sun Also Rises* Speaks for the Lost Generation (1926), p. 696; *The Sound and the Fury* Launches Faulkner's Career (1929), p. 805; *Our Town* Opens on Broadway (1938), p. 1099; *The Grapes of Wrath* Portrays Depression-Era America (1939), p. 1138.

RIETVELD DESIGNS THE RED-BLUE CHAIR

Category of event: Fashion and design
Time: 1918-1919
Locale: Utrecht, The Netherlands

Gerrit Rietveld's "red-blue" chair illustrated the program of the Dutch avant-garde de Stijl movement and was an influential early example of the machine aesthetic of modernism

Principal personages:
GERRIT THOMAS RIETVELD (1888-1964), a Dutch designer and architect
THEO VAN DOESBURG (CHRISTIAN EMIL MARIE KÜPPER, 1883-1931), the founder of *De Stijl*, a Dutch magazine published from 1917 to 1931
PIET MONDRIAN (1872-1944), an artist whose paintings legitimated de Stijl as an influential movement of the early twentieth century

Summary of Event

At the age of eleven, Gerrit Rietveld was an apprentice in his father's cabinet-making shop, designing and building pieces derivative of medieval and Louis XV styles. By 1915, after he had finished an additional apprenticeship with the premier goldsmith in Holland and had successfully completed several pieces of furniture in the studio of his drawing teacher, the Dutch architect J. P. Klaarhamer, Rietveld opened his own shop in Utrecht. His early work was typical of the rectilinear crafts-man style of early twentieth century architects and designers in Western Europe and the United States, displaying a simple, unpretentious attitude toward both materials and construction.

After World War I, however, Rietveld's work moved in a new direction. Between 1918 and 1920, he designed a variety of domestic objects, ranging from chairs and lamps to a baby buggy, that were experiments in a new sort of modern sensibility, dependent on neither historical precedents nor craft-production concerns. Rietveld "exploded" his designs, reassembling the parts so that normally massive everyday objects were replaced by pieces that were lighter than the originals in both appearance and construction.

The chairs, in particular, united functional and theoretical concerns. Perhaps influenced by the writings of the American architect Frank Lloyd Wright, who visited Holland in 1909 and whose designs generated considerable interest in Europe, Rietveld began to test the variety of ways in which construction, form, and materials might be manipulated. A central innovation of Rietveld's work was a redefinition of the meaning of space. In all of his designs, from buildings to buffets, from chairs to toys, Rietveld recognized that space was a central, significant, and neglected element in design. Space became a meaningful component of every piece, intersecting with and penetrating its structure. The range and depth of these experiments, es-

pecially in furniture design, were the basis of much of Rietveld's later achievement in architectural design.

The red-blue chair, built in 1918, is a perfect illustration of the ways in which Rietveld's interest in space allowed him to attend to both practical and abstract design objectives. From 1916 on, Rietveld and his craftsmen experimented with a variety of construction theories and practices. The most provocative of these was a manipulation of the Cartesian coordinates of zenith, abscissa, and ordinate into a structural module, the elements of which might be pivoted, extended into planes, and repeated to form furniture. Rietveld decided to construct a chair that would exploit this theoretical idea while at the same time using the dimensions and proportions of the furniture he had made in Klaarhamer's studio.

The protoype chair was made of inexpensive pieces of unpainted wood; thirteen listels act as the chair's structural framework, and two pieces of plywood form the back and seat of the design. In addition, traditional wooden pegs were used to join the parts of the chair together; for the most part, though, the pegs were invisible. The original design included pentagonal sidepieces set below the arms, but these were removed soon after construction.

While its appearance does not seem to promise the comfort of a traditionally upholstered chair, the seat and back of the red-blue chair do support the body in a relaxed seated posture, and one can comfortably sit in that position. The hard surfaces and angular qualities of the red-blue chair, however, reinforce the design's primary purpose as a kind of three-dimensional theorem: a demonstration of seat construction, an examination of spatial plasticity, and a diagram of the forces of pressure and weight. For example, the separation of supporting and supported parts infuses the chair with the appearance of weightlessness and celebrates the mysterious properties of space. The red-blue chair reveals that while space may seem to be defined by juxtaposed, contrasting solid forms, it is simultaneously an uninterrupted void.

The addition of color to the design reinforced the chair's sculptural qualities. The first versions of the chair were either bleached to emphasize the lines of the wood grain or stained a neutral black. After Rietveld joined the de Stijl group in 1919, perhaps at the suggestion of the group's founder and leader, Theo van Doesburg, a painted version of the chair appeared on the cover of the magazine *De Stijl*. The chair's design evolved to include a red backrest and a blue seat, and the listels were lacquered black, with bright yellow ends. These color choices were not capricious but were made to emphasize the chair's abstract qualities and to reinforce the active interplay between the continuous and contiguous spaces that surround and penetrate it.

The color scheme and the form of Rietveld's red-blue chair point up a number of the issues with which Rietveld would grapple throughout his distinguished career. In Rietveld's hands, furniture became both architectural and sculptural, symbolically and communicatively uniting function and aesthetics. In the early 1920's, he built a group of dynamically formalistic wooden buffets, tables, and chairs. His experiments with metal, however, were less successful and less innovative. In the late 1920's and early 1930's, Rietveld's rather clumsy tubular-steel designs were manufactured by the

Dutch firm of Metz and Company, and in the 1940's, he made a few pieces in bent aluminum. Happily, Rietveld continued to create wooden chairs throughout his life. In 1934, he cantilevered the seat, back, support, and base planes of his "zig-zag" chair and added the oblique angle to the vocabulary of seating. Rietveld's "crate" system, designed during the Depression for Metz and Company, celebrated the material qualities of wood itself. Although the crate design was originally commissioned to create furniture suitable for weekend houses, Rietveld's intention was to offer a readily available collection of useful and inexpensive pieces. Using industrial-quality untreated red spruce of the sort used for packing cases, Rietveld designed the first "knock-down" furniture. Many of these pieces repeated the projection and criss-crossing of structural lines into space that was a characteristic of Rietveld's work beginning with the red-blue chair.

Despite the breadth, depth, and quality of Gerrit Rietveld's work, he is best known for one of his earliest pieces. His important interior designs, his innovative architectural commissions such as the Schroder House (1924) and Ilpendam House (1958-1959), and his experiments with furniture, which lasted into the 1950's, were all outgrowths of Rietveld's interest in the geometry of lines and planes and the shape and meaning of enclosed and enclosing space. These preoccupations were first made manifest in the red-blue chair, which illustrated a provocative and significant new way of thinking about the relationships between objects and their environments. The red-blue chair is a classic illustration of important developments in modern art, architecture, and design.

Impact of Event

Because furniture-making is generally considered an "applied" or "minor" art, individual pieces are rarely given the status that was almost immediately attached to the red-blue chair. While domestic designs such as furniture are often used to experiment with stylistic and technological innovations, architecture is more commonly celebrated, both as an art form and as an exercise in functional problem-solving. Thus furniture and its design are commonly viewed as less important than architectural projects or the visual arts.

This was not the case in the de Stijl movement, which generated high-quality projects in architecture, typography, painting, and furniture. Within de Stijl, furniture design was given an unusual amount of attention, a fact that accounts for Rietveld's early prestige in the group. Although he joined de Stijl after designing the prototype for the red-blue chair, the chair is regarded as a significant example of the movement's aesthetic and as a prime illustration of the de Stijl principles of neoplasticism and abstract geometry. The chair's significance in this regard is underscored by its role in stimulating the theoretical and conceptual work of two central members of de Stijl, Theo van Doesburg and Piet Mondrian.

"De Stijl," Dutch for "the style," is the name taken by a group of radical artists, writers, and architects organized by the semitheoretical architect Theo van Doesburg in Leiden in 1917. The group published a monthly magazine, *De Stijl*, in which

it argued for a new style of visual arts that might stimulate and mirror the new style of life emerging in post-World War I Europe. Van Doesburg edited the magazine from its conception until his death, and he used the publication to espouse the "neo-plastic" aesthetic, which rejected overt representation, celebrated the straight edge and the plane, and limited its palette to the use of the primary colors and black, white, and gray. Van Doesburg's inclusion of Rietveld's design in a 1919 issue of *De Stijl* signaled a long-lasting collaboration between the two men and a broadening of the movement's concern with development of a unified approach to the arts.

Piet Mondrian is probably the best-known member of de Stijl. Van Doesburg may have been the driving force behind the movement, but Mondrian was its most successful practicioner. He championed the primacy of painting in the creation of the utopian future that was at the center of the de Stijl vision. He was particularly concerned with reforming the visual arts so that they could take their proper place at the center of life, providing organizing principles and generating a new moral code. Like Rietveld's red-blue chair, Mondrian's paintings experiment with the neoplastic aesthetic. As a matter of fact, Mondrian wrote a pamphlet in 1920, *Le neo-plasticsme*, which he dedicated to a future shaped by this new form of art. Curiously, Mondrian believed that as reform took hold, painting would gradually disappear as a meaningful art form. This concept is nicely paralleled in Rietveld's red-blue chair, which may be seen as dissolving into the surrounding space.

De Stijl, like the Russian constructivist and the German Bauhaus movements, explored a broad spectrum of art forms. The de Stijl vision was a modern one, emphasizing an abstract, rational, and revolutionary relationship between the arts and industrial production that, adherents believed, would lead to the creation of a modern, utopian society. The modern movement in design was characterized by an emphasis on the illustration of abstract principles and a passion for simplicity, flavored by interest in the emerging promise and requirements of machine production.

In an interesting evolution of his early training, all Rietveld's post-World War I designs, including the red-blue chair, were produced according to a sort of industrial rationale. He was interested in producing furniture that could be manufactured by machine for a modest price—at once making it readily available and freeing the craftsman from the tedium of repetitive manual labor. This romantic connection of industrialization and social ideals was typical of the late nineteenth and early twentieth centuries. For the most part, the resulting designs were pseudomechanistic at best; while the modern aesthetic celebrated, and perhaps even revered, the machine, few such designs were produced under industrial conditions, and even fewer were mass-produced. Most of Rietveld's furniture, like the red-blue chair, was built in his Utrecht shop. It was not until 1971, when the Italian firm of Cassina began to reproduce a number of classic designs of the early modernists, that the chair was part of anything resembling factory production, and its price has remained beyond the purchasing power of most consumers.

Given Rietveld's background and his interest in producing well-designed products for everyday use, it is ironic that his most famous chair is valued more as a work of

art than as a functional seat. The contradiction, however, does not diminish the significance of what he accomplished. The red-blue chair occupies a central position in the history of design because of its preliminary conclusions to the issues that would preoccupy Gerrit Rietveld in his other designs (including seventy-four other pieces of furniture), because of its power as a physical manifestation of the tenets of de Stijl, and because of its concrete illustration of the philosophy of modern design.

Bibliography

Baroni, Daniele. *The Furniture of Gerrit Thomas Rietveld.* Woodbury, N.Y.: Barron's, 1977. Translated from an Italian original, this volume continues to be a central source for those interested in Rietveld's work. Divides his career into three phases and contextualizes his furniture designs within the larger body of his oeuvre. Well-illustrated, though with mostly black-and-white plates.

Brown, Theodore M. *The Work of G. Rietveld, Architect.* Cambridge, Mass.: MIT Press, 1958. Though primarily concerned with Rietveld's architectural commissions, this detailed and organized volume does treat his furniture designs. A bit dry. Appendix includes translations and transcriptions in Dutch of several essays by Rietveld, notes, index, and bibliography.

Friedman, Mildred, ed. *De Stijl, 1917-1931: Visions of Utopia.* Minneapolis, Minn.: Walker Art Center, 1982. This catalogue of an exhibition organized by the Walker Art Center is lavishly illustrated and includes well-written essays on various elements and personalities of the de Stijl movement by prominent scholars. Excellent and comprehensive biography section with short bibliographies, chronology, and index.

Jaffe, Hans Ludwig C. *De Stijl 1917-1931: The Dutch Contribution to Modern Art.* Cambridge, Mass.: The Belknap Press of Harvard University Press, 1986. A complete and exhaustive history of de Stijl that also considers the movement's influence on modern arts and life. Added emphasis given to work of Piet Mondrian. A few plates (all black-and-white), notes, and bibliographical references.

Overy, Paul. *De Stijl.* London: Studio Vista, 1969. An excellent general overview of ideas, projects, and personalities. Mediocre illustrations, adequate bibliography.

J. R. Donath

Cross-References

Hoffmann and Moser Found the Wiener Werkstätte (1903), p. 79; Hoffmann Designs the Palais Stoclet (1905), p. 124; The Deutscher Werkbund Combats Conservative Architecture (1907), p. 181; The Futurists Issue Their Manifesto (1909), p. 235; *De Stijl* Advocates Mondrian's Neoplasticism (1917), p. 429; German Artists Found the Bauhaus (1919), p. 463; The Soviet Union Bans Abstract Art (1922), p. 544.

GERMAN ARTISTS FOUND THE BAUHAUS

Category of event: Architecture
Time: 1919
Locale: Weimar, Dessau, and Berlin, Germany; Chicago, Illinois

Despite the Nazis' opposition—or perhaps because of it—the Bauhaus achieved international fame as the most innovative and progressive art school of its time

Principal personages:
WALTER GROPIUS (1883-1969), the founder and first director of the Bauhaus and the most influential post-World War I era European architect
JOHANNES ITTEN (1888-1967), a Swiss painter who developed the course that was the backbone of the Bauhaus curriculum
LÁSZLÓ MOHOLY-NAGY (1895-1946), a painter, photographer, and graphic designer who helped to develop the Bauhaus philosophy and spread it worldwide
WASSILY KANDINSKY (1866-1944), a Russian-born painter, graphic artist, and writer who devised a course in form and harmony for the Bauhaus curriculum and who also wrote one of the school's most influential texts
PAUL KLEE (1879-1940), a painter and writer whose publications during his years on the Bauhaus faculty proved to be of great significance for modern art
LYONEL FEININGER (1871-1956), the first teacher appointed by Gropius and the first American at the Bauhaus
LUDWIG MIES VAN DER ROHE (1886-1969), a leading architect of the International Style who was director of the Bauhaus from 1930 to 1933

Summary of Event

On April 1, 1919, the architect Walter Gropius accepted the directorship of the Weimar Academy of Art with the understanding that it would be combined with the Weimar Arts and Crafts School, which had been closed since 1915. When Gropius arrived in Weimar, he already had in mind a name—Das Staatliche Bauhaus—and a well-conceived program for the new school, which he outlined in a four-page proclamation.

Like many others before him, Gropius believed in the necessity of uniting the fine arts (architecture, painting, and sculpture) with the crafts. Thus, he was working within the traditions of the English Arts and Crafts movement and the German Werkbunds (workshops). Gropius contributed to these traditions his own conviction that architects, painters, and sculptors should not merely work with craftspersons but must be craftspeople themselves. When he declared that there was no essential difference between the artist and the craftsperson—that the artist is an exalted crafts-

person—he was advocating a revolutionary new principle of learning by doing, of developing an aesthetic based on sound craftsmanship.

Gropius' ideas not only gave a new direction to aesthetics but revolutionized the actual practice of teaching as well. The basis of the Bauhaus program was a foundation course designed to free the student from past experiences and prejudices. This course, developed by Johannes Itten, was a six-month introduction to materials and techniques, utilizing basic practical experiments as well as the exact depiction of actual materials. Students were also encouraged to avoid classical traditions in favor of studying non-Western philosophies and mystical religions. In the beginning, almost no thought was given to the machine or to art's role in an industrialized world. The curriculum, however, was constantly changing and developing. By 1923, for example, the emphasis was on training designers for industry; later, Gropius increased the accent on architecture, declaring his intention to create an architecture adapted to the world of machines, radios, and fast motor cars—an architecture the function of which would be clearly recognizable in its form.

The history of the Bauhaus can be divided into three periods: the Weimar period of 1919 to 1925, the Dessau period of 1925 to 1932, and the Berlin period of 1932 to 1933. The Weimar period, though marked by financial difficulties for the school, was an exciting time, characterized by enthusiasm for new experiments and new beginnings. Gropius appointed some of the leading artists of the day to the faculty: Lyonel Feininger, Paul Klee, Wassily Kandinsky, Georg Muche, and Oskar Schlemmer taught painting, graphic arts, and stage design; Johannes Itten and László Moholy-Nagy gave the foundation course, and Gerhard Marcks taught pottery, sculpture, and graphics.

The antispecialist emphasis of the Bauhaus appealed to Kandinsky, who had always been interested in a synthesis of the various arts. Earlier, he had searched for ways in which music, painting, theater, and dance could be combined into one great, complete work of art; he believed, as did Gropius, that the artist's ultimate goal was the production of a unified work of art in which no distinction between monumental and decorative art remained. At the Bauhaus, Kandinsky continued his search. He would, for example, create a painting and then ask a musician to use the painting as inspiration for a composition. A dancer would then be asked to devise a choreography in keeping with the music.

Klee, on the other hand, was strongly influenced by the constructivist atmosphere of the Bauhaus and experimented with his own personal forms of geometric abstraction. During the 1920's, he painted works of fantasy created out of abstract elements, with the total effect being organic rather than geometric. To achieve an effect of fluidity and a sense of form produced by growth and change, he worked mostly with combinations of ink and watercolor.

While the faculty and students at the Bauhaus were busily involved with their own experimental forms of art, opposition to them was growing stronger in the city of Weimar. From the very beginning, some citizens had objected to Gropius' restructuring of the Weimar Academy of Art; for example, one poster circulated in 1920 had declared that "our old and famous Art School is in danger . . . all to whom the

abodes of our art and culture are sacred are requested to attend a public demonstration." Part of the opposition came from people who simply clung to the past and refused to accept that the prewar world was dead. Additionally, the members of the old art academies and their bourgeois patrons resented and rejected changes in any form. From all these factions, there was much talk of the Bahaus' "art Bolshevism."

In 1925, hostile Weimar city officials finally forced the Bauhaus to close, but shortly after, supported by liberal civic leaders, it reopened in the larger industrial city of Dessau in new buildings designed by Gropius. The first excitement of breaking new ground that had characterized the Weimar Bauhaus was past; the Dessau Bauhaus was marked by an attitude of self-confidence, sobriety, and sense of purpose. The school became a center for the development of industrial design, creating prototypes for mass production while maintaining a balance between the aesthetic and the functional. Students were encouraged to experiment within the context of artistic expression.

Several former students joined the faculty, including the architects and designers Marcel Breuer and Herbert Bayer and the painter Josef Albers. In 1928, Gropius resigned as director and was replaced by Hannes Meyer, a Swiss architect who had little understanding of Gropius' concept of the integration of the arts. Meyer's narrow technological leanings and his Marxist political beliefs made many enemies, and he was replaced in April, 1930, by another architect, Ludwig Mies van der Rohe. Although Mies van der Rohe was a more capable administrator, he was unable to cope with the volatile political tension that had come to pervade German society. In 1932, the Nazis gained control of the Dessau parliament and forced the Bauhaus to close.

In the fall of 1932 in Berlin, Mies van der Rohe established the Bauhaus as a privately funded institution with no government subsidy. Soon after the school reopened, however, the Nazis took control of the country, with Adolf Hitler as chancellor. Declaring that the Bauhaus was one of the most obvious refuges of "the Jewish-Marxist conception of degenerate art," the Nazis invaded the school in April of 1933 with one hundred well-armed storm troopers and Berlin policemen, who checked everyone's credentials, arrested some faculty and students, and then padlocked the building.

Impact of Event

Shortly after the Nazis closed the Bauhaus, most of the faculty and many students left Germany in search of more liberal climates of thought. Kandinsky went to Paris, and Klee went to Berne; both continued to paint until their deaths. Itten settled first in Switzerland and, from 1938 to 1954, served as director of the Arts and Crafts School and Museum in Zurich. Moholy-Nagy, Breuer, and Gropius fled first to London; in 1937, they all came to the United States. Gropius and Breuer joined the architecture faculty at Harvard University, where Gropius became chairman of the department in 1938. Moholy-Nagy founded the New Bauhaus in Chicago (later the Institute of Design) and served as its director until 1946. Feininger settled in New York City in 1936

and continued to paint, while Bayer arrived there in 1938 and became a corporate director of art and design. Albers served as a professor of art at Black Mountain College in North Carolina from 1933 to 1949. In 1950, he became chairman of the department of design at Yale University.

As the Allied countries welcomed these emigrants from the Bauhaus, word of the school's fate at the hands of the Nazis ensured its fame throughout the world, and its reputation and influence quickly grew. The activities of Gropius and Breuer at Harvard, Moholy-Nagy in Chicago, Albers at Black Mountain College and Yale, and Bayer and Feininger in New York were the most obvious results of that influence.

Less obvious, but perhaps even more important, is the continuation of Bauhaus ideas in countless art schools that offer well-planned foundation courses and carefully designed projects of one kind or another as a stimulus to creativity. Art educators continue to place a great deal of faith in Bauhaus teaching methods, recognizing the value of individual differences. Both Klee and Kandinsky were good teachers, for example, but Klee gave his students almost unlimited freedom to explore on their own, while Kandinsky tended to be more dogmatic and demanding. Because the Bauhaus was revolutionizing both teaching and art theory, there were no appropriate textbooks, so many of the faculty wrote their own—Kandinsky's *Punkt und Linie zu Fläche* (*Point and Line to Plane*, 1947) and Klee's *Pädagogisches Skizzenbuck* (*Pedagogical Sketchbook*, 1953) remained in use in art schools for decades.

In spite of the many talented painters who taught at the Bauhaus, few painters of distinction actually emerged from among the school's students. The faculty painters had their greatest influence upon young painters in the countries to which they fled after 1933. The works of the Bauhaus painters were already well known in most of these countries, as they had exhibited outside Germany throughout the 1920's. Feininger, Klee, and Kandinsky had participated in many American exhibitions, especially the Société Anonyme and the Blue Four exhibitions in New York. In 1930 and 1931, exhibitions of Bauhaus art were organized by the Harvard Society for Contemporary Art, by the John Becker Gallery in New York, and by the Arts Club of Chicago.

Gropius and Mies van der Rohe, moreover, continued to be recognized as leading architects. Both exerted profound influence on the evolution of the International Style, perhaps the century's most important architectural development.

The Bauhaus changed the modern environment by transforming and reshaping interior, product, and graphic design. The effects of this transformation have become an accepted part of the environment, to such an extent that virtually anything "modern," functional, and geometric can be identified as being in "the Bauhaus style." Gropius, however, vehemently denied the existence of a Bauhaus style in anything, pointing out that the school's purpose was not the development of a uniform visual identity but the promotion of an attitude toward creativity that would result in variety. Nevertheless, many of Breuer's furniture designs have become classics (for example, his first tubular steel chair and his basic table and cabinet designs), as have Gropius' designs for standard-unit furniture. Many other successful designs

for stacking chairs, stools, dinnerware, lighting fixtures, and textiles came from the Bauhaus design studios and workshops. Moholy-Nagy, Bayer, and others revolutionized typographic design, and Moholy-Nagy's experiments in abstract film and photography began a new era in those media.

Any discussion of the impact made by the Bauhaus upon culture and society calls to mind an observation made by Mies van der Rohe in 1953. He stated that the Bauhaus' widespread influence upon progressive art schools came from the fact that it was never an institution with a clear program; it was an idea. He declared that such enormous influence cannot be achieved through organization or propaganda—only an idea spreads so far.

Bibliography

Bayer, Herbert, Walter Gropius, and Ise Gropius, eds. *Bauhaus, 1919-1928.* Reprint. New York: Museum of Modern Art, 1975. Originally published in 1938, this is still one of the most valuable accounts of the Bauhaus in Weimar and Dessau. Contains the texts of many proclamations, articles, and course notes written by Gropius and other faculty. Well-illustrated throughout, with black-and-white photographs, drawings, and diagrams.

Dearstyne, Howard. *Inside the Bauhaus.* New York: Rizzoli, 1986. Written by one of the few American students at the Bauhaus, who used his own letters to his family written during his years at the Bauhaus as the basis for his manuscript. Contains a history of the school, detailed descriptions of the studios and workshops, and personal recollections of faculty and other students.

Poling, Clark V. *Bauhaus Color.* Atlanta: High Museum of Art, 1975. An exhibition that illustrates the stylistic and theoretical characteristics shared by Bauhaus artists, with major emphasis on the use of color. Discusses the principles of color theory and their application. Contains many good illustrations.

Roters, Eberhard. *Painters of the Bauhaus.* Translated by Anna Rose Cooper. New York; Praeger, 1969. The author stresses both the influence painters had on the Bauhaus and how their associations with the school shaped their own work. A chapter is devoted to each of the ten most talented and influential painters at the Bauhaus. Well-illustrated, with both black-and-white and color photographs.

Whitford, Frank. *Bauhaus.* London: Thames and Hudson, 1984. A complete introduction to the Bauhaus, this book discusses ideas and philosophies, teaching methods, activities of the faculty, the daily lives of the students, and the social, economic, and political unrest of the times. Thoroughly documented and well illustrated. One of the most reliable surveys of the Bauhaus.

LouAnn Faris Culley

Cross-References

Hoffmann and Moser Found the Wiener Werkstätte (1903), p. 79; Hoffmann Designs the Palais Stoclet (1905), p. 124; The Deutscher Werkbund Combats Conserva-

tive Architecture (1907), p. 181; Behrens Designs the AEG Turbine Factory (1909), p. 219; Kandinsky Publishes His Views on Abstraction in Art (1912), p. 320; The Soviet Union Bans Abstract Art (1922), p. 544; Le Corbusier's Villa Savoye Redefines Architecture (1931), p. 869; Hitler Organizes an Exhibition Denouncing Modern Art (1937), p. 1083.

THE ART OF RADIO DEVELOPS FROM EARLY BROADCAST EXPERIENCE

Category of event: Television and radio
Time: The 1920's
Locale: The United States

Technical, patent, and licensing advances freed radio's visionaries and performers to cultivate their art by broadcasting news and entertainment to mass audiences

Principal personages:

DAVID SARNOFF (1891-1971), an early advocate of broadcasting to win mass audiences

GRAHAM MCNAMEE (1888-1942), a prominent announcer and newscaster in the 1920's

HAROLD W. ARLIN (1895?-1986), a young Westinghouse engineer who became radio's first full-time announcer

CHARLES B. POPENOE (1887-1929), a radio station manager and master of early broadcasting

FRANK CONRAD (1874-1941), a self-taught engineer who helped to popularize radio

THOMAS H. COWAN (1884?-1969), an announcer who helped to pioneer broadcast programming

LEE DE FOREST (1873-1961), a self-styled "father" of radio and an advocate of broadcasting

Summary of Event

Before the 1920's, technological advances in radio engineering, patenting, and production capabilities far exceeded the young industry's commercial exploitation of a mass listeners' market. American radio until then was the technical preserve of skillful amateurs, hobbyists, engineers, and scientists. New corporations exploring the field of radio such as Westinghouse, General Electric (GE), Western Electric, American Telephone and Telegraph (AT&T), and the Radio Corporation of American (RCA) were interested chiefly in radio's roles in wireless, radiotelegraphy, and telephone communication and, during World War I, in manufacturing radio equipment for the armed forces. Interest in voice or musical transmissions (radiotelephony) was minimal, and radio's business leadership considered its devotees eccentrics.

Prospects for changes in the radio industry were foreshadowed in 1919 by cross-licensing agreements (affecting patents) between Westinghouse, AT&T, GE, and RCA as well as by the subsequent pooling of functions among the corporations. RCA was permitted a near-monopoly of radiotelegraphy and the sale of the other corporations' equipment, AT&T controlled telephonic communications, and GE and Westinghouse shared the manufacture of radio equipment. Divisive competition within

the radio business was thus reduced. One company in particular profited from this arrangement; although Westinghouse's postwar sales fell sharply, the company's commercial potential was augmented vastly, first by acquisition of Edwin H. Armstrong's feedback circuit, then by his still more commercially viable superheterodyne circuits for radio sets.

Visionaries such as RCA's David Sarnoff had unsuccessfully appealed to industry leaders to embark upon mass-appeal broadcasting replete with news and entertainment, yet it was a gifted, self-trained amateur employed by Westinghouse, Frank Conrad, who somewhat inadvertently initiated radio's new era. Experimenting in his garage-laboratory in Wilkinsburg, Pennsylvania, in 1919 and 1920, Conrad not only used his equipment (licensed as 8XK) to talk to other amateurs but for their enjoyment also played phonograph records. Soon, with two sons announcing and a local music store furnishing phonograph records, he started a craze for more radios able to receive 8XK as the number of listeners multiplied.

Aware of the Conrad phenomenon—the real and prospective sales generated by it—Westinghouse vice president Harry Davis proposed to Conrad that a more powerful transmitter be built atop Pittsburgh's Westinghouse plant. The station, licensed by federal authorities as KDKA on October 27, 1920, and assigned the 360-meter channel, started by broadcasting news: four hours of returns from the Warren G. Harding-James Cox presidential election of November 2, 1920. White and Conrad's intentions were to continue offering regular broadcasts to listeners day by day, week by week, demonstrating that more radio sets could be sold once the general public perceived that the medium's offerings—its "art"—could be available to all. It proved a both successful and historic decision.

Encouraged by the experience of KDKA, Westinghouse established three new broadcast stations before the end of 1921: WJZ-Newark, KYW-Chicago, and WBZ-Springfield (Massachusetts). Its competitors—RCA, five smaller companies, and a municipality—swiftly followed. RCA, now listening to Sarnoff, by midsummer that year had scored its own coup by broadcasting the Jack Dempsey-George Carpentier prizefight from New York, an event reportedly heard by 300,000 people, some as distant as Florida. Westinghouse's WJZ-Newark station, under the direction of Charles Popenoe, countered by broadcasting the New York Yankees-New York Giants World Series three months later. These initial broadcasts were impromptu affairs; the personnel were untrained and unspecialized, and the equipment and facilities upon which they relied—microphones, transmitters, receivers, and studios—were unreliable and crude. Still, the experience gained paved the way for the emergence of distinct radio personalities—particularly announcers, sportscasters, and newscasters—as well as regularly featured programs.

Typical early broadcasts depended upon station personnel and a gamut of unpaid—if often high-quality and well-known—talent. Light variety shows developed to flesh out time. Broadcasts otherwise consisted of recorded and sometimes live concerts, selections from operas and sacred music, an occasional vocal group, soloists, pianists, weather forecasts, time signals, and news. Advertising was limited to

touting the stations' immediate interests, and no funds were solicited from commercial sponsors. As virtual masters of ceremony, announcers (recruited from a variety of backgrounds) before mid-decade quickly became prominent public figures, among them KDKA's Harold Arlin (who may have been the first), WJZ's Thomas Cowan, Milton Cross, Norman Brokenshire, and Bertha Brainerd, WEAF's Graham McNamee, and, elsewhere, Don Wilson and Harry von Zell.

Although sports and news did not become specialized features of station operations in the early 1920's, their potentials were still clearly recognized. After broadcasts of major sports events and scores, several announcers, including Major J. Andrew White, Ted Husing, Quin Ryan, Graham McNamee, Edwin Tyson, Lawrence Holland, Bill Munday, and Red Barber, gained notoriety as sportscasters. Similar differentiation occurred in radio news, which was initially the broadcast of relays of telephone, newspaper, or wire-service information to the radio stations. This too brought a number of prominent announcers before the public and prepared the field for special radio coverage and commentary by 1930.

Impact of Event

KDKA's 1920 breakthrough with the institution of regular broadcasting, and the rapid establishment of similar stations across the nation over the next few years, reflected a youthful industry's strategic quest for profits, first through sales of sets and equipment, then through the sale of time for purveyal of the products of others. Both interrelated strategies required a continuous enlargement and a persistent cultivation of the real and supposed tastes of mass audiences. Therein lay the matrix for radio's evolving art.

Because of the increasing availability and declining prices of radio sets and the lure of expanding broadcasts, sales of radio sets through the 1920's were phenomenal: Between 1922 and 1929, sales soared from $60 million to $842.5 million. Radio became a national rage; sets appeared in large stores and small shops, in taverns and schools, and, more notably, in more than a third of American households. Just as railroads had joined the nation's most remote places by steel links a generation earlier, so radio brought the world's fourth-largest country into still another reticulation of common daily experiences and values.

Even before the appearance of national radio networks in 1926, newscasting was becoming an important regular feature of most broadcasts, although it drew few sponsors. With the creation of major networks, the Columbia Broadcasting System (CBS) abandoned common "rip and read" news formats in 1929. Pointing the route others would follow, CBS replaced such formats with regular, accurately gathered, sponsored newscasts by Lowell Thomas—a colorful figure and a knowledgeable global traveler whom the radio generation came to venerate much as the first television generation would revere Walter Cronkite. With Thomas and his counterparts, newscasting was on its way to becoming an art.

By the mid-1920's, sportscasting was likewise becoming professionalized in the hands of Chicago's Harold (Hal) Totten and Quin Ryan, Detroit's Pappy Tyson and

Larry Holland, Atlanta's Bill Munday, and the University of Florida's Red Barber. In these as in other broadcast specialties, the broadcasters' voices, and thus personalities, made distinctive contributions to radio art. Graham McNamee epitomized this with his ability to hang listeners on every word, to mount suspense, and—the then-peculiar quality of radio—to lend every sentence immediacy.

Heavy from the start with offerings of classical and church music, broadcasts, under the guns of network rivalry as well as the need to preempt air time, soon exploited—and thereby began sanitizing and popularizing—jazz and "race" music, both of which would eventually be recognized as unique American contributions to world culture. New York's WJZ began the trend with bandleader Paul Whiteman's jazz concert featuring composer George Gershwin's specially written *Rhapsody in Blue* (1924). The program was lent respectability by the sponsorship of outstanding composers and conductors such as Serge Rachmaninoff, Leopold Stokowski, and Walter Damrosch—the latter of whom, through *The Music Appreciation Hour* of the National Broadcasting Company (NBC), brought varieties of music to more than six million schoolchildren. While the broadcast of classical music along with light and polite orchestral presentations continued to be the rule, late-night radio, encouraged by record companies profiting from sales of "race" records, relentlessly promoted jazz.

With the linkage of paying sponsors and advertising agencies to radio stations, scheduled dramas, variety shows, and comedies and their star personalities swiftly relegated news and sports to lesser portions of the broadcast day. Presented in December, 1923, as the first show with a series title, the *Eveready Hour* set the pace with its variety of famous talents. By 1925, two of what proved to be radio's longest-lived as well as more popular shows—WSM Nashville's *The Grand Ole Opry* and WLS-Chicago's *The National Barn Dance*—swelled the trend with their comedy routines and country music. Until the 1930's, the evening's prime time was filled with such shows. Many, like *The Cities Service Concert* or *The Palmolive Hour*, were orchestral, though these were interlarded by the late 1920's with a few forerunners of 1930's soap operas such as WJBO-Chicago's *The Smith Family* and NBC's *The Rise of the Goldbergs.*

With stations expanding their broadcast days, mornings, still devoid of "soaps," became a mixture of "wake-up" shows—Eugene "Cheerio" Field's was one of the most popular—and a collage of women's health and homemaking presentations that introduced such personalities as Betty Crocker, Julian Heath, Ida Bailey Allen, Mary Norris, and Royal Copeland. Intermixed with these were more of the light music and chatter shows already familiar to evening listeners.

By the end of the 1920's, broadcast programs in considerable variety were available to listeners everywhere for most, if not all, of each day. In its quest for profits, a radio industry devoted to broadcasting had by the end of the 1920's already explored and experimented with a considerable range of entertainments and attractions, touted by a new breed of public personalities—announcers, sportscasters, newscasters, comedians, orchestra leaders, conductors, composers, jazz musicians, educators, writers, actors, and dramatists. In company with reactive publics, such people estab-

lished criteria for the judgment of their performances as they became intimate, if invisible, components of America's daily life.

Bibliography

Allen, Frederick Lewis. *Only Yesterday: An Informal History of the Nineteen-Twenties.* New York: Harper & Brothers, 1931. A popular classic reprinted many times, this work places the emergence and impact of radio in the context of a unique and tumultuous decade. Allen is always good as well as insightful reading. Fifteen illustrations, brief bibliographical appendix, and index.

Barnouw, Erik. *A History of Broadcasting in the United States.* Vol. 1. *A Tower of Babel: To 1933.* New York: Oxford University Press, 1966. This is an authoritative, detailed, and insightful work. A fascinating read for scholars and laymen alike. There are sixteen pages of excellent period photos; serious readers will profit from ample footnotes, a superb bibliography, appendixes, and an extensive double-columned index. First-rate.

Chester, Giraud, Garnet R. Garrison, and Edgar E. Willis. *Television and Radio.* 4th ed. New York: Appleton-Century-Crofts, 1971. A readable, scholarly piece that not only provides useful descriptive material on early radio but also raises important questions about what criteria are most fairly applied to judging the art of radio (and television). Topical bibliography, no photos, but an extensive double-columned index. Useful as selective and comparative reading.

Douglas, George H. *The Early Days of Radio Broadcasting.* Jefferson, N.C. and London: McFarland, 1987. Matches Barnouw in authority, if not detail or range, and is also a fascinating read. Twenty pages of interesting old photos, brief chapter notes, an excellent, extensive bibliography, and a useful index. Must reading.

Schoenbrun, David. *On and Off the Air: An Informal History of CBS News.* New York: E. P. Dutton, 1989. A distinguished newsman of international reputation, Schoenbrun has interesting observations on the early days of radio at CBS in chapter 2. His critical comparisons of television and radio news reporting are valuable. Unfortunately, published memoirs of other early newsmen are hard to find. Eight pages of photos, but no other reader aids.

Wertheim, Arthur Frank. *Radio Comedy.* New York: Oxford University Press, 1979. A fine background for understanding the place and character of radio comedy in the 1920's and the early 1930's. An easy, scholarly read. Twelve pages of photos; no bibliography, but detailed chapter notes and a useful index. A valuable work.

Clifton K. Yearley

Cross-References

WSM Launches *The Grand Ole Opry* (1925), p. 675; The British Broadcasting Corporation Is Chartered (1927), p. 712; The *Amos 'n' Andy* Radio Show Goes on the Air (1928), p. 755; Radio Programming Dominates Home Leisure (1930's), p. 828; Goodman Begins His *Let's Dance* Broadcasts (1934), p. 968.

CHANEL DEFINES MODERN WOMEN'S FASHION

Category of event: Fashion and design
Time: The 1920's
Locale: Paris, France

Coco Chanel adapted British taste in menswear to women's clothing, creating a couture style that would define the modern woman of elegance throughout the twentieth century

Principal personages:

GABRIELLE "COCO" CHANEL (1883-1971), a fashion designer who designed for the New Woman of the 1920's and later

MISIA SERT (1872-1950), a friend to the artists of the Parisian avant-garde

JEAN COCTEAU (1889-1963), a poet, essayist, and dramatist with whom Chanel collaborated as costume designer

PIERRE WERTHEIMER (?-1965), a perfume manufacturer who produced and marketed Chanel perfumes, including "Chanel No. 5"

ARTHUR "BOY" CAPEL (1883-1919), a British entrepreneur, diplomat, and lover of Chanel who backed her first design establishments

HUGH "BEND'OR" GROSVENOR, (1879-1953), the Duke of Westminster, a suitor and lover of Chanel

KARL LAGERFELD (1938-), a fashion designer appointed in 1984 to head the house of Chanel

Summary of Event

World War I was an important dividing line between the old and the new in many aspects of life, and in no arena was it more decisive than in women's fashion. Corsets, boning, long skirts, and huge hats gave way to simpler, less confining designs just as upper-class restrictions on women gave way in many other aspects of life. Despite attempts to reinstate the old ideas as a new look, the tone set in the 1920's shaped fashion attitudes across all classes for much of the twentieth century. Chanel, both the woman and the designer, has become identified with this change. While not the first designer to inaugurate each element in the wardrobe of the "New Woman," Coco Chanel did create the ensemble epitomizing the new century. By taking many of the same steps that had revolutionized men's fashions in the early nineteenth century (adapting sporting clothes for general wear, applying lower-class functionality to clothing for the rich, and using limited color across the entire wardrobe) and especially by adapting menswear for women, Chanel offered women clothing that spoke of ease, independence, and elegance.

Financially backed and advised by Arthur "Boy" Capel, Chanel first found success in the wartime environment of refugees and profiteers in Deauville and Biarritz,

France. She sold looser, shorter, more practical dresses of "poor" fabrics such as woolen jersey at exorbitant prices. After the war, she concentrated her efforts in Paris, where both she and her fashions captured the look of *la garconne*, the French boy-girl known in America as the Flapper. She designed clothes for young, active women with bobbed hair and athletic, androgynous bodies. Simple clothes of knit fabrics, ingeniously cut and precisely tailored, permitted unheard-of freedom of movement. For day and evening wear, simple chemises without waists or busts required few or no undergarments. Suits adapted from British men's sportswear came with functional pockets in both shirt and jacket. Hems were short for both day and night. At Chanel's studios, decoration gave way to functional purity, in keeping with Art Deco standards. She rejected ornamentation in favor of cut, and she restricted color to the basics—navy, beige, and, especially, black. In 1925, she introduced "the little black dress" for evening. It was so simple, so pared to essentials, that the editor of *Vogue* magazine compared it to the Ford automobile—one model, exquisitely crafted as a uniform for all. Elegance was now a matter of cut and, above all, attitude.

Chanel's personal history is so colorful that it has detracted from the study and appraisal of her professional contributions. What is clear, however, is that she was uniquely positioned to exploit the changes underway in the 1910's and 1920's. Of lower-class origins herself, she took advantage of the economic dislocation that occurred after the war to associate with the rich and the avant-garde. Beginning frankly as an *irreguliere*, a kept woman, with a preference for British men of wealth, she exploited her supporters financially and socially while borrowing fashion concepts from their closets. Boy Capel started her in the couture business, though an earlier admirer had set her up in her first shop as a milliner. He also introduced her to British tailoring. A liaison with a Russian grand duke in the early 1920's brought with it a use of embroidery and exotic furs and, perhaps, even her interest in perfumes. During the years of her well-publicized liaison with the wealthiest man in England, the Duke of Westminster, from 1925 to 1931, she discovered tweeds, reemphasized menswear cuts, and draped daywear with ropes of real and fake jewels. Each season, her affairs were exposed by the gossip writers; each season, she revealed them herself on the runways. It was Chanel by Chanel—she lived her own clothes, and for a very high price, the client could too.

Jewels and perfumes were two areas developed by Chanel in the 1920's. The gifts of jewelry that she received from the Duke of Westminster were well known; one account attributes her interest in creating costume jewelry to her desire to wear her own wealth without appearing gauche. She opened her jewelry studio in 1924, creating pieces to fill the void left between real gems and cheap imitations. While many of the designs still associated with her name—including long jeweled ropes and heraldic blazons—were designed during this time, it was actually the 1930's that saw her greatest innovations. Of even greater long-term significance for the Chanel name was the creation of Chanel perfumes, beginning in 1921 with "Chanel No. 5." Chanel No. 5 was not the first perfume to take advantage of advances in synthetic chemistry, but it was the first to use an aldehyde base, permitting greater intensity

and stability of scent. Chanel played an important part in the design of the fragrance and its packaging, but in 1924 turned over production and distribution—and most of the profits—to perfumer Pierre Wertheimer.

Chanel was a male-identified woman, and she had few female associates. The exception was Misia Sert. Sert began as a musician and artist's model; as a result of her advantageous marriages and her irrepressible personality, by the 1920's she was hostess to the liveliest of Parisian avant-garde circles. Chanel met Misia Sert in 1921 and through her came to associate with the luminaries of the art world: Sergei Diaghilev, Igor Stravinsky, Pablo Picasso, Pierre Reverdy, and Jean Cocteau. Chanel was frequently very generous to artists in need, opening her home to them for extended periods or quietly bestowing on them the funds needed for their continuing productivity. She collaborated with Cocteau, designing costumes for a production of *Antigone* in 1923, for Diaghilev's ballet *Le Train Bleu* in 1924, and again in 1926 for Cocteau's *Orphée* (*Orpheus*, 1933).

Impact of Event

Chanel certainly did not invent everything attributed to her during the 1920's. She was not the first to bob her hair, dispose of her corset, shorten shirts, or design fragrances. She herself owed much to Paul Poiret, and many other designers were moving toward the creation of comfortable, boyish clothes during the decade. Much of Chanel's overwhelming impact is due to her longevity; she was a major designer in Paris for almost sixty years, from 1915 until her death in 1971. She was enormously successful in financial terms, and she set a style in the 1920's that other designers—and she herself—returned to for inspiration throughout the century. Furthermore, her designs, stressing simplicity as they did, could be copied and translated into ready-to-wear clothes. Thus, her fashion sense became a signature for women of all classes.

Perhaps the major example of the impact of Chanel's designs of the 1920's was Chanel herself. She continued her success into the 1930's, but she closed her couture house during World War II. Because of her questionable political allegiances during the Occupation, she fled to Switzerland in 1945. She did not return to Paris and reopen until 1954, when she staged a remarkable comeback. The new Chanel reacted as strongly against Christian Dior's then-fashionable "New Look" as the old Chanel had to the rigid look of the *belle époque*. To counteract it, she reinvented her look of the 1920's through a selective remembering of shapes, designs, and principles, refining the best of that early period into a signature style of the little black dresses, functional and perfectly proportioned suits, jewelry, and handbags with which her name became closely associated. One could argue convincingly that her reputation as a great fashion innovator owes as much to her own resurrection of her work as to a continuing legacy.

Whether or not this is so, the new Chanel caught the mood of the second half of the century as she had the first. This was especially true in the United States, where the Chanel label came to stand once again for quality and secure good taste. While

the American public believed that it learned fashion in the 1960's from the serene simplicity of Jacqueline Kennedy, she had learned it from Chanel. (When President John F. Kennedy was assassinated on November 22, 1963, his wife was wearing a Chanel suit.) In the late 1970's and 1980's, as more women moved into professional and managerial positions, latter-day versions of the collarless Chanel suit became a uniform of "dress for success."

The House of Chanel continued after the founder's death in 1971, though by the early 1980's it was no longer seen as a leading force. Perfume sales, still controlled by the Wertheimer family, were also in decline. Alain Wertheimer, grandson of Pierre, undertook to revitalize the Chanel name. Realizing that the couture operations had become little more than an expensive but necessary advertisement on behalf of the sale of perfumes and accessories, Wertheimer reorganized the business operations of Chanel and brought Karl Lagerfeld from Chloe to revamp the firm's image. As a designer, Lagerfeld carried on the Chanel tradition, sometimes as an echo of Chanel's greatest designs, sometimes as a fetish, while he also established his own reputation for fanciful designs. Under his direction, the House of Chanel regained some of its fashion leadership. The effect was exactly as Wertheimer desired: Sales of Chanel perfumes and accessories grew to more than four million dollars a year.

Few major designers of the second half of the century have not, at some time or other, paid homage to Chanel designs. For some, the homage becomes a principle underlying creativity; for others, it approaches complete imitation. Sonia Rykiel has not so much copied Chanel designs as drawn inspiration from her ideas of minimalist comfort: limited palette, liquid knits, carefully controlled proportions, contrast color bands, and the updated little black dress. Much the same can be said for a number of American designers who created for mass production: Claire McCardell, Anne Klein, and especially Vera Maxwell. The American designer Adolfo, however, has built a career on refined restatements of the Chanel suit.

The impact Chanel designs have had on the ready-to-wear market during the last decades of the twentieth century is really an enlargement of an earlier phenomenon. Even during the 1920's and 1930's, Chanel's designs encouraged "knockoffs." Because of their streamlined simplicity and their standardization, they were easy to copy. Chanel was sanguine about this copying, feeling that it was inevitable. Through the ready-to-wear trade, the wardrobes of most women in Europe and America came to bear the Chanel's impress, and the elegance of the Parisian woman, her fashion nonchalance of black, navy, and cream-colored basics set off by one or two remarkable accessories, still represents the elegance of Chanel.

Bibliography

Charles-Roux, Edmonde. *Chanel and Her World*. Translated by Dan Wheeler. New York: Vendome Press, 1981. A rich and informative compendium of historical photographs of Chanel, her circle, and her society. Annotations provide sufficient information to serve as a visual biography of Chanel. Gives more attention to Chanel's

society than to her work. Too-brief coverage of Chanel after World War II. Index and partial biographical dictionary.

_____. *Chanel: Her Life, Her World, and the Woman Behind the Legend She Herself Created*. Translated by Nancy Amphoux. New York: Alfred A. Knopf, 1975. Generally considered to be the most reliable of the many biographies of Chanel. Like others, Charles-Roux is more interested in her life in society, including her affairs, than in her contributions as a designer. Good grasp of her personality.

De Marly, Diana. *The History of Haute Couture, 1850-1950*. London: B. T. Batsford, 1980. History of the beginnings of haute couture, with emphasis on the late nineteenth and early twentieth centuries. Interesting chapters on the organization and financial aspects of the couture industry and on clients and their wardrobe requirements. Chanel is dealt with primarily in chapter 9. Black-and-white illustrations; brief bibliography.

Galante, Pierre. *Mademoiselle Chanel*. Translated by Eileen Geist and Jessie Wood. Chicago: H. Regnery, 1973. Another biographer seduced by Chanel's love affairs and the glitter of her circle; some attention to the business side of couture, the method of work in the salon. Strong grasp of the complexities of her personality.

Leymarie, Jean, with Catherine Hübschmann. *Chanel*. Translated by Jean-Marie Clarke. New York: Rizzoli, 1987. Purports to be an overview of the designs of Chanel in relation to the art of her age, though the connections made with pre-twentieth century art are occasionally fanciful. Perhaps more interested in art than in an analysis of Chanel's *oeuvre*. Well illustrated.

Madsen, Axel. *Chanel: A Woman of Her Own*. New York: Henry Holt, 1990. An update of the biography by Charles-Roux. With bibliography.

Mulvagh, Jane. Vogue *History of Twentieth Century Fashion*. London: Viking, 1988. Chronological arrangement of fashions in *Vogue*. The century is divided into segments of approximately six to nine years; each segment is introduced in a brief essay, and accounts of the individual years in fashion are given. Useful because so many other works are cavalier about the specific dates of fashion events. Copiously illustrated, but in small black-and-white reprints from the magazine.

Steele, Valerie. *Women of Fashion: Twentieth Century Designers*. New York: Rizzoli, 1991. History of women in fashion, written from a contemporary feminist perspective, highlighting the major role played by female designers in the period between the two world wars. Attention is also given to an international range of contemporary women designers. Moving postscript about acquired immune deficiency syndrome (AIDS). Extensive notes and bibliography. Many illustrations, some in color.

Jean Owens Schaefer

Cross-References

Diaghilev's Ballets Russes Astounds Paris (1909), p. 241; Poiret's "Hobble Skirts"

Become the Rage (1910), p. 263; Stravinsky Completes His Wind Octet (1923), p. 561; A Paris Exhibition Defines Art Deco (1925), p. 654; Schiaparelli's Boutique Mingles Art and Fashion (1935) p. 979; Dior's "New Look" Sweeps Europe and America (1947), p. 1346.

THE HARLEM RENAISSANCE CELEBRATES AFRICAN-AMERICAN CULTURE

Categories of event: Literature and music
Time: The 1920's
Locale: New York, New York

The Harlem Renaissance was a flowering of black culture, a celebration of blackness, and a sense of racial pride that continued to fuel vital works into the 1930's and beyond

Principal personages:
CLAUDE MCKAY (1889-1948), a poet with a working-class orientation whose poems were highly race-conscious
LANGSTON HUGHES (1902-1967), the most prolific and successful poet of the Harlem Renaissance
COUNTÉE CULLEN (1903-1946), a poet whose early work stressed the alienation of American blacks but who later emphasized universal experiences
FLETCHER HENDERSON (1897-1952), a bandleader whose style and arrangements first popularized swing music
DUKE ELLINGTON (1899-1974), a bandleader and composer whose works built on the rich traditions of black music
LOUIS ARMSTRONG (1898?-1971), a great jazz trumpeter, improviser, and scat singer whose instrumentals and singing were immensely popular

Summary of Event

In the years after World War I, Harlem's population was almost entirely black; the New York borough constituted the largest center of urban African Americans anywhere. Blacks poured in from all over America and the Caribbean, a migration at once optimistic and confident. During the 1920's and well into the 1930's, Harlem produced a cultural richness that made it a mecca for New Yorkers of all colors and creeds.

Writers and musicians were the heart of the Harlem Renaissance, helping to make Harlem a social and cultural magnet. Such writers as Claude McKay, Langston Hughes, and Countée Cullen were some of Harlem's brightest stars. They fostered a nationalism and an ethnic pride that strongly influenced later black writers.

Jamaican-born but having moved to the United States in 1912, Claude McKay glorified blackness. His fame rests on poems such as the first American collection of his work, *Harlem Shadows*, published in 1923. Although he had published three novels, some short stories, and an autobiography, McKay's best work remains his poems, which celebrate the Harlem proletariat and call for racial militancy. McKay's poems savored blackness in the midst of white hostility. His most famous poem, "If We Must Die," is often cited for its militant spirit. In it, McKay calls upon black

Americans to resist oppression even to death if necessary.

The most popular writer of the Harlem Renaissance was Langston Hughes. A prodigious writer, Hughes focused on the triumphs of the "little people" over adversity, the masses struggling to keep their American Dream alive. His characters, in both prose and poetry, suffer defeat and humiliation, but they are survivors. In such works as "The Weary Blues," "Let America Be America Again," and "Dreams," Hughes proclaims the desire and the need to save democracy for all Americans. He evokes universal values, not only black ones.

Like McKay and Hughes, Countée Cullen published poems in his youth, and by the early 1920's, his poetry was highly popular. In 1925, he published his first collection of verse, *Color*, which revealed a strong sense of racial pride. His anthologies *Caroling Dusk*, *Copper Sun*, and *The Ballad of the Brown Girl* were published in 1927, but in these works Cullen generally reduced his references to race. *Copper Sun*, for example, had only seven "race" poems, a fact that disappointed many readers.

Unlike McKay and Hughes, Cullen saw color in mostly negative terms, as in "The Shroud of Color," which focuses on the burden of being black. Cullen implies that the black is an alien in America, an exile from the African homeland. The price of being black and striving for full human rights was portrayed as a crushing weight. With the publication of *The Black Christ* in 1929, Cullen clearly moved away from race, presenting himself as a poet, not a black poet. It was his protest poems, however, that earned Cullen lasting fame.

African-American music was also being accepted and promoted in American culture by the 1920's. Jazz came of age, helped in large measure by white bandleader Paul Whiteman's introduction of classical jazz to New York in 1924. Yet it was mainly black bandleaders such as Fletcher Henderson, Duke Ellington, and Louis Armstrong who popularized jazz in and beyond Harlem.

Jazz dates from the post-Civil War era, when it was created out of a mixture of the blues, worksongs, and spirituals. In the early 1900's, New Orleans musicians were the first to employ jazz's characteristic improvisation. Henderson, Ellington, and Armstrong brought the style—with modifications—to New York's nightclubs, where both white and black patrons embraced it ardently. Ironically, the first major showplace for these bandleaders was the Cotton Club, which admitted only white people.

The growth of jazz was aided by the rise of the recording industry, bringing jazz to parts of America lacking live performances. Some critics, many of them black intellectuals, considered jazz unrefined, too raw, and even denigrating to the African American image. Jazz, though, became a craze, unstoppable.

On March 12, 1926, Harlem's Savoy Ballroom opened, an architectural and musical phenomenon. Its sheer size and elegant furnishings awed patrons and made it a showplace for music and dancing. Fletcher Henderson's orchestra performed there regularly, luring patrons with performer-audience interaction. Henderson is often credited with being the "father of swing," although he was strongly influenced by a young solo trumpeter, Louis Armstrong.

The Savoy was open to people of all classes and colors. Music was a serious

business there; besides the Henderson and Ellington ensembles, the bands of Benny Goodman, Tommy Dorsey, Count Basie, and Louis Armstrong were frequent performers. The Savoy gave opportunity to many musical talents, including such future singing greats as Bessie Smith and Ella Fitzgerald.

Duke Ellington expanded the boundaries of jazz as a composer and orchestrator. He was the master of form, a great synthesizer of jazz elements. His band developed a unique collaboration among leader, soloist, and group. Himself a fine pianist, Ellington refined jazz without taking away its spontaneity.

Louis Armstrong made his impact primarily as a solo artist. As early as 1923, he was noted for his stylish playing as a solo trumpeter in the King Oliver Creole Jazz Band, and he played with the Fletcher Henderson Orchestra in 1924. Armstrong had an intuitive genius that transformed the sound of jazz. He became a popular singer as well, his records selling in the millions.

These artists and many others contributed much to enrich black self-awareness and self-confidence. The 1930's, however, brought the Harlem Renaissance to a halt. The Depression hit Harlem hard. African-American financial institutions failed, taking with them not only financial savings but also many symbols of black aspiration. Yet the Harlem Renaissance continued until the riot of March 19, 1935. Responding to rumors of the death by beating of a black youth at the hands of police, thousands of Harlem's blacks went on a rampage, destroying not only millions of dollars worth of property but also hopes and dreams.

Impact of Event

The Harlem Renaissance gave rise to the "New Negro," proud of black culture yet determined to participate fully in American life. With Harlem in vogue during the 1920's, white people flocked to its nightclubs and theaters, attracted by the exotic and lively culture. In many blacks, a new self-consciousness and awareness was born. Black folktales and music were "discovered" and revitalized, serving as a therapy for both white and black.

Harlem's artists—writers, sculptors, musicians, dancers, and more—were very image-conscious. They promoted and advanced black talent, searching for black identity and a place within American society. They projected a black image that was respectable and strong, with character triumphing over race. Yet blacks were proud of their distinctive characteristics, too, and did not want to reject their past totally, though cultural integrity and commercial success were sometimes in conflict.

White America courted and cultivated Harlem's subculture. White patrons gave encouragement and funding to black talent, sometimes serving as guides and judges as well, and provided scholarships, grants, and outlets for black artists, particularly for writers. This dependency of black artists could, at times, subvert black sensibilities and interests—for patrons may have their own agendas.

Major publishing companies accepted and sought out black talent. None of the black writers' works became best-sellers, but they sold enough copies to warrant continued support by white publishers and critics. Though discrimination in the

publishing industry was not entirely eliminated, post-1920's black writers found doors more open than had earlier generations.

Whether younger black writers admired or rejected the works of the Harlem Renaissance, they could not ignore them. Such writers as Zora Neale Hurston, Richard Wright, and James Baldwin would carve out careers different from, yet building on, those of the giants of the 1920's. Reacting to the older writers, the new generation was stimulated to examine life for blacks as it was and as it could be.

The Harlem Renaissance reached beyond America. Peter Abrahams, a black South African writer, first read American black literature in a library in Johannesburg. He was enthralled by the poems, stories, and essays he found, and acknowledged the effect of such literature on his life by stating: "I became a nationalist, a colour nationalist, through the writings of men and women who lived a world away from me. To them I owe a great debt for crystallizing my vague yearnings to write and for showing me the long dream was attainable." Abrahams spoke for many African and Caribbean blacks eager to know that white people did not have a monopoly on the writing of real literature.

Nor did whites have a monopoly on composing and playing music. Black music influenced American culture even more strongly than black literature. Black music— spirituals, ragtime, and particularly jazz—intrigued white arrangers and composers. White pioneers in jazz such as Bix Beiderbecke, Jack Teagarden, Gene Krupa, and Benny Goodman studied jazz intently, often spending long hours in cabarets listening to black masters. At first merely imitative, these white musicians would go on to rival their teachers and then to dominate commercial jazz.

European musicians also became enamored of jazz. Among them, the composers Darius Milhaud and Kurt Weill helped pioneer continental classical jazz. (A wave of enthusiasm for Ellington and Armstrong's "hot" jazz swept Europe later.) Referring to classical jazz, Leopold Stowkowski said of the black musicians of America that "they are causing new blood to flow in the veins of music . . . they are path finders into new realms." This tribute was seconded by such great composers as Maurice Ravel and Igor Stravinsky, who acknowledged the strong links between jazz and much other modern music.

Jazz helped to interpret the spirit of the times, bringing joy and vigor to the post-World War I world. Along with it came popular dances such as the Turkey Trot, the Black Bottom, and the Lindy Hop. Talented black dancers and singers enabled this music to conquer a broad public and to be recognized as art.

Although older than jazz, the blues were mostly a fad for white composers and audiences. Blues music, however, became a craze in 1920's Harlem as an expression of black lives. Much of the popularity stemmed from singers such as Bessie Smith and, earlier, Ma Rainey. Blues songs mingled hope and realism with a weary determination; they were songs of the black masses struggling to be accepted for who they were.

Langston Hughes saw the blues as distinctly black, helping to free blacks from American standardization. Many of his poems, such as "The Weary Blues," reflect

the influence of the blues and use the music's structures, themes, and imagery. Later, younger writers such as Ralph Ellison and James Baldwin used the blues both to express sadness and also as a source of strength. An alternating expression of despair and hope, the blues were also sometimes a protest of societal conditions.

Although its artists produced important works of literature and music, the Harlem Renaissance proved above all to be important for its race-consciousness, a new sense that black people had a rich culture. To a degree, though, the Harlem Renaissance left a paradoxical gift: the lesson of its failures. Writers such as Countée Cullen and Claude McKay were not as innovative or as fresh as they could have been; they were tied too closely to white norms of art and culture to be true innovators. Heavily dependent on white patrons for approval, many black artists lacked a truly personal vision.

The Harlem Renaissance died in the mid-1930's, mortally wounded by both the Depression and the disillusionment of black artists who failed to find a common ideology to bind them together. Still, the Harlem Renaissance served as a symbol and a reference point. It was a stepping-stone for black writers and artists who followed, more sophisticated and cynical but proclaiming loudly and clearly that blacks must be free to be themselves.

Bibliography

Bontemps, Arna. *The Harlem Renaissance Remembered*. New York: Dodd, Mead, 1972. An excellent set of essays on leading figures of the Harlem Renaissance. Chapter 2 is particularly useful as an overview. Notes, a bibliography, and an index.

Butcher, Margaret J. *The Negro in American Culture*. 2d ed. New York: Alfred A. Knopf, 1972. A cultural history of blacks throughout American history. Traces folk and formal contributions of American blacks to American culture as a whole in historical sequence and topical fashion. No bibliography; index.

Davis, Arthur P. *From the Dark Tower*. Washington, D.C.: Howard University Press, 1974. Covers major black writers from 1900 to 1960. Divided into two long sections: "The New Negro Renaissance" (1900-1940) and "In the Mainstream" (1940-1960). Gives biographical details and selective bibliography for each author. Extensive quotes from authors' works. Photos of each author. Index.

Floyd, Samuel A. *Black Music in the Harlem Renaissance*. New York: Greenwood Press, 1990. Excellent collection of essays covering varied types of music and major black musicians. One essay on Harlem Renaissance activities in England. Many illustrations of musical works. Notes and references for each chapter. A superb bibliography, listing major composers and their works. Index.

Fullinwider, S. P. *The Mind and Mood of Black America*. Homewood, Ill.: Dorsey Press, 1969. A study of black myths and of the Harlem Renaissance revolt against these myths. Includes a look at several key figures of the Harlem Renaissance. Covers the 1880's to the 1960's. Chapters 2 and 6 are particularly helpful. Brief bibliography and an index.

Huggins, Nathan I. *Harlem Renaissance.* New York: Oxford University Press, 1971. An analysis of several black artists and their works within the context of American cultural history. Questions and challenges the quality of African-American artistic expressions. Photographs, notes, and bibliography for each chapter. An extensive index.

Lewis, David L. *When Harlem Was in Vogue.* New York: Alfred A. Knopf, 1981. An intellectual and social history covering many aspects of 1920's Harlem. Primary focus on written and musical events. Lavishly illustrated. A bibliography for each chapter and an index.

Shaw, Arnold. *Black Popular Music in America.* New York: Schirmer Books, 1986. A chronological study of black popular music from spirituals to funk. Shaw relates the debt of American popular music to black artists and songwriters and adds a "White Synthesis" to each chapter. Chapters 3, 5, and 7 are particularly helpful. Illustrated; a bibliography and discography are included for each chapter. Index.

Wintz, Cary D. *Black Culture and the Harlem Renaissance.* Houston, Tex.: Rice University Press, 1988. Examines the Harlem Renaissance as a social and intellectual movement within the framework of black social and intellectual history. Relates the Harlem Renaissance to earlier black literature and its new urban setting. Ties black writers to the larger literary community. Helpful figures and tables. Bibliography for each chapter; index.

S. Carol Berg

Cross-References

Bessie Smith Records "Downhearted Blues" (1923), p. 572; *The Great Gatsby* Captures the Essence of the Roaring Twenties (1925), p. 626; Armstrong First Records with His Hot Five Group (1925), p. 670; Ellington Begins an Influential Engagement at the Cotton Club (1927), p. 739; Billie Holiday Begins Her Recording Career (1933), p. 930; Wright's *Native Son* Depicts Racism in America (1940), p. 1185.

THE CABINET OF DR. CALIGARI OPENS IN BERLIN

Category of event: Motion pictures
Time: 1920
Locale: Berlin, Germany

The Cabinet of Dr. Caligari *was an artistic and commercial triumph that launched a wave of expressionistic filmmaking*

Principal personages:
ROBERT WIENE (1881-1938), the director of *The Cabinet of Dr. Caligari*
HERMANN WARM (1899-?), a set designer for the film
WALTER RÖHRIG (1893-?), a set designer for the film
WALTER REIMANN, a set designer for the film
HANS JANOWITZ, one of the two scriptwriters for *The Cabinet of Dr. Caligari*
CARL MAYER (1894-1944), the other scriptwriter for the film
WERNER KRAUSS (1884-1959), a star of the film as Dr. Caligari
CONRAD VEIDT (1893-1943), a star of the film as Cesare

Summary of Event

Das Kabinett des Dr. Caligari (1920, *The Cabinet of Dr. Caligari*) could only have been conceived as it was under a narrow set of circumstances. First was the upheaval of values in Germany after a series of disillusioning blows. These included defeat in World War I, the Spartacist (1919) and the Kapp (1920) uprisings against the unpopular Weimar Republican government responsible for the crippling Versailles Treaty, and the great inflation that, by the early 1920's, had wiped out the savings of Germany's middle class. In analyzing *The Cabinet of Dr. Caligari*, film critics agree that it was the first of many films of the period to reflect the *Weltanschauung* of troubled Germans questioning the nature of authority.

The second element was the mood of rebelliousness in the arts. Previous styles were associated with a culture that had bankrupted itself in war. Sigmund Freud had proved the significance of unconscious and dream states as components of reality; early twentieth century artists set themselves somehow to express these facets of reality. Expressionism in Germany, defined as the outward representation of inner reality, paralleled Surrealism in France as the artistic approach thought best to represent what was real. Depending on the artist's approach, this could mean the outward expression of the fundamental inner nature of a thing or, as in *The Cabinet of Dr. Caligari*, the visual expression of the world as subjectively perceived by a particular character. The film is considered to be the first and best of an era of great German films influenced by the expressionist style.

Third was the fact that cinema was still silent and experimental. This opened the way to the testing of various means of visual expression. Set designers Hermann

Warm, Walter Röhrig, and Walter Reimann were affiliated with the expressionist Berlin Sturm Society. Their painted sets reflected the mind of the insane narrator of the story. Using induced perspective and sharp contrasts of light and shadow, they created a medieval style town with narrow and angular streets and distorted houses, doors, and windows. The acting, especially that of Werner Krauss (Dr. Caligari) and Conrad Veidt (Cesare, his somnambulist), was similarly expressionistic, with inner emotions exaggerated and externalized. Expressionism thus belongs to silent films, where image and set predominate and the use of dialogue—grammar and syntax—would tend to dilute the intended effect, that of immediate comprehension of the subject's essence.

These three conditions help to explain certain features prevalent in German films of the 1920's: the fantastic or macabre subject matter (the world seen by unbalanced, anguished society), the city street or circus sideshow locales (places on the margins of propriety, symbolic of regression into childhood, anarchy, and sensuality, where the restraints of bourgeois values seemed absent), the theme of authoritarian tyranny versus chaos, and the motif of circular movement (an organ grinder's arm, Ferris wheel, or revolving door), a symbol of aimless, treadmill life.

The story line of *The Cabinet of Dr. Caligari* is as follows. Francis relates a strange experience, and the film is his description. Dr. Caligari arrives at the town fair with his sleepwalker act. Caligari is criminally insane; he has hypnotized Cesare to kill at his bidding, after predicting the victim's death in public. Cesare commits several murders, including that of Francis' friend Alan. Francis is determined to find Alan's murderer. Cesare also abducts Jane, Francis' sweetheart, but dies of exhaustion. Francis pursues Caligari to a lunatic asylum and finds that Caligari is the director, but that he has become insanely obsessed with totally dominating his hypnotized subjects. Cesare was his great experiment. When Cesare's body is brought in, Caligari cracks up and becomes an inmate.

With Francis' story concluded, the camera conveys the viewer back to the frame story and now reveals that Francis is actually an inmate of the asylum. The characters of his narrative—Jane, Alan, and Cesare—are also asylum figures; Francis' Dr. Caligari is, in fact, the real, though benign, asylum director. On seeing him, Francis becomes violent and must be straightjacketed.

Writers Hans Janowitz and Carl Mayer objected to the intrusion of this particular frame story. The frame added by director Robert Wiene opened the way to the expressionist sets (the figments of Francis' mad mind), which made the film more compelling.

It is interesting to note that in Jane's boudoir the plushy furniture is almost normal. Seen through Francis' eyes, the room is sensuously round, with many pillows and heart shapes, reflecting his passion for Jane. It is at once the essence of sexuality and the world seen through the eyes of one main character. Similarly, a scene set in a jail cell conveys the universal essence of confinement. The prisoner sits attached to a ball and chain on the floor of a dank, narrow cell.

The Cabinet of Dr. Caligari was an immediate success. It was perfect in its genre,

and imitators often failed by their excesses or obvious artificialities. Director Robert Wiene himself attempted to capitalize on "Caligarisme" in 1920 with his film *Genuine*, the name taken from a priestess who seduces and then kills her lovers. Its expressionist sets overpowered the acting, and the film failed. His 1923 adaptation of *Crime and Punishment* was more successful. The expressionist sets intruded more naturally, reflecting the hallucinations of despair in the mind of the protagonist.

Also successful in imitating *The Cabinet of Dr. Caligari* was Henrik Galeen's 1926 remake of *The Student of Prague*, with Veidt as the protagonist Baldwin, who gives his mirror image to a sorcerer in return for wealth and marriage to a beautiful and aristocratic woman. The image becomes his evil self, and when he finally shoots it, he kills himself. Most of the people connected with *The Cabinet of Dr. Caligari* found success after the film.

Impact of Event

When it was released in February, 1920, *The Cabinet of Dr. Caligari* was reviewed as "the first work of art on the screen." Opinions of its merits varied, but it was perceived by many critics as a film that liberated a new artistic medium and demonstrated what was formally and psychologically possible on the screen.

The significance of the film has two aspects: artistic and sociological. After its appearance, German film directors were in demand in Hollywood and elsewhere for their control of the whole creative process, through the perfect integration of plot, lighting, sets, and actors and the first use of completely mobile cameras. Moreover, the film successfully utilized expressionist techniques that would influence the films of Germany and elsewhere through the remainder of the twentieth century.

The sociological significance of the film is its depiction of the neurosis of the German collective mind after World War I. The films of a nation often reflect its collective mentality because they depend for their success on mass appeal. Siegfried Kracauer has asserted that the films of UFA (Universum Film Aktien Gesellschaft), the major German film company during the 1920's and 1930's, expressionistically reflected the German people's deeply rooted desire for strong government control as the alternative to national chaos. The bizarre atmosphere of unreason and dread conveyed by so many expressionist films led Kracauer to conclude that under Hitler, Germany carried out what had been anticipated by cinema.

Many German films adopted the theme of tyranny or chaos, in particular Ernst Lubitsch's *Madame Dubarry* (1919); F. W. Murnau's *Nosferatu the Vampire* (1922), Fritz Lang's *Dr. Mabuse der Spieler* (1922, *Dr. Mabuse the Gambler*) and Paul Leni's *Das Wachsfiguren kabinett* (1924, *Waxworks*). *Madame Dubarry*, set in the time of Louis XV, appeared at the time of the fall of the German monarchy. The film supports authority and drains the French Revolution of its significance, making its cause an unhappy love affair, with an angry lover getting the masses to take the Bastille. In 1921, Dmitri Buchowetsky's *Danton (All for a Woman)* also showed contempt for the French Revolution. The people abandon Georges Danton for Augustin Robespierre's promised free food.

Dr. Mabuse the Gambler, like *The Cabinet of Dr. Caligari,* employed a doctor who supposedly was insane and wanted power. Mabuse symbolized illegitimate authority inciting or hypnotizing others to do evil. The film also used expressionistic sets. In the three separate episodes of *Waxworks,* expressionist sets accompany the animation of the wax figures of tyrant-types Harun-al-Rashid (Emil Jannings), Ivan the Terrible (Conrad Veidt), and Jack the Ripper (Werner Krauss). Fritz Lang's *Metropolis* (1927) is rich with imaginative and symbolic sets. The great furnaces that support the futuristic city are seen by the workers as man-devouring Moloch. The dictator of Metropolis has an evil robot made, identical to the saintly Maria, to control the workers. At the end, the workers' representative shakes hands with the dictator, symbolizing the union of labor and a now-benign management.

Strict expressionism, using painted stylized set designs and filmed entirely indoors, under lighting that emphasized sharp contrasts and camera angles productive of grotesque images, gave way by 1929 to the New Realism. Dream sequences utilizing new Freudian symbols, such as those in G. W. Pabst's *Secrets of a Soul* (1926), no longer depended on Caligarian designs but were created by camera fades and concave or convex mirrors. Even so, numerous other German movies of the period and long afterward used expressionist devices for the visual projection of the macabre or the fantastic, even if expressionist stylization was used solely to create dramatic atmosphere or reflect a character's momentary hallucination.

Arthur Robison's *Schatten* (1922, *Warning Shadows*) projected the hallucinations of a jealous husband, his amorous wife, and her four lovers. A traveling showman hypnotizes each in turn, creating a series of shadow plays that the subjects perceive as real events. Murnau's *Der letzte Mann* (1924, *The Last Laugh*) starred Emil Jannings as a uniformed doorman at a fine hotel. His age causes his demotion to keeper of the latrine and an attendant loss of esteem. The revolving doors that symbolize the aimless, endless revolutions of life and fortune are expressionist. The film features a famous dream sequence with multiple exposures, distorting lenses, slow motion, stylized figures, and confused locales. Ernö Metzner's *Der Überfall* (1928, *The Accident*) could also be called expressionist for its use of distorted mirrors to create images in the mind of a man in trauma after an accident.

The Cabinet of Dr. Caligari reached the United States in April, 1921. A review in *The New York Times* described it as creating a new adjective for American filmgoers: "European." Hailing it as a perfect harmony of setting, plot, and acting in its expressionist style, the reviewer predicted a slew of poor imitations. The films of Fritz Lang, Ernst Lubitsch, and other German filmmakers who moved to the United States, certainly should not be classified as "poor."

Aware that realism is often inadequate, Orson Welles used both surrealistic dream sequences and expressionistic distortions to project inner emotion. Noteworthy was his *Macbeth* in 1948. Many of Alfred Hitchcock's black-and-white thrillers, from *Rebecca* (1940) to *Psycho* (1960), have expressionist moments. In Robert Siodmak's *The Spiral Staircase* (1945), expressionistic effects include the camera stalking the victim as if it were the criminal, deliberate camera distortions, and the symbolism of

the spiral stairs. Swedish director Ingmar Bergman must also be named in the context of expressionism.

As film historian Lotte Eisner noted, in 1919 artists were asking "Why depict realism? Everyone can see the real world." Artists must express personal visions of external facts, colored by the emotions that the facts provoke. Thus expression will always be skewed. *The Cabinet of Dr. Caligari* did not establish a genre, but its impact through its influence on expressionism in film has been immense.

Bibliography

Barlow, John D. *German Expressionist Film.* Boston: Twayne, 1982. Excellent survey of expressionism, with detailed summaries of films. The chapter on the heritage of expressionism alerts the reader to films currently available or shown in the media. Contains an extensive filmography.

Eisner, Lotte H. *The Haunted Screen: Expressionism in the German Cinema and the Influence of Max Reinhardt.* Translated by Roger Greaves. Berkeley: University of California Press, 1973. The classic treatment of German silent expressionist films. Expressionism as an intellectual movement is set against the background of German cultural tradition. Amply illustrated with stills; extensive filmography.

Furness, R. S. *Expressionism.* London: Methuen, 1973. An extensive discussion of the historical origins and precursers of expressionism in Germany and elsewhere. Evaluates the various definitions of expressionism. Goes beyond films to investigate expressionism in literature and other media.

Kracauer, Siegfried. *From Caligari to Hitler.* Princeton, N.J.: Princeton University Press, 1947. A psychosociological interpretation of German films of the 1920's and 1930's that views Germany as a nation in a post-Versailles Treaty malaise bordering on neurosis. Whole films reflected this, as well as manifesting a desire for a strong leader who would resurrect the nation. Highly recommended, though some analysts believe that Kracauer overinterprets.

Manvell, Roger. *The German Cinema.* New York: Praeger, 1971. A general history of German films, from origins to the 1960's. Two chapters devoted to the films of the Nazi period.

Daniel C. Scavone

Cross-References

Freud Inaugurates a Fascination with the Unconscious (1899), p. 19; Avant-Garde Artists in Dresden Form Die Brücke (1905), p. 134; Der Blaue Reiter Abandons Representation in Art (1911), p. 275; Jung Publishes *Psychology of the Unconscious* (1912), p. 309; Von Stroheim Films His Silent Masterpiece *Greed* (1924), p. 593; Gance's *Napoléon* Revolutionizes Filmmaking Techniques (1925), p. 642; Lang Expands the Limits of Filmmaking with *Metropolis* (1927), p. 707; Buñuel and Dalí Champion Surrealism in *Un Chien andalou* (1928), p. 750; Von Sternberg Makes Dietrich a Superstar (1930), p. 845; Lubitsch's *The Merry Widow* Opens New Vistas for Film Musicals (1934), p. 941.

JANTZEN POPULARIZES THE ONE-PIECE BATHING SUIT

Category of event: Fashion and design
Time: 1920
Locale: Portland, Oregon

Jantzen Knitting Mills devised a rib-knit elasticized one-piece (maillot) bathing suit in 1913 and popularized it in the 1920's

> *Principal personages:*
> JOHN ZEHNTBAUER (1884-1969), a cofounder of Portland Knitting Company and an innovative marketing strategist
> CARL JANTZEN (1883-1939), a cofounder of Portland Knitting Company and inventor of the elasticized rib-knit stitch for swimwear
> ROY ZEHNTBAUER (1886-?), a cofounder of Portland Knitting Company and innovator in retail sales
> MITCH HEINEMANN (1892-1972), a creative executive who originated and implemented Jantzen's successful advertising campaigns of the 1920's

Summary of Event

In 1913, John Zehntbauer, Roy Zehntbauer, and Carl Jantzen, owners of the Portland (Oregon) Knitting Company founded in 1909, were asked by a member of the city's rowing club to create a wool crewing suit for use on the Willamette River on cold days. The company produced a suit made of rib-knitted wool. Carl Jantzen had devised a machine that produced a tightly woven knitted-rib stitch used to manufacture hosiery and cuffs for woolen sweaters, socks, scarves, mittens, and caps. The Jantzen process, a revolutionary manufacturing procedure, created a stretchable, springy woolen cloth that retained its shape and did not absorb huge amounts of water. The young business executives utilized the stitch to manufacture the suit requested. The rower, satisfied with the garment, then wanted a full rib-knitted suit for swimming. The piece of swimwear originally manufactured was exceedingly heavy, two pounds dry and eight pounds wet, which was its major drawback.

A research team comprising the Zehntbauer brothers, Carl Jantzen, Sam Street, and printer Joe Gerber began to test swimwear. The two test sites were the pool at the local Young Men's Christian Association (YMCA) and the Willamette River. Before the end of 1913, their goal was achieved. Other members of the Portland Rowing Club team wanted to purchase copies of the lightweight, body-hugging rib-knitted suit. The Zehntbauers and Jantzen realized that a large market existed not only for men's but also for women's swimwear. In 1915, they began to manufacture for general sales elasticized rib-knitted swimwear for both men and women. A high volume of sales at the regional level led them in 1916 to decrease the production of sweaters and accessory items and to concentrate on rib-knitted swimming suits.

Market trends also indicated that swimwear for women represented a potential for growth in the garment industry.

The swimsuit that the Portland Knitting Company manufactured was referred to as a male or female tank suit or maillot, although the versions differed very little. They were made of elasticized rib-knitted wool in a number of colors with bright horizontal stripes across the chest, hips, and thighs. The maillot was manufactured in one piece, with deep cuts at the arm holes, a low rounded neckline (later, V-necks were added), narrow straps, and trunk extending to the top of the thighs. The suit also was distinctive in that it did not have nor need a drawstring at the waist. It was sold with the guarantee that it would fit any body type. Customers were amazed that a small, tightly knitted elasticized suit could expand to fit a large adult.

The popularity of the rib-knitted suit, especially among women, exceeded the expectations of the Portland Knitting Company's administrators. In 1917, the company sold approximately six hundred maillots; in 1919, forty-one hundred were purchased. To meet the demands of an ever-expanding market, the company expanded its operations. It changed its name in 1918 to Jantzen Knitting Mills, which ultimately became Jantzen Inc.

The group that accounted for the largest volume of sales was young women empowered by the woman's rights movement. Their assertion of independence was reflected in their manner of dress. Entrance by women during World War I into the work force, where greater physical movement was a necessity, supported the growing female demand for less restrictive and confining clothing. Lifting the restrictions on female movement quickly gave rise to the rejection of many of the impractical fashions of the past. The creative efforts undertaken by such European couturiers as Paul Poiret to revolutionize women's fashion and create the straight, slim "T-shaped" silhouette was a 1912 cultural crosscurrent that also made the female maillot costume acceptable.

Impact of Event

Young women were more than ready to set aside the cumbersome bathing suit that became fashionable in the mid-nineteenth century, when bathing was first considered socially acceptable. The suit, designed to cover most of the female form, comprised a short-sleeved knee-length dress that was worn over a pair of knickerbockers or bloomers. The dress, like the knickers, was plain, checked, striped, or floral in color. One of the more popular styles of the suit was dress and knickers made of dark blue or black serge. Accessories consisted of dark stockings and boots that laced to the mid-calf. A cloth bathing cap also was worn. Such items of apparel were suitable only for low-water wading and prevented women from engaging in the more vigorous sport of swimming.

The Jantzen maillot, designed to fit all body sizes and contours, was more appealing when worn by straight, tall, and slim young figures, male or female. Although the public accepted without controversy the male version of the maillot, women who appeared at beaches and amusement centers clad in a Jantzen suit were accused of

indecently exposing their bodies. Many enraged citizens demanded that officials pass ordinances to keep women from appearing in public wearing the suits. Many local governments did so, some even prohibiting women from wearing any type of one-piece swimwear. In 1922, maillot-clad women who appeared on the Chicago-area beaches in the Jantzen maillot were arrested. In 1924, Boston banned the costume. On the East Coast, plainclothed policewomen patrolled many beaches to prevent use of such facilities by females wearing maillots.

The executives of Jantzen undertook an extensive advertising campaign to sell the suit and further increase the already enormous demand for it. Marketing strategies entailed the creation of a positive image for wearers of the suit, especially women, and the acceptance of swimming as a valued recreational activity. Mitch Heinemann, one of Jantzen's first salespeople, was selected to direct the advertising campaign. Heinemann proved to be one of the garment industry's most daring and creative marketing specialists. He convinced Americans that the maillot was manufactured for swimming rather than for bathing. He visually bombarded the nation with the slogan The Suit that Changed Bathing to Swimming. By 1924, Johnny Weissmuller, who later was to portray Tarzan in numerous films, was wearing a Jantzen suit as a champion swimmer.

Another successful advertising device that Heinemann implemented was the production and distribution in 1916 of a sticker for car windshields and store windows. It depicted a woman clad in a red swimsuit in a diving position. By the end of the 1920's, ten million of the stickers had been given away. Some states attempted to halt the campaign by refusing to accord driving licenses to those individuals who displayed on their windshield the famous Jantzen logo, the Red Diving Girl or Jantzen Girl. Authorities claimed that the stickers reduced drivers' field of vision.

The Red Diving Girl emblem was the creation of two free-lance artists, Florence and Frank Clark. The Clarks submitted two designs for the logo. Both of the emblems graphically depicted a tall, slim, young woman in a red bathing suit, red cap, and mid-length red stockings. The Red Diving Girl in one design was captured in a realistic diving pose. Another design showed a stylized female figure clad in the same costume but captured in a graceful curved diving position. Joe Gerber, Jantzen's printer, made the selection. He chose the more stylized version of the Red Diving Girl. In addition to providing an image for stickers, the logo, as a result of customers' demands, was sewed on all swimwear sold by Jantzen. At first, the fourteen-inch felt emblem was attached to the chest of all suits; later, reduced in size to ten inches, it was placed on the bottom part of the suit.

Within a short time, the Jantzen Girl was the seventh most recognized of companies' logos. The image of the female figure would be modernized periodically, but the color of the suit remained, as did the suspended diving position. Notable graphic designers and illustrators besides the Clarks who gave graphic life to the Red Diving Girl were McClelland Barclay, Coles Phillips, and Alberto Vargas. Barclay, who established during the 1920's and the 1930's the image of the ideal American woman, was the illustrator who introduced the Red Diving Girl to readers of *The Saturday*

Evening Post. In 1941, Jantzen called upon Vargas to modernize the Red Diving Girl; his initial efforts appeared in an *Esquire* calendar given to three thousand customers.

In order to promote swimming and to make water sports a major leisure-time pursuit, Heinemann launched in 1926 a national "Learn-to-Swim-Week" campaign. Participants competed in swim meets, earned diplomas, and received discounts and merchandise from store tie-ins. Advertisements made clear that safety, physical fitness, and fun could all be more readily acquired if clad in a Jantzen swimsuit. Johnny Weissmuller was one of the live images that Heinemann used to draw attention to this campaign and the Jantzen swimsuit. Heinemann's use of soon-to-be discovered sports and film personalities to advertise Jantzen swimsuits was utilized effectively by his successors. In the 1940's, Jantzen employed an eighteen-year-old Hollywood High School student, James Garner, and a young woman known as Norma Jean Baker, who had not yet assumed the name of Marilyn Monroe, to promote its swimwear. In the 1947 Jantzen style book, Garner and Monroe were Jantzen's featured swimsuit models.

In 1928, encouraged by Heinemann, Jantzen established an amusement park, the Jantzen Beach Amusement Center. It was operated by the Hayden Island Development Corporation until July 7, 1970, when the huge complex was closed. Billed as the Coney Island of the Pacific Northwest, the Jantzen Beach complex, designed by architects Paul H. Huedepohl and Richard Sundeleaf, provided the public with four large swimming pools with water changed several times a day; poolside fashion shows; one of the United States' most spectacular roller coasters, the Big Dipper; Dodge-Em, a bumper-car ride; the Natatorium, a lavish indoor bathhouse; and a large, golden-canopied ballroom where more than four thousand individuals could dance to the "Jantzen Hop," written by Don DeForest and Irving Groth.

Within less than a decade after its introduction, the maillot was considered normative swimwear and Jantzen was the largest swimsuit manufacturer in the world. By 1925, the Jantzen maillot was sold in Europe, and soon after in South Africa, South America, and Australia. By the 1940's, other companies began to compete more aggressively with the Portland-based company for market shares. To retain a favorable sales volume, Jantzen introduced a new sweater line, but it continued to manufacture bathing suits and to serve as a trendsetter in the field of swimwear.

Bibliography

Bigelow, Marybelle S. *Fashion in History: Apparel in the Western World.* Minneapolis, Minn.: Burgess, 1970. A well-written and effectively organized volume on fashion from antiquity to recent times. Interesting section on approaches to the design of costumes. Limited but informative on swimwear. Illustrated.

Boucher, François. *Twenty Thousand Years of Fashion: The History of Costume and Personal Adornment.* New York: Harry N. Abrams, 1967. An overview of fashions and accessories from antiquity into the modern era. The individuals and forces that shaped modern modes of dress are discussed. Reproductions of paintings, photographs, and sketches effectively enhance the text.

Cleary, David Powers. *Great American Brands: The Success Formulas that Made Them Famous.* New York: Fairchild, 1981. A history of thirty-four American companies and their trademarked brands. The section on Jantzen provides insightful information on the company's marketing activities. A short account of how the company met the challenge of the revival of nude bathing is discussed as well as its pioneering ventures to create a smoke-free workplace. Pictures of the founders are included.

De Marly, Diana. *Fashion for Men: An Illustrated History.* New York: Holmes & Meier, 1985. A short but informative history of men's fashions, including swimwear, since the medieval period. Ninety-six illustrations, mainly reproductions of paintings and photographs. A very short glossary. Extensive bibliography.

Ewing, Elizabeth. *History of Twentieth Century Fashion.* Totowa, N.J.: Barnes & Noble, 1986. A fine social and intellectual history of fashion in modern times. Historical antecedents as well as particular styles and fashion events, such as sunbathing, are examined in a detailed but stylistically pleasing manner. Illustrated.

Lencek, Lena, and Gideon Bosker. "Making Waves: How Pacific Northwest Swimsuits Undressed America." *Pacific Northwest* 23 (July, 1989): 32-33, 87. A concise history of the Jantzen company, its marketing strategies, and its impact on fashion. A short history of another swimwear company, Rose Marie Reid, is included.

Nunn, Joan. *Fashion in Costume: 1200-1980.* New York: Schocken Books, 1984. An overview of fashion history from the medieval period until 1980. Illustrated with black-and-white sketches.

Tortora, Phyllis, and Keith Eubank. *A Survey of Historic Costume.* New York: Fairchild, 1989. Data are organized by dates, sex, age, and types of dress and accessories. Historical overviews are included of the social, political, and economic forces that gave rise to various styles of costumes from each era. Illustrated. Extensive bibliography.

Yarwood, Doreen. *English Costume from the Second Century B.C. to 1950 with Introductory Chapters on Ancient Civilizations.* London: Batsford, 1952. Definitions of fashion terms worked into body of text. Illustrations are black-and-white sketches. Information on swimwear is limited but informative.

Loretta E. Zimmerman

Cross-References

Brooks Brothers Introduces Button-Down Shirts (1900), p. 24; Poiret's "Hobble Skirts" Become the Rage (1910), p. 263; The Bikini Swimsuit Is Introduced (1946), p. 1324; Quant Introduces the Miniskirt (Early 1960's), p. 1824; Madonna Revolutionizes Popular Fashion (1980's), p. 2449.

THE MYSTERIOUS AFFAIR AT STYLES INTRODUCES HERCULE POIROT

Category of event: Literature
Time: 1920
Locale: Great Britain

Agatha Christie created detective Hercule Poirot, a shrewd and self-confident Belgian, who became the symbol of the golden age of the mystery genre

Principal personages:
> AGATHA CHRISTIE (1890-1976), a prolific mystery writer who introduced Hercule Poirot and several other fictional detectives
> ARTHUR CONAN DOYLE (1859-1930), the creator of Sherlock Holmes, the most famous fictional detective of all time
> DOROTHY L. SAYERS (1893-1957), a contemporary of Agatha Christie who created Lord Peter Wimsey, an unusual investigator and hero of mystery fiction
> MARY ROBERTS RINEHART (1876-1958), an American mystery novelist noted for her blend of horror and humor
> GEORGES SIMENON (1903-1989), a Belgian-French writer who created Inspector Maigret, a French counterpart of Sherlock Holmes
> ERLE STANLEY GARDNER (1889-1970), an American contemporary of Christie who created Perry Mason

Summary of Event

World literature, including that of England, is rich in the realm of the mysterious. Tales of supernatural heroes date back to ancient times. The literatures of Egypt, Greece, Rome, and most other early civilizations contain such accounts. Early Northern European literature contains tales of such heroes as Beowulf and Arrow-Odd. Not until the eighteenth century, however, did the modern mystery novel, built around fear and curiosity for their own sakes, begin to emerge.

Horace Walpole, the English author of *The Castle of Otranto* (1764), is often considered the originator of horror stories in their present form. During the nineteenth century, writers such as Edgar Allan Poe used a combination of reason and madness to raise mystery writing above the realm of entertainment and into the realm of the psyche.

The next significant development in mystery fiction was the detective mystery, usually featuring supremely skilled protagonists whose amazing abilities are equaled only by their self-confidence. The first and most famous of these heroes was Sherlock Holmes, created by Sir Arthur Conan Doyle in 1887.

As a young man, Doyle was an avid reader. Included in his reading were several

early detective stories; in reading such stories, though, Doyle felt that the abilities of the heroes were often insufficient to hold the reader's attention. Doyle thought that such early attempts relied more on circumstance than on the clever work of the detective to solve the mystery.

During his unrewarding career as a medical doctor, Doyle began to write mystery stories of his own. Beginning with *A Study in Scarlet* (1887), Doyle turned out a steady stream of mystery stories and novels featuring Sherlock Holmes. Although Doyle had some initial difficulty in getting the attention of publishers, Sherlock Holmes stories soon became popular both in England and in the United States. By 1900, the common perception of a detective was based on Sherlock Holmes, and the detective novel was a permanent reality in the literary world.

Following Doyle and Sherlock Holmes came Mary Roberts Rinehart, an American mystery novelist and playwright. Known for her clever, well-constructed plots and for her realistic characterizations, Rinehart also had the unique ability to combine horror and humor. Her most popular mystery novels include *The Circular Staircase* (1908) and *The Man in Lower Ten* (1909).

With the field of mystery fiction well established, Agatha Christie and her master detective, Hercule Poirot, made their grand appearance. Born and reared in the affluent middle class of late Victorian England, Christie seemed ill-suited to become immersed in a fictitious world of violence, murder, and intrigue. That fictitious world did have some real-life foundations; with the advent of World War I in 1914, Christie worked as a wartime pharmacist. In that position, she learned about the poisons that would become a vital part of her mystery novels.

Christie and her entire family were voracious readers, from the classic children's books of the day to the latest novels. Their reading included many mystery stories, including the early Sherlock Holmes exploits by Doyle. Christie's sister Madge first challenged her to write her own detective mystery. The challenge was made during World War I, when Christie was working as a pharmacist and when the war had separated her from her first husband, Archie Christie. The result of her sister's challenge was *The Mysterious Affair at Styles: A Detective Story* and the introduction of Hercule Poirot. After laying on a publisher's desk for two years, the book was published in 1920. The novel was a tremendous success—so much so that when Christie and her husband bought a new home, they named it Styles.

From the beginning of her mystery writing, Agatha Christie concentrated on developing plots that were ordinary but that contained a surprising twist. She never wanted an unusual crime with an unusual motive. Because of this, her novels became known for extremely clever plots, detailed character descriptions, and intricate interpersonal relationships. Perhaps more than any other writer of mystery fiction, Agatha Christie became a master of the art of misdirection.

Christie's ingenuity can be clearly seen in her creation of Hercule Poirot. In this creation, the historical context is significant. As a result of World War I, Belgian refugees were common in England. Poirot was a retired Belgian police officer who felt gratitude for the England that had aided his native land when it was overrun by

the German military machine. At the same time, Poirot expressed a humorous disregard for the investigative abilities of English detectives. Poirot was described as short, with an egg-shaped head and a luxuriant and generously waxed moustache. He was meticulous to the smallest detail, even in his private life, and always made the best use of his "gray cells," as he called the human brain.

The ability of Hercule Poirot to solve the most difficult of mysteries soon placed him on the level of the legendary Sherlock Holmes. In his observance of the smallest detail, he even surpassed his famous predecessor.

Impact of Event

The impact of Hercule Poirot on the field of mystery fiction was both immediate and extensive. Within two years, *The Mysterious Affair at Styles* was published in England and in the United States and was serialized in *The Weekly Times*, a leading English magazine of the day.

Agatha Christie was soon hard at work on her second novel, a spy thriller entitled *The Secret Adversary*. The new book, published in 1922, introduced two new heroes, Tommy and Tuppence Beresford. In the person of Tuppence can be seen Agatha Christie herself, especially her experiences during World War I. Following the book's publication, the demand for Agatha Christie's writings grew still further. She was soon writing a series of Poirot stories for *Sketch* magazine and was also working on her next full-length Poirot novel, *The Murder on the Links* (1923).

In her autobiography, Agatha Christie admitted that in her early work, she was writing in the tradition of Sherlock Holmes. Along with Hercule Poirot, she had also created Captain Hastings, Poirot's assistant and sometime narrator; Hastings' character had been clearly inspired by Watson, the narrator of the Sherlock Holmes stories. Realizing how close she was to Doyle's style, however, Christie made some major changes. One was to marry off Hastings in *The Murder on the Links*; Hastings appears only rarely in future Poirot novels until *Curtain: Hercule Poirot's Last Case* (1975), which is marked by the shocking death of Poirot himself.

One of the most popular of Christie's detective novels, and perhaps the most unique, is *The Murder of Roger Ackroyd* (1926). The story's twist, suggested to Agatha by Lord Louis Mountbatten, was that the narrator turned out to be the murderer. The book was written during the period when the author's first marriage was coming to an abrupt end; later, in *Unfinished Portrait* (1934), Christie gave a glimpse into the frustrations of that period of her life.

After Christie's second marriage, to a noted archaeologist, her novels began to include more stories of spying and international intrigue. These books include *Murder in Mesopotamia* (1936) and *Death on the Nile* (1937).

In 1930, Agatha Christie introduced another mystery-solving hero, a quaint and shrewd older woman named Miss Jane Marple. Every bit as clever as Hercule Poirot, but not nearly as self-confident, Miss Marple solves many crimes, such as *The Murder at the Vicarage* (1930).

Still in the early part of her writing career, Christie began to see her stories made

into plays and films. In 1928, *The Murder of Roger Ackroyd* was adapted as a play called *Alibi.* Although it was a success in London, Agatha was not pleased with the portrayal of Hercule Poirot. About the same time, one of her short stories, "The Coming of Mr. Quin," served as the basis for a film, which Christie also found unsatisfactory. She was more pleased with a German film based on *The Secret Adversary.*

In 1929, as the result of her general displeasure over the way in which her books were being adapted as plays and films, Christie began writing her first original play. *Black Coffee*, involving murder and a formula for deadly weapons, was a success in the summer of 1930. About 1945, Christie wrote a short story entitled "Three Blind Mice," which was expanded in 1952 as her best-known play, *The Mousetrap.*

During the course of her career, Christie published many short stories; in some, she used an investigator she created named Parker Pyne. Among the most interesting of her writings is *The Labours of Hercules: Short Stories* (1947), a collection of short stories featuring Hercule Poirot. The stories are based on the twelve labors of Hercules of ancient Greek mythology.

Hercule Poirot appeared in Agatha Christie novels over a period of fifty-five years. The end of Poirot reached the public only about a year before the death of his creator. Agatha Christie wrote *Curtain* several years earlier, but its publication was delayed by her daughter, Rosalind, until 1975. In *Curtain*, Poirot and Hastings return to Styles to solve another crime; Poirot then meets his death in an extremely sensational manner. In January, 1976, Agatha Christie joined her master detective in death.

An English acquaintance of Christie, Dorothy Sayers, also became a well-known writer of detective fiction. In 1930 and in 1931, Christie, Sayers and four other detective-story writers combined their talents in two unusual series for the British Broadcasting Company. The authors would write and read over the radio alternating episodes of the same story. The 1931 series, with twelve episodes, was coordinated by Sayers. Christie and Sayers continued their professional relationship for many years.

In her own detective novels, Sayers created Lord Peter Wimsey. Sayers' best-known novel *Murder Must Advertise* (1933), is set in an advertising agency where the author herself had worked as a copywriter. In style and in success, Sayers was Christie's closest rival in England.

Georges Simenon was a Belgian-French contemporary of Christie. Obviously influenced by the success of the English writers of detective fiction, Simenon created Inspector Maigret, a French detective who was designed to be more of a counterpart to Sherlock Holmes than to Hercule Poirot. Simenon wrote almost one hundred Maigret stories before his death in 1989.

Erle Stanley Gardner, an American contemporary of Christie, created Perry Mason, a defense attorney who introduced a new aspect to detective fiction. Perry Mason specialized in accepting clients who were seemingly guilty and then, at their trials, presenting sensational revelations of the real criminals.

In the course of her extraordinary writing career, Agatha Christie wrote sixty

novels, nineteen volumes of short stories, sixteen plays, and an autobiography. More translations have been made of her work than of that of any other English writer except William Shakespeare. By 1980, more than 400,000,000 copies of Agatha Christie books had been sold worldwide.

Bibliography

Christie, Agatha. *An Autobiography.* New York: Dodd, Mead, 1977. A personal look into the mind, private life, and work of the author. Gives a good survey of her books and explains how she received the ideas for them. Written over a fifteen-year period, the book ends eleven years before the death of the author. Edited by Christie's daughter and published after Christie's death. Includes a good pictorial section. Excellent reading for any fan.

Morgan, Janet. *Agatha Christie.* New York: Alfred A. Knopf, 1985. The only authorized biography of Christie. The author was given access to all the subject's papers and personal effects and was introduced to almost two hundred of Christie's friends. Morgan presents a strong personal touch, including one chapter devoted to the mysterious ten-day disappearance of Agatha after the breakup of her marriage to Archie Christie. A valuable resource.

Pearsall, Ronald. *Conan Doyle: A Biographical Solution.* New York: St. Martin's Press, 1977. An interesting account of the creator of Sherlock Holmes. The author discusses other interests of Doyle's such as spiritualism, the Boer War, and social reform and reveals how these interests influenced his writing. Contains a good pictorial section of Doyle and his family. One chapter is devoted to the rivals of Sherlock Holmes.

Rinehart, Mary Roberts. *The After House.* New York: Holt, Rinehart and Winston, 1914. An exciting example of the mystery fiction of Rinehart. Illustrates the ability of the author to weave an interesting plot through a diverse grouping of characters and reach a suspenseful climax. Also shows the role of emotion and passion in a criminal situation. Would appeal to most readers of mystery fiction.

Sayers, Dorothy L. *Murder Must Advertise.* New York: Harper & Row, 1933. An excellent detective novel by an author who worked closely with Christie on at least two occasions. In this book, Sayers introduced her own detective, Lord Peter Wimsey.

Simenon, Georges. *Maigret and the Man on the Bench.* Translated by Eileen Ellenbogen. New York: Harcourt Brace Jovanovich, 1975. Illustrates the amazing abilities of the French detective Inspector Maigret, who was created by Simenon. Has a good plot and would serve to introduce American readers of mystery fiction to the writing of Simenon.

Glenn L. Swygart

Cross-References

The Maltese Falcon Introduces the Hard-Boiled Detective Novel (1929), p. 793;

Hitchcock Becomes England's Foremost Director (1934), p. 946; The Sherlock Holmes Film Series Begins (1939), p. 1131; *The Maltese Falcon* Establishes a New Style for Crime Films (1941), p. 1223; *Dragnet* Is the First Widely Popular Police Show (1951), p. 1531; *The Mousetrap* Begins a Record-Breaking Run (1952), p. 1551.

MELVILLE IS REDISCOVERED AS
A MAJOR AMERICAN NOVELIST

Category of event: Literature
Time: 1920-1924
Locale: The United States and Great Britain

Critical, editorial, and biographical initiatives early in the twentieth century re-vived interest in the writings of Herman Melville and led to recognition of Melville as a major literary artist

Principal personages:

HERMAN MELVILLE (1819-1891), an American poet and writer of fiction finally acknowledged adequately decades after his death

D. H. LAWRENCE (1885-1930), the greatest of the English writers who participated in the Melville revival

FRANK JEWETT MATHER, JR. (1868-1953), an American art critic who championed Melville from the time of his centennial in 1919

ELEANOR MELVILLE METCALF (1882-1964), a granddaughter of Melville who facilitated the first biography of the writer

CARL VAN DOREN (1885-1950), an American critic who served as a pre-cursor of the Melville revival

RAYMOND M. WEAVER (1888-1948), the first biographer of Melville and first editor of his last prose work

Summary of Event

To appreciate the Melville revival, it is necessary to know something of the writ-er's earlier reputation. Herman Melville burst on the literary scene in his twenties with *Typee: A Peep at Polynesian Life* (1846) and *Omoo: A Narrative of Adventures in the South Seas* (1847), novels based on his experiences in the Marquesas Islands after he had deserted the whaling ship of which he had been a crew member. Taking greedily to these exotic romances, the public quickly made Melville famous.

Not content merely to capitalize further on this material, Melville penned a suc-cession of more serious books that disenchanted his readers. The strangeness of *Moby Dick: Or, The Whale* (1851) especially alienated the public, and a few years later, Melville gave up fiction for poetry. Gradually, Melville fell into literary obscu-rity. To support his family, he obtained a job in his mid-forties as a customs inspec-tor in New York. He died in 1891, and for several decades thereafter, literary histo-rians ignored him or mentioned him only briefly as the author of *Typee* and *Omoo*, often to compare him unfavorably with Robert Louis Stevenson—a writer who, ironically enough, owed his interest in the South Seas to his reading of Melville.

One of the few enthusiastic Melvillians, Carl Van Doren, contributed an essay on Melville to the new *Cambridge History of American Literature* (1917), and at Van

Doren's suggestion, a young Columbia University professor named Raymond M. Weaver joined in an effort to promote the Melville centennial in 1919. Discovering that no full-length biography of Melville existed, Weaver went to Eleanor Melville Metcalf, the writer's granddaughter, who supplied him with both recollections and previously unpublished manuscripts. Meanwhile, Frank Jewett Mather, Jr., published the best essay on Melville yet in the August, 1919, edition of a periodical simply called *Review.*

Weaver discovered a nearly finished short novel on which Melville had been working in his retirement. Set in the time of the Napoleonic Wars, it focused on a young merchant seaman impressed on a British warship who incurred the enmity of the ship's master-at-arms. The malicious officer accuses the innocent and uncomprehending Billy Budd of planning a mutiny; Billy, a stutterer, cannot defend himself verbally and instead strikes his accuser dead before the captain's eyes. Though a favorite with the captain and all his shipmates, the young man is tried, convicted, and hanged.

The appearance of Weaver's biography, *Herman Melville: Mariner and Mystic*, in 1921 generated new interest in Melville's work. The widely read American critic Van Wyck Brooks observed that Melville's name was suddenly "in everyone's mouth," although he conceded that soon Melville might be forgotten again. Still, Brooks pointed out, the publicity would undoubtedly bring Melville to the attention of at least a few readers who would permanently value his books.

Meanwhile, other champions of Melville were arising. Melville's reputation benefited particularly from the efforts of admirers abroad; Augustine Birrell, H. M. Tomlinson, and Viola Meynell were among the English writers heard from early in the Melville revival. The most influential of Melville's English critics, however, was famed novelist D. H. Lawrence, who in 1923 published a quirky but brilliant book called *Studies in Classic American Literature.* Despite its stodgy title, the book dealt wittily and perceptively with such already highly regarded American writers as Benjamin Franklin, Nathaniel Hawthorne, and Edgar Allan Poe—and devoted two chapters to Melville. Lawrence engaged in a certain amount of ridicule of all these American writers, including Melville, but he called *Moby Dick* "a surpassingly beautiful book."

Indeed, the Melville revival primarily rescued from oblivion Melville's tale of Captain Ahab's chase of the white whale, while the two early novels continued to attract much more notice than any of Melville's other later poetry and fiction. Critics began to praise the suspense in *Moby Dick*, the author's use of dramatic dialogue, and even the shifts in point of view that earlier critics had disparaged. Weaver's subtitle for his biography, *Mariner and Mystic*, clearly influenced commentators on the novel. No one had doubted Melville's qualifications as a mariner, but now *Moby Dick* was viewed (not always approvingly) as "a struggle between realism and mysticism." Readers continued to be exasperated by the novel, but they began to consider the possibility that the difficulties of Melville's style justified and even rewarded sustained attention. Questions such as "What does the great white whale repre-

sent?" and "Who or what is Captain Ahab?" were increasingly addressed.

Between 1922 and 1924, the publication of a sixteen-volume edition of Melville's complete works began to lead readers to consider not only the novels between *Omoo* and *Moby Dick* but also his later published fiction, including the long-neglected *Pierre: Or, The Ambiguities* (1852), *The Piazza Tales* (1856), and *The Confidence Man: His Masquerade* (1857), as well as his poetry. Especially important was the thirteenth volume of this edition, edited by Raymond Weaver, which included the previously unpublished short novel that Weaver decided to entitle *Billy Budd, Foretopman*. The manuscript presented editorial problems that Weaver did not handle expertly, but the fact of an important novel from Melville, written thirty years after he had supposedly given up fiction, at the time far outweighed the problems resulting from Weaver's shortcomings as an editor. Despite its cumbersome style, *Billy Budd* is an intriguing story of guilt and innocence, while in Captain Vere, who chooses to try Billy for murder and thereafter decides to execute him on the spot, Melville paints a classic struggle between professional duty and conscience. In the early years of the revival, this late work claimed little critical attention, but its existence made clear that Melville's fiction after that great classic could not be dismissed as airily as it had been for decades.

Impact of Event

In his essay "Tradition and the Individual Talent" (1919), T. S. Eliot argues that a new work of art not only adds to the existing tradition but also provokes a readjustment of the whole order of the works making up that tradition. Although Eliot could not at that point have been thinking of Melville, the idea certainly applies to him. In the 1920's, Melville's work was not precisely new, just newly acknowledged—though *Billy Budd*, of course, was just as new to its readers as any recent composition. That its recognition profoundly altered not only estimates of Melville the artist but also the canon of American literature cannot seriously be disputed.

Even geographically, the growing acknowledgment of Melville's greatness is significant. As late as the 1920's, the notion persisted that the history of American literature amounted chiefly to an account of New England writers, not only the still-revered Ralph Waldo Emerson, Nathaniel Hawthorne, and Henry David Thoreau, but also a host of others no longer seen as of the first rank: Henry Wadsworth Longfellow, Oliver Wendell Holmes, John Greenleaf Whittier, James Russell Lowell, and others less well-known. Of course, New Yorkers such as Washington Irving and James Fenimore Cooper had their place, but it was outside the perceived mainstream. Even a Missourian like Mark Twain settled in Hartford and could, after a fashion, be accounted the latest of the "Connecticut wits." The very fact of Twain's removal to New England suggests the potency of the region's aura.

The recognition of Melville and of his exact contemporary Walt Whitman made it impossible to see New England as the almost exclusive domain of nineteenth century American literature. These men were not only New York-born but were cosmopolitan in ways beyond the scope of the New England literary establishment. Whitman

celebrated the length and breadth of the land, and Melville had gone to, and sent his characters to, remote places around the globe. Even when Melville chose an American setting, as in his increasingly popular story "Bartleby the Scrivener," he hit upon a locale, in this case Wall Street in New York City, far from the ken of the New Englanders. Furthermore, he presents Bartleby as a victim of the new commercial and legal world; even Bartleby's well-intentioned employer contributes to the impersonal and dislocating forces that swamp the forlorn copier of legal documents.

Melville had furnished readers with his fresh vision back in the 1850's, but only seventy years later did it begin to expand the imaginative horizons of more than a handful of admirers. In the 1920's and 1930's, the new emphasis on the whole range of Melville works—including his long-neglected poetry—was an important constituent in revealing the longstanding provincialism in American literary criticism. Lewis Mumford's 1929 *Herman Melville*, for example, devoted eighteen pages to Melville's long narrative poem *Clarel: A Poem and Pilgrimage to the Holy Land* (1876).

Willard Thorp, a Princeton University professor, is given major credit for promoting the academic study of Melville. The introduction to his *Herman Melville: Representative Selections* (1938) made it impossible for responsible critics and literary historians to neglect either Melville or the body of his writings. In the next decade, Melville became a fixture in college surveys of American literature and increasingly the focus of specialized courses. Not only *Moby Dick* but also all three of the works in Melville's *The Piazza Tales*—"Bartleby the Scrivener," *The Encantadas*, and *Benito Cereno*—as well as *Billy Budd, Sailor* (the title adopted in the corrected edition of Harrison Hayford and Merton M. Sealts, Jr., in 1962) became staples of American literature courses, while *Pierre* often joined *Moby Dick* in courses focusing on longer American novels.

The title of the fourth book in Van Wyck Brooks's American literary history—*The Times of Melville and Whitman* (1947)—signifies the extent of Melville's eminence a quarter of a century after the revival began. The following year, the new *Literary History of the United States* (1948), of which Thorp was an editor, included Melville among the handful of writers allotted long individual chapters. Melville's *Battle-Pieces and Aspects of the War* (1866) came to be acknowledged as among America's finest war poems.

Another measure of the upswing in Melville's reputation is the quantity of scholarly writing devoted to him. From the late 1920's to the late 1980's, the number of annual books and articles on Melville had swelled from an average of five to approximately one hundred. The listing of editions of Melville's work occupied three columns in the 1990-1991 edition of *Books in Print*, including seven editions of *The Confidence-Man*, a book almost unread before the Melville revival. In few bookstores today will browsers fail to see a selection of Melville titles, including, interestingly, *Typee* and *Omoo*, now considered very minor Melville.

Bibliography

Brooks, Van Wyck. *The Times of Melville and Whitman.* New York: E. P. Dutton,

1947. Brooks is unusual among literary historians for his keen sense of place (his chapter "Melville in the Berkshires" is just one example), his engaging narrative style, and his infectious enthusiasm for literary culture. Although Melville by no means dominates this substantial volume, Brooks considers that in him and Whitman, America "had found its voices."

Howard, Leon. *Herman Melville: A Biography.* Berkeley: University of California Press, 1951. Several decades after publication, this book remains the best all-around life of Melville. Excellent insights not only into his life and thought but also into the reasons for America's failure to appreciate properly one of its greatest authors until well into the century following his death.

Matthiessen, F. O. *The American Renaissance: Art and Expression in the Age of Emerson and Whitman.* New York: Oxford University Press, 1941. One of the earliest studies to view Melville in relation to the sudden outpouring of great American literature in the mid-nineteenth century. Matthiessen concentrates on five writers, relates Melville closely to his friend Nathaniel Hawthorne, and breaks new ground in investigating the Shakespearean influence on Melville.

Parker, Hershel. *Reading Billy Budd.* Evanston, Ill.: Northwestern University Press, 1990. A close reading of the greatest discovery of the Melville revival. Parker examines a continuing liability of Raymond Weaver's pioneering efforts; despite the availability of the subsequent, and superior, Hayford-Sealts edition of *Billy Budd*, the refusal by many critics to take full advantage of it has had the effect of perpetuating the errors of this leader in the revival.

_____, ed. *The Recognition of Herman Melville.* Ann Arbor: University of Michigan Press, 1967. A generous selection of Melville criticism often otherwise accessible only with difficulty. Divided into four chronological sections, of which the third, "The Melville Revival: 1917-32," and the fourth, "Academic Recognition: 1938-1967," constitute a particularly illuminating account of Melville's remarkable resurgence. Parker's preface aptly summarizes the movement.

Parker, Hershel, and Harrison Hayford, eds. *Moby Dick as Doubloon: Essays and Extracts, 1851-1970.* New York: W. W. Norton, 1970. A venture similar to Parker's 1967 volume concentrating on Melville's most famous novel. The literally scores of authors represented furnish an unusually thorough summation of the ups and downs of critical reaction to Melville up to and after the revival. As valuable for understanding the inevitable shifts in critical perspective as for understanding Melville.

Weaver, Raymond M. *Herman Melville, Mariner and Mystic.* New York: George H. Doran, 1921. Though out of date and misleading in its tendency to use details from Melville's fiction as part of the biographical record, Weaver's book retains a place of honor as probably the single publication most responsible for the Melville revival.

Robert P. Ellis

Cross-References

Eliot Publishes *The Waste Land* (1922), p. 539; Joyce's *Ulysses* Epitomizes Modernism in Fiction (1922), p. 555; *The Sound and the Fury* Launches Faulkner's Career (1929), p. 805; Dickinson's Poems Are Published in Full for the First Time (1955), p. 1662.

BOULANGER TAKES COPLAND AS A STUDENT

Category of event: Music
Time: 1921
Locale: Fontainebleau, France

After winning a scholarship to a prestigious French music school, Aaron Copland reluctantly attended Nadia Boulanger's class on music theory, thus beginning a relationship that had profound consequences for the development of American music

Principal personages:

NADIA BOULANGER (1887-1979), an influential French composer, conductor, and teacher of music

AARON COPLAND (1900-1990), the first of Boulanger's American students and one of America's major composers

HERBERT ELWELL (1898-1974), a composer, critic, and teacher who studied with Boulanger between 1921 and 1924

WALTER PISTON (1894-1976), a composer and teacher who studied with Boulanger and whose 1941 book *Harmony* became an influential music textbook

SERGE KOUSSEVITZKY (SERGEY KUSEVITSKY, 1874-1951), the conductor of the Boston Symphony Orchestra and an ardent supporter of the compositions of Copland and Piston

VIRGIL THOMSON (1896-1989), a student of Boulanger who wrote highly unusual stage works in collaboration with Gertrude Stein

Summary of Event

Even by the age of eleven, Aaron Copland was composing short musical pieces. As a teenager, he tried to attend as many concerts as he could. He then turned to the study of musical theory, realizing that this was the only way to become a professional composer. Rubin Goldmark became Copland's teacher of theory between 1917 and the spring of 1921. Goldmark taught Copland the fine points of composition; Copland also studied piano under the tutelage of Leopold Wolfsohn and Victor Wittgenstein.

Copland read in the magazine *Musical America* of a plan by the French government to establish a summer school for American musicians in Fontainebleau, France. The plan intrigued Copland, who immediately sent in his application. He was readily accepted—becoming, in fact, the first student to be signed up for the unusual teaching experience.

During the four years that he studied with Goldmark, Copland worked hard and conscientiously, never getting more than a glimpse of Goldmark's other students. At Fontainebleau in the summer of 1921, his musical experience would be changed and enriched. Now he would be studying with other bright musical hopefuls.

One such friend was Djina Ostrowska, a harpist who was the only woman in the orchestra of the New York Philharmonic. Through continued urging and encouraging, Ostrowska persuaded Copland to attend one of Nadia Boulanger's classes. Copland, though, was of the opinion that he had already studied theory to an acceptable level; to attend another theory class, he thought, was unnecessary. Copland later recalled his pivotal discussion with Ostrowska:

> I said to her, "I've had three years of harmony. I'm not interested in harmony classes." But she repeatedly urged, "Just go and see the way she does it." So I allowed myself to be persuaded.

When Copland did succumb to Ostrowska's firm promptings, he was amazed to find a teacher who was able to show him new ways of looking at harmony. He later wrote, "I suspected that first day that I had found my composition teacher."

As a result of this meeting, Copland became the first American student to study with the renowned French teacher, paving the way for other Americans to cross the Atlantic and study at Fontainebleau. At the time Copland was introduced to Boulanger, she was already teaching harmony at the Paris Conservatoire. Music was Boulanger's life; as well as having a full complement of students, she taught organ and counterpoint at the École Normale de Musique. During the summer, she taught twice weekly at Fontainebleau. Even though Copland continued to participate in the musical experience at Fontainebleau, it was as a private student that he discovered the musical wealth represented by Boulanger.

There was no formal examination to be accepted as a student of Boulanger. At Copland's first meeting, he played a piece with a strong jazz idiom. Goldmark had considered it avant-garde, almost too modern for the time. Boulanger, though, liked the piece and invited Copland to return. Acceptance by a musician of such stature assured Copland's success as a composer. During the three years he studied with Boulanger, Copland's music matured and grew.

Nadia Boulanger lived what appeared to be a somewhat austere life. Boulanger's mother was of Russian aristocratic stock, and they lived contentedly in their Paris apartment. Each Wednesday afternoon, Boulanger and her mother entertained many musical greats. Copland was thus introduced to Boulanger's inner circle of friends, which included Igor Stravinsky, Darius Milhaud, Francis Poulenc, and Albert Roussel. Copland's musical mentor happened to be Stravinsky, and the opportunity to spend time with a composer of such stature influenced him greatly. The musical milieu that surrounded the Boulangers' apartment gave the young Copland all the confidence that any student could want.

While not the most obvious person to lead the way into twentieth century music, Boulanger was indeed in the vanguard of modern music. Copland recalled that he would often see Stravinsky's latest scores in her apartment; Boulanger also introduced Copland to the work of the innovative Viennese composer Gustav Mahler. In the summer of 1922, Copland and Boulanger studied *Das Lied von der Erde* (The

Song of the Earth), Mahler's latest composition.

Copland's early compositions were usually modest in breadth and depth. Although he wrote with a strong jazz idiom, Boulanger's method of teaching caused him to write much longer pieces. Whenever possible, Boulanger arranged to have her pupils' compositions played at local recitals. The celebrated American tenor Charles Hubbard, for example, sang two of Copland's songs, "Pastorale" and "Old Poem," with Boulanger at the piano. Such was Boulanger's enthusiasm for her students.

Over the years studying with Boulanger, Copland was encouraged to continue writing longer compositions. Soon he was writing two-page songs and three-page piano pieces. Copland responded to the encouragement and embarked on larger works that included the writing of full-length ballets that lasted as long as thirty minutes.

Boulanger's strictness (no student of hers ever arrived late for class more than once), tempered by her love for music, became her trademark. Recognizing that life as a student must end and earning a living as a composer must begin, Copland concluded his formal studies with Boulanger in 1924. Despite this break, Boulanger still remained a strong influence on Copland's musical life. She introduced Copland to Serge Koussevitzky, the renowned conductor of the Boston Symphony Orchestra; Koussevitzky, in turn, introduced many of Copland's works to the American public and thus was influential in ensuring his success as a composer.

Impact of Event

Copland was the first of many young American composers who studied with Nadia Boulanger; he was followed by, among others, Virgil Thomson, Melville Smith, Herbert Elwell, and Walter Piston. Although Copland was the first of these to study advanced composition, Thomson and Smith came to Paris shortly after Copland. These young American musicians were dedicated to studying composition with one of Europe's finest teachers.

What Boulanger managed to impart to her students was the richness of musical literature. Time and again her students, particularly Copland, would tap the vast knowledge that Boulanger drew from during her lessons. From the inauguration of the school for Americans in Fontainebleau, Boulanger embraced the potential of American music. During a conversation with Virgil Thomson, she mentioned that America was on the verge of producing some great music. While many of her European contemporaries shunned American music, Boulanger had the foresight to see it as an increasingly important part of the twentieth century music scene.

Because of the devotion Boulanger inspired in her illustrious students, her influence on major American composers is unquestioned. How that influence has manifested itself in the musical mainstream of America is less easy to determine. An answer to this may lie in what happened after Copland completed his formal training with Boulanger; Boulanger continued to give her opinion on the compositions shown to her as well as to introduce Copland to important musical figures.

Serge Koussevitzky was one such figure. Boulanger introduced Copland to Koussevitzky, and in their discussions, the conductor suggested that Copland write an

organ concerto. Koussevitzky was soon to take up the post of conductor of the Boston Symphony Orchestra, and the piece would feature Boulanger as soloist on the organ. What transpired was that the 1924 premiere of Copland's *Symphony for Organ and Orchestra* was performed by the New York Symphony Orchestra under the direction of Walter Damrosch. Copland was still a relatively unknown composer, but the concert brought him to the attention of the American music public, which was quick to acknowledge and appreciate the strong American idiom in his music.

Damrosch and Koussevitzky continued to premiere the music of Copland as well as that of other Boulanger students. This strong connection that had been formed between the Paris musical community and those of New York and Boston only enhanced the standing of American composers. Just as she had done in Paris, Boulanger continued to influence American music through her connections with influential composers and conductors.

Another important student of Boulanger was Walter Piston. While studying with Boulanger, Piston acquired a fine sense of counterpoint and was exposed to much new music. On returning to America, he accepted an academic position at Harvard University. When Edward Hill brought Piston to the attention of Koussevitzky, Piston's works, like Copland's before him, were premiered by the Boston Symphony Orchestra. During Piston's association with Koussevitzky, eleven of the composer's works were premiered. A considerable number of prizes and honors were given to Piston for his compositions.

While composing at Harvard, Piston was also writing. His *Harmony* (1941) soon became a standard text in music schools and was followed by *Counterpoint* (1947) and *Orchestration* (1955). His teaching, though similar to Boulanger's, was less pedagogic and aimed more at pointing out general principles of music. During his time at Harvard, Piston met some noted composers, among them Leonard Bernstein. Piston's mentor Koussevitzky also had Bernstein as a student, thus extending indirectly the influence that Boulanger had on the new American musical movement. Copland and Bernstein also became close friends.

Boulanger moved to America during World War II and taught at Wellesley College, Radcliffe College, and the Juilliard School of Music. Although her teaching methods remained much the same as when she taught at Fontainebleau and the École Normale de Musique, few of her students in the United States went on to become notable composers. Still, Boulanger continued to wield tremendous influence, and her effect on the development of many of America's most important composers assured her of a lasting legacy in American music.

Bibliography

Copland, Aaron, and Vivian Perlis. *Copland: 1900 Through 1942.* New York: St. Martin's Press, 1984. This is a firsthand account of Copland's early years, particularly his time in France. Perlis fills in the gaps in Copland's narrative; originally, Copland had granted Perlis interviews, which became the basis of a two-volume set on Copland.

_____. *Copland: Since 1943.* New York: St. Martin's Press, 1989. Completes the work that was begun in *Copland: 1900 Through 1942.* This extremely well-written volume concentrates on the influence Copland had on the musical world. Photographs, while not lavish, are well documented.

Kendall, Alan. *The Tender Tyrant, Nadia Boulanger: A Life Devoted to Music.* Wilton, Conn.: Lyceum Books, 1977. This book tries to portray Boulanger's life in more personal terms. Boulanger's many observations make the book useful in gaining an understanding of French music.

Monsaingeon, Bruno. *Mademoiselle: Conversations with Nadia Boulanger.* Translated by Robin Marsack. New York: Carcanet Press, 1985. Monsaingeon taped interviews with Boulanger over a five-year period, and she provides both her reflections on life and her philosophy of music. Unfortunately, Boulanger, who was never one to praise herself, speaks very little about her own motivations and aspirations.

Rosenstiel, Leonie. *Nadia Boulanger: A Life in Music.* New York: W. W. Norton, 1982. This is a comprehensive study of Boulanger's life. There is a discussion of Boulanger's relationship to her sister Lili, to whom she dedicated most of her teaching. Many interviews of former students were used as the basis for this somewhat dry yet informative biography.

Thomson, Virgil. *Virgil Thomson.* New York: Alfred A. Knopf, 1966. Thomson did not have such an intimate relationship with Boulanger as Copland did, a circumstance reflected in this book. What is most interesting is how differently Thomson and Copland viewed their musical experience in France. Many of Copland's friends were also Thomson's friends, and some of their shared experiences are given a completely different emphasis by Thomson than by Copland.

Richard G. Cormack

Cross-References

Mahler's Masterpiece *Das Lied von der Erde* Premieres Posthumously (1911), p. 298; Stravinsky Completes His Wind Octet (1923), p. 561; Hindemith Advances Ideas of Music for Use and for Amateurs (1930's), p. 816; Stravinsky's *The Rake's Progress* Premieres in Venice (1951), p. 1514; Bernstein Joins Symphonic and Jazz Elements in *West Side Story* (1957), p. 1731.

MAN RAY CREATES THE RAYOGRAPH

Categories of event: Art and motion pictures
Time: 1921
Locale: Paris, France

Man Ray created the Rayograph, a cameraless form of photography exploited by Ray and his followers in experimental photography and motion pictures

Principal personages:

MAN RAY (1890-1976), an American photographer and painter who gained fame in Paris during the 1920's for his experimental Rayographs and his photographic portraits of celebrities

JEAN COCTEAU (1889-1963), a renowned French poet, playwright, and filmmaker whose public support for Rayographs helped establish the photographer's international reputation

ROBERT DESNOS (1900-1945), a French poet and influential Parisian Surrealist who touted the Rayograph as belonging to the realm of poetry rather than to the visual arts

MARCEL DUCHAMP (1887-1968), Ray's lifelong friend and frequent collaborator, an iconoclastic French artist

FRANCIS PICABIA (1879-1953), a French painter who, with Ray and Duchamp, was a member of the New York and Paris Dadaist circles as well as the Parisian Surrealists of the 1920's

TRISTAN TZARA (SAMI ROSENSTOCK, 1896-1963), a Romanian poet and leader of the Paris Dadaists

Summary of Event

Man Ray was an American artist living in Paris during the heady 1920's, when the City of Light was the cultural capital of the world. A painter as well as a photographer, Ray, like many of his artistic colleagues, sought to push the aesthetic conventions of both media. In the process, as a result of an accident that occurred while he was developing photographs, Ray "discovered" the cameraless Rayograph in 1921.

As a painter, Ray's style evolved with and through cubism, Dadaism, and Surrealism. Although associated with these important movements, Ray is perhaps best described as an iconoclast whose basic pursuits were motivated by personal as well as artistic freedom. Like his peers, Ray was intrigued with new technological means of artistic expression, especially photography and its kinetic cousin, the motion picture.

Ray was born in Philadelphia in 1890 and at the age of fifteen was given the name Man Ray by his family, after it moved to New York City. As a teenager, he was an aspiring painter who took classes at New York's Academy of Fine Arts. In 1910, he became associated with New York photographer Alfred Stieglitz and Stieglitz's "291" gallery, where he absorbed the latest developments in both painting and photogra-

phy. His earliest photographs were expressive portraits in the Stieglitz manner. In 1915, Ray met French artist Marcel Duchamp, who became a decisive influence, a frequent collaborator, a close friend, and a worthy chess opponent (chess was the preferred game of the Dadaists). It was Duchamp who first encouraged Ray's interest in assemblages and collages and who urged the young American to move to Paris.

Prior to making his move, Ray—as well as Duchamp and French painter Francis Picabia—became involved with the New York Dadaist group. During its heyday from 1916 to 1922, the Dadaists—whether in Paris, Berlin, Zurich, or New York—attacked traditional artistic and societal norms, stressing the absurd nature of life and the role of the fortuitous in artistic creation. In part a reaction to the barbarisms perpetrated by the "civilized" nations of Western Europe during World War I, Dadaism also drew inspiration from the groundbreaking psychological ideas of Sigmund Freud and Carl Jung, especially those dealing with the unconscious and subconscious. Dadaism's whimsical faith in the role of chance in artistic creation was to prove pivotal in creating the mindset enabling Ray to "discover" the Rayograph.

In 1921, Ray moved to Paris, where he sought his fortune as a painter. Although encouraged in his painting by friends, Ray was forced by his inability to sell his paintings to rely on portrait and fashion photography to make a living. One night in late 1921, as Ray was making contact prints of fashion poses shot earlier in the day, an unexposed sheet of photographic paper accidentally was mixed into a group of already exposed prints in Ray's developing tray. As he waited in vain for an image to appear, regretting the waste of paper, Ray placed some laboratory equipment—a glass funnel, a glass graduate, and a glass thermometer—on top of the unexposed paper. When he turned on the light, an image began to form, "not quite a simple silhouette of the objects as in a straight photograph, but distorted and refracted by the glass more or less in contact with the paper and standing out against a black background, the part directly exposed to the light," Ray recalled in his 1963 autobiography, *Self Portrait.*

That fated, fortuitous photographic happening reminded Ray of his boyhood days in Philadelphia, when he had placed leaves in a printing frame with photographic paper and exposed them to the sun, thereby obtaining a white negative of the leaves. It illustrated the same principle that had been employed in the earliest photographic experiments of Thomas Wedgwood and Humphry Davy, who in 1799 also placed objects on sensitized materials, thus provoking the inventive-scientific quest that eventually resulted in practical photography.

Ray was ecstatic with his spontaneous invention. Grabbing whatever objects were handy—his hotel-room key, a handkerchief, pencils, a brush, a candle, and a strand of twine—the photographer churned out a batch of cameraless photographs that he immediately dubbed "Rayographs." Ray quickly discovered that he could place his randomly deployed objects directly onto dry photographic paper. The next day, when noted Dadaist poet Tristan Tzara spotted several of Ray's new creations, Tzara proclaimed them as "pure Dada creations" far superior to similar attempts—simple

flat textural prints in black and white—that had been made in 1918 by the German Christian Schad, an early Berlin Dadaist.

Impact of Event

The art world's fascination with Ray's cameraless photos had several major consequences. First, the Rayograph helped make Man Ray a celebrity. With Tzara's enthusiastic endorsement of Ray's work as an exemplar of Dadaist ideals, Ray's cameraless photos were soon embraced by all manner of Parisian painters, writers, and musicians. Ray was invited to fashionable parties, concerts, and gallery openings. He also was embraced by fashionable young women, including Kiki, Paris's most notorious model. No less a figure than poet Jean Cocteau commissioned a Rayograph for the frontispiece of a deluxe edition of his work. In the United States, *Vanity Fair* published a November, 1922, piece on Ray accompanied by four of his "meaningless masterpieces," thus launching the photographer onto the international scene.

Tzara once again waxed rhapsodic on the subject of the Rayograph in an introduction to the 1922 publication of *Les Champs Délicieux*, a portfolio of Ray's cameraless photographs. In 1923, the French poet Robert Desnos extolled the Rayograph's spontaneous beauty and suggested that it belonged to the realm of poetry, since it was neither completely abstract nor completely realistic. Even when the novelty of the Rayograph began to wane, Ray, by virtue of his newly elevated artistic and social status, was increasingly busy as a high-profile portrait and fashion photographer. His now more stable income and enhanced reputation enabled him to pursue his painting and other artistic activities with greater concentration and success. In the wake of the Rayograph's triumph, Ray's paintings and other *objets d'art* were accorded far greater regard and respect.

The discovery of the Rayographic principle, as mentioned, had first been made by Christian Schad in 1918, but Schad's cameraless photos, or Schadographs as they were dubbed by Tzara, faded into the footnotes of the decade's photographic annals. Given the Rayograph's greater depth, shading, and variety, Ray rightly deserves credit as one of the most significant photographic innovators of the 1920's. It is also important to emphasize that Ray had no knowledge of Schad's work; indeed, Ray's "discovery" was completely spontaneous and therefore his own.

With its notoriety and fashionable cachet, the Rayographic technique was picked up by others. Of these experimenters, the most significant were Lucia Moholy and László Moholy-Nagy. Using the term "photogram" to describe their investigations, which were carried out in the 1920's at the Bauhaus School in Germany, these cerebral explorers of light believed that a machine-based art such as photography should not involve personal feelings and traditional sentiments. Instead, they saw their photograms as formal light compositions. In contrast, Ray and his partisans regarded the Rayographs as Dadaist adventures relying on spontaneity, improvisation, and wit. Also significant was the fact of the Rayograph's unique singularity. Each cameraless photo was a one-of-a-kind creation for which no template, or negative, existed for precise duplication.

At a broader level, the notoriety of Ray's Rayographs triggered a host of other light-graphic experimentations. By the late 1920's, a debate about the intrinsic nature and functions of photography was raging. The basic issue pitted realism against abstraction. Ray offered an approach to abstraction based on the expression of chance effects and intuitive, even unconscious, states of mind and mood. Ray's cameraless images also were provocative in that they called into question traditional lines of demarcation between "fine" and "applied" art. With the collapse of the economies of the Western European and American democracies in the late 1920's and the subsequent rise of fascism in the 1930's, the debate over realism versus abstraction was largely deferred as artists, including photographers, turned to documenting the period's social and political upheavals.

In the 1920's, Ray also became a force in the quixotic evolution of the avant-garde or experimental film. His first filmic foray, *Le Retour à la raison* (1923, return to reason), incorporated an animated version of the Rayograph, in which Ray placed various objects directly onto 35 millimeter film and then exposed them to light. Again, no camera was employed. Using the Rayographic technique to register such common objects as sprinklings of salt and pepper, pins, tacks, and springs, Ray intercut these with camera-shot images of some of his Dadaist mobiles and shots of nude torsos. The rather randomly selected images were hastily assembled at the behest of Tzara, who wanted to include a cinematic experiment for what has now become known as the last Dadaist soiree. Ray described the effect: "It looked like a snowstorm, with the flakes flying in all directions instead of falling, then suddenly becoming a field of daisies as if the snow had crystallized into flowers. This was followed by another sequence of huge white pins crisscrossing and revolving in an epileptic dance, then again by a lone thumbtack making desperate efforts to leave the screen." Although the film was only three minutes long, Ray's Dadaist thwarting of conventional cinematic expectations associated with the making of films led to cries of protest and then of support, and finally to an intense debate. The Dadaists were delighted that Ray's film had been provocative. The soiree was an evening that has lived on in the chronicles of modern art.

Ray used the same Rayographic process for passages of *Emak Bakia* (1927), an experimental film influenced more by Surrealistic principles than those of the recently deposed Dada movement. More significant, Ray's films—including collaborations with Marcel Duchamp, of which only *Anemic Cinema* (1925) survives—constituted an important aspect of the 1920's continental avant-garde that offered a clear, indeed radical, alternative to the dominance of the Hollywood story film and to the documentary. By stressing abstract, nonrepresentational imagery and the role of the subconscious and unconscious in accord with the shifting precepts of Dadaism and Surrealism, Ray's films remain central and influential texts in the canon of the avant-garde or experimental cinema. They also demonstrated the clear and continuing relationships between photography and the motion picture.

The Rayograph, which is variously referred to as Rayogram, Schadograph, and photogram, remains a touchstone in the evolution of photography as a graphic art

form in which the basic concerns are aesthetic rather than representational. It also stands as a reminder of cameraless photography's most prominent and influential exponent, Man Ray. Ray, "the poet of the darkroom" as he was called by Jean Cocteau, received the Gold Medal at the Photography Biennale in Venice in 1961 and the German Photographic Society Cultural Award in 1966.

Bibliography

Berg, Charles. "Film and Photography." In *Film and the Arts in Symbiosis: A Resource Guide*, edited by Gary R. Edgerton. New York: Greenwood Press, 1988. A concise overview of the intertwined relationships between photography and the motion picture. Includes discussion of Ray's film *Return to Reason*. Bibliography.

Moholy-Nagy, László. *Painting, Photography, Film.* Translated by Janet Seligman. Cambridge, Mass.: MIT Press, 1969. Includes Moholy-Nagy's incisive account of "Photography Without Camera: The 'Photogram.'" Moholy-Nagy, in addition to being an artist, was a meticulous and visionary theorist whose ideas are as valuable today as they were in 1927. Copious illustrations include several cameraless Rayographs by Ray and photograms by Moholy-Nagy.

Penrose, Roland. *Man Ray.* Boston: New York Graphic Society, 1975. A thorough and balanced overview of Ray's varied accomplishments, reflecting insights based on Penrose's longstanding friendship with the artist. An essential and highly readable source. The comprehensive illustrations include reproductions of Rayographs as well as frames from the film *Emak Bakia*.

Phillips, Christopher, ed. *Photography in the Modern Era: European Documents and Critical Writings, 1913-1940.* New York: Metropolitan Museum of Art/Aperture, 1989. An essential collection of previously out-of-print or untranslated essays and prolegomena, including poetic paeans to Ray's Rayographs by Jean Cocteau and Tristan Tzara.

Ray, Man. *Self Portrait.* Boston: Little, Brown, 1963. A well-drawn chronicle of Ray's amazing life, focusing on his escapades in the avant-garde circles of Paris, New York, and Hollywood with the rich and famous as well as the talented and beautiful, including such eminent Ray compatriots as Marcel Duchamp, Pablo Picasso, and Alfred Stieglitz. Ray's vivid recollections are invaluable. Illustrated.

Rosenblum, Naomi. *A World History of Photography.* New York: Abbeville Press, 1984. Authoritative and lavishly illustrated history of photography, including discussions and examples of the cameraless photography of Man Ray, Christian Schad, Lucia Moholy, and László Moholy-Nagy. Bibliography.

Charles Merrell Berg

Cross-References

Stieglitz Organizes the Photo-Secession (1902), p. 63; Duchamp's "Readymades" Challenge Concepts of Art (1913), p. 349; The Dada Movement Emerges at the Cabaret Voltaire (1916), p. 419; Surrealism Is Born (1924), p. 604; Buñuel and Dalí Champion Surrealism in *Un Chien andalou* (1928), p. 750.

WITTGENSTEIN EMERGES AS
AN IMPORTANT PHILOSOPHER

Category of event: Literature
Time: 1921
Locale: London, England, and New York, New York

Tractatus Logico-Philosophicus *introduced the work of one of the century's most influential philosophers*

Principal personages:

LUDWIG WITTGENSTEIN (1889-1951), a twentieth century philosopher whose theories have inspired thinkers in many disciplines

OTTO WEININGER (1880-1903), the author of two books that shaped Wittgenstein's personal and philosophical perspectives

BERTRAND RUSSELL (1872-1970), a Nobel Prize-winning mathematician and philosopher who was Wittgenstein's teacher, mentor, and friend

FRANK PLUMPTON RAMSEY (1903-1930), a beloved friend whom Wittgenstein credited with the debates that helped to shape *Philosophical Investigations*

GOTTLOB FREGE (1848-1925), a philosopher and mathematician who postulated that words consist of symbolic functions and who often played "devil's advocate" to Wittgenstein

Summary of Event

Published in German in 1921 and translated into English in 1922, *Tractatus Logico-Philosophicus* remains a model of Ludwig Wittgenstein's spare, elegant prose. Consisting of seven postulates and their logical derivatives, *Tractatus Logico-Philosophicus* represents Wittgenstein's attempt to create a logical language, and thus a framework, for philosophical investigations.

Biographers agree that Wittgenstein's interest in philosophy began at around age eight or nine when he wondered if one was obliged to be honest at all times. His conclusion that situational honesty has advantages seems at odds with the unrelenting honesty that he customarily displayed when he matured. As a child, Ludwig Wittgenstein found it necessary to placate the adults in his life. His father, Karl, devoted himself to his extensive business interests. Leopoldene, his mother, devoted herself to her husband and to music, in that order. Although the youngest of eight children, Ludwig Wittgenstein found himself virtually an only child as a result of the fifteen-year gap between him and his next-eldest sibling, Hermine. While most biographers believe that the Wittgenstein children consisted of two separate generations, some theorists have argued that there were in effect three generations, by reason of the fifteen-year gap between Ludwig and Hermine. Apparently none of their children met Karl and Leopoldine's exacting standards; in any case, Ludwig's elder

brothers' suicides testify to a collectively unhappy childhood.

Introduced to Otto Weininger's books while still in his teens, Wittgenstein found himself drawn to Weininger's nihilistic philosophy. Weininger castigated women, denounced sexual love, disparaged Jews, and exalted suicide. Wittgenstein incorporated Weininger's harsh convictions into his life and, to some extent, his work, as exemplified by his unending search for purity and his personal definition of honesty and perfection.

Tractatus Logico-Philosophicus occupied Wittgenstein until 1918; he finished it while detained as a prisoner of war in Italy. In it, Wittgenstein argued that the world consists of facts and that language pictures, or models, these facts. Thus, he believed, language limits thought; as far as possible, therefore, language should be limited to elementary propositions. By "elementary proposition," Wittgenstein meant a concentration, a nexus, of names. An object can be named, but that name does not constitute the object. Internal properties, such as motion or location, of an object were designated as part of, or as belonging to, that object. One should be able to recognize the truthfulness of a proposition from its symbol—that part of the proposition that characterizes its sense—alone. Misunderstandings occur when two people use the same symbol differently.

In his preface to *Tractatus Logico-Philosophicus*, Wittgenstein stated that he had solved the problem of philosophical language. Wittgenstein's commitment to philosophy ruled his life, however, and his definition of honesty compelled him to rework some of this publication. *Philosophische Untersuchungen (Philosophical Investigations)*, published in 1953 after his death, includes these variations. Publication of *Philosophical Investigations* distinguished Wittgenstein as the author of not one but two major, but differing, philosophies.

During the years from 1929 to 1951 he taught at the University of Cambridge; during those years—and, indeed, for almost all of his lifetime—Wittgenstein kept notebooks of his philosophical musings. He liked to work his way through one philosophical problem and then move on to another one. He did not publish very much during his lifetime, but a number of his works drawn from his notes and lectures were published posthumously, as, of course, was *Philosophical Investigations.*

In *Philosophical Investigations*, Wittgenstein maintained his *Tractatus Logico-Philosophicus* format inasmuch as he numbered the paragraphs, but he expanded, expounded, and, at times, disagreed with his original ideas. In the newer volume, he portrayed language as a game. He defined a language "game" as a small portion of an entire language consisting of words and the actions they joined.

The language Wittgenstein proposed in *Tractatus Logico-Philosophicus*, consisting only of propositions, had severe limitations. He did not give examples of elementary propositions. His critics maintained that he did not because he could not; elementary propositions do not exist.

In *Philosophical Investigations*, he enlarged his ideas about names. For example, he asserted that language disguises thought but that a word has no meaning if it has nothing to correspond to it.

He did not change his ideas about the source of misunderstandings and the need for an agreement about definitions. In *Philosophical Investigations*, he proposed examining personal beliefs, asking, for example, how one knows and learns the meaning of a word. Wittgenstein now stressed the importance of personally understanding the underlying assumptions of the words one speaks.

Wittgenstein virtually abandoned the notion of an ideal philosophical language. Context assumed major proportions in his mature theory; objects related to and depended on their language game. For example, the meaning of the word "pain" depends both on personal conditioning history and the idiosyncratic meaning of the word "pain" in its context.

Wittgenstein discarded his central idea in *Tractatus Logico-Philosophicus* that sentences picture reality. Instead, in *Philosophical Investigations*, Wittgenstein asserted that idiosyncratic meanings and context dictate the meaning of a sentence. "Projecting," or attributing another's meaning to a sentence, constitutes, in Wittgenstein's philosophy, diseased thinking.

Described as detached and solitary by some, Wittgenstein nevertheless entered into several committed relationships, primarily with David Pinsent, Frank Ramsey, and Rush Rhees. That he expected others to use his ideas and to go beyond them summed up his general attitude.

Impact of Event

Credited with divorcing words from that which they represent, Wittgenstein inspired a number of thinkers in the twentieth century. Some of these philosophers, although building on his theory, either elaborated on it or used it as a springboard for their own ideas and thus might be said to have competed with him. Others devised theories that directly conflicted with his.

During his lifetime, Wittgenstein addressed the "Vienna Circle" that gave birth to the movement known as Logical Positivism, but he did not consider himself a member of it. This informal group met to discuss the philosophy of science; its members included Karl Menger, Kurt Godel, and Rudolf Carnap.

Influenced by *Tractatus Logico-Philosophicus*, the Logical Positivists credited Wittgenstein with an important aspect of their philosophy, the verifiability principle. They also credited him with substantiating logic and mathematics. The Logical Positivists believed that Wittgenstein defined a proposition as the sum of experiences that proved a proposition. In doing so, though, they neglected Wittgenstein's distinctions between tautologies and identities; the two definitions differed widely. Wittgenstein believed he had created a rule of thumb, not the universal application adopted by the Logical Positivists. Wittgenstein and the Logical Positivists also had significant differences about the limitations of language. For Wittgenstein, language could not encompass, or make, metaphysical assertions. In Wittgenstein's opinion, thoughts about mystical subjects occur only to those who view the world as a limited whole. Viewing the world as limitless fosters an expanded view of the range of possibilities. Obviously, Wittgenstein did not consider himself part of the Vienna Circle.

In 1933, Alfred Korzybski published *Science And Sanity: An Introduction to Non-Aristotelian Systems and General Semantics.* Korzybski drew on Wittgenstein's *Tractatus Logico-Philosophicus* to develop a system of language evaluation that he named "general semantics." While Korzybski used Wittgenstein's notions about words and objects, Korzybski departed from Wittgenstein's thinking when he abandoned Aristotelian logic; nevertheless, general semantics, which has influenced a number of twentieth century thinkers, owes Wittgenstein's work a significant debt.

Philosophers concerned with the acquisition of knowledge tend to divide along either Cartesian or Wittgensteinian lines. The basic differences between the two groups can best be summed up by defining Cartesian argumentation as the notion that beliefs reflect natural facts and Wittgensteinian reasoning as the conviction that a belief may reflect only social convention. Wittgenstein's contribution redirected philosophical attention from certainty to ambiguity. Incorporating ambiguity into philosophy and research tends to maximize answers and can often lead to more and other stimulating questions.

Some of the interesting questions stimulated by Wittgenstein's philosophy merge epistemology with neuroscience. Some researchers study human cognition by seeking to establish and understand the way the brain works. Others try to establish the theory that if a specific neuron structure does not exist, then a specific thought cannot exist. These discussions have generated noteworthy research into memory.

Wittgenstein maintained a lively interest in psychology, and at least two therapeutic approaches have developed from his work. The "social constructionists" influenced by Wittgenstein have revised family therapy by using a storytelling approach. They contend that each member of a troubled family has a disparate "story" about the family's problems. Such therapists think of themselves as storytelling experts who can listen to and merge the "stories" into a single version that everyone in the family can agree on as acceptable and workable. "Rational-emotive" therapists base their therapy more on general semantics than on Wittgenstein's ideas per se. Such therapists actively direct their clients to examine all sides of a question or problem and then to ask Wittgensteinian questions such as "How do I know?," "How can I prove it?" and "What other approaches can I find?" In addition, Wittgenstein's emphasis on the contextual has influenced many psychologists to take a more holistic approach to their discipline and has helped many physicians to learn how to listen to their patients.

When dying, Wittgenstein reportedly said, "Tell them I've had a wonderful life." He devoted himself to something he loved. Moreover, he wielded enormous influence in the disciplines that come under the rubric of philosophy, and the psychotherapy theories influenced by his work have helped untold numbers of people reconcile their problems.

Bibliography

Hartnack, Justus. *Wittgenstein and Modern Philosophy.* 2d ed. Notre Dame, Ind.: University of Notre Dame Press, 1985. Discusses and compares Wittgenstein's

early and mature philosophies. Hartnack devotes a chapter to Wittgenstein's influence on, as well as his differences with, the Logical Positivists. Another chapter outlines the work of some contemporary philosophers that Hartnack views as Wittgenstein's successors.

Korzybski, Alfred. *Science and Sanity.* 4th ed. Lakeville, Conn.: Institute of General Semantics, 1958. Introduces a system of evaluating words that, although built on *Tractatus Logico-Philosophicus*, expands it. General semantics retains Wittgenstein's basic premises about words and what they represent. It also includes Wittgenstein's mature theory of language games.

Monk, Ray. *Ludwig Wittgenstein: The Duty of Genius.* New York: Free Press, 1990. A comprehensive biography of Ludwig Wittgenstein, written by a philosopher and put into a historical perspective. Access to previously unpublished letters and writings gives this book a depth that others lack. Discusses Wittgenstein's sexual orientation frankly and with sensitivity.

Wittgenstein, Ludwig. *Philosophical Investigations.* Translated by G. E. M. Anscombe. New York: Macmillan, 1953. Contains a foreword by Wittgenstein explaining how he came to this theory and his thoughts about *Tractatus Logico-Philosophicus.* Reading *Philosophical Investigations* will open up new vistas to serious students of the philosophy of language as well as to those whose interests center on epistemology.

_____. *Tractatus Logico-Philosophicus.* Translated by D. F. Pears and B. F. McGuinness. Rev. ed. London: Routledge and Kegan Paul, 1974. This revision incorporates Wittgenstein's own suggestions along with comments that can be found in his correspondence with C. K. Ogden. Contains an introduction by Bertrand Russell.

Maxine S. Theodoulou

Cross-References

Freud Inaugurates a Fascination with the Unconscious (1899), p. 19; William James's *Pragmatism* Is Published (1907), p. 171; Jung Publishes *Psychology of the Unconscious* (1912), p. 309; Sartre's *Being and Nothingness* Expresses Existential Philosophy (1943), p. 1262; Lévi-Strauss Explores Myth as a Key to Enlightenment (1964), p. 1995; Derrida Enunciates the Principles of Deconstruction (1967), p. 2075.

HAŠEK'S *THE GOOD SOLDIER ŠVEJK* REFLECTS POSTWAR DISILLUSIONMENT

Category of event: Literature
Time: 1921-1923
Locale: Prague, Czechoslovakia

As Czechs celebrated the birth of their republic after World War I, Hašek's novel reminded them of human folly in times of crisis

Principal personage:
JAROSLAV HAŠEK (1883-1923), a controversial Czech writer who used his World War I experiences as inspiration for his masterpiece

Summary of Event

Jaroslav Hašek's *Osudy dobrého vojáka Švejka ve světove valky* (1921-1923; published in English first as *The Good Soldier: Schweik* in 1930 and in an authoritative translation as *The Good Soldier Švejk and His Fortunes in the World War* in 1973), is the story of a wise fool, Josef Švejk, who refuses to fight for the Austro-Hungarian cause when he is drafted into the army during World War I. Published over a two-year period, the novel was left unfinished when the author, Jaroslav Hašek, died suddenly in January, 1923; at that point, barely four volumes of his proposed six-volume story were complete. The novel, though, was already a popular success in the newborn Republic of Czechoslovakia.

What kind of book is *The Good Soldier Švejk*? It is a picaresque tale in substance and structure, and at first glance, it appears to be artless in execution. Closer inspection reveals the opposite, however; the reader discovers that the fat, balding, middle-aged ex-soldier Švejk is a man of deceptive qualities. Hašek leads him through a series of carefully prepared scenes designed to satirize the officialdom of an empire being gradually torn apart by war. At each step, from Švejk's arrest for making indiscreet remarks about the assassination of the Archduke Ferdinand, to his interrogation by civil and military authorities, to his enforced enlistment, to his postings as orderly to various officers, to his AWOL wanderings across the Central European landscape, the reader always confronts the same unruffled figure. The meaning of mighty events may elude him, but Švejk always understands the meaninglessness of the petty vanities and stupid decisions that swirl about him. Thus Hašek brilliantly carries off his double purpose as an entertainer and serious novelist. Readers relish seeing Hašek's little man win out against the bullies who confront him even as they witness the author's impassioned attack on militarism, religion, politics, and injustice.

The gestation of Hašek's novel occurred over at least a decade. In 1912, he published a collection of short stories, some of which concerned a soldier named Švejk. Five years later, there followed a more ample set of tales about Švejk's adventures as a prisoner of war in Russia. These stories, like the episodes in the novel, were partly autobiographical.

Like Švejk, Hašek came to soldiering almost as a last resort after a shiftless life. Born in 1883, he worked as a bank clerk before switching to journalism in Prague. A natural storyteller, he penned scores of anecdotal pieces for newspapers and magazines, all the while honing his skill by entertaining habitués of the city's taverns over steins of ale. Politically, Hašek was an anarchist, but a harmless one, despite his run-ins with the police. When war broke out, he was drafted into the Austrian army in 1915.

Hašek joined the Ninety-first Infantry Regiment—the same unit as Švejk—and served in southern Bohemia before moving east to Hungary and thence to the front in Galicia. He met few officers he admired; he detested most. In September, 1915, his unit was cut off as the result of a sudden Russian breakthrough, but although there was a chance to escape, Hašek surrendered himself to the Russians. Why he did so is not clear; perhaps it was a political decision, perhaps he was merely being an opportunist. Imprisoned in camps in the Ukraine and later in the Urals, he always tried to find ways to ingratiate himself with his captors. When news came of the formation of the Czechoslovak Legion—a volunteer force of Czechs and Slovaks in Russia, many of them former soldiers of the Austro-Hungarian armies—Hašek applied at once.

Soon he was active as a propagandist for the legion and other Czech organizations, but this nationalist phase was eventually succeeded by a Communist one; he joined the Red Army and the Russian Bolshevik Party in 1918. Two years later, however, he returned to Prague and nationalist politics. It must have seemed to him then that his long peregrinations were over. Foolishly, though, he alienated sympathizers when he brought back a wife from Russia without having divorced his long-suffering first wife, Jarmila, whom he had married in 1910. Scorned and distrusted on all sides, Hašek had to fall back on his literary talents, and it was not long before the novel about his good soldier began to take shape.

With these facts in mind, it is easy to understand some of the glaring differences between Hašek and Švejk. Clearly, the author's hard, physical life led to a premature death, but his frequent acts of opportunism—though often performed for reasons of survival—took their toll as well. By writing the novel, he may have hoped to create a sympathetic image of himself and thereby justify the vagaries of his existence. On the other hand, Švejk is stolid and predictable; he only appears stupid by pretending to agree with his superiors and following their orders to the letter. Thus, when Lieutenant Lukáš orders him to take care of his mistress' needs, no matter what, Švejk willingly obeys as she seduces him. Again, when Švejk assists the drunken chaplain, Katz, to administer the eucharist, or endures Lieutenant Dub's badgering, his refusal to protest speaks volumes. He is a malingerer, as his enemies say, but this is his way of fighting his private war against the system.

Impact of Event

Hašek's novel appeared when antiwar literature about World War I was still in its infancy. Its popular success in Czechoslovakia can be accounted for easily enough: It

was written in common Czech; the protagonist was regarded, tolerantly, as a buffoon, imagined more like the caricature figure he is in Josef Lada's series of cartoons (which illustrated the novel) than a rounded character; and Hašek's jeering attitude toward the late empire was readily shared by the citizens of the proud young state. The fact that, initially, the literary establishment ignored or savaged the book and its author can be explained for the opposite reasons: They felt that the book's language was "low" in style; that Švejk was a lowbrow figure, suitable for the semi-literate mass readership of the Sunday supplements but hardly worthy of serious discussion; and that Hašek's devious career and personality discredited him as a representative of the young republic's literature. In any case, neither the man in the street nor the intellectual, perhaps, thought very much about Hašek's antiwar theme.

Nor did people in the rest of the world, it would seem. In the aftermath of the worst war in history to that time, the sense of relief that the carnage was over was too great for people to be much concerned with antiwar writing. (A similar postwar reaction occurred after World War II, when a respite of several years was needed before interest in that war's fiction arose.) Moreover, people and governments were preoccupied by the inevitable problems of the Versailles treaty, postwar economic recessions, the Red Scare, and the sensations of liberalized entertainments and mores.

Still, the antiwar movement had begun during the war. Henri Barbusse published *Le Feu* (1916; *Under Fire*, 1916), a novel which established the tone, theme and structure of most antiwar literature of the next fifteen years. What is especially significant about Barbusse's work is that it appears to present direct, personal experience of the war; it seems to provoke a mood of pity and disillusionment in the reader; and it employs a vigorous, realistic style. Like Barbusse, his literary followers were veterans of the war and determined antimilitarists. Among the most representative of these were Ernst Jünger, who wrote *In Stahlgewittern* (1920; *The Storm of Steel*, 1929), E. E. Cummings, who wrote *The Enormous Room* (1922), and Robert Graves, who wrote *Goodbye to All That: An Autobiography* (1929). The big year for antiwar fiction was 1929, when two of the genre's most memorable novels appeared: Erich Maria Remarque's *Im Westen nichts Neves* (*All Quiet on the Western Front*, 1929) and Ernest Hemingway's *A Farewell to Arms*.

Yet Hašek's book is not an antiwar novel in the same way that those works are. For the most part, it avoids direct presentation of frontline fighting and destruction, only alluding to the aftermath of battle in sarcastic asides. The prevailing mood is not pity, nor even disillusionment, since Hašek's satiric eye is already predisposed to view men and events in a jaundiced manner. What it does instead is focus on the behind-the-front milieu, tracing the experiences of a single soldier. The society of army life is Hašek's subject, and he is both pitiless and amusing in his portrayal of it.

Švejk, at the center of this society, is an *eiron*, a self-deprecating comic figure, the kind known to audiences and readers since ancient times. Because he sees life as it is, he is a mystery and a troublemaker to those who wish to manipulate others to their ends. This latter group are the *alazons*, the self-important braggarts who are the necessary complement to the *eiron*. Švejk is a wise fool, knowing more than he

lets on and thus appearing as ingenuous to his tormentors. The reader knows that Švejk is not a simpleton because of his habit of telling long-winded stories whenever an incident reminds him of something that happened elsewhere. Often these tales befuddle or bore the other characters, but they provide the reader with a standard by which to judge the present situation. Moreover, although Švejk complies with orders, his very complacency reveals the senselessness of events. For example, when news comes that Austria is at war with Italy (thus beginning a war on two fronts, which every sensible leader in Europe wished to avoid), he says that

> now that we have one enemy more, now that we have a new front again, we'll have to be economical with our munitions. "The more children there are in the family, the more the rods are used," as grandpa Chovanec at Motol used to say. . . .

The wisdom of Švejk emerges in passages such as this, but it is also clear that Švejk is not a leader and cannot extricate his hapless society from the mess it creates.

Hašek's place in the history of Czechoslovakian literature is secure, as most critics now agree. In fact, he may be regarded as one of the founders of modern Czech writing. For much of European history, the lands of Czechslovakia have been ruled by other states or ideologies. Only between the world wars of the twentieth century and since late 1989 has the country been independent. Yet whatever their political fortunes, Czechs have produced a distinctive literary tradition. Hašek helped forward that tradition when, along with his contemporaries Franz Kafka and Karel Čapek, he defended personal liberty and decried modern tyranny and conformity. A similar vein of protest occurred after 1948, when the country fell behind the Iron Curtain and a new group of writers, including Milan Kundera and Václav Havel, emerged as opponents of the Communist regime.

In this perspective, Hašek's little man has an honorable place. Švejk is not handsome, not brilliant, but he is a free man and determined to remain so.

Bibliography

Arden, Stuart. "The Good Soldier Schweik and His American Cartoon Counterparts." *Journal of Popular Culture* 9 (Summer, 1975): 26-30. Amusing article, but finally misleading. Seeks to compare Hašek's character to a host of American cartoon characters, such as the Sad Sack, Willie and Joe, and Beetle Bailey, to which Švejk allegedly gave birth. The satiric purpose of Hašek compared to the comedic intent of cartoons is touched on briefly.
Fiedler, Leslie A. "Foreword: The Antiwar Novel and the Good Soldier Schweik." In *The Good Soldier: Schweik*, translated by Paul Selver. Reprint. New York: New American Library, 1963. Outlines the heroic tradition in European literature and shows how Hašek's novel is one of the pioneering works of the twentieth century antiheroic revolt. Moreover, Fiedler explores the author's abundant humor, which made the novel unique among antiwar fiction.
Klein, Holger, ed. *The First World War in Fiction: A Collection of Critical Essays.* New York: Barnes & Noble, 1977. Klein assembles eighteen essays on twenty-two

writers of 1920's war novels. Well-known novelists such as Hašek, Hemingway, and Remarque are discussed, but the work of lesser-known figures is highlighted as well.

Nimchuk, Michael John. *The Good Soldier Schweik.* Toronto: Playwrights Canada, 1980. A play by a Canadian dramatist based on Hašek's novel. Produced in Toronto in 1969, it was probably inspired by the short-lived Prague Spring of 1968. One of several theatrical and cinematic adaptations of the story that have appeared since the 1930's.

Škvorecký, Josef. "Czech Writers: Politicians in Spite of Themselves." *The New York Times Book Review*, December 10, 1989: 1, 43-45. A reflection on the events of the so-called Velvet Revolution of December, 1989, when the Communist regime of Czechoslovakia fell and was replaced by a democratic government led by dramatist Václav Havel. Škvorecký, a distinguished Czech novelist living in Canada, offers a sketch of the protest role Czech writers have played during times of autocracy since the Renaissance.

Stern, J. P. "War and the Comic Muse: *The Good Soldier Schweik* and *Catch-22.*" *Comparative Literature* 20 (Summer, 1968): 193-216. One of the best short studies of the novel. Stern is especially interested in Hašek's satire of militarism, which, he maintains, is often backhanded, coarse, and even unfunny. Relevant comparisons are made with Joseph Heller's classic of American experience in World War II.

The Good Soldier Švejk and His Fortunes in the World War. Translated by Cecil Parrott. London: Heinemann, 1973. Parrott's translation—the basis of this article—is the most authoritative version in English; Paul Selver's 1930 translation is a bowdlerized, abridged text only two-thirds of the original's length. Parrott offers an excellent biographical essay, includes many of Josef Lada's original illustrations with the text of the novel, and provides several useful maps of the region.

Eric Thompson

Cross-References

Heart of Darkness Reveals the Consequences of Imperialism (1902), p. 51; *The Metamorphosis* Anticipates Modern Feelings of Alienation (1915), p. 396; Eliot Publishes *The Waste Land* (1922), p. 539; *All Quiet on the Western Front* Stresses the Futility of War (1929), p. 767; Pasternak's *Doctor Zhivago* Is Published (1957), p. 1747; *Catch-22* Illustrates Antiwar Sentiment (1961), p. 1866; Havel's *The Garden Party* Satirizes Life Under Communism (1963), p. 1967.

SCHOENBERG DEVELOPS HIS TWELVE-TONE SYSTEM

Category of event: Music
Time: 1921-1923
Locale: Vienna, Austria; Boston, Massachusetts; and Los Angeles, California

Arnold Schoenberg developed his twelve-tone system, providing a systematic organization for atonal music and profoundly influencing music composition in the twentieth century

Principal personages:

ARNOLD SCHOENBERG (1874-1951), the originator of the atonal twelve-tone system of music composition, from which all further serialist music is derived

ALBAN BERG (1885-1935), a pupil of Schoenberg and a member of the Second Viennese School

ANTON VON WEBERN (1883-1945), a pupil of Schoenberg and the third member of the Second Viennese School

IGOR STRAVINSKY (1882-1971), a leading neoclassical composer

KARLHEINZ STOCKHAUSEN (1928-), a pupil of Webern and an important member of the second generation of twelve-tone composers who extended the principles of serialism beyond pitch to include other features of music

Summary of Event

Music from the seventeenth to the early twentieth centuries—from the simplest melody to the most complex symphony—was tonal. By 1907, however, after arriving at what they considered to be the limits of tonality, composers experimented with atonality. In 1923, Arnold Schoenberg premiered his organizational system called twelve-tone, or dodecaphony, thereby providing a bold new alternative for all future music composition.

In Western tonal music, one pitch or note out of the twelve chromatic notes is central to the composition and is called the tonal center, or tonic. All other notes seem to gravitate toward the tonal center and are in fact grouped in hierarchical order of importance around it. This organization determines the composition's key. Each key, or scale, consists of seven notes—the remaining five are peripheral and deemphasized—and forms the basis from which all melody and harmony is derived. Since notes are at relative intervals from one another, a composition can be transposed into any key by changing the tonic but retaining the same relative distance between remaining pitches. In the 1920's, after abandoning the tonal center and providing an alternative system of harmonic organization, Schoenberg fundamentally altered the prevailing conviction that music required tonality.

A native Viennese, Schoenberg was heir to the compelling musical tradition of the nineteenth century—Romanticism. Thoroughly German in nature and in origin and

in striking contrast to classicism, which presupposed the universality of emotion, Romanticism emphasized intense individual experience, including even the mystical realm of the subconscious. In their quest for emotional expression, late Romantic composers, most notably Richard Wagner, strained against the limits of traditional tonality. Emphasizing modulation (changes from one key or tonality to another) and chromaticism (greater use of the secondary notes between the principal notes of any key), Wagner attained the apogee of emotionalism and expression, yet all of Wagner's compositional techniques functioned within tonality.

By the turn of the twentieth century, many non-German composers, aided by a disillusionment with the pitfalls of extreme sentimentality and maudlin emotionalism seemingly inevitable in Romanticism and motivated by turbulent political and economic trends in the two decades before World War I, sought new forms of musical expression. In the post-Romantic era, several new styles emerged. A late nineteenth century resurgence of nationalism encouraged many composers, particularly those from countries without native historical musical traditions, to seek new forms of musical expression. The Russians Peter Ilich Tchaikovsky and Modest Mussorgsky, the Czech Antonin Dvořák, the Norwegian Edvard Grieg, the Englishman Ralph Vaughan Williams, and the American Charles Ives, for example, incorporated traditional folk songs in their compositions, wooing listeners from German Romanticism. Others, such as Gustav Holst, who was fascinated by Hindu mysticism, experimented with non-Western music. In France, a coterie of composers, most notably Claude Debussy, influenced by the Impressionist painters, developed a French Impressionist tradition of composition shunning the extreme emotionalism and grandiloquence of German Romanticism and embracing a delicate, evocative sensuality—in a sense, a more discreet French Romanticism.

In Germany and Austria, meantime, composers who were heir to German Romanticism continued writing in the Romantic style. Led by Schoenberg and influenced by the expressionist painters (including Schoenberg, whose paintings were already selling for high prices), these composers formed the expressionist school of composition. While French Impressionists sought a more discreet Romanticism, expressionism was passionate and unabashedly emotional. Focusing on the inner experiences of human beings, expressionism was also preoccupied with the subconscious world of dreams as described by the Austrian Sigmund Freud in his comparatively new psychoanalytical theory.

In his early compositions, following in the path forged by Wagner, Schoenberg explored the extreme limits of chromaticism by using large ensembles and lengthy Romantic musical forms. Soon, however, his post-Romantic expressionism was becoming atonal. It appeared that Wagner had carried musical expression to the limits of tonality, and a logical progression from Wagnerian chromaticism was toward atonality. The dissolution of tonality, however, required the abandonment of the traditional rules of composition. To provide an organizational framework for his atonality, therefore, Schoenberg developed his twelve-tone system. It was, he claimed, born of necessity.

It took several years of experimentation for Schoenberg to systematize atonality. By 1923, in his Five Piano Pieces, Op. 23, Schoenberg's twelve-tone system made its first appearance. For several years, he continued its refining. His Suite for Piano, Op. 25 (1924) marked the first use of twelve-tone as the structural basis for an entire composition, while the Wind Quintet, Op. 26, also from 1924, for flute, oboe, clarinet, bassoon, and French horn, was the first atonal composition for several instruments. By the time of his Variations for Orchestra, Op. 31, written between 1926 and 1928, Schoenberg had thoroughly explored and mastered his dodecaphonic system.

In providing structure for atonal compositions, Schoenberg's system grants equal emphasis for all twelve chromatic tones, which are presented in a series, or row. The pitches of the "tone row" are uniquely ordered for each composition. The row, with its peculiar sequence of intervals, must be played in sequence; notes can sound in any octave but cannot be repeated until the whole series has been played. Lest the system seem constricting or mechanical, variety is achieved by using the row in four forms: original, retrograde, inverted, and retrograde inversion. Additionally, the row can be divided into subgroups. Denoting a method, not a form of composition, twelve-tone can in theory be applied to any style of music. Initially, however, it was associated exclusively with Schoenberg and his pupils.

Retrospectively, twelve-tone appears a logical progression from the post-Wagnerian dissolution of tonality. In context, though, Schoenberg's system was revolutionary. Twelve-tone, he claimed, prophetically, would ensure German dominance in music for another century; Schoenberg's dodecaphony did, in fact, profoundly influence music composition in the twentieth century.

Impact of Event

In the 1920's, public acceptance of Schoenberg's revolutionary new system was woefully lacking. Shouting and booing at his concerts made listening virtually impossible, and fistfights were common among members of his audiences. Essentially a self-taught Viennese musician from a marginally middle-class family, Schoenberg never functioned within the mainstream of the Vienna musical establishment. Audiences and critics alike despised his music. Despite a lack of public support, however, Schoenberg received sanction from some of Vienna's most influential composers, most notably Gustav Mahler, who acted as his mentor. Mahler's attendance at Schoenberg's early concerts lent a modicum of credibility to the young composer's works.

In a bid to make his music more accessible to Viennese audiences, Schoenberg in 1918 conducted ten open rehearsals of his First Chamber Symphony, Op. 9 (1906). By providing the public with multiple opportunities for hearing the symphony as well as listening to Schoenberg discourse on it, the well-attended rehearsals successfully bolstered public approval of his music. Encouraged, Schoenberg organized the Verein für Musikalische Privataufführungen (the Society for Private Musical Performances) in order to increase the number of performances of his own work and the work of his contemporaries as well as to provide a protected environment in which

critics were banned. Slowly, Schoenberg's work gained greater public acceptance.

While later audiences have greeted his work with greater aplomb than did the conservative Viennese of the 1920's, Schoenberg's music has yet to attain popularity. The influence of his twelve-tone system upon composers, however, has been profound. While the dissolution of atonality required the abandonment of traditional roles of composition, twelve-tone provided a new harmonic framework within which atonality could function. As an organizational system, twelve-tone serialism has fundamentally shaped music in the twentieth century, as all later serialist music evolved from Schoenberg's original twelve-tone system.

Until the 1950's, however, twelve-tone was overshadowed by the other major compositional trend, neoclassicism. During the interim between the two world wars, two major factions evolved. One camp formed around Schoenberg and his atonal dodecaphony, with its roots planted firmly in the Romantic tradition of emotional expressionism. Another surrounded Igor Stravinsky and his ardently primitivistic, anti-Romantic neoclassicism. A polarization occurred between proponents of the two schools. Dodecaphony, however, was a system sufficiently rich in potential to prevail. For unlike neoclassicism, it is not related to any one style; rather, it is a method that can be applied to any musical form. Since the 1950's, dodecaphony has flourished as neoclassicism has declined—even Stravinsky incorporated the technique in his later compositions—and has remained a dynamic compositional technique.

Schoenberg's twelve-tone method was perpetuated and expanded by several talented pupils. A demanding taskmaster, Schoenberg was accorded high regard from his disciples, who jealously defended their teacher even as their own styles evolved in fundamentally different directions; while tutoring them in his own method, Schoenberg nurtured his pupils' individuality. Meanwhile, Schoenberg's acuity and compositional ability became legendary among his students, as he composed rapidly and copiously in their presence. Not content merely to identify students' mistakes, Schoenberg would instantaneously devise possible musical solutions for their edification.

Of all Schoenberg's students, Anton von Webern and Alban Berg became the most famous. Both became accomplished serialist composers whose music differed substantially from each other's and from their teacher's. Beginning their instruction with Schoenberg in 1904, they explored with him chromaticism, atonality, and ultimately twelve-tone, progressively embracing each method. While following their teacher in his forays into twelve-tone, both composers formed vastly personal styles. Berg, on the other hand, applied his master's methods with great freedom, using tone rows and tonal-sounding chords and thereby retaining vital connections with lyrical Romanticism. His lyric opera *Wozzeck* (1921) with its nearly tonal rows and forms adapted from classicism, is a perennial favorite. Webern, on the other hand, exemplified the more progressive potential of twelve-tone. Writing principally for chamber music ensembles, Webern used sparse instrumentation that focused on individual melody. Unlike Schoenberg and Berg, however, Webern abandoned the classic forms to write music that is athematic and devoid of tonality.

Gathering at the Darmstadt summer composers' program between 1946 and 1953,

a contingent of young composers inspired by Webern perpetuated and refined Schoenberg's dodecaphonic system. Most notable was Karlheinz Stockhausen, who extended the principle of tone rows to incorporate all elements of music, including timbre, rhythm, and dynamics, thus expanding the original twelve-tone into a comprehensive system that came to be known as serialism.

As his influence was spreading in Europe, Schoenberg's career in Austria and Germany was abruptly curtailed by Adolf Hitler's rise to power and subsequent banning of twelve-tone music. In 1933, Schoenberg, a Jew, emigrated to the United States to escape Hitler's tyranny. It was through teaching posts in Boston and at the University of California that Schoenberg's influence on American composers began. From 1933 to his death in 1951, Schoenberg taught a battery of new composers, including Leon Kirchner and John Cage. His influence upon Americans was immense, and his work affected even composers who had never been his pupils (most notably Roger Sessions, who further developed the twelve-tone technique). Unlike Stockhausen, who rigidly adhered to the techniques of serialism, Sessions incorporated twelve-tone into his music, which was a mixture of several influences.

As Schoenberg's twelve-tone remains a dynamic force, with members of each new generation of composers incorporating serialist techniques into their compositions, Schoenberg's reputation continues to grow. He has become arguably the most influential composer of the twentieth century.

Bibliography

Copland, Aaron. *The New Music, 1900-1960.* Rev. ed. New York: W. W. Norton, 1968. Originally written in 1944, but republished with additional comments by the author for the 1968 edition. Readable and informative introduction to new music for the general public written by one of America's premier composers. Contains 192 pages with index.

Hansen, Peter S. *An Introduction to Twentieth Century Music.* Boston: Allyn & Bacon, 1971. A 450-page survey of twentieth century music containing end-of-chapter bibliographies, index, and numerous musical examples. Useful, readable source on twentieth century music for the nonspecialist who is able to read musical notation. Provides detailed discussion of Schoenberg's music and its context.

Liebowitz, Rene. *Schoenberg and His School: The Contemporary Stage of the Language of Music.* Translated by Dika Newlin. New York: Philosophical Library, 1949. An older work in lecture format, but engaging and informative without requiring extensive specialized knowledge. Describes development of atonality and includes sections on Schoenberg, Berg, and Webern. Bibliography and index.

Machlis, Joseph. *Introduction to Contemporary Music.* New York: W. W. Norton, 1979. Also for the nonspecialist. Machlis provides a detailed 750-page survey of twentieth century music. Organized chronologically, with sections on Schoenberg firmly placing him in context. Contains appendices providing detailed definitions of basic musical concepts, dictionary of contemporary composers, and texts of vocal works. Liberally illustrated.

Rognoni, Luigi. *The Second Vienna School: Expressionism and Dodecaphony.* Translated by Robert W. Mann. London: John Calder, 1977. Detailed work tracing the transition from tonality through atonality to the twelve-tone system. Intended for the specialist with knowledge of harmony and theory but appropriate for the intelligent amateur. Illustrations, musical examples, footnotes, index.

Salzman, Eric. *Twentieth-Century Music: An Introduction.* Englewood Cliffs, N.J.: Prentice-Hall, 1967. A survey of twentieth century music aimed primarily at the specialist but appropriate for an informed amateur. Useful section on the impact of Schoenberg's music. Requires substantial knowledge of music history and theory. Illustrations, end-of-chapter bibliographies, index.

Smith, Joan Allen. *Schoenberg and His Circle: A Viennese Portrait.* New York: Schirmer Books, 1986. A nontechnical oral history project designed to preserve the memories of several people, including pupils, involved in Schoenberg's "Vienna circle." As such, a useful introduction to Schoenberg and his music, providing insights into Schoenberg's character and descriptions of the reception of his music in Vienna. Index, bibliography, illustrations, footnotes.

Mary E. Virginia

Cross-References

Mahler Revamps the Vienna Court Opera (1897), p. 7; Busoni's *Sketch for a New Aesthetic of Music* Is Published (1907), p. 166; Schoenberg Breaks with Tonality (1908), p. 193; Webern's *Six Pieces for Large Orchestra* Premieres in Vienna (1913), p. 367; Berg's *Wozzeck* Premieres in Berlin (1925), p. 680.

PIRANDELLO'S *SIX CHARACTERS IN SEARCH OF AN AUTHOR* PREMIERES

Category of event: Theater
Time: May 10, 1921
Locale: Rome, Italy

Luigi Pirandello's Six Characters in Search of an Author *opened to a hostile audience but received worldwide attention and became one of the most influential dramas of the modern period*

Principal personages:

LUIGI PIRANDELLO (1867-1936), a playwright who brought an absurdist vision to modern drama

GEORGES PITOËFF (1886-1939), the director who produced *Six Characters in Search of an Author* in France

GEORGE BERNARD SHAW (1856-1950), an English playwright who produced *Six Characters in Search of an Author* in England

MAX REINHARDT (MAX GOLDMANN, 1873-1943), a director who staged *Six Characters in Search of an Author* in Germany

Summary of Event

By 1921, Luigi Pirandello had established himself as an innovative short-story writer and novelist. Some of his dramas had already dealt with themes that focused on the relative nature of truth, but during World War I, Pirandello had been stricken with a profound sense of despair that allowed him to focus on the meaninglessness of existence and the irrationality of human actions. Out of his own personal suffering, he began to create a dramatic form that would express the sense of alienation that had become a part of the modern age. As early as 1918, he was obsessed with the notion that six characters were trying to get him to write a novel about them; however, he did not want to write their story, because he did not care about them or about anyone else.

The novel was not written, but Pirandello's idea evolved into the play *Sei personaggi in cerca d'autore* (1921; *Six Characters in Search of an Author,* 1922), a play in which six characters abandoned by their author barge into the rehearsal of a play and try to get the actors to let them create their own drama. Their story focuses on an eccentric man who encourages his wife to run off with a lover and who later finds himself about to have sex with his stepdaughter, unaware of who she is. The crux of the play, however, comes in the disparity between how the characters see themselves and how the actors portray them. As the stepdaughter and the father try to re-create the scene of their assignation and what led up to it, the truth becomes blurred by various accounts of events.

Six Characters in Search of an Author was produced by Dario Niccodemi at Teatro Valle in Rome on May 10, 1921. The spectators were offended when they entered the theater to see that the curtain had already been raised and that the stage had been set up for a rehearsal. When six characters walked out from the back of the auditorium, the audience booed. Some cried out "madhouse" and "buffoon." A riot broke out in the theater, and when Pirandello appeared on stage, the audience grew more raucous. Pirandello and his daughter hid for almost an hour and tried to sneak out a back alley, but Pirandello's hecklers pursued him through the street until he caught a taxi. After he left, the melee continued into the night.

Six Characters in Search of an Author evoked a powerful audience reaction in Rome, but when it played the Teatro Manzini in Milan on September 27, 1921, the play was a success, and the influence of Pirandello spread throughout the world. The play began to send shock waves across the theatrical worlds of Europe and America and was produced as far away as Tokyo and Buenos Aires. Between 1922 and 1925, it was translated into twenty-five languages. In England, the Lord Chamberlain prevented all public performances of the play on the grounds that the play would be spiritually disturbing to an audience. George Bernard Shaw, England's foremost playwright of the early twentieth century, arranged a private performance by the Stage Society on February 27, 1922. Shaw later stated, "I have never come across a play so original as *Six Characters.*" In America, *Six Characters in Search of an Author* appeared at the Princess Theater on October 30, 1922. Jack Crawford of *The Drama* called it "the most original drama I have ever seen" and awarded it the magazine's first prize among the year's foreign plays.

The greatest impact of *Six Characters in Search of an Author* came in France. George Pitoëff presented the play at the Théâtre des Champs Elysées in Paris on April 10, 1923. Although the audience response was not immediate, the play achieved critical acclaim. Pitoëff added to the play's effect by having the six characters brought down in an elevator, an event that stayed in the memory of many famous French playwrights. The play was also produced by the famous director Max Reinhardt in Germany, where it played 131 performances. Reinhardt added many expressionistic elements to the play.

Six Characters in Search of an Author caused such a cataclysmic reaction because it used the theater itself as a means of reflecting on the very nature of reality. Pirandello blurred the distinction between theater and life at the same time as he questioned the theatrics of everyday life. For Pirandello, the sense of self breaks down into a series of roles. The father in *Six Characters in Search of an Author* points out that people are not the same today as they were yesterday. Reality itself is in constant flux, and absolute truth is impossible to determine. In a universe where everyone lives in his or her private, illusory world, life itself becomes meaningless, and communication breaks down. In the play, the father even notes the inability of words to communicate. Pirandello posed a paradox that was to influence the direction of modern theater. For Pirandello, theater falsifies life, but life itself is no more than theatrics and is just as illusory as theater. Pirandello went beyond the bourgeois

theater of realism and opened up a theater that would not try to express reality in all of its details or try to reflect life in the guise of illusion. Instead, he created a theater that questioned the nature of reality and penetrated the illusion of theater. With *Six Characters in Search of an Author*, Pirandello brought theatricalism to the forefront of modern theater. As one playwright put it, "The entire theater of our era came out of the womb of that play, *Six Characters.*"

Impact of Event

When Pirandello wrote *Six Characters in Search of an Author*, Western civilization was still smoldering from the effects of World War I. Whatever was left of the nineteenth century concept of a harmonious world order held together by a sense of absolute values was blown away in the devastation of mechanized warfare. The old order and the great dynasties of Europe and Russia had crumbled, and no new order was there to take its place. In 1915, during the war, Albert Einstein refined his theory of relativity. His theory dismantled the Newtonian order of the universe that was held together by the immutable laws of physics. Time and space would no longer be considered fixed entities but could change depending on the position of an observer. Like Einstein, Pirandello also postulated a theory of relativity. The Father in *Six Characters in Search of an Author* continually points out that each person can only see the world through his or her point of view. Thus, life is based on illusion.

Playwrights in France influenced by the production of *Six Characters in Search of an Author* picked up on Pirandello's themes and style. Jean Giraudoux focused on characters who need to create illusions in order to survive. In *Intermezzo* (1933; *The Enchanted*, 1950), he shows how a young girl's illusions should not be destroyed outright. In *La Folle de Chaillot* (1945; *The Madwoman of Chaillot*, 1945), a group of old women need to hold onto the fantasy of an imaginary dog. Like Pirandello, Giraudoux focused on split and multiple personalities. Jean Anouilh also followed a Pirandellian line in his plays, which deal with characters who try to escape from themselves. In *Le Voyageur sans bagage* (1937, *Traveler Without Luggage*, 1959), Gaston, an amnesia victim, tries to escape from Jacques, his past self. In *Colombe* (1951; *Mademoiselle Colombe*, 1954), the young Julien is puzzled by the woman he loves, who is both an innocent young girl and a worldly actress.

Anouilh also used the play-within-a-play motif. In *La Répétition: Ou, L'Amour puni* (1950; *The Rehearsal*, 1958), a group of actors rehearsing a play discover the similarities between the characters they are playing and the lives they are leading. Anouilh carried the breakdown between theater and life one step further in *Le Rendez-vous de Senlis* (1941; *Dinner with the Family*, 1958). Robert gets actors to portray his parents, but the actors begin to take their roles seriously and get confused between illusion and reality. Like Pirandello's father, characters in Anouilh's play find themselves caught between trying to be what they want to be and accepting roles in which others have cast them. In *Becket: Ou, L'Honneur de Dieu* (1959; *Becket: Or, The Honor of God*, 1962), Thomas Becket, a profligate churchman, finds that he has no sense of self and honor, but as soon as he is made Archbishop of Canterbury, he

takes on the role of archbishop, defending the honor of God and opposing the king who appointed him. According to Thomas Bishop, both Giraudoux and Anouilh were familiar with the first production of *Six Characters in Search of an Author* in Paris.

Pirandello also had an influence on writer and philosopher Jean-Paul Sartre. Sartre's existentialist heroes seek to slough off their false identities and to free themselves from all illusions in order to accept the meaninglessness of life courageously. For Sartre, humans are always in a state of becoming and cannot be frozen into one role. In *Six Characters in Search of an Author*, the father refuses to have his whole life judged by one incident, just as Gaston in Sartre's *Huis-clos* (1944; *No Exit*, 1946) refuses to stand condemned for one act of cowardice. Sartre once commented that Pirandello was the most timely of all modern playwrights.

Pirandello's influence also carries over into the Theater of the Absurd. Samuel Becketts's tramps create illusions, play roles and act out games in a world where truth is relative and existence has no meaning. They also call attention to the fact that they are acting in a play that they wish would end. Interestingly, Jean Anouilh compared the opening of Beckett's *En attendant Godot* (1952; *Waiting for Godot*, 1954) with the opening of *Six Characters in Search of an Author* in Paris. Absurdist playwright Eugene Ionesco also owed a debt to Pirandello. Ionesco saw Pirandello's drama as a foundation, an archetype for the modern idea of theater. Ionesco's characters are reduced to purely mechanical roles. They not only live in a world of illusion, but they also forget who they are and fail to recognize the people they supposedly have known all of their lives. The father in *Six Characters in Search of an Author* notes that words cannot communicate his feelings because words cannot penetrate the perceptions others have of him. Similarly, in Ionesco's drama, language fails to communicate and is reduced to nonsense and cacophony. Absurdist playwright Jean Genet carried Pirandello's concept of theatricalism to its ultimate conclusion in *Le Balcon* (1956; *The Balcony*, 1957) where wars, revolutions, and struggles for power are played out through sexual fantasies enacted in a brothel.

In America, Pirandello's influence can be seen in some of the works of Eugene O'Neill. O'Neill's plays deal with doubles, masks, and the impossibility of living in a world without illusions. In *The Iceman Cometh* (1946), the characters withdraw into drunken stupors in Harry Hope's barroom and tacitly agree to accept one another's illusions. American playwright Edward Albee also used Pirandellian themes of illusion and reality. In *Who's Afraid of Virginia Woolf* (1964), a couple create a fantasy child and kill it off. Many "happenings"—staged events that took place primarily in the 1960's—as well as later performance art emphasized the blurring between art and life that is the focus of Pirandello's work.

Postmodern drama focuses on the loss of self in an age of media images. Pirandello's concept of having an audience watch actors watch characters playing roles is relevant in an age in which soap-opera characters can become more real than one's neighbors. In an era of image consultants, "spin merchants," and media events, Pirandello's theatrical ideas are alive and well.

Bibliography

Bassnett-McGuire, Susan. *Luigi Pirandello.* New York: Grove Press, 1983. Briefly discusses the political and personal influences on Pirandello's work and concentrates on a detailed analysis of the major plays. Also touches on Pirandello's one-act plays and mentions his use of stage directions. Contains photographs of international productions and a bibliography, which includes not only plays in translation but also a list of periodicals devoted solely to articles on Pirandello.

Bentley, Eric. *The Pirandello Commentaries.* Evanston, Ill.: Northwestern University Press, 1986. A series of articles by an eminent critic and theorist of modern drama, spanning a lifetime's work of penetrating insights into Pirandello's major dramas. The articles include a review of Gaspare Guidice's biography of Pirandello as well as a short biographical profile of Pirandello. The appendix has the short story that is the source for *Right You Are (If You Say So).*

Cambon, Glauco, ed. *Pirandello: A Collection of Critical Essays.* Englewood Cliffs, N.J.: Prentice-Hall, 1967. A diverse collection of critical articles, including Adriano Tilgher's influential analysis of Pirandello's drama, Wylie Sypher's discussion of Pirandello's cubist approach to drama, Thomas Bishop's article tracing Pirandello's influence on French drama, and A. L. de Castris' dissection of Pirandello's experimental novels. The book features a detailed chronology of Pirandello's life and a selected bibliography of critical works on Pirandello.

Giudice, Gaspare. *Pirandello: A Biography.* Translated by Alastair Hamilton. Rev. ed. London: Oxford University Press, 1975. One of the more comprehensive biographies of Pirandello, even though it is an abridged version of the original. Details much of Pirandello's personal life, using quotations from numerous personal correspondence and other primary sources. The book includes extensive descriptions of Sicilian life-styles and a good analysis of the political climate in Italy during Pirandello's lifetime. Does not provide a detailed discussion of his works.

Oliver, Roger W. *Dreams of Passion: The Theater of Luigi Pirandello.* New York: New York University Press, 1979. This study shows a connection between Pirandello's theory of humor and his drama. The book presents a close analysis of five major plays.

Paul Rosefeldt

Cross-References

Sartre and Camus Give Dramatic Voice to Existential Philosophy (1940's), p. 1174; *Waiting for Godot* Expresses the Existential Theme of Absurdity (1953), p. 1573; Ionesco's *Rhinoceros* Receives a Resounding Worldwide Reception (1959), p. 1812; Esslin Publishes *The Theatre of the Absurd* (1961), p. 1871; Tawfiq al-Hakim Introduces Absurdism to the Arab Stage (1961), p. 1893; *The American Dream* Establishes Albee as the Voice of Pessimism (1961), p. 1903; Weiss's Absurdist Drama *Marat/ Sade* Is Produced (1964), p. 2005.

GREAT EVENTS
FROM
HISTORY II

CHRONOLOGICAL LIST OF EVENTS

VOLUME I

VOLUME II

VOLUME III

VOLUME IV

VOLUME V